A Virgil Thomson Reader

A
Virgil Thomson
Reader

By VIRGIL THOMSON

With an Introduction by JOHN ROCKWELL

HOUGHTON MIFFLIN COMPANY BOSTON
1981

Library of Congress Cataloging in Publication Data

Thomson, Virgil, 1896–
 A Virgil Thomson reader.

 "Bibliography of published writings of Virgil Thom-
son": p.
 Includes index.
 1. Music—Addresses, essays, lectures. I. Title.
ML60.T515 780 81-6375
ISBN 0-395-31330-9 AACR2

Printed in the United States of America

P 10 9 8 7 6 5 4 3 2 1

✒ Contents

INTRODUCTION

❧ *Virgil Thomson*
a Franco-Missourian American

by JOHN ROCKWELL

ANY NOTABLE COMPOSERS have written notable criticism. But in the vast majority of cases, the criticism was either a self-justifying forum or an enforced way to earn money, grudgingly attempted and rapidly abandoned as soon as composition itself started to pay off. Virgil Thomson's criticism was sustained over nearly a lifetime, reached far beyond narrow self-advertisement, and not only equaled his best music in quality, but mirrored its attributes.

Any critic-composer reveals as much about his own music as he does about his ostensible subject. In Thomson's case, this synchronicity is particularly exact, given the co-equal nature of his gifts as a composer and a prose stylist. Indeed, Thomson himself stresses this kinship with his reiterated argument that composers make the best critics.

Non-composing critics have a vested interest in disputing this view, just as Thomson had his own self-justifications as grounds for advancing it. In fact, it would seem, criticism is a calling in itself, and critics both good and bad have emerged from every possible background. Still, the argument that composers know better than anyone else how music is actually made is a persuasive one. And being a composer may well have contributed to Thomson's refreshing cynicism about star performers and the self-satisfied conservatism of performing-arts institutions. The insights a composer with a trenchant prose style can bring to music criticism are considerable, and Thomson stands as exalted proof of that.

Chief among those insights was the most basic one: a commitment to the music of his time, meaning a solid knowledge and a willingness to approach new music not with bland "objectivity" but with unabashed

passion. This might seem a point hardly worth making, except that such a commitment remains the exception among practicing music critics. Most pay lip-service to the idea of championing new composers, or at least "responsible" ones. But their hearts lie in the past, with the music that first kindled their love for the art. As such they are no worse than most "music lovers." But they have abdicated their highest role.

With Thomson everything, new and old, was seen with a fresh, contemporary spirit, and one not limited to music. He didn't accept all that was new. But he was open to every stylistic persuasion, even if he did have a happily admitted bias for things French and American. He also concerned himself with music that most music critics didn't consider serious music at all — jazz, folk, gospel — and with the sociological ramifications of a supposedly "pure" art form. Thomson confronted the crisis of serious contemporary music in our century by refusing to wallow unduly in the notion of crisis in the first place. He wrote with enthusiasm and perception about the new music he liked, sweeping his readers along with him. By so doing, he built bridges — long dilapidated or never constructed — between music, the other arts, and the American intellectual community.

Those bridges benefited both music and the community at large. Any art form runs the risk of growing moribund if it becomes too self-involved. Good new music of the past may not have appealed at first to the conservative concert-going public. But it attracted the poets, painters, and dancers, as too much twentieth-century music has failed to do. In Paris in the twenties and thirties, however, music was central to avant-garde culture, and when Thomson returned to New York in 1940, he stayed alive to such kinships. In fostering them in his writings and his music, he fostered the art of music itself, by reaffirming the inevitable sterility of isolation.

Bridges have two ends, and Thomson's literary gifts helped enliven the intellectual community beyond inspiring a few writers and painters to listen to music. Intellectuals understandably concentrate on the written word, and American intellectuals have long turned their eyes toward Europe, to the detriment of a truly American culture. Thomson's European connections were impeccable, yet he maintained a graceful balance between his American instincts and his European culture. He was thus able to establish a style authentically and unmistakably American in both his prose and his music, and to have it accepted by American intellectuals because of its meticulously crafted polish.

Thomson's criticism stands in relation to the evolution of American music criticism in precisely the manner that his music relates to the overall evolution of American music. The greatest American composers, of this century and before, have been outsiders, men who accepted the historical

rootlessness of American life and turned instead to its folk traditions and within themselves to create something new. Establishment American musical culture up until the First World War, on the other hand, was intensely Germanic. Just as the Germans provided the model for our educational and scientific establishments, so did they for our musicians. Many American composers (John Knowles Paine, Edward MacDowell, Charles Tomlinson Griffes) were actually trained in Germany. So, too, the leading American critics around the time of Thomson's birth were steeped in German culture — men like William James Henderson and Richard Aldrich and, later, Olin Downes. They were also opposed to what they regarded as the more extreme trends in modern music, and largely oblivious to the validity or even the existence of a cultural life apart from the educated classes.

Thomson, with his Franco-American wit, Parisian elegance, and Missouri frankness, stood as an antidote to such weighty sobriety. And he fulfilled the same function with the latter-day Germanic school of American composers and intellectual critics, who sought with Serialism to resurrect the German hegemony. It is hard now, in this age of deliberate simplicity and repetition among so much of the musical avant-garde, to realize how radical Thomson's childlike tonalities and tunes and his innocently straightforward prose could seem. By hewing to Baptist hymns and Erik Satie, he ran the risk of being dismissed by soberer sorts as something fluffy and trivial.

But Thomson was no cheerfully marginal gadfly, full of fun but not worth taking too seriously. There are such critics, wise guys without substance, although Thomson can hardly be held responsible for what is really another, less honorable American tradition. With Thomson, the jabs were always backed by strength and style — at once "sassy and classy," as he put it. Just as a remarkable depth of emotion lurks beneath the lulling tunefulness and folkish abstraction of his two Gertrude Stein operas, so, too, in his criticism, a clarity of vision and a profundity of refined feeling are never far from the simply elegant surface.

Thomson managed a synthesis of European and American culture that can help resolve the long-standing blurring of this country's self-image. He makes the point in the conversation with Diana Trilling included in this volume that he and the other American artists in Paris between the wars didn't think of themselves as "expatriates"; they were simply Americans living abroad. In terms of position, power, and recognition, Thomson became an archetypal American Establishmentarian. But as a Missourian who attended Harvard, an American in Paris, a musician among critics, and a critic among musicians, he has really always been a little bit of an outsider. His music and his prose may have been artfully simple, but he avoided the primitivism of some American outsiders, and

he used his outsider perspective to see more truly than most of us can. Above all, he never turned his back on any of his homelands. Indeed, in his music and his prose, he has given us as profound a vision of American culture as anyone has yet achieved.

Missouri Landscape with Figures

❧ *Missouri Landscape with Figures*

To ANYONE brought up there, as I was, Kansas City always meant the Missouri one. When you needed to speak of the other, you used its full title, Kansas-City-Kansas; and you did not speak much of it, either, or go there unless you had business. Such business was likely to be involved with stockyards or the packing-houses, which lay over the Kansas line in bottom land. The Union Depot, hotel life, banking, theaters, shopping — all the urbanities — were in Missouri.

So was open vice. One block on State Line Avenue showed on our side nothing but saloons. And just as Memphis and St. Louis had their Blues, we had our surely older *Twelfth Street Rag* proclaiming a joyous lowlife. Indeed, as recently as the 1920s H. L. Mencken boasted for us that within the half-mile around Twelfth and Main there were 2,000 second-story hotels. We were no less proud of these than of our grand houses, stone churches, and slums, our expensive street railways and parks, and a political machine whose corruption was for nearly half a century an example to the nation.

Kansas, the whole state, was dry. And moralistic about everything. There was even an anti-cigarette law. Nearly till World War II, one bought "coffin nails" under the counter and paid five cents more per pack than in Missouri. Though Kansas had always been a Free State and supported right in Kansas-City-Kansas a Negro college, most of our colored brethren preferred Missouri, where life was more fun. The truth is that Kansas was Yankee territory, windy and dry, with blue-laws on its books; and the women from there wore unbecoming clothes and funny hats.

As for the food, a touring musician described a hotel steak with "I drew my knife across it and it squeaked." As late as 1948, motoring west with the painter Maurice Grosser, I caused him to drive in one day from

Slater, in Saline County, Missouri, to Colorado Springs, 714 miles, by insisting one must not eat or sleep in Kansas. He had yielded, he thought, to mere Missouri prejudice. But we stopped once for coffee and a hamburger (safe enough), and noticing under a fly-screen some darkish meringue-topped pies I asked the waitress what kind they were, she replied, "Peanut butter." Grosser says I turned to him and simply said, "You see?"

I learned in my grownup years how beautiful Kansas can be in the middle and west, an ocean of mud in winter and of wheat in summer, with a rolling ground-swell underneath and a turbulent sky above, against which every still-unbroken windmill turns like a beacon. I came also in those later years to respect her university at Lawrence, especially for music, and to read her free-speaking editors, William Allen White of Emporia, Ed Howe of Atchison. I have wished merely to point out here, in telling what life was like on the Missouri side, that any Southern child from there inevitably grew up making fun of Kansas.

Such fun, of course, was chiefly made in private. Publicly our city was for tolerance. As a multiple railway terminus, it offered welcome equally to old Confederates, to business families from Ohio and New England, to German farmers, brewers from Bavaria, cattlemen from Colorado and the West, to miners, drummers, and all railroaders, to Irish hod carriers, Jewish jewelers, Eastern investors, and Louisiana lumberjacks, to schoolteachers, music teachers, horse showers, horse doctors, to every species of doctor and clergyman, and to many a young male or female fresh off the farm. In such a cosmopolis mutual acceptance was inevitable. So also was a certain exclusiveness, based on contrasts in manners, morals, and religion.

In my family's case, these conditionings were home-based in "Little Dixie," a central Missouri farming region bounded north, northwest, and northeast by the Missouri River and centered commercially round Boonville, Marshall, and in early days the river town Miami. This district had been settled in the 1820s and '30s by planters from the eastern counties of Virginia and further populated after the Civil War from northern Kentucky. My Virginia great-grandfather Reuben Ellis McDaniel had brought with him in '41 from Caroline County a household of thirteen whites and sixty Negroes. In Missouri he grew hemp and tobacco, traded in staples for his neighbors, raised a family of twelve, took part in the founding of colleges and Baptist churches, sent his sons by riverboat to Georgetown College in Kentucky. My Thomson great-grandfather, also a Virginia Baptist, had preceded him by two decades. My mother's people, settled in Kentucky since the 1790s, did not come till nearly 1880.

Farmers my people were, all of them, with an occasional offshoot into law, divinity, or medicine, rarely into storekeeping, never into banking. Baptists they were too, and staunch ones. I do not know when it got

started in Virginia, this business of their being always Baptists, though family records show persecutions for it there in the eighteenth century. And certainly there had long been Baptists in Wales, where many came from. It may be that the Welsh ones (and my mother's people seem virtually all to have borne Welsh names) were Baptist when they landed, a Captain John Graves in 1607, a Gaines shortly after. But the Scottish Thomsons (arriving a century later) and the Scotch-Irish McDaniels may well have been converted in the colonies. In any case, all were Baptists, every forebear of mine known to me, and after the Civil War, Southern Baptists.

The third historical fact dominating my childhood — after three centuries of mid-Southern slave-based agriculture and of belief in salvation by faith leading to total immersion — was the Civil War. I never heard it called in those days anything *but* the Civil War, either, except for short simply "the war." And I was brought up on it. My Grandmother Thomson was a Confederate war widow; all her brothers had fought on that side too, one being killed. My great-uncle Giles McDaniel had at nineteen escaped from the Federal prison in St. Louis, where my grandfather lay dying, returned briefly to his family, then as an escaped prisoner made his way from Missouri to Canada and thence to Virginia, where he joined Lee. The Thomson great-uncles, as well, all had war histories. And since Grandma, who was a quietly wonderful storyteller, regularly spent the winter with us in Kansas City, it can be imagined in what detail the war was reviewed as lived through on a Missouri farm by a widow with three small children.

Grandma Thomson, born Flora Elizabeth McDaniel in 1830, was already seventy in my earliest memories of her. These picture her short and slender as to frame, dressed in blacks, grays, or lavender, carrying outdoors or to church a reticule (small handbag with a reticulated metal top that opened like a row of x's), and wearing a bonnet (crescent-shaped small hat, covered with flowers or jet, which sat on her parted hair just forward of the bun and was held there by ribbons tied beneath the chin). To others she appeared as a gentlewoman not hesitant of speaking up to anyone, black or white, afraid indeed of nothing at all save God's anger and of crossing city streets.

Quincy Adams Thomson, born in 1827, must have owed his pre-names to the presidential incumbent, since he had no family connection to Massachusetts. Like Flora McDaniel he was one of twelve, and when they were married in 1856 he was twenty-nine. At this point he acquired land from his father and built a house.

Not long afterward, Flora developed an eye condition that required her, for a specialist's care, to travel to Palmyra, near Hannibal. Arrived, she wrote him of her pregnancy by saying that on the boat she "would have enjoyed [his] society so much, and besides I had something to tell

you about which I will only say it gave me pleasure and leave you to guess."

A month later she is "trying to be patient" till they can be "reunited . . . at no very distant date." Then the next day,

> I received your letter this morning saying you had already started for Kentucky. It was probably better for you to go than Asa [one of his brothers], but if I had been at home I do not know that I would have consented to the arrangement. After all, I should perhaps be thankful you are going to Kentucky instead of Kansas, for though I could never blame you for responding to a call of duty from your parents or country, it would be hard to give you up even for a time.

She adds in postscript, "I wish you had written more about the Kansas excitement. I hear but little said about it here and have no idea what they are doing in Saline [County] and feel anxious to know."

This is all one reads right then, in her letters or his, about the coming troubles; but in October 1857 one of her brothers writes him from College Hill (Columbia, Missouri):

> What has become of Kansas? I can learn nothing from the newspapers. Sometimes I see a piece saying something about it, and very likely before I put the same paper down I see it contradicted. Can learn nothing for certain. Wish you would let me know when the election is to come off, or if it is over, what was the result of it: I do hope that the Missourians are not so foolish as to let it be taken from them (though I do really think they deserve it). Is Gov. Walker for or against the south?

By the end of 1861 the war was on. And Quincy Adams Thomson, wiry and passionate, looks in photograph like a hothead. A letter of September 3, 1861, written to his brother Asa, who was by that time with the Confederate troops, recounts the state of the war at home and of the absent brother's farm.

> Your horses look very well considering the work they have done. I broke your highlander mare, as you desired, and let a man in Col. Price's regiment by the name of Granville Botts have her, as you ordered, and I have no doubt but you have seen her before this time . . . I do not intend to let any more of your horses go, because you have not any more than you need for your farm . . .

> There has been much excitement here since you left. I have been from my business a great deal. We are still very fearful that the Federals will overrun this County before you all can get here. May the Lord forbid it, though we don't deserve to

be treated so well. Our trust is in God for the success of our cause, which is the cause of religious and political Liberty. Two of my brothers have been spared to get home from the scene of conflict and death safely, and I pray God that my other Brother may not only be thus highly blessed, but that he may come home to tell us that he has become the soldier of the true and living God.

This last refers, I presume, to Asa's unconverted state.

Eventually eleven of Quincy's brothers and brothers-in-law served the Confederacy. At this time my grandfather himself was thirty-four and twice a parent. One year later, when he left for the war, his wife was carrying her third child. Four months later still, he was dead. A group of some six hundred Confederate volunteers, mostly from Saline County and in large part friends, relatives, and neighbors, mounted on their own horses and in many cases accompanied by their Negro servants, had organized themselves into a regiment, elected one of their number temporary colonel, named others as officers and noncoms, and set out southwest to join General Sterling Price. Within a few days the regiment was surprised by Federal cavalry, captured, and shipped in open boxcars to a prison in St. Louis, arriving there on Christmas Day. Epidemic diseases broke out. Giles McDaniel escaped by blackening himself with a burnt cork. Most remained, awaiting transfer to the Confederate side in exchange for Federal prisoners. In January my grandfather died, probably of typhoid; and his body, shipped to his wife in Saline County, was buried in the graveyard of their country church. My father, born on January 12, was lifted up for one long look at his male parent. Later, from being told and retold the event, he almost remembered it. He was a redhead named Quincy Alfred, and he came to look very much like his father.

Flora Thomson had been expected to join her father for the duration. But on that point she was firm. She stayed on her farm, ran it with her own Negroes, not all of them available after Emancipation, and brought up her babies. If marauding troops came by, Blacklegs or Scalawags, she offered them food, which they would have taken anyway, and beddings-down in the hay barn. She never locked her door, esteeming such precaution distrustful of God and futile against armies.

By the mid-1870s she was moving her family winters to Liberty, Missouri, some twenty-five miles north of Kansas City, seat of a Baptist preparatory school and college named William Jewell, of which Reuben McDaniel had been a founder. Here my father studied Latin, English literature, and natural philosophy (as physics was called then); his brother Reuben read law; and his sister Leona (or "Lonie") was got ready for Stephens College, a Baptist female seminary at Columbia. But in those postwar times, with ex-soldiers going all wild and with several of her

brothers drinking far more than any gentleman or farmer should, Flora Thomson had added to her canons of Southern Baptist upbringing a clause about total abstinence. No liquor crossed her threshold, nor was it served in her children's houses. I have seen my Aunt Lonie's husband hide blackberry brandy in the carriage house and swallow aromatics after it rather than face her on the question.

My father, the youngest, was first to marry. My mother was eighteen, he twenty-one. His passion was romantic and intense, remained so till his death at eighty-one. Though he had a redhead's temper, I never heard him raise his voice to her. To be her husband was for him as proud a privilege as to be a Baptist or a farmer. For he loved farming too, loved land, loved growing things, loved ingenuities done by hands with wood and stone, loved everything about life in the country from Monday's sunrise to Sunday's dinner with guests brought home from church. His mother, respecting his needs, divided her land, gave him his share. Young Quincy thereupon built on it a frame cottage and moved into it with his bride.

My mother, though born on a farm in Kentucky (in 1865) and removed to Missouri at fourteen to live on another, had never known a farm life's loneliness. Her father, Benjamin Watts Gaines, born in 1832, had lived in a wide Boone County house full of children and visitors. The Civil War, less passionately viewed, I gather, in northern Kentucky than in central Missouri, had passed him by. Along with his brothers, he had offered himself to the Confederate troops, but he was refused for lacking two fingers. He does not seem to have insisted on showing them how remarkable a shot he was with the other three. Nor did he let the Federals draft him. He simply passed up the war, stayed home, and built a family. After bearing him seven children, his wife Mary Ely Graves died of a "galloping consumption"; and it was chiefly the sadness of her loss that caused his removal to Missouri in 1879. Here he again married a Kentucky woman, Elizabeth Hall, who gave him three more children. When he was not much over fifty, he sold his farm and built a house in nearby Slater. He never did a stroke of work again except for gardening. He lived to be a hundred.

As with so many Kentuckians, life at his house was a never-ending party. My mother, Clara May, from growing up in such a house and visiting in others like it, had been all her life a hostess or a guest. Young Quincy from across the road, with his strict devotion to a widowed mother, his relentless theological integrities, and his intensely romantic feelings about everything (indeed, I suspect there were in him, and in his father, possibilities of wildness), was polarized by the complementary characteristics of a young woman who, though she had many graces and all the household arts, knew only one rigor, that of speaking always with tact.

They were married in the fall of '83, and their first child Ruby Richerson came two years later. All that summer of 1885, with my father constantly out of the house on farm work, Mother had been much alone for the first time in her life. At twenty, pregnant and terrified, she acquired an ineradicable distaste for the country. What tactful softening up of my father's hard passion for the soil went on in the next few years one can only guess. But he did decide eventually on selling the farm. And so they moved to a tiny village called Nelson, where with his newly realized capital he set up a hardware store and tin shop.

The tin shop used his skills in tinkering, repairing, roofing, stovepiping, and the like. Making houses come to life was as good as tilling the ground. But he had no instinct for trade, no skill in collecting monies owed him. And so in about six years he had nothing left. It was probably the depression of 1893, as much as his own inexperience, that brought to an end his adventure in storekeeping. But he never mentioned the famous Panic to me, may not even have been aware of its relation to him; I learned of its existence years later from a history book. But by 1894, and no question about it, he had to move.

The move he made was that of many another farm boy in trouble; he took his family to the city and looked for work. The city was Kansas City (Missouri, of course) and the work he found was being a conductor on the cable cars. For over a year he shared a house on Brooklyn Avenue near Twenty-fourth Street with my Aunt Lula, Mother's sister, and his boyhood friend, my Uncle Charlie Garnett. Then he took a flat of his own at Tenth and Virginia, where on November 25, 1896, his last child was born, a son named Virgil Garnett.

Thirty-five years old, with a wife and two children in his charge and with no money at all save a modest wage, he did not look, to prosperous Saline County, exactly successful. I do not think, however, that my father had ever had much respect for success or any undue aspiration toward it. His mother had prayed for him to hear the "call" and become a preacher. He himself had early become resigned to not hearing it. Always a worker for the Kingdom and early ordained a deacon, he aspired to little earthly reward beyond being a son, husband, and father. Also, if possible, a householder, since living in rented premises (especially in a flat, where there was not even a flowerbed to dig in) seemed to him no proper way. But to buy or build a house he needed credit, and for credit he needed a steady job. The cable cars offered no such security, since their franchise even then was running out. So he took Civil Service examinations and was appointed to the post office. With a job involving tenure, he could borrow money. His sister Leona was married to a man of substance who had already bought from my grandmother her remaining property, replaced her pre–Civil War small farmhouse with a larger structure, and offered a perpetual home in it to both his wife's mother and his own. He

now lent my father, against mortgage, $3,000 for building a house. Thereupon a small lot was purchased on Wabash Avenue, at 2613, and a two-story frame house raised, my father being his own architect and contractor.

From here we moved some ten years later to a slightly larger house in the same block. Surrounding both were yards good for growing flowers and fruit trees and every vegetable. My father arranged his post office working hours so as to have daily a half day for gardening. He either rose at five and gardened till noon or went to work at five and gardened all afternoon. He "improved the place" also, building a stone cellar, putting in a furnace, wiring for electricity, painting, paper hanging, roofing, shingling. There was nothing about a house and yard he could not do, and with joy.

Mother was happy, too, because she could have company. Grandma Thomson came for a long stay every winter, arriving with sacks of chestnuts from my Uncle Will Field's trees and with a telescope valise full of quilt pieces. My cousin Lela Garnett, who would also spend winters with us, brought a piano into the house and gave me lessons on it. It was Lela who taught me, at five, to play from notes. Before that I had only improvised, with flat hands and the full arm, always with the pedal down and always loud, bathing in musical sound at its most intense, naming my creations after the Chicago Fire and similar events.

Mother's half-sister Beulah Gaines would come too, a pretty girl who laughed and danced. She could play anything at sight, delighted the other grownup young that way, who loved to stand round her at the piano and sing songs. There were sometimes whole house-parties of girl cousins and their chums. Where they all slept I do not know, certainly in one another's beds, possibly some on the floor. Cooking went on too, lots of it, and for weeks at a time dressmaking, for Mother could make anything out of cloth, even to tailoring a jacket. And there was china painting. From fifteen my sister Ruby had had lessons in that and in watercolor. From eighteen she received pupils in both and executed orders, firing her china in a gas kiln that stood in the basement. She filled the house with artifacts, earned her own money, and when the Garnett piano went away bought one for me to play and practice on.

A first cousin of my mother's, an amateur violinist, would sometimes play all evening with Lela accompanying; and I remember rolling on the floor in ecstasy at hearing for the first time in real string sound the repeated high F's of the *Cavalleria Rusticana* Intermezzo. By the time I was ten I was playing waltzes and two-steps and schottisches for my sister's friends to dance to. I had learned also by that age to dance the grownups' dances and to play their card games.

Card games and dancing had been brought into our house by my

mother's half-brother Cecil, who had come just out of Slater High School to work in Kansas City and to live with us. Handsome, full of jollities and jokes and card tricks, playing the banjo, knowing songs and darn-fool ditties, sophisticated about girls and adored by them, he filled the house with a young man's ease and laughter. And not long after Cecil came, his high-school chum also arrived from Slater. Being at work, they paid for their board; and every night's dinner now was a company dinner, with steak or chops, hot breads, three vegetables, and dessert. Afterward the boys got exercise by playing catch or wrestling. In winter there was sometimes reading aloud; the year round, almost always singing.

It was after the boys began to live with us that the larger house was bought. Sometimes their number grew to three or four. Eventually the group withered away, with Cecil going to work in California. Then after my sister's marriage in 1913, she and her husband took two of the upstairs rooms, furnished them with their own things, and lived there for ten years. So that still there was dinner every night, and lots of company. My father had for joy his house and garden; my sister had her artisan's life and no housekeeping; I had my music lessons and piano; my mother her Kentucky-style hospitality, so skillfully contrived that she was almost never seen at work, and so prettily administered that life seemed to be — as she had always thought it should be — one long party.

Nobody remembers being a baby, but I remember being a child of two or three and growing from there to school age. Against the backdrop of my father's small but comely house and on a stage peopled by characters of all ages, I took my place quite early as a child performer. I was precocious, good-looking, and bright. My parents loved me for all these things and for being their man-child. My sister, eleven years older, looked on me almost as her own. My relations were pleased at my being able to read and sing songs and remember things. So with all this admiration around (and being, in spite of the praise, not wholly spoiled) I early seized the center of the stage and until six held it successfully.

Beyond our residential neighborhood there were forays into the great world of downtown, of department stores with their smells of dress goods and with their stools that one could whirl around on. I was taken every October to the Carnival parade and carried home sound asleep by my father. But the greatest adventure was going to the depot to meet somebody, usually my grandmother. For this we traveled either on a cable car that went over a cliff and down a steep incline or on an electric one that went through that same cliff in a black tunnel. At the depot itself there were men with megaphones singing lists of railroad lines and towns and numbered tracks. As for the trains, their engines looked so powerful, in motion or at rest, that I did not dare go near them without

holding tightly to my father's hand. Even thus, my fear was awful. There was no identity at all between these monstrous machines and their toy images that I cuddled every night in bed.

My mother's sister Aunt Lillie Post could play, with all their pearly runs intact, variations on *Old Black Joe* and *Listen to the Mockingbird.* She did not consent to do this very often, being out of practice; but when she did, she evoked a nostalgia that I could know to have some connection with the prewar South. It was all very polished, poetic, and deeply sad. But saddest of all was a song my mother sometimes sang as prepayment for taking a nap. It was *Darling Nelly Grey,* and I could never listen to the end without tears in my throat. All other music, though a joy, was merely sound. But these souvenirs of an earlier Kentucky, rendered by women who remembered, no doubt, its Arcadian landscapes, their father as a young man, and their mother early dead, had over me a power so intense that, as with my terror of the engines at the depot, I could almost not bear for it to either go on or stop.

When I was only two, which I do not remember, and again when I was five, which I do, my father took me to Saline County for showing me off. I stayed at my Aunt Lonie Field's farm, with peafowls on the lawn, visited in Slater my Grandpa Gaines and Grandma Betty, spent nights in other houses, got chummy with a cousin of my own age, Bessie Field, attended my Grandma Thomson's seventy-first-birthday dinner, came home a traveled one.

Since my father's parents had both been born into families of twelve children, my father possessed at this time more than fifty first cousins. My mother's extant aunts and uncles and cousin connection would have seemed almost as numerous had not most of them lived in Kentucky, whence they came to visit us less frequently. In my own right I had eight aunts and uncles plus five more by marriage. From my first cousins and the children of my parents' cousins to my grandparents, with their own large numbers of brothers and sisters, my childhood was surrounded by a company that included persons of virtually every age, figure, and disposition. It is not to be wondered at that having long appeared successfully before such a varied public, I arrived at my school years self-confident, cocky, and brash.

Some of this expansiveness may have come from living close to Kansas. My cousins from Little Dixie, I must say, had none of it. In any case, in September of 1902, when still five (I would not be six till Thanksgiving), without the prelude of kindergarten or the benefit of any parental presence (my cousin Lela Garnett went along to enroll me), I entered first grade at the Irving School, on Prospect Avenue at Twenty-fourth Street, wholly unafraid and ready for anything.

PART 2

Early Articles

✋ Jazz

JAZZ, IN BRIEF, is a compound of (a) the fox-trot rhythm, a four-four measure (*alla breve*) with a double accent, and (b) a syncopated melody over this rhythm. Neither alone will make jazz. The monotonous fox-trot rhythm, by itself, will either put you to sleep or drive you mad. And a highly syncopated line like the second subject of the Franck Symphony in D minor or the principal theme of Beethoven's third *Leonora* overture is merely syncopation until you add to it the heavy bump-bump of the fox-trot beat. The combination is jazz. Try it on your piano. Apply the recipe to any tune you know. In case you are not satisfied with the result, play the right hand a little before the left.

The fox-trot, which appeared about 1914, is the culmination of a tendency in American dancing that has been active ever since ragtime was invented in the early years of the century. The Viennese waltz and its brother, the two-step, died about 1912. For two years following, fancy steps like the tango, the maxixe, and the hesitation, with their infinite and amazing variations, made anarchy in the ballroom. This was resolved by a return to the utmost simplicity, and the common language of legs became a sort of straight-away walk. Any man could teach his partner in ten steps his peculiar form of it, whether he called it the Castle walk, the lame duck, or what not.

Soon after this primitive step became established ballroom dancing began to show the disturbance that shook all of polite society when the lid

This essay, requested by Henry L. Mencken for *The American Mercury* and published in August 1924, is to my knowledge the first published effort submitting jazz to the procedures of musical analysis.

V.T.

of segregation was taken off of vice and the bordello erupted into the drawing-room. Ragging, a style of dancing with slight footwork, but with much shoulder-throwing, came home from the bawdy house bearing the mark of the earlier hoochie-coochie, a monotonous beat without accentuation. It infected the walk-steps, had a convulsion called the turkey-trot, which proved too difficult to keep up, and finally, calling itself both the one-step and the fox-trot, became national and endemic. The former name, which merely indicated a tempo, is no longer used. The tempo of the latter has been expanded to include it.

At present the fox-trot is our only common dance rhythm. Its speed varies from 66 to 108 half-notes to the minute. It will bear any amount of muscular embroidery, from the shimmy to the halt, because its rhythm is in the simplest possible terms. The Viennese waltz is practically extinct in America. What is now called a waltz is simply a three-four fox-trot, as the two-step was a four-four waltz. The rhythm of the Viennese waltz is | ♩ ♩ | or | ♩. ♪ ♩ | and that of the hesitation | ♩ ♩ 𝄽 | or | ♩ ♩. ♪ |. There is one accent to a measure, as indicated. The two-step also had one accent, | ♩. ♪ ♩ ♩ | or | ♩. ♪ ♩ |. But the fox-trot has two, | ♩ 𝄽 ♩ 𝄽 |, and the jazz waltz has three, | ♪ 𝄾 ♪ 𝄾 ♪ 𝄾 |. The waltz, however, is not at home in jazz. After a century of Europeans, from Schubert to Ravel, had played with it, there was small possibility for further rhythmic variation. It is not comfortable now, for the true waltz-step is almost impossible to do unless the music has a flowing rhythm to tempt a flowing motion of the body.

We learned syncopation from three different teachers — the Indians, the Negroes, and our neighbors in Mexico. [This is quite wrong; a Scottish source is more likely. V.T.] It had become firmly established before the Civil War. It is the characteristic twist of nearly every familiar old tune. The dance craze of the last twenty-five years has simply exaggerated it. Because the way to make a strong pulse on 3 is by tying it to 2, thus, | ♩ ♩‿♩ ♩ |. A silent accent is the strongest of all accents. It forces the body to replace it with a motion. But a syncopated tune is not jazz unless it is supported by a monotonous, accentless rhythm underneath. Alone it may only confuse the listener. But with the rhythm definitely expressed, syncopation intensifies the anticipated beat into an imperative bodily motion. The shorter the anticipation the stronger the effect. The systematic striking of melodic notes an instant before the beat is the most powerful device of motor music yet discovered. But a fluent melody with a syncopated accompaniment is an inversion of the fundamental jazz process, and its effect is sedative.

If certain formulas of beat produce motion, probably certain motions have suggested these formulas. But I have no stake in the hen-and-egg controversy. I wish merely to show that the peculiar character of jazz is a rhythm, and that that rhythm is one which provokes jerky motions of

the body. Instead of the following "normal" rhythms, | ♩ ♩ ♩ ♫ | and | ♩ ♫ ♩ ♫ | and | ♩ ♩ ♬ |, we have | ♫ ♩ ♩ ♩ | and | ♬ ♩ ♩ | and | ♪ ♩ ♪ ♬ | and | ♪ ♩ ♩. ♬ | — in brief, all the divisions which the masters of music-not-meant-for-dancing have used sparingly or with special antidotes, for the very reason that they make the body move instead of keeping it quiet so that the music can go forward.

Instrumentation is not an essential element in jazz, as anyone knows who has heard a good performer play it on the piano. It is possible to practically any group of instruments, because, above the rhythmic accompaniment, which also sets the harmony, it is contrapuntal rather than homophonic and does not require balanced timbres. Certain instruments and effects, however, are characteristic, especially the use of the saxophone, which, in pairs or in quartets, makes a rich and penetrating diapason, and the monotonous banjo accompaniment, giving out the ground-rhythm — a rhythm so sonorous that it would be unendurable were not its hypnotic effect turned into motor stimuli by cross-accents.

Another characteristic of jazz is its constant use of glissando. This has long been common on the trombone. It is also possible on the clarinet and the saxophone for about a major third. A descending succession of little glissandi makes the "laughing saxophone." The Frisco whistle plays a continuous glissando; and the glissando on a plucked string, introduced from Hawaii, has been applied to almost every stringed instrument except the banjo. It is difficult there because of the frets and because the banjo, having no sound-box, gives a tone which, though powerful, is of short duration.

With the growth of the contrapuntal style, necessary to disparate combinations, the varieties of wind tone have been considerably extended. Passionate or startling expression has been found in all sorts of vibrati and flutter-tonguing and in the covered tones of the muted trumpet and trombone, the muted clarinet, and the trombone played through a megaphone. Most of these devices, of course, are not new. Rimsky-Korsakov knew all the tricks on the trumpet that you now hear in the dance hall, and more. Berlioz employed the muted clarinet. Richard Strauss and Vincent d'Indy wrote years ago for quartets of saxophones. Stravinsky has even written glissandi for the horn! But the megaphone trick, which takes the blare out of the trombone and makes it sound like a euphonium, is probably new. Certainly the use of a free-hanging mute is new, though when it takes the form of a tin can or a silk hat it is no great addition to orchestral elegance.

In the current jazz one hears piano figures that are ingenious, counter-melodies that are far from timid, and experiments in instrumental balance that are of interest to any composer. The harmony itself is at times varied and delicate. The blues formula — subdominant modulation with alternations of tonic major and minor — is simple and effective. The chromatic

(or diatonic) succession of dominant ninths so dear to Franck and Chabrier has become popular, and the mediant or sub-mediant tonality for modulation offers a pleasing relief from the more obvious dominant. The Neapolitan sixth is quite common and even the "barbershop" chord — the augmented six-five-three, or German sixth — is sometimes used in a manner that is not at all crude.

These characteristics of jazz are partially supported by serious music and partially contributory to it. Classical composers snap up quickly any novelty that the makers of jazz invent. Union musicians often play one night at the movies, and the next night with the local symphony orchestra. They bring a few tricks to the latter, and they take home many more. Orchestral and harmonic styles in jazz are still experimental and shifting. But the essence of the thing remains free melody with a fox-trot rhythm underneath. That rhythm shakes, but it won't flow. There is no climax. It never gets anywhere emotionally. In the symphony, it would either lose its character or wreck the structure. In that respect it is analogous to the hoochie-coochie beat.

~ *Aaron Copland*

*A*ARON COPLAND'S music is American in rhythm, Jewish in melody, eclectic in all the rest.

The subject matter is limited but deeply felt. Its emotional origin is seldom gay, rarely amorous, almost invariably religious. Occasionally excitation of a purely nervous and cerebral kind is the origin of a scherzo. This tendency gave him a year or two of jazz-experiment. That has been his one wild oat. It was not a fertile one.

He liked the stridency of high saxophones, and his nerves were pleasantly violated by displaced accents. But he never understood that sensuality of sentiment which is the force of American popular music nor accepted the simple heartbeat that is the pulse of its rhythm, though it is the pulse of his own rhythm whenever his music is at ease.

His religious feeling is serious and sustained. He is a prophet calling out her sins to Israel. He is filled with the fear of God. His music is an evocation of the fury of God. His God is the god of battle, the Lord of Hosts, the jealous, the angry, the avenging god who rides upon the storm. Far from Copland's thoughts are the Lord as shepherd in green pastures, the Lord as patriarch, the God of Jacob, the bridegroom of the Shulamite, the lover, the father, the guide-philosopher-and-friend. The gentler movements of his music are more like an oriental contemplation of infinity than like any tender depiction of the gentler aspects of Jehovah.

Hence the absence of intimacy. And the tension. Because his music has tension. His brass plays high. His rhythm is strained. There is also weight; five trumpets and eight horns are his common orchestral practice. They give the tension and weight of battle. The screaming of piccolos and pianos evokes the glitter of armaments and swords. His instrumentation is designed to impress, to overpower, to terrify, not to sing.

~ ~ ~

All this I write is overstated. But I put it down because it seems to me to provide as good an evocative scheme as any for fitting together various observations about the way his music is made.

I note the following:

His melodic material is of a markedly Hebrew cast. Its tendency to return on itself is penitential. It is predominantly minor. Its chromaticism is ornamental and expressive rather than modulatory. When he sings, it is as wailing before the Wall. More commonly his material is used as a framework for a purely coloristic compilation.

By coloristic I mean it is made out of harmonic and instrumental rather than melodic devices. This compilation is picturesque and cumulative. It tends to augment its excitement, to add to weight and tension. His dominant idea of form is crescendo. This is Russian, because it is a crescendo of excitement. Of development in the classic German sense, the free development of Haydn and Beethoven, there is none.

His conception of harmony is not form but texture. Hence the absence of marked tonal modulation. His conception of instrumentation is not variety but mass. He has no polyphonic conception at all, because he is alone in his music. His commonest contrapuntal device is a form of canon, usually at the octave or unison, everybody doing the same thing at a different moment. This is counterpoint but not polyphony. He is not walking with God or talking with men or seducing housemaids or tickling duchesses. He is crying aloud to Israel. And very much as if no one could hear him.

The *Piano Variations* have not even this canonic counterpoint. They are a monody, one line repeated, not developed, lengthened out from time to time by oriental flourishes, accented and made sharp, orchestrated, as it were, by slightly dissonant octaves, by grace-notes and arpeggios.

I find the music of them very beautiful, only I wish he wouldn't play it so loud. One hears it better unforced. I miss in his playing of it the singing of a certain still, small voice that seems to me to be clearly implied on the written page.

∾ ∾ ∾

I also note this:

There is a certain resemblance of procedure between Copland, Antheil, Varèse, Chávez. This in spite of antipodal differences in their personalities and sentiments. Their common homage to Stravinsky honors the White Russian master more than it profits them. It creates a false community and obliterates distinctions. It also smothers quality.

The quality that distinguishes American writing from all other is a very particular and special approach to rhythm. It is in these composers when they forget Stravinsky; it is in all American music whatever its

school or origins. It is a quiet, vibratory shimmer, a play of light and movement over a well-felt but not expressed basic pulsation, as regular and as varied as a heartbeat, and as unconscious. It is lively but at ease, quiet, assured, lascivious.

Stravinsky knocked us all over when we first heard him, because he had invented a new rhythmic notation, and we all thought we could use it. We cannot. It is the notation of the jerks that muscles give to escape the grip of taut nerves. It has nothing to do with blood flow. It is spectacularly effective when used to express the movements it was invented to express. It is the contrary when imposed upon our radically different ones. How infinitely superior in simple effectiveness are our popular composers over our tonier ones. They have no technical drama of composition. They are at ease in their notation.

Our highbrow music, on the other hand, is notoriously ineffective. It is the bane of audiences at home and abroad, in spite of the very best will on everybody's part.

I deny that it is really as dull as it sounds. I think our gift, our especial gift, is the particular rhythmic feeling I have described. That is enough to make an epoch. It takes very little. The rest is framing. Our weakness is timidity, hence snobbishness and eclecticism.

Today we ape Stravinsky. Yesterday it was Debussy. Before, it was Wagner. Copland's best recommendation is that he is less eclectic than his confreres. I reproach him with eclecticism all the same.

There is real music in his pieces, true invention, and a high nobility of feeling. He is not banal. He has truth, force, and elegance. He has not quite style. There remain too many irrelevant memories of Nadia Boulanger's lessons, of the scores of Stravinsky and Mahler and perhaps Richard Strauss.

I wish they were plain thefts. Theft is refreshing and legitimate. Copland is like certain American poets (very distinguished ones; supply your own examples), who cannot quite forget their collegiate loyalty to Keats and Browning and who are more occupied with the continuation of some foreign tradition than with style, which is personal integrity.

This may explain a little why Aaron Copland is at the same time an inspired composer and only a comparatively effective one. Comparatively, because most American music is less effective in performance than his. In fact, his music is often so near to a real knockout that I am sometimes left wondering whether it is a case of a knockout not quite achieved or of an unwise application of the knockout technic to a case where persuasion were more to the point.

In any case, there is a problem of rhetoric for the American composer. The problem of adjusted emphasis, the appropriate stating and effective underlining of personal invention. This means selection and variety.

Forcing every idea into the key of the grandiose and the sublime is obviously false and in the long run monotonous.

I fancy there is more of use to us in the example of Verdi than in that of Wagner, Puccini even than Hindemith, certainly Bizet than Debussy, Schubert than Brahms. Simple clarity is what we need, and we will get it only by a radical simplification of our methods of composition. If Copland's simplifications are perhaps not radical enough for my taste, they are important simplifications all the same.

Because he is good, terribly good. A European composer of his intrinsic quality would have today worldwide celebrity and influence. It is a source of continual annoyance to me that his usefulness and his beauty are not fully achieved because he has not yet done the merciless weeding out of his garden that any European composer would have done after his first orchestral hearing.

The music is all right, but the man is not clearly enough visible through it. An American certainly, a Hebrew certainly. But his more precise and personal outline is still blurred by the shadows of those who formed his youth.

From *Modern Music*, January 1932.

❧ George Gershwin

GERSHWIN, Cole Porter, and Kern are America's Big Three in the light musical theater. Their qualities are evident and untroubling. Mr. Gershwin has, however, for some time been leading a double musical life. This is the story of his adventures among the highbrows.

His efforts in the symphonic field cover a period of about twelve years and include, so far as I am acquainted with them:

A Rhapsody in Blue, for piano and orchestra

Harlem Night, a ballet

Two concertos for piano and orchestra

An American in Paris, symphonic poem

to which has now been added an opera on a tragicomic subject, Porgy and Bess.

The Rhapsody in Blue, written about 1923 or 1924, was the first of these and is the most successful from every point of view. It is the most successful orchestral piece ever launched by any American composer. It is by now standard orchestral repertory all over the world, just like Rimsky-Korsakov's Scheherazade and Ravel's Bolero.

I am not acquainted with Harlem Night or the second Piano Concerto. I am not even certain that a second one exists, although I have been told so. I can only speak, therefore, of the Concerto in F and of An American in Paris. Both of these show a rather lesser mastery of their materials than the Rhapsody does. They have not, however, altered Mr. Gershwin's prestige. He has remained through everything America's official White Hope, and he has continued to be admired in music circles both for his real talent and for his obviously well-meant efforts at mastery of the larger forms. Talent, in fact, is rather easier to admire when the intentions of a composer are more noble than his execution is competent.

Just why the execution is not so competent as in the *Rhapsody* is not clear to me. I used to think that perhaps he was cultivating a certain amateurishness because he had been promised that if he was a good little boy and didn't upset any apple carts he might maybe when he grew up be president of American music, just like Daniel Gregory Mason or somebody. Either that, or else that the air of timid and respectable charm which those pieces play up was simply a blind to cover a period of apprenticeship and that one day he would burst out with some more pieces like the *Rhapsody in Blue*, grander. It seemed that such a gift as his, with ten years of symphonic experience, couldn't but turn out eventually something pretty powerful.

It has now turned out *Porgy and Bess*. When a man of Gershwin's gift, experience, and earning capacity devotes in his middle or late thirties three years of his expensive time to the composition of a continuous theatrical work on a serious subject, there is no reason to suppose that it represents anything but his mature musical thought and his musical powers at near their peak. The music, however, is not very different from his previous output of serious intent, except insofar as staging helps cover up the lack of musical construction. Hence it is no longer possible to take very seriously any alibi for his earlier works.

The *Rhapsody in Blue* remains a quite satisfactory piece. Rhapsodies, however, are not very difficult to write, if one can think up enough tunes. The efforts at a more sustained symphonic development, which the later pieces represent, appear now to be just as tenuous as they have always sounded. One can see through *Porgy* that Gershwin has not and never did have the power of sustained musical development. His invention is abundant, his melodic quality high, although it is inextricably involved with an oversophisticated commercial background.

That background is commonly known as Tin Pan Alley. By oversophisticated I mean that the harmonic and orchestral ingenuity of Tin Pan Alley, its knowledge of the arts of presentation, is developed out of all proportion to what is justified by the expressive possibilities of its musical material. That material is straight from the melting pot. At best it is a piquant but highly unsavory stirring-up-together of Israel, Africa, and the Gaelic Isles. In Gershwin's music the predominance of charm in presentation over expressive substance makes the result always a sort of *vers de société*, or *musique de salon;* and his lack of understanding of all the major problems of form, of continuity, and of straightforward musical expression, is not surprising in view of the impurity of his musical sources and his frank acceptance of them.

Such frankness is admirable. At twenty-five it was also charming. *Gaminerie* of any kind at thirty-five is more difficult to like. So that quite often *Porgy and Bess*, instead of being pretty, is a little hoydenish, like a sort of *musique de la pas très bonne société*. Leaving aside the slips,

even, and counting him at his best, that best which is equally well exemplified by *Lady, Be Good* or *I've Got Rhythm* or the opening of the *Rhapsody in Blue,* he is still not a very serious composer.

I do not wish to indicate that it is in any way reprehensible of him not to be a serious composer. I only want to define something that we have all been wondering about for some years. It was certain that he was a gifted composer, a charming composer, an exciting and sympathetic composer. His gift and his charm are greater than the gifts or the charms of almost any of the other American composers. And a great gift or great charm is an exciting thing. And a gifted and charming composer who sets himself seriously to learn his business is a sympathetic one. I think, however, it is clear by now that Gershwin hasn't learned his business. At least he hasn't learned the business of being a serious composer, which one has long gathered to be the business he wanted to learn.

Porgy is nonetheless an interesting example of what can be done by talent in spite of a bad setup. With a libretto that should never have been accepted on a subject that should never have been chosen, a man who should never have attempted it has written a work that has considerable power.

The more conventionally educated composers have been writing operas and getting them produced at the Metropolitan for twenty or thirty years. Some of them, Deems Taylor in particular, know quite well how to write in the larger formats. Year after year they write them, perfectly real operas on perfectly good subjects. And yet nothing ever happens in them. No significant musical misdemeanor ever seems to have been perpetrated. Gershwin does not even know what an opera is; and yet *Porgy and Bess* is an opera, and it has power and vigor. Hence it is a more important event in America's artistic life than anything American the Met has ever done.

But before I finally get around to saying all the nice things I have to say about it, let me be a little more specific about its faults and get all the resentments off my chest. Because I do resent Gershwin's shortcomings. I don't mind his being a light composer, and I don't mind his trying to be a serious one. But I do mind his falling between two stools. I mind any major fault he commits, because he is to me an exciting and sympathetic composer.

First of all, the opera is vitiated from the beginning by a confusion as to how much fake it is desirable or even possible to get away with in a work of that weight. The play, for instance, and the libretto derived from it, are certainly not without a good part of hokum. That can be excused if necessary. *La Traviata* and *Tosca* are not free of hokum either. Hokum is just theatrical technic got a little out of hand, tear-jerking for its own sake, an error of proportion rather than a lack of sentiment. The artificiality of its folklore is graver. I must hasten to add that Mr.

Gershwin is here a greater sinner than Mr. Heyward, because his work was executed later. Folklore subjects recounted by an outsider are only valid as long as the folk in question is unable to speak for itself, which is certainly not true of the American Negro in 1935.

Let me be clear about folk opera. *Lucia di Lammermoor* and *Madama Butterfly* are not Scottish or Japanese folk operas; they are simply Italian operas on exotic subjects. *Carmen* comes nearer because of its systematic use of Spanish popular musical styles. It is nonetheless a fake. Smetana's *Bartered Bride* is a folk opera and it is not a fake, because it is Bohemian music written by a Bohemian. It is not so fine a theater work as *Carmen*, but it is better folklore. Hall Johnson's music for *Green Pastures* and the last act of his *Run, Little Chillun* are real folklore and also folk opera of quite high quality. *Porgy and Bess*, on the other hand, has about the same relation to Negro life as it is really lived and sung as have *Swanee River* and *Mighty Lak' a Rose*.

The most authentic thing about it all is George Gershwin's sincere desire to write an opera, a real opera that somebody might remember. I rather fancy he has succeeded in that, which is pretty incredible of him too, seeing how little he knew of how to go about it. His efforts at recitativo are as ineffective as anything I have heard since Antheil's *Helen Retires*, where a not dissimilar effect was got by first translating the play into German, then composing music for the German text, and finally translating this back into English. The numbers which have rhymed or jingled lyrics are slick enough in the Gershwin Broadway manner. But his prose declamation is full of exaggerated leaps and unimportant accents. It is vocally uneasy and dramatically cumbersome. Whenever he has to get on with the play he uses spoken dialogue. It would have been better if he had stuck to that all the time.

As for the development, or musical build-up, there simply isn't any. When he gets hold of a good number he plugs it. The rest of the time he just makes up what music he needs as he goes along. Nothing of much interest, little exercises in the jazzo-modernistic style, quite pleasant for the most part but leading nowhere. The scoring is heavy, overrich, and ineffective. Throughout the opera there is, however, a constant stream of lyrical invention and a wealth of harmonic ingenuity.

There is little drama in the orchestra and little expression in the melodies, prettily Negroid though they be. The real drama of the piece is the spectacle of Gershwin wrestling with his medium, and the exciting thing is that after all those years the writing of music is still not a routine thing to him. Such freshness is the hallmark of *les grandes natures*. Every measure of music has to be wrought as a separate thing. The stream of music must be channelized, molded, twisted, formed, ornamented, all while it is pouring out molten hot from that volcano of musical activity, Mr. Gershwin's brain. Never is the flow inadequate. Never does his vigi-

lance fail to leave its print on the shape of every detail. *Porgy* is falsely conceived and rather clumsily executed, but it is an important work because it is abundantly conceived and executed entirely by hand.

There are many things about it that are not to my personal taste. I don't like fake folklore, nor fidgety accompaniments, nor bittersweet harmony, nor six-part choruses, nor gefiltefish orchestration. I do, however, like being able to listen to a work for three hours and being fascinated at every moment. I also like its lack of respectability, the way it can be popular and vulgar and go its way as a professional piece without bothering about the taste-boys. I like to think of Gershwin as having presented his astonished public with a real live baby, all warm and dripping and friendly.

In a way, he has justified himself as a White Hope. He has written a work that can be performed quite a number of times, that can be listened to with pleasure by quite different kinds of people, and that can be remembered by many. If its eminence, as Shaw once said of John Stuart Mill, is due largely to the flatness of the surrounding country, that eminence is nonetheless real.

From *Modern Music,* November 1935.

✌ Swing Music

S WING MUSIC is for the layman just a new name for what another generation called jazz. It serves not infrequently, even among its intellectual amateurs, to distinguish jazz of some artistic value from the commercial product. Among professionals, however, it means a certain kind of rhythm. In defining the nature of that rhythm I am going to write a brief history of popular dance steps and their music from the beginning of jazz, around 1912, to the present day.

Primitive, or pre-swing, jazz is definable as an ostinato of equally accented percussive quarter-note chords (these take care of rhythm and harmony) supporting a syncopated melodic line.

I am defining here dance-jazz as it was to be heard almost anywhere between 1912 and 1932. The introduction into popular dance music of the jazz formula, or unvarying accent, was a basic simplification that made possible an added complexity in the ornamental and expressive structure.*

Elsewhere in print are lists of musical means and devices commonly employed in jazz performance. All I care to recall here is that an ostinato of percussive quarter-note chords was their basic support both rhythmically and harmonically.

* Stravinsky's *Sacre du Printemps*, written in 1912, exploits an identical procedure. (It opens, by the way, with a "hot" solo for bassoon beginning on high C.) The *Danse des Adolescents* begins with equally accented percussive chords to which are added irregularly placed *sfz* stresses and, later, hot solos in nonvertical counterpoint. The contrast between control and spontaneity is the most striking thing of its kind in classical music.

I mention the parallel to show that the dissociation of rhythm from beat took place in different kinds of music and on two continents at the same time. It was nobody's invention.

Swing music is based on a different kind of ostinato. Its rhythm (to use the language of versification) is a rhythm of quantities, not a rhythm of stresses.

Let us examine dance rhythms a little and see how they got that way.

Pre-jazz Ragtime Two-step. | ♩ ♩ ♩ ♩ | ♩ ♩ ♩ ♩ |

Jazz Fox-trot. Basic simplification. | ♩ ♩ ♩ ♩ | ♩ ♩ ♩ ♩ |

Tango. Enter the Latin influence. | ♩. ♪ ♩ ♩ | ♩. ♪ ♩ ♩ |

Parisian Tango. Takes on jazz accent. | ♩. ♪ ♩ ♩ | ♩. ♪ ♩ ♩ |

Charleston. Jazz takes a tango accent. | ♩. ♪♩ | ♩. ♪♩ |

Rumba. Spanish America goes Negroid. | ♪ ♩ ♪ ♫♫ | ♪♩ ♪ ♫♫ |

Beguine. Spain is buried in the jungle. | ♫♫ ♫♫ | ♫♫ ♫♫ |

Lindy Hop. Swing approaches. | ♩ ♩ ♩ ♩ | or | 𝄾 ♩ 𝄾 ♩ |

Continental. Swing is here. |♪ ⁊ ♯♩♪ ⁊ ♯♩ ♪ ⁊ ♯♩♪ ⁊ ♯♩|

with the (tr) markings above, *without accent*

Spain is back on the dance floor and Africa at her drums, while the richest fancies of melody and harmony frolic in uncontrolled improvisation through the agency of our old friend the two-step.

Let us examine this tabulation more closely. All these dances are of New World origin. The tango is a modern name for an Argentine version of the nineteenth-century habanera (from Havana). The two-step is a 4/4 (*alla breve*) version of the Boston, as distinguished from the Viennese, or whirling waltz. Hesitations, maxixes, barn dances, turkey trots, lame ducks, the superb and buoyant Castle walk, were all New World steps. The fusion of the Hispanic, Anglo-Celtic, and Negroid elements of all these into a single formula was a twenty-years' dance war. It was fought out in Paris mostly, where the Hispanic and the Anglo-Celtic elements could meet on neutral ground. Each side, as we shall see, had its Negro troops.

By 1918 Anglo-America had stripped herself down to the fox-trot and the one-step, Latin-America to the tango. In the mid-twenties the battle was still a stalemate. Since French tax laws obliged all nightclubs to have both kinds of orchestras, American trumpet players were fraternizing at the bar with Argentine accordion players. The two sides didn't mix musical efforts much, but the tango unconsciously equalized its accents.

The folks back home were getting bored with all this undramatic trench war. The United States went wild first, and when the dust died down, it was evident that their new wildness, the Charleston, had somewhere or other acquired a suspiciously Hispanic accent. (It had long been the custom of W. C. Handy and the Mississippi Valley school to use a tango-bass in the middle section of a Blues number.)

Then Latin America got jittery too. She went Negroid in the form of rumbas and beguines. The original habanera downbeat reappeared along with floor-length dresses and the Boston waltz. The United States countered with the even fancier Lindy hop and a return to the prewar two-step (off the beat).

With swing music approaching, Latin America held out for a strong downbeat, Anglo America for a strong offbeat. Latin America offered a percussive shimmer on its other beats, Anglo America a rest. Swing rhythm was the solution. The shimmer was kept, but on the offbeats only, and accents were sacrificed by both sides. The percussive shimmer would stop where a beat was expected to occur, only the beat didn't occur. The treaty was signed in the form of an international ballroom accomplishment named appropriately for the chief battleground and popularized from Hollywood, the Continental.

All the characters of our little history are now happily united. The 4/4 Boston waltz, or two-step, is the new basis of operations. Body positions and some footwork are added from the Lindy hop and the tango (all passion restrained, however).

The percussive basis of the new music is now the West Indian shimmer. Downbeats are expressed only by a cessation of that shimmer. Here, therefore, is the special characteristic of swing music. It is founded on a purely quantitative (rather than an accentual) rhythm.*

Melody, harmony, and all thumpy percussion are henceforth liberated from formal rhythmic observances. The melodic instruments are not obliged even to syncopate, either by delay or by anticipation. They are free to improvise (it is more often the harmony that remains fixed than the tune) in that sort of spontaneous lyrical effusion mixed with vocal imitation and instrumental virtuosities that the French call so charmingly "le style hot."†

They are not really free not to play "hot"; that is to vary and to contradict at every possible point the underlying measure, because quantitative rhythm is a very powerful thing, as impressive and as boring over

* Quantitative rhythm is not new in musical art. The merry-go-round, the hurdy-gurdy, and the pipe organ have no accents at all, only quantitative rhythm.

† The technic of this improvisation was developed from the free two-measure "breaks" of the early Blues.

any length of time as organ music. Its emotional impassivity incites to emotional wildness, to irregular pattern, to strange timbres, to mysterious outbursts and inexplicable tensions.

It also liberates for free expressive use all the short or thumpy sounds of the percussion section. And few things in music are as expressive as a thump. One cymbal or snare drum being sufficient to keep up the swing, regularly placed *sfz* stresses become in themselves a form of hot solo exactly as they do in the *Sacre du Printemps*.

Liberating the percussive banjo, guitar, and piano also liberates the harmony section from rhythmic control. Hence we have all the emotional elements of the orchestra disengaged from point-counterpoint and released for free polyphony. Steady support underneath by a nonemotional quantitative rhythm both stimulates and accentuates the superposed emotional expression. The result at its best is sumptuous.

I shall not here go into detailed recounting of the higher points of contemporary swing art. They are discussed vigorously in Monsieur Hugues Panassié's fine volume, *Le Jazz Hot.** You will find there a wealth of fact about "le style Chicago" and "le style New Orléans." About the instrumental innovations of Bix Beiderbecke and Muggsy Spanier (good jazz and swing music have never been Negro monopolies). Of what distinguishes "le style hot" from "le style straight." Of the art of five-part improvisation. Of the diverse merits of the divers famed "solistes hot." Of the difference between real and merely commercial jazz. You will be inducted into an orderly study of the historical and stylistic development of the whole business from Handy to Ellington, with special attention to the Chicago school, where the categorical German and the spontaneous Negro musicalities united to produce in Louis Armstrong (originally from New Orleans) a master of musical art comparable only (and this is my comparison, not M. Panassié's) to the great castrati of the eighteenth century. His style of improvisation would seem to have combined the highest reaches of instrumental virtuosity with the most tensely disciplined melodic structure and the most spontaneous emotional expression, all of which in one man you must admit to be pretty rare. You will also learn something (though not really enough) of the fascinating lingo the swing people use. You will weep tears over the author's efforts to define the word in French, its musical significance being hardly covered by *balancement* and matters being in no way helped by the already accepted French usage of *swing* as a term in pugilism. You will find all this and many more matters of both historical and esthetic importance discussed in *Le Jazz Hot*, the whole topped off by photographs of great men, indexes, and a bibliography of records.

* Hugues Panassié, *Le Jazz Hot*, Paris, 1934. (*Hot Jazz: The Guide to Swing Music;* 1936 American edition reprinted by Negro Universities Press.)

I cannot compete with M. Panassié in either learning or enthusiasm. I can only come back to what I started out to do, which is to state in these pages (being asked) a definition of swing music (the estheticians of swing having neglected that point) which I believe to be correct. That definition, to sum up, is this. Swing music is a form of two-step in which the rhythm is expressed quantitatively by instruments of no fixed intonation, the melodic, harmonic, and purely accentual elements being freed thereby to improvise in polyphonic style.

POSTSCRIPT: I haven't stated, I find, just why swing music swings and beat music doesn't. Remember the Viennese waltz? Well, the whole story is there. It isn't the strong downbeat that makes a dancer swing. A strong downbeat only makes him whirl. A strong offbeat makes him jerk. A percussive roll or trill is what makes him swing. Give him the roll and no beat and he can neither whirl nor jerk. He can only swing and that lightly, because there is no place for the swing to take him. He can also sit still and listen.

From *Modern Music,* May 1936.

✌ Swing Again

IN MAY 1936 I stated that "swing music is a form of two-step in which the rhythm is expressed quantitatively by instruments of no fixed intonation, the melodic, harmonic, and purely accentual elements being freed thereby to improvise in polyphonic style."

That definition is pretty pompous, but I think it still holds. However, since quantitative rhythm is a concept that a great many people do not understand, my definition has remained not only undisputed but also unaccepted. I am therefore taking this occasion, which arose from an invitation to review Benny Goodman's concert in Carnegie Hall (a quite uninteresting concert on the whole), to talk some more about quantitative rhythm and its function in swing music, in the hope of further clarifying a little the bothersome question, What is swing music anyway?

The melodic matter of swing, though frequently charming, I have never found especially novel or significant. The easygoing *fioritura* of the New Orleans school and the tighter contrapuntal textures of Chicago are equally mannerisms of style; they are not of the essence. They are only significant as indicating, by their presence at such a high degree of elaboration, that there must be some pretty solid underpinning to make such elaboration possible. The constant use of the air-and-variations form is of no significance either, a string of variations being the loosest of all musical forms and at its best only a shape, never a structural system. Similarly as regards contrapuntal freedom, harmonic and instrumental variety. That is all superstructure too. It certainly astonishes no one acquainted with modern musical resources. The existence of such a practical superstructure makes it certain, however, that there is also method. The important place that improvisation has in swing-playing is conclusive. Nobody improvises publicly without a method. Communal improvisation without it is a clear impossibility.

Now the sleuths, amateur and professional, who have looked for this basic method have mostly been taken in by the lingo. Let me remind them that *hot* does not mean passionate. It means rhythmically free, and it applies only, in consequence, to melody or to percussion. More important than that, that swing music rarely has any literal swing in it. Certainly nothing like the swing Viennese waltz music has. At most it sort of quivers or oscillates rapidly like a French clock. At its best it has no motor effects at all. Good jam invariably sounds not unlike a Brandenburg concerto, where every voice wiggles around as rapidly as you please, the rhythmic basis or center remaining completely static and without progression or development of any kind.

If dance music doesn't swing, is it dance music? Answer, no. Motor impulses in dance music are a *sine qua non*. But nobody dances to jam anyway. What kind of metrical routine, then, has replaced the rhythmic beat? That there is a metrical routine of some kind is obvious. Otherwise the rhythmically free (or non-metrical) "hot licks" would not be free. They would be just a vague melopoeia without tension. Their freedom is real and exciting only because it exists by contrast to a fixed measure of some kind. Also, collective improvisation is not possible without a metrical basis. There is only one answer, because there is only one known form of meter besides the meter of beats. That is the meter of quantities.

Here is the root of the matter. Beat music is accentual music; its rhythmic measure-unit is a succession of blows of varying force. Its effect on the listener is muscular. It is the music of the march, the dance, the religious or sexual orgy. Quantitative music has no accent; it is serene. Its rhythmic measure-unit is a unit of length. Its effect on the listener is likely to be hypnotic. When practiced with sufficient subtlety it becomes not only the lullaby, but also the ballad, the music of prose declamation, of religious rite, of contemplation, of the imaginative intellect.

The piano, the drums, all the stick-and-hammer family, are primarily accentual instruments, although the length, or vibrating time, of the tone produced is usually controllable. The bowed instruments are primarily quantitative, though they can play a fairly presentable accent too. The wind instruments, both brass and wood, are almost completely quantitative, their bravest attacks being always more vocal than percussive, and their diminuendos having always a very audible stopping place. The organ (reed or pipe) is one hundred percent quantitative, no accent of any kind being possible at any time and all tones being completely sustainable. Likewise for the modern electronic instruments, though a fairly successful imitation of string pizzicati is often added to their organlike range of sounds. The plucked instruments are equivocal. Banjo, guitar, and harp are chiefly accentual. The lute less so. The harpsichord not at all, because it has no accents. Harpsichord music therefore is always quantitative, in spite of the nonsustaining tone of the instrument.

It resembles organ music far more than it resembles piano or harp music. I am now going to explain how in swing music a similar phenomenon takes place, whereby the foundational underpinning, its basic rhythm, although quantitative in character, gets expressed by nonquantitative instruments, by drums, guitars, cymbals, pianos, and hand-plucked string basses.

The basic routines of the rhythm section in a swing band are as follows:

Tom-tom, bass drum, snare drum, or string bass	1 2 3 4 — x ♪ ♩ x ♪ ♩
String bass	1 2 3 4 — ♪ ♩ ♪ ♩ ♪ ♩ ♪ ♩ (slap pluck slap pluck)
Cymbal (with hard stick) x represents the stroke, o the damping.	1 2 3 4 — ♪ ♩ ♪ ♪ ♩ ♪ (o x o x)
Snare drum (with sticks, brushes, or dragging brush)	1 2 3 4 — ♪ ♩· ♪ ♩· (non cresc non cresc)

There are some variations on the above, such as the double cymbal-stroke on counts 2 and 4 (with damping on 1 and 3) and the double brush-tap on the snare drum (also used on counts 2 and 4). Also the combinations of all these. The hot drum solo is not a basic routine but a cadenza. It is made to sound as different as possible from the basic routines by the use of *sfz* stresses in unexpected places and the temporary introduction of new patterns, sometimes in a variant meter and sometimes in free prose. It is only a cadenza, however, a little spurt of very exciting freedom in the midst of the grind.

Notice in the routine exposed above the consistent placing of what looks like a strong accent on counts 2 and 4. This cannot be what it looks like, because a musical structure of any length cannot be made on a routine of strong offbeats, since the tendency of any regular strong beat is to become itself the downbeat of the measure. Robert Schumann was fond of playing around with offbeats and frequently got his interpreters into a lot of trouble on their account. No. 1 of the *Phantasiestücke* is a celebrated example, a clear rendition of its rhythmic content (as written by the composer) being one of the more difficult feats in piano-playing.

By what agency is the tonic measure-accent expressed then in swing music if not by the rhythm section of the band? Certainly not by the melody instruments, the saxes, trumpets, clarinets, et cetera. These play with the greatest rhythmic freedom, varying continually both their accents and their quantities to exploit the rich fancy of the arranger and

the tonal resources of the instruments. The harmony section, that is, piano, guitar, and the like, seems to string its chords on a rhythmic routine not unlike that of the rhythm section itself. I repeat that there is no tonic measure-accent, that the measure-unit in swing music is a measure of quantities and not of accents at all.

Let me represent the quantities in a measure of four-four time by the following pictures. I presume an instrument of unvarying pitch.

The numbers represent the four counts of the measure. They are theoretically of equal length. In musical performance, number 4 is usually a shade longer than the others. This imperceptible hold (familiar to all organists and harpsichordists) serves to define the measure's limit and to produce a tiny semblance of downbeat at the beginning of the following measure. The horizontal lines represent the duration of the unvarying sound, the blanks between them its absence. There are no stresses. You could play it on an electric buzzer. These two patterns are for theoretical purposes identical, because, unless there is in any measure of repeating pattern a tonic accent on 1 and 3, there is no tonic accent at all (or any measure either, except of two counts), and nobody can ever know which came first, the sound or the silence.

Now superpose on these theoretical, quantitative designs the formulas given above for basic swing rhythm and you will see what happens in a swing band. Remember that the instrumental strokes cannot be considered as marking tonic measure-accents, because they are all offbeat strokes. Yet they must mark something, or they wouldn't be there. They must therefore mark the quantities. The taps and plucks do coincide, as a matter of fact, with the beginning and ending of the units of the quantitative pattern. The cymbal and the snare-drum roll, having a sound of some duration, can actually express these quantities. More often than not, however, in good swing-playing, the continuing, or exactly quantitative, sounds are dispensed with on account of their insistent character, the taps and plucks being left to play the perverse role of indicating and defining a kind of rhythmic pattern that they are by nature incapable of stating in all its plenitude.

Now the two quantitative measure-patterns drawn above, although identical when expressed in quantitative sound, are not identical when expressed by dry taps. Such taps, if placed on counts one and three, would create a tonic measure-beat. Consequently they are placed on two and four in order to make it clear that there is no tonic measure-beat.

The cymbal and snare drum occasionally add their precise statement of quantitative pattern number 2 to reinforce the same point.

The result of this elaborate procedure is an amplification of the expressive range. The listener, like the improvising player, is not whipped back and forth by any muscular reactions to regular beats. So marked, in fact, is the absence of regular beats that most players are obliged to keep themselves aware of musical time by rapid foot-patting. Neither is the listener lulled to sleep by an expressed quantitative routine (which can be very monotonous indeed). The pluck-and-tap rhythm is equal and delicate. It never becomes a beat. But it reminds one at all times of that underlying measure of length which is the structural unit of the whole music, reminds one so gently but so continuously that both the invention and the comprehension of musical structures is greatly facilitated.

Notice the high degree of intellectual and nervous excitement present in any swing audience. The listeners do not close their eyes and sink into emotional or subjective states. They sit up straight, their eyes flash, they applaud the licks. They occasionally jerk on the absent downbeat, but on the whole they seem to be enjoying one of those states of nervous and muscular equilibrium that make possible rapid intellection.

Quantitative rhythm in music has long been known to have special characteristics, not the least noticeable being a tendency to develop complex textures for nonemotional purposes, the organ works of Sebastian Bach and his predecessors being pretty spectacular in that way. Beat music, on the other hand, is always emotional and tends to hide rather than parade its complexities. The whole matter, however, has been very little discussed. Even the term "quantitative rhythm" is unknown to many musicians, although the musical notation we all use is as strictly a quantitative conception as though accents didn't exist. Musicians all know there is something rather special about the pipe organ, but they mostly consider the unvarying nature of an organ tone to be a defect rather than a characteristic. I don't want to go into all that any further just now. But I do want to note that quantitative music is having a renaissance under our very noses and that the plucked or tapped instruments are occupying an important place in that renaissance, a place not unlike that occupied by the harpsichord in the equally quantitative music of the seventeenth and early eighteenth centuries.

From *Modern Music,* March 1938.

PART 3

Paris

❧ Antheil, Joyce, and Pound

IN 1921, EUROPE ITSELF had been my objective. That was where the good teachers lived and all the best composers — Stravinsky, Ravel, Schönberg, Strauss, Satie, and masses of ingenious other ones, especially among the French, from the aged Fauré, Saint-Saëns, and d'Indy through the middle-aged Florent Schmitt and Paul Dukas down to Darius Milhaud, not thirty, and Francis Poulenc, just eighteen. Already twenty-four myself, I had then needed to finish learning before I could get on with music writing. In 1925, four years later, only the musical pouring out was urgent; everything else I did got in its way. I had practiced successfully organ playing, teaching, and conducting; but I did not want to be going on doing any of them. They filled up my waking mind with others' music. When I remarked this to Edward Burlingame Hill, my chief instructor, he declined to press me — like my father on the subject of going to war — pointing out that if I cared about such things I could easily have a professor's career at Harvard, with no doubt a composing and performing life as well, but that if I needed just then only to compose, I had every right to follow my impulse. It had never been my habit to relinquish a thing while learning to do it, but rather to give up only that which I had proved I could do. (A mastered branch could be picked up again.) In quitting at that time teaching and performance, I set for all time my precedent, incorrigibly to be followed in later life, of walking out on success every time it occurred.

My return to Europe in 1925 was therefore both a coming-to and a going-from. I was coming to the place where music bloomed. I was leaving a career that was beginning to enclose me. I was also leaving an America that was beginning to enclose us all, at least those among us who needed to ripen unpushed. America was impatient with us, trying always to take us in hand and make us a success, or else pressing us dry

for exhibiting in an institution. America loved art but suspected distinction, stripped it off you every day for your own good. In Paris even the police were kind to artists. As Gertrude Stein was to observe, "It was not so much what France gave you as what she did not take away."

But even Eden charges room and board. And in resigning from self-support off two byproducts of my musical education, I had kept back a third as ace in hole, that of writing about music. This, I made believe to friends and family, was the least demanding of all and the most remunerative, and would therefore be the least inhibiting. I believed this myself for a while; but when I got to France I never wrote again for *Vanity Fair* or for *The New Republic* or for Mencken's *American Mercury*, though all wrote me they awaited pieces, as did *The Dial* by way of its new editor, Marianne Moore.

The money I had come abroad with in September, exactly $500, was gone by April; but I did not tell my family that, because I did not wish to worry them or put my father to undue sacrifice. Actually, after a bad time in the fall of 1926, I did ask him for $100, which he sent without question. That winter and spring I also had small gifts from friends and eventually a commission. In the summer of 1927, again destitute, I saved the life of Jessie Lasell, Hildegarde Watson's mother. Out of gratitude she sent me $125 a month for about three years. There were briefer patrons too, and an occasional fee for performing my music. All in all, I lived for eight years "without turning an honest penny," as I put it. Or a dishonest one, for that matter. For whenever I borrowed money I paid it back. You have to do that when you are poor, to keep your credit.

Living again in the rue de Berne, so far my Paris base, little by little I established outposts across the Seine. The first of these was at 12, rue de l'Odéon, where I already knew Sylvia Beach and was a frequenter of her hospitable bookstore, Shakespeare and Company. And it was there that I made friends with the composer George Antheil, truculent, small boy-genius from Trenton, New Jersey, and the very personal protectorate of Sylvia, James Joyce, and Ezra Pound.

I envied George his freedom from academic involvements, the bravado of his music and its brutal charm. He envied me my elaborate education, encouraged me to sit out patiently the sterile time it seemed to have brought. In a *pneumatique* of November 12, he wrote, "Let me say what I said last night, that I believe in you more than I believe in certainly any other American, and perhaps even a lot more of other nationalities." Antheil's warmth and admiration cheered me through that worried fall, until by January I was deep in a three-movement piece.

That winter George was composing a jazz symphony for some twenty-two instruments. His *Ballet Mécanique* was finished, awaiting its premiere till the piano manufacturer who had had the rolls cut should be able to solve the problem of synchronizing sixteen pianolas, the number George

had set his heart on for producing a loudness matching that of the large percussion group. The work eventually achieved public performance, but without mechanical synchrony or quite sixteen pianos. Meanwhile he would play the rolls on one piano, pumping hard to keep up enough wind pressure for sounding all the notes at maximum; and in his low-ceilinged, one-room flat he managed to make quite a racket.

For composing in tranquillity he had hired a room around the corner and put in it an upright piano not mechanical. Here he composed daytimes, going home for lunch and dinner with his tiny Hungarian wife, Böske, in their room above Sylvia Beach's bookstore. I sometimes used to spend the night in the narrow hotel room, just opposite the barracks of the Garde Républicaine, and be wakened by the sounds of horses' hooves as the troop pranced through the gates to exercise. I slept there because by Christmas I had moved to Saint-Cloud, where Theodore Chanler had lent me an apartment.

Teddy, then eighteen, represented an experiment in upper-class male education, since he had opted, just out of school, to become a composer without taking time out for college, but wholly through studying with Nadia Boulanger and living in Europe. From Christmas till April that year he would be visiting his mother in Rome. The two-room flat in Saint-Cloud that he had invited me to occupy was at 66, avenue de Versailles, on the top floor of the topmost house of the topmost hill, and its view was panoramic. This included the distant Sacré Coeur and the nearer Eiffel Tower, on which at night there was played out in lights, putting Times Square to shame, a repeated drama of being struck by zigzag yellow lightning, then consumed by red flames, after which white stars and comets appeared and finally the name of the sponsor, Citroën.

A friend from the Harvard Liberal Club, Maurice Grosser, in France on a fellowship and practicing to be a painter, came there to stay with me and share expenses. These were minimal, since the wife of the landlord, himself a retired butcher and devoted vegetable gardener, would send up lunch at cost. Then after a morning's work and a tasty meal, we would walk, breathing damp fresh air, in the Saint-Cloud forest on leaf mold and under trees — all green moss on their northern sides, full at their tops of gray, ball-shaped mistletoe. Or we would walk along the Seine and round the Longchamp racetrack in the Bois de Boulogne, sometimes to Paris itself, or to Versailles for cakes and tea, and then walk back.

Sometimes still other friends came out for lunch, the writers Janet Flanner, Sherry Mangan, Victor Seroff (then practicing to be a pianist and living just below at Boulogne-sur-Seine). Every week I went to town by train to show Nadia Boulanger my progress on a piece called Sonata da Chiesa. I also made sketches for my Symphony on a Hymn Tune; but these I did not show her, knowing that once the Church Sonata was fin-

ished my time of taking lessons would be over. I also went to Paris at other times for seeing people, going places, doing things; and it was when I loitered too late to catch the last train back from Saint-Lazare that I would spend the night in Antheil's room at the Hôtel de Tournon.

I often loafed at Sylvia Beach's shop, where I had the privilege of borrowing books free. And I went to parties at her flat, also in the rue de l'Odéon, shared with Adrienne Monnier. If angular Sylvia, in her box-like suits, was Alice in Wonderland at forty; pink-and-white, buxom Adrienne in gray-blue uniform, bodiced, with peplum and a long, full skirt, was a French milkmaid from the eighteenth century. At her bookstore opposite Sylvia's, La Société des Amis des Livres, she published a magazine, *Le Navire d'Argent*; and under the same imprint a French translation of James Joyce's *Ulysses*, by Valéry Larbaud, was about to be issued. When the book was ready, Adrienne invited Picasso to illustrate it. He demurred, probably out of friendship for Gertrude Stein; but he did consent to read it, a thing he rarely did for any book. After he had returned the manuscript, he comforted Miss Stein, "Yes, now I see what Joyce is, an 'obscure' that everybody will understand" (*"un obscur que tout le monde pourra comprendre"*).

Joyce and Stein, I must explain, were rivals in the sense that, viewed nearby, they appeared as planets of equal magnitude. Indeed the very presence of them both, orbiting and surrounded by satellites, gave to Paris in the 1920s and '30s its position of world center for the writing of English poetry and prose. Hemingway, Fitzgerald, and Ford Madox Ford; Mary Butts, Djuna Barnes, and Kay Boyle; Ezra Pound, e. e. cummings, and Hart Crane worked out of Paris and depended on it for judgment, as often as not for publication too. And all were connected in some way to Stein or Joyce, sometimes to both.

The stars themselves came together just once — briefly and both consenting. That was at the house of the sculptor Jo Davidson. And since Joyce was by that time almost blind, Miss Stein went into another room to meet him, rather than that he should be led to her. But when they had approached, exchanged greetings and goodwill phrases, they found nothing to say to each other, nothing at all.

It was through Sylvia Beach that I first met Joyce (at her flat, I think). But it was more in company with Antheil that I used to see him. When during the spring of 1926 Antheil's music and mine began to appear together on programs, Joyce always came to hear us and never failed to tell me that he liked my work. That the compliment was sincere I had no reason to doubt; that it was pleasing to me, coming from so grand a source, no one need doubt. Nevertheless, when in the mid-1930s, after my opera *Four Saints in Three Acts*, for which Gertrude Stein had written the libretto, had received some recognition, Joyce offered me his own collaboration, I demurred, as Picasso had done, and for the same reasons.

I did not feel like wounding Gertrude Stein, or choose to ride both ends of a seesaw.

What Joyce proposed was a ballet, to be based on the children's-games chapter of *Finnegans Wake*. He gave me a hand-printed edition of that chapter, with an initial designed by his daughter Lucia; and he offered me, for the final spectacle, production at the Paris Opéra with choreography by Leonide Massine. I did not doubt that a ballet could be derived from the subject. My reply, however, after reading the chapter, was that though anyone could put children's games on a stage, only with his text would such a presentation have "Joyce quality." I did not add that in place of the pure dance spectacle proposed, one could imagine a choreographed cantata using Joyce's words.

It was from a literary source that I had first heard of Antheil, through an article in *La Revue de Paris*. The writer had quoted from another work of letters, Ezra Pound's book *Antheil and the Treatise on Harmony*. Antheil was being launched, in fact, by Pound, past master at launching careers (though before this, only for poets). Joyce, Monnier, Beach, the world of Shakespeare and Company, all were fascinated by Antheil's cheerful lack of modesty. He was in fact the literary mind's idea of a musical genius — bold, bumptious, self-confident; he was also diverting. The resistance to Antheil came from music circles. In spite of the rue de l'Odéon publicity and in spite of a gift for blowing his own horn, George had not broken into the concert programs, even the modernistic ones. His chief glory came from the still unperformed *Ballet Mécanique*, composed originally to accompany a film of that name designed by the painter Fernand Léger but early detached from it. Besides this music, and an unfinished Jazz Symphony, his repertory consisted of a half dozen songs, a youthful piano piece entitled *Airplane Sonata*, a Symphony for Five Instruments, and a string quartet. For Ezra Pound's violinist friend Olga Rudge he had written also a Sonata for Violin and Piano, percussive throughout and with bass drum laid on at the end. And he was composing that spring and summer of 1926 a Symphony in F, to be played the next season in a concert he himself would organize. I rather think, however, that his first Paris concert performances came through me.

The Société Musicale Independente, founded in 1909 by Gabriel Fauré, was still active, with Ravel, Koechlin, Casella, Falla, Stravinsky, Schönberg, and Bartok on its board. Boulanger, a member of the program committee (and with Walter Damrosch, her colleague at Fontainebleau, available for bringing in Americans to subsidize it), had conceived the idea of a special concert, outside the regular subscription, devoted to young American composers. On the program were to be my Sonata da Chiesa for five instruments, piano pieces by Herbert Elwell, a song with flute and clarinet and two pieces for violin and piano by Aaron Copland, a piano sonata by Walter Piston, and a violin-piano sonata by Theodore Chanler.

All the works, except one of Copland's violin pieces, were receiving their first performance anywhere; all were to be played by first-class artists; and all were the work of Boulanger's pupils. Adding the Antheil String Quartet was my idea; and that too was to be a first public performance.

All these pieces were characteristic of the newest in American talent, as well as of postwar Parisian ways, which is to say that they applied old-master layouts to contemporary melodic inspirations and harmonic concepts. My way of doing this, also Antheil's, was derived from the latest works of Igor Stravinsky; the others had theirs more from Boulanger, who was both an organist conditioned to Bach and a pupil of Gabriel Fauré. A certain unity of musical method, nevertheless, underlay personal variations and gave to the concert a recognizable impact, just as fine executions gave it brilliance. There were lots of people present, lots of laudatory reviews later, along with some shocked ones, the latter mostly with regard to my Church Sonata, which consisted of a chorale, tango, and fugue and made funny noises.

My report on the concert to Briggs Buchanan, my chief confidant, itemizes:

1. The audience was distinguished;
French music represented by Boulanger, Florent Schmitt, Louis Aubert, Albert Roussel, Ingelbrecht, others.

Society as mentioned in the program [a long list of patrons and patronesses].

French criticism by Paul Le Flem, Boris de Schloezer, André Coeuroy, Raymond Petit.

American music (though their works were not played) by George Foote, Walter Damrosch, Edmund Pendleton, Roger Sessions, Blair Fairchild.

American critical intelligentsia by Pierre Loving, Gilbert Seldes, Manuel Komroff, Ludwig Lewisohn.

American diplomacy by the military attaché (in dress uniform), tone-deaf but serious in the performance of his assignment.

James Joyce also appeared. He never goes out.

2. The performances were uniformly excellent.

3. The program was impressive, though long and tiresome. (Six first auditions are too much.)

The most impressive work (by number of players engaged, novelty of form, and strangeness of noises produced) was the Sonate d'Eglise by V. Thomson. Second in importance on the program (though, in my opinion, not inferior in quality, probably even superior) was the String Quartet of George Antheil. The other works, more modest in pretension, less well realized in style, but all genuinely musical in conception and not bad to listen to, were distinguished by the second movement of Chanler's Violin Sonata, which is a real piece.

And of my own piece:

> In general one may say that leaving out about two ill-advised experiments, the instrumentation is unquestionably a knock-out. The chorale has a genuinely new idea. The other movements decently satisfactory. The faults are a dangerous rigidity of rhythmic texture in the chorale, an excessively contrapuntal style in the fugue, and an immature comprehension of the profundities of classical form. The work manifests, however, a mind of great strength and originality. The public awaits (or ought to) with eagerness Mr. Thomson's next work, a symphony in the form of variations on an American hymn tune.

Hardly any time after this concert, I was taken to a chubby and personable young woman who was in the mood to entertain artistically. Alice Woodfin, a musician herself but also a frequenter of society, was the go-between. Mrs. Christian Gross, sugar millionairess and wife of the first secretary of the American Embassy, had a palatial flat on the Champ-de-Mars at 1, avenue Charles-Floquet — also so much income and so little technique for spending it that when buying Catherine the Great's emerald necklace at Cartier's she had modestly asked if it would be all right to pay at the end of the month. She thought it would be lovely to have concerts of my music at her house; and when I suggested sharing these with Antheil to make the repertory larger (also, his name was better known than mine), she was overjoyed. Four weekly concerts were therefore announced (with tea before and champagne after), Antheil's strong-arm squad, commanded by Ezra Pound, taking care of the guest list and handling finances.

The programs, elegantly performed, contained my Sonata da Chiesa, conducted by Vladimir Golschmann, and Five Phrases from the Song of Solomon, accompanied by percussion and sung by Alice Mock. Antheil's chamber works were also exposed; and a final gala at the Théâtre des Champs-Elysées presented for the first time publicly his *Ballet Mécanique*, played with lots of percussion, including two airplane propellers, but only one mechanical piano. I did not attend this concert, since no work of mine was on the program, and since I was a little disturbed by George's and Ezra's secrecy with regard to material benefits. Ezra did say to me, on a bench in the Luxembourg Gardens, "If you stick around with me, you'll be famous." But in view of how domineering he was, I was not interested in being made famous by him, nor in sticking too close; and he must have felt this. In any case, our brief association ended. A decade later Ford Madox Ford recounted that at one of Mrs. Gross's musicales Ezra had pointed me out to him: "You see that little man there? That's the enemy."

That fall an orchestral concert was held in the Salle Gaveau at which Antheil's Symphony in F had its premiere. Vladimir Golschmann con-

ducted; and everybody was well paid, including, I believe, the press. As for me, I had received from Mrs. Gross at the end of our series a check for $500, this to be considered as commissioning a work. I wrote the work but was never able to deliver it, because by fall she had left her fine flat, her husband and children, and eloped with a Mexican. As innocent at musical patronage as at social climbing, she did not again, to my knowledge, essay either; rumor had it she was content with love.

Sometime that spring I had written to Briggs Buchanan, regarding the winter just past, that Antheil had been its "chief event."

> For the first time in history, another musician liked my music . . . said hello. Somebody recognized what I was all about. Or recognized that I was about something worth looking at. Imagine my gratitude. More particularly since this support and admiration came from the first composer of our generation (of this there isn't any doubt) and was supported by deeds. I must admit that the encouragement has been mutual, that the contact has bucked up George just as much as me, perhaps more. The point remains, Antheil is the chief event of my winter. He has admired me, he has quarreled with me about theories, he has criticized my pieces, he has consulted me about his, he has defended me to my enemies, to his enemies, to my friends, to his friends . . . He has talked, walked, and drunk me by the hour. He has lodged me and fed me and given me money. At this very instant he is trying to persuade a rich lady to give me money instead of to him, although he is perfectly poor himself.

For this effort I had only Antheil's word, for the name of the lady not even that. It is true that he had once given me, at his wife Böske's suggestion, when I was destitute, 500 francs (twenty dollars). It is also true that we were companions and believed in each other. My estimate of him as "the first composer of our generation" might have been justified had it not turned out eventually that for all his facility and ambition there was in him no power of growth. The "bad boy of music," as he was later to entitle his autobiography, merely grew up to be a good boy. And the *Ballet Mécanique*, written before he was twenty-five, remains his most original piece.

New York heard this work on April 10, 1927, along with the Jazz Symphony, at a Carnegie Hall concert vastly publicized and vastly disastrous to Antheil's career. In despair he acquired lung spots; in a long Tunis vacation he cured them. A few years later, after a not wholly successful essay at German-language opera (entitled *Transatlantic* and produced in Frankfurt), he returned to America, where for the rest of his life he earned his living and took care of his health. The living was made not only by writing music, which he did for Hollywood films with some

distinction, but also by writing for newspapers on subjects unrelated to music. He conducted a syndicated column of advice to the lovelorn, basing his answers on the probable influence of certain endocrine glands (thymus, thyroid, pituitary, adrenal) over the questioner's destiny. And during World War II he wrote astonishingly accurate military prophecy for a newspaper editor, Manchester Boddy, of the *Los Angeles Daily News*. He also composed one striking ballet (on a Spanish subject out of Hemingway), several English-language operas, and six symphonies.

Earlier that season, in late June of 1926, Ezra Pound's opera had been performed in a stylish execution before a choice intellectual public at the Salle Pleyel in the rue Rochechouart, where Chopin and Liszt had played. The text was François Villon's *Testament;* and the orchestra contained a *corne,* or animal's horn, five feet long, that could blow two notes only, a bass and the fifth above it, but with a raucous majesty evocative of faraway times. The vocal line, minimally accompanied, was a prosodization of Old French, which Ezra was said to know well. The music was not quite a musician's music, though it may well be the finest poet's music since Thomas Campion. For one deeply involved with getting words inside music, as I was, it bore family resemblances unmistakable to the *Socrate* of Satie; and its sound has remained in my memory.

I had been heartwarmed through a cold and dismal autumn, that year of my return, by the affection of a poet, Sherry Mangan, and sustained in my musical hopes by the faith of a composing contemporary, George Antheil. My music's steady flow had finally begun on the heights of Saint-Cloud through the generosity of the younger composer Theodore Chanler and the companionship of the painter Maurice Grosser. Toward the end of spring, back in Paris, I had experienced for a short time complete poverty. After that had come performances of my work, and these had led to money enough for getting through the summer. With my patron's gift of $500 I went off at the end of July to Thonon-les-Bains, near Evian, where I wrote music and rowed on Lake Geneva. There I also met a Frenchwoman forty years older who became my close companion for thirteen years (not mistress, not pseudomother, but true woman-friend, ever jealous and ever rewarding) till her death at eighty-three on the eve of World War II.

❧ Langlois, Butts, and Stein

LOUISE LANGLOIS (née Philibert) was slender, wore her gray hair short, and smoked constantly. Born in Besançon (place de la Préfecture), she practiced the historic courage of the Franche-Comté along with the indefatigable letter writing of the French educated classes. Her father, born around 1800, had brought up nine children, and at eighty got another on the chambermaid. Louise, the youngest legitimate one, was the darling of her next older brother, a naval officer, later admiral. All their grown lives they wrote each other every day. She married late; he never. Her husband, Dr. Jean-Paul Langlois, had been a professor of physiology. Her friends were chiefly men of learning and general staff officers, powerful people, busy people, all running something. Her closest man friend outside the medical and military clans had been Lucien Herr, librarian and later director of the Ecole Normale Supérieure, Alsatian exile from 1871, long-time chief of the Socialist Party, guide and counselor to Jaurès and Léon Blum. Herr's widow once lent me, for a month, their farmhouse retreat near Montfort-l'Amaury, where I learned from the abundance of Beethoven and of books about Beethoven in his private library the meaning of this composer as a freedom prophet for socialists of the Second International. Madame Langlois's constant traveling companion summers was a woman physician, Russian by birth, who addressed her both ironically and affectionately as "Princesse."

Surrounded from childhood by persons of power and brains, she had early become adept, as an academician said of her, at attaching to herself men of quality. ("*Elle a toujours eu le don de s'attacher des hommes de valeur.*") She must have suspected me one of those, because after a brief exchange of courtesies between us in a hotel hallway, she set herself out to become my friend; and within three days I was regularly taking my

after-lunch coffee with her and her companion. We also went on sight-seeing trips together, swapped books, played bridge. By the time we had got back to Paris we were as chummy as a child and its grandmother. Christian Bérard, who came from that kind of people himself, asked in astonishment, after one encounter, "How ever did you *meet* a French-woman of that class?"

Actually that class, the upper-bracket professionals, is the one with which I have always got on best. Even in France, with its secretive fam-ily life, I had been received without abrasions in exactly such a clan, the Faÿs, almost as a member of it. There, in an atmosphere at once of friendship and formality, being asked to dinner when there were no other guests and only everyday foods or to tea when we sat down to it in the dining room, twelve strong around a special cake, I had recognized my Missouri grandparents and my Kentucky great-aunts, with their taffeta shirtwaists and diamond earrings, their involvements with religion and church, their sumptuous cooking.

With Madame Langlois (and I never called her anything but that) there was no misunderstanding about important matters. We viewed art, families, friendships, ethics, learning, politics, and patriotism with a closer consanguinity than might have been thought possible, given the distance that lay between us in age, geography, reading, upbringing, and language. Watching her behavior was always a lesson. At her hus-band's graveside she had refused to shake hands with Alexandre Mil-lerand, President of the Republic, because he had failed to support her husband's research program. The manservant in her boulevard Saint-Germain apartment had shown devotion during her husband's last ill-ness; and on account of her gratitude for this she could not fire him, though he was stealing both money and furniture. So she gave up her apartment, pensioned him off, and went to live for the rest of her life, ten years, in a hotel. Again, crossing the place Denfert-Rochereau alone on February 7, 1934, when masses of students, fascists, paid hoodlums, and police were involved in a far-from-spontaneous repeat of the previ-ous day's place de la Concorde "massacres," she said to the cop who had warned her she must not venture beyond the sidewalk, "I walk where I choose." And she crossed without harm, on her way to play bridge with Mary Reynolds, Marcel Duchamp, and one of her lovely old generals, Filloneau. Just as Roman Catholicism was her faith and France her coun-try, moral elegance and personal bravery were her habit, affection and friendship her daily rite and virtually sole occupation.

Philip Lasell had come from America that fall and taken a room next to mine in the house at 20, rue de Berne. Gifted for many things but working at none, Hildegarde Watson's cousin was a playboy of won-drous charm. For him I served as guide to the intellectual life, though he

also used, in this same way, Jean Cocteau, Mary Butts, and the young French novelist René Crevel. In December, leaving for the South, he dramatized his departure with what I described to Buchanan as

> a sort of ethereal Proustian quarrel (a marvelous quarrel conducted with the greatest dignity and the nearest to an open display of affection that we have ever allowed ourselves. A sort of tearful but indignant graduating exercise, Philip doing his best to be hard toward the institution he was so fond of, and the best he could achieve being to offer me his ten Picasso's from which he has never been separated more than three days since he bought them in 1923).

The quarrel being no more than a gesture of temporary farewell, the gift was refused, though the framed gouache prints (five of musicians and five of cardplayers) remained on my mantel for some months. Much later, leaving for America, he offered them again; and this time I accepted a gift but chose, since I could have whichever I preferred, a painted sculpture by Arp made out of wood. René Crevel got the Picassos, which I was happy to abandon. Having lived with them, I knew they were not my magic. The Arp is still with me and gives happiness. The quarrel was so void of significance that I joined Philip in April in the South, and it was through him that I came to know Mary Butts.

Mary was an Englishwoman of gentle birth, a roisterer, and a writer of intensely personal fiction. She was also quite handsome, with her white skin and carrot-gold hair. Her favorite dress was sweater and skirt (the British national costume); and she was fond of wearing, under a tipped-up man's felt hat, a single white jade earring, dollar-size. Like all the well-brought-up English, she got up in the morning. (Young Americans like to stay up late and sleep till noon.) Every day, too, she wrote with pen in bound notebooks. She kept herself and her house very clean, and roistered only when the day was done. Then she would have tea, toddle out to a café, meet friends, go on from there. The toddling was caused by a knee that if not carefully handled would slip out of joint. It did not interfere with dancing in the walk-around fashion of the time or with a reasonable amount of country walking. What Mary liked most, however, come six of an evening, was a long pub crawl — going with loved ones from bar to bar, dining somewhere, then going on, tumbling in and out of taxis, fanning youth into a flame. Come midnight she would as leave go home and write.

I used to call her "the storm goddess," because she was at her best surrounded by cataclysm. She could stir up others with drink and drugs and magic incantations, and then when the cyclone was at its most intense, sit down at its calm center and glow. All her short stories are of moments when the persons observed are caught up by something, inner or outer, so irresistible that their highest powers and all their lowest

conditionings are exposed. The resulting action therefore is definitive, an ultimate clarification arrived at through ecstasy. This kind of experience, of course, is the very nut and kernel of classic tragedy; and Mary liked using it for leading people on till they shot the works. There was no evil in her; her magic was all tied up to religion and great poetry. But she was strong medicine, calling herself in joke my "unrest cure." And she was sovereign against my juvenile reserves, my middle-class hypochondrias, my "pessimisme américain," as Kristians Tonny was to call it. (She used to say that a European young man, waking up in the morning, opens the window, breathes deeply, feels wonderful, while his contemporary from America closes the window, then rushes to a mirror to look for signs of decay.)

Accustomed as I had been from my earliest times to strong home remedies, and knowing well the advantages of ecstasy, I still did not like having my emotions manipulated; my resistance to the machinery of Southern Baptist conversion had not made me an easy mark. Nor could Mary's history of men quite recommend her. Marriage to a poet (John Rodker), a daughter by that marriage, escape from it to the Continent with a tall Scot who practiced black magic and took drugs, the ensuing death of the Scot, an unforgiving mother, a demanding literary gift quick to bud but slow to ripen — all this had made her a strong woman, as her natural warmth had made her a good one, her classical education and high breeding (granddaughter of William Blake's friend and patron Captain Butts) a sweet and lively one. But none of it had trained her for mating with a musician. Nor could I at thirty take on for long a greedy and determined *femme de lettres* some seven years older. The mental powers were too imposing, the ways inflexible. We had lovely times together — warmths, clarities, and laughter. Then bickering began; and though our separation was not casual, by the time the year was out we were not meeting. That was in 1927. When she died in 1937 I felt almost like a widower.

In one poem Mary had declared her theme:

> From ritual to romance
> Two mediocrities:
> That is to say, without the high-strung moment
> Which in the transition, the passage,
> Undoubtedly occurs.

In another her nostalgia:

> O Lord, call off the curse on great names,
> On the "tall, tight boys,"
> Write off their debt,
> The sea-paced, wave curled,
> Achilles' set.

And back in her own south country, she had pronounced her prayer for abundance:

> Curl horns;
> Straighten trees;
> Multiply lobsters;
> Assemble bees.

It was through Mary that I knew the opium world, at least that part of it which involved our friends. If I had encountered the drug at twenty I should certainly have tried it. At thirty I was afraid. But I respected its users and did not show disapproval. For the next five years I shared many a pipe vicariously. Once I held a friend's hand through withdrawal. I still enjoy the sweetish smell of the smoke, rather like that of maple syrup cooking.

My friendship with Gertrude Stein dates also from the winter of 1925 and '26. Though addicted from Harvard days to *Tender Buttons* and to *Geography and Plays* (almost no other of her books was yet in print), I still had made no effort toward the writer. I wanted an acquaintance to come about informally, and I was sure it would if I only waited. It did. Having heard in literary circles that George Antheil was that year's genius, she thought she really ought to look him over. So through Sylvia Beach she asked that he come to call. George, always game but wary, took the liberty of bringing me along for intellectual protection, sending me in Saint-Cloud a *pneumatique* that said, lest I hesitate, "we" had been asked for that evening. Naturally I went. Alice Toklas did not on first view care for me, and neither of the ladies found reason for seeing George again. But Gertrude and I got on like Harvard men. As we left, she said to him only good-by, but to me, "We'll be seeing each other." And still I made no move till late the next summer, when I sent her a postcard from Savoy, to which she replied.

I was thirty that year; and there had been dinner at Josiah Lasell's flat in the Palais Royal. At Christmas, according to my accounting of it to Buchanan, I attended

> two family dinners, great rowdy affairs with punch and champagne and children and movies ... of Charlie Chaplin and turkeys from Lyon as big as sheep and plum puddings from London and mince pies from a swell Negro restaurant. And an eggnog party in the afternoon. A Xmas Eve tea with Bernard [Faÿ] and Sherwood Anderson. A Xmas Eve party at Gertrude Stein's with carols and a tree and a Xmas cake with ribbon and candles on it. A dance Xmas night at Nancy Cunard's with Eugene [McCown] and the hard-drinking artist set.

On New Year's Day I took Miss Stein a musical manuscript, the setting for voice and piano of her *Susie Asado*. Reply was instant:

I like its looks immensely and want to frame it and Miss
Toklas who knows more than looks says the things in it please
her a lot and when can I know a little other than its looks but
I am completely satisfied with its looks, the sad part was that
we were at home but we were denying ourselves to everyone
having been xhausted by the week's activities [actually that
was the day she cut off her hair] but you would have been the
xception you and the Susie, you or the Susie, do come in soon
we will certainly be in Thursday afternoon any other time it
is luck but may luck always be with you and a happy New
Year to you

> Always
> Gertrude Stein.

My hope in putting Gertrude Stein to music had been to break, crack
open, and solve for all time anything still waiting to be solved, which
was almost everything, about English musical declamation. My theory
was that if a text is set correctly for the sound of it, the meaning will
take care of itself. And the Stein texts, for prosodizing in this way, were
manna. With meanings already abstracted, or absent, or so multiplied
that choice among them was hopeless, there was no temptation toward
tonal illustration, say, of birdie babbling by brook or heavy heavy hangs
my heart. You could make a setting for sound and syntax only, then add,
if needed, an accompaniment equally functional. I had no sooner put to
music after this recipe one short Stein text than I knew I had opened a
door. I had never had any doubts about Stein's poetry; from then on I
had none about my ability to handle it in music. In the next few months
I made several Stein settings, the last being a text of some length en-
titled *Capital, Capitals*, composed for four male voices and piano. This is
an evocation of Provence — its landscape, weather, and people — imag-
ined as a conversation among its four capital cities — Aix, Arles, Avi-
gnon, and Les Baux; and it takes upwards of twenty minutes to perform.
But long before that was composed I had asked Miss Stein to write me
an opera libretto, and we had sat together for picking out a subject.

The theme we chose was of my suggesting; it was the working artist's
working life, which is to say, the life we both were living. It was also my
idea that good things come in pairs. In letters, for instance, there were
Joyce and Stein, in painting Picasso and Braque, in religion Protestants
and Catholics, or Christians and Jews, in colleges Harvard and Yale, and
so on to the bargain basements of Gimbel's and Macy's. This dualistic
view made it possible, without going in for sex unduly, to have both male
and female leads with second leads and choruses surrounding them, for
all the world like Joyce and Stein themselves holding court in the rue de
l'Odéon and the rue de Fleurus. I thought we should follow overtly, how-
ever, the format of classical Italian opera, which carries on the commerce

of the play in dry recitative, extending the emotional moments into arias and set pieces. And since the eighteenth-century *opera seria*, or basic Italian opera, required a serious mythological subject with a tragic ending, we agreed to follow that convention also, but to consider mythology as including not just Greek or Scandinavian legends, of which there were already a great many in operatic repertory, but also political history and the lives of the saints. Gertrude liked American history, but every theme we tried out seemed to have something wrong with it. So that after I had vetoed George Washington because of eighteenth-century costumes (in which everybody looks alike), we finally gave up history and chose saints, sharing a certain reserve toward medieval ones and Italian ones on the grounds that both had been overdone in the last century. Eventually our saints turned out to be baroque and Spanish, a solution that delighted Gertrude, for she loved Spain, and that was far from displeasing me, since, as I pointed out, mass-market Catholic art, the basic living art of Christianity, was still baroque. And Maurice Grosser was later to remind us that musical instruments of the violin family still present themselves as functional baroque forms.

Our conversations about writing an opera must have taken place in January or February of 1927, for by March 26 Miss Stein had "begun Beginning of Studies for an opera to be sung." "I think," her note went on, "it should be late eighteenth-century or early nineteenth-century saints. Four saints in three acts. And others. Make it pastoral. In hills and gardens. All four and then additions. We must invent them. But next time you come I will show you a little bit and we will talk some scenes over."

The same day, "The saints are still enjoying themselves." Four days later they had gone firmly Spanish. "I think I have got St. Thérèse onto the stage, it had been an awful struggle and I think I can keep her on and gradually by the second act get St. Ignatius on and then they will be both on together but not at once in the third act. I want you to read it as far as it has gone before you go . . ."

Going refers to my departure for the South, where I stayed till May, a little bit with Philip Lasell but mostly with Mary Butts, wrote *Capital, Capitals*, also some organ variations on Sunday school hymns. Alice Toklas must have decided by this time not to dislike me, because Gertrude's letters contain warm messages from her (referred to now as Alice) and constant declarations of Alice's admiration for my music. I had in fact become a member of the household and had begun introducing into it my close associates.

I began with three poets — the Frenchman Georges Hugnet, the Belgian Eric de Haulleville, and the American Sherry Mangan — plus a French prose writer, Pierre de Massot, who wrote very beautifully but very lit-

tle. My painter comrades at this time were Christian Bérard, Léonid Berman, Eugene Berman, and Kristians Tonny. I also knew Pavel Tchelitcheff, but so did Gertrude. Léonid she never took up with. Tchelitcheff, Bérard, and Eugene Berman (or "Pavlik," "Bébé," and "Genia") were in full reaction against cubism and striving steadfastly to express, as Picasso had loved to do two decades earlier, tenderness, mystery, and compassion. Pavlik and Bébé painted only people; Genia preferred deserted architecture. Léonid's subjects even then were ships, the sea, and fishermen. Tonny, much younger, was a virtuoso draftsman of Flemish fantasy.

All these young painters, along with the poets, came later to be termed neo-Romantics; and their movement had influence not only among the twenty-to-thirty-year-olds but also among older artists. Picasso himself, about 1930, essayed to take over the mystery, humanity, and ink blots of Bérard; but he could never quite get back for use again the compassion he had felt when he was young and poor. So he turned to the harsher and more calculated spontaneities of surrealism. Gertrude Stein, affected by us all, began at this time a series of landscape books that initiated the slow return to emotional content and naturalistic speech that were to give such impressive results at the end of her life. In mid-April of 1927, still writing on *Four Saints*, she had sent word that "the opera has given me lots of ideas for a novel I want to write one." And in July, with the opera barely finished, she wrote of "progressing with my novel," *Lucy Church Amiably*.

The movement's literary mentor was Max Jacob — poet, painter, satirical storyteller, Picasso's friend from early youth, a Jew from Brittany, a penitent, a Catholic, and something of a saint. Max who had seen Jesus twice — in 1909 on his own Montmartre wall, at Montparnasse in a cinema five years later — was mean and generous, envious and kind, malicious and greathearted. Most important of all, he could speak straightforwardly, whether ridiculing bourgeois ways or recounting religious experience. Gertrude, who had known him in prewar days, had long since ceased to receive him, on account of his uncleanly person and bohemian ways, which at that time had included sniffing ether. After his martyrdom at German hands in 1944, she spoke of his work with admiration and with respect.

The group had no mentor for painting — could have none — because the only artist its members admired wholeheartedly was Picasso; and he was not available to the young. On the contrary — dyspeptic, worried, watchful — he led his life in terror of them, his all-seeing eye and whiplash wit alert to every prey. When Gertrude hung a neo-Romantic landscape by Francis Rose, Picasso asked the painter's name and then the price. To her reply that she had paid 300 francs (twelve dollars) he mut-

tered, half smiling, "For that amount one can get something quite good."

The painters of our group, no father to guide them, developed unsteadily. As draftsmen, all were strong; in painting it is doubtful whether any ever grew to be a master. Three of them, however — Bérard, Tchelitcheff, and Eugene Berman — became world figures in stage design; and Tonny has decorated many an inside wall. Léonid Berman alone, remaining strictly an easel-painter, continued to view his seas and their folk, his complex interpenetrations of land and water under a quivering sky, with the directness of his early vision.

The poets led less glorious careers. Sherry Mangan was a man of parts, a classical scholar, a lover of women, fine food, and drink. Yet for all his indomitable persistence, he became, as poet, a sterile virtuoso (which can happen with the Irish). So he turned to sex, marriage, book design, journalism, and revolution (as a Trotskyist), in all these domains cutting quite a figure. But in spite of his mastery of the literary forms, he was a failure in them all. He met death in Rome at sixty with an expression of surprise on his handsome face, though he had written me within the week, "There is so little time." Eric de Haulleville died earlier, around forty. He had written well, received awards. The poet in my Paris grouping who failed least toward his art, the one with whom I was most closely associated at this time and who was also most elaborately bound to Gertrude Stein, was Georges Hugnet.

Hugnet was small, truculent, and sentimental, a type at once tough and tender, of which I have known several among the French. (The conductor Roger Désormière was like that; so today is the composer Pierre Boulez.) Self-indulgent early about food and drink, by sixty Hugnet suggested a miniature Hemingway. At all ages his conversation had been outrageous and, if you can stand outrage, hilarious. Rarely have I heard matched the guttersnipe wit with which he could lay out an enemy. His poetry is liltingly lyrical, pleasingly farfetched as to image, and sweet on the tongue. His most striking contributions to letters, all the same, have been histories of the Dada and surrealist movements and an unfinished memoir of Paris intellectual life under the German occupation.

I knew Georges in 1926, took him to Gertrude early in 1927. He was beginning then, since no one else was doing it, to publish his own poetry and that of his friends, his father (a furniture manufacturer with taste in letters) staking him to the costs. The books came out in limited editions with illustrations by distinguished modern artists. Sold by subscription, they paid their way on condition that nobody receive royalties and the publisher take no salary. Under the imprint Editions de la Montagne, Hugnet that year brought out books by himself, Théophile Briant, and Eric de Haulleville. Others followed by Tristan Tzara, Pierre de Massot, and Gertrude Stein. This last was a collection of ten word portraits accompanied by drawn likenesses of the subjects, the texts appearing in

both English and French, the translations produced by Hugnet and myself. The subjects were:

drawn by:

If I Told Him:
 A Completed Portrait of Picasso himself
Guillaume Apollinaire Picasso
Erik Satie Picasso
Pavlik Tchelitcheff
 or Adrian Arthur himself
Virgil Thomson Bérard
Christian Bérard himself
Bernard Faÿ Tonny
Kristians Tonny himself
Georges Hugnet E. Berman
More Grammar Genia Berman himself

Translating Gertrude Stein had been Madame Langlois's idea, and she had worked out with my aid a piece called *Water Pipe (Conduite d'Eau)*. The original had been printed in the first number, dated February 1927, of *Larus The Celestial Visitor*, Sherry Mangan's magazine, of which, according to the masthead, I was "editor in France." And the translation had been read aloud before a literary gathering at the house of Miss Natalie Barney — salonnière from Ohio, Rémy de Gourmont's *"amazone"* — at an after-tea program devoted to Miss Stein, where I also sang my settings of *Susie Asado* and *Preciosilla*. Madame Langlois, attending as well to honor the poet, there encountered a scholastic friend, the historian Seignobos, who was so dumbfounded at meeting her in a salon several ways "far-out" that he blurted, "What are you doing *here?*" right in front of the amazon-hostess.

Another acquaintance of Miss Barney and of Gertrude Stein, the Duchesse de Clermont-Tonnerre (a member of Miss Barney's feminist literary group that called itself l'Académie des Femmes, the duchesse also wrote memoirs under her maiden name, Elisabeth de Gramont), paid honor to us by having performed at her house in the rue Raynouard, during a Grande Semaine costume party, our cantata *Capital, Capitals*. Getting ready for this occasion, I had holed up in a hotel on the rue Jacob (my definitive move to the Left Bank), where I made ink copies for the four men to sing from and where I rehearsed them letter-perfect for the event. In the last days my bass took sick; and since replacement then was not feasible, I ended by singing his solos from the piano. The party was very handsome, with the garden paths outlined in blue cup candles and behind bushes a quartet of hunting horns. But the residence, an eighteenth-century gatehouse, was not large; and when the billionaire great beauty

Ganna Walska arrived in a *robe de style* six feet wide and surely ten feet from toe to train, the Duchesse, meeting her at the door, exclaimed, "But you know the size of my rooms. Go right out to the garden." And there all evening, in bright white satin, barebreasted and bejeweled, she paraded like a petulant peacock. The Misses Stein and Toklas also came, having delayed their summer exodus by over a month.

All that winter and spring, while I was serving Gertrude Stein as translator, impresario, music setter, and literary agent, she was working for me too, trying every way she knew to find money for me to live on while our opera got composed. She had done her best with Miss Etta and Dr. Claribel Cone, art collectors from Baltimore; and I had played music for them to no great cash result. Nor had her efforts with a rich friend from Chicago, Mrs. Emily Chadbourne Crane, yet turned to money. She had consulted the sculptor Jo Davidson about other prospects; and he right away had called up Miss Elsa Maxwell, whose life work was showing people how to spend money. Miss Maxwell immediately invited me to lunch at the Ritz, where at a table of twelve I sat down between her (oh yes, at her right) and a Roman principessa and where, between cocktails and bridge, she outlined for me in detail a custom-made career, which she herself was to take in hand right off.

The first item was to be a commission from the Princesse Edmond de Polignac for a work to be performed the next season at one of this lady's regular musical receptions. The last item was to be a production of my opera at Monte Carlo in the spring of 1929, two years thence. And we were both to lunch with the princesse the next Saturday. The Monte Carlo deal appeared to me more credible than the other, because Miss Maxwell was employed at that time by the principality of Monaco as a promoter of its gambling casino, hotels, and beach. It was due to her work and presence, indeed, that the Côte d'Azur, formerly just a wintering place, was beginning its fabulous life as a summer resort. There she might indeed have been able to throw weight, perhaps even to give orders. But the princesse (née Winnaretta Singer) was not only socially stable, she was quite accustomed to making up her own mind and was herself a musician.

I do not know whether Miss Maxwell's plans encountered resistance, or whether she had been bluffing all the time. I do remember that the lunch in the avenue Henri Martin never came off and that within a week after the one at the Ritz, Miss Maxwell made six engagements with me in three days and failed to appear at any of them, leaving word the last time that she had quit Paris. Jean Cocteau, to whom I told the story, offered to write the princesse himself, explaining that I was not to be judged from my acquaintances in café society. But I discouraged this, doubting she had ever heard of me.

Cocteau, who had known me since 1921 but who had just lately de-

cided to become acquainted also with my music, now came, at the invitation of Mary Butts, to my narrow room in the Hôtel Jacob, where, accompanying myself at the piano, I sang him *Capital, Capitals*, all four voices. The work pleased him, he said, by its solidity, "like a table that stands on its legs, a door one can open and close."

As I reread now our letters written at that time, I am struck by the intensity with which Miss Stein and I took each other up. From the fall of 1926, in fact, till her death in July of 1946 we were forever loving being together, whether talking and walking, writing to each other, or at work. Once we did not speak for a four-year period, having quarreled for reasons we both knew to be foolish; but for the last two years of even that time we wrote constantly, our pretext being opera business. I translated into French with Madame Langlois *Water Pipe* and *A Saint in Seven*, with Georges Hugnet *Ten Portraits* and excerpts from *The Making of Americans*. I also produced from among my friends a publisher, Sherry Mangan, who printed her work extensively, or caused it to be printed, including the parallel versions of Hugnet's *Enfances* and her English paraphrase of it, which later appeared as *Before the Flowers of Friendship Faded Friendship Faded*. I set to music *Susie Asado, Preciosilla, Portrait of F. B., Capital Capitals*, and a film scenario written by her in French and entitled, *Deux Soeurs Qui Ne Sont Pas Soeurs*. Also two operas, both of which she wrote for me on themes thought up by me. Moreover, I brought about the eventual performance and musical publication of these works in every case, though at all times she did what she could to further our interests. She even offered the services of Picasso as stage designer for *Four Saints*, a collaboration which I declined, preferring to remain, except for her, within my age group. I did, in fact, right then beseech Bérard to consider designing an eventual production, though at that time he had not touched the theater. He said yes with joy and began instantly giving off ideas.

All these maneuvers, I remind myself, had to do with a work not yet in existence, for the first opera's libretto, begun in March, was not completed till mid-June; and at that date there was still not any music. There could not have been; I had not seen the text. I was given this almost complete at the end of June, but I did not receive the whole libretto till a month later. When she sent it from the country, I was still at the Hôtel Jacob et d'Angleterre without a penny. By the time it reached me I had embarked on an expedition that was to keep me from composing for several months.

This began as a motor trip through Brittany and Normandy with Hildegarde Watson's mother, Mrs. Chester Whitin Lasell, and a teenage grandchild, Nancy Clare Verdi. It turned into a two-months' caring-for-the-sick when Mrs. Lasell came down in Rouen with an ear infection. By good luck, and through my friendship with Madame Langlois, I was able

to command, in August, out-of-town and out-of-season visits from a first-class otolaryngologist. When eventually the mastoiditis had been cleared up without surgery, Mrs. Lasell was grateful and became for several years my patron. In late September she returned to Whitinsville. In October I ordered clothes and looked for a flat. By November I had taken a studio on the quai Voltaire and begun composing *Four Saints in Three Acts*.

ॐ *Paris, April 1940*[*]

*D*EAR M. L.:
 It's been a long cold winter and on the whole one of the nicest I've ever spent, although I am not one that cares much as a rule for snow and ice.

One of the delights of this pleasant city has always been its poverty of music. Not concert music and opera; we have more of those than New York has; but music-in-the-air, I mean, that ambience of musical noises, the sound of gramophones and radios, of vocalists at practice and of pianists at play, not to speak of junior's ineluctable assiduity on the saxophone, that make residence in any American city predominantly an auditory experience. Italy is noisy with music like America, only the pitch is higher; and the sound of an Italian village in the evening can be pretty beautiful sometimes, especially if each of the five or six cafés has an outdoor loud-speaker to blend the bleatings of infants and of tenors into a sumptuous tutti that quite puts to shame any timidly insistent nightingale that may be needing to voice its libido in a garden.

Well, this year not only have the lights been dimmed in the Ville-Lumière (and very prettily too), but sound has been reduced to present needs. Street-singers have disappeared; buses disappear after nine o'clock at night; even in the day they are fewer. After midnight, when the cafés close, there is literally no noise anywhere except for a few taxis and private cars bringing private people home from private gatherings. One never hears a radio through a window anymore; I think that the strict

[*] Mr. Thomson's letter to Minna Lederman, editor of *Modern Music*, arrived only a few days before the fateful tenth of May which ended the eight months' "peace" described here.

application of the regulations about not letting light filter through curtains and shutters makes everybody unconsciously more careful about noise, though there are no regulations on the subject any different from those already in force. (Imposing your radio on the neighbors has for some years been frowned on by the law.)

Anyway, Paris, which has always been, compared to New York or to anything Italian, a quiet city (only London, which is lonesome, as Paris distinctly is not, can be more tomblike at night) has become even more reposeful to the ear than it was. One almost wishes for a little roar sometimes, so pleasantly suburban have our lives become.

Of course, in peacetimes (a silly word that, because never have I passed such a peaceful time as these first eight months . . .) just as Paris was the one musical capital where one didn't have to hear any music one didn't want to hear, it was also the best place there was for hearing practically any music old or new that one did want to hear. The latter charm has disappeared. One does not hear any new music; there isn't any. There are a few modern concerts, of course; the Triton puts on a show occasionally; the subventioned orchestras play their minimum legal number of minutes per year of first auditions of French work. The radio tootles its way through many a trio for wind instruments in ye moderne style. There is plenty of all that and innumerable festivals of Ravel. But still there isn't much that could be classified as musically news.

Perhaps I had better say just what there is, beginning with the radio. The British radio is occupied entirely with cheery numbers of a music-hall nature meant for soldiers and with comforting political speeches for the home folks. The French radio does plays, modernistic chamber music, classics from discs, and political propaganda in foreign languages. Never have I heard so much German on the air. The two Paris operas and the symphony concerts are broadcast regularly also. Germany gives us, in addition to the famous and completely charming Lord Haw-Haw (in English), symphony concerts (largely Wagner) and excellent American jazz. The best radio jazz in Europe always did come, I don't know why, from Florence and from Berlin. Since the stations of Danzig, Warsaw, and Katowice were taken over by the Germans, they have been putting out the same massive orchestral programs as Berlin and Hamburg and the same excellent American jazz, all with added kilowatts. Prague does not seem to have been incorporated into that particular chain. Its programs, less massive and less jazzy, continue to send out the Czechish Opera and to indulge the Czechish taste for string quartets. The Rhineland stations do quartets too and a good deal of Mozart and Haydn. Vienna is mostly waltzy now and Budapest Hungarian-dancy. Algeria and Morocco play native-style music too. Spain not; from there one gets little beyond politics and church services. And Spanish church music would seem to rest content on the Bostonian Catholic level where it has

reposed for some years already. The Belgian stations have picked up a little, but on the whole their public seems to prefer light music of the Delibes sort and dance music that is definitely "sweet." Holland and Switzerland hold the fort for Sebastian Bach and for the oratorio style. Italy, in addition to the Florentine jazz I mentioned above, and to some quite decent news broadcasts in various languages, has been doing super-first-class opera. Most of the good Italian singers being at home this year, because their government is as skittish as ours is about giving out passports, the operas in both Milan and Rome have been brilliant as to execution. I heard a *Trovatore* one night that revealed a degree of expressive variety and of theatrical power I didn't know was in the old thing. The roles were sung by Maria Caniglia and Cloe Elmo and Gigli and Valentino. Marinuzzi conducted, and I assure you the orchestra "talked." I also heard, superbly rendered, Pizzetti's *Fedra*. It is quite a fine piece, *Pelléas et Mélisande* keyed up (or down, as you like) to the melodramatic intensity of *Tosca*. I doubt if it will change any composer's life much, but it is certainly a fine big number. My radio doesn't get Moscow very well or Helsinki or Athlone, but when it does the programs seem to be mostly routine stuff one knows and the performances in no way extraordinary. I might close the subject of radio by mentioning that last summer, when I was in Italy, the young people used to sit around pretty sadly till eleven o'clock, when the Juan-les-Pins station began its international hour of popular music; and that even they sat quietly enough through a certain number of Spanish tangos and French javas and the inevitable *Santa Lucia* (the hour's theme song) for the satisfaction of hearing real American music, by which they mean Duke Ellington and Bob Crosby et al. If you could see the faces light up when that comes on, you would understand why America, with immigration to it virtually stopped by both their government and ours, still represents to the youth of Italy a dream country, although instead of its being the Country of Business Opportunity it once was, it has become now The Land of Beautiful Music. They don't call that music jazz or swing or anything special; they call it *la musica americana*. And their hats are off to it.

To return to Paris and to what we have here. The orchestra concerts are very much what they always were (except for one orchestra less), and they all play to full houses at the same time, which is Sundays at a quarter to six. There are Polish and Finnish benefits at other times. The Polish programs seem to concentrate on Chopin, not a semi-quaver of Szymanowski or of his friends. The Finnish ones make a little gesture about Sibelius, a tiny little gesture, you know, nothing graver than *Finlandia* and a few songs. I fancy it is considered that the playing of a whole symphony might conceivably alienate Parisian sympathies.

Wagner has been played, and all went off fine. Three pieces were announced for the end of a regular Sunday, though later two of these were

removed, as presumably the playing of the first would provoke such a demonstration that the others couldn't be got through. Demonstration there was, indeed, but all for Wagner. When the conductor (it was Paul Paray) first appeared there was a tumult of angry protest demanding why he had cut out two of the numbers. So he made a speech that didn't make much sense, as it had evidently been prepared in view of an anti-German demonstration, about how he had been a soldier in the other war and that culture knows no frontiers. Applause and loud cheers from all and some grumbling from the Wagner aficionados, who still wanted their three pieces. They didn't get them; but the *Tannhäuser* overture they did get was cheered for a quarter of an hour. All that was two months or more ago; I haven't heard of any Wagner being played since.

The opera repertories are much as always, except for no Wagner, although works that require lots of scene shifting are avoided, because the stagehands are mostly mobilized.

Alfred Bruneau's *Le Rêve* has been revived. I haven't seen it; Mary Garden tells me it is Bruneau's best work and that the American baritone Andrèze is superb in it. I did see Xavier Leroux's *Le Chémineau* for the first time in nearly thirty years (the French Opera of New Orleans used to give it) and was delighted. It has a good libretto by Jean Richepin; it is admirably written for voices and sonorously orchestrated. Its musical material is honest and direct. There are tender passages and great climaxes and from beginning to end less folderol and musical chi-chi than I've practically ever heard in my life. It is music that is both competent and sincere. Such music is shockingly rare in this age of our art's decline. Hearing it led me seriously to wonder whether any effort toward sincerity, the kind of terrific and humane sincerity that makes Molière Molière, for example, has ever been systematically exerted in music. Maybe a little by Sebastian Bach and by Schumann and a very little by Brahms. Practically everybody else has had his eye on a different ball, either the sharpness of auditive effect or the force of personal projection, or the sensuality of mystic contemplation, not to speak of the celebration of traditional rites, theatrical and religious. I have no conclusions to offer on the subject; I merely note that Leroux's *Le Chémineau* provoked that bit of meditation one Sunday afternoon.

Honegger's *Jeanne au Bûcher* for orchestra, chorus, soloists, and Ida Rubinstein (isn't the text by Claudel? I think it is) I missed last June and again of late here. Music lovers consider it a most impressive work. In Brussels recently its performance provoked a francophile demonstration, although Honegger is, I believe, technically Swiss.

The Milhaud *Medea* goes on being announced and postponed year after year. A part of it was given (successfully, I believe) last spring in Flemish at the Antwerp Opera. Flemish Antwerp has been for several years now Europe's Hartford.

There is stage music by Sauguet with Sheridan's *School for Scandal*, now playing to good houses. Haven't been. There are no new movies, French movie production being, ever since September, at a standstill.

෴ ෴ ෴

I fancy my account of these little matters doesn't make very clear why I have enjoyed my winter so much. I'm not sure I know exactly. I've tried to tell you what it's like here musically; for other matters there are plenty of reports in the weekly press. What I can't describe very well is the state of calm that permeates our whole intellectual life. Not the vegetable calm of a backwater country or the relative and quite electric calm that is supposed to exist at the center of a moving storm. Rather it is the quietude of those from whom have been lifted all the burdens and all the pressures, all the white elephants and all the fears that have sat on us like a nightmare for fifteen years. I am not referring to any imminence of German invasion or of its contrary. I am talking about that imminence of general European cultural collapse that has been hanging over us ever since the last war ended. As long as the tension was mounting everybody was unhappy. Fascism in Italy, the Jewish persecutions in Germany, the Civil War in Spain, a hundred other scenes of the heartbreaking drama have kept us jittery and trembling. It has been imagined and hoped that possibly some of the brighter boys might stop the progress of it all by taking thought. Our opinions were demanded on every imaginable variety of incident in power politics and in class warfare, whether we had any access or not to correct information (which we usually didn't) or any degree of political education that would make our opinions worth a damn, even if we had had access to the facts. For ten years now all sides have been pressing us to talk; indeed many have talked, and I should say that in consequence a great deal less real work got done in those years than was done in the preceding decade.

That's all over now. We are on the chute. And in spite of the enormous inroads on a man's time and money that being mobilized represents, and in spite of the strictness of both military and political censorship over all sorts of intellectual operations, the intellectual life has picked up distinctly. The lotus-land of whether surrealism is really gratuitous and whether such and such a picture by Picasso is really worth the price asked (for, dear Reader, it was indeed by becoming passionate over such matters that many fled the impossibility of being anything beyond merely passionate over matters like Jewry and Spain, because they knew that mere passion wouldn't get anybody anywhere and that passion was all anybody had to offer on any side, excepting maybe a little a quiet opportunism in England and in Russia), anyway, the 1930s, that stormy lotus-land of commercialized high esthetics to which New York's Museum of Modern Art will long remain a monument, have

quietly passed away. It is rather surprising and infinitely agreeable to find
that poets now are writing poetry again rather than rhymes about cur-
rent events; that painters paint objects, not ideas; that composers write
music to please themselves, there being no longer any Modern Music
Concert committees to please. Most surprising and agreeable of all is the
fact that the young (with so many of their elders away now and with all
their elders' pet ideas very definitely on the shelf) have again become
visible as young. They are doing all the things they haven't been allowed
to do for some time, such as talking loud in cafés and sleeping with peo-
ple of their own age. Also, instead of discussing esthetics with intelli-
gence and politics with passion, as their elders did, they are discussing
esthetics with passion and politics with intelligence. I find the change a
happy one indeed. I also find distinctly agreeable the presence around of
young poets and young painters who look us squarely in the eye and say
"hooey," who don't even look at us at all if they don't feel like it, who
behave toward us, their elders, exactly as we behaved toward ours some
twenty-five years ago and as no young people have been quite able to
behave really since.

I must admit that young composers are not as visible in the cafés as
poets are; they never were. Pianists, however, peep out from every cor-
ner. To a man, and at all ages, they are occupied with what seems to be
the central esthetic problem in music today, the creation of an acceptable
style-convention for performing Mozart. I've spent a good deal of time
at that job too this winter, and I have found out some things about
Mozart's piano music I will tell you another time . . .

I've discovered music all over again. And it turns out to be just as it
was when I was seventeen, the daily function of practicing a beloved in-
strument and of finding one's whole life filled with order and with energy
as a result.

But of all that, more another time. Give my best to the fellahs.

<div style="text-align: right">Je t'embrasse en camarade,
Virgil</div>

From *Modern Music*, May 1940.

❧ A Portrait of Gertrude Stein

GERTRUDE STEIN in her younger days had liked to write all night and
sleep all day. She also, it seems, ate copiously, drank wine, and
smoked cigars. By the time I knew her, at fifty-two, she ate abstemiously;
she neither drank nor smoked; and she was likely to wake, as people do
in middle life, by nine. Her volume had been diminished too. Her appear-
ance, nevertheless, on account of low stature (five feet two), remained
monumental, like that of some saint or sibyl sculpted three-fourths life
size. Her working powers also were intact, remained so, indeed, until her
death at seventy-two.

Actually a whole domestic routine had been worked out for encourag-
ing those powers to function daily. In the morning she would read, write
letters, play with the dog, eventually bathe, dress, and have her lunch.
In the afternoon she drove in the car, walked, window-shopped, spent a
little money. She did nothing by arrangement till after four. At some
point in her day she always wrote; and since she waited always for the
moment when she would be full of readiness to write, what she wrote
came out of fullness as an overflowing.

Year round, these routines varied little, except that in the country, if
there were house guests, excursions by car might be a little longer, tea or
lunch taken out instead of at home. When alone and not at work, Ger-
trude would walk, read, or meditate. She loved to walk; and she con-
sumed books by the dozen, sent to her when away from home by the
American Library in Paris. She read English and American history, mem-
oirs, minor literature from the nineteenth century, and crime fiction,
rarely modern art-writing, and never the commercial magazines. When
people were around she would talk and listen, ask questions. She talked
with anybody and everybody. When exchanging news and views with

neighbors, concierges, policemen, shop people, garage men, hotel servants, she was thoroughly interested in them all. Gertrude not only liked people, she needed them. They were grist for her poetry, a relief from the solitudes of a mind essentially introspective.

Alice Toklas neither took life easy nor fraternized casually. She got up at six and cleaned the drawing room herself, because she did not wish things broken. (Porcelain and other fragile objects were her delight, just as pictures were Gertrude's; and she could imagine using violence toward a servant who might break one.) She liked being occupied, anyway, and did not need repose, ever content to serve Gertrude or be near her. She ran the house, ordered the meals, cooked on occasion, and typed out everything that got written into the blue copybooks that Gertrude had adopted from French school children. From 1927 or 1928 she also worked petit point, matching in silk the colors and shades of designs made especially for her by Picasso. These tapestries were eventually applied to a pair of Louis XV small armchairs (*chauffeuses*) that Gertrude had bought for her. She was likely, any night, to go to bed by eleven, while Miss Stein would sit up late if there were someone to talk with.

Way back before World War I, in 1910 or so, in Granada, Gertrude had experienced the delights of writing directly in the landscape. This does not mean just working out of doors; it means being surrounded by the thing one is writing about at the time one is writing about it. Later, in 1924, staying at Saint-Rémy in Provence, and sitting in fields beside the irrigation ditches, she found the same sound of running water as in Granada to soothe her while she wrote or while she simply sat, imbuing herself with the landscape's sight and sound. In the country around Belley, where she began to summer only a few years later, she wrote *Lucy Church Amiably* wholly to the sound of streams and waterfalls.

Bravig Imbs, an American poet and novelist who knew her in the late twenties, once came upon her doing this. The scene took place in a field, its enactors being Gertrude, Alice, and a cow. Alice, by means of a stick, would drive the cow around the field. Then, at a sign from Gertrude, the cow would be stopped, and Gertrude would write in her copybook. After a bit, she would pick up her folding stool and progress to another spot, whereupon Alice would again start the cow moving around the field till Gertrude signaled she was ready to write again. Though Alice now says that Gertrude drove the cow, she waiting in the car, the incident, whatever its choreography, reveals not only Gertrude's working intimacy with landscape but also the concentration of two friends on an act of composition by one of them that typifies and reveals their daily life for forty years. Alice had decided long before that "Gertrude was always right," that she was to have whatever she wanted when she wanted it, and that the way to keep herself wanted was to keep Gertrude's writing always and forever unhindered, unopposed.

Gertrude's preoccupation with painting and painters was not shared by Alice except insofar as certain of Gertrude's painter friends touched her heart, and Picasso was almost the only one of these. Juan Gris was another, and Christian Bérard a very little bit. But Matisse I know she had not cared for, nor Braque. If it had not been for Gertrude, I doubt that Alice would ever have had much to do with the world of painting. She loved objects and furniture, practiced cooking and gardening, understood music. Of music, indeed, she had a long experience, having once, as a young girl, played a piano concerto in public. But painting was less absorbing to her than to Gertrude.

Gertrude's life with pictures seems to have begun as a preoccupation shared with her brothers, Michael and Leo. The sculptor Jacques Lipschitz once remarked to me the miraculous gift of perception by which these young Californians, in Paris of the 1900s, had gone straight to the cardinal values. Virtually without technical experience (since only Leo, among them, had painted at all) and without advice (for there were no modern-art scholars then), they bought Cézanne, Matisse, and Picasso. In quantity and, of course, for almost nothing. But also, according to Lipschitz, the Steins' taste was strongest when they bought together. Gertrude and Leo did this as long as they lived together, which was till about 1911. Michael, who had started quite early buying Matisses, kept that up till World War I. After Gertrude and Leo separated, she made fewer purchases and no major ones at all, save some Juan Gris canvases that represented a continuing commitment to Spanish cubism and to friendship. She could no longer buy Picasso or Cézanne after their prices got high, or after she owned a car. But throughout the twenties and thirties she was always looking for new painters, without being able to commit herself to any of them till she discovered, about 1929, Sir Francis Rose. From him she quickly acquired nearly a hundred pictures, and she insisted till her death that he was a great painter. No other collector, no museum, no international dealer has yet gone so far.

Looking at painting had been for Gertrude Stein a nourishment throughout the late twenties and thirties of her own life. She never ceased to state her debt to Cézanne, for it was from constantly gazing on a portrait by him that she had found her way into and through the vast maze of motivations and proclivities that make up the patterns of people and types of people in *Three Lives* and in *The Making of Americans*. "The wonderful thing about Cézanne," she would say, "is that he was never tempted." Gertrude Stein's biographers have stated that Picasso also was a source for her and that in *Tender Buttons* she was endeavoring to reproduce with words the characteristic devices of cubist painting. There may even be in existence a quotation from Gertrude herself to this effect. But she certainly did not repeat it in the way she loved to repeat her allegiance to Cézanne. I myself have long doubted the validity, or at

any rate the depth, of such a statement. An influence of poetry on painting is quite usual, a literary theme being illustrated by images. But any mechanism by which this procedure might be reversed and painting come to influence literature (beyond serving as subject for a review) is so rare a concept that the mere statement of Gertrude Stein's intent to receive such an influence surely requires fuller explanation. Let us try.

First of all, *Tender Buttons*, subtitled *Objects . . . Food . . . Rooms*, is an essay in description, of which the subjects are those commonly employed by painters of still life. And cubist painting too was concerned with still life. Cubism's characteristic device in representing still life was to eliminate the spatially fixed viewpoint, to see around corners, so to speak, to reduce its subject to essentials of form and profile, and then to reassemble these as a summary or digest of its model. Resemblance was not forbidden; on the contrary, clues were offered to help the viewer recognize the image; and cubist painters (from the beginning, according to Gertrude) had been disdainful of viewers who could not "read" their canvases. (Today's "abstract" painters, on the other hand, maintain that in their work resemblances are purely accidental.)

According to Alice Toklas, the author's aim in *Tender Buttons* was "to describe something without mentioning it." Sometimes the name of the object is given in a title, sometimes not; but each description is full of clues, some of them easy to follow up, others put there for throwing you off the scent. All are legitimately there, however, since in Blake's words, "everything possible to be believed is an image of truth," and since in Gertrude Stein's method anything that comes to one in a moment of concentrated working is properly a part of the poem. Nevertheless, unveiling the concealed image is somewhat more difficult to a reader of *Tender Buttons* than to the viewer of a cubist still life. For a still life is static; nothing moves in it; time is arrested. In literature, on the other hand, one word comes after another and the whole runs forward. To have produced static pictures in spite of a nonfixed eyepoint was cubism's triumph, just as giving the illusion of movement within a framed picture was the excitement of vorticism, as in Marcel Duchamp's *Nude Descending a Staircase*. To have described objects, food, and rooms both statically and dynamically, with both a painter's eye and a poet's continuity, gives to *Tender Buttons* its particular brilliance, its way of both standing still and moving forward.

Now the carrier of that motion, make no mistake, is a rolling eloquence in no way connected with cubism. This eloquence, in fact, both carries forward the description and defeats it, just as in cubist painting description was eventually defeated by the freedom of the painter (with perspective making no demands) merely to create a composition. Cubism was always, therefore, in danger of going decorative (hence flat); and the kind of writing I describe here could just as easily turn into mere wit and ora-

tory. That cubism was something of an impasse its short life, from 1909 to 1915, would seem to indicate; and there were never more than two possible exits from it. One was complete concealment of the image, hence in effect its elimination; the other was retreat into naturalism. Both paths have been followed in our time, though not by Picasso, who has avoided abstraction as just another trap leading to the decorative, and who could never bring himself, for mere depiction, to renounce the ironic attitudes involved in voluntary stylization.

Gertrude, faced with two similar paths, chose both. During the years between 1927 and '31, she entered into an involvement with naturalism that produced at the end of her life *Yes Is for a Very Young Man*, *Brewsie and Willie*, and *The Mother of Us All*, each completely clear and in no way mannered. She was also during those same years pushing abstraction farther than it had ever gone before, not only in certain short pieces still completely hermetic (even to Alice Toklas), but in extended studies of both writing and feeling in which virtually everything remains obscure but the mood, works such as *As a Wife Has a Cow, a Love Story*; *Patriarchal Poetry*; and *Stanzas in Meditation*.

Her last operas and plays are in the humane tradition of letters, while her monumental abstractions of the late 1920s and early 1930s are so intensely aware of both structure and emotion that they may well be the origin of a kind of painting that came later to be known as "abstract expressionism." If this be true, then Gertrude Stein, after borrowing from cubism a painting premise, that of the nonfixed viewpoint, returned that premise to its origins, transformed. Whether the transformation could have been operated within painting itself, without the help of a literary example, we shall never know, because the literary example was there. We do know, however, that no single painter either led that transformation or followed it through as a completed progress in his own work.

Gertrude had been worried about painting ever since cubism had ceased to evolve. She did not trust abstraction in art, which she found constricted between flat color schemes and pornography. Surrealism, for her taste, was too arbitrary as to theme and too poor as painting. And she could not give her faith to the neo-Romantics either, though she found Bérard "alive" and "the best" of them. She actually decided in 1928 that "painting [had] become a minor art again," meaning without nourishment for her. Then within the year, she had found Francis Rose. What nourishment she got from him I cannot dream; nor did she ever speak of him save as a gifted one destined to lead his art — an English leader this time, instead of Spanish.

In her work, during these late twenties, while still developing ideas received from Picasso, she was also moving into new fields opened by her friendship with me. I do not wish to pretend that her ventures into romantic feeling, into naturalism, autobiography, and the opera came

wholly through me, though her discovery of the opera as a poetic form certainly did. Georges Hugnet, whom I had brought to her, was at least equally a stimulation, as proved by her "translation" of one of his extended works. She had not previously accepted, since youth, the influence of any professional writer. Her early admiration for Henry James and Mark Twain had long since become a reflex. She still remembered Shakespeare of the sonnets, as *Stanzas in Meditation* will show; and she considered Richardson's *Clarissa Harlowe* (along with *The Making of Americans*) to be "the other great novel in English," But for "movements" and their organizers in contemporary poetry she had the greatest disdain — for Pound, Eliot, Yeats, and their volunteer militiamen. She admitted Joyce to be "a good writer," disclaimed any influence on her from his work, and believed, with some evidence, that she had influenced him.

She knew that in the cases of Sherwood Anderson and Ernest Hemingway her influence had gone to them, not theirs to her. I do not know the real cause of her break with Hemingway, only that after a friendship of several years she did not see him anymore and declared forever after that he was "yellow." Anderson remained a friend always, though I do not think she ever took him seriously as a writer. The poet Hart Crane she did take seriously. And there were French young men — René Crevel, for one — whom she felt tender about and whom Alice adored. Cocteau amused her as a wit and as a dandy, less so as an organizer of epochs, a role she had come to hold in little respect from having known in prewar times Guillaume Apollinaire, whom she esteemed low as a poet, even lower as a profiteer of cubism. Pierre de Massot she respected as a prose master; but he was too French, too violent, to touch her deeply. Gide and Jouhandeau, making fiction out of sex, she found as banal as any titillater of chambermaids. Max Jacob she had disliked personally from the time of his early friendship with Picasso. I never heard her express any opinion of him as a writer, though Alice says now that she admired him.

In middle life she had come at last to feel about her own work that it "could be compared to the great poetry of the past." And if she was nearly alone during her lifetime in holding this view (along with Alice Toklas, myself, and perhaps a very few more), she was equally alone in having almost no visible poetic parents or progeny. Her writing seemed to come from nowhere and to influence, at that time, none but reporters and novelists. She herself, considering the painter Cézanne her chief master, believed that under his silent tutelage a major message had jumped like an electric arc from painting to poetry. And she also suspected that its high tension was in process of short-circuiting again, from her through me, this time to music. I do not offer this theory as my own, merely as a thought thrown out by Gertrude Stein to justify, perhaps, by one more case the passing of an artistic truth or method, which she felt strongly

to have occurred for her, across one of those sensory distances that lie between sight, sound, and words.

There was nevertheless, in Alice Toklas, literary influence from a non-professional source. As early as 1910, in a narrative called "Ada," later published in *Geography and Plays*, a piece which recounts Miss Toklas's early life, Gertrude imitated Alice's way of telling a story. This sentence is typical: "He had a pleasant life while he was living and after he was dead his wife and children remembered him." Condensation in this degree was not Gertrude's way; expansion through repetition (what she called her "garrulity") was more natural to her. But she could always work from an auditory model, later in *Brewsie and Willie* transcribing almost literally the usage and syntax of World War II American soldiers. And having mastered a new manner by imitating Alice Toklas in "Ada," she next mixed it with her repetitive manner in a story called "Miss Furr and Miss Skeen." Then she set aside the new narrative style for nearly thirty years.

In 1933 she took it up again for writing *The Autobiography of Alice B. Toklas*, which is the story of her own life told in Miss Toklas's words. This book is in every way except actual authorship Alice Toklas's book; it reflects her mind, her language, her private view of Gertrude, also her unique narrative powers. Every story in it is told as Alice herself had always told it. And when in 1961 Miss Toklas herself wrote *What Is Remembered*, she told her stories with an even greater brevity. There is nothing comparable to this compactness elsewhere in English, nor to my knowledge in any other literature save possibly in Julius Caesar's *De Bello Gallico*. Gertrude imitated it three times with striking success. She could not use it often, because its way was not hers.

Her own way with narrative was ever elliptical, going into slow orbit around her theme. Alice's memory and interests were visual; she could recall forever the exact costumes people had worn, where they had stood or sat, the décor of a room, the choreography of an occasion. Gertrude's memory was more for the sound of a voice, for accent, grammar, and vocabulary. And even these tended to grow vague in one day, because her sustained curiosity about what had happened lay largely in the possibilities of any incident for revealing character.

How often have I heard her begin some tale, a recent one or a faraway one, and then as she went on with it get first repetitive and then uncertain till Alice would look up over the tapestry frame and say, "I'm sorry, Lovey; it wasn't like that at all." "All right, Pussy," Gertrude would say. "You tell it." Every story that ever came into the house eventually got told in Alice's way, and this was its definitive version. The accounts of life in the country between 1942 and 1945 that make up *Wars I Have Seen* seem to me, on the other hand, Gertrude's own; I find little of Alice in them. Then how are they so vivid? Simply from the fact, or at least so

I imagine, that she would write in the evening about what she had seen that day, describe events while their memory was still fresh.

Gertrude's artistic output has the quality, rare in our century, of continuous growth. Picasso had evolved rapidly through one discovery after another until the cubist time was over. At that point, in 1915, he was only thirty-three and with a long life to be got through. He has got through it on sheer professionalism — by inventing tricks and using them up (tricks mostly recalling the history of art or evoking historic Spanish art), by watching the market very carefully (collecting his own pictures), and by keeping himself advised about trends in literary content and current-events content. But his major painting was all done early. Igor Stravinsky followed a similar pattern. After giving to the world between 1909 and 1913 three proofs of colossally expanding power — *The Firebird, Petrouchka,* and *The Rite of Spring* — he found himself at thirty-one unable to expand farther. And since, like Picasso, he was still to go on living, and since he could not imagine living without making music, he too was faced with an unhappy choice. He could either make music out of his own past (which he disdained to do) or out of music's past (which he is still doing). For both men, when expansion ceased, working methods became their subject.

One could follow this design through many careers in music, painting, and poetry. Pound, I think, continued to develop; Eliot, I should say, did not. Arnold Schönberg was in constant evolution; his chief pupils, Alban Berg and Anton Webern, were more static. The last two were saved by early death from possible decline of inspiration, just as James Joyce's approaching blindness concentrated and extended his high period for twenty years, till he had finished two major works, *Ulysses* and *Finnegans Wake.* He died fulfilled, exhausted, but lucky in the sense that constant growth had not been expected of him. Indeed, for all that the second of these two works is more complex than the first, both in concept and in language, it does not represent a growth in anything but mastery. Joyce was a virtuoso type, like Picasso, of whom Max Jacob, Picasso's friend from earliest youth, had said, "Always he escapes by acrobatics." And virtuosos do not grow; they merely become more skillful. At least they do not grow like vital organisms, but rather, like crystals, reproducing their own characteristic forms.

Gertrude Stein's maturation was more like that of Arnold Schönberg. She ripened steadily, advanced slowly from each stage to the next. She had started late, after college and medical school. From *Three Lives,* begun in 1904 at thirty, through *The Making of Americans,* finished in 1911, her preoccupation is character analysis. From *Tender Buttons* (1912) to *Patriarchal Poetry* (1927) a quite different kind of writing is presented (not, of course, without having been prefigured). This is hermetic to the last degree, progressing within its fifteen-year duration from

picture-words and rolling rhetoric to syntactical complexity and neutral words. From 1927 to 1934 two things go on at once. There are long hermetic works (*Four Saints in Three Acts, Lucy Church Amiably,* and *Stanzas in Meditation*) but also straightforward ones like *The Autobiography of Alice B. Toklas* and the lectures on writing. After her return in 1935 from the American lecture tour, hermetic writing gradually withers and the sound of spoken English becomes her theme, giving in *Yes Is for a Very Young Man,* in *The Mother of Us All,* and in *Brewsie and Willie* vernacular portraits of remarkable veracity.

Her development had not been aided or arrested by public success, of which there had in fact been very little. The publication of *Three Lives* in 1909 she had subsidized herself, as she did in 1922 that of the miscellany, *Geography and Plays. The Making of Americans,* published by Robert McAlmon's Contact Editions in 1925, was her first book-size book to be issued without her paying for it; and she was over fifty. She had her first bookstore success at fifty-nine with the *Autobiography.* When she died in 1946, at seventy-two, she had been working till only a few months before without any diminution of power. Her study of technical problems never ceased; never had she felt obliged to fabricate an inspiration; and she never lost her ability to speak from the heart.

Gertrude lived by the heart, indeed; and domesticity was her theme. Not for her the matings and rematings that went on among the Amazons. An early story from 1903, published after her death, *Things as They Are,* told of one such intrigue in post-Radcliffe days. But after 1907 her love life was serene, and it was Alice Toklas who made it so. Indeed, it was this tranquil life that offered to Gertrude a fertile soil of sentiment-security in which other friendships great and small could come to flower, wither away, be watered, cut off, or preserved in a book. Her life was like that of a child, to whom danger can come only from the outside, never from home, and whose sole urgency is growth. It was also that of an adult female who demanded all the rights of a man along with the privileges of a woman.

Just as Gertrude kept up friendships among the Amazons, though she did not share their lives, she held certain Jews in attachment for their familylike warmth, though she felt no solidarity with Jewry. Tristan Tzara — French-language poet from Rumania, Dada pioneer, early surrealist, and battler for the Communist party — she said was "like a cousin." Miss Etta and Dr. Claribel Cone, picture buyers and friends from Baltimore days, she handled almost as if they were her sisters. The sculptors Jo Davidson and Jacques Lipschitz, the painter Man Ray she accepted as though they had a second cousin's right to be part of her life. About men or goyim, even about her oldest man friend, Picasso, she could feel unsure; but a woman or a Jew she could size up quickly. She accepted without cavil, indeed, all the conditionings of her Jewish back-

ground. And if, as she would boast, she was "a bad Jew," she at least did not think of herself as Christian. Of heaven and salvation and all that she would say, "When a Jew dies he's dead." We used to talk a great deal, in fact, about our very different religious conditionings, the subject having come up through my remarking the frequency with which my Jewish friends would break with certain of theirs and then never make up. Gertrude's life had contained many people that she still spoke of (Mabel Dodge, for instance) but from whom she refused all communication. The Stettheimers' conversation was also full of references to people they had known well but did not wish to know anymore. And I began to imagine this definitiveness about separations as possibly a Jewish trait. I was especially struck by Gertrude's rupture with her brother Leo, with whom she had lived for many years in intellectual and no doubt affectionate communion, but to whom she never spoke again after they had divided their pictures and furniture, and taken up separate domiciles.

The explanation I offered for such independent behavior was that the Jewish religion, though it sets aside a day for private atonement, offers no mechanics for forgiveness save for offenses against one's own patriarch, and even he is not obliged to pardon. When a Christian, on the other hand, knows he has done wrong to anyone, he is obliged in all honesty to attempt restitution; and the person he has wronged must thereupon forgive. So that if Jews seem readier to quarrel than to make up, that fact seems possibly to be the result of their having no confession-and-forgiveness formula, whereas Christians, who experience none of the embarrassment that Jews find in admitting misdeeds, arrange their lives, in consequence, with greater flexibility, though possibly, to a non-Christian view, with less dignity.

Gertrude liked this explanation, and for nearly twenty years it remained our convention. It was not till after her death that Alice said one day,

> You and Gertrude had it settled between you as to why Jews don't make up their quarrels, and I went along with you. But now I've found a better reason for it. Gertrude was right, of course, to believe that "when a Jew dies he's dead." And that's exactly why Jews don't need to make up. When we've had enough of someone we can get rid of him. You Christians can't, because you've got to spend all eternity together.

From *New York Review of Books,* July 7, 1966.

PART 4

From
"The State of Music"

From *The State of Music* by Virgil Thomson. This book, originally published in 1939, was revised in 1961, when Thomson added new material, which appears in brackets.

✌ A 1961 Preface

THIS BOOK was written in 1939. By November of that year, when it was issued, Europe was in armed conflict. The two decades that have passed since then have witnessed a world war, the deliberate murder of millions, the substitution for the customary class warfare of an international economic war called "cold," a stabilization of trade-union privilege at the highest level ever known, the partition of Germany, the isolation of China. The last decade has encountered too a revolt of the colonial peoples, and undergone in Europe and America a prosperity boom.

Music during this time, save for a certain broadening of its distribution, has changed little. That is why it has been possible to envisage reprinting now a book depicting its state twenty years back. For music as an art evolves ever so slowly; and even its business is conservative, resistant to change.

Mostly what has changed in twenty years is the economic and political background. These changes, however, are so tremendous that almost everybody under thirty-five is dazzled by them, unable to see through them or around them, and tends in consequence to view today's world of art as also full of novelty.

It is not necessary, of course, that young people have a great knowledge of history. A belief in their own time is far more useful. But when we see them, as we do today in music, painting, and poetry, mistaking for deep originality and for invention diluted versions of our century's earlier masters (who really *were* radical), then one does feel moved to remind them that we too, when young, had an intellectual life and that an inflated market is merely an inflated market.

This book is completely out of date as regards fees, art prices, and the cost of living. It describes, on the contrary, a world that had suffered for

ten years from monetary depression. During those years, especially after Germany had sacrificed both personal and religious freedom to a controlled economy, the West went liberal. At least the Popular Front in France and the New Deal in America represented an effort to redefine wealth so as to include working power and to give this power a protection comparable to that constitutionally accorded to real property.

The book is constantly preoccupied, in consequence, as indeed we all were in those days, with establishing a practical basis for demanding and obtaining, as musicians, a voice in the directing of music's affairs. We no longer believed in the disinterestedness of the amateurs and the businessmen who were still trying to administer our properties when they couldn't even handle their own.

That aspect of the book is not out of date at all. Indeed the recall of such reflections can be useful against the time when some other crisis, economic or political, may force the workers in art — today's young or tomorrow's — to rise from their beds of ease. The outer world is moving fast, but art is of permanent value. And if the makers of art do not claim as a permanent right their intellectual privileges and just emoluments, nobody will do it for them. Quite the contrary, unless they watch out very carefully, some church, some state, some business combine will be running their lives. And it should not be so. I do not myself believe today will last; but whether it lasts or not, all should be ready for change and for taking advantage of it.

It is because I find the esthetic and the economico-political aspects of the book so largely valid still that I do not feel impelled to write another version of it, a 1960 version. Its quality and its nature are of 1939. The young people — and I do hope they will read it — may be shocked at how much we cared, and surprised at our thinking we could change anything. But that is exactly the point; we could and did. Before World War II individual people actually could change things or get them changed. Since that time private and small-group actions have become more hazardous. This is the secret canker at the heart of today's young. And nothing can be done about it. But life was better, even without money, when fear was not there.

Among the artistic professions discussed in this book, the one least altered in twenty years is that of poetry. England and France, I should say, are suffering, though perhaps only temporarily, a diminution of its flow. The United States goes right on producing the chief contributions to English-language poetry, just as South America does for Spanish. Germany, though inactive now, has seen fulfilled in life and closed by death the career of Bertolt Brecht, a rare one for our century in that Brecht was both a dramatic poet and a political poet of the left, in a time when few poets have been gifted for the stage and when most of the finest have traveled with the right in politics.

With respect to their income sources, poets have not changed at all. They teach, lecture, read, sell manuscripts, and marry. In France they live off the practices of diplomacy and art criticism (being paid for the latter in pictures they can sell later, and do). In New York they write art criticism, but do not get paid in pictures, or very much in money either. They may, after ten years, be rewarded with a mission by a modern museum.

Now poets' publicity is the shield and buckler of modern art, and has been so since early in the century. Picasso's name has been made, sustained, and kept before the public by poets — by Max Jacob, Gertrude Stein, Guillaume Apollinaire, Jean Cocteau, André Breton, and Paul Eluard. These authors, plus Louis Aragon, also furnished Picasso with the intellectual nourishment he needed for keeping his output contemporary, saved him the trouble of going places and reading books. They earned their pay; I've no reproach to make them. But I do reproach American poets, who are contributing little of value just now to any painter's culture and surely nothing at all to the public's understanding of art, with jeopardizing what is left of their intellectual position by writing on a subject outside their experience. With their professional integrity about all they have left in life, they should be more careful of it. Book reviewing pays better and is less demeaning.

Painters themselves are benefiting vastly from the new prosperity. As my dealer friends tell me, everything sells. They also tell me that an American school of painting now exists, that it is visible everywhere as today's dominant school, and that this school leads the market. Esthetic controversy too runs higher in America than elsewhere — that bitter war between "abstract" painting and the "figurative." The outlying regions, from Paraguay to Vietnam, are producing pictures, just as they erect buildings, that are imitated as closely as possible from the modernistic work exposed in New York. It is only at the market centers of painting, New York and Paris, that the classical techniques and the planned image are being defended. One has only to walk through the biennial world shows of São Paulo and Venice to realize the facile one-worldness with which all God's chillun got modern art. And I mean slapdash modern art, wildly ostentatious and superficial but unquestionably paying allegiance to the "abstract" masters.

These masters, from the Dutch and Russian pioneers of 1910 through the mature work of Mondrian — by way of the cubists, the futurists, the Dada toymakers, and the surrealists — were already history when this book was written. And the accidental and "action" techniques had been practiced for nearly two decades. Indeed, to my knowledge, no such new techniques have been discovered since. What has changed is their distribution, now vast; they are even taught in kindergartens. Also the coming into fame of an American school that practices artistic free-

wheeling exactly as it drives cars — with refinement and with gusto.

My chapter on the painters, therefore, I find to be out of date chiefly with regard to their general prosperity, though that has always in our century run higher than the prosperity of poets or of composers. The esthetics of art are exactly as before 1940, and the painters behave both in the studio and out exactly as they have always done. Wealth is becoming to them; they remain bohemian and good fellows. And wholly inept at organization, even the Americans.

Music, on the other hand, though its esthetics remain also much the same, has undergone a considerable reorganization of its distribution, its patronage, and its pedagogy. European radio, state-owned and tax-supported, has become a major agent for commissioning and disseminating contemporary work. America, for tax reasons, has developed foundational support for the arts. And even our government, under the Eisenhower administration, has sent music, ballet, and theater troupes round the world and enlarged its cultural offices abroad, its libraries, and its art shows, to a point where all these now count as items of cultural export. And our music schools are, at least for the present, the best. We are the only country, moreover, besides France, that has first-class composers of all ages and all schools. Every other nation, compared to these two, seems provincial, sectarian, or in some other way limited.

Back in the 1930s, as this book explains, the WPA, or Works Progress Administration, played a vigorous role in American music both for executants and for composers. Being basically a program for alleviating poverty, it died when war ended the depression. ASCAP, on the other hand, the American Society of Composers, Authors, and Publishers, was playing no significant role at all in serious music at the time. And BMI, a rival society owned by broadcasters, had not come into being. The battle between these two leviathans, started in 1940, is still being fought. I shall not go into its nature or progress save to point out that both sides have found they need the intellectual support, the prestige, of the serious composer and have now come round to collecting and distributing in quite impressive amounts performance fees for serious music.

As a result, and also as a result of enlarged foundational patronage, today's young composers get commissioned, paid, played, and even published. They are not yet living on their take; only five standard composers in America can do that. The rest still teach, mostly in universities. But they are better off than their European confreres, who are paid less for their teaching. And the whole composing tribe today, especially in America, has more outlet for its product than formerly.

This prosperity, like that of the painters, has changed nothing in the musician's way of working, though it will need to be considered by the reader when this book gets now and then overtearful about the composer's sad lot. The absence of easy money during the 1930s will also seem

to many a sufficient explanation for the book's constant preoccupation with reorganization and reform. Financial crisis, of course, can easily provoke such thoughts. But a stimulus, while explaining perhaps the existence of its reaction, does not necessarily explain it away. Thought once taken must be judged as thought. I believe, moreover, that today's crisis in musical style — for music has a style crisis just as painting has — may be better resolved by economic descriptions, sociological studies of the market, and reflections about political theory than by esthetic philosophizing. That part of the book, however unconvincing my conclusions may seem, remains its fundamental message and one far less outdated than an unreflecting boom generation might tend to consider it. Outdated by what? I ask.

Music's stylistic crisis is discussed a good deal in the book. The history of our musical language from early Christian psalmody through today's arithmetical abstractions is a continued story. The late eighteenth century witnessed for the literature of music its highest point of organization, flexibility, spaciousness, and expressive variety. The evolution of our idiom's tonal possibilities and the codification of its grammar were complete by 1914. Since that time expressive variety has still been possible, because every age uses its language to describe its own gamut of feeling. But there has been no further structural growth, only constriction. Now to abandon the formal language and to replace it by arithmetical structures is a perfectly legitimate effort on the part of our electronic and otherwise advance-minded composers. It is also a normal effort to an age brought up on the mystical idea that progress is a continuum rather than on the scientific studies of evolution and growth that demonstrate such processes to possess usually a beginning, a middle, and an end.

Today's fixation on musical experiment comes from both impulses. One of these is to assume that innovation is the only historic value. The other is to believe that innovation is always available. These two propositions define the ideals of today's musical left wing. And both are unacceptable to the right and center. The right and center, in fact, tend to consider the left as not advanced at all, merely mistaken. And the bitterness with which the dispute is conducted is further aggravated by rivalries involving commissions, performances, publication, and jobs.

Insofar as it is a war between generations, the younger one will win, of course, by mere survival. But the "advanced" position, as a position, is weaker today than last year. Its supply of ideas for innovation, its inspiration, is failing visibly. Its leaders are carefully, and not always under cover, moving to the right. Its next year's job defenses will certainly follow another line. The whole quarrel, I must say, is futile and tiresome; but there it is. Prose literature in general, that of the young certainly, has never been more naturalistic than now; poetry, painting, and music, by workmen of any age, have rarely been more mannered. This is to-

day's stalemated situation at ten years past the middle of a century that has formerly known huge activity in the arts.

With the worlds of transport and politics in rapid movement, with consumer production (and population) rocketing, with revolution on the march in every continent, and with matter itself turned active and unimaginably destructive, the arts today, save possibly history and reporting, seem relatively static, certainly timid, sectarian, and prissy. It might be the time to write another *State of Music,* but I do not think so. What music needs right now is the sociological treatment, a documented study of its place in business, in policy, and in culture. I am not prepared by training for such a work. Nor need I report much more on just music itself. I did that in the *New York Herald Tribune* from 1940 through 1954, and the results have been published in several books. The best I can do right now is to annotate this one and send it forth again.

It is a period piece certainly, but also a historic one, since no similar sum-up has been attempted since. The chapters about painters and poets are a bit frivolous, always were. The straight musical parts are better. Even the chapter on the economic conditioning of musical style, admittedly a scherzo, has in it far more than just a nubbin of truth. The account of music's business life has had to be put in accord with today's business facts. The political and organizational analysis of music reads to me still for the most part as correct, though it may seem to many, in a time that finds all political thought suspect and any proposal terrifying that might make any organization more efficient, bad taste to bring such matters up at all.

Save for a few corrections of phrase, most of my additions have been placed in brackets and printed along with the text to permit cursive reading. Once in a while I have omitted a page or paragraph that merely itemized some former status. In view of the sometimes extensive additions, it may turn out I have rewritten *The State of Music* after all. I hope not. I liked the book as it was, and still have for it some esteem. Enough, in fact, that I have only tried bringing it up to date at all in order to avoid being viewed as a period piece myself.

What I have not tried to do — could not possibly do — is to compensate for the fact that while the world has been changing a lot, and music a little, I have aged by twenty years. From a smart aleck just turned forty I have become an elder statesman. I may not be any wiser now, but more people believe what I say. Consequently, I am more careful about my language. Translating my thoughts of yesteryear, however, into my language of today would not benefit them. They are better in the words of their time, belong there, mean more. Anybody who can use them in the living that he is doing will surely be able to use also a bit of the truculent temper with which they are expressed. That is part of their urgency. And

if the ideas themselves lack urgency now, there is no point in reprinting this book.

I may write another book one day. If I do, it will be about other ideas and another time. But both that time and my view of it will have grown out of those described here. "Music Between the First Two World Wars," the present theme, is surely but the first act of a drama. At least it is the first one in which I played an adult role. Everything in music before 1914 belongs to history anyway, and not because a big war started then but because a long evolution ended then. My adult musical life happens to be contiguous with the time of music's beginning to be not anymore a part of a clear historical development. Like English literature after Shakespeare or French after Racine, music seems to be more a matter of change, constant change in subject and sound, than of growth.

This constant change, as in the literary products of mature languages, takes place more and more against a backdrop of the art's own history. Music in our time may be only the banal story of its mishaps and adventures since 1914. Nevertheless the play is not over. And since 1939 there have been changes of scenery and of tempo. A second act is surely going on. But one cannot now foresee its curtain-line.

It has been some pleasure, going over this book, to resee a past time through an eyewitness then twenty years younger. It is for readers twenty and more years younger now that I have made changes. My generation may well have preferred it as it was. But they don't need it. Today's young people may, just may, find in it some tiny spark or taper to help them explore the larger labyrinth that music has become since World War II.

V. T.

✌ Our Island Home

or What It Feels Like to Be a Musician

EVERY PROFESSION is a secret society. The musical profession is more secret than most, on account of the nature of music itself. No other field of human activity is quite so hermetic, so isolated. Literature is made out of words, which are ethnic values and which everybody in a given ethnic group understands. Painting and sculpture deal with recognizable images that all who have eyes can see. Architecture makes perfectly good sense to anybody who has ever built a chicken coop or lived in a house. Scholarship, science, and philosophy, which are verbalizations of general ideas, are practiced humbly by all, the highest achievements of these being for the most part verifiable objectively by anyone with access to facts. As for politics, religion, government, and sexuality, every loafer in a pub or club has his opinions, his passions, his inalienable orientation about them. Even the classical ballet is not very different from any other stylized muscular spectacle, be that diving or tennis or bullfighting or horseracing or simply a military parade.

Among the great techniques, music is all by itself, an auditory thing, the only purely auditory thing there is. It is comprehensible only to persons who can remember sounds. Trained or untrained in the practice of the art, these persons are correctly called "musical." And their common faculty gives them access to a secret civilization completely impenetrable by outsiders.

The professional caste that administers this civilization is proud, dogmatic, insular. It divides up the rest of the world into possible customers and noncustomers, or rather into two kinds of customers, the music employers and the music consumers, beyond whom lies a no man's land wherein dwells everyone else. In no man's land takes place one's private life with friends and lovers, relatives, neighbors. Here live your child-

hood playmates, your enemies of the classroom, the soldiers of your regiment, your chums, girlfriends, wives, throwaways, and the horrid little family next door.

Private human life is anything but dull. On the contrary, it is far too interesting. The troublesome thing about it is that it has no real conventions, makes no inner sense. Anything can happen. It is mysterious, unpredictable, unrehearsable. Professional life is not mysterious at all. The whole music world understands music. Any musician can give to another a comprehensible rendition of practically any piece. If there is anything either of them doesn't understand, there are always plenty of people they can consult about it.

The professional rules are extremely simple. In the unwritten popular vein, or folk-style, anything goes. If a piece is written out and signed, then all the musician has to do is to execute the written notes clearly, accurately, and unhesitatingly at such a speed and with such variations of force as are demanded by the composer's indications, good common sense, and the limitations of the instrument. Inability to do this satisfactorily can be corrected by instruction and practice. The aim of instruction and practice is to enable the musician to play fast and slow and loud and soft in any known rhythm, whether of the pulsating or of the measured kind, without any nondeliberate obscurity, and without any involuntary violation of the conventions of tonal "beauty" current in his particular branch of the art. The musician so prepared is master of his trade; and there are few emergencies in professional life that he cannot handle, if he still likes music.

Private life, on the other hand, is beset by a thousand insoluble crises, from unrequited love to colds in the head. Nobody, literally nobody, knows how to avoid any of them. Religion itself can only counsel patience and long-suffering. It is like a nightmare of being forced to execute at sight a score much too difficult for one's training on an instrument nobody knows how to tune and before a public that isn't listening anyway.

Yet plain private life has to be lived every day. Year after year we stalk an uncharted jungle with our colleagues and our co-citizens. We fight with them for food and love and power, defending ourselves as we can, attacking when we must. The description of all that is the storyteller's job. I would not and could not compete. From the musical enclosure or stockade, all that really counts is the easy game nearby, the habitual music consumer.

Sometimes a consumer is musically literate to the point of executing string quartets in the home. Sometimes he can't read a note. He is still a consumer if he likes music. And he likes music if he has visceral reactions to auditory stimuli.

Muscular reactions to such stimuli do not make a music lover. Almost

anybody can learn to waltz, or to march to a drum. My father and his mother before him were what used to be called "tone-deaf." They never sang or whistled or paid any attention to musical noises. The four to six hours a day piano practice that I did for some years in my father's house never fazed either of them. They would read or sleep while it was going on as easily as I read or sleep on a railway train. Their rhythmic sense, however, was intact and quite well developed. They could even recognize a common ditty or hymn tune, provided they knew the words, by the prosodic patterns of its longs and shorts. I do not doubt that intensive drilling could have developed their musical prowess to more elaborate achievements. Knowing their lives as I do, I doubt if either of them would have had a better life for having wasted time on an enterprise for which he had no real gift.

The music consumer is a different animal, and commerce with him is profitable. We provide him with music; he responds with applause, criticism, and money. All are useful. When Miss Gertrude Stein remarked that "artists don't need criticism; all they need is praise," she was most certainly thinking about the solitary arts, to which she was especially sensitive, namely, easel-painting and printed poetry. The collaborative arts cannot exist without criticism. Trial and error is their modus operandi, whether the thing designed for execution is a railway station, a library, a "symphonic poem," a dictionary, an airplane for transatlantic flights, or a tragedy for public performance.

Consumer criticism and consumer applause of music, as of architecture, are often more perspicacious than professional criticism and applause. What one must never forget about them is that the consumer is not a professional. He is an amateur. He makes up in enthusiasm what he lacks of professional authority. His comprehension is intuitive, perfidious, female, stubborn, seldom to be trusted, never to be despised. He has violent loves and rather less violent hatreds. He is too unsure for hatred, leaves that mostly to the professionals. But he does get pretty upset sometimes by music he doesn't understand.

On the whole he is a nice man. He is the waves around our island. And if any musician likes to think of himself as a granite rock against which the sea of public acclaim dashes itself in vain, let him do so. That is a common fantasy. It is a false image of the truth, nevertheless, to group all the people who like listening to music into a composite character, a hydra-headed monster, known as The Public. The Public doesn't exist save as a statistical concept. A given hall- or theaterful of people has its personality, of course, and its own bodily temperature, as every performer knows; but such an audience is just like any other friend to whom one plays a piece. A performance is a flirtation, its aim seduction. The granite-rock pose is a flirting device, nothing more. The artist who is really indifferent to an audience loses that audience.

While I was growing up in Kansas City, the consumers I came in contact with were very much as I describe them here. Later, when I went to college, I encountered a special variety, the intellectual music fancier. This is a species of customer who talks about esthetics all the time, mostly the esthetics of visual art. He views modern music as a tail to the kite of modern painting, and modern painting as a manifestation of the Modern Spirit. This is all very mystical, as you can see. Also quite false. There is no Modern Spirit. There are only some modern techniques. If it were otherwise, the market prices of music and painting and poetry would not be so disparate as they are.

The intellectual music fancier is useful as an advertising medium, because he circulates among advance-guard consumers. He is psychologically dangerous to musicians, however, because he insists on lecturing them about taste. He assumes to himself, from no technical vantage point, a knowledge of musical right and wrong; and he is pretty sacerdotal about dispensing that knowledge. He is not even a professional critic, responsible to some publication with a known intellectual or advertising policy. He is likely to have some connection with the buying or selling of pictures. He is a snob insofar as he is trying to get something without paying for it, climbing at our expense. And his climb is very much at our expense if we allow him to practice his psychological black magic on us, his deadly-upas-tree role, in the form either of positive criticism or of a too-impressive negation. On the whole, he is not as nice a man as the less intellectual consumer; and he must be handled very firmly.

In dealing with employers, professional solidarity, lots of good will, and no small amount of human forbearance are necessary. Musicians backstage quarrel a good deal among themselves. They practically always present a united front to the management. It isn't that one dislikes the management especially, or disapproves of his existence. He is simply a foreigner. On the job to be done, he just doesn't speak our language.

Verbal communication about music is impossible except among musicians. Even among them there is no proper vocabulary. There is only technical jargon plus gesture. The layman knows neither convention. He cannot gesture about another man's trade, because a trade's sign language is even more esoteric than its jargon. If he knows a little of either, communication merely becomes more difficult, because both jargon and sign language have one meaning for the outside world, a dictionary meaning if you like, and five hundred meanings for the insider, hardly one of which is ever the supposed meaning. The musician and his employer are like an Englishman and an American, or like a Spaniard and an Argentine. They think they are differing over principles and disliking each other intensely, when they are really not communicating at all. For what they speak, instead of being one language with different accents, as is

commonly supposed, is really two languages with the same vocabulary. The grammar is the same grammar and the words are the same words, but the meanings are not the same meanings. The plain literal meanings of words like *pie, lamb,* and *raspberry* are different enough between America and the British Isles. For an inhabitant of either country even to suspect what the other fellow means by general words like *gratitude, love, loyalty, revenge,* and *politeness* requires years of foreign residence.

So it is between us and our nonmusical collaborators. Preachers and theatrical directors, for instance, will practically always ask you to play faster when they mean louder; and they get into frightful tempers at what they think is a too-loud background for a prayer or soliloquy. Nine times out of ten the musician is playing just this side of inaudibility and is killing the effect not by playing noisily but by playing *espressivo.* He thinks an expressive scene needs an expressive accompaniment. It rarely occurs to him, unless told, to play *senza espressione.* He doesn't mind playing so when told, because *senza espressione* is a legitimate, though rarish, musical effect. It just doesn't occur to him usually.

It is impossible, however, for a layman to ask a musician to play without expression. He can demand a little less agony when the player gets clean out of hand, but that is as far as he can think technically. Even if he knows the term *senza espressione,* he imagines it to mean "in a brutal or mechanical manner," which it doesn't. To musicians it means "without varying noticeably the established rhythm or the dynamic level." It is far from a brutal or mechanical effect. It is a very refined effect, particularly useful for throwing into relief the expressive nature of whatever it accompanies.

Film directors are particularly upsetting to the musician, because, dealing with photography as they do, they live in constant fear lest music, the stronger medium, should take over the show. At the same time, they want it to sustain the show whenever the show shows signs of falling apart. They expect you, wherever the story is unconvincing or the continuity frankly bad, to deceive the audience by turning on a lot of insincere hullabaloo. Now insincerity on the part of actors and interpreters is more or less all right, but insincere authorship leads to no good end. Theater people and musicians all know this. Film people do not seem to. For all the skill and passion that have gone into the making of movies, the films are still a second-rate art form, like mural painting, because they try to convince us of characters and motivations that their own authors do not believe in, and because they refuse a loyal cooperation with music, their chief aid, choosing naively to use the more powerful medium as whitewash to cover up the structural defects of the weaker. It takes lots of tact and persistence to pull off a creditable job in such an industry.

The most successful users of music are the concert organizers. They confine themselves to saying yes and no. The workman never has much

trouble with an employer who knows what he doesn't want. On the contrary, negation simplifies everything; and one can then proceed by elimination. What gives a musician the jitters is positive criticism, being told in advance what the result should sound like. Such talk sterilizes him by bringing in emotive considerations (the layman's language lending more moral-value connotation to technical words than the workman's language does) at a moment when successful solution of the problem in hand, that of speaking to an audience expressively (though not necessarily *con espressione*), demands that he keep all moral values and taste connotations out of his mind.

I am trying to tell in this roundabout way what it feels like to be a musician. Mostly it is a feeling of being different from everybody but other musicians and of inhabiting with these a closed world. This world functions interiorly like a republic of letters. Exteriorly it is a secret society, and its members practice a mystery. The mystery is no mystery to us, of course; and any outsider is free to participate if he can. Only he never can. Because music-listening and music-using are oriented toward different goals from music-making, and hence nobody really knows anything about music-making except music-makers. Everybody else is just neighbors or customers, and the music world is a tight little island entirely surrounded by them all.

❧ The Neighbors
or Chiefly About Painters and Painting

*I*T IS NOT HEALTHY for musicians to live too close to the confraternity. The white light of music is too blinding, and professional jealousies are a fatigue. One needs friends of another mind. A great deal of my own life seems to have been passed among painters. My sister, who was ten years older than I, was a china-painter. She earned a good living at it and paid for my music lessons, bought me my first piano. The house was full always of her colleagues and customers and the blessed odor of turpentine. To this day that resinous acridity seems to me the normal atmosphere for music to breathe and grow in.

Perhaps that is why Paris, where one is surrounded by painters, has always reminded me of Kansas City; and no doubt that is why I feel at home there. Because Paris contains, or did some years ago, by census, sixty thousand artist-painters earning their living at their trade. Believe it or not, sixty thousand professional easel-painters. Naturally one is surrounded by them. And a pleasant lot they are too, cheerful and healthy and leading regular lives.

Not orderly lives, by any means, because disorder, both material and moral, is of the essence in a painter's life. Their incomes and their love lives are as jumpy as a fever chart. Their houses are as messy as their palettes. They view life as a multiplicity of visible objects, all completely different. A dirty towel in the middle of the floor, wine spots on the piano keys, a hairbrush in the butter plate are for them just so many light-reflecting surfaces. Their function is to look at life, not to rearrange it. All of which, if it makes for messiness in the home, also makes for ease in social intercourse. This plus the fact that they all have perfectly clear consciences after four o'clock, or at whatever hour the daylight starts giving out.

The painter's whole morality consists of keeping his brushes clean and

getting up in the morning. He wakes up with the light, tosses till the sun is overhead, then gets up and starts moving around. He works moving around. Drawing, engraving, and watercolor sketching can be done seated. But oil painting must be done on foot, walking back and forth. It entails no inconsiderable amount of physical exercise and that among turpentine fumes, which keep the lungs open. Hence your painter is on the whole a healthy and a cheerful man. His besetting maladies are digestive, due to poverty, undernourishment, and irregular meals. He requires lots of food. In middle and later life he sometimes has rheumatism. But he is seldom too ill to paint.

As soon as the light goes bad his painting day is over. He thereupon refreshes his mind by making love to his model or by quarreling with his wife, and goes out. From four till midnight he is gay and companionable. After midnight he is disagreeable, because he knows he should be in bed. It is chiefly after midnight that he takes to alcohol, when he takes to it at all. He is a man of moderate habits, abundant physical energy, and a lively though not scholarly mind. (He doesn't like to tire his eyes by sustained reading.) He has social charm, generosity (except about other painters), and a friendly indifference to music that is a constant refreshment for musicians. Unseduced by the mere charm of sounds, unimpressed by the ingenuities of musical workmanship and the triumphs of voluntary stylization, he goes straight to the heart of the matter when he goes in for music at all. He will sometimes tell you in five words what a piece is all about, a thing no musician ever knows and no music lover ever even tries to know.

He is usually nonpolitical, though his ways are democratic. He resides among the poor, visits in châteaux, and walks unscathed through the intrigues of the literary cenacles. He makes love to princesses as if they were housemaids and to housemaids as if they were princesses, accepting service and presents from both. He has no class hatred because he has no class. He combines the ferocious independence of the solitary intellectual with the dignity of the skilled manual worker.

He bands together for esthetic purposes much more frequently than for economic. Unlike the musician, who is a union man and a petty bourgeois with an organized orientation in class-struggle tactics and consequently a tendency toward political affiliations (he is usually either a Third-International Communist or an extreme-right reactionary*); unlike the poet, who has an overelaborate education and no economic place in society at all and who tends hence to shoot the works politically by attaching his unrequited social passions to some desperate and recondite cause like Catalan autonomy, Anglo-Catholicism, or the justification of

* Still true in South America.

Leon Trotsky;* unlike the sculptors and the architects, who in order to function at all must pass their lives in submission among politicos and plutocrats; unlike the doctors, the scholars, and the men of science, who are a whole social class to themselves, and who function as a united political party for the maintenance of that stranglehold on the educational system which they acquired during the nineteenth century; unlike the manufacturers and the merchants, who know their cops and their aldermen and who always vote (to say the least); unlike actors and theater people, who, whether poor or prosperous, are vagabonds, but who do have a trade union of sorts and an enormous class solidarity; the painter is a man of no fixed economic orientation, no class feeling, and very little professional organization of any kind.

Since the abolition of the guilds by the French Revolution, no painters' union or academy has ever been seriously effective. (Similarly, no dealers' consortium or trust has ever put the economic squeeze on painters as a group.) The British Royal Academy is little more than a Kiwanis Club or a Fifth Avenue Merchants' Association. American Artists' Equity is notoriously ineffective at defending the painter's rights in the sale of his reproductions and at collecting what is owed him by clients and dealers. The painters don't even run an educational institution of any very dependable kind. They refuse to systematize. There is some virtue in this refusal. Alone among all the higher skills, painting is still learned rather than taught. In the state-endowed academies, in the private ateliers, in art students' leagues, in life classes at provincial museums, oil painting and its allied techniques are considered by students and instructors alike to be progressively acquired skills rather than a corpus of esoteric knowledge progressively administered. Even the Dynamic Symmetry racket, which is an attempt to subject easel-painting, so recently free from their domination, to the ancient rules of decorative design, must eventually be submissive to the judgment of the Seeing Eye.

The Seeing Eye has no opinions. A still life, a nude, a landscape (no matter what sentimental tie-up may be involved in the painter's choice of subject), is exactly what the painter puts down and what any beholder sees when he looks at it. Very little more is involved. The painter's technique, however complete, however analytic, can only describe particular objects. It is incapable of stating a general idea or of depicting the emotional, the utilitarian value of anything. Hence the great moral freedom of painters as a race. They keep a cleaner separation than any other kind of man I know between their lives and their works, even, in their work, between vision and execution. Their vision is personal and subjective, their rendering of it precise, objective, nonemotional. All the emotional things like sexuality, politics, elegance, family life, and religion are kept

* In 1960, read Algerian autonomy, Zen Buddhism, or beatnik Bohemia.

strictly in the background of their lives as private games, subjects for talk, indulgences for the darker hours of the day.

They can accept without mental trickery the dictates of fashion and of politics about what fashion and politics think is appropriate subject matter for painting, especially if large commissions are involved. What do they care whether their model is supposed to represent Jesus Christ or Lucifer or Love in Idleness or Mr. John Rockefeller or The Conquest of Tahiti or The Workingman Triumphant or Agriculture Shaking Hands with the Machine Age? He is just a model to them. And the drapery is just so many varied textures, each reflecting light in its own way to the Seeing Eye. An apple, a banknote, a pair of buttocks — all is one to them, because all is infinite multiplicity.

[In 1960, masses of them have followed the fashion (a strictly upper-class one) for concealing the subject matter. This is accomplished through stylistic devices variously known as action painting, abstract expressionism, and (to use my word for it) crypto-Impressionism. Such concealment works less well for union halls, churches, post offices, or travel posters than for restaurants, nightclubs, hotels, international administrations, and university premises. It does not work at all for portraiture. But painting, in a time of easy money, follows the taste of those spending that money. And the taste of today's ruling group in the West favors a minimum of imagery.]

Mark you, my portrait of The Painter is of the ideal, or rather the average painter, the easel-painter as he exists among his sixty thousand brethren in Paris or New York. The painter in isolation is another man. If you take him out of his water and put him on an island somewhere, out of the reach of other painters and with no access to a picture merchant, or if you send him to teach in some provincial agglomeration where there is no rivalry and no market, he goes very bad indeed. All alone he must cover the social gamut. He must drink and make merry and change wives and raise children; he must go to cockfights and gamble and collect folklore and spend money; he must patronize the local whorehouse and picket the local pants factory and waste his eyes reading books. It is too big a job. If the booze doesn't get him, the bourgeoisie must. A sad man indeed is the painter exiled from his kind.

An embittered man is the painter who overindulges in applied art. Patterns, posters, costumes, theater, the painter does better than the specialists. Because where the specialists have only a bag of tricks, the painter has some hard-earned general knowledge about color, light, proportion, and arrangement for high visibility. He enjoys making applications of this knowledge, playing new tricks on old trades, giving everything style, getting paid for it. The indulgence is a pleasant one indeed. The effects of overindulgence are emptiness, staleness, sterility, and bad temper.

Even the much-admired virtuoso skills allied to oil painting should not

be indulged in any more than is necessary to prove that one can do them if one has to. The etching, the dry-point, the silver-point, the watercolor are too pretty to be much good. It is easy to do them with charm, well-nigh impossible to give them any force. Preoccupation with such minor matters is the mark of a painter who is trying to go commercial respectably or professorial with impunity.

Commissioned portrait painting is also a deviation. Because the problems of painting are three and only three; animate objects, inanimate objects, and scenery. The sum-up of them all is the licentious picnic (the landscape with draped figures, undraped figures, and food). The portrait that isn't ordered is perfectly legitimate. It is just a draped figure, and resemblance doesn't matter. But facial resemblance, which is what people pay for in paid portraits, is outside the canon of painting. It is a trick, a gift. It cannot be learned or taught. The painter who can pull it off steadily seldom pays much attention to the serious problems of painting. Doesn't have to, because resembling portraiture is well paid. He is ashamed, though, because he is held in low esteem by his kind. Moreover, that psychic intimacy with the sitter that is necessary for the execution of good portraiture is upsetting to the nervous system and undermines character; also the continuous frequenting of politicians and of the rich that is necessary both to get portrait commissions and to execute them is in itself a full-time occupation and not a very noble one.

As for mural painting, only second-raters ever do it a second time. The only special technique involved is the getting of jobs. Excellent painting can perfectly well be done on a wall, of course, or on a ceiling. It can be done on a bar mirror in epsom salts, on a candy box, on the back of a hairbrush, or around the legs of a piano. It must always be an image, it must depict something, however abstractly. It must create an illusion. If it sacrifices representation to anything else it is decorative design; and that is another man's trade. The real trouble about large-scale mural painting in our epoch is that unless it is executed in a precious material, in which case it is not freehand painting but something else, it must inevitably compete with other large-scale paid advertising in color, that is to say, electric signs and billboards. In consequence, it tends toward blatancy and oversimplification and thus fails to profit by those fuller resources of the painter's technique, the deployment of which would be his only legitimate excuse for being engaged in paid advertising at all.

[In 1960, the current scheme is to employ in business rooms and executive offices not wall paintings but framed oil pictures chosen for their lack of easily read imagery and the known high price of their painters' signatures. Such pictures have a resale value, of course, that murals do not; and any of them will go into any office as well as any other. Abstract or nonfigurative painting has come thus to serve business as a symbol of disinterested effort while actually, in a time of rising art prices, mak-

ing money for the firm. The painter, moreover, in this happy deal has been spared the indignity of practicing applied art.]

There is no way around it. The painter who doesn't paint pictures is a routine man and a bore. The painter who is predominantly an easel-painter is a noble animal and a charming neighbor. He is the type-practitioner in our age of the arts both beautiful and liberal. This has not always been so. The seventeenth century had its priests and preachers whom it counted on for inspiration, as well as for the work of the world; these directed the religious wars and the colonial expansions, the exploration of three continents and the taming of wild folk. The eighteenth century had its philosophers and journalists, its generalizing men of letters, and counted on them for social guidance and for prophecy. The nineteenth century sucked its vitality for industrial and business expansion out of poets, musicians, and scientists. Big business today lives on the calculators and the mathematical physicists, while the arts of music and literature, completely divorced from the realities of supranational cooperation, fecundate in a vacuum, drawing their moral support in this depressing enterprise from the only really classless man there is, the painter, and leaving to him in turn the center of the world's artistic stage, as well as the privilege of collecting most of the receipts.

The depiction of the visible world might well have been left to him too, did not journalism and photography cover the ground more thoroughly. As a matter of fact, painting and photography work very well side by side just as poetry and journalism go hand in hand and often hand in glove. The boom in oil painting that has lasted from 1860 on, from the pre-Raphaelites and the impressionists through the cubists, surrealists, neo-Romantics, and neo-abstractionists is exactly contemporary with the rise of commercial photography. Photography has taken over from painting nearly that whole mass of boring and fastidious work that is represented by illustration, documentation, and personal portraiture. Both arts have prospered in consequence.

But with all the photography that goes on in the world (there is even "abstract," or nonrepresentational photography), one might expect the photographers themselves to be more in evidence than they are. I must say they are fairly noticeable in Germany, which is the ancestral home of The Toy, her modern form of toy consciousness being a passion for optical instruments and for playing with them in public. Elsewhere, although everybody knows a photographer or two, one is rarely surrounded by them as one is surrounded by painters in Paris, by men of letters in London, by musicians in Vienna, by schoolteachers in Boston, and by publicists in New York.

They are strange little men, photographers, always a bit goofy and incommunicable. They live on idiosyncratic observation, on fancy. Practicing the most objective technique known to art, they cherish a violent

life of the imagination. They are sad, pensive, and introverted, leading
their lives in raincoats. They have bad complexions and are riddled with
chronic diseases, usually of nervous origin. [Their women's-wear wing,
on the other hand, wears dudish clothes, drives foreign cars, frequents
the glamour world, and collects art. They still have allergies.]

Journalists are plentiful everywhere and entertaining too, full of jokes
and stories. Only their jokes are not very funny and their stories not
quite true. Their information is always incomplete, because nobody tells
them the truth about anything. Though they think themselves pundits
all, their philosophy of life and their techniques of expression are in-
curably, dogmatically superficial. Their private lives are full of banal
domesticity and melodrama. They are, to a man, either dyspeptic or alco-
holic or both. They must be avoided in bands, because they bring out the
worst in one another. Singly they are warm and companionable, make
devoted friends.

As for the sculptors and the architects, they are a pretty negligible
company. The former are personally vain and professionally pretentious.
They are troublesome when they turn up; but they turn up rarely now-
adays, their art being in decline. The latter exist in abundance but are
tame and lacking in savor. They frequent the rich and are impressed.
They marry above themselves and send their children to schools they
can't afford. They are good enough neighbors; they will always lend you
a cup of oil. But there is no real sustenance in them.

Theatrical people are better. They are ostentatious and repetitive, but
they have a playfulness and a complete lack of grownup morality that
are refreshing. They are superb in times of depression. In the long run,
of course, they are unfrequentable on account of their late working hours,
just as vocalists are unfrequentable because they are always having to go
to bed. The latter are companionable and good cooks (I count them
among the nonmusical neighbors because, as everybody knows, they are
mostly not very musical), but they are neurotic. They can't drink or
smoke or stay up after ten o'clock without worrying about themselves.
And they are completely fee-minded. Dancers are autoerotic and have
no conversation.

No, seriously, it is the painters who by their numbers, by their charm
and healthiness, and by their unique social freedom, have imposed upon
the twentieth century their own type as the model of what an artist
should be like. If all art in Walter Pater's day could be said to "aspire to
the condition of music," all artists, certainly all artists today, aspire to the
condition of the painter, envying him his regular life, his cheerfulness,
his fecundity, his vigorous energies, his complete lack of emotional com-
plexity, and (among the higher-flight ones) certainly, yes, very certainly,
his income.

℘ Survivals of an
Earlier Civilization
or Shades of Poets Dead and Gone

POETRY IS the oldest of the arts and the most respected. The musical tradition we practice has scarcely a thousand years. Architecture, sculpture, and decorative design have passed since ancient times through so many esthetic revolutions that very little is left in them of any authoritative tradition. Improvisational one-man easel-painting in oil (painting as we know it) dates barely from the seventeenth century.

Poetry, as we know it, goes straight back to the Greeks and to the Hebrew children. There has been no interruption for twenty-five hundred years in the transmission of its technical procedures, no hiatus in the continuity of its comprehension by the literate classes of Europe. It has survived changes in religion, political revolutions, the birth and death of languages. Its classic masters enjoy a prestige scarcely exceeded by that of the Holy Evangelists. By populace and scholars alike they are admired above confessors and martyrs, priests, prophets, historians, psychologists, romancers, and ethical guides, and far above statesmen or soldiers, orators or newshawks. For they and their heirs are the recognized masters of the most puissant of all instruments, the word.

The poetic prestige remains, but the poetic function has contracted. As champions of the arts of love, poets made war for centuries on the Christian Church and won. As analysts of its motivations and as experts of amorous device, they were the undisputed masters of that subject till Sigmund Freud, a nerve doctor, beat them at it in our own day. (Karl Marx, a nineteenth-century economist, had already beaten them at social analysis and at political prophecy.) With love now the specialty (in every aspect) of the medical profession, with government (both past and future) better understood by sectarian political groups and better explained

by journalists, with dramaturgy better practiced in Hollywood and Join-ville and Rome, and storytelling done more convincingly by the writers of police fiction, what is there left for the poet to do that might even partially justify his hereditary prestige?

He could retreat into "pure" poetry, of course; and he often tries to. Much good may it do him. Because the sorry truth is there is no such refuge. In recent years the poets have talked a good deal about "purity." I am not sure what they mean by "pure" poetry, unless they mean poetry without a subject matter; and that means exactly nothing.

Music and painting can exist perfectly well without a subject matter, at least without any obvious or stated subject matter. Painting of this kind is called "abstract." Musicians used to distinguish between "pro-gram" music and "absolute" music. The latter term meant music without a literary text or any specific illustrative intention, that is to say, instru-mental music of an introspective nature. Neither "abstract" painting nor "absolute" music is any "purer" than any other kind of painting or music, and no painter or musician ever pretends it is. It is merely more obscure. When painters speak of "purity of line," they mean a complete lack of obscurity. When they speak of a "pure" color, they mean a shade that is unequivocal. Say an artist's intentions are "pure," if you must. That means he is not commercial minded. The word *pure* cannot possibly have any meaning when applied to the content or structure of literature. Poetry could be pure only if it could be devoid of meaning, which it can't. You can make nonsense poetry, certainly; you can dissociate and reassociate words. But you cannot take the meanings out of words; you simply can't. You can only readjust their order. And nobody can or ever does write poetry without a subject.*

What subjects, then, are available to the poet today? Practically none. Money, political events, heroism, science, mathematical logic, crime, the libido, the sexual variations, the limits of personality, the theory of revo-lution: the incidents of all these are more graphically recited by journal-ists, the principles better explained by specialists. There really isn't much left for the heirs of Homer and Shakespeare to do but to add their case histories to the documentation of introspective psychology by the practice of automatic writing. Highly trained in linguistics (though the philolo-gists are not bad at that either) and wearing the mantle of the Great Tra-dition, admired unreasonably and feared not unreasonably (for they are desperate men), they still have, as poets, no civil status, no social func-tion, no serious job to do, and no income.

They haven't even any audience to speak of. For some time now they

* "Purity," as applied to poetry, is chiefly used by the French and refers, I think, to the philosophical noninvolvement and near-to-hermetic verbiage of Mallarmé, Rimbaud, Valéry, and their derivatives.

have been depending mainly on one another for applause. Hence the high intellectual tone of all they write. I mean that for fifty years poetry has mostly been read by other poets, and that for a good thirty years now it has mostly been written to be read by other poets. [Add twenty years to these figures.]

The impasse is complete. Contemporary civilization has no place for the poet save one of mere honor. Science, learning, journalism, fiction, religion, magic, and politics, all his ancient bailiwicks, are closed to him formally and completely. He is allowed to render small services to these now and then as a disseminator of existing knowledge. He is always regarded, however, by the specialists as a possible betrayer; and consequently at no time is he allowed to speak on such subjects with any but a temporarily delegated authority.

His lot is a tragic one. Nothing is left him of his art but an epigone's skill and some hereditary prestige. This last is still large enough to give him face in front of his co-citizens and to keep up the recruiting. It doesn't pay anything at all, of course. It won't buy a beer, a bus fare, or a contraceptive. Nor does it prevent the darkest despair from seizing him when he is alone. [Nowadays a bit of a market has developed for lectures, readings, personal appearances, and the sale of manuscripts.]

The prestige of classic poetry is enough to explain the market among cultured women for poets as lovers. I use the word *market* deliberately, because in these love affairs a certain amount of money nearly always changes hands. The poet with no job and no private resources is a liability to his intimates. If he has a job, he is usually too busy working at it to take on seriously a love affair with a woman of leisure. If he has money from home, he always keeps somebody else or spends it on riotous living. Any independent woman who gets involved with a poet had better figure that he is going to cost her something sooner or late, if only for bailing him out of hospitals.

For poets live high. When one is as poor as they, budgets make no sense and economies make no sense. Nothing makes any sense but basic luxury — eating well, drinking well, and making love. Independent and well-to-do women whose sex mechanisms are excited by intellectual conversation are very useful indeed to poetry, provided they don't go motherly. (Poets don't care much for maternal types, and they have a horror of fatherhood.) They serve the poet as muse, audience, and patroness all in one as long as they last. This isn't long usually. They get scared off by the violence of it all, as well as by the expense, and take up with a musician.

Everything the poet does is desperate and excessive. He eats like a pig; he starves like a beauty; he tramps; he bums; he gets arrested; he steals; he absconds; he blackmails; he dopes; he acquires every known vice and incurable disease, not the least common of which is solitary dipsomania.

All this after twenty-five, to be sure. Up to that age he is learning his art. There is available a certain amount of disinterested subsidy for expansive lyrical poetry, the poetry of adolescence and early manhood. But nobody can make a grownup career out of a facility for lyrical expansiveness. That kind of effusion is too intense, too intermittent. The mature nervous system won't stand it. At about twenty-six, the poets start looking around for some subject matter outside themselves, something that will justify sustained execution while deploying to advantage their linguistic virtuosity.

There is no such subject matter available. Their training has unfitted them for the rendering of either those religious-political-and-epic or those humane-philosophical-and-dramatic subjects that were formerly their special domain. They are like certain scions of ancient families who have been brought up to look and act like aristocrats but who don't know beans about government. They even write more like heirs of the great dead than like creators of living literature. Their minds are full of noble-sounding words and a complete incomprehension of everything that takes place beyond the rise and fall of their own libidos. They cannot observe; they cannot even use words and syntax objectively. They are incurably egocentric.

This explains the high mortality, both literary and physiological, that takes place among poets around the age of thirty. Faced with a cultural as well as an economic impasse, some hang on just long enough to finish a few extended but essentially lyrical works conceived in their mid-twenties and then die of drink, dope, tuberculosis, or plain suicide. Others, especially in England, become journalistic correspondents at twenty-six. The French tend toward the civil and consular services. Americans become pedagogues or reporters. A few marry rich widows. This last solution need not be counted as a literary mortality. On the contrary, it gets the poet over some difficult years of transition without forcing him into drugs or invalidism; so that when the lady sees financial ruin approaching, the poet can and most frequently does start a new literary life, this time as a prose author with an objective method and a recognizable integration to his time.

For the poet who insists on remaining a poet, there is a compromise formula. He must manage to get through his youth either with a small patrimony or with enough health left to allow him to work at a regular job of some kind, preferably not connected with literature. [Grants and fellowships help.] In this case he usually settles down in his thirties to steady domesticity with a woman approaching (though never topping) his own social class and disappears into the landscape of ordinary life, carefully budgeting his leisure, his income, and his alcoholic intake. He keeps up his poetic correspondence (one of the strange things about poets is the way they keep warm by writing to one another all over the world)

and occasionally takes part in esthetic controversy, all the while laying regularly but slowly his poetic eggs and publishing them in book form at three-to-five-year intervals. These eggs are called "poems of some length," and they essay to treat of historical or sociological subject matter in the epic style. The manner is essentially lyrical, however; and since lyricism without youth, without expansiveness, and without heat is a pretty sad affair, the best that can be said of these estimable efforts is that they are "the work of a mature talent," that they are "masterly," that they show a "profound feeling" for something or other. The fact remains that they are fairly ineffectual and are less read, on the whole, than his youthful works. An edition of five hundred to two thousand copies is disposed of, with luck, to libraries and bibliophiles, both of these being collectors of poetry for its prestige value. Sometimes the edition doesn't sell at all, in which case the publisher puts down his loss to prestige advertising. Most publishers do a few such volumes a year, because they think it a good idea to have some poetry in the catalogue.

These middle-aged poets are just as charming as ever and much easier for peaceable persons to go about with than the young ones, because their habits are not such a strain on one's vitality. They are busy men with always time for a chat. They love to do you favors. They are good fathers, faithful husbands, and fine hosts. Once in a while they go out on an all-night binge; and their wives don't really mind, because a binge makes hubby feel like a dangerous fellow again. It builds him up to himself. And at no risk. Because he rarely does anything on these nights out but sit with a crony and talk.

Poets at any age make sound friends. They are always helping you out of jams. They give you money. They respect your working hours but don't scold you when you don't work. They practice conversation as an art and friendship as a religion. I like too their violence, their fist fights with cops, their Parisian literary wars. [My publisher says they are more peaceful now. Does he know, I wonder, all the tougher beatniks of the San Francisco dock school? And as I write, Cocteau and Breton are still at it in the Paris press with hammer and tongs, bell, book, and candle.] The displays of pure bitterness that one observes among them in England I find less invigorating, because the intensity of these seems to be due not so much to professional disagreement as to that exercise of social hatred within one's own class that seems to be the characteristic and special quality of British life just now.

I like their human warmth, their copious hospitality (however poor they may be), their tolerance about morals and their intolerance about ideas, their dignified resignation at all times. I even like their wives and their animals (for they mostly have wives and they all have cats or dogs or horses). Mostly I like their incredible loyalties. They are the last of honor and chivalry. They may be sordid sots or peaceful papas or gigolos

on a leash. They imagine themselves to be knights errant jousting before the Courts of Love. And they act accordingly, observing incomprehensibly delicate scruples, maintaining principles and refinements of principles that reason, common sense, and social convention have long since discarded as absurd. I knew a poet once who refused to salt his food when dining at a certain house, because, intending later to make love to the hostess, he would have considered it a breach of his obligation as a guest to attempt any violation of his host's home life after having "eaten his salt." He was remembering, no doubt, some Arabic or medieval saw. He was not remembering that the "salt" of the precept could only have nowadays a symbolic meaning and that the food he partook of had already been salted in the cooking.

I like also their preoccupation with religion, the black arts, and psychoanalysis, and their inability to practice any of these consistently, even in an amateur way. They could, of course, if they were not, at the same time, so egocentric and so responsible to a tradition. Anybody can be clairvoyant or perform a miracle here and there who really wants to and who isn't afraid of the techniques. Unfortunately the techniques are all extremely dangerous to handle. That these techniques occasionally work, there is, I think, no question. Illnesses, accidents, cures, and suicides, the favorable or unfavorable outcome of amorous projects and business deals, even the finding of lost objects, can be and every day are effected from a distance by interested outsiders. Prophecy is extensively carried on today through the techniques of numerology and of astrological calculation. A more active interference in other people's affairs is operated by the employment of three different kinds of technique. The hocus-pocus of medieval black art is far from uncommon, as are also the rituals of voodoo and fetish. Prayer, incantation, and trance are even commoner. Willful exploitations of animal magnetism, of psychological domination, and of euphoric states are the bases of organized religions practicing openly. These last means are employed quite frankly in every domain of modern life, even (and by both sides) in class warfare. Organized salesmanship depends on little else, as do equally the morales of citizen armies and of militant political parties.

The poets seldom succumb to the temptation of tampering with any of these techniques, though they are not infrequently the victims of such practice by members of their own households. They don't do it themselves because the practice of poetry is exactly contrary in method to the exertion of secret or of psychological influences. Poetry is practiced today and, so far as I know, is only practiced in the manner that used to be called the tradition of Humane Letters, which is to say that it is written by one man to be read by all men and that it makes to him who reads it exactly whatever sense it would make to any other disinterested reader. Its vocabulary consists of neutral dictionary words. Magic practices, on

the other hand, require the use of an emotional and hermetic vocabulary comprehensible in its full meaning only to initiates and hence effective psychologically far beyond the dictionary meanings of the words used or the normal significance of the gestures that accompany them. For all his egocentricity, the poet is not antisocial. The practice of magic is thoroughly antisocial, because all the techniques of it depend for their working on the breakdown of somebody's personality.

Now the barriers of personality are the highest product of culture and of biological evolution. Their erection is the modus operandi, and the interplay of persons and groups around them is the unique end of what almost anybody means by civilization. Naturally their destruction is antisocial and anticultural. And just as naturally, the poets, being the direct heirs of the oldest tradition of thought in civilization, are more aware than most men of the existence of anticultural practices and of the danger to all concerned of any self-indulgence in that direction.

Organized religions and organized devotion to revolutionary political ideals are rarely in the long run antisocial, though I would not say so much for high-powered salesmanship. The poet's objection to organized religions (and most poets are, if not antireligious, at least anticlerical) is that all religions are opposed to the intellectual tradition; they are the enemies of poetry and humane letters. And so are all enterprises that keep large groups of people united by the exploitation of animal magnetism (read "sex appeal"), mental domination, and euphoric states. Such enterprises are, by definition, not antisocial if large numbers of people are involved. They are simply anticultural. They may be aimed at an admirable end, and they are very tempting indeed if they seem to be about to effect political changes of a collectivist nature. But no matter how eager your poet may be to aid in the achievement of the desired end, he views with alarm any means of doing so that might render those left alive after the achieving of it mentally unfit to enjoy the thing achieved. His greatest value in revolutionary movements, for instance, is his incessant and tiresome insistence on the maintenance at all times of the full intellectual paraphernalia.

Laymen are likely to think the poets are just being fanciful when they talk about magic and sorcery. This is not so. They are talking very good sense indeed, though their terminology may be antiquated. As a matter of fact, they are the only group of men in the world that has any profound prescience about the unchaining of the dark forces that has taken place in our century. Their chief utility to us all is that they help us to fight those dark forces by the only effective means there is or ever has been. I mean the light of reason, the repetition of sage precept, and the continual application to all the dilemmas of human life of the ancient and unalterable principles of disinterested thought.

It seemed a few years ago as if psychiatry might be about to provide a

bulwark against obscurantism. The number of psychiatrists and psycho-analysts who have themselves fallen for the delights of mental domina-tion, who, by inducting their patients into a state of euphoria through which no reality can pierce, have covered up their failure to produce in these a realistic attitude toward society, the number, I say, of such phy-sicians is too large. As venal a branch of science as that cannot be counted a bulwark of civilization. No doubt the material handled is dangerous. For the subconscious can only be plumbed by breaking down all personal barriers; there cannot be left even the curtained impersonality of the con-fessional. The slightest misstep in the handling of this doctor-patient intimacy produces a permanent enslavement of the patient and another scar on the already hard crust of the doctor's sensitivity. Let us charitably call such physicians "martyrs to science," like those laboratory men who lose hands finger by finger working with radium. The intimacy of psycho-analysis is very much like radium, in fact, and like black magic too. It works, of course. But many a body and many a soul get burned to a crisp in the process.

Poets are always getting burned; but mostly it is only their bodies that suffer, as anybody's body does who fans his youth into a flame. They rarely get burned by poetry. For the material of poetry is words, and words by themselves can only give off light. They never give off heat unless arranged in formulas. Poets hate formulas.

This is what Parisian literary wars are mostly about. They are attacks on formulas that have become powerful within the profession. The clear-est statement of principle goes bad if it is repeated too often. It ceases to be a statement and becomes a slogan. It loses its meaning and takes on power. The literary mind considers (and rightly) that any statement which carries more power than meaning is evil. War is therefore declared on the author of the statement in point, by another author, usually on some pretext of personal prestige. As the war goes on from wisecrack to manifesto to calumny, authors get involved who don't even know the original belligerents or the incidents of provocation. Everybody calls everybody else horrid names, and a great deal of wit is unleashed. Then it all dies down and everybody makes up. But the formula, having now been subjected both to the light of reason and to all the thirty-two posi-tions of ridicule, is no longer any good to anybody. Analysis and laughter have broken its back. The Demon is foiled. Demagogy is frustrated. Poetry is thereupon vigorous again and abundant till the next time a formula starts to rear its Sacred Head.

When I speak of statements that have more power than meaning, I am not referring to hermetic poetry, obscure poetry, or ordinary nonsense. These are not meaningless matters. On the contrary, they are overfull of meaning. Some poets wish to mean so many things at once that they can only write at all by the technique of multiple meaning, the most

ancient of all poetic techniques, and newly come again to favor through the prestige of the physical sciences, which have made spectacular advance in our century by means of the dissociationist discipline. There is non-Aristotelian poetry just as there is non-Euclidian geometry. You cannot subject poetry to the conventions of common sense. Not, at least, if you want it to mean anything more than journalism does. There is that kind of verse, of course, too; and it sells extremely well; but it is journalistic verse for vulgar usage, fake folklore. I might cite Kipling, Edgar Guest, R. W. Service, and E. A. Robinson as successful practitioners of it. It bears the same relation to poetry that *Mighty Lak' a Rose* does to music. Nobody in the profession takes it any more seriously than that. William Blake, Mallarmé, Gertrude Stein, and Lewis Carroll, on the other hand, however hermetic, however obscure or seemingly nonsensical, are taken very seriously indeed by the profession. They are taken as a bitter pill by many, but they are taken to heart by everybody, however little any given poet may enjoy their competition. Even the plain public knows them for original masters.

There is no way out of the poet's plight. The best he can do for the present is to write poetry as if nobody were listening (a supposition not far from the truth) and to occupy the rest of the day as best he can. Earning money by writing poetry is out of the question, unless he can adapt himself to the theater, which is not easy for him to do. The real difficulty about writing poetry is filling up the other twenty-three and a half hours a day. For, compared with the laboriousness of music writing and oil painting, there is very little real work involved in poetical composition. Lengthy reflection is involved and mental discipline and the nervous intensity of occasional concentration. But none of these takes time out of a man's life. The mind prepares itself in secret, underneath life's surface occupations. Putting down the result on paper is no job at all compared to the stroke-by-stroke improvisation of an oil painting or the note-by-note inditing of a musical score.

If the poet works at a regular job, he hasn't got enough time to shake around and keep his ideas in solution. He crystallizes. If he doesn't work at a regular job, he has too much leisure to spend and no money. He gets into debt and bad health, eats on his own soul. It is very much too bad that his working life includes so little of sedative routine.

I have mentioned the theater as a possible outlet for poetry and as a source of financial intake for the poet. For fifty years the poets and theater people have been flirting with one another. In the great times of poetry they did more than that, of course; but even still some poet every now and then writes a playable play in verse. In our own day e. e. cummings, T. S. Eliot, W. H. Auden, and Bertolt Brecht have held the attention of theater audiences that did not consist merely of other poets. On the whole, however, your modern poet conceives his art as a solo per-

formance. He despises interpreters and relinquishes with great reluctance the splendid isolation of print. Also, theater people themselves, although less devoted than poets imagine to the naturalistic style, are nevertheless a bit suspicious of the modern poet's hermetism. The poet, of course, is suspicious of everything that has to do with money-making. (Poor child, he has rarely made any since Tennyson.) Also, his confirmed egocentricity makes it difficult for him to render character objectively, which it is necessary for him to do if the poetic theater is to be anything more than a morality play or a cerebral revue.

The musical theater, the opera, he approaches with more good will than he does the spoken theater, though he is not too happy even there about sharing honors with a composer. I realize that the composer usually steals the show, sometimes deliberately; but it is still not certain that a loyal collaboration with composers and singers would always leave the poet in second place. It most certainly would not if the art of intoned heroic declamation ever got revived. Such a revival would be necessary if tragedy were to become popular again in our ultramusical age. And the rebirth of a popular taste for tragedy is not at all inconceivable in a world where moral elegance, economic determinism, and personal defeat are about the only aspects under which the interplay between character and social forces can be described convincingly.

Let me sum up by repeating. That music is an island, like Ceylon or Tahiti, or perhaps even more like England, which Bossuet called "the most famous island in the world." That the waters around it are teeming with digestible fish that travel in schools and are known as painters. That swimming around among these at high speed and spouting as they go are prehistoric monsters called poets, who terrify all living things, fish and islanders alike. That these monsters are quite tame, however, in spite of their furious airs, and that since they have no industrial value just now, and since their presence offers no real danger to musical life or to the fishing industry (for they attack only one another), they are allowed to survive and are occasionally given food. Indeed, their evolutions offer a spectacle that is considered by the islanders to be not only picturesque but salutary, instructive, and grand.

❧ Life Among the Natives
or Musical Habits and Customs

MUSICAL SOCIETY consists of musicians who compose and musicians who do not. Those who do not are called "musical artists," "interpreters," "executants," or merely "musicians." Those who do compose have all been executants at one time or another. One only learns to create performable works of music by first learning to perform. The longevity of musical works, however, is dependent on their being performable by executants other than the composer. This particular relation between design and execution is peculiar to music.

There is no such thing today as a serious painter who doesn't execute his own canvases. In the great days of Italian painting there was a tradition of workmanship that envisaged and even required the use of apprentice help. Veronese, for example, was a factory of which the large-scale execution and quantity production were only made possible, at that level of excellence, by the existence of such a tradition. The movie studios today produce as they do by means of a not dissimilar organization. Such formulas of collaboration are indispensable whenever a laborious art has to meet a heavy public demand. Even still the "mural" painters use assistants. But without an apprentice system of education, it is not possible to train assistants in a brush technique similar to the master's, or to depend on them for quick comprehension of his wishes. Hence the cooperation is not very efficient, and little important work can be delegated. Art painting is really a one-man job today.

Poetry too is nowadays a one-man job. It neither derives from declamatory execution nor contemplates its necessity. Poets don't begin life as actors or elocutionists, and certainly actors and elocutionists do not commonly or normally take up poetic composition. Poetry, like prose writing, is not even recited at all for the most part. It is merely printed. Such reading of it as still goes on takes place privately, silently, in the breast;

and although many efforts have been made to reinvigorate the art by bringing it out of the library and back to the stage and to the barrelhouse (there is also a certain market for *viva voce* "readings" at women's clubs and on the radio and for recordings of the poet's voice), on the whole your enlightened poetry fancier still prefers his poetry in a book. There are advantages and disadvantages in the situation, but discussion of them would be academic. The facts are the facts. And one of the cardinal facts about the poetic art today is that declamation is not essential to it.

Music is different from both poetry and painting in this respect. A musical manuscript is not music in the way that a written poem is poetry. It is merely a project for execution. It can correctly be said to consist of "notes" and to require "interpretation." It has about the same relation to real music that an architect's plan has to a real building. It is not a finished product. Auditive execution is the only possible test of its value.

Architects seem to get on perfectly well without having to pass their youth in the building trades. The successful composers of the past (and of the present) have all been musical artists, frequently virtuosos. The celebrated exceptions of Berlioz and Wagner are not exceptions at all. Because Berlioz was master of the difficult Spanish guitar, and Wagner was a thoroughly trained conductor. (He could also play the piano well enough to compose quite difficult music at it, though not well enough to perform that music effectively after it was written.) Conducting, as we know it, was at least half his invention (Mendelssohn was partly responsible too), and he wrote the first treatise on the subject. He was one of the most competent executants of his century, unbeatable in an opera pit.

A further special fact about music writing is that it is not only a matter of planning for execution but also of planning for execution by another, practically any other, musician. It may not be better so, but it is so. Interesting and authoritative as the composer's "interpretation" of his own work always is, necessary as it is frequently for the composer, in order to avoid misreading of his intentions, to perform or conduct his own piece the first time or two it is played in public, still a work has no real life of its own till it has been conducted or performed by persons other than the composer. Only in that collaborative form is it ripe, and ready to be assimilated by the whole body of music consumers. A musical page must be translated into sound and, yes, interpreted, before it is much good to anybody.

At this point criticism enters. It used to amuse me in Spain that it should take three children to play bullfight. One plays bull and another plays torero, while the third stands on the sidelines and cries "olé!" Music is like that. It takes three people to make music properly: one man to write it, another to play it, and a third to criticize it. Anything else is just a rehearsal.

The third man, if he plays his role adequately, must analyze the audition into its two main components. He must separate in his own mind the personal charm or brilliance of the executant from the composer's material and construction. This separation is a critical act, and it is necessary to the comprehension of any collaborative art work.

Criticism of the solitary arts is possible but never necessary. In the collaborative arts it is part of the assimilation process. It is not surprising, therefore, that the criticism of music and of the theater should be vigorously practiced in the daily press and widely read, and that architectural criticism, which occupies whole magazines to itself, should be exercised by reputable scholars as well as by the most celebrated architects of our time, whereas the daily reporting of painting shows turns out to be almost nothing but merchants' blurbs and museum advertising. Poetry-reviewing, on account of poetry's small public, is pretty well limited to the advance-guard literary magazines. When verse is covered by the daily and weekly press, the reviewing of it is done by definitely minor poets, who fill up their columns with logrolling.

The separateness of design and execution in the collaborative arts is not necessarily to the esthetic disadvantage of these, as the poets like to pretend. It is, on the whole, rather an advantage, I think; but we shall speak of that another time. Music's particular version of that duality, in any case, is what makes composers the kind of men they are. The necessity of being a good executant in order to compose effectively makes their education long and expensive. Of all the professional trainings, music is the most demanding. Even medicine, law, and scholarship, though they often delay a man's entry into married life, do not interfere with his childhood or adolescence.

Music does. No musician ever passes an average or normal infancy, with all that that means of abundant physical exercise and a certain mental passivity. He must work very hard indeed to learn his musical matters and to train his hand, all in addition to his schoolwork and his play life. I do not think he is necessarily overworked. I think rather that he is just more elaborately educated than his neighbors. But he does have a different life from theirs, an extra life; and he grows up, as I mentioned some time back, to feel different from them on account of it. Sending music students to special public schools like New York's High School of Music and Art or the European municipal conservatories, where musical training is complemented by general studies, does not diminish the amount of real work to be got through. It merely trains the musician a little more harmoniously and keeps him from feeling inferior to his little friends because of his musical interests. In any case, musical training is long, elaborate, difficult, and intense. Nobody who has had it ever regrets it or forgets it. And it builds up in the heart of every musician a

conviction that those who have had it are not only different from every-body else but definitely superior to most and that all musicians together somehow form an idealistic society in the midst of a tawdry world.

For all this idealism and feeling of superiority, there is nevertheless a rift in the society. The executant and the composer are mutually jealous.

The executant musician is a craftsman. His life consists of keeping his hand in, and caring for his tools. His relation to the composer is that of any skilled workman in industry to the engineer whose designs he exe-cutes. He often makes more money than the composer, and he refuses to be treated as a servant. He is a hard-working man who practices, per-forms, gives lessons, and travels. He not infrequently possesses literary cultivation. He is impressed by composers but handles them firmly and tries to understand their work. His secret ambition is to achieve enough leisure to indulge in musical composition himself. Failing that, to become an orchestral conductor. He doesn't mind teaching but on the whole pre-fers to play. He doesn't become a confirmed pedagogue except under eco-nomic pressure, when he can't earn a living by execution. He enjoys excellent health, can't afford to waste time being ill, in fact, and often lives to an advanced age. He pretends to a certain bohemianism, is really a petty bourgeois. His professional solidarity is complete. His trade unions are terrifyingly powerful and not unenlightened. Economically, humanly, and politically the workman he most resembles is the printer.

The composer is a transmuted executant. He practices execution as little as possible, but he hasn't forgotten a thing. It is his business to know everything there is to know about executants, because he is de-pendent on them for the execution of his work. Executants, being embar-rassed by the composer's broader knowledge, try to avoid the composer. Composers, on the other hand, fearing to be cut off from communication with the executant world, are always running after executants and pay-ing them compliments and begging to be allowed to play chamber music with them, in the hope of picking up some practical hints about instru-mental technique. On the whole, composers and their interpreters get on politely but not too well. Composers find executants mean, vain, and petty. Executants find composers vain, petty, and mean. I suspect the executant's potential income level, which is much higher than the com-poser's, is at the bottom of all this high-hatting.

Composers by themselves don't get on too badly either, but they don't like one another really. They are jovial, witty, backbiting. When young they keep up a courteous familiarity with one another's works. After thirty they preserve an equally courteous ignorance of one another's works. Their professional solidarity is nil. Even in the well-organized and very effective European societies for the collection of performing-rights fees, they are likely to let a few semi-racketeers do the work. They grumble no end about how they are robbed by managers, by performers,

and by their own protective associations; but they don't do anything to change matters. Politely gregarious but really very little interested in one another, they are without any of that huddling tendency that poets have, without the simple camaraderie of the painters, and with none of that solid fraternalism that is so impressive among the musical executants. [Enormous advances in composer solidarity, noted elsewhere in this book, have taken place since 1940.]

The island of music is laid out in four concentric circles:

1. The outer one defines the requirements of Minimum Musicianship. These are musical literacy and an ability to play some instrument otherwise than by ear. Singing doesn't count in the literacy test. The basic instrumental skill usually turns out to be piano-playing. There are some exceptions; but roughly speaking, our musical state can be said to consist of fourth-grade pianists.

2. The next circle includes everybody who can play any instrument properly. Call this the region of Special Skills. It is divided into pie-shaped sections, each representing an instrument. The piano has its section here just as the other instruments do, and there is a small terrain allotted to singers. The singers who have a right to inhabit the region of Special Skills are more often than not those who have had operatic experience. Although the pie-shaped sections are pretty well walled off one from another, they are open at both ends. There is free access to them from the surrounding suburbs of Minimum Musicianship, and through any of them it is possible to pass into the higher circles.

3. The third region is Orchestral Conducting. Its altitude and climate are salubrious; the good things of life abound, including high public honor. The superiority of conducting as a professional status over mere instrumental virtuosity is due to the fact that its practice requires a broader understanding of both technique and style than playing an instrument does. Its practitioners have a happy life, not only on account of the attendant honors and general prosperity, but also because it is technically the easiest specialty in all music. Residence in this region is usually limited, however, to persons who have migrated into it from the region of Special Skills. Normally there is no other access.

4. The inner circle and summit of our mountain city is Musical Composition. One does not have to go through Orchestral Conducting to get there; one can jump right over from Special Skills. It is a little difficult to get there directly from Minimum Musicianship. It is the summit of music because extended composition requires some understanding of all musical problems. Composers are the superior class in a musical society for the simple reason that they know more than anybody else does about music. This superiority is not necessarily reflected in their income level.

The opera singer is a special form of singer and a special form of mu-

sician. He is the only kind of singer, for instance, who has to know something about music, though he doesn't have to know much. He bears the prestige of a great art form and dresses handsomely for the role. His glamour in the nineteenth century was equal to that of conductors and movie stars today, and he is still not badly paid when he has work.

The way he lives is the way all other executants would like to live; his house is the type-habitation of the Musical Artist. Not plain slummy like the poet's narrow hole, or barnlike and messy like the painter's, the musical artist's house or flat can best be described, I think, as comfortable but crowded. No doubt the model is, unconsciously, a star's dressing room. It is full of professional souvenirs and objects of daily utility all mixed up together. It resembles at once a junkshop, a photographer's vestibule, a one-man museum, and a German kitchen. There is always food around. The furniture is luxurious looking but nondescript. No matter how spacious the rooms, the inhabitants are always too big for them.

Any musician has a tendency to fill up whatever room he is in, but the opera singer is especially permeating. He just naturally acts at all times as if he were singing a solo on a two-hundred-foot stage. His gestures are large and simple; and he moves about a great deal, never looking at anybody else and never addressing a word to anybody privately, but always speaking to the whole room. He has a way of remaining quiet, motionless almost, when not speaking, but alert, like a soloist between cues. He is hard-working, handsome, healthy (though somewhat hypochondriac). When hope is gone he drinks. Till then he cares for his health and is cheerful. He knows entertaining anecdotes and loves to do imitations of his colleagues. He lives embedded among scores and photographs and seldom changes his residence.

Composers, on the other hand, are always moving. A painter I know calls them "neat little men who live in hotel rooms." They are frequently unmarried; but unmarried or not, they are super-old-maids about order. [Bachelor composers, to mention only the dead, include Handel, Beethoven, Schubert, Liszt, Chopin, Brahms, Moussorgsky, Rossini, and Ravel.] The papers on their desks are arranged in exact and equidistant piles. Their clothes are hung up in closets on hangers. Their shirts and ties are out of sight, and their towels are neatly folded. There is no food around. There isn't even much music around. It is all put away on shelves or in trunks. Ink and pencil are in evidence and some very efficient rulers. It looks as if everything were ready for work.

Living in hotels and temporary lodgings, and frequently being unmarried, your composer is a great diner-out. Of all the artist-workers, he is the most consistently social. Those painters who live in touch with the world of decorating and fashion are not infrequently snobs, for all their camaraderie and democratic ways. The composer is not a snob at all. He

is simply a man of the world who dresses well, converses with some brilliance, and has charming manners. He is gracious in any house, however humble or grand; and he rarely makes love to the hostess. He eats and drinks everything but is a bit careful about alcohol, as sedentary workers have to be.

He has small illnesses often and gets over them. His diseases of a chronic nature are likely to be seated in the digestive organs. He rarely lives to a great age unless he keeps up his career as an executant. After all, the child who practices an instrument properly usually learns to live on what muscular exercise is involved in musical practice and in the ordinary errands of education. If he continues throughout his adult life some regular instrumental activity, he keeps well and lives to be old. If he gives up that minimum of muscular movement and alternates heavy eating with the introspective and sedentary practice of musical composition, he is likely to crack up in the fifties, no matter how strong his digestive system or his inherited organic constitution.

If he can survive the crack-up, he is good for another twenty years, frequently his finest and most productive. Your aged poet is rarely as vigorous a poet as your young poet. Your aged painter is tired, and his work is repetitive. The grandest monuments of musical art are not seldom the work of senescence. *Parsifal* was written when Wagner was seventy, *Falstaff* when Verdi was past eighty. Brahms published his first symphony at forty. Rameau's whole operatic career took place after fifty. Beethoven's last quartets, Bach's *Art of the Fugue*, César Franck's entire remembered repertory, were all composed by men long past their physical prime.

The composer does not have a turbulent life, even in youth, as artists are commonly supposed to. He is too busy working at his trade. He leads, I should say, the quietest of all the art-lives. Because music study takes time, music writing is laborious, and manuscript work cannot often be delegated to a secretary. In middle life your composer takes rather elaborate care of his health.

His professional prestige and social charm, moreover, can bring him opportunities for wealthy marriage. His behavior in such a marriage will be described in another chapter.

❧ How Composers Eat
or Who Does What to Whom and Who Gets Paid

IT IS NOT necessary here to go into the incomes of musical executants. They have engagements or they don't. If they don't, they take pupils. If they can't get pupils they starve. If they get tired of starving they can go on relief. Unemployed musicians of high ability and experience are shockingly numerous in America. The development of sound films and the radio has thrown thousands of them into technological unemployment. The musicians' union has a very large relief budget, however, and the WPA formerly gave musical work to many. Eventually their situation is that of all artisan wage-workers in crowded crafts. Their large numbers and their powerful union organization have made it advisable to handle the problem of large-scale indigence among them by means of a definite social policy. This policy is operated in part directly by the union itself (plus some free-lance philanthropic organizations like the Musicians' Emergency Relief Committee) and partly by the state and federal governments through unemployment insurance and Social Security.

Composers, being professional men and none too well organized either, have not yet found themselves the object of public concern. They do have, however, their little financial problems, I assure you, not the least of which is bare existence.

The poet of thirty works, whenever possible, at something not connected with literature. The composer practically always works at music, unless he can manage to get himself kept. He plays in cafés and concerts. He conducts. He writes criticism. He sings in church choirs. He reads manuscripts for music publishers. He acts as music librarian to institutions. He becomes a professor. He writes books. He lectures on the Appreciation of Music. Only occasionally does he hold down a job that is not connected with music.

A surprisingly large number of composers are men of private fortune.

Some of these have it from papa, but the number of those who have married their money is not small. The composer, in fact, is rather in demand as a husband. Boston and New England generally are noted for the high position there allotted to musicians in the social hierarchy and for the number of gifted composers who have in consequence married into beds of ease. I don't know why so many composers marry well, but they do. It is a fact. I don't suppose their sexuality is any more impressive than anybody else's, though certainly, as intellectuals go, the musician yields to none in that domain. After all, if a lady of means really wants an artistic husband, a composer is about the best bet, I imagine. Painters are notoriously unfaithful, and they don't age gracefully. They dry up and sour. Sculptors are of an incredible stupidity. Poets are either too violent or too tame, and terrifyingly expensive. Also, due to the exhausting nature of their early lives, they are likely to be impotent after forty. Pianists and singers are megalomaniacs; conductors worse. Besides, executants don't stay home enough. The composer, of all art-workers in the vineyard, has the prettiest manners and ripens the most satisfactorily. His intellectual and his amorous powers seldom give out completely before death. His musical powers not uncommonly increase. Anyway, lots of composers marry money, and a few have it already. Private fortune is a not unusual source of income for musicians. It is not as difficult for a rich man to write music as it is for him to write poetry. The class censorship is not so strict. The only trouble about wealth is that spending it takes time. The musician who runs all over town giving lessons and playing accompaniments has often just as much leisure to write music as does the ornamental husband of a well-to-do lady living in five elegant houses.

Many composers are able to live for years on gifts and doles. Include among these all prizes and private commissions. I don't suppose anybody believes nowadays that money one has earned is any more ennobling than money one hasn't. Money is money, and its lack of odor has often been remarked. Gifts sometimes have strings, of course; but so has any job its inconveniences. Equally punctured, I take it, is the superstition formerly current that struggle and poverty are good for the artist, who is a lazy man and who only works when destitute. Quite the contrary, I assure you. Composers work better and faster when they have a bit of comfort. Too much money, with its attendant obligations, is a nuisance to any busy man. But poverty, illness, hunger, and cold never did any good to anybody. And don't let anyone tell you differently.

The number of composers who live on the receipts from their compositions is very small, even in Europe, though on both of the northwestern continents that number is larger in the field of light music than it is in the domain of massive instrumentation and extended form. We owe it indeed to the composers of light music that we get paid at all for our

performing rights, since it is they who have always organized the societies for exacting such payment and furnished the funds for fighting infringers in the courts.

Royalties and performing-rights fees are to any composer a sweetly solemn thought. They are comparatively rare, however, in America, since composers, even composers of popular music, are nothing like as powerfully organized there for collecting them as the electrical and banking interests (whose shadow darkens our prospects of profit in all musical usages) are for preventing their being collected. So that when every now and then some composer actually makes enough money off his music to sleep and eat for a while, that is a gala day for the musical art. He feels like a birthday-child, of course, and fancies himself no end. Let him. His distinction carries no security. And he had better keep his hand in at performing and teaching and writing and at all the other little ways he knows of turning a not-too-dishonest penny. He had better seize on the first flush of fame too to "guest-conduct" his own works. This brings in two fees at once, one for his conducting and one for his performing rights. Invariably the composer who has enough composer-income to live on can pick up quite decent supplementary sums, as well as keep his contacts fresh, by not giving up entirely traffic in the by-products of his musical education. [Since this was written both ASCAP and BMI have developed vastly as collectors and distributors of performance rights in "serious" music. And the foundations are commissioning composers.]

I have been running on in this wandering fashion because I wanted to show how flexible is the composer's economic life and how many strings he has to his bow. Briefly, the composer's possible income sources are:

1. Non-Musical Jobs, or Earned Income from Non-Musical Sources.
2. Unearned Income from All Sources.
 a. Money from home
 x. His own
 y. His wife's
 b. Other people's money
 x. Personal patronage
 i. Impersonal subsidy
 ii. Commissions
 y. Prizes
 z. Doles
3. Other Men's Music, or Selling the By-products of His Musical Education.
 a. Execution
 b. Organizing musical performances
 c. Publishing and editing
 d. Pedagogy

 e. Lecturing
 f. Criticism and musical journalism
 g. The Appreciation Racket
 4. The Just Rewards of His Labor.
 a. Royalties
 x. From music published
 y. From gramophone recordings
 b. Performing-rights fees.

Every composer receives the money he lives on from one of these sources. Most have received money from several. I have lived on nearly all of them at one time or another.

Between the extremes of being too rich for comfort and being really poor, the amount of money composers have doesn't seem to affect them very much. Photogenic poverty and ostentatious spending are equally repugnant to their habits. The source of their money has, however, a certain effect on their work. We have noted that the composer, being a member of the Professional Classes, enjoys all the rights and is subject to the obligations of what is known as Professional Integrity. This does not mean that he enjoys complete intellectual freedom. He has that only with regard to the formal, or structural, aspects of his art. His musical material and style would seem to be a function, at any given moment, of his chief income source.

❧ Why Composers Write How

or The Economic Determinism of Musical Style

EFORE I GO on to explain how a composer's chief income source
affects his musical style, I think I had better say what is ordinarily
meant by style in music. It is not the same thing as style in literature,
for instance, which is mostly considered nowadays to be personal. The
word *style* is employed in four ways with regard to music.

Its most precise usage is a technical one. The phrases "fugal style,"
"canonic style," "modal style," and the like are all descriptions of syn-
tactic devices. They are methods of achieving coherence. More recent
devices of similar nature are the "chromatic" style, the "atonal" style,
the "dissonant tonal" style, even the "jazz" or "swing" style. These last
two refer, of course, to rhythmic texture within a given tonal syntax; but
the rhythmic texture of jazz is just as much a technical device for achiev-
ing coherence as the twelve-tone-row system of atonality is.

The ensemble of technical procedures plus personal mannerisms that
marks the work of any given composer or period of composition is also
referred to as the style of that composer or period. One can say that a
piece is written in the style of Schumann or in the style of Handel or in
the style of Debussy. Writing "in the style of" is taught at some music
schools. It is used in musical practice chiefly for the "faking" (improvisa-
tion from a figured bass) of harpsichord accompaniments to pre-nine-
teenth-century music and for the composition of Roman Catholic masses,
the "style of Palestrina" having been firmly recommended to modern com-
posers by Pope Pius X's encyclical of 1903 known as *De Motu Proprio*.

Pianistic, violinistic, vocal, and similar adjectives, when they qualify
the word *style,* indicate a manner of writing that is convenient to the
instruments so referred to, that is "grateful" to execute upon them, or
that suggests their characteristics.

The word is used sometimes also in a qualitative sense. An artist is said

to perform with "good" or "bad" style. A piece may not be said to be written in good or bad style, but if it is well written it may be said to have "style."

For the present discussion I shall try to limit the word to its first associations, to the divers syntactic devices that are available to any composer. This is the commonest usage of the word as applicable to composition. A composer's choice among these devices I shall call his stylistic orientation. It will not be necessary, I think, to employ the executional and qualitative meanings at all. It will be necessary, however, to distinguish between style and subject matter.

The subject matter of vocal music is its verbal text. The subject matter of theater music is whatever the stage directions say it is. The subject matter of an instrumental concert piece is not necessarily what the composer says it is. If he calls it *The Rustle of Spring* or *Also Sprach Zarathustra*, we can take him at his word. But if he calls it Fifth Nocturne or Symphony in F, we can never be sure. Sometimes it is an objective piece that was written to illustrate some program that he isn't telling us, and sometimes it is a depiction of nonverbalized visceral feelings. In the latter case, the subject matter is pretty hard to describe verbally. *Absolute* was the nineteenth-century term for such music. That meant that no matter how the composer wrote it or what he was thinking about, the piece could be satisfactorily enjoyed without verbal aids. The term *absolute* being now superannuated, I propose to substitute *introspective;* and I think we can apply it as *absolute* was applied, to all music that has no verbal text, no specific usage, and no evocative title.

Let us now return to the four sources of income and examine their relation to the composer's work in general and to his stylistic orientation in particular.

1. *Non-Musical Jobs,* or *Earned Income from Non-Musical Sources.* The composer who lives by non-musical work is rare; but still there are some. The chief mark of his work is its absence of professionalism. It is essentially naive. It breaks through professional categories, despises professional conventions. The familiarity with instrumental limitations and current interpretative traditions that composers have who are constantly working with the executant world is of great practical advantage in most respects. Your naive composer has no such mastery of well-known methods, no such traditional esthetic. The professional makes esthetic advance slowly, if at all, progressing step by step, in touch at all times with the music world. The naif makes up his music out of whole cloth at home. He invents his own esthetic. When his work turns out to be not unplayable technically, it often gives a useful kick to the professional tradition. The music of Modest Moussorgsky, of Erik Satie, and of Charles Ives did that very vigorously indeed.

The naifs show no common tendency in stylistic orientation. Their repertory of syntactical device is limited to what they can imitate plus what they make up for themselves. They are like children playing alone. Their subject matter is likely to be the great literary classics, their comprehension of these atavistic and profoundly racial. They put Dante to music, and Shakespeare, dialogues of Plato, the Book of Revelation. They interpret these in terms of familiar folklore, remembered classics, and street noises. They derive their melodic material from hymns and canticles, from jazz-ways and darn-fool ditties. They quote when they feel like it. They misquote if they prefer. They have none of the professional's prejudices about "noble" material or about stylistic unity. They make music the way they like it, for fun. The naifs are rare whose technique is ample enough to enable them to compete at all with Big Time. They mostly flower unknown and unheard. Those whom we do encounter are angels of refreshment and light, and their music is no small scandal. Its clarity is a shock to the professional mind. It doesn't hesitate about being lengthy or about being brief, and it neglects completely to calculate audience psychology. It is not made for audiences. As Tristan Tzara said of Dada, it is a "private bell for inexplicable needs." It is beyond mode and fashion. It is completely personal and gratuitous.

2. *Unearned Income from All Sources.*
 a. *Money from home*
 x. *His own*

The composer whose chief revenue comes from invested capital shows the following marks of his economic class:

His subject matter reflects the preoccupations of his kind. In the present age it reflects that avoidance of serious remarks that is practiced in capitalist circles today. He tends to write playful music, to seek charm at the expense of emphasis. He abounds in witty ingenuities. He is not much given nowadays to writing introspective music. Before World War I, when refined Europeans with incomes gave most of their time to introspection, both sentimental and analytic, the financially independent composer wrote a great many symphonies and reveries. Ernest Chausson and Albéric Magnard should serve to fix the prewar type for us. Francis Poulenc will do for the European postwar capitalists. In America there is John Alden Carpenter.

The stylistic orientation of the rich composer is toward the French salon school. He goes in for imagistic evocation, witty juxtapositions, imprecise melodic contours, delicacy of harmonic texture and of instrumentation, meditative sensuality, tenderness about children, evanescence, the light touch, discontinuity. Debussy is his ideal, though Debussy himself was not financially independent till after his second marriage.

y. *His wife's*

The composers who have married their incomes are not so likely to be Debussyans as they were in 1920. If they marry too young they don't get much time to write music anyway. They are put through the paces of upper-class life pretty much all day long. [Or else forced into films and TV and teaching, to prove to the family that they *can* earn money.] If they marry in middle life, their working habits are already formed. So is their stylistic orientation. Sometimes nothing changes at all, especially if there isn't too much wealth around. If there is a lot of it, class pressure is pretty strong. The composer subjected to this is likely to turn toward capitalistic proletarianism. There are two common forms of this. One is the exploitation of ornamental folklore (somebody else's folklore). The other is a cult of urban populistic theatrical jazz (jazz by evocation) and of pseudo-Viennese waltzes.

The relation of music-writing to unearned income is about like this. Unquestionably children get the best preparation for professional life in families that are well enough off to have access to good instruction. In families where there is big money around, the children are always kept so busy learning how to live like rich people that serious musical instruction is usually out of the question. The families of professional men, of schoolteachers, of civil service employees, and of shopkeepers continue to supply the bulk of talent to the artistic professions. [Skilled union labor is rising now as a favorable background for leisure and for educational access.] The musician rarely inherits from such a family enough to live on once he is grown and educated. In richer families he seldom learns much music. When he does, or when, having mastered his art in less disturbing circumstances, he insures his future income by marriage, there is nothing to prevent his achieving the highest distinction as a composer. He does, however, tend to write the kind of music I describe.

The sources of contributory income are without effect on the gentleman composer (or on any other for that matter), unless they provide what would be enough money to live on if he were not independent, and unless, of course, the professional experience entailed may give him a bias toward the piano or the violin or some other instrument. He has class bias about both subject matter and style, but he does not have any of the occupational conditionings of the musical journalist, of the pedagogue, or of the executant concert artist.

b. *Other people's money*

Let us take for granted that every professional composer has had access to adequate instruction. It is necessary to assume this, because if he hasn't by the age of twenty-five come into contact with all the chief techniques, he must count as a naive composer. The naifs, like the com-

posers of popular music, can achieve high distinction; but their music is
never influenced by the source of the money they live on. If it were, they
would not be naive. Naifs exist in all classes of society. Professional mu-
sicians are mostly bourgeois, indeed mostly petty bourgeois.

It is not certain that this is the necessary class situation of the com-
poser, as we have just seen. It is simply that the rich are mostly too busy
and the poor too poor to get educated in musical technique. Musical in-
struction is so expensive, even in slum music schools, that only the bour-
geoisie has complete access to it; and only those families who live in the
more modest economic levels of the bourgeoisie have sufficient leisure to
oversee a proper musical upbringing. This is why, although there is some
ruling-class art-music, there is no proletarian art-music at all except what
is written at the proletariat from above. The poor farmer and the moun-
taineer, the slum child and the segregated Negro, have open to them only
the simple popular ways, the folkways. They make beautiful music, very
beautiful music indeed. Jazz, swing, hoe-downs, chanties, hymn lore from
the Southern uplands, work songs, dance ditties, cowboy laments, fiddle
jigs, torch songs, blues, ballads from the barrack room and barrelhouse,
children's games, prison wails, collegiate comics, sentimental love songs,
country waltzes, mambos, sambas, Lindy hops, and the syncopated
Scotch-African spirituals — nine-tenths of all these are made up and
brought to their definitive shape by poor people. It isn't musical vigor or
inspiration that the poor lack. They have everything for making music
but access to the written tradition. Massive instrumentation and the
structural devices that make possible the writing of long pieces are the
property of the trained musician, and he comes mostly from the lower
levels of the bourgeoisie.

x. Personal patronage

Let us now tell how a composer (we have already got him educated)
gets hold of money to live on when he hasn't a rich papa or wife. It is
extraordinary the amounts of money, just plain gift money, that a com-
poser with some social charm (and they all have that) can put his fingers
on, especially in early manhood. Some go on getting it till they die.

There seem to be two formulas for giving money to composers. One is
direct subsidy. The other is the commissioning of works. The latter is
really a kind of subsidy, because the ordering of musical works is prac-
tically never an expression of a patron's or of a foundation's musical
needs. Half the time they don't even have the work performed once it is
delivered. In cases where they do, there is always an air of philanthropy
around, and a careful disclaiming of any responsibility on the patron's
part for the nature and content of the piece. The piece is usually an or-
chestral or chamber work called Symphony or Sonata or something
equally noncommittal.

i. *Impersonal subsidy*

Composers living on subsidies personal or impersonal tend to write introspective music of strained harmonic texture and emphatic instrumental style. They occasionally write very long pieces. They are not much bothered about charm, elegance, sentiment, or comprehensibility, though they are seldom deliberately hermetic. They go in for high-flown lyricism and dynamic punch, less for contrapuntal texture, unless that seems to heighten lyrical expansiveness. They are revolters against convention. At least, that is their pose. Beethoven is their ideal; and they think of themselves as prophets in a wilderness, as martyrs unappreciated, as persecuted men. Appearing to be persecuted is, of course, their way of earning their living. The minute they lose the air of being brave men downed by circumstances, they cease to get free money. Because people with money to give away don't like giving it to serene or well-adjusted characters, no matter how poor the latter may be. When a composer who has been living for some years on patronage and gifts starts earning money, there is always a noticeable change in his music. His subject matter becomes less egocentric. His musical style becomes less emphatic and a good deal easier to follow. He eventually stops overwriting the brass in his orchestral scores.

ii. *Commissions*

Composers who can pull down commissions all their lives are rare. But my theories about economic determinism do not demand that the composer live from any given source for a long time before his music begins to reflect that source. On the contrary, I maintain that composers vary their manner from piece to piece in direct conformity with their income source of the moment, the subject matter and the stylistic orientation of any musical work being largely determined by the source of the money the composer is living on while writing that piece.

Privately commissioned works, therefore, should show some kind of uniformity. Which they do. Less Beethovenesque than the works of the steadily subsidized, less violent, and less animated by personal dynamism, they lean toward an abstract style. I am not even certain that the international neoclassic style was not invented as a sort of *lingua franca* that could be addressed to any possible patron or patroness anywhere in the Western world. [The 1960 international style is similarly functional, but it is chromatic and non-tonal instead of diatonic.] During the 1920s there were just about enough available patronesses in America, France, Belgium, Germany, England, Switzerland, and Hungary, all put together, to enable a clever composer to get hold of, with luck, about one of these commissions a year. This gave him a basic income of from one to two thousand dollars.

What was the international style for commissioned works? It was a

dissonant contrapuntal manner welded out of the following hetero-
geneous elements, all chosen for their prestige value:

A. The animated contrapuntalism of J. S. Bach,
B. The unresolved dissonances of Debussy and Richard Strauss, and
C. The Berlioz tradition of instrumentation.

This is the instrumentation of Berlioz, Bizet, Saint-Saëns, Rimsky-
Korsakov, Chabrier, Debussy, Ravel, and Stravinsky. It is differential
instrumentation. Clarity and brilliance are achieved by keeping the differ-
ent instruments at all times recognizably separate. A thin and reedlike
fiddle tone is presupposed.

The rival tradition is that of Meyerbeer, Wagner, Brahms, Tchaikov-
sky, Mahler, Strauss, and Puccini. This is absorptive instrumentation.
Emotional power and tonal weight are achieved by lots of doubling at the
unison, which is to say by the building up of composite instrumental tim-
bres, all sounding somewhat alike but differing greatly in weight and
carrying power. It presupposes a husky and vibrant fiddle tone. The Ger-
man tradition is a perfectly good one, as you can see from the big names
connected with it. It has not enjoyed the same international prestige,
however, since World War I, as the Franco-Russian.

D. To these elements were added frequently a fourth, the recon-
structed or modern French sonata form — a device practiced originally
by the pupils of César Franck and expounded at Vincent d'Indy's Schola
Cantorum.

The sonata form was invented in Berlin by C. P. E. Bach; and it flow-
ered in Vienna as the favored continuity device of Haydn, Mozart, Bee-
thoven, Schubert, Schumann, Brahms, and Mahler. It was introduced into
France by Reyer in 1845, practiced and fought for by Camille Saint-
Saëns, and finally domesticated by César Franck. Since the death of
Johannes Brahms it has been very little practiced in Vienna. What is
practiced today in Paris (and internationally) is not the Viennese sonata
form at all. It is a French reconstruction for pedagogical purposes. D'Indy
is largely its inventor. It is based on certain practices of Haydn and
Beethoven. It has not yet been successfully introduced into Vienna. It
enjoys worldwide prestige, however, a prestige borrowed from that of
the Viennese masters and based on the extreme simplicity of the recon-
struction, all of which makes it just fine for the Appreciation books. The
Viennese form, when it was alive, was never very teachable, because no
two examples of it were near enough alike to make standardization pos-
sible. The good ones all seem to be exceptions to some rule, of which no-
body has ever seen a typical case in point. [Neither Haydn, Mozart, nor
Beethoven ever spoke of sonata form. The first reference to it in print
occurs, according to Paul Henry Láng, in 1828.]

The French orchestral palette presents no especial difficulties. Any good student can handle it. And the writing of animated counterpoint in the dissonant style is easy as falling off a log. The real difficulty about any contrapuntal style is length and always has been. Now the modern-music fans likes his pieces fairly long. Nothing under twenty minutes will impress him very much. And twenty minutes of wiggly counterpoint are too much (because too vague) for anybody. [This applies equally to to-day's pulverized (or one-note-at-a-time) counterpoint.] Bach had the same problem to face. Fugal construction helped him over many a bad moment. But modern audiences won't listen to fugues very long or very often. They lack punch. Sonata form, even in its rather static recon-structed version, is about the only dependable device (outside of verbal texts and literary programs) that will enable a composer to give continu-ity to a long and varied movement. [Today's involvement with canonic textures and rhythmic permutations, though inevitable to an atonal style, makes for even less variety.]

It offers free play to sustained lyricism, to stormy drama, and to em-phatic orchestration. But there are two musical styles it cannot digest very well, the animated contrapuntal and the strictly dissonant. The first is inimical to it because that kind of counterpoint, whether practiced in a Brandenburg concerto or in a jam session, being a cerebral manifesta-tion, is viscerally static. And sonata form is only good for dramatizing visceral states, which are never static, which, quite to the contrary, are constantly varying in intensity, constantly moving about over the pleasure-pain and the tranquillity-anxiety scales. Systematic dissonance is inimical to the essential virtues of sonata form for a similar reason, those virtues being all of a dramatic nature. The sonata is abstract musical theater, a dramatization of nonverbalized emotions. There is no sonata without drama, contrasts, the interplay of tensions. Systematic disso-nance, like systematic consonance, is the contrary of any such interplay. It too is viscerally static.

For the bright young composers of the world, who knew all this long ago, to have gone in as thoroughly as they did, between the years of 1920 and 1935, for such an indigestible mixture, such a cocktail of cul-ture as the international neoclassic style, leaves us no choice but to ascribe to them a strong non-musical motivation. The sharing of the available private commissions of the Western world among a smallish but well-united group of these composers I maintain to have been the motivation. That and the corollary activities of winning prizes and foun-dational awards and eventually, when all the prizes and all the possible commissions have been had, of grabbing off one of the finer teaching jobs. [The adoption after World War II of another international style (this one chromatic) and its triumph in all the European modernistic

festivals, as well as over the German publishers' cartel and over the commissioning of music by European radio establishments, make it fairly clear that I was right about the earlier one.]

In any case, all international styles are a gift to pedagogy. We shall go into that in another place, perhaps. Here just let me mention the slight but interesting differences possible within the internationalist conception.

For commissions and festivals, a long piece is indicated in dissonant contrapuntal style, neutral in emotional content and hermetic in expression. It should be a bit difficult to listen to and very difficult to comprehend, yet withal skillful enough in instrumentation that nobody could call the work incompetent. A maximum of complexity and a minimum of direct significance are the desiderata.

y. Prizes

For prize competitions the above strict formula needs a little alleviation. Sometimes the injection of a lush tune here and there will satisfy the judges of the candidate's fitness for eventually pleasing a large public. More respectable, however, is the substitution of folklore for original melodic material. Folklore, as you can easily see, adds popular charm without the loss of cultural prestige. [Today folklore is out, Indian or Japanese influence very much in.] A high dosage of dissonance proves the candidate's modernism. A bit of counterpoint will show his good will toward pedagogy. And brilliant orchestration guarantees musicianship. Prize committees, mark you, never judge musical mastery on anything but orchestration. They can't. Because counterpoint is too easy to write; anyone can do it; everything sounds well enough; no judgment of its merits is possible. And harmony is difficult to judge; the gulf is of but a hairsbreadth between superb and lousy. Melodic material, tunes, can only be judged by the way they stand up under usage. Formalized construction is not one of the essential elements of music, but that too can only be judged from usage. Instrumentation is the one element of musical composition that is capable of being judged objectively today, because it is the one element that is taught, learned, and practiced according to a tradition that has been unbroken for a hundred years, and that is accepted intact, especially the French version of it, by all educated musicians.

The international-style music world used to be a well-organized going concern, with its own magazines, its "contemporary music" societies, its subsidies, its conspiracies, and its festivals. Of late years business has not been so good. Private commissions are scarce, institutional funds diminished, the societies defunct or moribund, the public fed up. The high-pressure salesmanship that forced into the big orchestral concerts (by pretending that an international movement should be supported on nationalistic grounds) music that was never intended for anything but

prize-winning and the impressing of other musicians, has given a black eye to all music written since 1918. The general music public and the trustee class have both revolted. The conductors have seized the occasion to pull the cover over to their side of the bed, thus leaving quite out in the cold the problem of contemporary composition in large form (which presupposes as an essential factor in the equation the presence of a large general public). I know there still appear new pieces periodically on the orchestral programs, though less frequently than before 1932, the year in which the trustees of the Philadelphia Symphony Society formally warned Leopold Stokowski to lay off modern music. Everywhere the preceding decade's chief offender (the international style) is taboo. Boston is an exception in this, because one of the movement's chief ornaments, Walter Piston, is head of the Department of Music at Harvard; and his works must of course be performed. The new pieces most orchestras play nowadays are in the vein of prewar post-Romanticism. They are chiefly by schoolteachers and children just out of the conservatories. They are often tuneful and pleasing. They seldom get a second performance, however, even when the first goes over big, as it does not infrequently. I don't think the conductors quite want any composer to have a steady public success. They consider success their domain. And their success depends on keeping orchestral performance a luxury product, a miraculously smooth, fabulously expensive, and quite unnecessary frame for sure-fire classics.

[This paragraph describes the end of the Depression decade. In 1960, at the end of a boom decade, an internationally subsidized contemporary-music combine is prospering again, with trustees and general public again resisting it.]

z. *Doles*

A special category of patronage is the government dole. When home relief is a composer's chief source of income, he isn't likely to write music at all. Life is too difficult, too desolate. When, as in Europe, it is less than minimum sustenance, he tends to become proletarian class conscious, to tie up with a Marxian party (usually the Communist), and to produce angry music of exaggerated simplicity and a certain deliberate vulgarity.

The WPA, America's work-relief organization, never had a Composers' Project. A number of composers were engaged, however, to write music for theatrical productions; and quite a few more were placed on the regular Music Project as executants. The WPA theater people did quite well by music. They showed as good taste in their choice of composers as they did in their choice of plays and directors. The Federal Theater was for the years 1935 and 1936 the most vigorous new art movement in the whole West. The music written for its productions varied greatly in style and subject matter, as all music must that is ordered with a specific art

purpose in view. The composers who wrote music for the Federal Theater are not classifiable as dole subjects or charity cases. They were earning their living by musical composition, and their music bears all the marks of music that has paid its way.

[Today, in 1960, there is no work relief, only temporary unemployment insurance. Commissions designed, however, for a specific sort of performance (and paying for that performance), such as the Ford Foundation's orchestra and opera commissions, are not dissimilar to work relief, though they are aimed less at helping composers than at creating repertory.]

3. *Other Men's Music, or Selling the By-products of His Musical Education.*

a. *Execution*

People who earn their bread by playing the piano or playing the organ or playing the violin or conducting, by musical interpretation in short, are the most timid of all when they start writing music. They have only one idea in their heads and that is to write "gratefully" for the instrument in question. They often succeed in doing so. Their subject matter is likely to be pale, wan, and derivative.

This was not always so. Exploring the musical possibilities of any new instrument or medium is a job for persons who play that instrument. The history of violin composition in the seventeenth century, of writing for the harpsichord and for the organ clear up to the death of J. S. Bach, of piano music in the nineteenth century, of jazz music in our own, is the history of performing virtuosos who composed. From the time of Corelli and Domenico Scarlatti to Chopin and Franz Liszt, all the solo instruments were the springboards of musical art; and many of the greatest masters of musical composition earned their living by instrumental virtuosity, even by the interpretation of other men's work. Richard Wagner was about the last of the great interpreter-composers in the nonpopular tradition. [Strauss and Mahler were also conductor-composers. Today we have Manuel Rosenthal, Leonard Bernstein, Juan José Castro, and Carlos Chávez.]

Today all composers can play an instrument still, and most can conduct if they have to, but they avoid doing either steadily. Instrumental virtuosity and the interpretation of "classical" music have both reached the point of diminishing artistic returns to the composer. The expansion of techniques has so slowed down that regular practice is no longer a source of constant revelation to him. Rather it stupefies his imagination and limits his musical horizon.

This is not true in the jazz world, where technique is still expanding. Duke Ellington has been a number-one jazz pianist and a number-one jazz composer. But the music of Ignaz Paderewski, of Ferruccio Busoni,

of Charles-Marie Widor, and of Fritz Kreisler (even including his clever fakings of early violin writers) cannot possibly be considered to be anything like so high-class as their instrumental performances were.

A bit of concert work is good for composers in their youth. The organ and the kettledrums seem to be especially useful for amplifying the musical conceptions of people brought up on the pianoforte or the violin. The first introduces them to quantitative meter. The second sharpens their sense of pitch. Both are invaluable trainings in rhythmic exactitude and in notation.

b. and c. *Organizing, publishing, and editing*

The organizing of concerts and the publishing business are both bad for composition. They are businesses, not crafts. They contribute nothing to a composer's musical experience. The composers who get involved with them write music less and less. Arranging and editing are all right. The trouble with them is that they don't pay enough. It is rare that a composer can exist on their proceeds for any length of time. They are best done by performers and conductors as a sideline.

d. *Pedagogy*

I sometimes think the worst mischief a composer can get into is teaching. I mean as a main source of income. As a supplementary source a little of it doesn't hurt, is rather good, in fact, for clarifying the mind. A little criticism or musical journalism is good too. A lot of either is not so good, because they both get you worried about other men's music. Whenever the by-products of his musical education become for any length of time the main source of a composer's income, occupational diseases and deformities set in.

As everybody knows, schoolteachers tend to be bossy, pompous, vain, opinionated, and hard-boiled. This is merely their front, their advertising. Inside they are timid and overscrupulous. Their music, in consequence, comes out looking obscure and complex. Its subject matter, on the other hand, and its musical material are likely to be oversubtle and dilute. When we say nowadays that a work is "academic" we mean all this and more. We mean that the means employed are elaborate out of all proportion to the end achieved.

When I speak of pedagogues I mean teachers who live by their teaching, whether they teach privately or in institutions. All teachers who live by teaching are alike. The holders of sinecure posts are an exception. The director of any French conservatory, for instance, is always an elderly composer of distinction. He is not expected to do anything but an overseer's job, to protect, from the vantage point of his years and experience, the preservation intact, with all necessary renewals, of whatever tradition of musical instruction that institution represents. He is not expected to bother with administrative detail or to drum up trade for his institution

or to have anything whatsoever to do with trustees. He may dine occasionally with the Minister of Public Instruction and the Secretary for Fine Arts. An hour a day will cover all his duties. His job lasts till he dies, short of public moral turpitude on his part. A smaller sinecure sometimes available to young composers is the librarianship of a conservatory. The rarity of sinecures in the United States is one half the trouble with music-teaching. Save for the occasional composer-in-residence who teaches part time, almost any young person's college job ends by taking about fifty hours a week to accomplish and to keep. The other half is what is the matter with music-teaching anywhere, with living off any of what I have called the by-products of a musical education. It is the constant association with dead men's music that they entail. Only in vacation time, if there is money left to take a vacation, does the schoolteacher get a chance to forget all that, to put the classics out of reach at the bottom of his mind, well out of the way of the creative act. Daily dealing with the music of the past is probably all right after fifty. It never fails to produce in a younger man a derivative manner of writing that no amount of surface complexity can conceal.

Teachers tend to form opinions about music, and these are always getting in the way of creation. The teacher, like the parent, must always have an answer for everything. If he doesn't he loses prestige. He must make up a story about music and stick to it. Nothing is more sterilizing. Because no one can make any statement three times without starting to believe it himself. One ends by being full of definite ideas about music; and one's mind, which for creative purposes should remain as vague and unprejudiced as possible, is corseted with opinions and *partis pris*. Not the least dangerous of these *partis pris* is the assumption that since the finest examples of musical skill and stylization from the past (the socalled classics) are the best models to expose before the young, they are necessarily the best models for a mature composer to follow in his work. This is very nearly the opposite of the real truth. As Juan Gris used to say about painting, "The way to become a classic is by not resembling the classics in any way."

When I speak of teaching, I mean teaching for money; and I deplore it, for composers, as a habit-forming vice. I would not wish, however, that the young composer be denied access to professional counsel. He is, in fact, not denied it. Professional composers are only too delighted to read over the works of the young and to give advice where needed. They enjoy the homage implied; they like the chance to steal a good trick; they like seeing their own tricks stolen and advertised. All this can take place without any exchange of money. It is free graduate instruction. Elementary instruction (which is a bore to give) must always be paid for, and usually the student gets his best money's worth from regular pedagogues who are not composers.

Allow me, please, at this point to digress a little further on the subject of how people learn to write music. You never learn anything technical except from somebody who possesses technique. You can only learn singing from someone who has sung, piano-playing from a reasonably competent pianist, conducting from a conductor; and you can only acquire so much of these techniques as the instructor himself has mastered. There are, however, elementary subjects which are so conventional that their mastery requires no personalized skill and implies no higher achievement. It is not necessary, for example, or even very desirable to try to learn grammar from a poet. Any schoolteacher is better, can show you better how to parse, decline, and diagram according to accepted convention. So with solfeggio, counterpoint, fugue. They are stylized drills, not living skills. Harmony is the difficult branch to learn, because it is neither really stylized nor really free. I doubt if anybody can teach it satisfactorily; but even still a routine pedagogue is usually quicker and more effective about it than a composer is. Orchestration is different. It can only be learned from a composer or from a professional orchestrator. The subject is a completely practical one and requires a practical man. All the textbooks are by practical men like Berlioz and Strauss and Rimsky-Korsakov and Widor. Musical form is also a practical matter. It is scarcely a subject at all and can only be advised about after the fact. There is no textbook on the subject.

How then can musical education be organized so that the instructor's as well as the student's interest may be respected? Singing and playing must be taught, as they are now, by singers and players or by ex-singers and ex-players. The elements of musical theory (that is to say harmony, counterpoint, fugue, and musical analysis) should be taught, as they are not always now, by trained seals, which is to say by persons especially prepared for that drillwork, by pure pedagogues. Instrumentation must be taught by composers; there is no way around it. But since the composer is not much benefited musically by teaching, some arrangement must be reached that will serve his interests as well as the student's. One of the best is to use as professors of instrumentation only men over fifty. These can teach an hour a day something they know without getting vicious about it. Also, the whole system of musical instruction must be coordinated and watched over by a composer, an elderly one preferably, and one for whom the job is either a sinecure or else a quite negligible source of income. It should never be full-time work.

As for the actual composition of music in the early stages of a student's career, he had better keep that as separate as possible from his life as a student. Let him show his efforts to other composers, to friends, to anybody but to his professors. Unless the teacher in question is or has been, just a little bit, a successful composer, the student will only get discouragement out of him.

e. and f. *Lecturing, criticism, and musical journalism*

Turning an odd penny here and there by lecturing doesn't count. Earning one's bread by lecturing does. But lecturing is not a trade in itself; it is always something else. Either it is teaching, or it is criticism, or it is the Appreciation racket, or it is musical interpretation. Sometimes it is all four. I mention it separately, merely because it is a common way of earning money.

Criticism and musical journalism are also frequent sources of contributive income to composers. They seldom provide a full living. The only kind of written musical criticism that really feeds its writer is a permanent post on a metropolitan daily. Musical composition seems to be quite impossible to combine with such a full-time job. [I managed it, all the same, as music critic of the *New York Herald Tribune* from 1940 to 1954.] In any case, these "major" critics never seem to write much music, not the way drama critics write plays. Writing occasional articles, however, is an inveterate habit of composers. The profession is incurably literate. Such writing is interesting to the musical public because it is both authoritative and passionately prejudiced. It is interesting to the composer because he can use it to logroll for his friends and to pay off old scores against his enemies, as well as to clarify for himself periodically his own esthetic prejudices. Also, the attendance at concerts that writing criticism entails keeps him informed of current trends. Left to himself, he rather tends to avoid hearing music, to insulate himself against currents and to fecundate in a vacuum. Now a vacuum is not a very good place to fecundate in; at least it is not a good place to cook up collaborative art. Daily intercourse with other men's music deforms any composer's work in the direction of a timid traditionalism. Such is the music of the schoolteachers, the choir masters, the touring virtuosos, and the conductors. But ignorance of what is going on in the world of music is even more deforming. One doesn't so much need to know what the other composers are up to as one needs to know what the interpreters are up to. One needs to keep in touch with what happens when scores get made audible.

Painters can fecundate in a vacuum if they really have to; the naive painters are numerous. Poetry too can flourish far from the madding crowd and often does, going off periodically into retirement being quite a habit of poets. Think too of all the excellent lyrical verse that gets written year after year by private persons. Music, even naive music, has always been written in or near the great centers of musical activity. The isolated composer, like the isolated surgeon or architect, is a rare animal.

As I said before, contributive sources of income seldom influence a composer's stylistic orientation. Only a full support can do that. Their chief influence is technical. Just as a little teaching is good for any musical executant, and a little musical execution for any composer, a little criti-

cism is a valuable experience too for any musician. It teaches him about audiences. Nobody who has ever tried to explain in writing why some piece got a cold reception that he thought merited better, or why some musical marshmallow wowed them all, has ever failed to rise from his desk a wiser man. And the composer who has written criticism with some regularity — who has faced frequently the deplorable reality that a desired audience effect cannot be produced by wishful thinking — inevitably, unconsciously, in spite of his most disdainful intentions, cannot help learning a good deal that is practical to know about clarity, coherence, and emphasis.

Composers' criticism is useful to the layman also. As I have said before, the function of criticism is to aid the public in digesting musical works. Not for nothing is it so often compared to bile. The first process in that digestion is the breaking-up of any musical performance into its constituent elements, design and execution. In this analytic process, the composer is of the highest utility. All musicians can judge the skill of a musical execution, because all musicians are executants. (The practice of publishing musical criticism written by musical illiterates is disappearing from even the provincial press.) But if the critic is only an executant and has never practiced musical creation, his interest is held far more by the refinements of execution than by the nature of the music itself. Inevitably he tends to glorify the executant (with whom he identifies himself) and to neglect or to take for granted the piece played. Because of the fact that performers advertise and composers don't, the criticism of composition in the musical trade weeklies is a complimentary gesture only and is extremely limited in space. Even the daily press, for all its official good will toward novelty, cannot get around the fact that the work of prosperous persons like conductors, opera-singers, and touring virtuosos has more "news value" than the work of composers, most of whom don't even make a living from their work. So that inevitably most musical criticism is written from the performer's point of view.

The composer-critic identifies himself imaginatively with the author of any work he hears. He knows exactly (or has a pretty good idea) when the composer and the interpreter are in the groove and when they are getting in each other's hair. He is likely to be a shade indifferent about execution, unless the latter is quite out of keeping with the style of the work executed. Nevertheless, he does know about execution, in addition to knowing about design; and he can explain to others wherein their pleasure or displeasure is due to the design and wherein to execution and where to a marriage of the two.

The criticism of poetry is written nowadays almost exclusively by poets for other poets to read. It is highly technical and bitterly controversial. The layman scarcely ever sees it. It has nothing to do with any absorptive process among the reading public, because there isn't any

reading public for poetry. The criticism of painting is written by collectors, museum directors, and dealers' hired men. Since a painting is a piece of property and hence always belongs to somebody, any criticism written by the person it belongs to or by anybody connected with him or by anybody who has a rival picture or kind of picture to sell or who makes his living by showing pictures or by advising buyers is about as interesting as musical criticism would be if it were written by the manager of the New York Philharmonic. Painters writing about one another, when they don't go overfulsome, can be pretty nasty; they often lack even that commercial courtesy that dealers' representatives preserve toward one another. Prefaces to the catalogues of dealers' shows and many of their reviews are blurbs by unemployed poets; they are not even openly paid advertising. The writing of art history (which is criticism too, of course) is more reliable. At least it is when it is written by scholars with a steady job and no dealer or museum connections. On the whole, there is no disinterested criticism of contemporary painting and not very much of poetry. There is only blurb and bitterness.

Music, theater, and architecture have a copious literature of contemporary criticism, because they have, to begin with, a public, and because that public is essentially disinterested. It doesn't own works of music or plays; and works of architecture, though they are real property, are not often owned by the persons who use them. The dominating role in this copious literature of criticism is played by the composers, the dramatic authors, and the architects themselves. Dancing and the movies also have a good public, and lots of criticism of them gets published. Most of it, unfortunately, is either trivial or venal, because choreographers and cinema directors, the only people who know anything about design in their respective arts, have so far mostly kept out of it.

No art in its first expansive period needs criticism anyway. There isn't time to bother with anything but creation and distribution. With further expansion of the movie trades momentarily arrested by international trade wars, by financial crises, and by the menace of television, a certain amount of soul-searching does go on in the movie world; and a few historical books have been written. It is quite certain that if the movies continue to function as an entertainment form we shall see an increasing amount of critical writing about them from persons experienced in their making. [Ditto for television.]

g. *The Appreciation Racket*

Every composer is approached from time to time by representatives of the Appreciation Racket and offered money to lecture or to write books about the Appreciation of Music. Unless he is already tied up with the pedagogical world, he usually refuses. If he makes his living as a teacher,

refusal is difficult. I've seen many a private teacher forced out of business for refusing to "cooperate" with the publishers of Appreciation books. Refusal of public-school credits for private music study is the usual method of foreclosure. The composer who teaches in any educational institution except a straight conservatory is usually obliged to "cooperate." The racket muscles in on him. His name will be useful; his professional prestige will give a coloration of respectability to the shady business. He is offered a raise and some security in his job. He usually accepts.

Every branch of knowledge furnishes periodically to the layman digests of useful information about that branch of knowledge and elementary handbooks of its technique. Simplified explanations of the copyright laws, of general medicine for use in the home, of the mathematics of relativity, of how to build a canoe, a radio set, or a glider, of home dressmaking, of garden lore, of how to acquaint yourself with classical archaeology in ten volumes, and of how to see Paris in ten days — this literature is in every way legitimate. Some of the most advanced practitioners in every branch of knowledge have at one time or another paused to write down in nontechnical language what was going on in their branches. The artistic professions have a large literature of this sort, the present book being an example. Biographies of celebrated musicians, histories of the symphony orchestra with descriptions of the commoner instruments, synopses of opera plots, memoirs of singers and their managers, even of musical hostesses, all go to swell the general knowledge about music and how it lives. Works of a scholarly or pedagogical nature, like treatises on harmony, on acoustics, on instrumentation, or bibliographies of historical documents, need no justification at all. They are instruments for the direct transmission of professional knowledge.

What needs some explaining is the Appreciation literature, which transmits no firm knowledge and describes no real practice. The thing nearest to it is the physical culture advertisement that proposes to augment the muscular and virile forces of any customer who will buy the book and do what it says for five minutes a day. Obviously, five minutes a day of gymnastics, any kind of gymnastics, with or without a book, will inside a week produce a temporary enlargement of the muscles exercised. Equally, the deliberate listening to music, any kind of music, five minutes a day for a week will sharpen momentarily the musical listening ability. If the Appreciation Racket were no more than a pretext for habituating listeners to musical sounds, it would be legitimate advertising, destined, with luck, to swell the number of possible concert customers.

What distinguishes it from the physical culture schemes is the number of reputable musicians, philanthropic foundations, and institutions of learning connected with it and the large amounts of finance capital behind

it. So much money and so much respectability behind a business that hasn't very much intrinsically to recommend it is, to say the least, suspect.

When I say the books of Music Appreciation transmit no firm knowledge and describe no real practice, you will either believe me or you won't. I have no intention of exposing in detail here the operating methods of that sinister conspiracy or of attacking by name the distinguished musicians who have signed its instruments of propaganda. If you are a musician, all I need say is, just take a look at the books. If you are not, avoid them as you would the appearance of evil.

It is as difficult for the layman to avoid contact with Music Appreciation as it is for the musician. Children in elementary schools get it handed out to them along with their sight-singing. So far as it is just a substitution of European folklore for American folklore and made-up exercises, not much real harm is done. At least, not as long as the center of attention remains instruction in sight-singing rather than the tastefulness of the pieces sung. It is in the secondary schools, with the introduction into education of mere listening, that is to say, of a passive musical experience, to replace performance, which is an active experience, that Appreciation begins to rear its ugly head. In secondary schools, especially in those where instruction is accomplished according to the pedagogic devices known as Progressive Education, passivity seems to be the chief result sought. A proper, that is to say, an enthusiastic, receptivity to canned musical performance is highly prized by "progressive" educators.

In colleges the Appreciation of Music is a snap course, and as such it fills a need for many a busy (or lazy) student. As anything else it is hard to defend. For professional music students it is confusing, because the explanations are esthetic rather than technical; and esthetics are a dangerous waste of time for young practical musicians. What they need is musical analysis and lots of execution. For nonprofessional students also it is a waste of time that might be spent on musical practice. The layman's courses for adults in ordinary civil life are an abbreviated version of the collegiate Appreciation courses. They offer nothing more (technically) than could be learned in one music lesson from any good private teacher. The rest is a lot of useless and highly inaccurate talk about fugues and sonata form, sales talk for canned music really.

The basic sales trick in all these manifestations is the use of the religious technique. Music is neither taught nor defined. It is preached. A certain limited repertory of pieces, ninety percent of them a hundred years old, is assumed to contain most that the world has to offer of musical beauty and authority. I shall explain in a moment how this repertory is chosen by persons unknown, some of them having no musical authority whatsoever. It is further assumed (on Platonic authority) that continued auditive subjection to this repertory harmonizes the mind and

sweetens the character, and that the conscious paying of attention during the auditive process intensifies the favorable reaction. Every one of these assumptions is false, or at least highly disputable, including the Platonic one. The religious technique consists in a refusal to allow any questioning of any of them. Every psychological device is used to make the customer feel that musical nonconsumption is sinful. As penance for his sins he must:

A. Buy a book.
B. Buy a gramophone.
C. Buy records for it.
D. Buy a radio.
E. Subscribe to the local orchestra, if there is one.

As you can see, not one of these actions is a musical action. They are at best therapeutic actions destined to correct the customer's musical defects without putting him through the labors of musical exercise. As you can also see, they entail spending a good deal more money than a moderate amount of musical exercise would entail. Persons whose viscera are not audiosensitive need very little musical exercise anyway. To make them feel inferior for not needing it and then to supply them with musical massage as a substitute for what they don't need is, although a common enough commercial practice, professionally unethical.

If you will look at almost any of the Appreciation books you will notice:

A. That the music discussed is nearly all symphonic. Chamber music (except string quartets) and the opera are equally neglected.

B. That the examples quoted are virtually the same in all the books.

C. That they are quoted from a small number of musical authors.

D. That ninety percent of them were written between 1775 and 1875 and are called Symphony Number Something-or-Other.

All this means that by tacit agreement Music is defined as the instrumental music of the Romantic era, predominantly symphonic and predominantly introspective. At least that that repertory contains a larger amount of the "best" music than any other. This last assumption would be hard to defend on any grounds other than the popularity of the symphony orchestras (plus their gramophone recordings and radio transmissions) performing this repertory.

A strange thing this symphonic repertory. From Tokyo to Lisbon, from Tel Aviv to Seattle, ninety percent of it is the same fifty pieces. The other ten is usually devoted to good-will performances of works by local celebrities. The rest is standardized. So are the conductors, the players, the soloists. All the units of the system are interchangeable. The number of first-class symphony orchestras in the world is well over a thousand.

Europe, exclusive of the Soviet Union, counts more than two hundred. Japan alone is supposed to have forty. They all receive state, municipal, or private subsidy; and the top fifty have gramophone and radio contracts. All musical posts connected with them are highly honorific. Salaries, especially for conductors and management, are the largest paid anywhere today in music. The symphony orchestras are the kingpin of the international music industry. Their limited repertory is a part of their standardization. The Appreciation Racket is a cog in their publicity machine.

It is not my intention here to go into the virtues and defects of the system beyond pointing out that the standardization of repertory, however advantageous commercially, is not a result of mere supply and demand. It has been reached by collusion between conductors and managers and is maintained mostly by the managers, as everybody knows who has ever had anything to do with the inside of orchestra concerts. To take that practical little schematization of Romanticism for the "best" in music is as naive as taking chain-store groceries for what a gourmet's merchant can provide. For a composer to lend the prestige of his name and knowledge to any business so unethical as that is to accept the decisions of his professional inferiors on a matter gravely regarding his profession. I do not know whether it would be possible to publish a book or offer a course of instruction in music appreciation that would question the main assumptions of the present highly organized racket and attempt to build up a listener's esthetic on other assumptions. I doubt if it would, and the experience of various well-intentioned persons in this regard tends to support my doubts. Their attempts to disseminate musical knowledge among musically illiterate adults seem to have led them eventually to substitute for instruction in listening some exercise in musical execution, such as choral singing or the practice of some simple instrument like the recorder. It would seem that such execution, which, however elementary, is a positive musical act, gives not only its own pleasure of personal achievement but also not inconsiderable insight into the substance of all music.

Do not confuse the Appreciation Racket with the practice of musical analysis or with the exposition of musical history. These are legitimate matters for both students and teachers to be occupied with. I am talking about a real racket that any American can recognize when I describe it. It is a fake-ecstatic, holier-than-thou thing. Every school and college, even the most aristocratically antimusical, is flooded with it. Book counters overflow with it. Mealy mouthed men on the air serve it in little chunks between the numbers of every symphony-orchestra concert broadcast. It is dispensed in high academic places by embittered ex-composers who don't believe a word of it. It is uncritical, in its acceptance of imposed repertory as a criterion of musical excellence. It is formalist, in its in-

sistence on preaching principles of sonata form that every musician knows to be either nonexistent or inaccurate. It is obscurantist, because it pretends that a small section of music is either all of music or at least the heart of it, which is not true. It is dogmatic, because it pontificates about musical "taste." Whose taste? All I see is a repertory chosen for standardization purposes by conductors (who are musicians of the second category) and managers (who are not even musicians), and expounded by unsuccessful pianists, disappointed composers, and all the well-meaning but irresponsible schoolteachers who never had enough musical ability to learn to play any instrument correctly.

The musical ignorance of the army of teachers that is employed to disseminate Appreciation should be enough to warn any musician off it. Most composers are wary at first. Then it becomes tempting, because the money looks easy; and they think they at least will not be disseminating ignorance. Also in academic posts there is considerable straight pressure brought to bear. Nine times out of ten the young composer who is trying to make a modest living out of teaching harmony or piano-playing is ordered to get up a course in Appreciation (the tonier institutions are now calling it Listening) whether he wants to or not. He can make his own decision, of course; but I am telling him right now what will happen if he gets caught in those toils. He will cease to compose.

It always happens that way. No professional man can give himself to an activity so uncritical, so obscurantist, so dogmatic, so essentially venal, unless he does it to conceal his fundamental sterility, or unless he does it with his tongue in his cheek. In the latter case he gets out of it pretty quick. In the former case he gets out of composition instead. He gets out with some regret, because his professional status is lowered. But there is nothing to be done about that. Appreciation teaching is not even a Special Skill of any kind. It is on the level of Minimum Musicality, as everybody in music knows.

So your composer who sticks at it becomes an ex-composer and an embittered man. Always beware of ex-composers. Their one aim in life is to discourage the writing of music.

[These paragraphs on Music Appreciation have been preserved in the present edition because I rather enjoy their fine fury. Also because they brandish for the first time two fighting terms that have since been widely used in musical polemics. These are Appreciation Racket and the Fifty Pieces. Both are still capable of inflicting insult because both still bear a high percentage of truth. Within two years, indeed, after this book's appearance, documented studies of both subjects had become available — of music as it was being explained to laymen over the radio by the late Walter Damrosch, and of the standard orchestral repertory as programmed by sixteen subscription societies since 1812. The Appreciation studies appeared in a quarterly published by the Institute of Social Re-

search, *Studies in Philosophy and Social Science,* later in book form. The orchestral repertory was analyzed in a 1941 pamphlet from the University of Indiana by Dr. John H. Mueller and his wife Kate Hevner, these studies being later amplified and published in book form by Dr. Mueller.

Both books are now standard texts in musical sociology. And they are far more devastating than my remarks. The researches that went into these studies, though in progress when I wrote this book, had not yet appeared in print. Nor was I aware of them. But the disquiet that musicians felt about Appreciation and about the standardized repertory had already so far penetrated the universities that sociologists had picked these subjects out as matters meriting investigation.

As of 1960, the radio offers little of either Music Appreciation or orchestral repertory. The explaining of music to laymen in our colleges is pretty firmly in the hands of musical technicians. (Even musicologists are not generally allowed to teach the course.) And orchestral performances are disseminated for the most part (in America) by public concerts and by recordings. The recording companies still restrict their orchestral output to fairly familiar stuff, indeed very much so right now, the vogue for stereophonic or binaural reproduction having given them another excuse for recording the standard works all over again. They have usually found some such technological pretext about every ten years since recording began, and they will go on doing so, I am sure, until philanthropic (or government) subsidy shall have taken the responsibility for recording symphonic, chamber, and operatic music out of commercial hands, as it did long ago their performance.]

4. *The Just Rewards of His Labor.*
 a. and b. *Royalties and performing-rights fees*
This brings me to the last kind of composers' income, namely, receipts from his own musical works as published, performed, or recorded. It is sad that these should come last. If they were not so rare they would naturally have come first. Well, the facts are the facts. Performing-rights fees and royalties on copies sold are about the last thing any composer need ever expect to live on. His children sometimes come in for a bit of gravy. (The heirs of Ethelbert Nevin are doing quite well, thank you.)

I had better explain here something about royalties and performing-rights fees. Printed music brings to its composer (theoretically) a fee of ten percent of the marked retail price for every copy sold. I say theoretically, because many European publishers don't pay anything to the author. They think they are doing enough for him when they publish his work at all. If he pays the expenses of publication, he is usually allowed his ten percent. Gramophone recordings also bring to the composer a royalty of

so much per record sold. This fee is generally paid. The performing-rights fees of published music, like the recording fees, are currently shared between the publisher and the composer. If a piece has words, the author of the words gets a part of the composer's share.

There exist in all Western countries mutual protective societies of composers, authors, and publishers, whose purpose in life is to enforce the payment of performing-rights fees by producing organizations. In Europe these societies cover all the public usages of music, whether there is an admission charge or not, by cinemas, theaters, broadcasting stations, opera houses, concert halls, churches, cafés, nightclubs, and municipalities. Even musical mendicants are not exempt from payment. In the United States the American Society of Composers, Authors, and Publishers, commonly known as ASCAP, functions similarly, but really covers not much except the usages of dance music and popular songs. [More now, especially from radio.] Theatrical music is covered, by courtesy, through the Dramatists' Guild of the Authors' League of America. No performing-rights fees are collected in America at all, except by individual contract (which means there is no minimum payment), from symphony orchestras, traveling concert artists, the major opera houses, the schools, colleges, churches, and clubs. [The last two are still exempt.] In many cases of unpublished works in large form played by chamber or symphonic organizations, no fee is paid to the composer at all, not even a rental fee for the use of score and parts. This situation will not long continue, but for the present it is the case. It is the unique and sole reason for the existence in Europe of a much larger number of art-composers who live off their just share in the profits of the commercial exploitation of their work than exists in the United States. [Still true.] Such composers are almost nonexistent in America. Let us call them, for the sake of brevity, successful composers (successful being understood here to mean earning a living by writing music).

Of all the composing musicians, this group presents in its music the greatest variety both of subject matter and of stylistic orientation, the only limit to such variety being what the various musical publics at any given moment will take. Even the individual members of the group show variety in their work from piece to piece. This variety is due in part to their voluntary effort to keep their public interested and to enlarge their market. (Stylistic "evolution" is good publicity nowadays.) A good part of it is due also to the variety of usages that are coverable by commercially ordered music. Theater, concert, opera, church, and war demand a variety of esthetic solutions for individual cases according to the time, the place, the subject, the number and skill of the available executants, the social class, degree of musical cultivation, and size of the putative public. Music made for no particular circumstance or public is invariably ego-

centric. Music made for immediate usage, especially if that usage is proposed to the composer by somebody who has an interest in the usage, is more objective and more varied.

Successful composers are often accused of repeating themselves. In real truth they repeat themselves less often than the unsuccessful ones do. The latter keep writing the same piece over and over in the hope they can make it clearer next time, make people understand somehow. Successful men are often accused of compromising with public taste (which is assumed to be bad taste and profitable to cater to). I assure you that first-string composers have reputations to keep up, and that anyone who has a paying public (however small) is less tempted to "write down" to that public than the prize-and-commission-supported are to "write up" to musical snobs. I also assure you that public taste is not necessarily bad taste, any more than private taste is necessarily good taste, and that the quickest way for a successful composer to stop being a success is for him to vulgarize his work. Success is like travel; it broadens a man, makes him at once more objective and more passionate about the things that matter to him. There must be inconveniences about living off the just rewards of one's labor, but I don't know what they are. I have never known an artist of any kind who didn't do better work when he got paid for it.

The composer who lives on music-writing invariably tends toward the theater. Handel and Verdi and Gershwin are classic examples. I do not know, in the last two or three hundred years, of any composer who has lived for very long off the exploitations of symphonic and chamber music. The semi-popular song writers don't do too badly, and certainly Richard Strauss receives, now that he is old, a respectable income from his orchestral music. [Igor Stravinsky too, since Strauss's death.] But by and large, the theater is where the money is and where most of the composers are who have once had a taste of that money. Movies, opera, incidental music, ballet — these are the musical forms that feed their man. Composers who get fed by them have plenty of time to write a more disinterested music if they wish. Many do. All I am saying is that the commercially successful professional composer (and by commercially successful I mean he eats) is likely to be a theater man. That is his occupational deformity, if any.

To sum up and conclude:

Every composer's music reflects in its subject matter and in its style the source of the money the composer is living on while writing that music. This applies to introspective as well as to objective music.

The quality of any piece of music is not a function of its author's income source. One has only to remember history to know otherwise. J. S. Bach and César Franck were church organists. Handel and Verdi and

Gluck and Rameau were theater men. Beethoven skimped along on patronage and publishers' fees. Wagner (after his exile) and Tchaikovsky lived on gifts. Chopin and Liszt were concert pianists and also gave lessons. Mendelssohn was a gentleman of means. Haydn received a salary for writing music and for organizing musical entertainments at the country house of one Count Esterházy. Schumann was a musical journalist. A great many modern composers are pedagogues. One might mention Hindemith, Schönberg, d'Indy, and practically all the Americans. Bernstein and Chávez are conductors. Satie was a post-office employee, Moussorgsky a customs official, Cui a chemist. Mozart did everything in music at one time or another except journalism. Palestrina and Debussy lived on their musical receipts till they got tired of starving and married rich widows. One could go on, but I think this should be enough to show that excellent music can be written on almost any kind of money.

Anyone who wishes to follow this matter through musical history in more detail is warned not to consider contributive income as very important. It amplifies a composer's practical experience, when it has to do with music; but it does not determine either his style or his subject matter. Nothing does that but what he is actually living on. Nothing impresses a man deeply except what pays him a living wage.

❧ How to Write a Piece

or Functional Design in Music

I AM NOW going to list the commoner uses of music and describe some of the considerations that composers take account of when designing music for those uses.

The Dance Song

"Popular" music leaves the composer's hands in most cases as a song consisting of identical stanzas (known as "verses") and a refrain of thirty-two meaures (known as the "chorus"). This is the basic "form" for publication and for professional transmission. Rarely does this "form" fail to be altered in auditive usage. Frequently the verse disappears and the chorus becomes the whole tune. It is repeated with varying instrumentation for dancing, cut up and reharmonized for pianistic fun, distorted in stage shows and movies to accompany acrobatics, emotional scenes, and pageantry. The jazz boys make fanciful variations on it for nondancing listeners. A dozen completely different versions of the same title are sold as gramophone records or transmitted nightly by orchestras over the air.

The subject matter in all these transformations is a thirty-two-measure tune. The musical style of its amplification and rendition is personal to every performer or performing group. The "form," usually a series of variations, is determined by each separate usage and fitted to whatever overall timing is desired. The use of the variation series as a formula of composition comes from no highbrow motivation; it is simply that the variation series is the second simplest way of stretching any short piece of music out to fit a longer piece of time, the first and easiest way being

exact repetition. Dance players, church organists, and the leaders of military bugle corps don't hesitate to use exact repetition. It is not advisable, however, for jazz bands playing to seated auditors to repeat exactly, because both the band and the listeners would get bored.

The whole procedure of musical composition is evident in a lively way in the small improvisational jazz groups. These employ a free contrapuntal style of playing, because it is easier to improvise counterpoint than harmony (unless you are playing a multiple-voiced instrument, like the piano or banjo or guitar, or an instrument with chord buttons, like the accordion). The use of the variation series and wherever possible of the "imitative" style of counterpoint saves effort and gives coherence to the whole. The solo cadenza (called in jazz jargon a "chorus") keeps up the interest of the players and produces the profitable rivalries that come from personal success. Each player takes a chorus to make it all seem fair and friendly, takes it when he feels like it, stops when through. All, so far, is unconscious, automatic. Where does reflection come in? What has to be decided on by somebody? Three things only. The tune, the time to start, and the time to stop. The first constitutes the subject of the music. The last two define the proportions of its form — the speed, intensity, and extent at which musical development within the variation series can take place. The variation series is not a form; it is a continuity device. The song-with-verse-and-chorus is a form, but one that exists chiefly on paper. In practice, the small disc, the three-minute jazz number, the song-and-dance come as near being musical forms as so-called popular music has to offer, because they are at least bits of continuity within a dimension.

Music and Photography

As is well known, the movie was never a silent entertainment. The quiet tick-and-flicker of an unaccompanied film is dangerously soporific, no matter how clear the images or how exciting the story. From the earliest days of the movies, the film exhibitor has called in the aid of musical accompaniment to help him keep the house awake and to lend emotional poignancy to the dangerously frigid spectacle of a series of photographs. To this day the movies are dependent on music to hold the observer's attention and to direct his emotional responses. All of which means that the movie is a true musical form, as truly a musical form as the opera, though without as yet the opera's inseparable marriage of music to words.

Most descriptions of the movies are descriptions of the working methods by which they are made. I do not think these are immutable. Just because it is common practice to take the photographs and then to mount (or "cut") the film and finally to pin on some music, it does not follow

that a film made after a musical composition could not be equally effective. The collaboration problem between movie director and composer is not dissimilar, in fact, to that of the choreographer and the composer who make a ballet. The best result obtains when neither gets very far in time ahead of the other.

The whole esthetic of the movie derives from the fact that it is a photograph. Like all photography, it is naturally low in emotive appeal. We can stand a lot more blood and burst war babies in a movie than we can in real life or on a stage. It is also low, for the same reasons, in human friendliness. The screen having no human odor at all, the friendliness is all out in the house, never between house and stage. Great actors get carried in triumph by their admirers; but movie stars, unless they are well protected, get torn to pieces by theirs, because these, not recognizing their idol in his human form and with unfamiliar odor, can only achieve a mystic communion with his image by destroying his flesh.

Its naturally low emotive appeal leads the film in three directions:

1. The depiction of natural scenery, as in documentaries.
2. Exploitation of the pathos of the human face, as in realistic fiction dramas with stars.
3. The flight into fantasy, as in comics and animated cartoons.

Conscious compensation by directors and cutters for photography's naturally low emotive appeal has produced a final product with a rather high emotive appeal, higher at least than is commonly obtainable by visual means. The mobility of the camera (plus music) has produced a flexible and powerful art form.

The same mobility is responsible for the movie's gravest inherent difficulty, the jerkiness of photographic continuity. It would be absurd to keep the camera in one place all the time, as long as it can so easily be moved around. This constant shifting of the point of vision over an enormous variety of locales does make, however, for visual discontinuity. This discontinuity in turn is compensated for by an elaborate refinement of cutting. Good cutting is the most admired technique in movie-making, the most difficult, and the most indispensable. When each scene's visual time-length is adjusted to a desired emotional impact, and the whole series of scenes bound together by music, you have a narrative that is not at all low in emotive power, even though the music for the most part at present is not very well adapted to its function.

Documentary subjects are the easiest kind of movie to write music for. The fantasy and the comedy are next. There exists a goodly number of excellent scores of all three kinds. I have never heard a satisfactory musical accompaniment to a spoken film drama. It was all very easy pinning music on to "silent" Westerns. Schubert's *Unfinished Symphony* and Debussy's *En Bateau* were adequate for anything. It is speech that has

brought back the film's essential jerkiness, by interrupting the musical continuity.

For comics and documentaries and fantasies there is no grave trouble. All the composer needs to do is to put a continuous accompaniment of appropriate style under each sequence, making just enough timed illustrative "effects" to give everybody a slight shock at the major shifts in the narrative. Even if there is a speaker in the documentary, or some wisecracks to insert in the comic film, all is easy. The music can be stopped for short moments, its volume brought up or down, without its real progress being destroyed.

Before speech came in, the drama film presented the same problem as these others, the chief thing needed being musical continuity interspersed with timed "effects." What has not been satisfactorily solved yet is how to put music to the spoken drama film. How to make music that will be important enough to carry your big moments, and at the same time keep out of the way of the dialogue, is the problem. The future of the drama film depends on its solution. Otherwise, the movies will find themselves more and more limited to the making of documentaries, comedies, fantasies, and something like revues. The film drama cannot live without music, as stage drama can. And it is not getting much use right now out of the music it is living with.

The problem is not insoluble. It is really one of definition. Is the movie a visual art form, or is it predominantly verbal? It is a visual art form, of course; don't forget it is a photograph. Its humanly expressive range runs from pantomime to pageantry and back, and not much further. But its intensity of expression within that range is greater than any hitherto available. The presentation in a theater of panoramic views of natural scenery and of gigantic enlargements (called "close-ups") of the human face is a possibility absolutely new to art, a possibility that is unique to the moving picture. Fantasy is not unique to the movies. The three-dimensional theater has its fantasy too, which is just as amusing as trick photography. Sleight of hand, for instance, is more convincing on a stage than on a screen. And the plastic possibilities of stage scenery, with its variety of stuffs and colors, its enormous range of luminosity, are greater than any plastic beauty the movies (even the colored movies) can touch. Human speech has more variety and more power in a theater; music sounds better in a concert hall. Even radio crooning (that close-up of the human voice) is more poignant without visual interference.

The animated cartoon, charming as it is, is not characteristically cinematographic. It is not even necessarily a photograph. It is a free-hand drawing, photography being merely its commonest projection method. Its relation to naturalistic cinematography is that of marionettes to the real-actor stage. Its whole esthetic, in fact, is that of the marionette theater, even to the use of strained vocalization. Its designers can produce

masterpiece after masterpiece because they face no new esthetic problems.

Now any art medium derives its own esthetic, as well as its power, from what is different about it, not from what is common to it and to other media. And what is specifically different about the movies from all other forms of theatrical entertainment is their ability to move our hearts by true representations of natural scenery and enlargements of the human face. If you will look back in your memory, or into the history books, you will find that at least nine-tenths of all the really famous and unforgettable films are films that were photographed mostly out of doors. And at least one of the most celebrated films in the world, Karl Dreyer's *La Passion de Jeanne d'Arc*, consists in large part of nothing but close-ups taken without make-up on anybody's face. There is no getting around it. The stage can beat the movies at painted scenery, at the plastic disposition of stuffs and colors and lights. The movies are inalienably (even in their most fantastic moments) tied up to some kind of naturalism. The two-dimensional monochrome screen (colored films are very little colored, and at best they derive more of their definition from chiaroscuro than from chromatics), the husky and booming voices, the shortness of scenes and consequent nervousness of even the best "continuity," these technically imposed distortions are as much stylization as anybody can stand. Further distortion of reality is unprofitable.

Plots need not necessarily be naturalistic. They can be as conventional, as romantic, as fantastic as you like; and the high-flown heroic is their oyster. The movies do not have (necessarily) plot trouble, and they are certainly not limited in subject matter. They don't have (necessarily) acting trouble anymore since a natural style of acting has been adopted. Everybody just acts as natural as he can, and he does that in houses and on grass and in front of landscapes that, if not always quite credible realistically, are invariably naturalistic in intention. What kind of trouble then do they have? They have trouble about words and music.

Words and music are an ancient marriage, the marriage whose eldest offspring are song and the opera. Words go all right with visual spectacles too; that makes the "legitimate" theater. Music and pantomime go fine; that is ballet. Music and photographs of real people or scenery are okay; that is the documentary film. Even music and printed words don't bother anybody; that's what you have at the beginnings of films in a section called Titles and Credits. The combination works one hundred percent.

The aim and problem of the narrative film is nothing more or less than effective narration. Film narrative is photographic narrative, and in a photograph people are not convincing unless they look and act natural. If one wishes to look approximately natural, one had better not try to do too much explaining by gestures and facial pantomime, unless the limits

of the medium impose that procedure. Before the days of the sound film, that was the narrative method, that and occasional subtitles. Today it would be ridiculous not to profit by the added naturalism of speech, to pretend that stylized pantomimic explanations are obligatory, when everybody knows they are not. There are no films anymore, excepting those of Charlie Chaplin, without some verbal text. That text is inevitably naturalistic too. It is frequently enlivened by wit and wisecrack, just as ordinary conversation is. Seldom is there verbal fantasy or imagery, because these fall outside the naturalistic convention.

There are no films at all without music, which is more necessary even than the spoken word. It ties together the jerky narration (unless the composer of it makes the mistake of changing his music every time there is a change of scene, in which case he exaggerates the jerkiness). It produces quick, strong emotional reactions to reinforce the slow, weak ones that are all you normally get out of photography, out of anything visual, in fact. It also keeps the audience awake.

Photography, words, and music, how may these three elements be welded into an effective narrative? You can't cut one out, because the movies cannot do without music, and it would be a little silly today to try to do without speech. Intoning the speech, as in opera, is entirely out of the question in any dramatic medium so completely tied up to naturalism. To put continuous music under the speech ("melodrama" is the technical term for this combination), is just as unsuitable to the naturalistic style as operatic recitativo. It is always corny and unconvincing unless the music has some naturalistic excuse for being there. To limit the subject matter of films to stories in which music can be constantly present on naturalistic excuses would be to hamstring the art.

What is done is to open with music under the titles and credits, and then to alternate straight spoken passages with melodrama, with music, and with noises. Noises and music don't go badly together, curiously enough. There is a constant tendency to try to get the music and the words together also, to interpolate songs, because the fact is there isn't enough emotion-producing music in the fiction film today. And there is no musical continuity whatsoever. The documentaries use a continuous symphonic score and a fairly continuous speaker. The procedure works admirably; it does not make "melodrama," because the music is accompanying the film (not the speaker), and the speaker is commenting the film (not the music). Music and speech exist in such spectacles at the same time; but they have no real connection, hence no serious interference.

There is a tendency in French movie-making to restore the continuous musical accompaniment, only interrupting it for important speeches, and cutting down the total amount of speech in the film to as small a proportion as possible. The system seems to work fairly well and would work

even better if the composers who sign the scores could be given time to write their own music, all of it, and if a relatively stable dynamic level for sound recording could be established. As it is, two hours of interesting music cannot be written and orchestrated in a week; and even if they could, the fading-away and loudening-up practice is musically unsatisfactory, though necessary for the sake of speech clarity. It contradicts all dynamic variety that takes place at the music's source and makes the orchestra sound as if it were playing steadily fortissimo in a swell box.

Even this excellent compromise system tends to limit the movies' subject matter. It works best, really works, only on plots that do not involve music. Because you can't have both stage music and pit music unless you have both a stage and a pit. All movie music comes from the same place, which is a loud-speaker somewhere near the screen. It is musically unclear to jump from commentary or background music to realistic music of any kind, and quite impossible to play the two off against each other antiphonally, unless the sounds come from different places. Using two loud-speakers would be useless, would merely destroy the illusion that any of the music at all comes from the screen. A sharply marked duality of musical style is the only feasible way of marking the transition from background music to realism; and that is a technique not easily applicable, unless one man really writes all the music, or unless two men really write it, casting themselves, as in a play, for their characteristic and personal qualities.

At present, the system of nearly continuous accompaniment, even if the music written for it were stylistically satisfactory, and even if the dynamic level of recording could be adjusted so that clear words and expressive music could cohabit without friction, is still unsatisfactory for themes that involve much musical pageantry. It is oversufficient and tiresome for any subject that deals familiarly with middle-class life. Music here gets in the way of naturalistic conversation and almost inevitably turns the story into melodrama. The French system is at its best in dramas about life among the dregs and the outcasts or about life in exotic and lonely landscapes, life at sea or in unfrequented mountain lands, deserts, places where people speak in dialect or with stylized accents and where everything is strange and violent and very sad indeed. The absence from middle-class life that is inherent in such subjects makes it possible to use such a stylized convention as the nearly continuous musical accompaniment interspersed with picturesque speech.

The tie-up with middle-class naturalism, which seems to be ineluctable, has forced the American films to lean more and more on dialogue (for its naturalistic value) and less and less on music, thus sacrificing a great deal of music's emotional value and practically all of its value as continuity. This choice is not an improper one, but it has created a difficulty. Because the movies cannot live without lots and lots of music, and

the insertion of lots and lots of music into naturalistic plays with middle-class dialogue is just now quite out of the question.

There are two ways currently employed of getting music back into the films. One is the interpolation into comic and light sentimental subjects of songs, dances, and nightclub scenes, the presence of the latter being a firm convention in French films, where they correspond to the ballet convention of French opera. Less universal, but not uncommon in America, is the insertion of jolly male choruses, military band music, arias from popular grand opera, and bits of such symphonic compositions as are familiar to radio audiences. All these are introduced with a naturalistic excuse of some kind; they are plot music and count as realistic detail, never as commentary or as continuity. They are music, however; and that is always a help. The other way is used for more serious and tragic themes. It demands the insertion, wherever possible, of commentary music. In order that this commentary be not too prominent, an attempt is made to write it in a neutral style. The result is not really neutral; let us call it, for lack of a better term, pseudo-neutral music. There are special composers in all the centers of film manufacture who specialize in writing this. Do not despise them. They are experts and know what they are doing. They are writing a musical journalese. Their aim is to make music that will be rich in harmonic texture and sumptuous in orchestration, but whose melodic material and expressive content will be so vague that nobody will notice it. Such music fulfills its minimum architectonic function of tying together the continuity at the points where it is absolutely necessary that that be done. It is also useful for underlining a bit of humor or a heart throb and for creating fortissimo hubbub at the beginning and end of films, the time when people are changing their seats. It gives a general air of luxury by being there at all and by being orchestrated in the "picturesque" style of 1885, the style of Chabrier and of the early Richard Strauss. Its power of self-effacement is its real virtue. Few persons excepting those of predominantly auditive memory (and these rarely go to the movies) can ever remember anything about the music of serious drama films, even whether there was any or not. It is discreet; it is respectable; it comes and goes without being noticed. It carefully avoids ever making any underlining that might engage it subsequently to a close collaboration with the film story. It retires completely before the speaking voice, no matter how banal a remark that voice may be about to utter.

Neither of these ways is very satisfactory. The first turns everything into a musical comedy. The second is both architecturally and emotionally inefficient, because music can't be neutral and sumptuous at the same time. Not in this post-Wagnerian age. A really neutral music would be admirable, if it could be written. It would certainly provide a better contrasting background than the pseudo-neutral does for the insertion of stylized musical numbers. And it would serve as a sonorous foundation

on which to erect musical climaxes that could support the big punches of the narrative in a pretty impressive way. It might even provide an approach to the central problem of words and music.

I do not know whether it is possible in this generation to develop a neutral music style. It existed in Europe from the Council of Trent to the middle of the eighteenth century. Its remains are buried in the pedagogical convention known as "strict" counterpoint. The basic rule of such music was the avoidance of any tonal formula that was at all noticeable or that was in any way specifically expressive. The German Romantic rule, our present tradition, is to make the music everywhere as noticeable and as expressive as possible. The international neoclassic style that I spoke about in another chapter was the product, in part, of an attempt to revive nonexpressive counterpoint. Its practitioners thought to neutralize the expressive value of unresolved dissonances by making the employment of these obligatory and consistent. It cannot be said that strictly dissonant counterpoint, however useful as a pedagogic device, has provided the world with a stylistic discipline that quite fulfills the functions of the classic one. Rather it is a commentary on the more ancient rules that would make no sense at all to one who was not trained on these. The twelve-tone system of atonality is rather less neutral and more expressive than tonal counterpoint. If either of these modern conventions, or a revival of the classic one, should prove useful in the composition of film accompaniments, nobody would be more delighted than I; but so far I must say they have not done anyone much good. I must make an exception or two, for in French films I have occasionally heard an apt usage of dissonant counterpoint. Not for its expressive value; that is easy and no trouble. I mean as something approaching a really neutral background music, a *senza espressione* style that throws whatever is seen against it into high relief.

It is really too bad the movies got born a century late. They would have served as an ideal dramatic medium for Richard Wagner. He, of course, is every movie director's dream of a musician. He wouldn't have needed neutral music; he would have taken us all to Valhalla on continuous hubbub with intense expressivity everywhere. And no tommyrot about pretending that the speaking voice is essential to realism or that middle-class life is in any way interesting. He would have placed the films, once and forever, on that high heroic plane that their colossal powers of visual depiction demand for them. History has willed it otherwise. Wagner did his heroic job, did it on the opera. It is too late now to do the same job on the movies, because the same battle can't ever be fought twice. His goddesses and heroes are fat theatrical screamers who stand around among cardboard rocks and wander through canvas forests. There is nothing naturalistic or credible about them; they are symbols embedded in concert music. But embedded they are; and Wagner is

dead, and stage opera, too, very nearly. The films will have to go now in another direction and invent a new musical stylization. There is nothing to do about being born too late except to become a primitive.

The movie people are all very proud of their art's achievements. They think the movies are in every way just grand. Actors pretend otherwise, but they all think so too; and they are out for movie jobs to a man. Literary authors hate the movies with a violence, whether they work in the films or not. And composers of music, whether they work in films or not, are sad, unhappy, and nervous about them.

Any further progress esthetically in "pictures," as Hollywood so unpretentiously calls them, depends on first restoring the musical continuity. Emotional superpower must start from there. In order to restore musical continuity, either spoken dialogue must be thrown out or a new and practical working solution must be found for the words-and-music problem, a solution that will permit words and music either to let each other alone or to help each other out. At the moment, they are in each other's hair; and the low emotional tension that results is of very little support to the pallid and anesthetic spectacle of narrative photography.

There has been a lot of talk about movie opera. Movie opera is a dead end. At least it is if by movie opera you mean the screening of well-known stage operas. Original screen opera might be possible if it were called something else. But the word *opera* throws both directors and composers into nervous states that render them unfit for responsible art work. No art form is so little understood or so stupidly practiced as the opera in this age of its decline. Even over the radio very little has been done except to broadcast repertory stage works, though heaven knows the opera as a musical form is God's gift to the microphone. Writing contemporary operas for the crooning technique, how has everybody been so dumb as to miss it? I can only explain that miss on the ground that the word *opera* produces such sunspots on the mental retina that once it is mentioned nobody can see anything but *Tristan* and *Faust* and *Il Trovatore*. I must say that making original screen opera will be no such child's play as making radio opera would be. But the movie banks have money, great big electrical money. There could be no real harm in their making half a dozen screen operas, if only to find out what not to do once the word *opera* shall have been got out of the way and it shall have become thenceforth possible to make serious musical fiction films. [Televised opera can be quite beautiful in Europe. Italy uses for the most part standard repertory; Holland commissions new works.]

Musical Theater

Opera is complete musical theater.

Musical theater is a collaboration of the verbal, the visual, and the

tonal arts, usually with intention to instruct. The place of music in such
a collaboration varies from epoch to epoch. A drumroll to send up the
curtain, accompaniments for dancing and acrobatics, an interpolated song
here and there, the eternal off-stage trumpet calls, all these are incidental.
It doesn't make much difference whether they are well made or only fair.
The quality of the music makes, however, a great deal of difference when
that music is tied to the dialogue. Such a tie is the specific characteristic
of serious opera. Because of it, opera has the most ancient heritage of
any theatrical form still practiced in the Western Hemisphere.

The Greek tragic theater, like most religious ceremonies everywhere,
was originally danced and sung. Even as late as Periclean times, when the
poets had hogged the show for themselves, and the only religion left in
it was a sort of civic morality, the mass recitations were still intoned and
the chorus that intoned them pranced on in ceremonial quickstep. The
Christians took over many of the Greek theatrical procedures for use in
their ceremony of the Mass. This latter is a combination of tragic spec-
tacle (the sacrifice of Our Lord is reenacted) with practical magic, the
elements of bread and wine being transubstantiated into the flesh of
God and devoured beneficially by the initiates. Even the word *clericus*
(or clergyman) means, in late Latin, an actor. To this day the Mass is
danced and sung, which is to say that the text is intoned and all the
movements are regulated. There is even provision for the interpolation
of musical set pieces, of choral entries, and of parades. The reprosodiz-
ing of the whole liturgical repertory to fit medieval Latin, which had be-
come quite different in sound from classical Latin, and the composing of
set pieces to ornament this repertory occupied most of Europe's musical
world for a thousand years, from the seventh to the seventeenth centuries.

The opera, as we know it, was invented in Florence around 1600, for
the purpose of performing non-Christian (specifically, Greek mythologi-
cal) tragic plays in Italian. The intention was anti-ecclesiastical. But the
method employed for carrying out this intention was to take over (to
take back rather) and to laicize all the musical procedures of the Church.
Nothing could have been more intelligent. Because the formal procedures
of music, as we have mentioned before, are not bound up with any ideo-
logical content. Also because these procedures were in this case exactly
the musical procedures of the Greek tragic mythological theater, the art
that it was desired to restore.

If musicians could ever get it through their heads again, after seventy-
five years of having forgotten it, that the operatic form is nothing more
or less than the form of the Christian Mass, as well as that of the Greek
tragic theater, there would be far fewer unsuccessful operas produced in
Europe and America every year. One single principle underlies the de-
sign, the structure of complete musical theater (whether you call that

opera or music-drama). The basic routine of this, as of the Mass and of the ancient poetic stage, is intoned speech. Successive reformers of the opera (every time the opera gets domesticated to a new language it has within a century to be reformed) have varied the proportion of intoned dialogue, set piece, and instrumental illustration; but they have never thrown out the central procedure, which is intoned dialogue. One might even say that the way to reform opera anywhere is to bring back the attention of composers to the basis of all opera, intoned speech.

You cannot write an opera, as you can a song, by making up a tune and then fitting words to it. You have to start from a text and stick to it. You must scan it correctly and set it to tunes convincingly. In the more vigorous operatic epochs singers even articulate it comprehensibly. Speech so scanned and set, if intoned with clear articulation, is both easier to understand and more expressive than speech that is not intoned; and it can be heard farther.

All the rest of an opera is just icing on the cake. You can put in all the set pieces you like and all the symphonic reinforcements. You can have the most beautiful scenery and clothes money can buy, or you can do without. You can regulate the singers' every movement, or you can let them wander around from bench to tree. You can add ballets, earthquakes, trained seals, trapeze acts, and an orchestra of a hundred and fifty musicians with sirens and cowbells. The more the merrier, because the opera is a complete art form like the Mass, the Elizabethan theater, and the movies. An ideal opera contains one of everything. It is better than a circus because it can include a circus. Also, as at the circus, the audience is part of the show.

The opera has no time limits. It can last ten minutes or seven hours. It has few limits of subject matter. Religious, moral, or even politically revolutionary themes that would be censored elsewhere so quickly you wouldn't know what had happened are accepted without shock at the opera (and understood). It has no limits about vocal or instrumental style. It is stylistically the freest of all the musical forms and the most varied. It can stand any amount of interpolated numbers, musical, scenic, or acrobatic. Its one limitation is the condition of its amplitude. It must always be a bunch of actors in character singing a play to an audience. Not singing a lullaby or a love song or a lament for virginity betrayed, but singing the remarks and speeches that make up a theatrical narrative. It is not a symphony with voices or an oratorio with scenery or an instrumental accompaniment to a pantomime, though at times it has tended to degenerate into all these.

Let us repeat it over and over. Basic opera is nothing more or less than an intoned play. Start from there, as the opera did and as every reformer of the opera has to, and you will arrive at complete musical theater. Start

from anywhere else, and you arrive at incomplete musical forms and at
very uninteresting theater.

<center>༺ ༺ ༺</center>

I shall skip along briefly over the forms of incomplete musical theater
such as Protestant church services, plays with incidental music, military
ceremonies, and home weddings. The music to these is a sort of yardage
that is cut to fit the cue sheet and the colonel's taste. Putting incidental
music to spoken plays does pose a structural problem of acoustic place-
ment, any given bit of music becoming for the play scenery or property
or framing, accordingly as the musicians executing it are placed in the
wings or on the stage or in a pit. The combination of instrumental ac-
companiment with nonintoned speech, melodrama, adds tension to very
short moments of a play; its abuse is a corny effect. A general rule of
use to composers and play directors is that music for plays works best
if it makes some kind of continuity when played without the textual
interruptions.

The most interesting musically of the incomplete musico-theatrical
forms is the ballet. The great secret about that, the open secret that com-
posers tend to forget, is that ballet music is, believe it or not, dance music.
Its first function is muscular, helping the dancers move themselves
around. It is a whip, not a musical meditation. Its rhythmic substructure
is essentially percussive, because only beat music moves muscles. Music
that has a quantitative rhythmic substructure without percussive thumps,
the kind of music that comes from pipe organs, merry-go-rounds, player
pianos, harpsichords, and really hot jazz orchestras, is not good for pro-
voking large muscular movements. The jitterbug twitch is about as far
as any of these can go.

Ballet music is not limited to percussive music. It is extraordinary the
amount of static tone pattern that can be got into it if you play this off
frankly against the muscle music. Stylistically the ballet is a rich and
ample music form, capable of almost as great variety of expression as the
opera itself. I call it incomplete, compared to the latter, because of its lack
of human song. Efforts have been made to add singing to the ballet; but
these have not very often been successful, because singing is a more
powerful medium of expression than bodily movements are. Every time
you put vocalism alongside of dancing, the dancing has a way of becom-
ing invisible. And the addition of dancing to a primarily vocal manifesta-
tion like opera, though a bit of ballet is pleasant enough as an interlude
in a long vocal evening, certainly tends to diminish the intensity of the
storytelling at that point. Intoned speech, however, is a strong enough
foundation to support any and every kind of ornamental addition that
might possibly enrich the whole spectacle, whereas pantomime and
bodily prowess, no matter how breathtaking, are not a strong medium

of expression. They are always tending (this is history) to lose what expression they have and to become just empty conventions. Reformers of the ballet are invariably preoccupied with trying to make stage dancing mean anything at all.

Like the movies, the ballet is a visual spectacle; and like all things visual, it is emotionally cool. It needs music for continuity and for emotional intensity. Mixing it with opera is always exciting, though sometimes a little precarious. It is advantageous to the opera to have the movements of the actors regulated by an experienced choreographer. Even naturalistic opera profits by such collaboration. But that does not make a ballet of the opera any more than having a high-class artist design scenery and costumes will turn the visible stage into an oil painting.

Ballet is the expression of human sentiments by means of the muscular members. Its higher schools are opposed to any facial pantomime whatsoever, because facial expressions of any intensity tend to weaken the force of the body's all-over expressiveness, to personalize a highly impersonal art. Ballet is much enhanced, however, by scenery and clothes. The addition to one long-distance visual effect, which is dancing, of another, appropriate decoration, doubles the power of the whole visual spectacle. Just as the addition of music, which is auditory, to declamation, which is also auditory, makes the opera the most powerful auditory expression there is. Putting music under dancing is fine, because dancing needs it. Putting vocalism and dancing together is rarely effective for more than a short moment. Alternating dancing with vocalism, on the other hand, is completely satisfactory and charming, whether that is done with the grandeur of Lully's and of Rameau's sumptuous ballet-operas or with the unpretentious and simple good humor of that ever-popular number, the song-and-dance.

Concert Music

The concert is the purest form of music, though not the most complete. It is not a complete art form, like the opera, because it is limited to music. It is even a less complete musical form than the opera, because its repertory is limited formally to pieces of a certain length and stylistically to those of a certain respectability. It is music, only music, and (theoretically) high-class music. It tells no story, serves no didactic purpose; and the only spectacle it offers is that of men at work.

It is a very intense little affair. It is the islanders' form of the Communion of Saints, a communication from musicians to the "musical." For outsiders it is either a social ceremony or a place to let the mind wander pleasantly. For the unmusical this mind-wandering consists chiefly of sexual stirrings and memories of natural scenery. The musically sensitive find sometimes that music stimulates thought. The meditative possibili-

ties of musical listening are of the highest psychological value; I would not deny them to anyone. Only I insist that persons in a concert hall who are doing their own private business, whether that business is looking impressively social or thinking about love or laying plans for tomorrow, are not necessarily receiving any musical communication, though sometimes they may be doing that too.

In general, the best receivers of musical communications are persons of some active musical experience, persons whose visceral reactions are sensitive to auditory stimuli and who have some acquaintance from practice with the musical conventions by which these reactions are habitually stimulated. Such people are said to "understand" music. You can teach musical analysis to the tone deaf; but you cannot make them understand music. Because the first condition of musical understanding is some visceral responsiveness to sound, and that you simply have from birth or you haven't. The blood flow, the liver, the ductless glands, the digestive juices are beyond voluntary control or training. If your reactions to musical sounds are sufficient to make concentration on these a pleasant activity, then of course the conscious mind comes into the process, comes in just as automatically as the viscera do, though a little later in time.

The process of intellection about music that all musical persons go through as they hear music is not a process of describing to oneself verbally the music's meaning. It is a process of being aware sensuously of certain visceral changes and clearly, auditively, separately aware of the sounds that provoke them. This dual process is quite facile when the music is familiar; hence everybody loves old music. With new music everything is much more difficult. Both the visceral reactions and the auditive experience that provokes them must be tasted, very much as one tastes strange foods. One isn't always sure right off whether one is going to "like" them or not. This process of discrimination is an intellectual (though largely unconscious) exercise of personal taste. Taste is knowing what you don't like. It is the knowledge of what you personally cannot take, what you must keep your viscera from getting too intimate with till your mind gets used to the novelty and you can accept the whole thing into your repertory of digestible experiences.

Music that is novel in stylistic orientation, that impinges strangely on the musical ear, provokes violent demonstrations of acceptance and refusal. The broader the musical experience of the listeners present, the more violent the public demonstration. In the great musical centers there is not seldom a physical brawl. The following principles govern taste judgments:

1. The degree of any group reaction, favorable or unfavorable, is more significant than its direction. Its strength is roughly proportional, over a

certain period of time, to the expressive power of the work. An inexpressive work creates little disturbance.

2. The direction of the judgment, for or against, of each separate listener is influenced by his financial interest.

Teachers resist anything which contradicts what they have been telling their students or that threatens to put them in a position of ignorance in front of these. They don't like envisaging a loss of student prestige, because that loss means eventually a money loss.

Composers resist anything that threatens competition. If a work is in similar vein to some piece of theirs, but more expressive, they hate it. Anything in similar vein, but definitely less expressive, they love. About anything quite different from their own work, they are benevolent but fairly silent, because they are already planning a little theft or two of a device.

Persons who have some musical experience but who are not making any money to speak of out of it have a relatively disinterested musical taste; and since the human mind always loves a little bit of change, these persons are eager to understand and to accept. They constitute an advance guard for the absorption of new music.

In places where musical sensitivity is so great and musical experience so general that everybody likes nearly everything, the musical tradition is said to be "decadent." Enormous quantities of music are consumed, but none of it means much. It is elaborate in construction and texture, low in expressive content. In such places and at such times, the consumption of old music (music already absorbed by the profession long ago) reaches a degree of popularity equal to (and in the final stages of decay superior to) that of new music. Nobody cares about either style or design. The music world is like a drunkard who has no digestion. He can't eat. He can only swallow more and more alcohol, any alcohol, till he falls down one day in delirium tremens. All the categories get confused and the values falsified. The opera becomes instrumental and unsingable. Ballet, instead of standing on its toes and holding its stomach in, which is where the ballet belongs if it expects to execute any variety of large free movements, stands flat on its feet and sticks its stomach out, waves an arm, and loses its balance. Song-and-dance folklore is imported from foreign climes, and the concert world is taken over by incompetent soloists and by overcompetent orchestral conductors who streamline the already predigested classics to a point of suavity where they go through everybody like a dose of castor oil.

As you see, this description fits quite accurately Germany for the last seventy-five years and not too badly the whole international music world. The concert tradition everywhere is esthetically in a bad way; it can't

keep its eyes off the past. The opera too looks pretty sick as contempo-
rary art. None of this is anybody's fault. Civilizations rise and civiliza-
tions die, and they usually overlap by several centuries. I am not writing
a history of musical civilizations; I am describing the state of music. And
the state of art-music everywhere in the West (I don't know Asia or
Islam) is unquestionably more than a little bit decadent.

In the Americas popular music is very healthy indeed, though this does
not mean that the Great Tradition is about to be taken over by the swing
cats. Maybe it is and maybe it isn't; I wouldn't know. It does mean,
though, that there is more good music around than ever gets through to
the opera houses and to the trusts of concert management. These last,
with their one thousand symphony orchestras around the world, how-
ever much invested capital they may represent, have about the same rela-
tion to today's creative activity in music that the museums (including the
so-called modern museums) have to contemporary painting. There are
musical activities of a popular nature and others of a recondite intellec-
tual nature (far from popular) that enclose the nuclei of the next musical
civilization. Without going into the ways and means of forcing that,
which would be another book and which could not possibly represent
anything but wishful prophecy on my part, it is still easy to see, nonethe-
less, that the official, the rich opera-and-concert world of today is the
resplendent tail end of a comet that has already gone around the corner.

The principal "form," design, or pattern involved in concert music is
the concert itself, which is a sort of musical meal, proceeding, as meals
do, from heavy to light in digestibility. A good deal of ingenuity and taste
goes into the designing of this meal, into the fitting of admissible pieces
together so that they fall within a given time limit (a quite strict one in
most cases) in mutually advantageous juxtaposition. But program making
is not musical composition any more than hanging a show of pictures is
oil painting. And the analysis of concert pieces shows that they nearly
all have some kind of a plan. If enough pieces have the same kind of plan,
that plan gets called a "form."

As I have said before, I am not very fond of the word. I do not think
that sonatas and rondos and such are musical forms. I think they are
merely rhetorical devices. I except the dance meters, which have a metri-
cal convention, and the round, the canon, the fugal exposition, which fol-
low a tonal one. In any case, information about them is not lacking. You
can read them up in the Appreciation books (mostly misinforming, I
admit) or in the professional textbooks of musical analysis (which are
better). You can learn about them all in half an hour.

Such matters have a practical interest for persons who write music and
a lesser but also certain interest for executants. Detailed knowledge about
them is just as useful to the layman as a recipe for angel-food cake
would be to an unmarried dockhand. The only real problem involved in

musical rhetoric is how to make a piece last some time without getting vague. It must hold the auditor's interest without confusing him. And it must do this, as the movies do it, by continuity.

Music's first dimension is length, a length of time. An important expression of any emotional thing (and music is certainly not much but emotional) requires time. Short expressions can be intense, but only long ones can be ample. Coherence, in any piece of time, requires a continuity plan. Music made to be heard must be very simple indeed, must repeat its chief material over and over. It is not like a book, where the reader can stop and turn back and get the plot straightened out if he forgets. It must have such a simple layout or build-up that nobody can fail to follow it.

If you are still interested in how this gets accomplished, go to the books. The commoner layouts are all listed there and can be learned very quickly. What is important, however, about the structure of a piece is not what layout is used and with or without what traditional observances, but whether an average musician can understand the music. Can he memorize it well enough in a week to communicate it to another average musician? This is where the well-known formal layouts come in. Classifying the layout is the first step in musical analysis. And musical analysis is (usually) the first step in memorizing. That is about its last utility too, I suspect, that it is an aid to memory. Indeed it is a great aid, and the ability to practice it is indispensable to active musicians. I doubt that it is of much value to passive listeners.

Now don't imagine for a moment that I despise musical passivity. No sight is more pleasing to a composer than that of a houseful of completely quiet people listening to some work of his being executed. If any of them are listening analytically, that is perfectly all right by me. The analysis of my music has never lost me a customer yet. But for those who enjoy taking music passively (which is the only way most people not musicians can take it at all), I've an idea the process works better when their minds are really passive. Both to musicians and to laymen I recommend the mastery of noncerebral receptivity. You can take the piece apart at some other time, at a time when time itself is not of the essence. A run-through performance is for nourishment, not analysis. Let the music quicken your pulse and thicken your blood and turn over your liver and digest your food. Let your mind alone and don't worry about the second theme. Try the music on and see if it fits as is. You'll find yourself remembering it much better than if you tried to analyze it and in doing so missed half of it.

In my college days I used to go to the Boston Symphony concerts every week. I found that if I arrived with my conscious mind already at a certain degree of musical saturation, as I often did, the only way I could understand anything the orchestra played was by not listening con-

sciously at all. I would read the program. The Boston Symphony program in those days was a whole book, full of historical information and quotations. There was enough to last a good two hours; and all very diverting it was too, and cultural, and harmless. The music provided just enough slight-annoyance value (like railway-riding noises) to keep my attention on the reading. And the reading provided a subject for conscious attention to play with that enabled me to really hear the music. Occasionally the music would pull me away from the book and make me listen to it all over me. More often I just read on, paying no attention to the music, and of course never missing a note of it. Later I usually remembered it all, remembered it a great deal better than I would have if I had gone to sleep trying to listen analytically.

Musical analysis is a musician's job, just as chemical analysis is a chemist's. A concert is not, after all, even in its most recondite and tendentious examples, a display of musical specimens. A music library is that, if you must; but a concert is a meal. It is a feast, a ham sandwich, a chocolate sundae, nourishment to be absorbed with pleasure and digested by unconscious processes. The body has more use for music than the mind has. Take it or leave it according to the body's taste. Express your pleasure by applause, your displeasure by whistling and stamping, or by not coming again. If you live in a social group that cultivates musical opinions, tell your friends exactly what you thought of a piece afterward, if you thought about it afterward at all. If not, say so. And if your responses to the tonal art are low, then why be bothered with concerts anyway? There are always prize fights and tennis matches and matinees and dancing and eating and taking a walk and having a baby and quarreling and reading a book and getting tight. You are wasting good time to submit yourself to music unless you understand it viscerally. If you do understand it that way, then serious musical study and listening will be profitable to you. Otherwise I am afraid they will just confuse the mind with culture. I respect and admire sincerely persons who admit they are not interested in music.

Literally thousands of people go to concerts who are not responsive to music. Maybe I underestimate the musicality of opera and concert subscribers. I hope so, but I am not convinced. The audiences at cheap popular orchestral concerts are just like audiences everywhere, and I understand their responses without any trouble. The well-to-do (usually female) subscriber, I do not really believe to be musically alert. I am convinced, though I can't prove it, that about one-fourth of the persons who go regularly to high-class concerts have no interest in what they hear and don't remember what they hear, that they are present from quite other than musical motivations, and that they know in advance they are going to be bored. There is, of course, no way of verifying my proportion. It might be much lower or much higher.

In any case, there are plenty of bored ones. Everybody knows that. The more expensive the seats the more boredom there is, as a general rule. These bored ones swell the receipts, of course; but they lower the potential of communication. If they are too numerous, they act as insulators and there is no communication. The receiving potential of audiences runs approximately as follows:

The most sensitive is the hand-picked invited audience, exception being made for invited radio audiences, which consist of stooges.

Next come the audiences for chamber-music concerts. These contain a high proportion of professional musicians and almost no outsiders.

Audiences at concerts of pianists and solo violinists react rather strongly, on account of the large number of persons present who know from practice the technique and repertory of these instruments.

The same applies in a lesser degree to audiences for vocal soloists and for choral groups. Applause may run high; that means very little. In fact, the lower the culture level of any audience, the greater that audience's enthusiasm for what it can understand.

The symphony addicts are, it seems to me, not very receptive, though the poor things haven't had much chance to receive, I must say, since world repertory got standardized. The resident orchestras suffer too from the social glamour brought to them by their rich founders and their pseudo-philanthropic trustees. This prestige brings in large numbers of impressive box holders and subscribers whose active musical experience is low compared to their passive experience. (They have been to everything.) Even among the musical persons present, there are many who have only the vaguest acquaintance with orchestral instruments. Musical communication to these persons is a little incomplete. To the others it is practically nil. I know ladies who have been going to symphony concerts since childhood and who are lucky if at sixty they can recognize eight pieces out of the about fifty that make up the permanent repertory. These women are not stupid; they are just not very musical. They go to symphony concerts for reasons. I don't mean always social reasons, either, although a great many people do go to symphony concerts to be seen, just the way they used to go to the opera. What they like about orchestral concerts mostly, I think, is (a) the conductor and (b) the resemblance of the musical execution's super-finish to that of the other streamlined luxury products with which their lives are surrounded. They feel at home, as if they were among "nice things," and as if the Revolution (or whatever it is that troubles rich people's minds) were far, far away. I don't think they are entirely bored. But I have always found them musically not very discriminating.

The invited radio audience is sterile. Practically no communication takes place at all; it isn't allowed to. The audience is only there to keep the players from inattention or from getting mike fright. It is an unpaid

stooge. Applause is only allowed on cue; an adverse reaction of any kind is forbidden, and would be cut off the air if it took place.

Don't try to tell me that much communication is going on, either, from the broadcasting room to the fireside listener. The listener begins by receiving a communication; but as soon as he learns that his reactions are producing no counterreaction, he stops reacting. The radio concert is a good occasion to practice noncerebral listening at home, to hear music while reading a book or washing dishes. Otherwise, the whole effect of radio concerts is dogmatic and scholastic, due to the absence of give-and-take. The best ones are those broadcast from public halls, because there you get a bit of the artist-audience interaction. Even in these broadcasts, there is always a speaker who manages to give you the idea that he is a hired salesman trying to make you sign something about the classics. It is pathetic the way he pleads with us to please believe everything in music is just hunky-dory, when we all know perfectly well that that last piece was a turkey and the house a frigidaire.

The Women's Club concert, the School-and-College-Trade concert, and the Modern Music concert are special formulas. Each has its own repertory and its style of rendition, determined by the character of its stylized public. This public has in each case a moderately intense but stylized receptivity. Its reactions to any piece vary little all over the world.

The club formula aims to charm rather than to instruct. It avoids both novelty and brilliance. The school-and-college formula aims to instruct, and to this end seeks the shock value of novel or rare repertories rather than stylish execution. A too-sophisticated execution is rather frowned on, in fact, and rightly, for it would get in the way of musical communication. For unfamiliar music a neutral rendition is better than a misapplication of some colorful technique.

Modern Music programs are made up almost exclusively of first performances in the locality. The audience is restless, picturesquely dressed, intellectually distinguished, and international-minded. At least two-thirds of it is practicing musicians and other professionals. It is a hotbed of musical politics. Critical acrimony runs high.

From 1919 to 1929, these concerts represented the international front-line trench of the newer new music. Since that time new music, at least the music of the younger composers, has appeared more often in the theater, in the films, on the radio, and in private concerts. This is because the societies for the promulgation of modern music (those that still exist) have come to represent a vested interest, the right of the previous decade's bright young men to censor this decade's production and to decide on its worthiness for performance beside their own. This decade's bright young men have, in consequence, adapted their music to commercial and

private outlets, to the rather considerable advantage of both music and its commerce. The next decade's young (they are turning up in some abundance of late) show signs of inventing a less internationalist form of new-music concert and naturally of running it themselves, as the young people of the 1920s did. They will not do much about concerts of any kind, however, as long as there is a chance of their getting into commerce with applied music.

Just a word about the stylistic conventions of the Modern Music societies. An ideal program for any concert would be made up of pieces that were never intended to be played in concert. Such a program would have a rich variety of subject matter and of musical style. As soon as a series of concerts, however, becomes a production outlet, composers start producing for that outlet. The concerts of any Modern Music society are primarily an outlet for the group of composers who constitute its program committee. Any piece is refused that is more spectacular in subject matter or treatment than the pieces it must appear beside, or sufficiently less spectacular so that somebody's music (you never know whose) might be made to sound a little silly. Let us suppose a young man writes a piece for private reasons, and that some society produces it, and no great harm is done. He is promptly asked to submit another and encouraged to write something especially for the society. That means he must keep in mind, while writing his piece, its relation to the kind of thing that it is likely to have to appear on the program with. If he transgresses that consideration, his piece will not be performed. A piece will be performed by somebody who has kept in mind the unannounced works.

The esthetic problem thus posed for all composers who do not have a society of their own, but who would like an outlet, is that of writing music that will not seriously endanger the success of certain other music. Professional advantages are offered as reward for happy solutions. The result of it all, in the 1920s, was the creation of an international school that tended to become neutral in subject matter and conformist in style. Everybody wonders why the modern symphonies played at endowed symphony concerts sound tame. That is the condition of their being played at all, that they shall not seriously compete with standard repertory. People wonder too why so much of modern music, though it sounds violent, seems to say nothing. That, my children, was the condition of its being played in the concerts of the international Modern Music ring. The dissonant contrapuntal was the only style admitted. It naturally got more and more so and just as naturally less and less expensive. I shall never forget the scandal in the world of modernist music that greeted the appearance in 1927 of Sauguet's ballet *La Chatte* and in 1934 of my own opera *Four Saints in Three Acts*. After twenty years of everybody's trying to make music just a little bit louder and more unmitigated than any-

body else's, naturally everybody's sounded pretty much alike. When we went them one better and made music that was melodic and harmonious, the fury of the vested interests of modernism flared up like a gas tank. That fury still burns in academic places. In my own case it is strongest where I was educated. At Harvard and among the Nadia Boulanger coterie in Paris I am considered a graceless whelp, a frivolous mountebank, an unfair competitor, and a dangerous character.

❧ A 1961 Postlude

MARY GARDEN used to tell young opera singers, "Take care of the dramatic line and the musical line will take care of itself." She did not mean, of course, that good acting can justify bad singing. Merely that good singing must find its expression through the shape of that which it was designed to express.

Music is designed to express feelings. These are the sole subject of its communication, the only inner reality it deals with. And the difference between one state of feeling and another, as expressed in music, is largely a matter of shape — shape of melody and shape of larger form. Concentration on anything else gives to a musical action a self-indulgent quality that limits communication. It also tends to break down communal effort.

Painting and poetry, one-man jobs, can be self-operative. Music is practiced today only as a collaboration. Even solo improvisation — one of the stricter forms of composition — is nothing but personal fancy within a familiar frame. The whole musical art involves cooperation from the ground up — cooperation, good will, and loyalties. And this cooperation, I maintain, must be used for musical purposes only. I also maintain that musical purposes can be correctly defined only by the profession. If the profession neglects its duty in this matter, groups less responsible to music take over.

That the composing of music is a profession I think I have demonstrated. If I have, then the next step now is for the composers themselves to assume control of everything that regards music — its performance, its distribution, and its explanation. They must exercise an authority comparable to that exercised by the practitioners of law and medicine. Otherwise music will cease to be a liberal art and become a consumer commodity, an article of commerce, an arm of the state.

The history of the liberal professions in the Soviet Union can be a lesson to us all. Literature, painting, and music there have all relinquished their pride. And though they are highly remunerated, their products are virtually without distinction. The legal profession has not done much better, one gathers, largely because Russian law at the beginning of the Revolutionary period already lacked solidly based traditional procedures. Medicine, on the other hand, and scientific research and scholarship — if we except the brief attempt of certain biologists to differ with the rest of the world about the inheritance of acquired characteristics — have maintained international standards.

The submissiveness of the liberal arts in Russia to political (they call it ideological) control has retarded cultural development and will continue to do so for many years in spite of what seems just now to be a slight lifting of the political pressures. The Russian Association of Professional Musicians, which was in no way opposed to the Revolution, and which merely aspired to guide the new music life in a responsible manner, early offered to the state its cooperation. Its manifesto of 1924 is realistic about Russian musical problems and no end penetrating in its criticisms of the West. Its 1926 declaration is far less ambitious, far more subservient to party ideals. In 1932, in spite of an even humbler statement of servitude, the association was abolished.

Whether a less toadying attitude toward the political authority would have preserved the organization one cannot really know. I suspect it might have, knowing governments, all governments, for the bullies they are and how their truculence tends to collapse before a determined group. Perhaps the Russian musicians got organized too late. Ah, but that is exactly my argument. Now, in a time of peace and prosperity, it may be possible to develop a world setup capable of surviving local changes in power, economics, and ideology. In the midst of political changes, it is not.

There is less probability in the West right now of a Marxist political revolution than there is of a massive reorganization of music's distribution that might be operated by businessmen inspired by the profit motive and abetted by governments avid for culture advertising. Such a reorganization is indeed in process and in danger of handing over musical standards to irresponsible agents. The German composers, wise in our time, saw to it that in the whole postwar restoration in Germany of music's business — its performance, its publication, its patronage, and naturally its pedagogy — they kept a controlling hand. The authority of a small group of them, about ten, today amounts virtually to a veto power over all musical usages; and they have not wielded their power unworthily. A profession, after all, is ever consecrated and responsible. Responsible to itself, I mean. And not to itself as a power group, but to itself as the sole possible preserver of its knowledge and skills. A pro-

fession that is not intellectually autonomous is merely a trade and its product merely a consumer commodity.

When music shall have become just another consumer commodity like chewing gum, its grand epoch will be over. Already a great deal of it is designed, like central heating, to be merely present. Keeping the rot peripheral, preventing it from infecting the heart, is not going to be easy. Too many people make money out of it. But let this book sound a warning, however muted, for musicians to be on their guard lest their rights be handed to outsiders.

I do not like what has happened to music in Russia, and I do not like the whole of what is happening here. There is lots of music around and lots of what passes for its patronage; but there is certainly a tendency parallel to the Russian experiment toward integrating the arts into an industrial-commercial-educational complex, at the expense of their autonomy. Education should serve art, not the contrary.

Autonomy, intellectual and financial, is unquestionably the ideal state for any profession, both for its own well-being and for its contributions to culture. And the West, through its long experience of liberal institutions, is better prepared than Russia for developing professional autonomies. It is quite possible that we shall never know here the degrading lack of intellectual freedom that Russia inherited from the czars and augmented under the Soviet hierarchy. But it is just as possible that we may have to fight a bit toward continuing our own intellectual rights. Believe me, they are under attack.

Such attacks are not always as overt as those of the late Senator McCarthy. They may be masked as encouragement of the arts, with administrators put in control and subsequent threats of withdrawing support; or as documentary studies of the market, which prove that most of the voters prefer corrupt art (as if that fact were either significant or new); or as the protection of a national recording industry, though there is no such thing — there are merely cartels that have made it harder to transport a gramophone record across a frontier than a pint of opium.

The role of the arts in contemporary society, Eastern or Western, is more obscure in this century than it has sometimes been in previous ones. That indecision is not due to the aspirations toward autonomy that are common to all the arts. Quite the contrary, as I have tried to show, autonomy makes their functioning more clear, as well as more powerful. If this is so, one must believe in the arts and give them their head. And their head men (in music it is the composers) must not avoid to lead. Lead where? Toward professional autonomy.

Take care of the professional line and the artistic line will take care of itself. That was my message in 1939. It still is.

PART 5

On the "New York Herald Tribune"

✑ The Paper

THE *New York Herald Tribune* was a gentleman's paper, more like a chancellery than a business. During the fourteen years I worked there I was never told to do or not to do anything. From time to time I would be asked what I thought about some proposal regarding my department; and if I did not think favorably of it, it was dropped.

The city room was an open space filled with flat-top desks, the classical stage set of a newspaper; but what went on there bore no resemblance to the behavior of city staffs in plays and films. I never saw anyone use more than one telephone at a time, and I never heard anyone raise his voice. Exception was the plaintive call of "Copy!" from someone sending a late review down to the typesetters page by page. Self-control was the rule on that floor, just as the avoidance of any haste that might make for error was the style of the linotypers and proofreaders on the floor below.

But if the *Herald Tribune* was a decorous paper, it was also a hard-drinking one. The Artist and Writers Restaurant next door, on Fortieth Street near Seventh Avenue, a former speakeasy run by a Dutchman named Jack Bleeck, received from noon till morning a steady sampling of our staff, of writers from *The New Yorker*, who seemed in general to like drinking with us, of press agents, play producers, and after-theater parties. After the Late City Edition had been put to bed (in those days around half past midnight), our night staff and the working reviewers would gather there to wait out the next half-hour till freshly printed papers were sent down. Everyone read first his own column and after that those of the others. Then we all complimented one another, as one must before discussing points of style or judgment.

The whole staff was pen-proud, had been so, it would seem, since 1912, when Ogden Reid, inheriting the *New York Tribune* from his father

(Ambassador to England Whitelaw Reid), had turned it into a galaxy of stars. And until his death in 1950 it stayed luminous. After that, the care for writing faded and the drinking in Bleeck's bar lacked stamina. I do not insist that drinking and good English go together, though certainly over at the *Times,* on Forty-third Street, the staff seemed neither to roister much nor to write very impressively. In my own case, Geoffrey Parsons had no sooner opened the possibility of my writing for the *Herald Tribune* than a dinner was set up at the Players' Club, with a dozen of the paper's best-drinking old hands, to test my sociability. That was in September, and I passed all right.

It was still not known, of course, how I would behave in front of a deadline. And Parsons, naturally worried on my first night, prowled about till I had finished writing, then held his breath in the composing room while I checked my proofs. He suggested in these one change, the omission of a slap at the audience ("undistinguished" had been my word). At Bleeck's, when the papers came down, my piece read clearly as a strong one, though it contained, I knew, any number of faults, including seventeen appearances of the first personal pronoun. I had entitled this review of the concert that opened the Philharmonic's ninety-ninth season *Age Without Honor*; and I had snubbed the orchestra's conductor, John Barbirolli, by publishing with it the photograph of his concertmaster, Michel Piastro. It was unfavorable throughout — "hard-hitting," my admirers at the bar called it — and it ended with a quote from my companion of the evening (actually the painter Maurice Grosser), "I understand now why the Philharmonic is not a part of New York's intellectual life."

Hired on a Thursday afternoon, I had covered the Philharmonic that night. The next day I reviewed from its home ground the Boston Symphony's opening. The following Tuesday I attended the season's first New York concert of the Philadelphia Orchestra. For the weekend after that, in my first Sunday piece, I compared these groups. And if my first review had been brutal with overstatement, my second set a far more gracious tone ("peaches and cream," Parsons called it).

The quality of this piece was not always to be kept up. Sometimes I would write smoothly, sometimes with a staccato rhythm, darting nervously from thought to thought and failing to carry my readers with me. But on the whole I interested them; and almost from the beginning I did observe standards of description and analysis more penetrating and of coverage more comprehensive than those then current in the daily press. I was aware of this; the music world was aware of it; my colleagues on the paper were immediately aware of the fact that my work had presence. Ettie Stettheimer, neither a musician nor a journalist, compared it to "the takeoff of a powerful airplane." My editors, of course, knew the dangers of so showy an ascent. Also that I was heading into a storm.

For from my first review they received, as did I, reams of protest mail. Mine I answered, every piece of it, and with courtesy. "I thank you for the warmly indignant letter," was one of my beginnings, before going on to some question raised, such as, for instance, that of my own competence. Before very long the editors, aware through the secretarial grapevine of how I could win over to me many an angry correspondent, would send me their own mail for answering, thus making clear that no protest would be heard behind my back.

But at the beginning they showed me only the favorable letters. It must have been two years before Mrs. Ogden Reid, almost more active at the paper then than her husband, admitted that there had been demands for my beheading. What kept the paper firm regarding me, she said, had been the fact that those who wrote to praise me were important novelists like Glenway Wescott, enlightened museum directors like Alfred Barr, art-minded lawyers like Arnold Weissberger, and public-spirited heads of university music departments, such as Douglas Moore — in short, what she called "intellectual leaders" — whereas the protesters were practically all just quarrelsome types without responsibility ("nuts" is the word for these) or, worse, spokesmen for the performing institutions.

The most persistent of these last turned out to be the Metropolitan Opera Association, whose powerful hostesses, bankers, and corporation attorneys seemed to feel that their names on the board of any enterprise ought to render it immune from criticism. At the slightest lese majesty they would make truculent embassies to the paper demanding that I be fired. Urged thus to remove my predecessor, Lawrence Gilman, Ogden Reid had twenty years earlier inquired, "Who's running this paper?" Similarly rebuffed regarding me, the ambassadors would remark that with the death of Mr. Gilman music criticism had lost a great prose writer.

The Philharmonic board, though no less disapproving, early gave up direct intervention in favor of a business maneuver. One of its members did inquire whether I would accept board membership, but I declined. And several, I believe, "spoke" to Mrs. Reid. But the business threat was early provoked, at the end of my second week, when I diagnosed the soprano Dorothy Maynor as "immature vocally and immature emotionally." From e.e. cummings came, "Congrats on the Maynor review. Eye 2 was there." The Columbia Concerts Corporation, however, of which the Philharmonic's manager, Arthur Judson, was president, held a board meeting, and not for determining Miss Maynor's fate, but mine. The decision, one heard, was to withdraw all advertising until my employment at the paper should be ended. This plan might have been troublesome to carry out, since it would have denied our services to all Columbia's artists. But at the time the threat seemed real enough to provoke intervention by another impresario.

Ira Hirschmann, a business executive married to a professional pianist, Hortense Monath, and friend of another, the ever-so-respected Artur Schnabel, had been presenting for several seasons, under the name New Friends of Music, weekly Sunday concerts of the chamber repertory. But weekdays he was advertising manager of Bloomingdale's. So when Hirschmann heard about Columbia's plan, he went to our advertising manager, Bill Robinson, and said, "Mr. Thomson has not yet reviewed my concerts unfavorably, though he well may do so. But whatever happens, I shall match, line for line, any advertising you lose on his account." I did not know about this incident till two years later. But it helps explain the patience of my editors with a reviewer who was plainly a stormy petrel. As a storm bird, I should have preferred to sail above the clouds; but to get there I might have to fly right at them, and bump my beak against their leaden linings.

After twenty years of living inside Europe, I knew well the grandeurs and the flaws of music's past, and that with a big war silencing its present, composition's only rendezvous was with the future. America, for the duration, might keep alive the performing skills. But her strongest composers had shot their bolt in the 1930s and retired, as the phrase goes, into public life, while the younger ones, who had not yet done so, were getting ready either to be mobilized or to avoid that. The time was not for massive creativity, but rather for taking stock. My program therefore was to look as closely as I could at what was going on, and naturally to describe this to my readers, who constituted, from the first, the whole world of music. The method of my examination and my precepts for progress turned out to be those laid down exactly one year earlier in *The State of Music*.

These principles engaged me to expose the philanthropic persons in control of our musical institutions for the amateurs they mostly are, to reveal the manipulators of our musical distribution for the culturally retarded profit makers that indeed they are, and to support with all the power of my praise every artist, composer, group, or impresario whose relation to music was straightforward, by which I mean based only on music and the sound it makes. The businessmen and the amateurs, seeing what I was up to, became enemies right off. Those more directly involved with music took me for a friend, though Germans and the German-educated would bristle when I spoke up for French music or French artists. They would even view my taste for these as a somewhat shameful vice acquired in France.

The opposite was true, of course. I had not come to admire the musical workmanship of France from merely living there; I had lived there, at some sacrifice to my career, because I found French musical disciplines favorable to my maturing. Nor did the Germans suspect how deeply I distrusted their arrogance. For French arrogance about music is merely

ignorance, like Italian arrogance, or American. But the Germanic kind, based on self-interest, makes an intolerable assumption, namely, its right to judge everything without appeal, as well as to control the traffic — as if past miracles (from Bach through Schubert) were an excuse for greed. And all those lovely refugees — so sweet, so grateful, and so willing to work — were to be a Trojan horse! For today the Germanics are in control everywhere — in the orchestras, the universities, the critical posts, the publishing houses, wherever music makes money or is a power.

I made war on them in the colleges, in the concert halls, and in their offices. I did not hesitate to use the columns of my paper for exposing their pretensions; and I refused to be put off by sneers from praising the artists of my choice, many of them foreign to the Italo-German axis. My editors found this method not unfair, for they too, through our European edition, were Paris-oriented. The Germanics would never admit, however, that distributed attention was not mere Francophilia.

My literary method, then as now, was to seek out the precise adjective. Nouns are names and can be libelous; the verbs, though sometimes picturesque, are few in number and tend toward alleging motivations. It is the specific adjectives that really describe and that do so neither in sorrow nor in anger. And to describe what one has heard is the whole art of reviewing. To analyze and compare are stimulating; to admit prejudices can be helpful; to lead one's reader step by step from the familiar to the surprising is proof of polemical skill. And certainly musical polemics were my intent, not aiding careers or teaching Appreciation. And why did a daily paper tolerate my polemics for fourteen years? Simply because they were accompanied by musical descriptions more precise than those being used just then by other reviewers. The *Herald Tribune* believed that skill in writing, backed up by a talent for judgment, made for interesting and trustworthy reviews, also that the recognition of these qualities by New York's journalistic and intellectual elite justified their having engaged me. Moreover, in spite of some protests and many intrigues against me, all of which followed plot lines long familiar, I caused little trouble. If some business or political combine had caused the paper real embarrassment, either through loss of income or through massive reader protest, I should most likely not have survived, for the Ogden Reids, though enlightened, were not quixotic. As Geoffrey Parsons remarked some two years later, "It is possible to write good music criticism now, because no group is interested in stopping you." Which meant, I presume, that I was not a danger to the war effort.

The *Herald Tribune* represented in politics the liberal right, a position usually favorable to the arts. The Know-Nothing right and the Catholic right, as well as the Marxist left, are in all such matters, as we know, unduly rigid. And papers of the moderate left tend, in art, to be skimpy of space — the sheets of massive circulation even more so. But papers

that are privately owned and individually operated make their address
to the educated middle class. *The New York Times* has regularly in its
critical columns followed a little belatedly the tastes of this group; the
Herald Tribune under Ogden Reid aspired to lead them. It did not there-
fore, as the *Times* has so often done, shy away from novelty or elegance.
So when I took as a principle for my column that "intellectual distinction
is news," the city desk, though not quite ready to admit so radical a con-
cept, found my results lively, especially my wide-ranging choice of sub-
jects and my indifference to personalities already publicized to saturation,
such as Marian Anderson and Arturo Toscanini. In fact, when somewhat
later John Crosby, then a staff writer, was asked to start a radio-and-
television column, hopefully for syndication, the managing editor warned
him against overdoing big-time coverage. "Spread yourself around like
Virgil Thomson," he said. "Surprise your readers."

Except for courtesy coverage of opening nights at the Philharmonic
and the Metropolitan Opera, I must say that my choice of occasions was
by the conventions of the time wildly capricious. My third review was of
a woman conductor, Frédérique Petrides, leading thirty players in a piece
by David Diamond. In my second week, reviewing two Brazilian pro-
grams at the Museum of Modern Art, I poked fun at the public image
of that institution, at folklore cults in general, at all music from Latin
America, that of Villa-Lobos in particular, and found an error in the
museum's translation of a title from the Portuguese. I also discovered,
for myself at least, a group of young people called the Nine O'Clock
Opera Company, all just out of the Juilliard School, singing in English
at the Town Hall to a piano accompaniment Mozart's *The Marriage of
Figaro*.

My attack on Dorothy Maynor appeared on October 24, a subse-
quently much-quoted piece in praise of Artur Rubinstein on October 26.
On the twenty-eighth I reported on a WPA orchestra led by Otto Klem-
perer. On the thirty-first appeared a review of Jascha Heifetz entitled
Silk-Underwear Music, in which I called his playing "vulgar." The im-
precision of this adjective and the shocking nature of my whole attack
brought protests on my head from Geoffrey Parsons as well as, through
intermediaries, Heifetz. Tasteless certainly were my adjectives weighted
with scorn; but I could not then, cannot now, regret having told what I
thought the truth about an artist whom I believed to be overestimated.
To all such reputations, in fact, I was sales resistant, like William James,
who had boasted, "I am against greatness and bigness in all their forms."

That winter, along with covering a handful of standard soloists —
Josef Hofmann, Jan Smeterlin, Kirsten Flagstad, Arturo Toscanini, John
Charles Thomas — and with a reasonable attention paid to the orchestras
and the opera, I reviewed Maxine Sullivan (singing in a nightclub), Paul

Bowles's music for *Twelfth Night* (on Broadway, with Helen Hayes and Maurice Evans), Walt Disney's *Fantasia*, a score of musical books and magazines, a student orchestra, two youth orchestras, an opera at the Juilliard School, a Bach oratorio in a church, a Broadway musical by Kurt Weill, Marc Blitzstein's far-to-the-left almost-opera *No for an Answer*, Stravinsky's Violin Concerto turned into a ballet, several other dance performances involving modern music, an economics-and-sociology report from Columbia University on the "hit" trade in popular songs, the Harvard Glee Club ("fair but no warmer"), Holy Thursday at Saint Patrick's Cathedral, a Negro preacher in New Jersey who wore frilled white paper wings over his blue serge suit and played swing music on an electric guitar (he was my Easter Sunday piece), some comical press-agentry received, a WPA orchestra in Newark, three other suburban and regional orchestras, a swing concert at the Museum of Modern Art, an opera at Columbia University, a *Southern Harmony* "sing" in Benton, Kentucky, the Boston "Pops" in Boston, and the Goldman Band in Central Park. By the following season's end I had got round to examining the High School of Music and Art and to considering the radio as a serious source. Recordings I did not touch; another member of my staff had them in charge.

This staff consisted of myself and three assistants — Francis Perkins, who also served as music editor, Jerome D. Bohm, and Robert Lawrence. Bohm, who had conducted opera in his Berlin student days under Leo Blech, was a German-oriented voice teacher and opera coach. Lawrence, already beginning his career as a conductor, was an enthusiast for French music, especially Berlioz. Perkins, though not professionally a musician, was widely read in music's history and devoted to exactitude. Since 1922 he had kept a catalogue, with dates and places, of all the orchestral and operatic works performed in New York City. This was the extension of a somewhat less careful listing begun in 1911 by Edward Krehbiel, and it was unique. He also kept well-indexed clipping books containing all the reviews and news relating to music that appeared in the paper. And he had a shelf of reference books, many of them bought by him, for checking instantly the spelling of a name, the title of a work, the facts about almost anything connected with repertory. And until the department acquired a secretary, it was Perkins who kept the catalogue and scrapbooks up to date, as well as sorting out the publicity and announcements, which arrived in vast abundance at the music desk.

For doing this he often worked late into the night, "mopping up," as he called it, until three or four or five, then attended early Mass, had breakfast, and went home to sleep. A vintage Bostonian and proudly a Harvard man, he allowed himself no weakness or neglect, nursemaiding and housemaiding us all, lest some misstatement or a skimpy coverage

make the paper inglorious. He it was who had in the 1920s and '30s widened the coverage from just the Carnegie-and-Town-Hall beat by slipping out in the course of many an event to visit half of another, something modern usually, that was taking place over at Hunter College or downtown at the New School for Social Research. At this time still a bachelor, he was, as our secretary said, "married to the *Herald Tribune*"; and if he did not sleep on the premises (as he sometimes did at concerts), he very often spent the whole night there.

Replying to my mail, to all those "letters fan and furious" that I sometimes published along with my answers in lieu of a Sunday think-piece, had early earned me stenographic aid. So when the managing editor lent me his own secretary for use on Tuesdays, his day off, this unprecedented precedent caused Perkins too to ask for help, which was granted. And eventually, at her own request, my secretarial abettor, Julia Haines, was allowed to work wholly for the music department, a happy arrangement that long survived my tenure.

Julia was a jolly and sharp-tongued Irishwoman who, from having been around some twenty years, was on girl-to-girl terms with the secretaries of Ogden Reid, Helen Reid, and Geoffrey Parsons. Her discretion was complete, and so was her devotion to me. She told her colleagues all the favorable news, showing them admiring letters from prominent persons and unusually skillful replies of mine to the opposition. In return they kept her informed of good opinions received in their offices. If they let her know of any trouble about me, she did not pass that on. They could hint, however, at some complaint that Parsons or the Reids would not have wished to make directly. And she would pass back my reply, embarrassing no one.

She also, on the paper's time, typed all my private correspondence — answers to inquiries about publication, to engagements offered, even to personal letters. And thanks to her use of the secretarial back fence, my life was completely exposed. I liked it that way, and so did my employers. Thus no tension that might arise risked becoming exaggerated, a situation especially valuable with regard to Helen Reid. For though we shared mutual admiration, I almost invariably rubbed her the wrong way. My impishness and my arrogance were equally distasteful, and something in my own resistance to her dislike of being rubbed the wrong way led me over and over again to the verge of offense.

Nevertheless, in spite of our tendency to draw sparks from each other, we worked together quite without distrust. After I had once procured music for the Herald Tribune Forum, a three-day feast of famous speakers held every year in the Hotel Waldorf-Astoria ballroom, she offered to pay me for doing this every year; when I declined payment, my salary was raised. She did not interfere in any way with my department's oper-

ations, but eventually she came to ask my advice about pressures and complaints received regarding these operations. And when the general manager of the Metropolitan Opera, Rudolf Bing, surely displeased with my reviewing of his policy statements, sought to cultivate her favor through invitations to his box, she showed him where her confidence lay by inviting me, along with my chief supporter, my discoverer indeed, Geoffrey Parsons, to lunch with him at the paper.

With Parsons there was never misunderstanding. He admired me, forgave me, adopted me into his family. Besides, he was committed to making a success of me, since my appointment had been wholly of his doing. When I misbehaved, as in the Heifetz review, he would correct me kindly, clearly, with reasons, and with always a joke at the end. When during one of my contests with the Metropolitan Opera, he found in my answer to their protest a reference to the "ladies" of the Opera Guild, he reminded me that "lady" is an insulting term because of its irony. "Always attack head-on," he said. "Never make sideswipes and never use innuendo. As long as you observe the amenities of controversy, the very first of which is straightforward language, the paper will stand behind you."

Nevertheless, he would send to my office from time to time a letter pained, impatient, and unclear. These, I came to believe, meant he had been asked by someone, probably Mrs. Reid, to "speak to Virgil." The speakings were not, of course, unjustified, merely out of proportion to the visible fault. And they were not phrased in Geoffrey's normal way, which was ever of wit and sweetness. I would acknowledge them with all delicacy of phrase, almost as if Geoffrey were some irate unknown, and then be more careful for a while. These occasions were not frequent, and no enmity seemed to build up through them. After my first two years they happened rarely, and during the last twelve almost not at all. I must eventually have learned smoother ways, for in 1946, on my fiftieth birthday, Carleton Sprague Smith could say, "Six years ago Virgil was one of the most feared men in New York; today he is one of the most loved." Imagine that!

My errors, when they occurred, were of two kinds, those which shocked the prejudice of readers and those which caused inconvenience to management. In the first kind of case I was merely cautioned to watch my language, use no slang, explain everything, be persuasive. For indeed, in expository writing, failure to convince is failure *tout court*. Inconvenience to management arriving through complaint from prominent persons was not necessarily unwelcome, however. The Metropolitan Opera, the Philharmonic, the Museum of Modern Art, the radio establishments that presented Toscanini or owned Columbia Concerts, these were familiar opponents, and battling with them was tonic to us all. For

that sport, methods of attack and defense were our subjects of gleeful conference, punctilio and courtesy our strategy; getting the facts right was our point of honor, exposing them to readers our way of being interesting.

The orchestras from out of town, such as Boston and Philadelphia, sent us no embassies. And the standard touring soloists one rarely heard from, even indirectly. What seemed most to bother Mrs. Reid and Geoffrey was unfavorable comment on a suburban affair. My questioning the civic value to Stamford, Connecticut, of a quite poor symphony orchestra brought two strong letters from Parsons. Conflict with Manhattan millionaires, I could read between the lines, was permitted, but not with country clubs. Suburbia had long supplied the nut of our liberal Republican readership, and the paper's eventual drama of survival came to be played out against the sociological transformation of those neighborhoods. Discouraging suburbia about anything, I understood, was imprudent. For the richer suburbs, like churches, accept only praise.

Geoffrey was right, of course; he always was. My quality as a reviewer came from my ability to identify with the makers of music; and when I spoke both as an insider to music and warmly, my writing, whether favorable or not, was communicative. But I simply could not identify with organizers and promoters, however noble their motives. Going out of one's way to cover something not usually reviewed is a lark, provided you can get a lively piece out of it. If not, wisdom would leave it to the merciful neutrality of the news columns. But when you are new to reviewing and still reacting passionately, you are not always led by wisdom. And later, when you have more control, you are not so passionate. Neither are you quite so interesting. Because the critical performance needs to be based on passion, even when journalism requires that you persuade. And in the early years of my reviewing, Geoffrey was like a guardian angel, an athletic coach, and a parent all in one, hoping, praying, and probably believing that with constant correction and copious praise I could be kept at top form.

I had entered music reviewing in a spirit of adventure; and though I never treated it as just an adventure, I did not view it as just journalism either. I thought of myself as a species of knight-errant attacking dragons single-handedly and rescuing musical virtue in distress. At the same time I ran a surprisingly efficient department, organized a Music Critics' Circle (still in existence), started a guest column on radio music, by B. H. Haggin, and a jazz column, with Rudi Blesh as star performer. When the war removed two of my staff members, I employed Paul Bowles to substitute for one of them and took on later the composer Arthur Berger; I also caused the engagement of Edwin Denby for a year and a half as ballet reviewer; and I established a panel of music writers from outside

the paper who helped us keep the coverage complete. This pool of "stringers" constituted a training corps that comprised my future music editor, Jay Harrison, and the later *New York Times* staff writers Theodore Strongin and Allen Hughes. At one time or another it included the music historian Herbert Weinstock and the composers Elliott Carter, John Cage, Lou Harrison, William Flanagan, Lester Trimble, and Peggy Glanville-Hicks.

I used no one not trained in music, for my aim was to explain the artist, not to encourage misunderstanding of his work. I discouraged emotional reactions and opinion-mongering on the grounds that they were a waste of space. "Feelings," I would say, "will come through automatically in your choice of words. Description is the valid part of reviewing; spontaneous reactions, if courteously phrased, have some validity; opinions are mostly worthless. If you feel you must express one, put it in the last line, where nothing will be lost if it gets cut for space."

My copy was never cut; neither did it ever make the front page. I wrote in pencil, proofread the manuscript before sending it down, preferring, should errors occur, that they be my own. After the first year I did not go downstairs at all, checking my Sunday proofs at home, sent there by messenger. In my first weeks I had asked Francis Perkins how long it would take to get over being unduly elated or depressed at a musical event. "About six years," he had said. And he was right. After that time I could write a review, go off to bed, and wake up in the morning with no memory of where I had been or what I had written. Twice, to my knowledge, I reviewed a contemporary work without remembering I had done so two years earlier. And in both cases my descriptions were virtually identical in thought, though not in words.

I had established my routines very early. During seven months of the year I wrote a Sunday article every week and averaged two reviews. During the summer months I did no reviewing; I also skipped seven or eight Sunday articles. Since these could be sent from anywhere, I toured on musical errands of my own or stayed in some country place writing music. I also wrote music in town, published books, went in and out on lectures and conducting dates. The paper liked all this activity, because it kept my name before the public. Also because I usually came back with a piece about San Francisco or Texas or Pittsburgh (after the war, Europe and Mexico and South America, too), which was good for circulation. To the Herald Tribune Forum, I added for musical relief opera singers, Southern hymn singers, Negro choirs, and Robert Shaw's Collegiate Chorale. In all these arrangements, my dealings with Helen Reid were quite without friction or misunderstanding. Indeed, unless I look at my scrapbooks I can hardly remember my last ten years at the paper, so thoroughly satisfactory were they to us all and so little demanding of

my time. The dramas had all come in the first four, for those were the years when I was learning my trade while working at it. These were also, of course, the war years, naturally full of emergencies, revelations, excitements, departures, arrivals, surprises, and strange contacts.

✑ *Articles and Reviews,*
1940 – 1945

1940

Age Without Honor

✑ THE Philharmonic-Symphony Society of New York opened its ninety-ninth season last evening in Carnegie Hall. There was little that could be called festive about the occasion. The menu was routine, the playing ditto.

Beethoven's Overture to *Egmont* is a classic hors d'œuvre. Nobody's digestion was ever spoiled by it and no late comer has ever lost much by missing it. It was preceded, as is the custom nowadays, by our national anthem, gulped down standing, like a cocktail. I seem to remember that in 1917 and 1918 a sonorous arrangement of *The Star-Spangled Banner* by Walter Damrosch was current at these concerts. After so long a time I couldn't be sure whether that was the orchestration used last night. I rather think not. Last night's version seemed to have more weight than brilliance. It had the somber and spiritless sonority of the German military bands one hears in France these days. That somberness is due, I think, to an attempt to express authority through mere blowing and sawing in the middle ranges of the various instruments, rather than by the more classical method of placing every instrument in its most brilliant and grateful register in order to achieve the maximum of carrying power. I may be wrong about the reasons for it, but I think I am right about the general effect, unless my seat was in an acoustical dead spot of the hall, which I do not think it was. The anthem, to me, sounded logy and coarse; it lacked the buoyancy and the sweep that are its finest musical qualities.

Elgar's "Enigma" Variations are an academic effort not at all lacking in musical charm. I call them academic because I think the composer's interest in the musical devices he was employing was greater than his effort toward a direct and forceful expression of anything in particular. Like most English composers, Elgar orchestrates accurately and competently. Now, when a man can do anything accurately and competently he is always on the lookout for occasions to do that thing. In the Con-

tinental tradition of music writing orchestration is always incidental to expression, to construction, to rhetoric. Many of the greatest composers — Chopin and Schumann, for instance — never bothered to become skillful at it in any major way. Others, like Beethoven and Brahms, always kept its fanciness down to the strict minimum of what expression needs. I've an idea the Elgar Variations are mostly a pretext for orchestration, a pretty pretext and a graceful one, not without charm and a modicum of sincerity, but a pretext for fancywork all the same, for that massively frivolous patchwork in pastel shades of which one sees such quantities in any intellectual British suburban dwelling.

Twenty years' residence on the European continent has largely spared me Sibelius. Last night's Second Symphony was my first in quite some years. I found it vulgar, self-indulgent, and provincial beyond all description. I realize that there are sincere Sibelius lovers in the world, though I must say I've never met one among educated professional musicians. I realize also that this work has a kind of popular power unusual in symphonic literature. Even Wagner scarcely goes over so big on the radio. That populace-pleasing power is not unlike the power of a Hollywood class-A picture. Sibelius is in no sense a naif; he is merely provincial. Let me leave it at that for the present. Perhaps, if I have to hear much more of him, I'll sit down one day with the scores and find out what is in them. Last night's experience of one was not much of a temptation, however, to read or sit through many more.

The concert as a whole, in fact, both as to program and as to playing, was anything but a memorable experience. The music itself was soggy, the playing dull and brutal. As a friend remarked who had never been to one of these concerts before, "I understand now why the Philharmonic is not a part of New York's intellectual life."

OCTOBER 11, 1940

Sonorous Splendors

❧ AND SO in cerulean sunshine and through indescribable splendors of autumnal leafage, to Boston the Hub of the Universe, the Home of the Bean and the Cod. The home as well of the Boston Symphony Orchestra, the finest by all-round criteria of our resident instrumental foundations.

The sixtieth season of its concerts opened this afternoon with Vaughan Williams's *London Symphony*. I remember hearing the work nearly twenty years ago in that same Symphony Hall, Pierre Monteux conducting. It is the same piece it was then too, in spite of some cuts operated by the composer. The first two movements are long, episodic, disjointed. The third is short, delicate, neatly sequential, compact, efficacious, charming. The finale is rich and varied. Its musical material is of high quality, its instrumental organization ample and solid. Also it is not

without expressive power. Perhaps one is accustomed to the lengthiness and the slow reflective atmosphere of the symphony by the time one gets to this movement. The improvement in melodic material that manifests itself as the work progresses helps too. In any case, the last two of the symphony's four movements are anything but dull, which the first two are, and more than a little.

Making a program out of only that and Beethoven, out of one live Englishman and one dead German, classic though he be, is an obvious reference to current events and sympathies. The reference might have turned out in its effect to be not nearly so gracious as in its intention had those last two movements of the *London Symphony* not been in themselves so impressive, the finale so deeply somber. It was written in 1913, I believe. It might have been written last month, so actual is its expressive content.

The Vaughan Williams symphony served also as a vehicle for a display of orchestral virtuosity on the part of Dr. Koussevitzky and his men, such as few orchestras are capable of offering their subscribers. Not that the piece itself is of any great difficulty; it is only reasonably hard to play, I imagine. But the Boston organization is in such fine fettle after its Berkshire season that every passage, any passage, no matter what, serves as a pretext for those constant miracles of precision and of exact equilibrium that a first-class orchestra is capable of.

Musically considered, these refinements are more of a delight in themselves than a help of any kind to the work played. They rather tend, especially in the fine molding and rounding off of phrases, to interrupt the music's continuity, to give it an exaggerated emphasis all over that obliterates any real emphasis or meaning that the score may imply. Only the toughest of the classics and the most glittery of the moderns can satisfactorily resist that kind of polish.

The Beethoven Fifth Symphony resists it quite satisfactorily indeed. Dr. Koussevitzky, be it said to his credit, doesn't try to get away with too much careful molding, either. Rather he puts his effort into a rhythmic exactitude that adds to Beethoven's dynamism a kind of monumental weight that is appropriate and good. When he tries to achieve more of that weight by forcing the strings beyond their optimum sonority, the result is not so good. The sound that comes out is less loud and less weighty than that which would have come out if the point of maximum resonance had not been surpassed.

All instrumentalists know this; and conductors, of course, know it too when they are calm enough to remember it. But at the back of every conductor's mind is a desire to make his orchestra produce a louder noise than anyone else's orchestra can produce, a really majestic noise, a Niagara Falls of sound. At some time in the course of nearly every concert this desire overpowers him. You can tell when it is coming on by the

way he goes into a brief convulsion at that point. The convulsion is use-
ful to the conductor, because it prevents his hearing what the orchestra
really sounds like while his fit is on. But if you listen carefully and
watch, you will usually find that the sound provoked by any gesture of
the convulsive type is less accurate in pitch and less sonorous in decibels
than a more objectively conducted fortissimo.

It may seem graceless on my part to mention here a fault almost no
conductor is free of and to imply by so doing that there is something
particularly regrettable about Dr. Koussevitzky's sharing it. I do mean
to imply exactly that, however, because somewhere, sometime, some
conductor must get around to doing some serious work on the orchestral
fortissimo comparable to the work that has already produced from our
orchestras such delights of delicacy. And I think it not unfair to suggest
that perhaps our finest instrumental ensembles might be just the groups
to profit most by such an effort, that maybe it is even their duty to do
something about correcting the inefficiencies that come from being over-
strenuous.

OCTOBER 12, 1940

Velvet Paws

∾ THERE IS a whispering campaign around New York which would
pretend that the Philadelphia Orchestra has gone off too, and seriously.
Do not believe it. The Philadelphia ensemble is as fine a group of or-
chestral players as exists anywhere, and the sounds that emerge from
their instruments are in every way worthy of the superb musicians who
play these instruments. Certainly last night's performance showed no
evidence, to my ear, of carelessness, of indifference, or of sabotage.

Nowhere else is there such a string choir; one would like to stroke its
tone, as if the suavity of it were a visual and a tactile thing, like pale
pinky-brown velvet. If memory does not trick, that luxurious and justly
celebrated string tone is less forced, less hoarse and throaty than it was
in the days of the all too Slavic ex-King Leopold, now of Hollywood.

There are conductors more highly paid than Eugene Ormandy, in all
probability. There are certainly some more highly advertised. Very few
musicians anywhere in the world, however, conduct an orchestra with
such straightforwardness, such lively understanding, such dependable
architectonics. No lackadaisical daisy he, and no Holy Roller either. His
every gesture is civilized, sane, effective. The resultant musical perform-
ance is in consequence civilized, sane, and effective beyond all compari-
son with that of his more showily temperamental colleagues.

Last night's program opened with Mr. Ormandy's own reorchestration
of a Handel piece here entitled Concerto for Orchestra in D major. For
once let us praise a man for tampering with the classics. The score is as

brilliant and gay and Handelian as one could wish. I found it no end jolly.

This reviewer also sat through another Sibelius symphony, No. 1, listening attentively. The melodic material was everywhere of inferior quality; the harmonic substructure was at its best unobtrusive, at its worst corny. The scoring seemed accurate and sure-fire, not a cough in a carload.

The formal structure, such as there was, was a smooth piecing together of oddments, not unlike what is known to the film world as "cutting." As in a well-cut film, occasions for compensating the essential jerkiness of the flow were exploited whenever they could be found; at those moments something took place not unlike the "plugging" of a theme song.

There is not space here, nor time tonight, to go into the Sibelius matter any further than this. Suffice it to say that for the present I stick to my opinion of last Friday, which was that I found his music "vulgar, self-indulgent, and provincial." Respighi's brilliant but meretricious *Feste Romane* sounded last night like good clean musical fun in comparison.

OCTOBER 16, 1940

Great Music

֍ IT IS NOT easy to define what we mean by great music, but it is very easy to agree that the nineteenth century produced lots of it. It is also easy for musicians to agree that Frédéric Chopin was one of the great composers of that century, quite possibly the very greatest of them all. Last night a whole fistful of Chopin's greatest works were played in Carnegie Hall by one of our greatest living pianists, Artur Rubinstein.

Mr. Rubinstein is a delight to watch as well as to hear. Though he is as fastidious as one could wish in his musical execution, his platform manner is straightforward, well bred, businesslike. His delicacy is delicate, his forte powerful. His marksmanship is superb, his melodic tone rich and deep. He can play loud and soft and fast and slow without interrupting the music's rhythmic progress. He is a master of his instrument and of the music he plays, and he finds no reason for attracting undue attention to anything else. He is authoritative, direct, and courteous, like the captain of a transatlantic liner.

His pianism is of the close-to-the-key school. Hence the good marksmanship. Hence, also, its lack of any bright, pearly brilliance. His arms and torso are of stocky build. Hence the power of his climaxes, the evenness of his pianissimo. He is Polish by birth, if I mistake not. Hence his complete at-homeness in Chopin's music, like a host in his father's house.

He is most at home in straightforward pieces, like the etudes, and in long, massive works like the sonatas, the ballades, the scherzos, works that call to action his mastery of dramatic line, of architectural sweep. He plays the tricky mazurkas and nocturnes with less ease. They don't

give him enough room to move around in, and so he rather streamlines them than builds them.

His rubato is of the Paderewski tradition. I do not know how that tradition got started, but I do not think it comes from Chopin. It sounds Viennese to me.

Chopin's prescription for rubato playing, which is almost word for word Mozart's prescription for playing an accompanied melody, is that the right hand should take liberties with the time values, while the left hand remains rhythmically unaltered. This is exactly the effect you get when a good blues singer is accompanied by a good swing band. It is known to the modern world as *le style hot*. The Paderewski tradition of Chopin playing is more like the Viennese waltz style, in which the liberties in the melody line are followed exactly in the accompaniment, the two elements keeping always together and performing at the same time a flexible distortion of strict rhythm that manages by its very flexibility to keep the procedure from seeming arbitrary or the continuity from collapsing. Mr. Rubinstein is skillful at this kind of rubato. He keeps the music surging. But I don't believe for a moment it resembles anything Frédéric Chopin ever did or had in mind.

On more than this count does Rubinstein make one think of Paderewski. Among his encores (he played the C-sharp minor Waltz and the Etude for the Little Finger also) he gave such a rendition of the A-flat Grande Polonaise as it has not been my pleasure to hear in many a day. Such steadiness, such power, such fury, such truly magnificent transcending both of the piano's limitations and of his own customary accuracy were the very substance of Paderewski's greatness. They were Mr. Rubinstein's last night, a final jewel in his already laureate crown.

OCTOBER 26, 1940

Silk-Underwear Music

♫ Robert Russell Bennett's *Hexapoda*, five musical sketches of the jitterbug world, are pretty music. Also, they are evocative of swing music without being themselves swing music or any imitation of swing music. They manage with skill and integrity to use swing formulas as a décor for the musical depiction of those soul states and nerve reflexes that swing lovers commonly manifest when exposed to swing music. They are, in addition, magnificently written for the violin. They come off, as the phrase has it, like a million dollars.

Jascha Heifetz's whole concert rather reminded one of large sums of money like that. If ever I heard luxury expressed in music it was there. His famous silken tone, his equally famous double-stops, his well-known way of hitting the true pitch squarely in the middle, his justly remuner-

ated mastery of the musical marshmallow were like so many cushions of damask and down to the musical ear.

He is like Sarah Bernhardt, with her famous "small voice of purest gold" and her mastery of the wow technique. First-class plays got in her way; she seldom appeared in one after thirty. Heifetz is at his best in short encore pieces (the Bennetts are beautifully that) and in lengthy chestnuts like Spohr's *Gesangscene,* an old-time war-horse for violinists, where every device of recitative style, of melodic phrase turning, and of brilliant passage work is laid out, like the best evening clothes and the best jewelry, for Monsieur to put his elegant person into. No destination, no musical or emotional significance, is implied.

The Richard Strauss Sonata, a work of the author's early manhood, lacks none of that composer's characteristic style. The themes could only be his (albeit one was practically straight out of *Carmen*), bombastic, second rate (I except the one that starts the last movement, which is bombastic and first rate), inflated, expressing nothing but the composer's fantastic facility, his jubilant gusto at writing music. Mr. Heifetz's execution of this was almost embarrassingly refined.

Of his Mozart, the less said the better. It is of the school that makes a diminuendo on every feminine phrase ending, that never plays any phrase through with the same weight, that thinks Mozart's whole aim was to charm, that tries so hard to make out of the greatest musician the world has ever known (those are Josef Haydn's words) something between a sentimental Pierrot and a Dresden china clock that his music ends by sounding affected, frivolous, and picayune. If that is Mozart, I'll buy a hat and eat it.

I realize that my liking or not liking what Mr. Heifetz plays and how he plays it is a matter of no import to the stellar spaces in which he moves. But it happens that I did go to the concert last night and that I did listen pretty carefully to his superb (there is no other word but the nineteenth-century one) virtuosity. It was admirable and fine and swell and O.K. and occasionally very, very beautiful. The fellow can fiddle. But he sacrifices everything to polish. He does it knowingly. He is justly admired and handsomely paid for it. To ask anything else of him is like asking tenderness of the ocelot.

Four-starred super-luxury hotels are a legitimate commerce. The fact remains, however, that there is about their machine-tooled finish and empty elegance something more than just a trifle vulgar.

OCTOBER 31, 1940

Correct and Beautiful

↬ STRAIGHTFORWARDNESS on the concert platform is something rarely encountered except on the part of children and of the very finest

artists. Straightforwardness in musical execution is practically met with only on the part of great artists. Kirsten Flagstad is straightforward in her platform manner and in her musical interpretations.

She is not, for that, an unsubtle musician. Nor is her majestic voice an unsubtle instrument. All the shading is there that one might wish and all the refinement of expression that lieder repertory requires, which is much. But such an assured mistress is she of her voice, and so clear is her comprehension of the songs she sings, that she is not constrained to seek to please her listeners by any trick of willful charm or cuteness or feigned emotion.

In consequence, she can afford the highest luxury of the concert stage, which is to sing the songs of Brahms and Grieg and Hugo Wolf and of our American song writers as simply and as candidly as Alfred Lunt, say, might read Shakespeare's sonnets in a drawing room. No intonation is false, no word unclear, no sentiment either under- or overstated. By eschewing exploitation of her personality, she warms all hearts to that personality. By not feeling obliged to give her operatic all to every tender melody, she offers us each song as if it were a living thing in our hands, like a bird.

Our century has known great mistresses of vocalism and many intelligent interpreters of songs. I doubt if there has existed within the memory of living musicians another singer so gifted as to voice, so satisfying as to taste, and withal such mistress of her vocal instrument as Kirsten Flagstad. Some singers sing by nature, others take lessons for years. It is scarcely more than once or twice in a century that any vocalist ever masters his voice with the kind of mastery that pianists have of the piano, masters it seriously and completely, while he is still in command of all his vocal resources. Mostly they sing by ear and learn to use the voice correctly only after its best notes are worn out and gone. Miss Flagstad has a great voice now which she handles as if it were a racehorse she had bred and trained.

She can sing loud and she can sing soft. She can sing fast and she can sing slow. She can sing high, low, in strict time, in free time, with clear words, on pitch, swelling or diminishing in volume. This, plus a clear comprehension of the human significance of the music one wishes to sing, is the whole art of singing.

Her voice must not have been an easy one to train, either. Her high, low, and middle registers are noticeably different in timbre. Her scale is as smooth as that of a flute or trumpet; but her ranges, heard separately, are as sharply differentiated as the ranges are of any other wind instrument. One of the most satisfying qualities of her singing is the way her chest-voice sounds like chest-voice, her head-voice like head-voice, and her middle-voice like ordinary speech, while at the same time the

transition from one range to another is so gentle and so even as to be virtually imperceptible excepting when there is a skip in the melodic line.

Edwin McArthur accompanied from memory. He gave support, allowed flexibility, was in general straightforward and highly pleasant to hear. He was more like a partner in an adequately rehearsed duet than like the more usual obsequious accompanist.

NOVEMBER 9, 1940

Complete Authority

ᴏ̃ᴗ JOSEF LHEVINNE seems to have replaced the late Leopold Godowsky as the acknowledged master of piano mastery. A full house paid him homage last night at Carnegie Hall as he, in turn, paid his audience the honor of executing a distinguished program of the piano's masterworks with authority and no playing down to anybody.

A more satisfactory academicism can scarcely be imagined. Mr. Lhevinne's performance, especially of the Schumann Toccata and the Chopin Etudes, was both a lesson and an inspiration. He made no effort to charm or to seduce or to preach or to impress. He played as if he were expounding to a graduate seminar: "This is the music, and this is the way to play it."

Any authoritative execution derives as much of its excellence from what the artist does not do as from what he does. If he doesn't do anything off color at all, he is correctly said to have taste. Mr. Lhevinne's taste is as authoritative as his technical method. Not one sectarian interpretation, not one personal fancy, not one stroke below the belt, not a sliver of ham, mars the universal acceptability of his readings. Everything he does is right and clear and complete. Everything he doesn't do is the whole list of all the things that mar the musical executions of lesser men.

This is not to say that tenderness and poetry and personal warmth and fire are faults of musical style, though they frequently do excuse a faulty technique. I am saying that Mr. Lhevinne does not need them. They would mar his style; hence he eschews them. He eschews them because his concept of piano music is an impersonal one. It is norm-centered; it is for all musical men. Any intrusion of the executant's private soul would limit its appeal, diminish its authority.

Thus it is that Mr. Lhevinne's performance is worthy of the honorable word *academic*. And if he seems to some a little distant, let us remind ourselves that remoteness is, after all, inevitable to those who inhabit Olympus.

NOVEMBER 18, 1940

Music from Chicago

~~ THE Chicago Symphony Orchestra sounds like a French orchestra. Its fiddle tone, thin as a wedge, espouses by resemblance those of oboe and trumpet, absorbs nothing, stands clear in the orchestral bouquet. All the instrumental sounds stand clear and separate. Their harmony is one of juxtaposition, not of absorptive domination. As in an eighteenth-century flower picture, all is distinct, nothing crushed.

Brahms's Third is the best built, the most continuous of his symphonies; and it contains, on the whole, the strongest melodic material of the four. With no weakness of structure to conceal and no gracelessness in its musical content to disturb the clarity of its message, it offered to Frederick Stock occasion for one of those rare and blessed readings in which the music seems to play itself. Especially the end movements, the first and the last, floated on a Viennese lilt, pastoral, poetic, and effortlessly convincing. The passage in the finale was particularly happy where the winds play sustained harmonic progressions which the violins caress with almost inaudible tendrils of sound, little wiggly figures that dart like silent goldfish around a rock.

Roy Harris's *American Creed* invites kidding, as all of his programistically prefaced works do. If we must take his music as he offers it, however, we risk refusing a quite good thing. No composer in the world, not even in Italy or Germany, makes such shameless use of patriotic feelings to advertise his product. One would think, to read his prefaces, that he had been awarded by God, or at least by popular vote, a monopolistic privilege of expressing our nation's deepest ideals and highest aspirations. And when the piece so advertised turns out to be mostly not very clearly orchestrated schoolish counterpoint and a quite skimpy double fugue (neither of which has any American connotation whatsoever), one is tempted to put the whole thing down as a bad joke.

The truth, however, is other. Mr. Harris, though the bearer of no exceptional melodic gifts and the possessor of no really thorough musical schooling, has an unquenchable passion to know and to use all the procedures of musical composition. He has pondered over the medieval French melodic line and over the problem of continuous (nonrepeating) melodic development, and he has come by this road to understand where the crucial problem lies in America's musical coming-of-age. That problem would seem to be how shall we absorb all of European musical culture rather than merely that current in Vienna between the years 1790 and 1890. Harris has learned by meditation and hard work that if we expect to produce music worthy to rank with that of the Viennese masters we must go through a selective evolution comparable to that which took place in Europe for at least three centuries before the miracle of Vienna occurred.

He knows that musical material, even folklore material, is as international as musical form and syntax, that localism is no more than one man's colorful accent. He knows this so well that he avoids, as though it were of the devil, any colorful accent whatsoever. He puts his musical effort on serious problems of material and of form. He does not always get anywhere in his music; but it is serious music, much more serious music than his blurbs would lead one to believe.

He is monotonous in his material and in his form. (All his pieces begin alike.) But every now and then something really happens. It happened last night in the closing pages of both movements of his *Creed*. It was unexpected, original (in spite of the Stravinsky allusion), and beautiful. And it had exactly as much to do with America as mountains or mosquitoes or childbirth have, none of which has any ethnic significance whatsoever.

NOVEMBER 21, 1940

Theater and Religion

꙼ MANAGERS refer to him as The Maestro. Orchestral players call him The Old Man in much the same spirit of reverence and fear with which persons resident on the banks of the Mississippi never use any other name for that mighty stream than simply The River. This department had anticipated employing the polite but noncommittal form, Mr. Toscanini. After last Saturday night's rendition of the Verdi Te Deum and Requiem, we feel more like shouting: "The Old Man is back!"

No better piece could he have chosen than the Verdi Requiem to make us appreciate his qualities as a master of musical theater. Gaudy, surprising, sumptuous, melodramatic, and grand is Verdi's homage to Italy's poet and his own dear friend Manzoni. No religious musical work of the last century is more sincerely or more completely what it is. Theatrical religion or religious theater? Let him answer who could tell us the same of nineteenth-century Neapolitan church architecture. Nowhere as in Naples does the eye find such constant verification of what the ear tells us when we listen to Palestrina, to Bach, to Mozart — namely, that to the sincerely religious there is no difference between sacred and secular style.

Verdi, though not a particularly pious man, was a sincere Catholic; he was also a man of the theater and an Italian. His Requiem is as sincere a piece of theatrical Italian Catholicism as has ever been written. Sincere Protestants often find it shocking. Sincere nonbelievers are likely to find it comic. But so might any one find the Dies Iræ itself who had no stomach for horror.

The only sound esthetic standard I know of that covers all works and epochs is that anything is all right if it is enough so. That is to say that extremism in art, when it really is extreme, and middle-of-the-road normal-

ity, when it is really clear and comprehensible to all men, carry in their very extremism and universality the hallmarks of their authenticity. The Verdi Requiem has never raised any eyebrows in Naples (with which city, the seat of Verdi's greatest operatic successes, I like to identify it spiritually) or even in Milan (where it was first performed, in 1874). The question of its acceptance into the musical tradition of Protestant America is still, on account of its extreme theatricality, undecided.

As music that is not only very beautiful in itself, but that is also really "enough so," I give it my vote. I have not always been of that mind; I have long considered it an oddity of which the intrinsic worth scarcely justified the difficulties of a proper execution. After Saturday's performance I have no reserves.

The Maestro conducted it as if it were no more complicated than the "Miserere" from *Il Trovatore* and no less splendidly compelling than *Otello* or *La Traviata*. The Westminster Choir, handsomely gowned in white satin and violet velvet of ecclesiastical cut, sang perfectly. But perfectly. The soloists, Zinka Milanov, Bruna Castagna, Jussi Bjoerling, and Nicola Moscona, sang like stars from some celestial opera house. The two ladies merit each a mark of 99 percent for their rendition of the impossible Agnus Dei passage in parallel octaves unaccompanied. The kettledrummer, whose name I do not know, merits mention in heaven for his two-stick, unison explosions in the Dies Iræ and for the evenness of his Verdian *ppppp* rolls elsewhere.

Worthy of mention, too, is the implied homage to a regretted musician in the choice of this particular program by Mr. Toscanini to raise money for the Alma Gluck Zimbalist Memorial of the Roosevelt Hospital Development Fund. Just as the great expatriate Italian could have chosen no work more advantageous for himself to conduct, I can think of no more appropriate piece of music with which to honor the memory of a much-loved opera singer than Verdi's sincerely and superbly operatic Requiem.

NOVEMBER 25, 1940

Pipe-Organ Obsession

ɷ IT BECOMES increasingly clear to this listener that Leopold Stokowski's concept of orchestral music is derived from organ playing. He cares nothing for the spontaneous collaboration that is the joy of ensemble players, the kind of perfect concord that swingsters call being "in the groove" and that French instrumentalists refer to as "the little blue flame." He treats his men as if they were 110 stops of a concert organ, each complete with swell box, all voiced for solo use, and mutually adjusted for producing balanced chords of any timbre at any degree of loudness or softness.

His latest seating arrangement is an adaptation to orchestral uses of

pipe-organ antiphony. He long ago did away with the classical symphonic antiphony of first violins on one side against seconds on the other, through both of which pierce succeeding layers of supporting woodwind, brass, and percussion. He has his musicians arranged now with all the strings massed at back center as if these were a single homogeneous body of foundation tone, like Great Organ diapasons, with woodwinds out in front, like a Choir Organ, or *positif*, and with the brasses at the right and left downstage corners, like the heavy solo reeds of a French organ, the horns playing antiphonally on one side against the trumpets and trombones on the other.

This massive acoustico-architectural layout established, he proceeds to play on the whole thing with his bare fingers as if it were a solo instrument. Nothing is left to the musicians' personal taste or feeling. He even went so far last night as to mold William Kincaid's flute passages by hand, an insulting procedure toward an artist of Kincaid's stature, but a necessary procedure for producing the kind of one-man musical performance that Mr. Stokowski has in mind.

He carries his pipe-organ obsession even to the extent of imitating organ rhythm. Now the organ, a mechanical wind instrument, knows no lilt or swing. It executes an even scale and an evenly progressive crescendo or diminuendo. It can play *sforzando* and *fortepiano*, but its accent knows no beat. Its rhythm is entirely quantitative, a question of long and short note values, never of beat stresses varied within the measure.

To have made Brahms's Haydn Variations, with their Viennese lilt and only occasional passage of nonaccentual music that sets off by contrast their otherwise steadily swinging rhythm, into something that sounded like nothing so much as a skillful organ transcription of these same Variations is a triumph of will power as well as of conductorial skill. The thoroughness and clarity of the technical procedures by which this deformation was operated make any questioning of its esthetic value seem like quibbling, since, as always with Stokowski, the means employed, no matter what esthetic end is achieved by them, are a contribution to orchestral technique.

It is just as well that he chose for his technical exhibition last night music that could take it. Beethoven's *Leonora* Number 3, Brahms's Haydn Variations, and Siegfried's Death Music from *Die Götterdämmerung* are all foolproof and virtuoso-proof. No matter how you play them, they sound.

Shostakovich's Sixth Symphony, like all the later works of that gifted and facile composer, is pretty hard to conceal too. It is clear, obvious, effective, old-fashioned. It is not, perhaps, as successfully pulled off as his First and Fifth. Its allegiance seems to be divided between a romanticized, and hence attenuated, neoclassicism and a full-blooded Muscovite orientalism à la Borodin. Each movement begins with a gesture of good

will toward the lately reputable International Style and goes off as quickly
as possible into the atmospheric marketplace-and-landscape painting that
Russians have always loved. It is a pleasant piece and at moments not
without a certain concentration. If it were signed by an American com-
poser, say Harl McDonald or Walter Piston, it would be classifiable as
good salable academicism.

DECEMBER 4, 1940

The Verdi Case

~ HEARING last Monday Verdi's *The Masked Ball* at the Metropol-
itan Opera House has led me to wonder why that work, so satisfying
orchestrally and so brilliant in its vocal writing, has never moved much
the layman's simple heart and why, even among musicians, it is more
admired than deeply loved.

It is easy enough to pick flaws in the book, for these are many and
grave. The heroine has no character; she is a lay figure. The hero has
little more, not enough to make him interesting. An opera can get away
with a vague tenor (Mozart's *Don Giovanni* does) if the heroine is a live
woman and the villain sufficiently wicked. It is hard to interest an audi-
ence in two lovers whose personalities are so imprecise and whose pas-
sion is so trivial.

The lovers are further thrown into shadow by the lady's husband,
Renato. This future regicide is an extremely interesting person. He is
kind, loyal, and passionate. All one's sympathy goes out to him. It seems
a pity that such a tactful and forbearing spouse, once he had got his silly
wife home from a midnight expedition where she had gone to gather a
magic herb some fortuneteller had told her about and where she had
ended by compromising her husband in front of his political enemies, it
seems really too bad that after their long walk home in the snow he didn't
sit down with her and quietly, by some straight-from-the-shoulder ques-
tioning, find out what really had or hadn't been going on and then decide
on some sensible course of action. I was sorry to see a good man's home
broken up so uselessly.

Oscar, the king's frivolous page, whose indiscretions betray his mas-
ter's interests every time he opens his mouth, was a favorite of Verdi
himself among his dramatic creations. Musically this preference is un-
derstandable, because rarely has a composer expressed so well frivolity
and lighthearted empty-headedness as they are implied in Oscar's stac-
cato coloratura airs. The trouble with this role nowadays is the necessity
of its being sung by a woman. Italian stage conventions are more precise
than ours about femininity and masculinity. Consequently travesty is
easier to get away with in Italy than here. It is virtually impossible on

the Anglo-Saxon stage for a woman to represent an effeminate youth without seeming merely to be playing a male role ineffectually.

The opera's libretto is not its only fault. Its very musical strength is its weakness. The expressive nature of the orchestral accompaniments, the appropriateness of the contrapuntal writing, the sustained characterization of individual parts in the concerted numbers, the thematic unity of the whole work, are justly celebrated. Neither Meyerbeer nor Rossini ever etched a theatrical design more deeply. Richard Wagner himself, though a more sumptuous painter of psychological traits, was less practical in his timing. Verdi did an A-1 professional job on *The Masked Ball*.

But music never lives by its professional quality. It lives by its tunes. And the tunes in *The Masked Ball* are every one of them tricky. Let us except the baritone aria "Eri tu," Oscar's "Saper vorreste," and just possibly the Laughing Chorus. All the others fall somewhere between broad simplicity and complex full expression.

La Traviata and *Il Trovatore* are full of simple melodies that depict character and feeling in elementary but universally acceptable music. Wagner, at his best, and Mozart wrote melodies that express the same broad values but that comment more profoundly on the drama at the same time.

The orchestral accompaniment of *The Masked Ball* is a more elaborate picture of the play than is the orchestral accompaniment of any opera Verdi had previously written. It sounds like the best French contemporary work, bearing little resemblance to the previously current Italian style that Wagner described as "making the orchestra sound like a big guitar." The trios, quartets, and other ensemble pieces are equally fine. The melodic material all these are made out of is simply not good enough. The tunes are pretty, little more. They lack the grand and elementary plainness of those in the earlier works. And they lack the penetrating accuracy of great stage music. They are affected and soft, like the libretto.

One could put the blame for the whole trouble on the libretto if one didn't know that Verdi's career was always dominated by the same problem. In *Aïda* he went back to broad and straightforward writing. But he was obsessed by the desire to make Italian operas that would be as penetrating psychologically as French operas and as sumptuous harmonically as the German. He mastered psychological penetration instrumentally and wrote, in *Otello* and *Falstaff*, two of the most sumptuous musical works of the century. He could write big simple melodies and magnificent vocal bravura passages. He never learned how to build a melodic line that would be at the same time monumental and penetratingly expressive of the text. This inability to interpret character delicately is what gives to *Otello* and *Falstaff* a certain air, in spite of their instrumental de-

lights, of banality. The same inability gives to *La Traviata* its rough grandeur.

The lack of really delicate delicacy in Verdi's melodic contours, compensated though it be by pungent orchestration and the soundest dramatic building, makes the whole body of his work seem just a bit commercial. One is more often tempted, in fact, to take off one's hat to his triumphs of pure musical theater than one is to bare one's head before any revelations of the subtleties of human sentiment or the depths of the human heart.

<div style="text-align: right">DECEMBER 8, 1940</div>

Mozart's Leftism

✍ PERSONS OF humanitarian, libertarian, and politically liberal orientation have for a century used Beethoven as their musical standard-bearer. I employ the word *use* deliberately. Because it is hard to find much in Beethoven's life or music — beyond the legend of his having torn up the dedication of his "Heroic" Symphony to Napoleon when that defender of the French Revolution allowed himself to be crowned Emperor — to justify the adoration in which he has always been held by political liberals.

Wagner, yes. Wagner was full of political theory; and he got himself exiled from Germany (losing also his conducting post at the Dresden Opera) for participating in the unsuccessful revolutionary uprising of 1848 beside his friend, the philosopher of anarchy, Mikhail Bakunin. If he had not gone pseudo-Christian and jingo at the end of his life, he would probably be venerated by members of the Third and Fourth Internationals in the same way that Beethoven is worshipped (rather than listened to) by adherents of the Second.

Mozart, both his life and his works inform us, was more continuously occupied than either of these other composers with what we nowadays call "leftism" (not to be confused with "left wing," Communist Party euphemism meaning the Communist Party).

Mozart was not, like Wagner, a political revolutionary. Nor was he, like Beethoven, an old fraud who just talked about human rights and dignity but who was really an irascible, intolerant, and scheming careerist, who allowed himself the liberty, when he felt like it, of being unjust toward the poor, lickspittle toward the rich, dishonest in business, unjust and unforgiving toward the members of his family.

As a touring child prodigy Mozart was pampered by royalty, though he worked hard all the time. But after the age of twelve he was mostly pushed around by the great, beginning with Hieronymus Colloredo, Archbishop of Salzburg, going on through Grimm and Madame d'Epinay in Paris, and ending with the Emperor Francis I of Austria. He took it

like a little man, too. Few musical lives bear witness to a more complete integrity of character in sickness and in health, in riches and in poverty, such little riches as he knew.

Mozart was not embittered by illness and adversity; he was tempered by them. Furthermore, he was acquainted with French libertarian ideas, having been fully exposed to these in Paris, where he spent his twenty-third year. But he was never at any time a revolter. He was an absorber and a builder. He never tried to throw out of the window his Catholic faith or his allegiance to his Emperor, in spite of much unpleasant treatment from both Church and State. He merely added to them his belief in human rights and the practice of Masonic fellowship as he had learned these in Paris and in Vienna.

The three great theater-pieces of his maturity, *Die Zauberflöte*, *Le Nozze di Figaro*, and *Don Giovanni*, are all celebrations of this faith and fellowship, of what we should call liberalism or "leftism" and what the eighteenth century called Enlightenment.

Die Zauberflöte, in spite of its obscure libretto, is the easiest of these to grasp. Mozart, like practically all other self-respecting men in those days, like the French king and his own Emperor Josef II and like our own George Washington and Benjamin Franklin, was a Freemason. Freemasonry was not the anti-Catholic secret society it became in nineteenth-century America, and it was far from being the conspiracy of job-holding that it developed into under France's Third Republic. It was more like Rotary. Something between that, perhaps, and middle-of-the-road Marxism. It softened the manners and broadened the viewpoint of all classes in society. Even in Austria, the most retarded country in Europe politically, its fellowship was practiced, at least after Maria Theresa's death, without interference or suppression.

On account of changes that were operated upon the libretto of *Die Zauberflöte* during its composition and mounting, the fairy-story allegory it tells has always been considered obscure. Obscure it is in its details, if you like, in its mixing up of Zoroaster with Egypt and Japan. But surely its main moral is clear, that married happiness and dignity are to be won only by renouncing pride and snobbery and by conducting oneself as an ethical being. And certainly its textual references to liberty, equality, and fraternity are unmistakable.

If this were Mozart's only work with ideas of the kind in it, we could discount its humanitarian content as we discount the stilted verses of *Idomeneo*. But it is not. *Figaro*, to Beaumarchais's satirical play, was revolutionary in its egalitarianism; and *Don Giovanni* is the most humane and tolerant piece about sacred and profane love that anybody has ever written.

In Lorenzo da Ponte, who made the libretti for *Figaro* and *Don Giovanni*, Mozart had a collaborator ideal to his taste. They worked together

so closely that the libretti seem almost to have been made to fit the music, the music to come spontaneously out of the libretti. With a da Ponte text he was able to do completely what he was able later to do only partially with Schikaneder's fairy tale *Die Zauberflöte* — namely, to transform the whole thing into an expression of his own ideas.

The reason why the "meaning" of the two more naturalistic works is less easy to grasp than that of the fairy tale is that the humanitarianism of the fairy tale is its only easily comprehensible element. In the others practically everything is stated directly *but* the composer's attitude toward his characters.

Beaumarchais's *The Marriage of Figaro* is social satire, a poking fun at the nobility for not being noble enough. It is closer to pamphlet journalism than to humane letters. It is what we might call a snappy and sophisticated little number. Mozart and da Ponte changed all the accents, made everybody human, gave to all the characters, to masters and servants alike, the human dignity of their faults and of their virtues. They produced out of a piece of propaganda that was scarcely literature one of the most touching pictures of eighteenth-century life that exists.

Don Giovanni is a tragicomedy about sacred and profane love. Its dramatic tone is of the most daring. It begins with a rape and a homicide, goes on to a dirty comic song, a series of seductions, a sort of detective-story pursuit of the murderer in which one of the seduced ladies plays always a high comedy role, a party, a ballet, a supper scene with music on the stage, another attempted rape, a supernatural punishment of the villain, and a good-humored finale in which everybody reappears but the villain and the corpse, by now long since become a statue.

The villain is charming; the ladies are charming; everybody in the play is charming. Everybody has passion and character; everybody acts according to his passion and his character. Nobody is seriously blamed (except by the other characters) for being what he is or for acting the way he acts. The play implies a complete fatalism about love and about revenge. *Don Giovanni* gets away with everything, Donna Elvira with nothing. Donna Anna never succeeds in avenging her father's murder. Punishment of this is left to supernatural agencies. Love is not punished at all. Its sacred (or at least its honorable) manifestations and its profane (or libertine) practice are shown as equally successful and satisfactory. The only unsatisfied person in the play is Donna Elvira, who is not at all displeased with herself for having sinned. She is merely chagrined at having been abandoned.

Mozart is kind to these people and pokes fun at every one of them. The balance between sympathy and observation is so neat as to be almost miraculous. *Don Giovanni* is one of the funniest shows in the world and one of the most terrifying. It is all about love, and it kids love to a fare-ye-well. It is the world's greatest opera and the world's greatest

parody of opera. It is a moral entertainment so movingly human that the morality gets lost before the play is scarcely started.

Why do I call it leftist? I don't. I say the nearest thing we know to eighteenth-century Enlightenment is called today liberalism or leftism. But there is not a liberal or leftist alive who could have conceived, much less written, that opera. It is the work of a Christian man who knew all about the new doctrinaire ideas and respected them, who practiced many of the new precepts proudly, and who belonged to a humanitarian secret society; but who had also suffered as few men suffer in this world. He saw life clearly, profoundly, amusingly, and partook of it kindly. He expressed no bitterness, offered no panacea to its ills. His life was the most unspeakable slavery; he wrote as a free man. He was not a liberal; he was liberated. And his acquaintance, through doctrine and practice, with all the most advanced ideas of his day in politics, in ethics, in music, was not for nothing in the achievement of that liberation.

DECEMBER 15, 1940

1941

French Music Here

℘ DARIUS MILHAUD has communicated to me the catalogue of an exhibit held recently at Mills College, Oakland, California, for the two weeks from November 27 through December 11, 1940, of Erik Satie's manuscripts. These manuscripts, the property of Milhaud, were brought by him last summer from France at some inconvenience, since the traveling facilities available at that time did not always include transportation of unlimited personal impedimenta. That Milhaud should have made room for these at the cost of leaving behind manuscripts and orchestral material of his own for which he might have need during his stay here is evidence of the esteem in which he holds the unpublished works of the late Sage of Arceuil.

The catalogue, which contains 105 items, mentions fourteen bound booklets that average forty pages each and fourteen paperbound booklets that run as righ as twenty-five pages each. In addition, there are the twenty-four-page orchestral score of *Five Grimaces* for *A Midsummer Night's Dream* and a score of fifteen pages of a piece called simply *Danse*, dated December 5, 1890, later incorporated into the longer work entitled *Three Pieces in the Shape of a Pear*. There are sketches from three ballets, *Jack-in-the-Box*, *Relâche*, and *Mercure*, and from the marionette opera *Geneviève de Brabant*. Also songs. Famous ones like *Le Chapelier*, from *Alice in Wonderland*, and *La Statue de Bronze* and dozens of unpublished waltz songs and other such light matter written dur-

ing the eight (or was it twelve?) years that Satie earned his living by playing the piano at a small theatrical establishment called The Harvest Moon (La Lune Rousse), an enterprise of the type known as *cabaret Monmartrois* or *boîte de chansonniers.*

There are counterpoint exercises too, and fugues and chorales from his second student days when, already forty, he enrolled at Vincent d'Indy's Schola Cantorum and for four years went through all the scholastic musical grind he had skipped in youth. And there are letters, forty-three of them, to Darius Milhaud, photographs, programs, clippings, and accounts. Item 47 is a first edition of *Images,* by Claude Debussy, with a dedication to Satie from his lifelong friend.

The collection, as one can see from the above brief digest, is an extensive one. Its importance depends on what one thinks of Erik Satie as a musical figure. This writer is in agreement with Darius Milhaud and with some of the other contemporary French composers in placing Satie's work among the major musical values of our century. He has even gone so far in print, nearly twenty years ago, as to parallel the three German B's — Bach, Beethoven, and Brahms — with the three S's of modern music — in descending order of significance, Satie, Schönberg, and Stravinsky.

That is a personal estimate, of course, though one agreed to by many musicians in France and some elsewhere. I should not wish to force my personal musical tastes on anyone, any more than I should want anybody else's forced on me. If you love Mahler, for instance, Mahler is your oyster; and the same goes for Strauss, Sibelius, Palestrina, and Gershwin. But there are certain key personalities without some acceptance of which it is impossible to understand and accept the music of the place and epoch that they dominated. And Erik Satie is one of those.

French and other Parisian music of the 1930s has been but little performed in America. (That is an old quarrel of mine with the League of Composers.) Such of it as has been performed here is usually considered to be mildly pleasant but on the whole not very impressive. This estimate is justified only on the part of persons uninitiated to its esthetic. And its esthetic, as was that of Debussy, is derived directly from the words and from the works of Satie, whose firmest conviction was that the only healthy thing music can do in our century is to stop trying to be impressive.

The Satie musical esthetic is the only twentieth-century musical esthetic in the Western world. Schönberg and his school are Romantics; and their twelve-tone syntax, however intriguing one may find it intellectually, is the purest Romantic chromaticism. Hindemith, however gifted, is a neoclassicist, like Brahms, with ears glued firmly to the past. The same is true of the later Stravinsky and of his satellites. Even *Petrushka* and *The Rite of Spring* are the Wagnerian symphonic theater

and the nineteenth-century worship of nationalistic folklore applied to ballet.

Of all the influential composers of our time, and influence even his detractors cannot deny him, Satie is the only one whose works can be enjoyed and appreciated without any knowledge of the history of music. These lack the prestige of traditional modernism, as they lack the prestige of the Romantic tradition itself, a tradition of constant revolution. They are as simple, as straightforward, as devastating as the remarks of a child.

To the uninitiated they sound trifling. To those who love them they are fresh and beautiful and firmly right. And that freshness and rightness have long dominated the musical thought of France. Any attempt to penetrate that musical thought without first penetrating that of Erik Satie is fruitless. Even Debussy is growing less and less comprehensible these days to those who never knew Satie.

When Satie used to be performed here occasionally, the works were found difficult to understand. French music in all centuries has been rather special, not quite like anything else. In our century it has become esoteric to a degree not currently admitted even in France. It has eschewed the impressive, the heroic, the oratorical, everything that is aimed at moving mass audiences. Like modern French poetry and painting, it has directed its communication to the individual.

It has valued, in consequence, quietude, precision, acuteness of auditory observation, gentleness, sincerity, and directness of statement. Persons who admire these qualities in private life are not infrequently embarrassed when they encounter them in public places. It is this embarrassment that gives to all French music, and to the work of Satie and his neophytes in particular, an air of superficiality, as if it were salon music written for the drawing rooms of some snobbish set.

To suppose this true is to be ignorant of the poverty and the high devotion to art that marked the life of Erik Satie to its very end in a public hospital. And to ignore all art that is not heroic or at least intensely emotional is to commit the greatest of snobberies. For, by a reversal of values that constitutes one of the most curious phenomena of a century that has so far been occupied almost exclusively with reversing values, the only thing really hermetic and difficult to understand about the music of Erik Satie is the fact that there is nothing hermetic about it at all.

It wears no priestly robes; it mumbles no incantations; it is not painted up by Max Factor to terrify elderly ladies or to give little girls a thrill. Neither is it designed to impress orchestral conductors or to get anybody a job teaching school. It has literally no devious motivation. It is as simple as a friendly conversation and in its better moments exactly as poetic and as profound.

These thoughts occurred to me the other evening at a League of Com-

posers' concert of recent works by Milhaud. Not a piece on the program
had a climax or a loud ending. Nothing was pretentious or apocalyptical
or messianic or overdramatized. The composer's effort at all times was to
be clear and true. And when I saw the catalogue of the Satie manuscripts
and learned how Milhaud had brought them to America at the cost of not
bringing all his own, when I remembered also the brilliant and theatri-
cally effective works of Milhaud's youth, *Le Boeuf sur le Toit* and *Le
Train Bleu* and *La Création du Monde*, I realized that after Satie's death
he had been led, how unconsciously I cannot say, to assume the mantle
of Satie's leadership and to eschew all musical vanity. That, at any rate,
is my explanation of how one of the most facile and turbulent talents of
our time has become one of the most completely serene of modern mas-
ters, and how, by adding thus depth and penetration and simple human-
ity to his gamut, he has become the first composer of his country and a
leader in that musical tradition which of all the living musical traditions
is the least moribund.

JANUARY 5, 1941

The Hindemith Case

∿ PAUL HINDEMITH'S music is both mountainous and mouselike.
The volume of it is enormous; its expressive content is minute and not
easy to catch. His output is voluminous; that implies a certain facility.
His tonal grammar and syntax are perfectly clear; that is evidence of care
taken. His work has style also; and that is proof of its artistic integrity,
of an integration between what its author feels and what his listener hears.

There is nevertheless a good deal that is obscure about it. How often
has one sat through pieces by Hindemith that seem to make sense musi-
cally but little or no sense emotionally! Even so ingratiating a piece as the
Third String Quartet sounds more like the work of a composer who had
nothing better to do one morning than like something that had got itself
born out of inner necessity. His work could hardly be called hermetic,
because hermetism is always pretty compact. I should say that the ob-
scurity one encounters in it is due rather to the diffuseness of its thought
than to any especial concentration of meaning or any rigidly novel
technique.

It is not, properly speaking, academic music. It is too loosely put to-
gether for that. It is clearly written down but not much polished, and it
meanders more than is considered good "form" in academic circles. Also,
its instrumentation, though completely sure-handed, is rarely brilliant or
"effective" in the way that the work of celebrated pedagogues is likely
to be. He does not seem to be interested in stylistic or cultural show-
ing off any more than he is in emotional expansiveness or emotional
concentration.

His music exerts a great fascination, however, over music students; and it is not without a certain impressiveness for the music public in general. It is obviously both competent and serious. It is dogmatic and forceful and honest and completely without charm. It is as German as anything could be and farther removed from the Viennese spirit than any music could possibly be that wasn't the work of a German from the Lutheran North. It has no warmth, no psychological understanding, no gentleness, no *gemütlichkeit*, and no sex appeal. It hasn't even the smooth surface tension of systematic atonality. It is neither humane nor stylish, though it does have a kind of style, a style rather like that of some ponderously monumental and not wholly incommodious railway station.

Having reflected in this vein for some years about Hindemith's non-programmatic music, it was with the hope of maybe finding I was all wrong that I went to hear the National Orchestra from Washington play symphonic excerpts from *Mathis der Maler* last Tuesday evening. I wanted to see what the least picturesque composer alive would do with the most picturesque subject imaginable. I remembered his having tried his hand some years ago at a picturesque subject drawn from modern life in an opera called *Neues vom Tage,* and I remembered having been amused at the way he had managed to write music for that work that was at the same time both ponderous and cute.

Mathis der Maler turned out to be more of same, only more serious in tone, on account of its subject matter, which has to do with three religious pictures by Mathias Grünewald — a Descent of Angels, an Entombment, and a Temptation of Saint Anthony. The subject is an ambitious one and presents a problem of musical method for which there is no precedent in musical tradition.

There are several classic procedures for representing visual images by means of music. There is the ancient and simple one employed by Rameau and Handel and Sebastian Bach, which is to imitate in the melodic contours either the silhouette or the characteristic motion of the thing one wishes to describe, valleys being exalted, for instance, the crooked being made straight and the rough places plain, Adam falling out of paradise, troupes of angels tripping down the major scale, and gentlemen attempting from love's sickness to fly-y-y-y-y-y-y-y in vain. There is also the Romantic procedure of adding to this auditive and kinetic vocabulary of visual suggestion a subjective description of the emotional effect of it all on some sensitive observer or participant. Bacchanalian routs, debauches in Venusberg, Swiss mountain weather, graveyard ballets, and visits to hell on Walpurgisnacht are common in nineteenth-century music.

Mendelssohn's contribution to landscape technique consisted in making the observer always the same man, himself. In Scotland, in Italy, in fairyland, he is always Mendelssohn, sympathetic and sensitive and strictly nonparticipant. The modern French technique of musical land-

scape painting, of which Debussy was the most skillful practitioner, is essentially Mendelssohnian, though the expressive range and psychological intensity of Debussy's work are greater than those of Mendelssohn's because it is not bound to the German conception of thorough bass or to the idea of "developing" the thematic material. It conceives any melodic line as a self-sufficient expressive unit, counterpoint as a plurality of such units, harmony and rhythm as coloristic ornamentation to melody. "Form" in the German sense of harmonic progress is something to be avoided, since it implies that the author is either going somewhere or trying to make a point, instead of receiving and transmitting a series of related impressions from some point of view where he is supposed to remain motionless, his will immobilized by the intensity of the visual-auditive photographic process of which he is a passive agent. Musical landscape painting does not need "form" in the sense of progress. It needs, on the contrary, a static musical unity based on the orderly and sequential statement of all the things that need to be said in order to make the piece a description of its subject.

All these procedures exist as known ways of translating sight into sound. There is no known way of translating into sound visual pictures that have already been translated into so stylized a medium as painting. A composer's version of a painter's version of the Church's version of scenes from sacred history is what *Mathis der Maler* purports to be. As such it is naturally not very successful. It couldn't be. When one considers, in addition, that Hindemith has never properly liberated himself from the German bass, that his rhythm is constrained and unimaginative, that whenever he can't think what to do next he writes imitative counterpoint, that his melodic contours, though dignified enough, are inexpressive, that his creative concentration is too diffuse to allow him to write effectively either visual music or subjective emotional music, it is surprising that the *Mathis* triptych should come off at all.

It comes off, just as all his music does, in spite of everything, by good intentions and by being playably orchestrated. The Entombment has a certain directly expressive quality, though the influence of Grünewald would seem to be present more as private stimulus to the composer's invention than as anything a listener need take cognizance of. The Descent of Angels and the Temptation of Saint Anthony are not handled as convincingly as other composers have handled similar subjects. Saint Anthony's victory over temptation, for instance, is represented by a routine Lutheran chorale harmonized for brass in a routine manner that might just as well represent Mr. Hindemith's satisfaction at getting to the end of his piece as a saint's triumph over his lower nature.

Mathis der Maler is typical of North Germany at its best and of modern scholastic facility at its worst. It is complex, ineffective, unpolished, lacking in both grace and expressive power. All the same, it has a moral

elevation and a straightforward, if clumsy, honesty that make impossible not to respect and admire it for being at all times unquestionably "good" music.

FEBRUARY 9, 1941

Revueltas

♫ EUROPE HAS often produced composers like the late Silvestre Revueltas, the Americas rarely. Our music writers are most likely to do the light touch with a heavy hand. Revueltas's music reminds one of Erik Satie's and of Emmanuel Chabrier's. It is both racy and distinguished. Familiar in style and full of references to Hispanic musical formulas, it seeks not to impress folklorists nor to please audiences by salting up a work with nationalist material. Neither does it make any pretense of going native. He wrote Mexican music that sounds like Spanish Mexico, and he wrote it in the best Parisian syntax. No Indians around and no illiteracy.

The model is a familiar one of the nationalist composer whose compositional procedures are conservative and unoriginal but whose musical material consists of all the rarest and most beautiful melodies that grow in his land. Villa-Lobos is like that and Percy Grainger; so was Dvořák. The contraries of that model are Josef Haydn and Satie and a little bit Georges Auric — certainly Darius Milhaud. These writers use the vernacular for its expressivity. But their musical structure and syntax are of the most elegant. Their music, in consequence, has an international carrying power among all who love truly imaginative musical construction.

Revueltas's music could never be mistaken for French music. It is none the less made with French post-Impressionist technique, amplified and adapted to his own clime. It is static harmonically, generously flowing melodically, piquant and dainty in instrumentation, daring as to rhythm. He loves ostinato accompanying figures and carries them on longer than a more timid writer would. He orchestrates à la Satie, without doubling. He fears neither unexpected rhythmic contrasts nor familiar melodic turns. His music has grace, grandeur, delicacy, charm, and enormous distinction.

MARCH 4, 1941

Sacred Swing

♫ LAST SUNDAY I went to Newark to attend the evening services of a Negro congregation known as The Church of God in Christ, where Bishop Utah Smith, a traveling evangelist of that denomination, was closing his engagement. Brother Smith is a stocky gentleman in his mid-

forties, neither old nor young, whose musical accomplishments had been signaled to me by swing experts. He is known in religious circles as The One-Man Band, was so introduced, in fact, by the local pastor. His whole musical equipment is an electric guitar, his only vestment an ordinary sack suit of dark blue, with a pair of white wings made of feathered paper attached to his shoulders like a knapsack by crossed bands of white tape.

His religious message is delivered more by music and dancing than by preaching. Only after the preliminary prayers, solos, and congregational hymns are over does he take charge of the meeting. Then an open space is cleared between the chancel rail and the first congregational seats. These last are allowed to be wholly occupied, no mourners' bench being reserved at all, since the nature of the service is one rather of general rejoicing than of personal penitence. The Bishop makes a few remarks to the congregation and then, without any formal address or other preface, goes straight into his number, if I may so refer without irreverence to his music-making.

He plays the guitar with a high pickup that fills the auditorium with a rich and booming sonority. He does not sing. He only plays and, like all swingsters, pats his foot. His musical fancy is of the highest order. I have rarely heard such intricate and interesting swing. From time to time he shouts: "I've got wings! Dust my feet!" Persons in the congregation reply with: "Dust my feet!" with "Praise the Lord!" and similar ceremonial phrases, as is customary among many colored religious groups. Practically everybody claps his hands in time to the music, claps on the offbeat, as is also customary in swing circles.

The music goes on for quite a long time, the Bishop swinging chorus after chorus with ever-increasing fantasy and insistence. Various persons of the congregation who feel so inclined first edge timidly toward the edge of the open space and then one by one start dancing. Each dances alone, some with raised and some with lowered head, all with eyes closed. Some jerk a little; others do rapid and complex footwork. The floor sways with their impact as if about to collapse. When the music stops, the dancers come out of their trancelike absorption and regain their seats as calmly as persons leaving any ballroom floor.

At no time during my stay did I observe any licentious behavior or other evidence that the ceremony was not a bona fide religious manifestation. Bishop Smith himself, though full of humor and jollity, and not without a certain showmanship, impressed me as a sincere and probably a consecrated character. And if I was not conscious during my one brief visit to his services of any extraordinary or commanding inspiration in them, neither was I aware of anything that might make me think them phony.

In any case, his musical gift is real and his musical imagination abun-

dant. I am, consequently, taking occasion this Easter Sunday to make reference to what struck me as an interesting musical manifestation and to point an example from contemporary life of the truism that in those societies or groups where religion is most vigorous there is no difference whatever between the sacred and the secular musical styles, the consideration of what is sacred and what is profane in music applying only to the moral prestige in society of the ceremonies that it accompanies. As a swing artist Bishop Utah Smith is worthy to rank among the best. As a stimulator of choric transports he incites the faithful to movements and behavior not very different from those of any true jitterbug. Myself, I found it distinctly pleasant to hear good swing music and to observe its effects in surroundings imbued with the white magic of Protestant Christianity rather than among alcoholic stupidities and even more somber diabolisms of the nightclub world.

APRIL 13, 1941

Fa Sol La Fa Sol La Mi Fa

❧ THESE ARE the syllables used by oldsters in rural regions of the South to intone the major scale, exactly as they were used in the British Isles long before Shakespeare. Indeed, the Elizabethan fa la la is no more than a conventional reference to the habit of singing any part song first with the tonal syllables, so that melodies may be learned before words are attempted. So, still, is the custom in all those parts of America where *The Sacred Harp* and *Southern Harmony* are used as singing books.

The former is common in Georgia, the Carolinas, Kentucky, Tennessee, Alabama, Arkansas, Louisiana, and Texas. It has been reissued four times since its first appearance in 1844 and has sold upward of five million copies.

Southern Harmony, published in 1835, sold a half-million copies before the Civil War, then was out of print till the Federal Writers' Project of Kentucky, under the sponsorship of the Young Men's Progress Club of Benton, Marshall County, reprinted it in facsimile in 1939.

By far the most celebrated in musicology circles of all the American song books, since Dr. George Pullen Jackson of Vanderbilt University revealed it to the learned world through *White Spirituals in the Southern Uplands*, its usage among the folk is confined today to a very small region in southwest Kentucky. William ("Singing Billy") Walker, its author, considered it so highly that he ever after signed himself, even on his tombstone, A.S.H., meaning "Author of *Southern Harmony*." Today it is used by about forty old people, who meet every year at the County Court House of Benton and sing from nine till four.

I went to hear the *Southern Harmony* singing this year, lest it cease to exist before another, though most of the ancients looked healthy enough,

I must say, and sang with a husky buzz; and a handful of youngsters of forty or more seemed active in perpetuating the style and repertory of it all.

The style is that of all back-country vocalism: a rather nasal intonation, a strict observance of rhythm and note (plus certain traditional ornaments and off tones), and no shadings of an expressive nature at all. Each song is sung first with the fa-sol-la syllables and then with its words. Various persons take turns at leading. The effect of the syllable singing is rather like that of a Mozart quintet for oboes; the effect of the verbal singing not unlike that of a fourteenth- or fifteenth-century motet.

The repertory is all the grand and ancient melodies that our Protestant ancestors brought to America in the seventeenth and eighteenth centuries. Most are pentatonic and hexatonic, many of them Dorian or Phrygian in mode. The part-writing is French fifteenth-century. There are usually three parts: a bass, a tenor (the melody), and a treble. Both of the latter are doubled at the octave by women, making of the whole a five-part piece. Since chords of the open fifth are the rule and parallel fifths common, the addition to these of constant octaves gives to the whole an effect at once of antiquity and of modernism. Each part is a free melody, constantly crossing above or below the others; no mere harmonic filling attenuates the contrapuntal democracy. There is something of the bagpipe too, in the sound of it all, as well as in the configuration of many of the tunes.

Though the words are always sacred words (often of high poetic quality), neither the *Southern Harmony* nor *Sacred Harp* singings are, strictly speaking, religious manifestations. The proof of that is the fact that they have never become involved in the sectarian disputes that are the life of religion. Religion is rather the protective dignity under which a purely musical rite is celebrated. That rite is the repetition year after year of a repertory that is older than America itself, that is the musical basis of almost everything we make, of Negro spirituals, of cowboy songs, of popular ballads, of blues, of hymns, of doggerel ditties, of all our operas and symphonies. It contains our basic conceptions of melody, of rhythm, and of poetic prosody. It contains in addition the conception of freedom in part-writing that has made of our jazz and swing the richest popular music in the world.

To persons traveling southward I do not recommend the *Southern Harmony* singing as the best introduction to this repertory. The ancients are too few in number and too note-bound, and the singing is far too slow for city tastes. Easier to find on any summer Sunday and more lively in tone and rhythm are the devotees of the *Sacred Harp*. The style and repertory are similar, but the vigor of the rendition is greater. If pos-

sible, buy a book and learn to sing yourself from the square and trian-
gular notes. It is more fun that way.

<div align="right">

MAY 26, 1941

</div>

Haydn, Beethoven, and Mozart

∾ LATELY I have been reading and rereading the Haydn piano sona-
tas. Like all of Haydn's music they represent a gold mine of melody and
of instrumental imagination. There is scarcely one that does not contain
some passage familiar to us all, familiar, I may add, more often than not
because of Beethoven's unacknowledged quotation of it in sonata or sym-
phony. They also represent, as do equally the piano sonatas of Mozart
and of Beethoven, the counterpart to the symphonies of these masters.
If one wants to understand the latter, one must study the former; and
vice versa.

What strikes me most about Haydn is that of the three great Viennese
masters he is by far the most melodious. His thematic invention is the
most varied of them all and his thematic development the most tuneful.
His whole musical concept is lyrical. For this reason he is at his best in
the nonlyrical movements. The first movement and the minuet are com-
monly his richest. The development of his first-movement themes through
a cycle of sonata-form modulations gives symmetry and weight to what
might be merely graceful if no such formal layout were employed. Simi-
larly, the minuet's quality of dance music enforces a certain objectivity
upon his process of composition that adds to Haydn's abundance of per-
sonal fancy the welcome solidity of a straightforward and easily under-
stood human significance. The rondo, Haydn's most frequently observed
last-movement scheme, gives too much play to his musical imagination,
obliges him too little to expression. The same is true of his slow move-
ments, which are melodious and full of incidental invention, but which
do not say much.

The truth is that Haydn wrote music like an old bachelor (which he
almost was). A self-contained and self-sufficient lyricism is its dominant
characteristic, an avuncular generosity its chief means of contact with the
listener. Of humane objectivity it has virtually none save in the jolly and
waltzlike dance movements, where he remembers his peasant upbringing.
The encounter of his native lyrical abundance with sonata-form formal-
ities, however, as that takes place in his first movements, produces a kind
of three-dimensional grandeur that is acceptable in terms of its sheer
musical magnificence, without regard to what its expressive intention
may be. In this respect Haydn's instrumental music looks backward to
that of Domenico Scarlatti and the Bach family, just as his oratorios re-
semble strongly those of Handel. His technical procedures are those of

Romanticism; but his thought is neither expansive, like Beethoven's, nor dramatic, like that of Mozart. It is a lyrical fountain forever overflowing and constantly inundating everybody with song.

Beethoven really *was* an old bachelor. But he never liked it. All his music is cataclysmic, as if he were constantly trying to break out of solitude. His first movements state the problem squarely. His slow movements are less interesting, because they try unsuccessfully to avoid it; they tread water. His minuets and scherzos reopen the problem and announce the hope of a solution. The finales, often the finest and certainly the most characteristic movements in Beethoven, are the solution that the whole piece has been working up to. That solution is usually of a religious nature. It represents redemption, the victory of soul over flesh. It varies from calm serenity to active triumph, but joy is its thesis. In the Ninth Symphony a German ode on that subject is inserted to clinch the matter. The bonds of solitude are broken because they are imagined as being broken. That breaking is of a purely mystical nature, a temporary identification of the self with God or with all humanity. The form of the musical expression is free and infinitely varied. The finales show Beethoven at his most personal and most masterful. They are grand, terribly serious, and, for the most part, inspiring.

Solitude was unknown to Mozart. Except for a short time in Paris, just after his mother died there, he was probably never in all his life alone for so much as half a day. His music, likewise, is full of dramatic animation. His themes are like people, his developments a working out of their contrasting natures. His first movements, in spite of the beauty of their material, are little more than a first act or prelude to the drama of the rest. The slow movements are always the crux of the matter, the freest, grandest, and most fanciful part of any Mozart sonata or symphony. They are impossible to interpret unless one considers them as theater, as a dramatization of real characters, a conflict among other people's emotions. The minuet which follows (in the quartets it more commonly precedes) is pure ballet. It has nothing to do with Haydn's peasant gambols. It is slow and stately and complex. It too shows a conflict of sentiments, as if the dramatic struggles of the preceding movement were here resolved, or at least appeased, through observance of the social amenities. It is a terse and static little affair.

The finales are not dramatic at all. They are mostly fast and always furious. Nothing in music, excepting maybe five or six of the Bach organ fugues, have that kind of power and insistence, as of an element unchained. They do not have to be played at breakneck speed. Those for piano solo definitely profit by moderation in this regard. But rhythmic tension they must have and dynamic contrast. They are the moral of the piece. They show, as Mozart was always trying to show in his operas, how marvelously vigorous life can be when people make up their minds

to put their petty differences on the shelf and to collaborate in full good will at being human beings together. Their whole effect can be spoiled unless the preceding movement, whether that is an adagio or the more usual minuet, is presented at a contrasting tempo. Any speed that suggests the scherzo in rendering a Mozart minuet not only falsifies the significance of the minuet itself but steals, as well, the fire of the movement that follows.

DECEMBER 21, 1941

1942

Understanding Modern Music

COMMON BELIEF has it that new music is difficult to understand, while older and more familiar music presents comparatively few problems of comprehension. I do not think this is true. It is certain that in the epochs of rapid esthetic advance there is always some time lag between the understanding of new work on the part of persons connected with the movement that produces it and the understanding or acceptance of that same work by the general public of music lovers. Professional musicians and pedagogues, if they happen not to be part of the inner circle where such work is being produced, are sometimes more uncomprehending than the general public, even.

But this age is not one of rapid advance in music. It is one rather of recession. The great frontal attack on musical conservatism that is still known as Modern Music took place between 1885 and 1914. Its salient victories include the works of Richard Strauss, of Debussy, of Ravel, of Schönberg, Stravinsky, and Erik Satie. No composer has made since 1914, if we except the works that some of these same men wrote after that date, any impression on his time comparable to that made by these composers during the great revolutionary years before the other World War.

We have since witnessed the triumphal progress of careers laid down before that war, and we have assisted at the test flights of two minor musical movements. The first of these, characteristic of the 1920s, was known to its adepts as Contemporary Music and included two branches, the Twelve-tone School (seated in Vienna with an outpost in Berlin) and the neoclassicists, or School of Paris. A second movement (also seated in Paris) was the characteristic musical movement of the 1930s and is called neo-Romanticism. It is exactly contemporaneous with the painting movement of the same name.

I call the last two decades and their characteristic movements minor, because they were occupied chiefly with the exploitation of technical devices invented by a previous generation. I may be underestimating the

neo-Romantics. Indeed I hope I am, because I am one of their founding fathers. But the possibility that the progress of the movement may have been only interrupted by the present war rather than terminated by it cannot obscure the fact that the neo-Romantics, like the neoclassicists before them, represent for the most part a novel usage of syntactical devices perfected long before rather than any notable discoveries in musical technique.

The gamut of musical device that was correctly called Modern, or "revolutionary," before 1914 is now taught in most of our schools and colleges. In any case, it is available to educated composers; and the whole musical public has been exposed to it for twenty-five or more years. Many of the works that exemplify it have enjoyed, indeed, a worldwide success. There is no reason why anybody in the music world, professional or layman, should find himself in the position of not understanding a piece of twentieth-century music, if he is willing to give himself a little trouble.

It is probably the fact that today's music is at least partially comprehensible to all that makes it so amazing to some. The habit of merely enjoying music without attempting to understand it literally is a comfortable one. And it is far easier to indulge that habit in listening to the music of another age and century than it is when music made in our own time is being played. Because, in spite of the worst will in the world, no listener can fail to penetrate, at least partially, a contemporary work.

The art music of the past, most of all that eighteenth- and nineteenth-century repertory known as "classical" music, is, on the other hand, about as incomprehensible as anything could be. Its idiom is familiar. But its significant content is as impenetrable as that of the art work of the Middle Ages. It was made by men whose modes of thought and attitudes of passion were as different from ours as those of Voltaire and Goethe and Rousseau and Casanova and Heine and Lamartine and Victor Hugo were different from those of Bernard Shaw and Marcel Proust and Ronald Firbank and e. e. cummings and Gertrude Stein and Mickey Mouse and William Saroyan. Not that these more recent writers are always of the utmost limpidity. On the contrary, they are mostly either deceptively lucid or deceptively obscure, as is the custom of our century. But it is difficult not to find in ourselves, as twentieth-century men and women, some spontaneous identification with the world that they depict. Whereas the travels of Lord Byron, the private lives of John Keats and of Emily Dickinson, are as far from anything we have ever known as is the demise of Richard Wagner's Isolde, who, having nothing organically wrong with her, stands in the middle of a stage and falls dead merely because her lover has just died of real wounds gotten in a fight.

These reflections occurred to me one evening apropos of a gathering that I had attended to hear some musical compositions by Stefan Wolpe. Mr. Wolpe is a skilled composer whose works have so far been little per-

formed here, on account of what passes in professional circles for their extreme difficulty both of execution and of interpretation. In one corner four musicians were gathered together to glance at the scores of the music played and to discuss its nature and merits. That they all understood it both as to technique and as to substance is proved by the fact that they found themselves in perfect agreement about these. Four musicians who agree on practically nothing else in music not only thought that Mr. Wolpe's work was interesting and excellent (that would have been easy), but thought so for the same reasons.

Those same four musicians are irreconcilably divided about Mozart and about Sibelius. None of them would be capable of explaining in any reasonable manner at all a sonata by Haydn, much less of convincing the others that his explanation was correct. Their divers comprehensions of Schumann's piano music, of the Beethoven quartets, of Schubert, and of Chopin, though they might agree on the excellence of all these, have nothing in common. On controversial figures like Brahms and Berlioz and Wagner they could almost come to blows.

And so I got to thinking about what is called "difficult new music," and I concluded that there is no such thing anymore. There used to be, I presume. It certainly must have taken more than good will and a mild effort of the mind for persons hitherto unacquainted with Debussy's work to accept and understand *Pelléas et Mélisande* in 1902. In 1941 there is no longer any really novel music. There is only live music and dead music, the music of our time and the music of other times.

Dead music is very beautiful sometimes and always pretty noble, even when it has been painted up and preened by the undertakers who play or conduct it with such solemnity at our concerts. Live music is never quite that beautiful. Neither that beautiful nor that dumb. Because live music speaks to us all. We may not like what it says, but it does speak. Dead music, that whole baroque, rococo, and romantic repertory we call "classical," is as comfortable and as solacing to mental inactivity as a lullaby heard on a pillow made from the down of a defunct swan.

I am not proposing its abolishment from our lives or from our concerts. No sensible person would wish to be without access to the history of culture. I am merely saying to those persons who think the music of today is accessible to the comprehension of only a limited group that it is, on the contrary, much easier to understand than the music of the past. Very few people have any real comprehension at all of the art of preceding generations, of what it is all about and of how the men felt who made it. Those who do have an inkling or two about it, who have made up for their own use a certain way of envisaging the relics of times past by applying to their interpretation facts and principles they have learned from modern life, are, of course, always persons who have a pretty comprehensive acquaintance with the music of the modern world. All mod-

ernists are not necessarily musicologists. I have known people who understood Stravinsky or Schönberg pretty thoroughly but whose knowledge of Bach and Beethoven was conventional and unreflected. I have never, however, known a person with any original or penetrating knowledge about the musical past who had not arrived at that understanding by first mastering the elements of the divers musical procedures that lay about him.

There are difficulties about presenting large quantities of new music in our orchestral concerts, but these are chiefly monetary. Live music requires the payment, for one thing, of a performing-rights fee to its author, which most dead music does not. More costly than this modest outlay is the rehearsal time (at the Philharmonic this comes to something like ten dollars a minute) necessary for getting a new piece into shape. These are not, however, unsurmountable difficulties, as has been proved during Dimitri Mitropoulos's present visit. This skilled orchestral foreman has managed to prepare lengthy and complex novelties for all his programs and to prepare them all, whether one approves or not of each interpretation, with complete thoroughness.

I do not pretend that the new works this conductor has been giving us are all of equal and certifiable excellence. If one wants guaranteed literature one has to stick pretty close to Shakespeare and the Bible. I am merely saying that the interpretation and the understanding reception of new music are not today rare or recondite accomplishments. Naturally, the separation of repertory into works we want to keep and works we want to throw away is a choice we are not obliged to face in dealing with the "classics." But that separation is a very exciting occupation both for producers and for audiences. It is what brings real life and occasionally real profits to the theater, to the movies, to the jazz world. Continuous opportunity for its practice at Carnegie Hall is the only means I have to suggest (and we have all worried about this) for restoring our major orchestra to its rightful place in our intellectual life.

JANUARY 4, 1942

Conducting Modern Music

❧ THE PRIME consideration in interpreting new musical works is to avoid doing anything that might possibly make these appear to be emulating the music of the past. Such emulation may or may not have been a part of the composer's intention, but playing it up in presentation produces a false relation between a work and its own time that is fatal to the comprehension of the work by its own time. Dressing and directing *Hamlet* as if it were a modern play is a piquant procedure. Treating a modern play as if it were Shakespeare's *Hamlet* can only make for pretentiousness and obscurity.

There is a prestige attached to any art work that has survived the death of its author which no work by a living hand can enjoy. This fact of survival is correctly called immortality, and that immortality surrounds the surviving work with a white light. In that radiance all becomes beautiful. Obscurities disappear too, or at least they cease to bother. When I refer, as not infrequently I do, to live music and dead music, I mean that there is the same difference between the two that there is between live persons and dead ones. The spirit and influence of the dead are often far more powerful than those of the living. But they are not the same thing, because you can only argue *about* them, never *with*. The dead have glory and a magnificent weight. The living have nothing but life.

The glorification of the dead is a perfectly good thing. Indeed, the greater civilizations have always done it more than the lesser. But a clear separation of the dead from the living is also a mark of the higher cultures. That is the fecundating drama between tradition and spontaneity that keeps peoples and empires alive. Consequently no good is accomplished by pretending, or seeming to pretend, that a work by Igor Stravinsky or Aaron Copland is a museum piece, because it isn't and won't be till they are dead, if then. And framing such a work among museum pieces in such a way that it appears to be subsidiary to them invariably makes the living work seem deader than a doornail. Its lack of white-light immortality makes it appear gravely inferior to the works on the same program that have such an aura and glamour.

The moral of this explanation is that new works must be played alone, in company with other new works, or surrounded by old ones carefully chosen, if one wishes to bring out their resemblances to the traditional past as well as their essential differences from the past. A new work may not be the most important piece on the program; but unless it is the determining item in the choice of the whole program, it will always sound like second-rate music, because it is pretty certain to be placed in unfair glamour competition with the classics of repertory. Modern music indiscriminately programmed, no matter what kind of music it is, is framed to flop.

Neither can it be interpreted in the same style as older music. Insufficient rehearsal often works to a new piece's advantage. When there isn't time to do much but read the notes and observe the author's tempos, it gets a neutral reading that is at least better than a false interpretation. If the conductor has time to work it up into an imitation of all his favorite war-horses or to streamline it into a faint reminder of Beethoven and Tchaikovsky, it is very difficult for the listener to hear anything in it but a memory of these authors, or at most a feeble attempt to dethrone them by being arbitrarily different.

The best international style for playing the classics is one which reduces them to a common denominator of clarity and elegance. That was

always Toscanini's force as a conductor of standard repertory. He was never very effective as a conductor of modern music (and he avoided it whenever possible, for that reason, I imagine), because he knew no other way of conducting anything. Characteristic national differences, which are of minor importance in standard repertory but which are the very essence of modern stylistic comprehension, seem to have escaped him. And being a musician of too high temperament to be satisfied with a merely neutral reading of anything, he wisely refrained from taking on a job in which neither he nor the living composer was likely to do much shining.

The conductors who do best by the music of our century are seldom equally good at interpreting all the kinds of it. Koussevitzky does well by anything Russian and fair by the English and the Americans, provided these last are not too local in flavor. He is not bad with German music, adds to it a Slavic elegance that is sometimes advantageous. French music escapes him utterly, in spite of his many years' residence in Paris. Mitropoulos is at his best with the central-European styles. Beecham is fine for English music, for all Slavic, for some German, for anything that has lyric afflatus or rhythmic punch. The Germans are rather messy when they play German music — always were, as Richard Wagner pointed out. Some are excellent with French music, however — Furtwängler, for instance, and Stock of Chicago. Italians do not always do their best by Italian works, especially those of strong French influence, though they do beautifully by anything Germanic, even Brahms. Only the French (and a few Germans) make sense with French music. Nobody, literally nobody, who has not passed his formative adolescent years in this country ever conducts American music with complete intelligibility.

The basis of American musical thought is a special approach to rhythm. Underneath everything is a continuity of short quantities all equal in length and in percussive articulation. These are not always articulated, but they must always be understood. If for any expressive reason one alters the flow of them temporarily, they must start up again exactly as before, once the expressive alteration is terminated. In order to make the whole thing clear, all instruments, string and wind, must play with a clean, slightly percussive attack. This attack must never be sacrificed for the sake of a beautiful tone or even for pitch accuracy, because it is more important than either. Besides, once a steady rhythm is established, the music plays itself; pitch and sonorities adjust themselves automatically; as in a good jazz band the whole takes on an air of completeness.

French music is the nearest thing in Europe to our music, because French rhythm, like ours, is less accentual than quantitative. Keeping downbeats out of a Debussy rendition, for instance, is virtually impossible to anybody but a Frenchman. Steady quantities, a little longer than

ours and requiring no percussive definition at all, are its rhythmic foundation. Definition is achieved by a leisurely breathing between phrases and an almost imperceptible wait before attacking, with no added force, what in any other music would be played as a downbeat. As with American music, a proper rhythm is cardinal and must be achieved before the pitch and the tone production can be polished up.

Modern German music is not very interesting rhythmically. It needs no exact quantities, only a thwacking downbeat. Even that can be advanced or held back, as is the Viennese custom, to express sentiment. What is most important is to get the harmony right, for pitch is all-important to the German mind. Get the harmony right and don't go *too* sentimental. Nothing else counts, provided care for the harmony includes a clear plotting out of the key relations in the whole piece. This means being sure there is always plenty of bass at the piece's joints.

Russian music is an alternation of very free rhythms with rigid and insistent ones. The latter are easy to render. But few conductors ever take enough liberties with the sentimental passages. English formulas are always closely related to the Russian (*vide* the English novel and the English Church). In music, both peoples conceive of rhythm as either nonexistent or quite inflexible. Both observe beat rhythms too, not quantities. And both alternate speech inflections with footwork, as in a song-and-dance. The chief difference between them is that the Russian mind dramatizes itself with a grandiloquent simplicity, whereas the English tradition values a more intimate and personal kind of forthrightness in the expression of tender thought. The grander passages of both repertories may be rendered with the utmost of pomp and of panache.

Matters like these seem to me more important to restate than international esthetic principles. All conductors know nowadays what the neoclassic style is all about. Also the neo-Romantic style and the twelve-tone syntax. And certainly the survivals of late Romanticism are not difficult to decipher. But these are the stylistic elements that underlie all modern music; they have been written about ad infinitum and ad nauseam. What I am pointing out is that underneath these international tendencies and observances there are ethnic differences that must be taken account of. Also to remind my readers that these ethnic differences preclude the possibility that conductors of foreign upbringing now resident among us will play a leading role in our present musical expansion. They render great service by their constant acts of good will toward homemade music. But they have only the vaguest idea of what it's all about. And so has that part of our musical public that hears it only through their well-intentioned but unconvincing renditions.

JANUARY 25, 1942

Master of Distortion and Exaggeration

〰 IF ONE HAD never heard before the works Vladimir Horowitz played last night in Carnegie Hall, or known others by the same authors, one might easily have been convinced that Sebastian Bach was a musician of the Leopold Stokowski type, that Brahms was a sort of flippant Gershwin who had worked in a high-class nightclub, and that Chopin was a gypsy violinist. One might very well conclude also that Liszt's greatest musical pleasure was to write vehicles for just such pianists as Vladimir Horowitz. The last supposition would be correct. Lizst was that kind of pianist himself, and he turned out concert paraphrases of anything and everything from the *Faust* waltzes to Palestrina motets. Whether he was quite the master of musical distortion that Horowitz is, history does not record; but I think there is little doubt possible that a kinship of spirit exists between the two pianists. One has only to hear Horowitz play Liszt's music to recognize that.

Do not think, please, that my use of the word *distortion* implies that Mr. Horowitz's interpretations are wholly false and reprehensible. Sometimes they are and sometimes they are not. His Bach is no worse, and no better than Stokowski's, on which I take it to be modeled. His Brahms may be less light-minded on other occasions than it was last night. His Chopin varied a good deal during the evening. The B-flat minor Sonata was violent, coarsely conceived, melodramatic. He made its Funeral March sound like a Russian boat song by accenting all the offbeats of the bass, and he turned its serene middle section into the most affected of nocturnes. His Etudes, however, were recognizable and, of course, quite brilliant, as they should be; and the A-flat Waltz (an encore) was as normal as his Liszt.

Supernormal would be a better word for the way he renders the works of the great Hungarian Romantic. He seems to have a perfectly clear understanding of what they are about and a thorough respect for them. He exaggerates when exaggeration is of the essence, but he never tampers with their linear continuity. He makes all the right effects, and he makes them in the right places. The only distortion is one of aggrandizement. He plays the Liszt pieces faster and louder and more accurately than anybody else ever plays them. Sometimes he plays the music of other composers that way too, and the effect is more tremendous than pleasant. In Liszt it is both tremendous and pleasant, because Liszt's music was written for that kind of playing and because Mr. Horowitz really loves and understands that kind of music. It is the only kind that he approaches without fidgeting, and last night it was the only kind the audience didn't cough through.

If I speak chiefly of interpretation, it is not that I am wanting in admiration of Mr. Horowitz's justly acclaimed technical powers. But these

powers are exploited by a violent and powerful personality that is, after all, a part of his virtuoso equipment. Paderewski had and Artur Rubinstein has a strength of crescendo comparable. E. Robert Schmitz has an equal cleanness of articulation and a more even trill. Josef Lhevinne's octaves and general marksmanship are at least as good. And almost any of the more poetic virtuosos, Rudolf Serkin or Robert Casadesus, for example, has a lovelier tone. But none of these pianists is so free from respect for the composer's intentions, as these are currently understood. Horowitz pays no attention to such academic considerations. He is out to wow the public, and wow it he does. He makes a false accent or phrasing anywhere he thinks it will attract attention, and every brilliant or rapid passage is executed with a huge crescendo or with a die-away effect. It is all rather fun and interesting to students of what I like to call the wowing technique. It is a great deal more than that, however, when he gets into his own arrangement of Liszt's arrangement for one piano of Saint-Saëns's arrangement for two pianos of the latter's orchestral version of his own song called *Danse Macabre*. His rendition of that number is in every way the berries.

Marialo March 7, 1942

The Gluck Case

❧ The Juilliard School used to give modern operas. They did but they don't anymore, as the ditty hath it. Their latest production was Gluck's *Iphigenia in Tauris*, a work which sometimes passes in the modern world for the most classic of musical classics, but which in its own day was considered a triumph of novelty and of fashion. I have no quarrel with a pedagogical policy that eschews today's modernism in favor of that of a century and a half back. I am all for bringing up the young on the ancient models of things, even though this may imply glorification of the Agamemnon family. The young take more things in their stride than we do maybe, anyway, including what Mr. John Peale Bishop once rhymed so prettily as "Iphigenia's incestuous desires." The purpose of this article is not to correct anybody's morals but to offer a warning to whom it may concern that Gluck's operas are not quite such model matter for musical imitation as their historical prestige might suggest.

That prestige is as much a result of publicity as it is of intrinsic musical excellence, though the latter, as anyone knows, is not wanting. Gluck had a gift from his prodigious early years of making himself a center of controversy and of intellectual excitement. He perfected this gift in Italy, where he learned, as well, a great deal about sheer theater and became a skilled harmonist and orchestrator. Counterpoint he never mastered, but he got to be extremely expert at musical declamation. Arriving in Paris with this far-from-negligible equipment for dramatic composition, he

proceeded to make himself a protagonist and eventually the victor in one of those Parisian wars about esthetics that have long been characteristic of French life.

The Gluck-Piccinni quarrel was really a continuation of the famous *querelle des bouffons* which had been going on for half a century. Everybody from Rameau to Jean-Jacques Rousseau had taken part in it. Its chief point of controversy was the respective virtues of the French and Italian operatic styles. The former prized correct declamation above melodic charm and admitted symphonic interludes as desirable to full musical expression. The latter prized tunefulness and easy theatrical effect and refused to consider music as at any point subservient to literature. The French side called the Italian school irresponsible and frivolous; the Italian defenders (Jean-Jacques among them) found the French opera static, pompous, and dull.

Piccinni was a charming composer, in many ways more gifted than Gluck; and he was fabulously successful at the Opéra. Gluck's backers were mostly literary people. What they wanted was a composer who could placate the melody fanciers without sacrificing correct declamation or obscuring the literary content of a dramatic poem. Gluck was exactly what they needed, an Italian-trained composer with a healthy German respect for the French language. And so they turned him on to the business of staging a contemporary literary movement by pretending merely to revive the past.

This latter game is an old French strategy. Racine had taught manners, language, and moral conduct to the bourgeoisie and to the court of Louis XIV by pretending merely to retell the plots of Seneca and Euripides. The authors of the Enlightenment were busy preparing (quite consciously) a political revolution; but to conceal the novelty of their reflections about society, economics, and law they pretended that they were merely studying ancient Greece and Rome. When Greco-Roman analogies were insufficient they brought the prestige of the natural sciences into play and based their argument on a wholly fictitious figment known as the "natural man." Gluck took advantage of this argument in his famous preface to *Armide* to pretend that his music was superior to that of all other composers because, whereas theirs was merely music and perishable, like all that follows fashion, his could never die, being a true depiction of "nature" itself. (By "nature" he meant, as any man of the eighteenth century did, what the nineteenth called "human nature" and what our own is likely to term "psychology.") I have heard Salvador Dali defend his painting with the similar argument that it was superior to mere "art" because it was an exact picture of his own dreams (dreams being the only "reality" surrealism admits).

All this is purest sales talk. Dali is an intellectually fashionable painter, as Gluck was an intellectually fashionable composer. The more they try

to explain this fact away, the more it becomes clear that their relation to a literary movement is fuller justification for the fame of their work than either their original power or their intrinsic skill, though in neither case is the latter element negligible. For all his talk of "reforming" the opera, Gluck did nothing of the kind. Dr. Paul Henry Láng, of Columbia University, likes to maintain that he had no influence on any subsequent operatic composition. Berlioz certainly admired and studied the orchestral writing in Gluck, because he quotes liberally from it in his *Treatise on Instrumentation*. Wagner used him as a battle cry for his own career, which he also called a "reform," and rewrote some of the scores in order to make them sound more convincingly proto-Wagnerian. All this has accomplished exactly what Gluck's own polemics accomplished, namely, to keep him famous, though his operas are given more and more seldom. The revival of interest in pre-Revolutionary French opera that has accompanied our own searchings among seventeenth- and eighteenth-century composers for reference points in defense of modernism has occasionally foundered on Gluck, for the simple reason that Lully and Rameau, its real masters, are not easily singable by modern voices. And so managers and conductors are likely to make a point of reviving Gluck and pretending that it is pre-Romantic opera.

This is not true. The literary content of Gluck's librettos is the purest Classic Revivalism; and the Classic Revival, like the subsequent Medieval Revival, is one of the more sentimental and obscurantist aspects of the Romantic movement. Particularly is this true in music, where there were not any ancient texts to revive. Gluck's choral passages are Protestant hymnody of the school popularized in America by Lowell Mason. His arias are watered Handel. His characters are artificial without being even symbolic. His recitativo, the second-best element of his musical composition (after the instrumentation, which is tops, in spite of his abuse of string tremolando), is definitely inferior to that of Rameau, on which it is modeled. Because of his contrapuntal deficiency, his music is lacking in animation and in interior life. His melodies follow the harmony rather than generate it. The whole is lacking in surprise. Every number is predictable after four bars.

The most nearly individual note in his music is one derived from its literary and fashionable associations. That is a sort of sugary pastoral flavor that permeates his whole concept of classical antiquity. Everybody on the stage walks around as blithely as if he were about to become an ancestor, or a Founding Father of some future republic. The Agamemnons even, that bloody and incestuous clan, express themselves musically with all the placidity of a prosperous agricultural family. They complain about hard times, of course, as is the habit of such families; but they are really mostly busy impressing everybody with how noble they are in their suffering.

Many people find Gluck's music enchanting. Some of these like it because they like sugar from any period. Others like it because they think they get a glimpse through it of pre-Revolutionary operatic style. To these latter I suggest that they beg, bully, and bargain with the producing agencies till they get a chance to hear the operas of Rameau and of Handel. Once acquainted with these, I doubt if they will still take Gluck's classical antiquity seriously, just as there is no possibility of really liking his camouflaged Romanticism with anything like the warmth we feel toward the full-blooded article in Mozart and in Beethoven.

As a career boy, he made his fortune and got knighted by the Austrian emperor. He was a second-class composer nevertheless. As a reformer he was a washout. As a successor to the great of his century he was as distinctly an anticlimax as are the well-known lines from Iphigenia's first aria in Tauris (a companion piece to our own "for God, for country, and for Yale"):

> J'ai vu se tourner contre moi
> les dieux, ma patrie et mon père.

MARCH 8, 1942

The Toscanini Case

❧ ARTURO TOSCANINI's musical personality is a unique one in the modern world. One has to go back to Mendelssohn to find its parallel. A reactionary in spirit, he has nonetheless revolutionized orchestral conducting by his radical simplification of its procedures. Almost wholly devoted to the playing of familiar classics, he has at the same time transformed these into an auditory image of twentieth-century America with such unconscious completeness that musicians and laymen all over the world have acclaimed his achievement without, I think, very much bothering to analyze it. They were satisfied that it should be, for the most part, musically acceptable and at all times exciting.

Excitement is of the essence in Toscanini's concept of musical performance. But his is not the kind of excitement that has been the specialty of the more emotional conductors of the last fifty years. Theirs was a personal projection, a transformation through each conductor's own mind of what the conductor considered to be the composer's meaning. At its best this supposed a marriage of historical and literary with musical culture. It was derived from the conducting style of Richard Wagner; and its chief transmitters to us have been the line that is von Bülow, Nikisch, and Beecham. For musicians of this tradition every piece is a different piece, every author and epoch another case for stylistic differentiation and for special understanding. When they miss, they miss; but when they pull it off, they evoke for us a series of new worlds, each of these veri-

fiable by our whole knowledge of the past, as well as by our instinctive sense of musical meaning. Theirs is the humane cultural tradition. And if their interpretations have sometimes been accompanied by no small amount of personal idiosyncrasy and a febrile display of nerves, that too is a traditional concomitant of the sort of trancelike intensity that is necessary for the projection of any concept that is a product equally of learning and of inspiration.

Toscanini's conducting style, like that of Mendelssohn (if Wagner is to be believed about the latter), is very little dependent on literary culture and historical knowledge. It is disembodied music and disembodied theater. It opens few vistas to the understanding of men and epochs; it produces a temporary, but intense, condition of purely auditory excitement. The Maestro is a man of music, nothing else. Being also a man of (in his formative years) predominantly theatrical experience, he reads all music in terms of its possible audience effect. The absence of poetical allusions and of historical references in his interpretations is significant, I think, of a certain disdain for the general culture of his listeners. In any case, whatever he may have inherited of nineteenth-century respect for individualistic culture was sacrificed many years ago to an emphasizing of those musical aspects that have a direct effect on everybody. It is extraordinary how little musicians discuss among themselves Toscanini's rightness or wrongness about matters of speed and rhythm and the tonal amenities. Like any other musician, he is frequently apt about these and as frequently in error. What seems to be more important than all that is his unvarying ability to put over a piece. Like Mendelssohn, he quite shamelessly whips up the tempo and sacrifices clarity and ignores a basic rhythm, just making the music, like his baton, go round and round, if he finds his audience's attention tending to waver. No piece has to mean anything specific; every piece has to provoke from its hearers a spontaneous vote of acceptance. This is what I call the "wow technique."

Now, what are we accepting when we applaud a Toscanini rendition? Not personal poetry, certainly; nor any historical evocation; nor a literal reading of a classic score. I think it is his power of abstraction we are acclaiming, the abstraction of a piece's essential outline. If he has reduced conducting motions to their basic outline too, that is not mere elegance on his part, nor ostentation either; it is a systematic throwing away of all refinements that might interfere with his schematic rendition. His whole accent is on the structure of a piece. Its thematic materials are the building blocks with which that structure is erected. Expression and ornamentation are details to be kept in place. Unity, coherence, and emphasis are the qualities that must be brought out.

Both theatrical experience and poor eyesight are probably responsible for the Toscanini style. When one cannot depend on reading a score in public, one must memorize everything. And when one memorizes every-

thing, one acquires a great awareness of music's run-through. One runs it through in the mind constantly; and one finds in that way a streamlined rendering that is wholly independent of detail and even of specific significance, a disembodied version that is all shape and no texture. Later, in rehearsal, one returns to the texture; and one takes care that it serve always as neutral surfacing for the shape. For shape is what any piece is always about that one has memorized through the eye and the inner ear. Playing a piece for shape and run-through gives (if the piece has shape at all) the most exciting effect that can ever be produced. It is the same procedure as that of directing a melodrama on the stage, character and dialogue being kept at all times subsidiary to the effects of pure theater, to the building up in the audience of a state of intense anxiety that is relieved only at the end of the last act.

The radical simplification of interpretative problems that all this entails has changed orchestral conducting from a matter of culture and of its personal projection into something more like engineering. Young conductors don't bother much anymore to feel music or to make their musicians feel it. They analyze it, concentrate in rehearsal on the essentials of its rhetoric, and let the expressive details fall where they may, counting on each man's skill and every player's instinctive musicianship to take care of these eventually. Poetry and nobility of expression are left for the last, to be put in as with an eyedropper or laid on like icing, if there is time. All this is good, because it makes music less esoteric. It is crude because it makes understanding an incidental matter; but it is a useful procedure and one wholly characteristic of our land and century. About its auditory result I am less enthusiastic than many. I find Toscanini's work, for the most part, spiritually unenlightening, except when he plays Italian music. But that is only a personal experience; many musicians find otherwise. And those of us who like more differentiation, more poetry, and more thought in our music, who find his much advertised fidelity to the notes of musical scores to be grossly exaggerated, his equally advertised "perfection" to be more so, and both of these aims, even when achieved, to be of secondary importance, even we must admit, nevertheless, the reality of Toscanini's musicianship and achievements. For good or for ill, and most probably for good, orchestral conducting will never be the same again.

I say most probably for good, because it is noticeable already that lesser conductors analyze music better than they used to and that this simple extraction of a work's formal essence tends to facilitate rather than to obfuscate differentiations of style and expression in the conducting of men whose musical experience is more limited but whose general culture is more ample than Toscanini's. Many of his contemporaries and most of his famous predecessors have had more interesting minds. Almost none

has been so gifted a natural musician and so strictly professional a showman. He has simplified the technique of the art by eliminating all the hangovers of Late Romantic emotionalism and by standardizing a basic technique of musical rendition that is applicable to any piece in the world, whether one understands its spirit or not. This may be treason to culture, or it may be merely a radical purging of culture's own fifth column. I fancy it includes a bit of both. In any case, I believe that the introduction of a new cultural understanding into orchestral rendition, as one observes this in the work of Alexander Smallens, for instance, and in that of most of the other good American conductors, is as directly traceable to Toscanini's having previously eliminated practically all cultural understanding from it as the means of their doing so have been facilitated by his radical simplifications of conducting procedure.

Toscanini's influence lies, so far, chiefly in America. Europe follows Furtwängler and Beecham and French conductors like Monteux and Münch. It has no need of exchanging their interpretations or their working methods for anything so oversimplified as Toscanini's. The Romantic tradition has already transformed itself there into a modern tradition that is as rich and as complex and as generally satisfactory to the mind as the tradition of Wagner and Nikisch was. That tradition is too complex for us. We admire the work of the great European conductors, but we do not quite understand how it is done. A century of importing them has not revealed their secrets to our local boys. We watched Toscanini work for ten years at the Philharmonic; and now there are 30,000 symphony orchestras in the United States, practically all of them led by the local boys. He is the founding father of American conducting. Whether we like or not the way he interprets music (and I don't much, though many do), his place in our musical history is certainly an important one.

In any European sense, he is not a complete musician, as the late Karl Muck was, and perhaps not even a great technician, as Reiner is, for example. He is too completely self-taught to be wholly responsible to any Great Tradition. But he is a thoroughgoing professional, although self-taught; and he has shown our musicians how to be thoroughgoing professionals too, although self-taught. The value of this contribution to our musical life cannot be overestimated. Any influence Toscanini might possibly have on European musical life would be anti-cultural. His ruthless clearing away here, however, of Romantic weeds and unsuccessful implantations has made a space where conductors are already being grown locally. And a steady supply of good American conductors to the local market is the thing above all else needful right now to the public understanding and the autochthonous development of American musical composition.

MAY 17, 1942

Shower of Gold

❧ WANDA LANDOWSKA'S harpsichord recital of last evening at the Town Hall was as stimulating as a needle shower. Indeed, the sound of that princely instrument, when it is played with art and fury, makes one think of golden rain and of how Danaë's flesh must have tingled when she found herself caught out in just such a downpour.

Landowska's program was all Bach and Rameau, with the exception of one short piece by Froberger. She played everything better than anybody else ever does. One might almost say, were not such a comparison foolish, that she plays the harpsichord better than anybody else ever plays anything. That is to say that the way she makes music is so deeply satisfactory that one has the feeling of a fruition, of a completeness at once intellectual and sensuously auditory beyond which it is difficult to imagine anything further.

On examination this amplitude reveals itself as the product of a highly perfected digital technique operating under the direction of a mind which not only knows music in detail and in historical perspective but has an unusual thoroughness about all its operations. There are also present a great gift of theatrical simplicity (she makes all her points clearly and broadly) and a fiery Slavic temperament. The latter is both concealed and revealed by a unique rhythmic virtuosity that is at the same time characteristic of our century and convincingly authentic when applied to the execution of another century's music.

It is when this rhythm is most relentless that I find Wanda Landowska's work most absorbing. Free recitative and the affetuoso style she does with taste, and she spaces her fugal entries cleanly. But music becomes as grand and as impersonal as an element when she gets into a sustained rhythmic pattern. It makes no difference then whether the music is dainty, as in the Rameau suite played, or dancy and vigorously expository, as in both the Rameau suite and the Bach B-flat Partita. It is full of a divine fury and irresistibly insistent.

There is no need of my reviewing the works played, which are all great music, save perhaps to pay tribute to Rameau, who got so much of the sweetness of France, as well as its grace and its grandeur, into his E-minor Suite. And to mention the romantic and rhapsodical beauty of a piece by Johann Froberger entitled *Lament Composed in London to Dispel Melancholy to Be Played Slowly with Discretion.*

OCTOBER 22, 1942

Strauss and Wagner

❧ THREE OF Richard Strauss's operas — *Salomé, Elektra,* and *Der Rosenkavalier* — have provoked worldwide admiration. Their musical

style has long been called by the vague term "post-Wagnerian." Their whole method, musical and dramatic, seems to me, however, to merit a more specific denomination. The German esthetic most current in poetry, painting, and the theater arts during the epoch of their composition has always been known as expressionism or, in German, *Expressionismus*.

Considering the important role played in the very creation of these works by literary and theatrical modernism, it is only just to their composer to credit him with having something on his mind beyond a mere continuation or extension of the Wagnerian musical technique. Two of them were made in close collaboration with a poet, Hugo von Hofmannsthal. The other, *Salomé*, uses as libretto the translation of a tragedy written originally in French by Oscar Wilde. It is not to be denied, I think, that however old-fashioned this sort of literature may seem nowadays, all three plays have a linguistic style and a moral (or amoral) consistency that make them more distinguished entertainment than any of the mythological poems that Richard Wagner (who was not properly a man of letters at all, in spite of his large literary production) ran up for himself. Wagner's best works are full even of musical inequalities, and the dichotomy between their musical vigor and their religio-philosophico-poetic flaccidity has always been a scandal. Strauss's three great ones (I do not know his others well) are all of a piece. You can take them or leave them, but you cannot separate their music from what it expresses.

Strauss's concept of dramatic composition, though derived from Wagner's, turns out in practice to give a quite different result. It begins, of course, by accepting the Wagnerian formula of the convulsive accompaniment and of the expansion of time. I do not know where Wagner picked up the idea of scrapping all accompanimental formality, of eschewing, I mean, all orchestral figurations of an abstract character. Neither Gluck nor Beethoven nor Weber nor Meyerbeer nor Berlioz, from all of whom Wagner appropriated theatrical procedures, ever did anything of the kind. They made their accompaniments appropriate and expressive, but it never occurred to any of them to destroy their function as a sort of auditory proscenium by whose static structure the more sensitive and personal music of the characters themselves is framed and intensified.

Characterization and all personal expression are classically the role of the vocal line and take place on the stage, just as atmosphere and dramatic emphasis are that of the orchestra and belong in the pit. In Wagner, and even more in Strauss, the orchestra takes over the work of characterization as well as that of emotional analysis and amplification, leaving little for the singing actors to do beyond a certain amount of intoned speech-imitation in the low register, punctuated by intensely pushed out cries in the upper. Not appearing ridiculous while they stand around waiting for their emotions to be described by the orchestra has always been the acting problem of Wagnerian singers. Nobody minds the eight

to twelve minutes of relative immobility during which the Countess
Almaviva in Mozart's *Marriage of Figaro* sings her "Dove sono" or
Charpentier's *Louise* describes her own love life in an aria beginning,
"Depuis le jour." But when Sieglinde, in the first act of *Die Walküre*,
has nothing to do but cross the stage once while the orchestra plays a
fifteen-minute footnote, it becomes evident to all that something should
really be arranged to keep her presentably occupied.

Strauss avoided this kind of situation by choosing stories about people
who were not too dignified, who were, indeed, human — all too human
(preferably outrageous) — and by putting the playwriting of these into
skilled hands. He did not ask his artists either to stand around doing
nothing or to do very much continuously expressive singing (they've
enough to do getting the notes right). He gave them instead a literary
and orchestral blueprint for acting all over the stage. Hence it is that,
though the vocal line is always rather static and often musically nonde-
script, the visual drama, like the auditory orchestral one, is constantly
and intensely convulsive. The convulsiveness all around is greater than
in Wagner, can afford to be so because Strauss, a composer of much ex-
perience in the concert forms, can always make an act hold together, give
it shape, progress, and conclusion, no matter how much violence goes on,
even at a length, as in *Elektra*, of more than two hours.

It is not my thesis that Strauss is the greater composer of the two. He
is not. His thematic invention is too often bromidic and careless. He is a
better musician than Wagner, yes, though not nearly so original nor
powerful a musical mind. His operas (or music-dramas) are certainly
made after the Wagnerian model. But what happened to the Wagnerian
model in Strauss's hands is something like this: He kept the convulsive
accompaniment and the augmentation of time; but, feeling a need to cor-
rect the embarrassment to actors and to the public that Wagner had
caused by taking most of its dramatic responsibility away from vocal
expression, he called in expert literary men, who tightened up the
plays, while they searched in legend and in abnormal psychology
for subjects suitable to convulsive orchestral treatment by a master
hand.

It is exactly this research into the lurid and its rendering in the cata-
clysmic style that constitutes the kind of German art known to its practi-
tioners as *Expressionismus*. Musically and musico-dramatically Strauss is
its world master, and the Metropolitan Opera Company's present *Salomé*
I recommend as a vigorous production of one of its masterpieces. It is not
incorrect to call Strauss's music post-Wagnerian; it is merely insufficient.
Because expressionism represents a rebirth rather than a mere survival
of the Wagnerian music-drama, the term is sufficient only if we admit, as
I see no reason for not admitting, that the whole expressionist movement,

which was larger than any one man's contribution to it, came into existence spiritually, as well as temporally, after Wagner.

<div align="right">DECEMBER 13, 1942</div>

1943

Acquaintance with Wagner

∿ ABOUT ONCE a year your reviewer ventures to dip an ear again into the Wagnerian stream. He thinks he ought to find out whether anything about it has changed since the last time or if anything has possibly changed in him that might provoke a reversal of judgment about it all and a return of the passionate absorption with which he used to plunge himself into that vast current of sound. This season's expedition took him to hear *The Valkyrie* last Tuesday evening at the Metropolitan Opera House. So far as he could tell, nothing has altered since last he heard the work.

The tunes are the same tunes as before, some excellent and some not so excellent. The symphonic development of the leitmotifs continues to vary in interest according to the musical value of the leitmotifs themselves. Those that contain chromatic progressions, arpeggios, or skips of a major sixth still become monotonous on repetition, while those based on narrower skips and diatonic movement continue to support expansion without strain. Wagner never learned the elementary rules of thumb that aided Bach and Handel and Haydn and Mozart and even Schubert to estimate the strength of melodic materials. His rhythmic patterns are frequently monotonous too; and he has a weakness for step-wise modulating sequences *à la rosalie*.

The instrumentation remains rich in sound and highly personal. And if it often creates its theatrical excitement by the use of mere hubbub, that excitement is still a dependable effect and the instrumental dispositions involved are acoustically sound. It has long seemed to me that Wagner's original contributions to musical art are chiefly of an orchestral nature. Indeed, orchestration is the one element of musical composition in which Wagner had sound training, exception being made for the rules of German declamation, which he derived for himself by studying the works of Mozart and Weber and Meyerbeer. His music writing is more varied in quality than is that of any other composer of equal celebrity, even Berlioz; but no matter what the quality, it always sounds well. It is always instrumentally interesting and infallibly sumptuous.

Sometimes the musical quality runs high too. There are unforgettable moments of invention in any of Wagner's operas, though the percentage

of memorable pages out of his whole production will probably be inferior to that in Verdi and certainly far less than what one can find in Mozart. And their excellence is not due wholly to orchestral orotundity; he often wrote charmingly for the voice as well. He wrote rather more effectively, however, it seems to me, for the higher voices than for the lower. His tenor and soprano roles are more pleasing and more expressive than his alto, baritone, or bass writing. His Ortruds and his Frickas are always a slight bore; and King Marke, Wotan, Hunding, Fafner, even for habitual Wagnerians, are proverbially great big ones. He had little feeling for the heavier vocal timbres, and there is no real liberty in his handling of them.

Well, all that is all that. Wagner was a gifted and original composer, though an unusually uneven one. And his lack of early musical instruction is probably the cause of his major faults, though I doubt if ignorance could be held responsible for any of his virtues. He was not, as a matter of fact, an ignorant man; he was merely an autodidact, lacking, like most autodidacts, more in esthetic judgment than in culture. He read voluminously and understood what he read; he reflected in a penetrating way about esthetic matters, and he mastered easily any musical technique he felt he needed. His troublesomeness on the musical scene has always been due less to the force of his musical genius (which was recognized from the beginning) than to the fact that neither instinct nor training had prepared him to criticize his own work with the objectivity that the quality of genius in it demanded. As a result, every score is a sea chest full of jewelry and jetsam. Fishing around for priceless bits is a rewarding occupation for young musicians, just as bathing in the sound of it is always agreeable to any musical ear. But musicians are likely to find nowadays that the treasure has been pretty well combed and that continued examination of the remnants yields little they hadn't known was there before.

What continues to fascinate this writer is not Wagner's music but Wagner the man. A scoundrel and a charmer he must have been such as one rarely meets. Perfidious in friendship, ungrateful in love, irresponsible in politics, utterly without principle in his professional life, and in business a pure confidence man, he represents completely the nineteenth-century ideal of toughness. He was everything the bourgeois feared, hoped for, and longed to worship in the artist. The brilliancy of his mind, the modernity of his culture, the ruthlessness of his ambition, and the shining armor of his conceit, even the senile erotomania of his later years, all went into a legend that satisfied the longings of many a solid citizen, as they had long before made him an attractive figure to aristocrats and intellectuals.

To know him was considered a privilege by the greatest figures in Europe, though many of these found the privilege costly. His conversation

was stimulating on every subject; his wit was incisive and cruel; his polemical writing was expansive, unprincipled, and aimed usually below the belt. He was the most inspiring orchestral conductor and the most penetrating music critic of his century. His intellectual courage and the plain guts with which he stood off professional rivalries, social intrigues, political persecution, and financial disaster are nonetheless breathtaking for the fact that his very character invited outrageous fortune.

All this remains; it is available in many books. The music remains too; and it is available at virtually every opera house in the world. It would not bring out the crowds or incite conductors and vocalists to the serious efforts it does if it did not have, in spite of its obvious inequalities, strength beneath its fustian still. To deny that strength were folly. To submit to it is unquestionably a pleasure. But what your reviewer would like most of all is to have known the superb and fantastic Wagner himself.

FEBRUARY 21, 1943

The Personality of Three Orchestras

〰 ORCHESTRAS are not wholly the product of their conductors. Their conductors train them and put them through their paces in public. But the conductor is one personality, and the orchestra is another (in private life a hundred others). A good orchestral concert is really more a duet than a domination.

Our three great Eastern ensembles, for instance — the Philadelphia, the Boston, and the New York Philharmonic — are as different from one another as the cities that created them and that forged them slowly into the image of each city's intellectual ideals. Conductors from outside have been had in to aid this formation, and a few of these have left traces of their own taste on that of the cities they have worked for. But chiefly their function has been to care for a precious musical organism, to watch over it, to perfect it in the observance of the musical amenities, and to allow it to mature according to its own nature and in accordance with its community's particular temperament. The conductor is never a static participant in such a process. He matures too, in harmony with the community, if he stays a reasonable length of time, is nourished and formed by local ideals, becomes a part of the thing to which he has contributed his abilities.

Serge Koussevitzky and Eugene Ormandy are cases in point of my thesis. They have been ripened and refined by their association with the Boston and the Philadelphia orchestras in a way that was not predictable at all during their previous careers. It was obvious always that both would go far, but it was not indicated to prophecy that Koussevitzky, the temperamental Slav, would become a master of orchestral understatement or that Ormandy, the boyish and straightforward central European,

would become a sort of specialist of delicately equilibrated orchestral sensuality. These developments, I am sure, are as legitimately creditable to environmental influence as to any previously manifested characteristics. Contact with orchestras of powerful temperament and specific orientation, as well as responsibility to cities of ancient and irreducible character — Boston, the intellectually elegant and urbane; Philadelphia, where everything, even intellectual achievement and moral pride, turns into a luxury, into a sort of sensuous awareness of social differences — contact, conflict, and collaboration between their strong European and the even stronger local traditions have given to these conductors their quality of being both the creature and the guiding hand of their own orchestras.

It is surprising (and most pleasant) to observe how two orchestras as accomplished as these can differ so completely in the kind of sounds they make. Boston makes thin sounds, like the Paris orchestras, thin and utterly precise, like golden wire and bright enamel. Nothing ever happens that isn't clear. No matter what the piece, no matter how inspired or how mistaken the conductor's understanding of it, the Boston execution is always transparent. So perfectly turned out is any of its executions that, whether becoming to the work or not, it has a way of separating itself from it. It neither conceals the work nor presents it; it walks down the street beside it rather, very much as a piece of consummate dressmaking will sometimes do with the lady who thinks she is wearing it.

The Philadelphia sonorities are less transparent, and the tonal balance is less stable. Because the sounds that make it up are all rounder and deeper and more human. They breathe; they seem almost to have sentience. They have a tactile quality, too, like a skin you might touch; yet they are never heavy nor hot. They are warm and moist and alive compared to Boston's Swiss-watchlike mechanism. As a price of this vibrancy, however, the Philadelphia Orchestra is not always easy to conduct. It is probably the most sensitive orchestra in the world. The leader can get a fortissimo out of it by lifting a finger, and he can upset the whole balance of it by any nervousness. Boston is tougher, more independent. No matter how the conductor feels or what mistakes he may make, the orchestra always plays correctly, saves its own face and his. Philadelphia is less objective, less rigidly mannered. But at its best it gives a more touching performance, achieves a more intimate contact with its audience. Boston, for all its glacial perfection, has no intimacy at all. No matter where one sits, the music seems very far away.

Our Philharmonic is a horse of another color and one that has had far too many riders. It has been whipped and spurred for forty years by guest conductors and by famous virtuosos with small sense of responsibility about the orchestra's future or about its relation to our community's culture. It has become erratic, temperamental, undependable, and

in every way difficult to handle. The sound of it has of late years been more like an industrial blast than like a musical communication. By moments there has been lovely work, but such moments have had an air of being accidental, the result of one day's well-being in the life of a neurotic. When the Philharmonic has been good it has sometimes been very good, but when it has been bad it has as often gone clean out of bounds.

Mr. Rodzinski has undertaken to heal its neuroses. At least we presume that is what he has undertaken. Because improvement is noticeable already in tonal transparency, and a faint blush seems to be appearing on the surface of the string sounds. Rhythmic coordination, too, though far from normal, is definitely ameliorated. It is to be hoped sincerely that progress will continue. But let no one imagine that forty years of ill treatment are going to be wiped out in a season. The Philharmonic will have to be retrained from the ground up, schooled for dependability, and accustomed to being able to count on its conductor. Under a steady and responsible hand it should in time develop into a team worthy of its magnificent personnel and of its nationwide public. What specific virtues it may eventually develop are unpredictable. At present its faults, like those of any spoiled child or horse, are more easily definable than its qualities. But it would be surprising if an orchestra so carefully selected, functioning in a city so sophisticated musically as New York, did not, once convalescence from old ills is firmly established, manifest characteristics of unique value.

OCTOBER 17, 1943

French Rhythm

∿ WHAT makes French music so French? Basically, I should say it is the rhythm. German musicians and Italian musicians tend to consider rhythm as a series of pulsations. French musicians consider pulsations as a special effect appropriate only to dance music, and they train their musical young most carefully to avoid them in other connections. In the Italo-German tradition, as practiced nowadays, the written measure is likely to be considered as a rhythmic unit and the first count of that measure as a dynamic impulse that sets the whole thing in motion. In French musical thought the measure has nothing to do with motion; it is a metrical unit purely. The bar line is a visual device of notation for the convenience of executants, but the French consider that it should never be perceptible to the listener.

The French conceive rhythm as a duality of meter and accent. Meter is a pattern of quantities, of note lengths. Its minimum unit in execution is the phrase. Accent is a stress that may occur either regularly or irregularly; but in any case, it is always written in. It may occur on the first note of a measure, but in well-written music it will usually appear more

frequently in other positions, since any regular marking off of metrical units tends to produce a hypnotic effect. French music, unless it is written for the dance or unless it aims to evoke the dance, has no dynamic propulsion at all. It proceeds at an even rate, unrolls itself phrase by phrase rather like Gregorian chant.

It is more than probable that the classical Viennese symphonists were accustomed to this kind of rhythmic articulation and took it for granted. Pulsation came into Viennese symphonic execution somewhere around 1830, after the waltz had come to dominate Vienna's musical thought. At any rate, discerning Germans have frequently pointed out the superiority of French renderings of their own classics. Wagner found the Beethoven symphonies far better played at the Paris Conservatoire than anywhere in Germany, and he based his own later readings on those of the French conductor Habeneck. Mr. Alfred Einstein, the German Mozart authority of our own day, has avowed in his book *Greatness in Music* his preference for French renditions of that composer. And certainly German organists have not in our century played Bach with any authority comparable to that of Saint-Saëns, Widor, Vierne, Guilmant, and Schweitzer.

This acknowledged superiority of the French approach to classical German music is due, I believe, to the survival in French musical practice of classical observances about rhythm, elsewhere fallen into disuse. Those same observances are responsible, I believe, for the vigorous flowering of new music in France that is the most noteworthy event in the musical history of the last seventy-five years. French harmonic innovations have been striking, but so were those of Richard Strauss and of Arnold Schönberg, of Gustav Mahler even. Everybody has played at inventing a new harmony. Scriabine in Russia, Ives in Danbury, Connecticut, were no less original harmonically than Claude Debussy. What their music lacks is true rhythmic life. The only music of our time that can compare in this respect with that of the school of Paris is American jazz. And this is based on the same duality of meter versus accent that lies at the basis of French music.

The French rhythmic tradition is at once more ancient and more modern than any other. It includes the medieval plainsong and the Benedictine restoration of this, in which a wholly quantitative syllabic execution without any stresses whatsoever turns out to be expressive and interesting. It includes the French medieval and Renaissance music that grew out of plainsong, the schools of Champagne and of Burgundy. It remembers its own Baroque and Rococo styles. It is least aware, perhaps, of the domain that is the very center and pivot of German musical understanding, the world of nineteenth-century Romanticism, though Chopin, Liszt, and, curiously, Schumann it considers as its own. All these it thinks of, along with Moussorgsky and Stravinsky and Spanish dance music and the pop-

ular music of Java and Bali and Morocco and the United States as in no way foreign to itself.

The binding element, the thread that runs through all these different kinds of music is an absence of pulsating rhythm. In Greek theory quantities are one element of rhythm; stress is another; cadence (or, in musical terms, phraseology) is the third. Pulsation has no place in this analysis. It is a special effect, derived from round dancing, only to be added to musical execution when round dancing is clearly implied as the subject of a musical passage. Its introduction elsewhere brings in a singsong element that tends to trivialize musical rhetoric. Bach played by Schweitzer or Landowska, Mozart and Haydn played by Beecham (who is no Frenchman but who is British enough to remember the eighteenth century as it was) and modern French music conducted by Monteux or played on the piano by Schmitz are anything but trivial.

Other artists in other repertoires have their charms and their especial powers, like Horowitz's Liszt, Toscanini's Wagner, Walter's Brahms. These always seem to me like cases of pure genius, supported (excepting possibly Walter) by no major tradition. But the others are not only supported by a major tradition, they support it, too. They are constantly tending it, pruning it, watering it, grafting new shoots on it, gathering from it new fruits. The parent stem of that tradition is, I think, a certain approach to rhythm. That approach is as ancient as Hellas, as far-flung as China, Marrakesh, and New Orleans, as up-to-date as boogie-woogie or the percussion music of John Cage. I take this occasion to speak about it because there is better access to it right now in New York City than there has been in some years and because I hope some of our young musicians, both composing and executant, may be induced here and now to profit by the occasion. I believe this view of rhythm to be the open sesame of musical advance today, exactly as it has been all through history.

NOVEMBER 14, 1943

American Rhythm

JOHN KIRKPATRICK, who gave a piano recital last night in Times Hall, has a way of making one feel happy about American music. He does this by loving it, understanding it, and playing it very beautifully. He plays, in fact, everything very beautifully that I have ever heard him play. But people who play that beautifully so rarely play American music that Mr. Kirkpatrick's recitals are doubly welcome, once for their repertory and again for his unique understanding of it.

The loveliness of his playing comes from a combination of tonal delicacy with really firm rhythm. Exactitude with flexibility at all the levels of loudness is the characteristic of American pianism that transcends all our local schools of composition. It is what makes us a major musical

people, and it is exactly this rhythmic quality that escapes our European interpreters. European tonal beauty, of course, more often than not escapes American pianists. Mr. Kirkpatrick's combination of European tonal technique with full understanding of American rhythm makes his playing of American works a profoundly exciting thing and a new thing in music.

Charles Ives's *Concord* Sonata was esteemed by Lawrence Gilman the finest piece of music ever written by an American, and it very well may be that. Certainly it is a massive hunk of creation; four massive hunks, in fact. Because it is really four symphonic poems, named respectively, "Emerson," "Hawthorne," "The Alcotts," and "Thoreau": four full-length portraits done with breadth, tenderness, and wit. "The Alcotts" is the best integrated of these and probably the most original, or indigenous, in its musical material and fancy. I suspect that concert audiences would take eventually to all these portraits if they were performed separately for a time, since the whole work is longer than the ones people are now used to listening to. In any case, here is music, real music; and Americans should have no difficulty accepting its subject matter or understanding its indigenous grandeurs.

Of the other works performed last night Theodore Chanler's Toccata in E-flat major seemed to me the most finely conceived and the most delicately indited. Roy Harris's early Piano Sonata, opus 1, is a coarse work and laborious. The MacDowell *Woodland Sketches* seemed charming and poetic, as always, but a little soft in their melodic material.

The encores consisted of two works by Stephen Foster, *The Old Folks' Quadrille* and a flute piece called *Anadolia;* a Prelude by Robert Palmer; Arthur Farwell's *Navajo War Dance,* and a *Trumpet Aire* by James Bremner, a composer of Revolutionary times. All these were good to hear, especially Mr. Palmer's strongly knit Prelude and Farwell's handsome evocation of Indian themes and rhythms. The others were agreeably antiquarian. And everything Kirkpatrick played turned into a poem.

NOVEMBER 24, 1943

Real Modern Music

ᗡ ARNOLD SCHÖNBERG's Piano Concerto, which received its first performance anywhere yesterday afternoon by the NBC Symphony Orchestra, Leopold Stokowski conducting and Eduard Steuermann playing the solo part, is the first original work for large orchestra by this master to be heard in New York since quite a long time back. For many of our young music lovers it is no doubt their first hearing of any orchestral work of its kind. One cannot be too grateful to Mr. Stokowski for giving himself the trouble to prepare it and for paying his radio listeners

the compliment of presuming their interest. It is an honor paid not only to one of the living masters of music but to the American public as well; and the General Motors Corporation, which sponsored the broadcast, should be proud of the event.

The piece, which lasts a shade under twenty minutes, consists of four sections neatly sewn together and played without pause — a waltz, a scherzo, an adagio, and a rondo. All are based on a single theme, though there is considerable development of secondary material in the scherzo. The musical syntax is that commonly known as the twelve-tone system, which is to say that the employment of dissonance is integral rather than ornamental. The expression of the work is romantic and deeply sentimental, as is Schönberg's custom and as is the best modern Viennese tradition.

The instrumentation too is characteristic of its author. It is delicate and scattered. The music hops about from one instrument to another all the time. It sounds like chamber music for a hundred players. There is plenty of melody, but no massing of instruments on any single line for giving the melody emphasis, as is customary in oratorical symphonic writing. The work is not oratorical, anyway. It is poetical and reflective. And it builds up its moments of emphasis by rhythmic device and contrapuntal complication, very much as old Sebastian Bach was wont to do. Its inspiration and its communication are lyrical, intimate, thoughtful, sweet, and sometimes witty, like good private talk. At no point is there grandiloquence or theater. The work derives much of its impressiveness from its avoidance of all attempt to impress us by force.

Its great beauty is derived partly from the extreme delicacy and variety of its instrumentation and partly from the consistency of its harmonic structure (a result of its observance of the twelve-tone syntax). Its particular combination of lyric freedom and figurational fancy with the strictest tonal logic places it high among the works of this greatest among the living Viennese masters (resident now in Hollywood) and high among the musical achievements of our century. With the increasing conservatism of contemporary composers about matters harmonic, many of our young people have never really heard much modern music. Radical and thoroughgoing modern music, I mean. It is too seldom performed. Well, here is a piece of it and a very fine one, a beautiful and original work that is really thought through and that doesn't sound like anything else.

Eduard Steuermann played the piano part with all delicacy and love. There isn't much in it to show off with (only two brief and fragmentary cadenzas, and they are not written for brilliance), but the piano is there all the time. It weaves in and out rather in chamber style, and Mr. Steuermann never overplayed it or underplayed it. Everybody gave his serious best to this serious and far from easy work. One came away almost not

minding that it had been preceded by the inexcusably long and dull commercial plug that the NBC hours sacrifice to sponsorship.

FEBRUARY 7, 1944

America's Musical Autonomy

∾ *White and Negro Spirituals* by George Pullen Jackson (J. J. Augustin, New York, 1944) is the fourth, and presumably final, volume of a study in United States musical folklore that has been full of sensational discoveries. Dr. Jackson has had the rare luck to come upon one of those keystones to the understanding of a subject such as scholars dream about. He has uncovered a vast body of religious folksong still in print and in current usage among the white population of this country. His penetrating analysis of this material has clarified the whole question of America's musical resources and made it possible henceforth to classify these with some completeness. It has also rendered it impossible for any informed person ever to take the United States, with our ethnic musical resources and our instinct for preserving them alive, for a second-class musical power.

Dr. Jackson's findings include the following:

All the early settlers brought songs with them.

Most of the latter, excepting those of British Isles origin, passed out of use as the languages in which they were sung gave way to English.

British folksongs of jiggy rhythm were the musical carriers of the religious Revival that started around 1800 in Kentucky and spread rapidly over the English-speaking world.

At about the same time books of traditional tunes with sacred words began to appear, as if a more conservative element among our rural population were desirous of preserving a precious heritage of modal melody from, on the one hand, being wiped out of existence through the spread of the "modern," or major-and-minor, harmonic style, and, on the other, being literally "sung to pieces" in camp meetings.

The publication of such collections, in the shape-notes of the fa-sol-la system, has continued to this day, though it has remained for Dr. Jackson to identify their contents as authentic and ancient folksong. "White spirituals" is the name he gives to these melodies. He has analyzed and catalogued in two of his previous volumes 550 of them.

Negro spirituals, of which some 900 different ones are already collected, are similar in style and construction to their white models and subsequent to these in appearance. One-third of these have already been identified as copies, or slight transformations, of white originals. The present volume contains a comparative catalogue (with words and music) of 116 spiritual songs, the Negro versions being collated on oppo-

site pages along with their previously known and published white originals from the British Isles.

A singing practice of many Negro congregations, especially of the Primitive Baptist faith, that is known among these as "long meter" — a vague and ultra-florid melopoeia with no rhythm in it at all, long thought to be an African survival of some kind — has been identified by Dr. Jackson as nothing less than a continuation into our time of the old Presbyterian psalmody, elsewhere completely lost since the late eighteenth century, at which time it seems to have been replaced by a simpler, livelier, and more rhythmic style of congregational singing.

The ethnic integrity of American folk music will be surprising news to many who have long held to the melting-pot theory of American life. There are probably a few French and a few Spanish tunes that have attained currency here beyond the confines of the regions where those languages are still spoken, but they are very few. Even German songs are rare among our non-German-speaking folk.

Secular origins for religious melody are, of course, as common here as anywhere else. The American dissenters did exactly what medieval Catholics and the Lutheran Reformationists had done. In Dr. Jackson's story, "the religious folk did not confine themselves in their tune selection to any particular type of secular song . . . The pioneer songsters borrowed indiscriminately from the English, Irish, Manx, Welsh, and Scotch. They took over everything they liked whether its song text had been of love, war, homesickness, piracy, robbery, murder, or lament for the dead. They adapted even large numbers of fiddle and pipe tunes — marches, reels, jigs, and hornpipes. But even though the American religious folk were not concerned as to the type of worldliness their favorite tunes had been steeped in, those airs had to be died-in-the-wool British . . . *All the known tunes adopted by American religious folk from sources other than British throughout the two-hundred-year period under consideration could be counted on the fingers of one hand.*"

The carriers of this great folksong movement from the British Isles to America and from New England to the South and the Middle West were not, as is commonly believed, the Methodists but chiefly the Baptists, though everybody eventually took part in it under the influences, first, of the Spiritual Revival of the early nineteenth century and later of the millennialist wave that flourished in the 1840s. John Wesley, the founder of Methodism, was opposed to it.

Of the latter, Dr. Jackson says, "No powerful religious movement, he knew, could do without a suitable body of song." So he set himself to provide this after the Lutheran model. But instead of picking up melodies from the "great body of English and Gaelic folk tunes still echoing in the British Isles as they had echoed since the time of the ancient bards, . . . he resolved to ignore what was at hand and borrow from afar — to pro-

vide the religious awakening with German tunes. These he found nota-
bly among the new-come Moravians who were just then taking root in
English soil. To selections of German Moravian tunes Wesley added airs
by Handel, Giardini, Lampe, and other composers of the imported elite
London musical circle, and it was this hodgepodge of everything but
good old English song that made up his first tune book for the Meth-
odists. *A Collection of Tunes, set to music, as they are commonly sung
at the Foundery*, London, 1742, set the pace for that upsurging group
in its early stages of growth."

White and Negro Spirituals tells one of the most fascinating stories in
the world, that of the secret, or nonofficial, musical life of this country.
It would seem that this is all bound up with religious dissent. It includes
as much dissent from official America as from official Europe. It is based
on the privilege of every man to praise God, as well as to court a damsel,
with songs of his own choosing. For two hundred years it has refused
institutional mediation in culture, as it has denied the necessity of insti-
tutional mediation for salvation. As a result, we have a body of British
song that has survived the efforts of churches, of states, and of schools
— for all have tried — to kill it. As a further result, we have a musical
life of high creative energy. It is characteristic of our history that that
life should be still today more vigorous and more authentic in rural re-
gions and among the economically submerged than among those of us
who are constantly subjected to the standardizing influences of radio, of
the public-school system, and of socialized religion.

MARCH 12, 1944

Equalized Expressivity

∾ ARTUR SCHNABEL, who played last night in Carnegie Hall the
second of three recitals presented by the New Friends of Music and de-
voted to the piano music of Beethoven, has for some thirty or forty years
made this composer the object of his especial attention. He passes, in-
deed, for an expert on the subject, by which is usually meant that his
knowledge of it is extensive and that his judgments about it are respected.
Any issue taken with him on details of tempo, of phraseology, of accent
is risky and, at best, of minor import. Minor too are criticisms of his
piano technique, which, though not first class, is adequate for the ex-
pression of his ideas. His ideas about Beethoven's piano music in general,
whether or not one finds his readings convincing, are not to be dismissed
lightly.

Neither need they, I think, be taken as the voice of authority. For all
the consistency and logic of his musicianship, there is too large a modi-
cum of late nineteenth-century Romanticism in Mr. Schnabel's own per-
sonality to make his Beethoven — who was, after all, a child of the late

eighteenth — wholly convincing to musicians of the mid-twentieth. No one wishes to deny the Romantic elements in Beethoven. But I do think that they are another kind of Romanticism from Schnabel's, which seems to be based on Richard Wagner's theories of expressivity.

Mr. Schnabel does not admit, or plays as if he did not admit, any difference between the expressive functions of melody and of passage work. The neutral material of music — scales, arpeggiated basses, accompanying figures, ostinato chordal backgrounds, formal cadences — he plays as if they were an intense communication, as if they were saying something as important as the main thematic material. They are important to Beethoven's composition, of course; but they are not directly expressive musical elements. They serve as amplification, as underpinning, frequently as mere acoustical brilliance. To execute them all with climactic emphasis is to rob the melodic material, the expressive phrases, of their singing power.

This equalized expressivity ends by making Beethoven sound sometimes a little meretricious as a composer. His large-scale forms include, of necessity, a large amount of material that has a structural rather than a directly expressive function. Emphasizing all this as if it were phrase by phrase of the deepest emotional portent not only reduces the emotional portent of the expressive material; it blows up the commonplaces of musical rhetoric and communication into a form of bombast that makes Beethoven's early sonatas, which have many formal observances in them, sound empty of meaning and the later ones, which sometimes skip formal transitions, sound like the improvisations of a talented youth.

The work that suffered least last night from the disproportionate emphasizing of secondary material was the Sonata, opus 111. Here Mr. Schnabel achieved in the first movement a more convincing relation than one currently hears between the declamatory and the lyrical subjects. And in the finale he produced for us that beatific tranquillity that was a characteristic part of Beethoven's mature expression and that had been noticeably wanting, though there were plenty of occasions for it, in the earlier part of the evening.

MARCH 28, 1944

Surrealism and Music

 THE SPRING number of *Modern Music* contains a reflective article on the place of music in modernist esthetics by a man who has admittedly little taste for the art and no precise knowledge about it. The author of this essay is André Breton, founder, defender of the faith, and for twenty years pope of the surrealist movement in French poetry, at present head of the surrealist government-in-exile in New York City.

Mr. Breton defends his own antagonistic attitude toward music on the

ground that it is identical with that of most of the nineteenth- and twentieth-century French poets. He admits, however, the desirability of some fusion between it and his own art. And he recommends to musicians a "return to principles" comparable to that which has made surrealism for two decades now the chief movement of renovation in European poetry.

The first observation needs no rebuttal. It is, alas, only too true that since the divorce of poetry from music (Thomas Campion was the last in England to practice both with distinction) the poets have manifested consistently a certain bitterness toward the rival auditory art. They have indited odes to it aplenty, I know, and spoken of it on many occasions most feelingly; but their homage has rarely been without guile. Shakespeare very nearly gave the plot away when he referred to music as a "concourse of sweet sounds." (Imagine the explosion that would have occurred had anyone dared in Shakespeare's London to call poetry a "running together of pretty words.") The great one eventually carried his campaign for the discrediting of music as a major art to the point of proclaiming it frankly "the food of love." His disinterestedness in this matter has not hitherto been questioned. But music died in England shortly after him.

What Mr. Breton, a poet, fails to consider here is the propaganda for the dignity and the grandeur and, most important of all, the meaning of music that was operated so successfully by the nineteenth-century philosophers. It is not the exceptional suffrages of Baudelaire and Mallarmé that have given to music its prestige in contemporary society but the systematic and relentless praise of its expressive powers by Hegel, by Schopenhauer, and by Nietzsche.

On the fusion, or re-fusion, of the two great auditory arts Mr. Breton adopts without argument the Wagnerian thesis that this is desirable. As a good Marxian he refuses the "reformist" program of closer collaboration between poets and composers, maintaining with some justice that poems "set to music" serve no valid artistic purpose and that opera librettos are and always have been a pretty silly form of literature. He seems to think that the fusion might be operated by some one man working at a high emotional temperature, and he suggests the passion of love as possibly useful to this end. What such a fusion would accomplish beyond a regression to primitive esthetics is not proposed to us. One wonders if Mr. Breton envisages as desirable a similar fusion of the visual arts, the reunion of painting and sculpture, for instance, with or without a framework of architecture, the event to take place by no collaborative procedure. One wouldn't wish that dish on his dearest enemy. The musical theater is only now recovering from Wagner's megalomaniac seizure of all its creative privileges, and convalescence is still far from complete.

That music should take a lesson from contemporary French poetry and

go back to principled operations is not a bad idea. That the functioning of the auditory invention be studied in its divergent manifestations of poetry and of music is an even better one. It is probable that persons of strong auditory memory vary in the relation that their auditory function bears to specific bodily regions. Audito-cerebral types are likely to make poets, orators, preachers, and even statesmen. Audito-visceral types, persons whose reactions to sound and to the memory of it are organic (which means emotional) rather than visual or muscular, make musicians. The audito-kinetic make dancers, acrobats, and the like. Persons for whom noise is merely a sexual stimulant, as it is for rats, may reasonably call music "the food of love"; and their type, though common, is a low one in the biological scale.

The fusion of divers artistic techniques through personal collaboration is an ancient procedure. Their simultaneous exercise by one person is an even more ancient procedure, a primitive one, to be exact. The desirability of reestablishing this in custom depends on the feasibility of trying to develop in human beings a generalized bodily reaction to sound in place of the specifically varied ones that seem to be at present a mark of the higher human types. The matter is worth investigating; but so far as anybody knows now, music is better off without its former legal and virtually indissoluble union to the word.

What Mr. Breton does not seem to have grasped about music is that, instead of being behind poetry in its evolution, it is in many ways more advanced. The dissociative process, which has made possible Mr. Breton's whole career and that of the poetic movement he presides over, has long since lost its novelty for composers. The composer who doesn't use it freely is simply not a very interesting composer; his work lacks fancy, surprise, richness, originality, depth. The right of poets to express themselves by means of spontaneous, subconsciously ordered sequences of material has seemed to many in our century a revolutionary proposition. It is, however, the normal and accepted way of writing music. Any imposition of logic upon this, whether in the form of allusions to classical rhetoric or in the observance of the only rigorous syntax known to our time, the twelve-tone system, is considered in some circles as dangerous radicalism.

The Romantic revolution, in short, was successful in music. It won real freedom for the composer. That it was not successful in literature is proved by the fact that Mr. Breton and his friends are still fighting it. Haydn, Mozart, and Beethoven, sometimes foolishly spoken of as classicists, were the most radical of libertarians; and sonata form, their favorite continuity convention, was, as is well known, no strict formula at all but the slenderest possible framework for the display of musical fancy and for the expansive expression of spontaneous, nonverbalized feeling.

Music's modern movement is another thing from poetry's. The verbal

art is still demanding liberty from intellectual restraints. The tonal art, that freedom long since gained and the things it was gained for saying long since said, has fallen, through the progressive lowering of its intellectual standards, into demagogic and commercial hands. Its modern movement is based on the demand that music be allowed to make some kind of plain sense again. We seek no loosening of our intellectual clothes; they are so loose now we can barely walk. What we want is readmission to intellectual society, to the world of free thought and clear expression.

It is more than probable that some of the surrealists' psychological devices for provoking and for sustaining inspiration can be used to advantage by composers, since they are largely of musical origin anyway. They cannot fail, certainly, to encourage spontaneity of auditory invention because they represent a return to the best Romantic practice in this regard. What they do not represent is any kind of novelty for the musical world. They are, in fact, what the post-baroque musical world is all about. And musicians are only too delighted, I am sure, to lend them for a while to poetry, with all good wishes for their continued success.

APRIL 2, 1944

Masterpieces

∾ THE ENJOYMENT and understanding of music are dominated in a most curious way by the prestige of the masterpiece. Neither the theater nor the cinema nor poetry nor narrative fiction pays allegiance to its ideal of excellence in the tyrannical way that music does. They recognize no unbridgeable chasm between "great work" and the rest of production. Even the world of art painting, though it is no less a victim than that of music to Appreciation rackets based on the concept of gilt-edged quality, is more penetrable to reason in this regard, since such values, or the pretenses about them advanced by investing collectors and museums, are more easily unmasked as efforts to influence market prices. But music in our time (and in our country) seems to be committed to the idea that first-class work in composition is separable from the rest of music writing by a distinction as radical as that recognized in theology between the elect and the damned. Or at the very least by as rigorous an exclusion from glory as that which formerly marked the difference between Mrs. Astor's Four Hundred and the rest of the human race.

This snobbish definition of excellence is opposed to the classical concept of a Republic of Letters. It reposes, rather, on the theocratic idea that inspiration is less a privilege of the private citizen than of the ordained prophet. Its weakness lies in the fact that music, though it serves most becomingly as religion's handmaiden, is not a religion. Music does not deal in general ideas or morality or salvation. It is an art. It expresses

private sentiments through skill and sincerity, both of which last are a privilege, a duty, indeed, of the private citizen, and no monopoly of the prophetically inclined.

In the centuries when artistic skills were watched over by guilds of workmen, a masterpiece was nothing more than a graduation piece, a work that marked the student's advance from apprenticeship to master status. Later the word was used to mean any artist's most accomplished work, the high point of his production. It came thus to represent no corporate judgment but any consumer's private one. Nowadays most people understand by it a piece differing from the run of repertory by a degree of concentration in its expressivity that establishes a difference of kind. And certain composers (Beethoven was the first of them) are considered to have worked exclusively in that vein. The idea that any composer, however gifted and skillful, is merely a masterpiece factory would have been repellent to Bach or Haydn or Handel or Mozart, though Gluck was prone to advertise himself as just that. But all the successors of Beethoven who aspired to his authority — Brahms and Bruckner and Wagner and Mahler and Tchaikovsky — quite consciously imbued their music with the "masterpiece" tone.

This tone is lugubrious, portentous, world shaking; and length, as well as heavy instrumentation, is essential to it. Its reduction to absurdity is manifest today through the later symphonies of Shostakovich. Advertised frankly and cynically as owing their particular character to a political directive imposed on their author by state disciplinary action, they have been broadcast throughout the world as models of patriotic expression. And yet rarely in the history of music has any composer ever spread his substance so thin. Attention is not even required for their absorption. Only Anton Rubinstein's once popular symphony, *The Ocean*, ever went in for so much water. They may have some value as national advertising, though I am not convinced they do; but their passive acceptance by musicians and music lovers can certainly not be due to their melodic content (inoffensive as this is) or to their workmanship (roughly competent as this is too).

What imposes about them is their obvious masterpiece-style one-trackness, their implacable concentration on what they are doing. That this quality, which includes also a certain never-knowing-when-to-stop persistence, should be admired by laymen as resembling superficially the Soviet war effort is natural enough. But that what these pieces are up to in any musical sense, chiefly rehashing bits of Borodin and Mahler, is of intrinsic musical interest I have yet to hear averred by a musician. And that is the whole trouble with the masterpiece cult. It tends to substitute an impressive manner for specific expression, just as oratory does. That music should stoop to the procedures of contemporary political harangue is deplorable indeed.

There are occasions (funerals, for instance) where the tone of a discourse is more important than its content, but the concert is not one of them. The concert is a habitual thing like a meal; ceremony is only incidental to it. And restricting its menu to what observes the fictitious "masterpiece" tone is like limiting one's nourishment to the heavier party foods. If the idea can be got rid of that a proper concert should consist only of historic "masterpieces" and of contemporary works written in the "masterpiece" tone, our programs will cease to be repetitive and monotonous. Arthur Judson, the manager of the Philharmonic, remarked recently that the orchestral repertory in concert use today is smaller than it was when he went into concert management twenty-five years ago, and this in spite of the fact that orchestras and orchestral concerts are many times more numerous. I suspect that this shrinkage may be due to a popular misconception about what constitutes quality in music.

If the Appreciation Racket were worth its salt, if the persons who explain music to laymen would teach it as a language and not as a guessing game, the fallacy of the masterpiece could be exposed in short order. Unfortunately, most of them know only about twenty pieces anyway, and they are merely bluffing when they pretend that these (and certain contemporary works that sort of sound like them) make up all the music in the world worth bothering about.

JUNE 25, 1944

Schönberg's Music

✣ ON SEPTEMBER 13 Arnold Schönberg, dean of the modernists, will be seventy years old. And yet his music, for all its author's love of traditional sonorous materials and all the charm of late nineteenth-century Vienna that envelops its expression, is still the modernest modern music that exists. No other Western music sounds so strange, so consistently different from the music of the immediately preceding centuries. And none, save that of Erik Satie, has proved so tough a nut for the public to crack. Only the early *Verklärte Nacht* has attained to currency in our concerts. The rest remains to this day musicians' music.

Musicians do not always know what they think of Schönberg's music, but they often like to listen to it. And they invariably respect it. Whether one likes it or not is, indeed, rather a foolish question to raise in face of its monumental logic. To share or to reject the sentiments that it expresses seems, somehow, a minor consideration compared with following the amplitude of the reasoning that underlies their exposition. As in much of modern philosophical writing, the conclusions reached are not the meat of the matter; it is the methods by which these are arrived at.

This preponderance of methodology over objective is what gives to

Schönberg's work, in fact, its irreducible modernity. It is the orientation that permits us to qualify it as, in the good sense of the word, academic. For it is a model of procedure. And if the consistency of the procedure seems often closer to the composer's mind than the expressive aim, that fact allows us further to describe the work as academic in an unfavorable sense. It means that the emotional nourishment in the music is not quite worth the trouble it takes to extract it. This is a legitimate and not uncommon layman's opinion. But if one admits, as I think one is obliged to do with regard to Schönberg, that the vigor and thoroughness of the procedure are, in very fact, the music's chief objective, then no musician can deny that it presents a very high degree of musical interest.

This is not to say that Schönberg's music is without feeling expressed. Quite to the contrary, it positively drips with emotivity. But still the approach is, in both senses of the word, academic. Emotions are examined rather than declared. As in the works of his distinguished fellow citizen Dr. Sigmund Freud, though the subject matter is touching, even lurid, the author's detachment about it is complete. Sentiments are considered as case histories rather than as pretexts for personal poetry or subjects for showmanship. *Die Glückliche Hand, Die Gurrelieder,* and *Pierrot Lunaire,* as well as the string sextet *Verklärte Nacht,* have deeply sentimental subjects; but their treatment is always by detailed exposition, never by sermonizing. Pierrot's little feelings, therefore, though they seem enormous and are unquestionably fascinating when studied through the Schönberg microscope for forty-five minutes of concert time, often appear in retrospect as less interesting than the mechanism through which they have been viewed.

The designing and perfecting of this mechanism, rather than the creation of unique works, would seem to have been the guiding preoccupation of Schönberg's career; certainly it is the chief source of his enormous prestige among musicians. The works themselves, charming as they are and frequently impressive, are never quite as fascinating when considered separately as they are when viewed as comments on a method of composition or as illustrations of its expressive possibilities. They are all secondary to a theory; they do not lead independent lives. The theory, however, leads a very independent life. It is taught and practiced all over the world. It is the *lingua franca* of contemporary modernism. It is even used expertly by composers who have never heard any of the works by Schönberg, by Webern, and by Alban Berg that constitute its major literature.

If that major literature is wholly Viennese by birth and its sentimental preoccupation largely Germanic, the syntax of its expression embodies also both the strongest and the weakest elements of the German musical tradition. Its strong element is its simplification of tonal relations; its weak element is its chaotic rhythm. The apparent complexity of the

whole literature and the certain obscurity of much of it are due, in the present writer's opinion, to the lack of a rhythmic organization comparable in comprehensiveness and in simplicity to the tonal one.

It is probably the insufficiencies of Schönberg's own rhythmic theory that prevent his music from crystallizing into great, hard, beautiful, indissoluble works. Instrumentally they are delicious. Tonally they are the most exciting, the most original, the most modern-sounding music there is. What limits their intelligibility, hamstrings their expressive power, makes them often literally halt in their tracks, is the naive organization of their pulses, taps, and quantities. Until a rhythmic syntax comparable in sophistication to Schönberg's tonal one shall have been added to this, his whole method of composition, for all the high intellection and sheer musical genius that have gone into its making, will probably remain a fecund but insupportable heresy, a strict counterpoint valuable to pedagogy but stiff, opaque, unmalleable, and inexpressive for free composition.

There is no satisfactory name for the thing Schönberg has made. The twelve-tone-row technique, though its commonest denomination, does not cover all of it. But he has made a thing, a new thing, a thing to be used and to be improved. Its novelty in 1944 is still fresh; and that means it has strength, not merely charm. Its usage by composers of all nations means that it is no instrument of local or limited applicability. Such limitations as it has are due, I believe, to the fact that it is not yet a complete system. So far as it goes it is admirable; and it can go far, as the operas of Alban Berg show. It is to the highest credit of Schönberg as a creator that his method of creation should be so valuable a thing as to merit still, even to require, the collaboration of those who shall come after him.

SEPTEMBER 10, 1944

Repertory

❧ It is a commonplace of contemporary esthetics that music of marked originality is likely to be found shocking by the epoch that gives it birth. The inability is notorious not only of the lay public but of trained musicians to perceive beauty in any work of which the style is unfamiliar. And program makers are aware that this blindness obtains not only with regard to contemporary composition but with regard to the past as well. When one considers the vast amount of music written since 1600 that is perfectly well known, published, and available for performance and that is never given by our operatic or orchestral establishments, in spite of the eagerness of conductors to vary their monotonous routine, one is obliged to conclude, I think, that the tininess of our effective repertory is due to psychological factors that are beyond anyone's power to control.

Epochs, styles, and authors all have a way of becoming invisible, of passing in and out of focus, rather, that is not easy to explain. The facts of this matter constitute the history of taste. Our inability to cope with the unfamiliar is equaled only by our inability to maintain interest in the too familiar, in that which is no longer in any way strange. The vogue of our popular songs is typical. Within a few years, sometimes within one year, it is possible to observe in succession the enthusiasm, the indifference, and the ridicule with which one of these is treated; and we have all experienced the renewed charm of some old song that has been left in limbo long enough to be all but forgotten. There is no way of preventing it: the things we get used to tend to become invisible. They are there all the time, and we know they are there, and we think we love them dearly; but if they were taken away we should half the time not remark any difference.

Schumann's music, for example, is in a decline of favor just now; nobody has a lively feeling for it anymore. Interpreters find it more and more difficult to render, audiences more and more difficult to listen to. It is passing out of our focus. Debussy is in an even more curious phase. He is listened to increasingly, understood less and less. Hadyn seems to be emerging from his recent obscurity and taking on contours again. Bach, after having been genuinely popular among the cognoscenti for thirty years, is losing a bit his appeal for intellectuals. Mozart has, in fact, taken Bach's place of late as the master most admired among connoisseurs. Wagner and Brahms have still a broadly based popularity but a markedly diminishing attraction for musicians. Verdi, though he has lost much of his former power over the masses, has acquired in the last twenty years a prestige in university circles that would have shocked profoundly musicians of fifty years ago.

Always, in the case of such revivals, there is perpetrated a certain falsification upon the original. No matter how much we pretend we are restoring old works to their pristine state, we are obliged at the same time to modernize them seriously. Returns to popularity of past styles in architecture and decoration have usually been accompanied, therefore, by complete resurfacing. The nineteenth century unpainted its Gothic monuments and left them a unified gray. It covered up the bare wood of its Louis XVI furniture with a bluish color known as Trianon gray. It built Greco-Roman houses everywhere and painted them white, which is still considered, indeed, to be the appropriate color for classical antiquity. In recent decades flamboyant Victorian interiors also have regained their charm through the use of white paint, which was practically never used on them originally but which our age finds cheerful and associates with asepsis.

The Bach revival of the 1830s, which Mendelssohn and Schumann fathered, translated this music into all the idioms of contemporary execu-

tant style, using Tourte bows for the orchestral suites and violin pieces, gigantic organs and choruses for the religious works, pianos for the domestic keyboard music, and employing a constant crescendo and diminuendo within all phrases, as was considered necessary at that time for true expression. Bach was modernized all over again in the early years of this century. His rhythm was made to sound more mechanical, dynamism was everywhere diminished, phraseology streamlined, the harpsichord revived, the old, small, bright-sounding organ restored to use.

A healthy traffic goes on nowadays in the reinstrumentation of eighteenth-century music of all kinds, but we do not do over the Romantics very much. Though the nineteenth century is dying slowly, there is vigor in its traditions still. Not for some time will they be forgotten so thoroughly that a resurfacing of the Romantic masters will be possible to envisage. When this does take place, they will lose, of course, the somber patina that a century of daily handling has laid upon them and appear as bright again to us as cleaned and revarnished masterpieces from the past do in a gallery of painting.

Meanwhile, we must put up with our own age, because, whether we like it or not, its habits are for us the facts of life. This age listens to a great deal of new music, likes practically none of it, but would not for the world forgo hearing it. It respects a vast repertory of old music, complains no end at the infrequency with which most of this is heard, discourages firmly the introduction of any of it into the major programs. Exception is made for pre-Romantic works when wholly reinstrumented. It holds to its Romantics with determination, will no more allow them to be restyled than it would consent to having its grandmother's face lifted. Grandma is not kept dressed in the style of her 1880 coming out, however; a seemly adaptation to the mode is encouraged. She is constantly told how young she looks. She is given the place of honor at every ceremony and treated generally with the consideration that we observe toward those who we know will not be with us forever. Her frequentation is considered to be a privilege for all and of inestimable value to the young.

OCTOBER 8, 1944

Pierre Monteux

∾ PIERRE MONTEUX's two-week visit as guest conductor of the Philharmonic-Symphony Orchestra has led music lovers of all schools (the critical press included) to two conclusions: namely, that this conductor has drawn from our orchestra more beautiful sounds and more beautiful mixtures of sound than any other conductor has done in many years, and that his readings of Brahms are highly refreshing.

It has been a long time, a very long time, since our Philharmonic

sounded like an orchestra. It has always been an assemblage of good players; and the changes of personnel operated last year by Artur Rodzinski, on his accession to the conductorship, have improved further its musical potentialities. Sometimes of late the playing has been most agreeable. Sometimes, too, no matter who was conducting, the performances have sounded more like a reading rehearsal than like a prepared execution. This lack of dependability in the ensemble — so noticeable in contrast to the solid teamwork, no matter who conducts them, in the orchestras of Philadelphia, Boston, and Chicago — has long been a trouble. As far back as 1936 Sir Thomas Beecham, who served a half season that year as guest, annoyed the directors considerably by replying, when asked to diagnose the musical ills of the organization, that though it contained many excellent players it was not an orchestra.

Many conductors, Mr. Rodzinski included, have produced a pretty good balance of timbres and made music, usually unfamiliar music, sound pretty well. Arturo Toscanini has occasionally, without any beauty of sheer sound being involved, made familiar music sound unusually eloquent. It has remained for Pierre Monteux to achieve what many of us thought was hopeless. He has made the Philharmonic play with beauty of tone, many kinds of it, and with perfect balance and blending — to sound, in short, like an orchestra, a first-class orchestra requiring no apology. And he has also played music as familiar as that of Brahms and Beethoven (not to speak of Debussy) with not only a wonderful beauty of sound but a far from usual eloquence as well. His is the way a real orchestra *should* sound, the way the first-class orchestras of the world all *do* sound. And this is the way many musicians have long wished the music of Johannes Brahms could be made to sound.

It is a strange anomaly that although Brahms's symphonic music is extremely popular (in some years it tops even that of Beethoven for frequency of performance), almost nobody's reading of it is satisfactory. How to discern the rhythm that underlies its slow and its energetic passages, to make these sound in any given piece as if they are all parts of the same piece, is one of the unsolved problems in music. Certainly the meditative ones require to be read as inward rather than as extrovert sentiment. And certainly the animated ones and the passages of broad eloquence, such as the codas and finales, tempt any conductor to make oratory out of them. But alterations of introversion with extroversion do not make a unity in the reading of anything, and there is no reason to suppose that so experienced and so consecrated a musician as Brahms was basically incoherent in thought. It is far more likely that his exact poetic temper, being profoundly personal, escapes us.

In my time only the late Frederick Stock of Chicago has been able to envelop the Brahms symphonies with a dreamy lilt that allows the soft passages to float along and the loud ones to sing out as elements of a

single continuity. A rhythmic propulsion that was steady without being rigid was the basis of these readings. Orchestral tone that was light in texture and wholly transparent was its superstructure. Mr. Monteux is less expert than Dr. Stock was at preserving a poetical and rhythmic unity throughout, but he is more expert than anybody at lifting the velvet pall that is accustomed in our concerts to lie over the Brahms instrumentation and allowing everything, middle voices too, to shine forth with translucency. His strings never obscure the woodwinds. His trumpets and trombones never blast away the strings. His horns, when force is indicated, play very loud; but their loudness is bright, not heavy; it is a flash of light rather than a ton of bricks.

Both these conductors have been celebrated for their renderings of French music, especially of Debussy, which requires a similar rhythmic continuity and identical refinements of balance. Sheer weight, like sheer brilliance, must always, in this kind of music, be avoided, because it destroys the translucency that is the music's main means of evoking an atmosphere. And the rhythm must be alive but steady, the cantilena floating in the delicate wavelike motion of this without effort or any insistence. Mr. Monteux, when playing both these composers, sometimes allows the slower passages to go dead. At these moments the rhythm stops supporting the flow of sound, all animation disappears, and the sounds themselves lose their ability to blend. But these moments are never long. As soon as the rhythm reasserts itself, the tonal fabric comes to life again and breathes like a sentient being.

Listening lately to Pierre Monteux conduct Brahms and Debussy on the same program brought to mind how much the music of these two authors is alike, or at least demands like treatment. The secret of their rhythm is very much the same secret. And nonviolation of their rhythm is essential and preliminary to producing among their orchestral sounds luminosity. That and the use of transparent, or nonweighty, orchestral tone. By what occult methods Mr. Monteux produces in our Philharmonic-Symphony Orchestra a real community of rhythmic articulation, not to mention the delights of delicate balance and blending that proceed from this, I cannot even guess. The guest conductors who have failed where he has succeeded would like to know too, I imagine.

NOVEMBER 12, 1944

Overtrained

❧ THE Boston Symphony Orchestra's first concert of the season, which took place last night in Carnegie Hall, consisted of two works and lasted two hours. They were beautiful works and were handsomely executed. With the exception of the difficult horn passage in the trio of Beethoven's *Eroica* scherzo, your commentator could find no fault in the playing. And yet he was aware of the slow passage of time.

Serge Koussevitzky's tempos were not slow. In the Beethoven symphony they were, in fact, most gratefully animated. And the mechanism of orchestral articulation was, as always with this group, delightful to observe. Everything was right, including William Primrose, who played the viola solo of Berlioz's *Harold in Italy.* It was the old story, I am afraid, of familiar pieces so elegantly turned out that one scarcely recognized them. They were not deformed. Their clear spirit was not violated. They were simply so completely groomed that one was not aware of any spirit present. The slickness of their surfacing made them seem hollow and laborious underneath, which they are not.

The truth of the matter, in my opinion, is simply that the Boston Symphony Orchestra is overtrained and has been for several years. Its form is perfect, but it does not communicate. The music it plays never seems to be about anything, except how beautifully the Boston Symphony Orchestra can play. Perfection of execution that oversteps its purpose is a familiar phenomenon in art. That way lies superficiality and monotony. And music has no business sounding monotonous, since no two pieces of it are alike. Whenever a series of pieces or of programs starts sounding that way you may be sure that the execution is at fault, is obtruding itself.

One longs, in listening to this orchestra's work, for a little ease. It is of no use for all the sonorous elements to be so neatly in place unless some illusion is present that their being so is spontaneous. Music is not the result of rehearsal. It is an auditory miracle that can take place anywhere. When it occurs among disciplined musicians its miraculous quality is merely heightened. When the frequency of its occurrence in any given group starts diminishing, there are only two possible remedies. Either the members must play together more often, or they must get some new pieces.

Obviously, this group does not need more rehearsing. And it knows now all the pieces there are in standard repertory; it even knows all the kinds of pieces there are for large orchestra. There is nothing to be done about it. It has passed the peak of useful executional skill, and executional hypertrophy has set in. The pattern is a familiar one, and regrettable. But there is no use trying to deceive oneself about it.

NOVEMBER 16, 1944

1945

Fairy Tale About Music

∾ RICHARD WAGNER'S *Die Meistersinger von Nürnberg,* which was given again at the Metropolitan Opera House last night after an interval

of five years, is the most enchanting of all the fairy-tale operas. It is about a never-never land where shoemakers give vocal lessons, where presidents of musical societies offer their daughters as prizes in musical contests, and where music critics believe in rules of composition and get mobbed for preferring young girls to young composers.

It is enchanting musically because there is no enchantment, literally speaking, in it. It is all direct and human and warm and sentimental and down to earth. It is unique among Wagner's theatrical works in that none of the characters gets mixed up with magic or takes drugs. And nobody gets redeemed according to the usual Wagnerian pattern, which a German critic once described as "around the mountain and through the woman." There is no metaphysics at all. The hero merely gives a successful debut recital and marries the girl of his heart.

And Wagner without his erotico-metaphysical paraphernalia is a better composer than with it. He pays more attention to holding interest by musical means, wastes less time predicting doom, describing weather, soul states, and ecstatic experiences. He writes better voice leading and orchestrates more transparently, too. *Die Meistersinger* is virtually without the hubbub string writing that dilutes all his other operas, and the music's pacing is reasonable in terms of the play. The whole score is reasonable. It is also rich and witty and romantic, full of interest and of human expression.

The first of the successful operatic comedies for gigantic orchestra, like Verdi's *Falstaff* and Strauss's *Rosenkavalier*, it is the least elephantine of them all, the sweetest, the cleanest, the most graceful. For the preservation of these qualities in performance, George Szell, the conductor, and Herbert Graf, the stage director, are presumably responsible. For the loan of some new scenery, which enhanced the final tableau, the Chicago Civic Opera Company merits our thanks. For careful singing and general musical good behavior all the artists deserve a modest palm.

Charles Kullmann, who sang the tenor lead, did the most responsible and satisfactory work altogether, I should say. John Garris as David, Herbert Janssen as Hans Sachs, and Gerhard Pechner as Beckmesser (and he didn't ham this role either) were highly agreeable. Eleanor Steber's Eva was pretty to look at but vocally satisfactory only at the difficult moments. Elsewhere there was a careless buzz in her voice. Emmanuel List, as Pogner, sang well but a little stiffly, keeping his voice down to match the others, who are all small-volume vocalists. Mr. Szell kept the orchestra down too, so that everybody could be heard. The performance all through was charming, intelligible, and a pleasure to this usually anti-Wagnerian opera fan.

JANUARY 13, 1945

Expressive Percussion

℘ JOHN CAGE, whose recent compositions made up the program of a concert given yesterday afternoon at the New School for Social Research, is already famous as a specialist in the use of percussive sounds. Two years ago the Museum of Modern Art presented pieces by him for a large group of players using flowerpots, brake bands, electric buzzers, drums, and similar objects not primarily musical but capable of producing a wide variety of interesting sounds all the same. The works offered yesterday included an even greater variety of sounds, all prepared by inserting bits of metal, wood, rubber, or leather at carefully studied points and distances between the strings of an ordinary pianoforte.

The effect in general is slightly reminiscent, on first hearing, of the Balinese gamelan orchestras, though the interior structure of Mr. Cage's music is not oriental at all. His work attaches itself, in fact, to two different traditions of Western modernism. One is the percussive experiments begun by Marinetti's Futurist Noisemakers and continued in the music of Edgard Varèse, Henry Cowell, and George Antheil, all of which, though made in full awareness of oriental methods, is thoroughly Western in its expression. The other is, curiously enough, the atonal music of Arnold Schönberg.

Mr. Cage has carried Schönberg's twelve-tone harmonic maneuvers to their logical conclusion. He has produced atonal music not by causing the twelve tones of the chromatic scale to contradict one another consistently, but by eliminating, to start with, all sounds of precise pitch. He substitutes for the chromatic scale a gamut of pings, plucks, and delicate thuds that is both varied and expressive and that is different in each piece. By thus getting rid, at the beginning, of the constricting element in atonal writing — which is the necessity of taking constant care to avoid making classical harmony with a standardized palette of instrumental sounds and pitches that exists primarily for the purpose of producing such harmony — Mr. Cage has been free to develop the rhythmic element of composition, which is the weakest element in the Schönbergian style, to a point of sophistication unmatched in the technique of any other living composer.

His continuity devices are chiefly those of the Schönberg school. There are themes and sometimes melodies, even, though these are limited, when they have real pitch, to the range of a fourth, thus avoiding the tonal effect of dominant and tonic. All these appear in augmentation, diminution, inversion, fragmentation, backward movement, and the various kinds of canon. That these procedures do not take over a piece and become its subject, or game, is due to Cage's genius as a musician. He writes music for expressive purposes; and the novelty of his timbres, the logic of his discourse, are used to intensify communication, not as ends in

themselves. His work represents, in consequence, not only the most advanced methods now in use anywhere but original expression of the very highest poetic quality. And this has been proved now through all the classical occasions — theater, ballet, song, orchestral composition, and chamber music.

One of the works was played yesterday by the composer, the other two by Arthur Gold and Robert Fizdale, duo-pianists. The perfect execution of these young men, their rhythm, lightness, and absolute equality of scale, and the singing sounds they derived from their pianos, in spite of the fact that the strings were all damped in various ways, made one wish to hear them operate on music less special, as well. The concert was a delight from every point of view.

JANUARY 22, 1945

The Poetry of Precision

✥ IGOR STRAVINSKY, who conducted the Philharmonic last night in Carnegie Hall, prefaced a delightful little concert of his own works with a spirited reading of Glinka's *Russlan and Ludmilla* overture and a correct but on the whole pedestrian excursion through Tchaikovsky's rarely explored Second Symphony. Whether this work is worthy of the respect that the greatest living Russian composer has long borne is not a matter on which this reviewer has any opinion. It is obviously a well-written work, full of fancy and originality and clearly expressed. Whatever feelings anybody may have about it (and feelings are all most people have about Tchaikovsky) are his own business. Myself, I was not enthralled; but I am not a Tchaikovsky fan.

Having long been a Stravinsky fan and long an admirer of the Piano Concerto that Beveridge Webster played so brilliantly last night, your reviewer spent one of the pleasanter moments of the season rehearing it under the composer's direction. Noble of thematic invention, ingenious of texture, and eloquently, grandiloquently sustained, this brilliant evocation of baroque musical sentiments and musical attitudes has too long been left on the shelf. It was last played here, if the files in my office are correct, exactly twenty years ago. If patrons walked out on it in scores then, as they did last night, one can understand the hesitancy of conductors to revive it. But if the ovation it received last night from those who stayed (and they were a vast majority) means anything prophetically, the concerto will one day be as popular as Tchaikovsky's in B flat.

Stravinsky's *Ode* retains its elegance on rehearing and gains in intellectual interest, but it remains for this observer a little distant in sentiment. The *Norwegian Moods* are not distant at all. They are warm and picturesque and cheerful, wonderfully melodious and impeccably tailored. At present a sort of *Peer Gynt* suite for the musically sophisticated, they

will shortly, I am sure, find themselves at home in the "pop" concerts. The *Circus Polka* has already done so. And indeed a lively picture it is of the sawdust ring. Apparently, the only music lovers who haven't enjoyed it are the elephants for whose dancing it was written. I am told that they scented satire in it, a bit of joking about their proportions (which they are extremely sensitive about) and didn't like working to it. They did not, however, walk out on it.

Mr. Stravinsky's conducting of his own works was, as always, a delight to those who take his works seriously. His rhythm was precise, his tonal texture dry, the expressivity complete. It was complete because only through the most precise rhythm and the driest tonal textures can the Stravinskian pathos be made to vibrate or the Stravinskian tenderness to glow. His is a poetry of exactitude, a theater of delicate adjustments in relentless march. Conductors who sweep through his works as if they were personal oratory of some kind inevitably find these going weak on them. Stravinsky admires Tchaikovsky but he doesn't write or feel like Tchaikovsky. How much added juiciness the latter can stand is an unsettled problem of interpretation. Stravinsky needs none. It is all written in. His scores are correctly indited, and the composer's reading of them is the way they go best.

FEBRUARY 2, 1945

Children's Day

∾ HEITOR VILLA-LOBOS, who conducted two of his Choros, Numbers 8 and 9, last night with the Philharmonic in Carnegie Hall, is one of the world's most prolific composers. Also one of the most gifted. His works are innumerable and full of bright ideas. Their excellent tunes, their multicolored instrumentation, their abundance of fancy in general, and their easy but perfectly real modernity of thought have placed them in repertory as valid musical creations of this century. For all the French influence on their harmonic texture (chiefly that of Milhaud) they are also valid musical creations of this hemisphere. They sound, as is indeed their composer's intention, most convincingly like Brazil.

Choros Number 8, last heard here at the World's Fair, sounds to me like rural Brazil, like rivers and plains and mountains and Indian villages and jungles. The jungles seem to have lots of trees in them, big ones and small ones, also some lurid snakes and wild animals. Certainly there are birds around of all sizes. And I thought I spotted, as the civilized note, a sturdy stock of American canned nourishment and a few reels of the best Hollywood sentiment.

Choros Number 9, which was a North American premiere, is more urban. It has dance music and crowds and general gaiety and some wit and quite a lot more Hollywood sentiment. It is all very pleasant, and it

is loosely enough constructed so that one doesn't have to pay attention all the time. The composer conducted one through both pieces with courtesy, making everything clear and keeping us interested at every moment. If one felt at the end like a tourist who has seen much but taken part in little, one was grateful for the trip all the same. One could almost hear the voice of the travelogue saying, "Now we are leaving beau-u-u-tiful Brazil."

We left it for the comfortably suburban Violin Concerto of Paganini and some astonishingly accurate violin playing by Zino Francescatti. And thus safely returned to Europe and the nineteenth century, we paid ourselves an old-style treat in the form of Liszt's great orchestral *Mephisto Waltz*, which was certainly the original of Ravel's *La Valse*. A wonderfully beautiful piece this, and not a bit devilish, just sweet and romantic and full of an inward light. Our thanks to Artur Rodzinski, who thought of playing it, and who played it enchantingly.

Mr. Rodzinski's little treat for himself, which he shared, of course, with us all, was the playing, to start the evening off, of Hadyn's charming and absurd *Toy* Symphony, a public tribute to his newborn son. Perhaps it was this preparation — the toy trumpet and the cuckoo and the whistles and all, then the educational trip through picturesque Brazil, the dressing-up-in-grandpa's-clothes effect of the Paganini concerto — that made the *Mephisto Waltz* sound like adult music. In any case it did. And it was most welcome.

FEBRUARY 9, 1945

The Sanguine Temperament

✣ THE CONCERT that Sir Thomas Beecham conducted with the Rochester Philharmonic Orchestra in Carnegie Hall on Saturday night was a personal triumph for the English leader. The massive applause that greeted his readings of Haydn, of Beethoven, of Berlioz, and of his own ballet music (out of Handel) could only have been gratitude for the grandeur and buoyancy of those readings as such, since the orchestral execution of the Rochester society is certainly no marvel for fine finish. When, at the close of the concert, the audience demanded extra numbers (the Andante from Elgar's String Serenade and the March from Sibelius's *Karelia* suite were what they got), it seemed reasonable to suppose that what they wanted was not so much further acquaintance with the pleasant but roughish playing of the Rochester band as more of Sir Thomas's deeply joyous music-making.

This reviewer confesses to a similar predilection for the Beecham readings. His Haydn has gusto and sentiment along with its grace. It breathes with ease and steps a real measure. It is no line drawing of antiquity but a full evocation in the round of music that everybody knows to have pas-

sion as well as decorum, but that no other conductor seems able to bring to life with quite that ruddy glow.

The new Handel-Beecham suite, which received its first New York hearing on this occasion, is out of a ballet entitled *The Great Elopement*, undertaken for the Ballet Theater, but not yet produced. Here is no sullen expatriate Handel, yearning after the Germany he grew up in (and never liked) or after the perverse and monumental Italy of his youth. It is the British Handel, as square-toed as a country squire, as witty as a London playwright, as dainty as a beau of Bath, as expansive as the empire itself.

Beethoven's Seventh Symphony received the roughest execution of the evening but the most enlightened reading it has had in my lifetime. Nothing in its whole progress was either long or wrong. And when one remembered the innumerable booby traps for conductors with which that work is sown, it was with amazement and respect that one observed Sir Thomas sidestepping them all and going straight to the heart of the matter. This heart is the funeral-march Allegretto, the saddest, the most tragic piece Beethoven ever wrote, surrounded and framed by three of the most exuberant affirmations that exist. We have had choleric Beethoven of late and melancholy Beethoven and even some lymphatic. Myself I like it sanguine, because I think that is the kind of man Beethoven was. And Sir Thomas's Seventh Symphony, for all its studied proportions, was abundantly that.

MARCH 19, 1945

Beethoven's Fifth

 BEETHOVEN's C-minor Symphony is the most famous piece of orchestral music in the world. Everybody knows it; everybody admires it. Other pieces have their devoted publics, but this one is accepted by all as the world masterpiece of monumental abstract, or "absolute," music. For the simplicity of its melodic materials, the nobility of its proportions, and its forthrightness of style it has been esteemed throughout the Western world for over a century now as a sort of Parthenon among symphonies. Yet what its means nobody really knows. It has been as much argued about as *Hamlet*, and it remains to this day as movingly obscure a work.

The Germans long ago associated its opening phrases with their favorite idea of Fate Knocking at the Door. The French have taken the work as a whole to be connected in some way with political liberalism. It was so completely appropriated as a theme song, in fact, by French socialists of the Second International that adherents of the Third and Fourth have tended rather to keep quiet about its possibly political sig-

nificance. Of late more conservative politicians have taken it over as the slogan, or symbol, of military victory, specifically the victory of the United Nations.

The Germans were clumsy not to think of this first; the victory idea would have fitted perfectly with their already popular interpretation of the piece as having to do with fate. It could have become thus a forecast of their "manifest destiny." Perhaps they felt its author was not quite the right man to put forward as the advocate of unbridled submission to authority. In any case, their propagandists have pretty much let the work alone. Whether ours would have done well to let it alone too was the subject of considerable reflection on your reviewer's part week before last, when George Szell conducted the Philharmonic-Symphony Orchestra through a thoroughly demagogic and militarized version of it.

If thinking of the work as embodying faith and hope has helped conquered nations to resist tyranny, that is all to the good. An energizing moral result is more valuable than any misreading of the composer's specific thought is dangerous. Besides, the piece will recover from its present military service just as easily as it has from its past metaphysical and political associations. But as a musician I was interested to observe the amount of distortion that Mr. Szell was obliged to impose on the work in order to make it seem to be representing military struggle and final victory.

There is no intrinsic reason, in this work or in any other, for considering contrast to mean conflict. The expression of strength, even of rudeness, in one chief theme of a piece and of pathos or tenderness in another does not mean that there is a war going on between the two sentiments. The highly contrasted materials of the Fifth Symphony have always seemed to me as complementary rather than conflicting. They make it whole and humane, the complete picture of a man. And I cannot find in the last movement of it, for all its triumphal trumpets, any representation, thematic or otherwise, of the victory of either sentiment. I find, rather, an apotheosis in which the two are transformed into a third expression, which is one of optimism and confidence, a glorious but still dynamic serenity. Neither assertiveness nor lyricism wins; they simply decide to cooperate.

This is no picture of military victory. It is the purest Hegelian dialectic, by which thesis and antithesis unite to form a synthesis. It may be an enlightened way of resolving contrasts, or even conflicts, this using of them as complementary floodlights toward a general luminosity. And it may be an enlightened way of envisaging postwar problems, including Germany itself, though I am suspicious of the Hegelian dialectic, which lends itself to much trickiness in handling. Like most other philosophic methods, it can be made to give any result the handler desires. But in no case is it involved with anybody's unconditional surrender. It offers ex-

actly the opposite kind of solution to a military victory. It is a peace proposition all round. Nowhere in Beethoven's Fifth Symphony, moreover, is there any suggestion of military operations, though other works of his portray them plentifully.

In order to throw the symphony into a key of direct action, Mr. Szell has been obliged to emphasize the assertiveness of the masculine material and to sort of slip over the significance of its tender and gentle passages. He made the strings play loud and rough, with that fierce impact that the Philharmonic strings achieve so admirably. He managed to keep the horns, with some difficulty, up to a reasonable balance with these for three movements. With the appearance of the trombones, at the beginning of the last movement, the horns appeared as hopelessly outclassed in the weight-throwing contest as the woodwinds had been from the beginning. The whole disequilibrium made Beethoven sound no end authoritative and didactic as a composer, which he certainly was, but also hopelessly incompetent as an orchestrator, which he was not. And it is exactly the musical ineffectiveness of the orchestral contrasts that proved, in spite of the moral impressiveness of the rendering, that violence was being done to the spirit of the work, whatever one may consider this to be.

Lots of people don't mind that sort of thing at any time; it rather amuses them. And nobody at all minds when it serves a national emergency. We were all interested, I think, to hear this piece played right up to the hilt as a sword of psychological warfare, as the symbol of military victory that it has come to represent in Allied strategy. I doubt if a more thoroughgoing job of the kind could be done on it; certainly none has been. And now that military victory seems to be imminent in the European theater, where the Fifth Symphony has its chief psychological utility, it is hardly to be expected that other conductors will attempt to carry it much farther in this direction. It is always a satisfaction to have visited the ultimate outpost of anything; and it is a pleasure to have viewed once this oh, so familiar piece in a new light, however false. But the expedition is about over now, and I imagine that all the conductors, including Mr. Szell, will be getting back to Beethoven's plain markings, or else inventing a new distortion of them to please other times.

MARCH 18, 1945

Bruckner

∿ ANTON BRUCKNER, whose Seventh Symphony was played last night in Carnegie Hall by the Philharmonic under Artur Rodzinski, became a cause in his own lifetime and has remained one ever since. The public has never either accepted or rejected him. Musicians have always loved or hated his music; they have never quite classified it. And yet its virtues and its weaknesses are admitted by all.

A high songfulness in the melody of it is one of its charms. A great suavity of harmonic figuration (one can scarcely call it counterpoint) is another. Real seriousness of thought and a certain purity of spirit it undoubtedly has. There is nothing vulgar, cheap, or meretricious about it. And it sounds extremely well; it is graciously written.

On the other hand, the eight symphonies, which constitute the major body of Bruckner's work, are none of them well integrated formally; they barely hang together. And their unvarying pattern of four-measure phrases brings them, like César Franck's two-measure monotony, dangerously close to a doggerel meter. Also, the melodic material, for all its grace, is derivative. Schubert, Brahms, and Wagner are never wholly absent from the memory as one listens. The music is intended, I think, to feel like Brahms and to sound like Wagner; and unfortunately it more often than not does just that.

It does another thing, however, which is probably not intentional but which gives it what personal flavor it has. It evokes, by orchestral means, organ registration. Bruckner uses his brasses exactly as an organist uses the reed stops; and he uses the woodwind more often than not as a choir organ, or *positif*. His masterful cleanliness in the antiphonal deployment of the different kinds of sound is the work of a great organ player, which he was. The looseness of his formal structures is due, no doubt, to the same professional formation, as is certainly his unvarying use of the apocalyptic climax to finish off his longer works.

There is a pious theatricality about all Bruckner's symphonies that, combined with his constant reverence toward his masters, makes them most attractive. They represent esthetically a philosophy of quietism, musically the ultimate of humility. They rest one; they are perfect to daydream to. Of real originality they have, I think, very little.

APRIL 6, 1945

Schuman's Undertow

✧ WILLIAM SCHUMAN's ballet *Undertow*, which will be played again tonight at Ballet Theater's closing performance of the season, has enlarged our acquaintance with this composer's personality; and I suspect it may be about to add something to the concert repertory of his works. It is the first narrative instrumental piece by him that many have had occasion to hear, possibly the first he has composed, though he has worked successfully in most of the other musical forms both vocal and instrumental. Whatever may be the future of Antony Tudor's ballet, there is probably an effective concert piece to be derived from this score.

There is no question, I think, that American composers by and large, at least those of the presently mature and maturing generation, have

done their most striking work in the theater. Also that the best training available for serious musico-theatrical work is practice in the concert forms. Interestingness of texture and soundness of continuity are the minimal requirements of concert audiences. On the other hand, concentration on a specific subject, the depicting of it without expansion or digression, which is the minimal requirement of any music destined for theatrical collaboration, is exactly where American concert composition tends to fall down. It is weak in specific expressivity partly because our American training in composition is formalistic, seeking chiefly abstract perfection, even at the expense of direct speech; and partly because our concert audiences are not sufficiently accomplished at seizing the meanings in music to require of musical composition the kind of coherence that readers demand of literature.

Formed entirely by American teachers and American audiences, William Schuman is a characteristic product of the American musical scene. He has written symphonies, string quartets, overtures, band pieces, and lots of choral works; and they have all been performed by major musical organizations. His workmanship is skillful, individual, striking. His expressivity has always been tenuous, timid, conventional. His serious works have shown a respectable seriousness of attitude without much private or particular passion, while his gayer ones have expressed either a standard American cheerfulness or the comforting bumptiousness of middle-quality comic-strip humor. He has written easily, abundantly, and in a technical sense well: but his music has been, on the whole, reticent, has communicated to the public little about himself or about anything else.

Undertow has a sounder proportion of matter to means. The story of this particular ballet has required, to begin with, vivid rather than formalistic treatment. That story, or plot, for all its inefficiencies as dramatic literature (it has a realistic but nonessential beginning and a nonrealistic, quite unbelievable ending; with all that public opinion around, the young man would certainly have been arrested for murder if he had committed one), has a serious subject, namely, the pathos of sexual initiation. The music is full of frustration and violence. It has a static intensity in the passages of pure feeling and a spastic muscular energy in the passages which depict physical action that are completely appropriate to the subject and completely interesting. The climactic pas de deux is the most realistic piece about sexual intercourse we have had since Shostakovich's *Lady Macbeth of Mzensk*. And the contrapuntal accompaniment to the scene of ganged-up lovemaking between one girl and four men is both exciting and convincing.

Whether Schuman has a real theatrical gift or merely certain qualities that are useful in the theater I am not sure. The whole score does not accompany the ballet as consistently as certain passages underline it strikingly. If Schuman is a born man of the theater, he ought to have

given to the choreographer, or secured from him, a closer communion.
But Tudor, who likes to work from ready-made music, may not be easy
to do a duo with. Further dramatic works from Schuman will no doubt
reveal further his qualities. For the present he has shown a gift for ex-
pressing the lurid; and the lurid has afforded him a more ample field for
exploiting his full powers as an artist than the formalistic, middle-ground
modernism of his concert style and the boisterous-but-not-much-else
Americanism of his assumed concert personality have done. Also, his
gift for massive orchestration, which lends so easily a merely demagogic
air to his concert works, becomes an element of magnificent emphasis
when applied to a melodramatic subject in a theater.

And so, viewed freshly through his new-found medium, Schuman
turns out to be not at all the composer of small expressive range and
assumed monumental proportions that his concert music has long led
one to consider him, but a man of high and spectacular expressive gifts
who has been constricted by the elegant abstractions of the American
concert style — and a little bit too, perhaps, by his youth. The concert
forms have been good schooling for him, but he has never expressed
himself in them with any freedom. The theater gives him elbow room.
His mind can move around in it. And his feeling-content, his compassion,
as well as his inveterate love for depicting physical movement, take on
an unexpected strength under the theater's channelization of them to
purposes of specific meaning. *Undertow* is not a masterpiece of music,
any more than it is of choreography. But it is full of music that says
something. It speaks. It can even be listened to. I think it will be
remembered.

APRIL 29, 1945

The Organ

∾ THE MODERN pipe organ and its repertory make a strange dichot-
omy. The instrument itself is the most elaborate, the most ingenious, the
most complex, and the most expensive of all instruments. Also one of
the most common. Hamlets that never saw a bassoon or a French horn or
an Australian marimba or even a concert grand piano will occasionally
house a quite decent one. City people give them away like drinking foun-
tains and altars and stained-glass windows. And yet, in two centuries
scarcely twenty pieces have been written for the organ that could be
called first-class music. The learning, the taste, the engineering knowl-
edge, and the skilled handicraft that go into the manufacture of even a
reasonably satisfactory instrument are enormous. Nevertheless, not one
major composer, since Sebastian Bach died in 1750, has written for the
organ with any notable freedom or authority. And very few have written
for it at all.

César Franck, perhaps, did the best, though none of his half dozen best organ pieces is as commanding a work as any of his half dozen best chamber and orchestral works. Also, Franck's position as a major composer in any medium is doubtful. The organ got much of their best work out of Frescobaldi and Couperin and Handel and Bach, not to mention a hundred other composers of the Baroque age. Since that time it is chiefly the second-rate that have written for it. Mozart, though a skillful organist himself, never wrote a solo piece for the instrument (though *Grove's Dictionary of Music and Musicians* lists seventeen sonatas for organ, "usually with violin and bass, intended to be used as graduales" in the Church service). Mendelssohn wrote six solo sonatas for it that are sound music, if more than a little stuffy. Brahms wrote eleven chorale preludes, his last opus number, of which two are genuinely inspired, though neither of these is particularly well conceived for the instrument. And there are twelve organ pieces by Franck that are respectable as music. The rest of the post-Baroque repertory has been written by the Gounods, the Saint-Saënses, the Regers, the Viernes, the Widors, and their like — at its best, second-rate stuff. Among the modern masters, only Schönberg, and that just once, has produced a work of any grandeur for the organ.

The cause of this neglect lies, I think, in the nature of the instrument itself, which has nowadays little but a glorious moment of history to offer. For the organ, like many another instrument of ancient lineage, did have its hour of glory. This hour, which lasted a good century and a half, say from roughly the year 1600 to quite precisely 1750, covers the whole of that period commonly known to the Fine Arts as the Baroque. And though in the visual techniques the high Baroque style is associated chiefly with the Counter-Reformation of the Catholic Church, the musical Baroque penetrated, both in Germany and in England, to the heart of Protestantism itself.

That was the age that created the fugue, the aria, the free fantasia, the opera, the oratorio. It invented the violin too, and carried to an apogee of musical refinement the keyed instruments, notably the organ and the harpsichord. It was the age of oratory in music, of the grandiose, the impersonal, the abstract. When it gave way in the middle of the eighteenth century to the beginnings of a more personalized romanticism, certain of its favorite media ceased to have effective power. The oratorio, for instance, has never recovered from that change in taste; nor have the fugue and its running mate, the free fantasia, ever since had quite the authority they enjoyed before. The opera survived by going in for personal sentiment in the arias and by giving up all that was merely grandiose in the set pieces. The violin also, played with the new Tourte bow (an invention of the 1770s), took on an appropriate sensitivity of expression. But the harpsichord fell wholly out of use, a new keyed instrument, the forte-

piano, offering possibilities of voluntary accent and of crescendo that were far more attractive to the Romantic mind than the equalized articulation and terraced dynamics of its predecessor.

The organ survived the Romantic revolution, but it lost its primacy among musical instruments. It remained (and remains still) firmly entrenched in its privileges as a handmaiden of religion; but it has never since dared venture far, as the rest of music has done, from the protecting walls of the Church. It plays today the tiniest of roles in the concert hall and in the theater, while attempts to give it a new (and secular) prestige through its exploitation in department stores and cinemas have merely ended by robbing it of what little secular dignity was left to it after a century and a half of cloistered servitude.

Nevertheless, the instrument went on growing. It hypertrophied, to be exact. All through the nineteenth and early twentieth centuries it got bigger and bigger. It grew row after row of additional pipes, which included every possible reminder of other instruments, including the human voice; and its caretakers imperiled its very existence by weighing it down with every imaginable useless labor-saving device. It went to leaf and flower, but grew very little musical fresh fruit. In our time a movement to restore to use the surviving organs of the Baroque age, which are fairly numerous in Europe, and the construction of new instruments modeled after the sound of these, have given us a new enlightenment, just as a similar revival in harpsichord-building has, about Baroque keyboard music. This revival, for all its antiquarian nature, has played a role in the drama of modernism. Whether it is capable of reinvigorating the organ as an instrument of contemporary expression I do not know. But certainly the communion it has provided with the Baroque keyboard repertory, which is one of the world's great musical literatures, is a closer one than was hitherto available. And that has brought fresh ideas into modern writing, just as the studies of medieval chant which the Benedictines of Solesmes carried out in the late nineteenth century had given a new life both to harmony and to the French vocal line, and just as the Greek studies of the late Renaissance in Italy had rendered possible about the year 1600 the invention of the opera.

And so the organ, in terms of its once central position in musical advance, is today, as it has been for nearly two centuries (and in spite of its continuing to be manufactured in ever more and more pretentious format), as dead as the harpsichord. But, as in the case of the harpsichord, an inspired resuscitation has given today's world of music a source of knowledge, of real acquaintance with the auditory past, that has brought the instrument back to a worthy and just possibly to a proud position in our creative life. Not that there is anything intrinsically unfortunate about having worked so long for religious establishments. But religious establishments have for so long dallied on the sidelines of mu-

sical advance that sacred organ composition, like any other musical enterprise limited to Church patronage, has usually found itself outclassed intellectually in the world of free artistic enterprise. And thus it is that antiquarianism and scholarship, for all their inspired sterility, have, by enabling us to hear Bach fugues as Bach himself heard them, made to music a gift that no other agency could have done, would have done, or, to stick to the simple fact, did do.

<div align="right">AUGUST 5, 1945</div>

Olivier Messiaen

∾ "ATOMIC BOMB of contemporary music" is the current Paris epithet for Olivier Messiaen. Whether France's thirty-seven-year-old boy wonder is capable of quite so vast a work of destruction as that unhappy engine I could not say. But certainly he has made a big noise in the world. And the particular kind of noise that his music makes does, I must say, make that of his chief contemporaries sound a bit old-fashioned.

What strikes one right off on hearing almost any of his pieces is the power these have of commanding attention. They do not sound familiar; their textures — rhythmic, harmonic, and instrumental — are fresh and strong. And though a certain melodic banality may put one off no less than the pretentious mysticism of his titles may offend, it is not possible to come in contact with any of his major productions without being aware that one is in the presence of a major musical talent. Liking it or not is of no matter; Messiaen's music has a vibrancy that anybody can be aware of, that the French music world is completely aware of, that has been accepted in France for the postwar period as, take it or leave it, one of the facts of life.

Messiaen's pieces are mostly quite long; and their textures, rhythmic and harmonic, are complex. In spite of their length and their complexity their sounds are perfectly clear. They are nowhere muddy in color but always sonorous. Their shining brightness takes one back to Berlioz. So also does their subject matter. "Dance of Fury for the Seven Trumpets," "The Rainbow of Innocence," "Angel With Perfumes," "The Crystal Liturgy," "Subtlety of the Body in Glory," "Strength and Agility of the Body in Glory," "The Combat of Life and Death," "God with Us," and "Vocal Exercise for the Angel Who Announces the End of Time" are some of the simpler subtitles. And the renderings of these are no less picturesque than Berlioz's description of doomsday (in the Dies Iræ of his Requiem Mass) for chorus and full orchestra plus twenty-eight trumpets and trombones and fourteen kettledrums.

For Messiaen is a full-fledged romantic. Form is nothing to him, content everything. And the kind of content that he likes is the ecstatic, the cataclysmic, the terrifying, the unreal. That the imagery of this should

be derived almost exclusively from religion is not surprising in a church organist and the son of a mystical poetess, Cécile Sauvage. What is a little surprising in so scholarly a modernist (he is organist at the cultivated parish of La Trinité and a professor of harmony at the Paris Conservatoire) is the literalness of his religious imagination. But there is no possibility of suspecting insincerity. His pictorial concept of religion, though a rare one among educated people, is too intense to be anything but real. Messiaen is simply a theologian with a taste for the theatrical. And he dramatizes theological events with all the sangfroid and all the elaborateness of a man who is at home in the backstage of religious establishments.

The elaborateness of Messiaen's procedures is exposed in detail in a two-volume treatise called *The Technique of My Musical Language* (*Technique de Mon Langage Musical;* Alphonse Leduc, Paris, 1944). The rhythmic devices employed, many of them derived from Hindu practice, are most sophisticated. The harmonic language is massively dissonant but not especially novel. It resembles rather the piling of Ossa on Pelion that formerly characterized the work of Florent Schmitt. There are layer cakes of rhythms and of harmonies, but there is little linear counterpoint. The instrumentation is admirably designed to contrast these simultaneities and to pick them out. Derived from organ registration, it exploits the higher brilliancies, as of mixture stops, to great advantage. The weaker elements of Messiaen's style are his continuity, which, like that of many another organist-composer, is improvisational rather than structural, and his melodic material, which is low in expressivity. The themes are lacking also in the tensile strength necessary to sustain long developments, because of his predilection for weak intervals (especially the major sixth and the augmented fourth) and for contradictory chromatics.

Among the works which one hopes will soon be heard in New York are *Forgotten Offerings* (*Les Offrandes Oubliées*) for voice with chamber instrumentation, by which Messiaen became known, way back in 1935 I think it was, as a major talent, and *The Nativity of Our Lord,* nine meditations for organ published in 1936. These pieces have charm and youth in them and a striking virtuosity of texture. Among the more recent works of some length are *Seven Visions of the Amen* for two pianos: *Twenty Admirations of the Infant Jesus* (unless I mistranslate *Vingt Regards sur l'Enfant Jésus*) for solo piano; *Three Short Liturgies of the Divine Presence* (they last a good half hour, all the same) for women's voices and orchestra, and a *Quartet for the End of Time* which was composed during his German captivity.

The most satisfactory of these works to me is the two-piano work. The most impressive to the general public, however, is the orchestral one, which was first presented last April at a concert of *La Pléiade* in the Salle

du Conservatoire. I have heard a recording of these liturgies made from a subsequent broadcast under the direction of Roger Désormière; and though certainly they have a spasmodic flow (and no little monotony) they do make a wonderful noise.

The instrumentation, though top-heavy, is utterly glittering. It consists of vibraphone, celesta, maracas, gong, tam-tam, nine sopranos singing in unison, piano, ondes Martenot (a form of theremin), and strings. The three sections are entitled "Antiphon of Interior Conversation (God present in us . . .)," "Sequence of the Word, Divine Canticle (God present in Himself . . .)," and "Psalm of the Ubiquity of Love (God present in all things . . .)." The text employed by the singers is on Messiaen's composition as were also the program notes printed on the occasion of the first performance. Of the Antiphon he writes:

> Dedicated to God present within us through Grace and the Holy Communion. After a most tender beginning ("My Jesus, My Silence, Abide with Me"), accompanied by the songs of distant birds (on the piano), there follows a middle section of great polyrhythmic and polymodal refinement. ("The Yes which sings like an echo of light." "Red and lavender melody in praise of the Father." "Your hand is out of the picture by one kiss." "Divine landscape, reverse your image in water.")

All these are clearly a believing organist's ideas. César Franck and Anton Bruckner, though neither had Messiaen's humor, worked from just such preoccupations. I once described this religio-musical style as the determination to produce somewhere in every piece an apotheosis destined at once to open up the heavens and to bring down the house. Certainly the latter action is easier to accomplish in modern life than the first. And certainly Messiaen has accomplished it several times in the *Liturgies*. The success of the accomplishment is due to a natural instinct for making music plus the simple sincerity of his feelings. These are expressed, moreover, through a musical technique of great complexity and considerable originality. The faults of his taste are obvious; and the traps of mystical program music, though less so, are well known to musicians, possibly even to himself. Nevertheless the man is a great composer. One has only to hear his music beside that of any of the standard eclectic modernists to know that. Because his really vibrates and theirs doesn't.

SEPTEMBER 23, 1945

A Miracle and a Monument

❧ MAGGIE TEYTE, who gave her second Town Hall recital of the season last night, is both a miracle and a monument. To have retained both her beautiful singing voice and complete mastery of it over a period

of some thirty-five years (I last heard her in 1912 at the Chicago Opera) is the miracle. The monumental nature of her work comes from the fact that she remains virtually alone today as an exponent of French vocal style of the period that preceded the other war. If you want to hear the Debussy songs and the Ravel songs and Fauré's sung by a vocalist who still knows what they sounded like in the epoch that saw their creation, there is no other living artist who can evoke them for you so authentically or so vividly. And if you want to hear the French singing style as Jean de Reszke invented it, as Muratore and Mary Garden practiced it, you will have to elbow your way into Town Hall the next time Miss Teyte gives a recital, though the house is already sold out, I believe.

That style is based technically on being able to sing any vowel in any color and at any degree of loudness or softness on any note of one's voice. It is based interpretatively on reading aloud. It is intoned elocution that uses so large a variety of vocal colorations that in no single piece is the gamut ever exhausted. Each song is a little drama, a slice of life that takes place in its own poetic climate, uses its own special and appropriate palette of sound. This vocal impressionism is of the utmost auditory richness, and also of the most intense poetic clarity. Such musical variety combined with ease of understanding, such apparent naturalism, is a summit of vocal art from which the singers of our epoch have long since declined. Miss Teyte alone has the key to it, the discipline of it, the workmanship and the knowledge to expose it before us.

It is a dramatic art. There is nothing personal or introspective about it, excepting that most of the repertory which shows it at its best is music of highly introspective subject matter. But introspective subject matter requires for its clear projection the most impersonal dramatic technique. Otherwise you get only obscurity. There is nothing inspirational about Miss Teyte's musical procedures. Her renderings are the product of discipline, reflection, and lots of rehearsal. Imagination and exactitude are what make them so dramatic. And naturally, they are not dramatic in any inappropriate sense. She projects poetry without getting theatrical. It is as if somebody were singing very beautifully and reading very beautifully at the same time.

It would be hard to say which songs she sang offered the greatest revelation. Her Fauré was marked by wonderfully unifying rhythm. Her Debussy had the real Debussy immobility, the rocklike reality of emotion that is the essence of Debussy. Her Ravel had a wiry delicacy that I have not heard applied to these songs since Eva Gauthier used to sing them for us with such fine awareness of their essential wit and parody.

Perhaps the grandest dramatic achievement of the evening was the letter scene from *Pelléas et Mélisande*, which Miss Teyte added at the close. This was so simple, so clear, and so relentless, so plain at the same

time, that one was reminded of how touching that opera can be when anybody lets us hear the words of it.

In face of such thoroughly conscious workmanship it seems almost unnecessary to mention Miss Teyte's personal charm. But that charm is itself so deeply gracious, and her schooled temperament as an actress and a musician is so wonderfully warmed by it, that the very sweetness and ease of her woman's personality become a part of her work as an artist. It is something of the kind, I am sure, that has made possible the miracle by which time has touched her singing so little.

DECEMBER 29, 1945

❧ *Articles and Reviews,* *1946 – 1954*

1946

Americanisms

❧ FOR ALL the vaunted virtuosity of the American symphony orchestras, your correspondent has long wondered what, if any, has been, or is likely to be, their contribution to art. American ensemble playing on the popular level has given to the world two, perhaps three, expressive devices of absolute originality. One is a new form of tempo rubato, a way of articulating a melody so loosely that its metrical scansion concords at almost no point with that of its accompaniment, the former enjoying the greatest rhythmic freedom while the latter continues in strictly measured time. Another characteristically American device is playing "blue," using for melodic expression constant departures from conventionally correct pitch in such a way that these do not obscure or contradict the basic harmony, which keeps to normal tuning. Simultaneous observance of these two dichotomies, one metrical and one tonal, constitute a style of playing known as "hot." And although precedents for this are not unknown in folklore and even in European art custom, our systematization of it is a gift to music.

Another device by which our popular ensembles depart from European habits is the execution of a volume crescendo without any acceleration of tempo. It is possible that Sebastian Bach may have played the organ without speeding up the louder passages, but Bach did not know the volume crescendo as we conceive it. He only knew platforms of loudness. The smooth and rapid increase of sound from very soft to very loud and back again is an invention of the late eighteenth century. It is possible, even today, only with a fairly large orchestra or chorus, on a piano, or on the accordion. It is the basic device of musical Romanticism; and the nineteenth century invented a fluid rhythmic style, in which pulsations were substituted for strict metrics, to give to the planned crescendo a semblance of spontaneity.

It was the conductor Maurice Abravanel who first called my attention

to the rarity of the nonaccelerating crescendo in European musical execution. It has long been used to suggest armies approaching and then going off into the distance, its rhythmic regularity being easily evocative of marching. But aside from this special employment it is foreign to Romantic thought. If you want to get a laugh out of yourself, just try applying it to Wagner or Chopin or Liszt or Brahms or Beethoven or even Debussy. These authors require a fluid rhythmic articulation. And though one may for rhetorical purposes, as when approaching a peroration, get slower instead of faster as the volume mounts, it is obviously inappropriate in Romantic music to execute a subjectively expressive crescendo or decrescendo without speeding up or slowing down.

The modern world, even in Europe, has long recognized the rhythmically steady crescendo as, in theory, a possible addition to the terraced dynamics of the eighteenth-century symphony. In fact, however, European composers have never, to my knowledge, used it without a specifically evocative purpose. Of the three most famous crescendos in modern music not one is both tonally continuous and rhythmically steady. Strauss's *Elektra* is tonally continuous, rising in waves from beginning to end; but it presupposes no exact metrics. Stravinsky's "Dance of the Adolescents" (from *The Rite of Spring*) and Ravel's *Bolero* do presuppose a metrically exact rendering, but they are not tonally steady crescendos. They are as neatly terraced as any Bach organ fugue.

The completely steady crescendo is natural to American musical thought. Our theater orchestras execute it without hesitation or embarrassment. Our popular orchestrators call for it constantly and get it. Our symphonic composers call for it constantly and rarely get it. The conductors of European formation, who lead most of our symphonic ensembles, simply do not understand it. Very few of them understand metrical exactitude in any form. American music, nevertheless, requires a high degree of metrical exactitude, emphasized by merely momentary metrical liberties. Also lots of crescendo, which is our passion. The music of Barber and Schuman and Piston and Hanson and Copland and Harris and Bernstein and Gershwin and Cowell and Sowerby and Randall Thompson and William Grant Still is full of crescendos. It is also full of rhythmic and metrical irregularities. But none of it is romantic music in the European sense, because the crescendos and the rhythmic irregularities are not two aspects of the same device. The separation of these devices is as characteristic of American musical thought as is our simultaneous use of free meter with strict meter and free with strict pitch. These dichotomies are basic to our musical speech.

Hearing Howard Hanson or Leonard Bernstein conduct American music is a pleasure comparable to hearing Pierre Monteux conduct French music or Bruno Walter interpret Mahler and Bruckner. The reading is at one with the writing. Our foreign-born conductors have given the

American composer a chance to hear his own work. Also, they have built up among the public a certain toleration of American music, or encouraged, rather, a toleration that has always existed. But they have built up also a certain resistance to it which did not exist here previous to the post–Civil War German musical invasion. This resistance comes from a complete lack of adaptation on the part of the European-trained to American musical speech. They understand its international grammar, but they have not acquired its idiom and accent.

Insofar as they are aware that there are an idiom and an accent (as several of them are), they are likely to mistake these for localisms of some kind. They are nothing of the sort; they are a contribution to the world's musical language, as many postwar Europeans are beginning to suspect. American popular music has long been admired abroad, but American art music is just beginning to be discovered. It would probably be a good idea for us here to keep one step ahead of the foreign market by building up a record library of American works in authoritative renderings by American-trained artists. Also to accustom our own public to this kind of authoritative collaboration. We shall need both a professional tradition and broad public support for it if we are to accept with any confidence the worldwide distribution of American music that seems to be imminent.

Actually we are producing very nearly the best music in the world. Only France, of all the other music-exporting countries, operates by stricter standards of workmanship and of originality. Not Germany nor Italy nor Russia nor England nor Mexico nor Brazil is producing music in steady quantity that is comparable in quality to that of the American school. And we are a school. Not because I say so, but because we have a vocabulary that anybody can recognize, I think, once it is pointed out, as particular to us.

JANUARY 27, 1946

After Thirty Years

❧ RICHARD STRAUSS's *Ariadne on the Isle of Naxos*, which was given its first professional New York performance last night at the City Center of Music and Drama, is considered by many Strauss fanciers to be its composer's masterpiece. That it is the work of a master there is no doubt. If it lacks, perhaps, the lurid vigor of *Elektra* and *Salomé* or the straight sex appeal of *Der Rosenkavalier*, it has a clarity of musical texture that is missing from these earlier works. It is indeed a pleasure to hear Strauss's music pruned of the 10,000 useless notes per act with which he was so long accustomed to clutter up his scores. *Ariadne*, though thin, perhaps, of expressive substance, has great charm, both melodic and harmonic, and its small clean orchestra is a perpetual delight.

Last night's performance of the work under Laszlo Halasz was a pleasure all round. The orchestra was lovely; the singers sang with style; the staging, if not especially witty or chic, was at the same time neither dull nor clownish. The work was not played for laughs or for easy applause; it was presented as a serious piece of theater, and the audience responded with gratitude to the compliment thus paid its intelligence.

It responded most of all to Virginia MacWatters, who sang the difficult coloratura aria with a purity of style and an accuracy of pitch unmatched in New York City by any other coloratura soprano during my reviewing years. Second in audience favor was Polyna Stoska, who sang the role of the composer. Ella Flesch, curiously, did not work at her best as Ariadne. She is a schooled artist, and her voice is a commanding one. But she mostly stood around looking like the Statue of Liberty and sang flat. The three ladies who waited on her in exile — Lillian Fawcett, Rosalind Nadell, and Lenore Portnoy — sang their trios with skill and beauty. James Pease, as the Music Master, was first-class in every way.

The work itself, from both the literary and the musical points of view, is what the Marxians would probably call "decadent capitalist art." It is shallow of substance and utterly sophisticated in style. It is a masterful display of learning, skill, and deliberate charm, all luxury and no meat. It evokes the eighteenth century through the conventions of the Reinhardt Baroque. It aims, one learns from the librettist von Hofmannsthal's own publicity, at a certain profundity, which this writer finds scant, and at a humor which he finds not very funny. Musically it is an elaborate joke about how much fun it is to play around with the classical techniques.

From any point of view, in fact, it is good to listen to, because it is in its own way a completely successful work. About what its place in musical history will be a century from now I have no guess. But for thirty years it has had a unique place in the contemporary world of music, and the City Center has contributed valuably to New York's intellectual life by making us acquainted with it. Whether in all those thirty years the Metropolitan Opera, upon whom the responsibility for our operatic culture has chiefly rested, could ever have produced it I do not know. Their setup is, of course, almost unbelievably inefficient, and the work requires skill and lots of rehearsal. In any case, the fact remains that *Ariadne auf Naxos* is New York news this morning and its City Center performance musically good news.

OCTOBER 11, 1946

Warm Welcome

✧ DAME MYRA HESS, who played a piano recital yesterday afternoon in the Town Hall, has, as a musician, instinct and intelligence. She has the quality which in France is called *musicalité*, the gift for making

music sound like music. Also, she is a workman of taste and refinement. She takes convincing tempos, phrases soundly, analyzes a work correctly, executes it with distinction. What she lacks is temperament, the power always to respond in public to her music's own sound, and to add, inevitably, communication. She plays intelligently, and she has a natural nobility. But she doesn't easily "give," as the young people would say.

Her playing yesterday of a Bach French Suite was pleasant, of two Beethoven works (the Six Variations, opus 34, and the A-flat Sonata, opus 110) pretty but distant. It was as if, having known them all her life, she was reminding other musicians of how they went. She did not so much play them as strum them. She exposed them clearly, sounded them out agreeably, but abstained from any personal involvement with their expressive content. The result was hard for a disinterested listener to keep his mind on. And her constant insertion of slight crescendos and decrescendos into every phrase removed from musical design its expressive urgency, reduced all to a lullaby.

Halfway through the Brahms F-minor Sonata (opus 5) a change took place. She got into the scherzo through its rhythm, stopped strumming and really played the piece. From there to the end of the work she made music squarely, forthrightly, convincingly, instead of just dreaming about it in a flowing robe. One realized then that her celebrity is not due merely to her admirable wartime activities. Here her work had a plainness of speech, an impersonal grandeur that was served rather than diminished by refinements of touch and phraseology.

Dame Myra is no devotee of the big tone, though she can play loud enough when she needs to. It is the breadth of her musical thought that gives dignity to her execution. For all the gentleness of her sentiments, the grace of her musical ornaments, the wit of her dry little scale passages, she is not a finicky musician. She is sensible, straightforward, and noble, when she gets warmed up.

Yesterday she was rather slow warming up, though the massive audience had warmed to her from the beginning, had stood up, indeed, to welcome her. Perhaps the gracious speech she made at the end of the first half of the program, in which she thanked America so prettily and with such sweet sincerity for its moral and financial help in continuing throughout the war daily free concerts at the National Gallery in London, had broken down by verbal means her previous emotional reserve. In any case, she was first-class when she finally got going.

OCTOBER 13, 1946

German Composers

∽ MUSICAL COMPOSITION in Germany and Austria, relieved from Nazi censorship by the Allied invasion, has gone back to where it left off

when Hitler came in. This is not to say that nobody in those countries wrote any good music during the Nazi years. I mean rather that the newer music now available there by print or performance bears a closer relation to that current in pre-Nazi times than most of the music honored by the Third Reich did. In other words, the break with the modernist tradition that accompanied the triumph of National Socialism is being repaired under the esthetically less dictatorial Allied Military Occupation.

The mending job will not, however, be complete, with no seams visible, because certain powerful influences on central Europe's music life that were exiled in the mid-1930s will never — can never — return. The principal of these is that of the twelve-tone trinity — Schönberg, Berg, and Webern. The first of these masters, now resident in California, is seventy-two years old and not in good health; the other two are dead. And though their influence might be expected to go on through their published works and through the teaching of their pupils, the curious fact is that in Germany it does not. There is a little of it left in Austria, where the pre-Schönbergian atonalist Josef Matthias Hauer survives, along with two or three Webern pupils. The younger Austrians mostly follow other leaders, other styles. In Germany this reporter inquired diligently without encountering one twelve-tone writer or finding any German musician who knew the existence of one in the land.

The influences of Paul Hindemith and of Kurt Weill, on the other hand, both resident in the United States, are considerable. That of the former is less notable on musical composition, curiously, than on pedagogy. Musicians who write like Hindemith are not so plentiful as those who teach his theory. In the process of getting the conservatories started again, a revision of German music teaching seems to be desired. And since personnel is lacking for the teaching of atonal theory, this school of composition is not represented on the faculties. But the Hindemith textbooks are held in high respect and seem likely to form the basis of the most advanced pedagogy. Hindemith's works are held in honor too, but rather as proof of their author's personal gift than as models being followed. In any case, though Hindemith is a burning subject of discussion in music circles, it is his undeniable influence on music teaching that is chiefly defended and attacked rather than his direct influence on musical composition. Evidences of the latter are, though not wholly lacking, more rare. In Germany, as here, he has formed more good teachers than he has successful composers.

Kurt Weill, though not a theorist at all, seems to have left a strong mark on German music. At least, there is an influence around that is not easily explainable through any of the existing pedagogical traditions and that this detective strongly suspects to come out of *Mahagonny* and *Der Dreigroschenoper*. The academic German styles today are two, the Hindemith style and the Reger style, both contrapuntal. Like all contrapuntal

styles, these are more entertaining to write in than to listen to; they lack expressivity. The rival style, which leans more on melodic and rhythmic device, is lighter of texture, more varied in expression, less pompous, and more easily digestible.

The most successful writer in this vein is Carl Orff, who lives near Munich. His works are chiefly dramatic oratorios, which is to say, choral works with orchestral accompaniment that require (or at least are enhanced by) staging. Their texts are elaborately cultural, their musical textures almost willfully plain. One, called *Carmina Catulli*, consists of odes by Catullus, in Latin, interspersed with modern recitatives, also in Latin, by the composer. Another, *Carmina Burana*, uses student songs in medieval Latin mixed with Old German. An opera entitled *Die Klüge* has a rhymed text by the composer. Another now nearing completion, *Die Bernauerin*, is in Bavarian dialect. The direct musical model of all these works is Stravinsky's *Les Noces*. They employ lots of rhythmic chanting, and the orchestral accompaniment is percussive. The music is simplified, however, to a point where the basic musical elements — melody, harmony, and counterpoint — are almost nonexistent. The rhythm itself, even, has not much intrinsic interest. What holds these works together is first-class handling of words and their excellent orchestration. Otherwise they are monotonous. Surprisingly enough, they have considerable success in performance, even on the radio, where stage spectacle is not there to help out.

More interesting musically, though also an example of the simplification for expressive purposes that I credit to Kurt Weill (radio work is also, no doubt, an influence), is the music of Boris Blacher and of his pupils. Blacher is Russian by birth, a child refugee of the Revolutionary years. He is musical director at present of the Russian-run Berlin radio station. His music, though aware of both Stravinsky and Satie, is gayer than that of either. At its simplest it is full of musical interest; at its most complex it is still full of life, clear, and expressive. His suite, *Concertante Musik*, would be an ornament to anybody's orchestral program. His pupil Gottfried von Einem, an Austrian, writes operas in which rumba rhythms turn up at the most tragic moments, unexpectedly but not always inappropriately. Blacher's work and von Einem's have a touch of wit that is welcome in German music. Blacher himself is the most vigorous single musical influence now present in the country.

Another composer that we shall all be hearing from is Kurt Hessenberg, of Frankfurt. This young man in his early thirties is the author of neo-Romantic songs, cantatas, and piano pieces that evoke directly and without detours the spirit of Schumann. His Symphony Number 2 is melodious and completely successful. Unfortunately it received a Nazi prize award in 1942, an honor which makes it something of a hot potato anywhere just now. It is a beautiful work, all the same, and will no doubt

come into its own later. Everybody, I am sure, will love it. It is quite without the turgidity of the German contrapuntalists and equally void of those vulgarities in sentiment and in style that make the works of the more official Third Reich composers (Werner von Egk, for instance) not worth worrying about at present. Hessenberg is a schooled workman and a composer of very real, if somewhat obvious, poetic feeling.

Blacher and Orff are the most original composers whose work this reporter encountered in Germany. Whether Orff can long remain acceptable to musicians I cannot say, though I doubt that he will. Blacher is growing in interest and influence, but I do not believe he will remain long in Germany. After twenty-five years, he seems to have had enough. Hindemith, whether or not he ever returns to the land of his birth and major successes, will certainly continue to occupy the central musical position there for many years.

OCTOBER 13, 1946

1947

A War's End

∾ *Modern Music*, quarterly review edited by Minna Lederman and published by the League of Composers, has ceased publication after twenty-three years. Musicians and laymen who are part of the contemporary musical movement will of necessity be moved by this announcement, because *Modern Music* has been for them all a Bible and a news organ, a forum, a source of world information, and the defender of their faith. It is hard to think of it as not existing, and trying to imagine what life will be without it is a depressing enterprise.

No other magazine with which I am acquainted has taken for its exclusive subject the act of musical composition in our time or sustained with regard to that subject so comprehensive a coverage. This one reported on France and Germany and Italy and England and Russia and Mexico and the South American republics, as well as on its own United States. It covered musical modernism in concerts, in the theater, in films, radio, records, and publication. Jazz and swing procedures were analyzed and calypso discovered in its pages. Books dealing with contemporary musical esthetics were reviewed. The only aspects of music excluded from it were those that make up the ordinary layman's idea of music, namely, its interpretation, its exploitation as a business, and its composition before 1900.

Modern Music was a magazine about contemporary composition written chiefly by composers and addressed to them. It even went into their politics on occasion. When our entry into the recent war brought to certain composers' minds the possibility that perhaps our government might

be persuaded not to draft all the younger ones, thus husbanding, after the Soviet example, a major cultural resource, Roger Sessions disposed of the proposal firmly by identifying it with the previous war's slogan "business as usual." And when, on the liberation of Europe, consciences were worried about musician collaborators, a whole symposium was published, exposing all possible ways of envisaging the problem. Darius Milhaud, as I remember, said that traitors should be shot, regardless of talent or profession. Ernst Křenek pointed out that Shostakovich, who had accepted from his own government artistic correction and directives regarding the subject matter of his music, was the prince of collaborators. While Arnold Schönberg opined that composers were all children politically and mostly fools and should be forgiven.

In the atmosphere of sharp esthetic controversy that pervaded the magazine and with its constant confrontation of authoritative statement and analysis (for there is practically no living composer of any prestige at all whose works have not been discussed in it and who has not written for it himself), wits became more keen and critical powers came to maturity. It is not the least of many debts that America owes Minna Lederman that she discovered, formed, and trained such contributors to musical letters as Edwin Denby, Aaron Copland, Roger Sessions, Theodore Chanler, Paul Bowles, Marc Blitzstein, Samuel Barlow, Henry Cowell, Colin McPhee, Arthur Berger, and Lou Harrison. My own debt to her is enormous. Her magazine was a forum of all the most distinguished world figures of creation and of criticism; and the unknown bright young were given their right to speak up among these, trained to do so without stammering and without fear.

The magazine's "cessation of hostilities," as one of its European admirers refers to the demise, is explained by its editor as due to "rising costs of production." Considering previous difficulties surmounted, I should be inclined to derive the fact from a deeper cause. After all, the war about modern music is over. Now comes division of the spoils. Miss Lederman's magazine proved to the whole world that our century's first half is one of the great creative periods in music. No student in a library, no radio program maker, dallying with her priceless back issues, can avoid recognizing the vast fertility, the originality, ingenuity, and invention that music has manifested in our time.

JANUARY 12, 1947

In the Royal Style

∾ THE Collegiate Chorale, conducted by Robert Shaw, gave last night in the Hunter College Auditorium an uncut performance of Bach's B-minor Mass. Though this lasted nigh on to three hours, your reporter experienced no fatigue and observed no sleepers. Indeed, it has not pre-

viously been his privilege to hear so thoroughly delightful a reading of this majestic work, though he has attended many. How Mr. Shaw worked his miracle on this most recalcitrant of pieces is the subject of this morning's sermon.

He started by organizing his musical effectives in proportions not unlike those available in the German eighteenth-century courts, for one of which the work was originally planned. A chorus of sixty mixed voices (American amateur female sopranos are not as loud as trained German boys), an orchestra of strictly chamber proportions, a harpsichord, an organ used with extreme discretion, and the necessary soloists were quite sufficient for volume and not excessive for the florid style. He further reduced the orchestral effectives in accompanying the solos and duets to single instruments or, in the case of string backgrounds, to two on a part. And then he rehearsed the choruses for lightness and clarity, the vocal soloists for harmonious blending with the instrumental soloists that accompany them.

As a result, the accompanied solos, in reality small chamber ensembles, took their place in the choral framework very much as the concertino group in a concerto grosso is set off against the larger instrumental body. The work became thus a dialogue, an antiphony, each kind of music being beautiful in its own way, the two kinds giving amplitude and perspective to the whole.

That whole turns out to be, as one might have expected, not at all a giant Lutheran cantata, nor yet a liturgical Mass, but a grand and sumptuous court oratorio on the subject of the Mass. Its grandeur lies in its vast proportions and in its completely simple expressivity, its sumptuousness in the extreme and formal floridity of the musical texture. Its layout is huge but perfectly clear; its style is the ultimate in ornateness. It is at once enormous and graceful, like the palace architecture of its time, complete with gardens, ponds, statues, and vistas.

Mr. Shaw preserved these proportions and all their grace by simply limiting his forces to a size capable of achieving grace. He added, moreover, a grace of his own in the firm lilt of his beat. His rhythmic alacrity evoked a court ballet. The *Cum sancto spiritu* that ends the Gloria was as gay as a hornpipe; and the bass aria, *Et in spiritum sanctum*, from the Credo, tripped along none the less reverently for being light on its feet. Just as the alto *Agnus Dei* might easily have rocked a cradle.

Rhythmic courage, tonal exactitude, pretty balances, and sweetness all round allowed the proportions of the work to take on full majesty without any heaviness. If Mr. Shaw and his admirable colleagues will give us such a performance annually, Bach's choral masterpieces will cease in short order to be merely edifying and become humane, as I am sure, from last night's performance of the Mass, they were conceived to be. The sacred music of the great masters is not designed to shake humanity; that

is a function of the theater. It is made to please God by fine workman-
ship. This one was planned, as well, to get its author a job at the Saxon
court.

JANUARY 29, 1947

Landscape Music

✧ THE Dallas Symphony Orchestra, Antal Dorati, conductor, gave
yesterday afternoon, in a program broadcast by NBC, the first perform-
ance of a work in four movements by Paul Hindemith entitled *Sym-
phonia Serena*. The symphony, this composer's second, is a large essay
in pastoral vein. Eschewing voluntarily all personal pathos, the composer
has aimed, I think, at a direct rendering of landscape. No land or seascape
so specific as that of Debussy's *Ibéria* or *La Mer* is invoked; but the piece
is a pastoral symphony all the same, a formal communion with nature not
dissimilar in approach to Mendelssohn's "Italian" and "Scottish" sym-
phonies. Whether the landscape is one with or without figures is hard to
say, though there is certainly an echo present in the slow movement. All
the same, there is no such broad humanity included as that which joins in
the village dancing of Beethoven's Sixth Symphony.

The first movement seems to be about the countryside, perhaps a walk
through this in spring or summer; at one point water, possibly a rivulet
or cascade, is suggested. The second, a scherzo for wind instruments
based on a quick-step theme by Beethoven, is light in texture and ex-
tremely animated. Possibly insect life may be its subject. The third is a
dialogue for two string orchestras, two solo strings (a violin and a viola),
and two more of the same playing offstage right and left. Its sentiment
is tender, sweet, and not without a deliberate nobility. Echo effects evoke
a décor with some distance in it. A certain pathos of expression indicates
a spectator. The last movement, which is one of considerable thematic
complexity, is certainly dominated by the sound of birds.

The entire piece is contrapuntally complex in the sense that almost no
theme is ever stated without a countertheme in contrasting rhythmic
values. This procedure gives objectivity to the expression, impersonality,
and reserve. The work is distinguished of texture and most agreeable in
sound (the dissonant diatonic is its syntax). It will take its place in the
repertory of evocation rather than in that of symphonic sermonizing.
Exactly what that place will be is difficult to predict; but if manliness of
spirit and sound workmanship have any carrying power in our land and
century, that place will be one of honor. Hindemith's *Symphonia Serena*
is a solid, conservative work from the studio of one of the solidest and
most conservative workmen alive.

FEBRUARY 2, 1947

The Philharmonic Crisis

℘ ARTUR RODZINSKI has gone and done it. For years the knowledge has been a secret scandal in music circles. Now he has said it out loud. That the trouble with the Philharmonic is nothing more than an unbalance of power. Management has usurped, according to him, certain functions of the musical direction without which no musical director can produce a first-class and durable artistic result. He has implied that no conductor, under present conditions, can keep the orchestra a musical instrument comparable to those of Boston and Philadelphia. He points to Arthur Judson, a powerful business executive who manages the orchestra as a sideline, as the person chiefly interested in weakening the musical director's authority. He is right; he is perfectly right; he could not be more right. An orchestra can use one star performer and one only. And such a star's place is the podium, not the executive offices.

The American symphony orchestra, like the American government, is an operation of three powers. Its trustees are the power responsible to the community. They provide (or collect) money and determine how it is to be spent; they hire a manager to handle the business details of concert-giving; and they entrust to a conductor the production of music for these. The manager in his office and the conductor before his orchestra both have full authority to run their departments, the trustees preserving a veto power over policies only. The trustees, a self-perpetuating body, are thus the initiators of the orchestra as a project and the court of final appeal about everything regarding it.

The musical director's job is the most responsible post of its kind in the world. He has all the authority of a ship's captain. Hiring and firing of musicians, their training and discipline, the composition of all programs and their public execution are his privilege. Any visiting conductor or soloist is a guest in his house. The manager's job is purely organizational, a routine matter that anyone can handle who has a knowledge of standard business methods and some diplomacy. The latter is essential for him, serving constantly, as he does, as go-between in whatever brushups occur between the conductor and the trustees. Since the symphony orchestra is a nonprofit-making institution serving the community in a cultural capacity, its trustees must be men and women of culture and of unquestioned civic responsibility, its conductor a musician with courage and judgment as well as technical skill, its manager a model of integrity and of tact.

The Philharmonic case is simple. Arthur Judson is unsuited by the nature and magnitude of his business interests to manage with the necessary self-effacement a major intellectual institution doing business with his other interests. He is also a man of far too great personal force to

serve effectively as a mediator between a proud musician and the equally proud trustees. That is probably why no conductor ever stays long enough with the Philharmonic to accomplish the job that everybody knows should be done, namely, to put the orchestra permanently on an artistic equality with the other American orchestras of comparable financial resources.

Artur Rodzinski has done more for the orchestra in that respect than any other conductor in our century has done. Mahler and Toscanini were greater interpreters, not such great builders. If Stokowski and Munch, also great interpreters, have been able this winter, as guests, to play upon the orchestra in full freedom and to produce from it sonorous and expressive beauties of the highest quality, that achievement has been made possible by Rodzinski's personnel replacements and his careful training. Such an achievement on the part of guest conductors has not heretofore been possible. Today the Philharmonic, for the first time in this writer's memory, is the equal of the Boston and Philadelphia orchestras and possibly their superior.

Stabilization of these gains is the next step indicated. With that in mind the trustees in December voted Mr. Rodzinski a long-term contract "without strings attached." One gathers that the contract he actually received contained not strings but chains, that his right to decide who besides himself shall conduct his orchestra, to confer with his guests about their programs, even to determine in full freedom his own was seriously jeopardized. It seems doubtful that any conductor would leave so important a post unless the working conditions were about to become intolerable. So far, they have not been that for him, and the orchestra's improvement under his leadership has proved that they were not.

What awaits his successor is anybody's guess. Dramas and heartbreaks probably, unless the trustees decide to hire another such orchestra builder and give him full power to go ahead and build. In that case, it is scarcely worthwhile to have provoked the present conductor into resigning. (The contention that he resigned merely because a better job was offered him is not credible, because there is no better job.) In any other case, the Philharmonic will decline as an orchestra as inevitably as winter will return. There is only one way to have a first-class orchestra and that is to let the conductor run it. If he fails, he can be replaced. But while he lasts he has to be given full musical authority as that is understood in the major symphonic establishments.

Rodzinski's career will not be gravely interrupted, we hope, by his courageous gesture. New York will miss him and regret his musical benefits bestowed. The last and greatest of these will have been the most valuable of all, if his exposure of what has long been known in music circles as a scandal and a shame shall encourage the trustees to correct it. There is no reason why the Philharmonic should not remain what it is

now, the tip-top executant musical organization of the world. All it needs is a competent and energetic musical director and a disinterested management.

FEBRUARY 9, 1947

The American Song

∿ ENGLISH-SPEAKING singers are trained and grow to maturity on one of the most curious musical literatures in the world. German vocalists cut their professional teeth on the lieder of Romantic masters and, if the voice is strong, on airs from Weber and Wagner. The Italians, to a man (or woman), sing Puccini and Verdi and very little else. The French have their Fauré, their Gounod, and their fragments from Massenet. All this is perfectly reputable music. The Continent has its popular religious pieces too, like Jean-Baptiste Fauré's *The Palms*, Adam's *Minuit Chrétien*, and Bach's *My Heart Ever Faithful*, also its glorified folklore like Irish mother songs and Italian boat pieces.

But just cross the Channel, and you find that the basic vocal repertory is not either the classics or the indigenous folk lyric. It is a commercial product known variously as "ballads" or "art songs" or just "songs," though it is not in a proper sense any of these things. You hear it in homes, at banquets, in recitals, and over the BBC. In its manlier forms it is a hearty baritone number about how "when we were young and I went down to Rio." Its tender mood deals with gardens and somebody referred to as "YOUUU." For a light touch children are introduced who resist medication or dislike the cook, though they never go so far as to refuse spinach. The American version of this vast Anglo-Saxon musical literature admires trees and sunsets, believes that marriages are made in heaven, faces the future with confidence, and enjoys playing cowboy.

There is nothing wrong, of course, about any of these ideas. They represent ethnic aspirations and touch infallibly the English-speaking heart. What is curious about the musical literature in which they are embodied is its stylistic vulgarity, its technical and esthetic ineptitude. The literary aspect of it, though often banal in verbiage, is as to sentiment perfectly sound and humane. But take a look, I ask you, at the musical settings; or listen to them at recitals. A sunrise is described in the idiom of *Tristan und Isolde*, trout fishing in that of *Pelléas et Mélisande*. A nursery incident may be blown up till it suggests *The Sorcerer's Apprentice*. As for mating, you would imagine the whole population sex-starved if you believed in the amorous intensity of our "art-song" harmonizations. The musical vulgarity of the literature I am describing is due, as a matter of fact, not only to its exaggerated passional make-believe but to its practice of describing everything, literally everything, in the musical language of love.

The stuff needs only comparison with the Continental equivalent for the technical ineptitude to be patent. The rhythmic inflections of the English language are more often than not correctly observed and neatly dramatized. But vowel quantities are handled with as complete disregard for their exigence as could well be imagined. An otherwise skillful song by the late Carl Engel asks that three beats of slowish time, plus a retard, be occupied to pronounce the word *stop*. And one by Baimbridge Crist, quoted in this composer's far-from-uninteresting brochure, *The Art of Setting Words to Music*, asks that the word *kiss* be held on a high F for something like five seconds. If you think my criticism finicky, just try this trick out; and you will discover that the result is neither English nor music.

The esthetic fault most commonly committed in American vocal music is the confusion of genres. Setting a simple love lyric as if it were an operatic aria removes all poignancy from the poem. Dramatic expression in music requires a dramatic situation in the text. The Continental song literature from Mozart through the German Romantics to Fauré, Debussy, Ravel, Sauguet, and Poulenc deals, in any one piece, with a single person in an unequivocal mood. No event, inner or outer, takes place; and no conclusion is arrived at, though the sense of the whole may be summed up in a final couplet. These are the classical limits of lyric poetry. The ballad form, as in *Der Erlkönig*, is equally set and stylized by its stanza construction. Epic recitation and dramatic narrative demand still another musical form. I accuse the English and American composers (especially the Americans) of having hopelessly confused one kind of poetic expression with another in their vocal concert music. I am not naming any names, because they are practically all guilty. Just listen, if you want examples, to the American group of any singer's recital program. Or take a look at what your kid sister is given by her vocal teacher.

Is it any wonder that our American singers are not masters and mistresses of their art, when the repertory they all learn music through is so incompetently composed? They don't know that English vowel lengths, like Continental ones, are immutable. They don't know that poetic expression, no matter what its subject, falls into four or five styles, or genres rather, and no more. They don't know that lyric poetry does not permit an aggressive mood, that impersonation of the poet by the interpreter is unbecoming to it, that it can be recited or sung but never acted, though the ballad style can, on the contrary, be dramatized up to the hilt.

How can they know these things when the composers of the music that is virtually their whole fare write as if they didn't know them either, and when singing teachers, for lack of a better repertory, give them for study year after year pieces that nobody can vocalize correctly or interpret convincingly because they are incorrectly composed? They are incorrect as to vowel quantities, false to the known esthetics of poetry, and irrespon-

sible in their misapplication of a climactic and passionate musical style to virtually any subject, even the sacred. America is full of beautiful young voices and high musical temperaments. The singing teachers are not bad either, on the whole. Students often learn from them to vocalize the long vowels quite prettily. After that they commit every fault. What about our composers sitting down and writing them something that can be sung without fault? Our playwrights write plays that can be acted. Our painters paint pictures that can be hung, looked at, lived with. Our better composers write fair symphonies and thrilling ballets. But the human voice they have left in second-rate hands. There are probably not twenty American "art songs" that can be sung in Town Hall with dignity or listened to there without shame. Nor are there five American "art composers" who can be compared, as song writers, for either technical skill or artistic responsibility, with Irving Berlin.

FEBRUARY 16, 1947

The Koussevitzky Case

☙ SERGE (or Sergei) Koussevitzky, conductor of the Boston Symphony Orchestra since 1924, is an aristocrat among American conductors and in Boston music circles something of an autocrat. Born seventy-two years ago in Russia and reared there in poverty (his family, though Orthodox Jews, never lived in a ghetto), he has attained wealth, worldwide fame, and the highest distinction in his profession. As a virtuoso on the double bass viol and as a conductor his ranking, by any standards, has been for many years among those of the very greatest in our time. As a composer he has contributed to the reputable literature of his instrument. As a publisher and a patron of contemporary music he has probably made a more lasting contribution to the art than any other single person living, excepting five or six composers. His place in its history is already assured and glorious.

Just to make assurance doubly sure, the Boston immortality machine has started issuing this winter what looks like a series of books bearing the papal imprimatur of the good Doctor (LL.D., honoris causa, Harvard, 1929, and elsewhere). M. A. DeWolfe Howe, official biographer to the Bostonian great, has furnished *The Tale of Tanglewood, Scene of the Berkshire Music Festivals* (Vanguard Press), with a preface by Mr. Koussevitzky himself. And Hugo Leichtentritt, a musicologist of repute and a former lecturer at Harvard University, has fathered *Sergei Koussevitzky, the Boston Symphony Orchestra and the New American Music* (Harvard University Press).

Both volumes are slender, and their tone is unctuous. The first sketches ever so lightly the history of the summer festivals that have now grown into a training school for composers, conductors, and orchestral musi-

cians. The second enumerates the American compositions played by Serge Koussevitzky and the Boston Symphony (sometimes under other leaders) since 1924. The list is large and impressive. If Mr. Leichtentritt's critical paragraphs are weakened by the fact that he has neither heard many of the works nor had access to their scores, the tabulation of Mr. Koussevitzky's public encouragements to American composers alone is of value as proving once and for all (if Walter Damrosch, Frederick Stock, Pierre Monteux, and Leopold Stokowski had not proved it before) that a sustained program policy supporting contemporary composition does not keep subscribers away from symphony concerts.

And now to supplement these two books, which are clearly official and more than a little superficial, arrives a full-length biography of the maestro which is neither. It is entitled simply *Koussevitzky*, by Moses Smith (Allen, Towne, and Heath). Announced for sale on February 15, its distribution has been held up for the time being by an injunction that prohibits its publication, sale, and distribution till Justice Sheintag of the New York Supreme Court shall have determined whether the book's circulation will do its subject "irreparable harm." If the present writer, who has read an advance copy received before the injunction was issued, is in any way typical of the American reading public, it certainly, in his opinion, will not. The only possible harm he can envisage to so impregnable a reputation as that of Serge Koussevitzky is that already done by his own efforts to suppress the book.

Moses Smith, a trained newspaperman, for many years critic of the *Boston Evening Transcript*, as well as a friend of Mr. Koussevitzky, has produced a far more thorough study, a better work of scholarship than either Mr. Howe or Mr. Leichtentritt, scholars both by trade. There seems little in the book of factual statement that is subject to question. Whether Mr. Koussevitzky, in view of his great devotion to the memory of his second wife, is made unhappy by mention of his first marriage, hitherto not publicized in America, is scarcely germane. Neither is his possible sensitivity to reports of his quarrels with musicians and with blood relatives. These are, as a matter of fact, common knowledge; and they legitimately form part of the whole story of his musical life, just as his first marriage does of any complete biography.

Judgments and opinions, expressed over any writer's signature, are, of course, personal. The conductor's legal complaint objected to Mr. Smith's statement that Koussevitzky had succeeded as a conductor in spite of imperfect training as a young man in musical theory and score-reading. This also, if I may make so bold, has long been common knowledge among musicians. Nor is the estimable doctor unique among the conducting great for being in a certain sense self-taught. Leopold Stokowski, Sir Thomas Beecham, and Charles Munch, great interpreters all of them, did not come to conducting through early mastery of the conservatory rou-

tines. They bought, muscled, or impressed their way in and then settled down to learn their job. They succeeded gloriously, as Koussevitzky has done. All honor to them. They have all, Koussevitzky included, contributed more of value to the technique of their art than most of the first-prize-in-harmony boys ever have.

But great pedagogues, and the good doctor is one, do hate hearing that their own education has not been conventional, though it rarely was. And all great artists loathe criticism. They do; they really do. What they want, what they need, what they live on, as Gertrude Stein so rightly said, is praise. They can never get enough of it. And sometimes, when they have come to be really powerful in the world, they take the attitude that anything else is libel and should be suppressed. Dr. Koussevitzky's complaint, as I remember, did not use the word *libel*. It spoke of possible "irreparable injury." Well, criticism is often injurious; there is no question about that. Many a recitalist, receiving unfavorable reviews, finds it more difficult to secure further engagements than if his reports had been less critical. Minor careers have been ruined overnight that way. Major careers are rarely harmed by criticism, because major artists can take it. They don't like to; but they have to; so they do. All the same, it is the big boys, the great big boys that nothing could harm, that squawk the loudest. I know, because I have been in the business for several years now.

Mr. Smith's book makes Koussevitzky out to be a very great man indeed, but it also makes him human. Gone is the legend of his papal infallibility. Renewed is one's faith in his deep sincerity, his consecration, his relentless will to make the world permanently better than he found it. Nobody, I am sure, can read the book through without admiring him more. And the faith of the pious need not be shaken by reading that he has not always been, toward his fellow man, just and slow to anger. Civilization would be just a racket if we had to learn the lives of its great men from their official biographers and their paid agents. And if infallibility must be proved by suppressing all the arguments against it, any pope who tries this, even if he succeeds, has by that very action relinquished the point.

Mr. Koussevitzky is not the only first-class conductor the Boston Symphony Orchestra has enjoyed. Nor does he any longer play the double bass in public, though when he did he was, by common consent, world champion. His unique position in a world full of excellent conductors, many of them devoted to contemporary music, is that he has played more of it, launched more of it, published more of it, and paid for more of it than anybody else living. That is the clear message of Mr. Smith's biography. Everything else — a petulant gesture here and there, a musical or family quarrel, a pretentious remark, a vainglorious interview, the present court action — all serve the picture; they bring him more vividly to life. How can anyone mind knowing them? Only he himself, apparently,

hasting fearfully toward Parnassus, though his throne there has long been reserved, and involved, no doubt, in a publicity apotheosis that has already begun, would see any value in posing before an already worshiping universe without the customary habiliment of one human weakness. His lawsuit, of course, adds to the tableau that he has essayed to compose so carefully just that.

FEBRUARY 23, 1947

New and Good

✧ ROGER SESSIONS, whose Piano Sonata No. 2 was played last night by Andor Foldes in a League of Composers concert at the Museum of Modern Art, is, in spite of considerable renown as a talked-about composer and a long history of success as a pedagogue, little known through his music. His production is small; and the few works available are seldom performed, because they are difficult to play and not easy to listen to. They are learned, laborious, complex, and withal not strikingly original. They pass for professors' music, and the term is not wholly unjustified. Because the complexity and elaboration of their manner is out of all proportion to the matter expressed. Nevertheless, they are impressive both for the seriousness of their thought and for the ingenuity of their workmanship. They are hard to take and even harder to reject. They represent the most embarrassing problem in American music, because though they unquestionably have quality, they just as certainly have almost no charm at all. And we have no place in our vast system of musical distribution for music without charm.

The piano sonata played last night by Andor Foldes (and dedicated to him) is Mr. Sessions's second. The first dates from nearly twenty years back. Like the first, it is composed in a dissonant tonal style. Unlike the first, it is in melodic idiom largely chromatic. Like all of this composer's music, it bears no clear marks of its national or local origins. It could have been written anywhere in the world — in Leningrad, Shanghai, Paris, Buenos Aires, Vienna, Rome, or Melbourne — as easily as in Berkeley, California, where it actually was composed, and by a man of any race and clime as easily as by a one-hundred-percent New Englander. Its speech represents the international neo-Classic style at its most complete and eclectic, though the feelings expressed in the work are derived from the violence-and-meditation contrast beloved of the German late Romantics.

It is not music of direct melodic or harmonic appeal for the uninitiated; nor has it great stimulus value for modernists, who have already heard elsewhere practically everything in it. All the same, it is interesting to listen to, because it is wonderfully, thoroughly sophisticated. The slow movement, moreover, is almost atmospheric. Operating in a small range

of pitch, with little variety of rhythm and, for once, no great variety of musical device employed, Sessions has achieved here a completely absorbing tranquillity. The work is not likely to be popular, I should think, either soon or ever. But it is not a negligible composition, and Roger Sessions has reminded us through it that his very existence as a musician is a far-from-negligible contribution to the history of music in America.

MARCH 17, 1947

"La Môme" Piaf

 THE PRESENCE among us of Edith ("la Môme") Piaf, currently singing at the Playhouse, is a reminder, and a very pleasant one, that the French *chanson* is an art form as traditional as the concert song. It has a glorious history and a repertory. Its dead authors and composers have streets named after them. Its living ones, just like the writers of operas, symphonies, and oratorios, enjoy a prestige that is not expressed in their income level. Its interpreters are artists in the highest sense of the term, easily distinguishable in this regard from the stars of commercialized entertainment.

If the official art music of our time expresses largely the life and ideals of the bourgeoisie and penetrates to the basic strata of society *from above*, the *chanson* is almost wholly occupied with depicting contemporary life from the viewpoint of the underprivileged and comes to us *from below*. The habitats of the official style are dressy places with a sanctimonious air about them. The *chanson* lives in neighborhood music halls, as the French call them, or what we refer to, using a French term, as vaudeville houses. The *chanson* has nothing to do with farm life, either. Farm workers, unless they are itinerants who spend their winters in town, sing, when they sing at all, an older repertory, that which we denominate folklore. The *chanson* is a musical art form of the urban proletariat.

Its social origins and preoccupations are expressed not only in the words of the songs but also, in performance, by a vocal style opposed in method to that of the vocal studios. The latter consider high notes their greatest glory and make every effort, in training the voice, to spread the quality of these downward through the middle and chest ranges. The *chansonniers* use principally chest resonances, carrying these as high in the vocal range as possible and avoiding pure head tone as rigorously as singers of the official school avoid an unmixed chest tone. Head tone is used, if at all, for comic or character effects, to represent the voices of children, of the not very bright, and of the socially hoity-toity.

Miss Piaf represents the art of the *chansonnière* at its most classical. The vocalism is styled and powerful; her diction is clarity itself; her phrasing and gestures are of the simplest. Save for a slight tendency to

overuse the full arm swing with index finger pointed, she has literally no personal mannerisms. She stands in the middle of a bare stage in the classic black dress of medium length, her hair dyed red and tousled, as is equally classical (Yvette Guilbert, Polaire, and Damia all wore it so), her feet planted about six inches apart; and she never moves, except for the arms. Even with these her gestures are sparing, and she uses them as much for abstractly rhetorical as for directly expressive purposes.

There is apparently not a nerve in her body. Neither is there any pretense of relaxation. She is not tense but intense, in no way spontaneous, just thoroughly concentrated and impersonal. Her power of dramatic projection is tremendous. She is a great technician because her methods are of the simplest. She is a great artist because she gives you a clear vision of the scene or subject she is depicting with a minimum injection of personality. Such a concentration at once of professional authority and of personal modesty is no end impressive.

If Miss Piaf had not impressed me so deeply with the authenticity of her repertory and her convictions about its rendering, I should have used my column today for praising Les Compagnons de la Chanson, a male chorus of nine singers who precede her on the program. They sing folksongs to the accompaniment of athletic pantomime with a perfection of drill, vocal and muscular, that is both side-splitting and utterly charming. If anybody wants to find a political reference in their song about a bear that terrified the village but became, when legally elected, as good a mayor as his predecessor, I presume such an interpretation could be discovered without too much effort, since otherwise the number has little point. Their imitation of an American radio quartet accompanied by a swing band, however, needs no further point than its excellent satire. Their work in every number is funny and unusually imaginative. "La Môme," or "Pal" Piaf, to translate her cognomen, may be strong meat, artistically speaking, for American theater audiences, but Les Compagnons are the sort of act we can take without any effort at all.

NOVEMBER 9, 1947

Lively Revival

∾ MARC BLITZSTEIN's *The Cradle Will Rock,* which was performed last night at the City Center under Leonard Bernstein's direction, remains, ten years after its first New York success, one of the most charming creations of the American musical theater. It has sweetness, a cutting wit, inexhaustible fancy, and faith. One would have to be untouchable (and who is?) by the aspirations of union labor to resist it. Last night's audience did not. No audience I have ever seen, in fact, ever has.

It was inevitable that the piece (call it, if you will, an opera, a musical comedy, or a play with music) should be revived; and it is a sound idea

to revive it just now. In a year when the Left in general, and the labor movement in particular, is under attack, it is important that the Left should put its best foot forward. There is no question, moreover, but that the Left's best foot is its Left foot. In the opinion of this reviewer, Mr. Blitzstein's *Cradle* is the gayest and the most absorbing piece of musical theater that America's Left has inspired. Long may it prosper; long may it remind us that union cards can be as touchy a point of honor as marriage certificates.

The Cradle is a fairy tale, with villains and a hero. Like all fairy tales, it is perfectly true. It is true because it makes you believe it. If the standard Broadway musical plugs what Thurman Arnold called "the folklore of capitalism," this play with (or "in") music recites with passion and piety the mythology of the labor movement. It is not a reflective or a realistic work. There is not one original thought or actual observation in it. Everybody is a type, symbolizes something, and the whole is a morality play. Its power is due in large part to the freshness, in terms of current entertainment repertory, of the morality that it expounds. That morality is a prophetic and confident faith in trade unionism as a dignifying force.

An equally large part of its power comes from its author's talent for musical caricature. He makes fun of his characters from beginning to end by musical means. Sometimes his fun is tender, as in the love duet of the Polish couple; and sometimes it is mean, as in the songs of Junior and Sister Mister. But always there is a particular musical style to characterize each person or scene; and always that style is aptly chosen, pungently taken off. The work has literary imperfections but musically not one fault of style.

Its presentation last night followed the style of its 1937 production, save for the substitution of Mr. Bernstein at a small orchestra in place of Mr. Blitzstein at a small piano. As before, there were costumes but no scenery. As before, the system of presentation was completely effective, though the orchestra added little musically. The cast was fair, some of it excellent, notably Will Geer and Howard da Silva, who had sung Mr. Mister and Larry Foreman in the original performances. Others were less than ideal, but that made little difference. The work is a tough one and hard to spoil.

NOVEMBER 25, 1947

Maurice Ravel

∾ TEN YEARS AGO next month, December 28, 1937, Maurice Ravel died. He was not old, only sixty-two. Many people living knew him well. I knew him myself a little. He was cultivated, charming, companionable, neither timid nor bold, in no way difficult. That is why he is not today,

nor was he during his lifetime, a misunderstood man or a misunderstood composer. For all its complexity of texture, wealth of invention, and technical originality, his work presents fewer difficulties of comprehension than that of any of the other great figures of the modern movement. Satie, Debussy, Schönberg, Webern, Stravinsky all remain, in many facets of their expression, hermetic. Ravel has never been obscure, even to the plain public. His early work produced a shock, but only the shock of complete clarity. Anybody could dislike it or turn his back, still can. Nobody could fail, nobody ever has failed to perceive at first sight what it is all about.

What it is all about is a nonromantic view of life. Not an antiromantic view, simply a nonromantic one, as if the nineteenth century had never, save for its technical discoveries, existed. All the other modernists were children of Romanticism — worshipful children, like Schönberg, or children in revolt, like Stravinsky, or children torn, like Debussy, between atavism and an imperious passion for independence. Even Satie felt obliged to poke fun at the Romantics from time to time. But for Ravel there was no such temptation, no Romantic problem. When twentieth-century models failed him he had recourse to eighteenth-century ones. And he used these not at all to prove any point against the nineteenth century, but simply because they were the most natural thing in the world for him to be using. Couperin, Rameau, and Haydn were as close to him as Chabrier and Fauré, his immediate masters.

Maurice Ravel was not interested in posing as a prophet, as a poet, or as a writer of editorials. He was no sybil, no saint, no oracle nor sacred pythoness. He was simply a skilled workman who enjoyed his work. In religion a skeptic, in love a bachelor, in social life a semirecluse, a suburbanite, he was not in any of these aspects a disappointed man. He was jolly, generous, a wit, a devoted friend, and as much of a *viveur* as his none-too-solid health and his temperate tastes permitted. His was an adult mind and a good mind, tender, ironic, cultivated, sharply observant. He was kind but not foolish, humane but not sentimental, easygoing but neither self-indulgent nor lazy. There was acid in him but no bile; and he used his acid as a workman does, for etching.

He considered art, and said so, to be, at its best, artifice, and the artist an artisan. For all the clarity that his music embodies, its crystalline lucidity in every phrase, it probably expresses less of personal sentiment than any of the other major music of our century. He worked in the free impressionist style, in the straight dance forms, in the classic molds of chamber music, and for the lyric stage. His masterpiece is a ballet. Always he worked objectively, with the modesty of an architect or a jeweler, but with the assurance of a good architect or a good jeweler. He was equally master of the miniature and of the grander layouts. At no necessary point does his expression lack either subtlety or magnitude. It lacks

nothing, as a matter of fact, except those qualities that are equally lacking, for instance, in La Fontaine and in Montaigne, namely, animal warmth, mysticism, and the darker aspects of spirituality.

Ravel was a classical composer, because his music presents a straightforward view of life in clear and durable form. The straightforwardness and the clarity are, I think, obvious. The durability will be no less so if you consider the hard usage that *La Valse, Daphnis et Chloë* (at least the Second Suite from it), the Bolero, the *Pavane for a Dead Princess*, the Piano Sonatina, and *Scarbo*, a pianists' war-horse, have been put through already. I call them durable because they stand up under usage. And they stand up under usage because they are well made. They are well made because they are clearly conceived and executed by an objective and responsible hand. The hand is objective and responsible in the way that it is because it is a French hand, one that inherits the oldest unbroken tradition in Europe of objective and responsible artisanry.

Ravel's music represents, even more than does that of Debussy, who was more deeply touched than he by both the Slavic and the Germanic impulses toward a spiritualization of the emotional life, the classic ideal that is every Frenchman's dream and every foreigner's dream of France. It is the dream of an equilibrium in which sentiment, sensuality, and the intelligence are united at their highest intensity through the operations of a moral quality. That moral quality, in Ravel's case, and indeed in the case of any first-class artist, is loyalty, a loyalty to classic standards of workmanship, though such loyalty obliges its holder to no observance whatsoever of classical methods. It is an assumption of the twin privileges, freedom and responsibility. The success that Ravel's music has known round the world is based, I am convinced, on its moral integrity. It has charm, wit, and no little malice. It also has a sweetness and a plain humanity about it that are touching. Add to these qualities the honesty of precise workmanship, and you have a product, an artifact, as Bernard Berenson would call it, that is irresistible.

France has for centuries produced this kind of art work and, for all the trials of the flesh and of the spirit that she is suffering just now, is continuing to produce it. Rosenthal, Sauguet, Poulenc, Jolivet, Barraud, Rivier, and the dodecaphonic young, these and dozens more have vowed their lives to sincerity of expression and to high standards of workmanship. The music of Milhaud and Messiaen has even grander aspirations. But all French composers, whether they care to admit it or not, are in debt to Ravel. It was he, not Gounod nor Bizet nor Saint-Saëns nor Massenet, nor yet César Franck nor Debussy, who gave to France its contemporary model of the composer. That model is the man of simple life who is at once an intellectual by his tastes and an artisan by his training and by his practice. He is not a bourgeois nor a white-collar proletarian nor a columnist nor a priest nor a publicized celebrity nor a job-

holder nor a political propagandist, but simply and plainly, proudly and responsibly, a skilled workman. Long may the model survive!

NOVEMBER 30, 1947

1948

On Being American

◆ WHAT IS an American composer? The Music Critics' Circle of New York City says it is any musical author of American citizenship. This group, however, and also the Pulitzer Prize Committee, finds itself troubled about people like Stravinsky, Schönberg, and Hindemith. Can these composers be called American, whose styles were formed in Europe and whose most recent work, if it shows any influence of American ways, shows this certainly in no direction that could possibly be called nationalistic? Any award committee would think a second time before handing these men a certificate, as Americans, for musical excellence. The American section of the International Society for Contemporary Music has more than once been reproached in Europe for allowing the United States to be represented at international festivals of the society by composers of wholly European style and formation, such as Ernest Bloch and Ernst Krenek. And yet a transfer of citizenship cannot with justice be held to exclude any artist from the intellectual privileges of the country that has, both parties consenting, adopted him, no matter what kind of music he writes.

Neither can obvious localisms of style be demanded of any composer, native-born or naturalized. If Schönberg, who writes in an ultrachromatic and even atonal syntax and who practically never uses folk material, even that of his native Austria, is to be excluded by that fact from the ranks of American composers, then we must exclude along with him that stalwart Vermonter, Carl Ruggles, who speaks a not dissimilar musical language. And among the native-born young, Harold Shapero and Arthur Berger are no more American for writing in the international neoclassic manner (fountainhead Stravinsky) than Lou Harrison and Merton Brown are, who employ the international chromatic techniques (fountainhead Schönberg). All these gifted young writers of music are American composers, though none employs a nationalistic trademark.

The fact is, of course, that citizens of the United States write music in every known style. From the post-Romantic eclecticism of Howard Hanson and the post-Romantic expressionism of Bernard Rogers through the neoclassicized impressionism of Edward Burlingame Hill and John Alden Carpenter, the strictly Parisian neoclassicism of Walter Piston, the romanticized neoclassicism of Roy Harris and William Schuman, the elegant

neo-Romanticism of Samuel Barber, the sentimental neo-Romanticism of David Diamond, the folksy neo-Romanticism of Douglas Moore, Randall Thompson, and Henry Cowell, the Germano-eclectic modernism of Roger Sessions, the neoprimitive polytonalism of Charles Ives, and the ecstatic chromaticism of Carl Ruggles, to the percussive and rhythmic research fellows Edgard Varèse and John Cage, we have everything. We have also the world-famous European atonalists Schönberg and Křenek, the neoclassic masters Stravinsky and Hindemith. We have, moreover, a national glory in the form of Aaron Copland, who so skillfully combines, in the Bartók manner, folk feeling with neoclassic techniques that foreigners often fail to recognize his music as American at all.

All this music is American, nevertheless, because it is made by Americans. If it has characteristic traits that can be identified as belonging to this continent only, our composers are largely unconscious of them. These are shared, moreover, by composers of all the schools and probably by our South American neighbors. Two devices typical of American practice (I have written about these before) are the nonaccelerating crescendo and a steady ground rhythm of equalized eighth notes (expressed or not). Neither of these devices is known to Europeans, though practically all Americans take them for granted. Further study of American music may reveal other characteristics. But there can never be any justice in demanding their presence as a proof of musical Americanism. Any American has the right to write music in any way he wishes or is able to do. If the American school is beginning to be visible to Europeans as something not entirely provincial with regard to Vienna and Paris, something new, fresh, real, and a little strange, none of this novel quality is a monopoly, or even a specialty, of any group among us. It is not limited to the native born or to the German trained or to the French influenced or to the self-taught or to the New York–resident or to the California bred. It is in the air and belongs to us all. It is a set of basic assumptions so common that everybody takes them for granted. This is why, though there is no dominant style in American music, there is, viewed from afar (say from Europe), an American school.

National feelings and local patriotisms are as sound sources of inspiration as any other. They are not, however, any nobler than any other. At best they are merely the stated or obvious subject of a piece. Music that has life in it always goes deeper than its stated subject or than what its author thought about while writing it. Nobody becomes an American composer by thinking about America while composing. If that were true Georges Auric's charming fox-trot *Adieu New York* would be American music and not French music, and *The Road to Mandalay* would be Burmese. The way to write American music is simple. All you have to do is to be an American and then write any kind of music you wish. There is precedent and model here for all the kinds. And any Americanism worth

bothering about is everybody's property anyway. Leave it in the unconscious; let nature speak.

Nevertheless, the award-giving committees do have a problem on their hands. I suggest they just hedge and compromise for a while. That, after all, is a way of being American, too.

JANUARY 25, 1948

The Problem of Sincerity

∾ IF ART is a form of communication, and music the form of art best suited to the communication of sentiments, feelings, emotions, it does seem strange that the clear communication of these should be beset with so many difficulties. Perfection of the technical amenities, or at least an approach to that, is more commonly to be met with in the concert hall than is a convincing interpretation of anything. They play and sing so prettily, these recitalists, work so hard and so loyally to get the notes of the music right that it is a matter of constant astonishment to me how few of them can make it speak.

Composers, too, have trouble communicating, especially American composers. They make you great, big, beautiful, shapely structures; but it is not always clear what purpose, with regard to living, these are intended to fulfill. One has a strange feeling sometimes, right in the middle of a concert season, that the music world, both the composers and their executants, are just a swarm of busy ants, accomplishing nothing to human eyes but carrying grains of sand back and forth. How much useful work anybody is doing, of course, is hard to know. But seldom, oh, so seldom, does a musical action of any kind speak clearly, simply, without detours.

Part of this inefficiency comes, I am sure, from the prestige of Romantic attitudes in an unromantic age. From the violinist in a Russian restaurant who hopes to be tipped for pushing his fiddle into your shashlik to the concert pianist who moons over the keys or slaps at them in a seeming fury, all are faking. They are counterfeiting transports that they do not have and that in nine cases out of ten are not even the subject of the music. For music of passionate and personal expressivity is a small part indeed of standard repertory. There is a little of it, though very little, in Mozart, a bit more in Beethoven, some in Mendelssohn, a great deal in Schumann and Chopin, less in Brahms, and then practically no more at all till you get to Bartók. Its presence in Bruckner and Mahler, though certain, is obscured by monumental preoccupations. Berlioz, Liszt and Wagner, Strauss and Schönberg, even Debussy and the modernists operate mostly on a level of complexity that prevents an efficient interpreter from going too wild and the meaning from getting too private. It is not that technical difficulties prevent introversion. But the simple fact

that the subject of most music is evocation obliges both composer and executant to objective procedures.

Music of personal lyricism — Schumann, for instance — can be played or sung without antics and often is. But it cannot be rendered convincingly without personal involvement. This poses the problem of sincerity. You can write or execute music of the most striking evocative power by objective methods, provided you have an active imagination. You can represent other people's emotions, as in the theater, by the same means, plus decorum. But you cannot project a personal sentiment that you do not have. If you fake it knowingly, you are dramatizing that which should be transmitted directly; and if you fake it unknowingly, you are merely, by deceiving yourself, attempting to deceive your audience.

Sincerity is not a requisite for theatrical work, for evocative work, for any music that is, however poetic, objective in character. Taste, intelligence, and temperament are the only requirements. These will enable you to get into any role and out of it again, to perform it perfectly, to communicate through it. They are not sufficient for a proper rendering of Schumann's songs or of the Bartók quartets. These you must feel. What gives to lieder recitals and string quartet concerts their funereal quality, when they don't come off, and their miraculous excitement, when they do, is the absence or presence of authentic feeling in the interpretation.

Any sincerely felt reading must be a personal one. Objective music has, more often than not, traditional readings that are correct. All traditional readings of the music of personalized sentiment are, by definition, incorrect. Because sentiments, feelings, private patterns of anxiety and relief are not subject to standardization. They must be spontaneous to have any existence at all, spontaneous and unique. Naturally, experienced persons can teach the young many things about the personalized repertory. But there is no set way it must be rendered, and any attempt to impose one on it takes the life out of it. The exactly opposite condition obtains regarding objective music. This benefits enormously from exact procedures and standardized renderings, from every thoughtful observance and precision. Personal involvement in it, the injection of sentiment, is a great foolishness.

The whole question of sincerity hangs on a difference between those feelings with which one can become temporarily identified by imagination and those which are one's own and relatively permanent. The former, which make for drama, constitute nine-tenths of the whole musical repertory and nine-tenths of any mature composer's available subject matter. Mixing the two kinds gets nobody anywhere. Treating personal music objectively gives a pedantic effect. Treating objective music personally gives a futile effect. Nevertheless, on account of the prestige that historical Romanticism enjoys, the latter procedure dominates our concert halls. All over America artists are endeavoring to treat the repertory, the

vast body of which is objective music, and composers are treating the monumental forms too, as if their personal fantasies about these were a form of communication. On the other hand, more often than not they treat personal music to a routined and traditional streamlining that prevents it altogether from speaking that language of the heart that is speech at all only when it comes from the heart. They should leave the stuff alone unless they are capable of spontaneity. Once rid of their romantic pretenses too, they would certainly do better with the rest of the repertory. For composers the urgency is even greater. Let them do theater and evocations to their hearts' content. But in the domain of private feelings, fooling around with those one does not have is suicidal.

FEBRUARY 8, 1948

Success Tactics

∾ BENJAMIN BRITTEN's *Peter Grimes*, which was added last night to the repertory of our Metropolitan Opera, is a success. It always is. Given in any language in a house of no matter what size, it always holds the attention of an audience. As given last night "the works," so to speak, which is to say, the full mechanism, musical and scenic, of a mammoth production establishment, it still held the attention.

This is not to minimize the excellences of the present production, which are many, or the care that has gone into it, which is considerable. It is merely to point out that the steamroller processing that our beloved Met, geared to Wagner, puts any new work through is one of the severest known tests for the strength of theatrical materials. If Mr. Britten's work came out scarcely in English, vocally loud from beginning to end, and decorated in a manner both ugly and hopelessly anachronistic, it also came through the ordeal with its music still alive and its human drama still touching.

Make no mistake about *Peter Grimes*. It is varied, interesting, and solidly put together. It works. It is not a piece of any unusual flavor or distinction. It adds nothing to the history of the stage or to the history of music. But it is a rattling good repertory melodrama. And if the executant artists, beginning with Emil Cooper, who conducted, going on through Frederick Jagel and Regina Resnik, who sang the tenor and soprano leads, to the smallest role in a large cast and even including the chorus, treated the work with no consideration for its special or poetic subject matter, but rather as disembodied, or "pure," theater, just "wow" material, that is exactly what the composer himself has done, what his score invites and asks for.

There is everything in it to make an opera pleasing and effective. There is a trial scene, a boat, a church (with organ music), a pub (with drinking song for the full ensemble), a storm, a nightclub seen through a window

(with boogie-woogie music off stage and shadow play), a scene of flagellation, a mad scene, and a death. There are set pieces galore, all different, all musically imaginative, and mostly fun. And there are a good half dozen intermezzos, most of which are musically pretty weak but expressive all the same.

The musical structure of the opera is simple and efficient. Everything and everybody has a motif, a tune or turn of phrase that identifies. The entire orchestral structure, and most of the vocal, is pieced together out of these in the manner of Italian *verismo*. The harmony is a series of pedal points broadly laid out to hold together the bits-and-pieces motif continuity. There is no pretense of musical development through these motifs, as in Wagner. They are merely identification tags. The music is wholly objective and calculated for easy effect. That is why it works.

It works even in spite of its none-too-happy handling of English vowel quantities. It sacrifices these systematically, in fact, to characteristic melodic turns, as if the composer had counted from the beginning on translation. A good part of the obscurity that was characteristic of last night's diction, in spite of the singers' visible efforts to project sung speech, was due to the deliberate falsity of the prosodic line. Mr. Britten is apparently no more bothered about such niceties than he is by the anachronisms of an almost popishly High Church service in an English fishing village of 1830 and an American jazz band in the same time and place. He has gone out for theatrical effects, got them, got his success. So did the Metropolitan. And still *Peter Grimes* is not a bore.

FEBRUARY 13, 1948

Composers in Trouble

THE RUSSIANS are at it again. First there appears in the left-hand column of *Pravda*'s front page a criticism of the nation's leading composers. They are charged with "formalistic" tendencies, with being influenced by the "decadent" West, with neglect of Russia's "classical" tradition, with failure to maintain the ideals of "socialist realism" and to ennoble as they ought the Russian people. Next the Central Committee of the Communist Party issues a formal denunciation by name and in detail. Next the offending works are removed from the theaters, the symphony concerts, and the radio. Then the composers under attack write open letters to *Pravda* and to the Central Committee thanking them for the spanking, confessing all, and expressing full intention, with the kind advice of the Committee, to reform. After that there is nothing for them to do but "purify" their music, to write new works that will hopefully be in accord with that "new look" that has been the stated ideal of Soviet musicians (and their political leaders) for the last twenty years. Then in a reasonable time they will mostly be back in favor.

For a Soviet composer there is no other solution. Publication and performance being a monopoly of the state, he cannot, nor can any group of composers, operate as a minority appealing to public opinion for justification. Never forget that in Soviet art there is no underground, no unofficial movement, nor, for the present, any possibility of one. This being so, and all observers agree that it is, let us examine, from previous occasions, what is likely to happen to Prokofiev, Shostakovich, Khachaturian, and company while they remain out of favor.

While Shostakovich was being disciplined in 1936 and 1937 for the "bourgeois" tendencies that Stalin himself had noticed in *Lady Macbeth of Mzensk*, his works intended for wide consumption were not performed or sold. His chamber music, however, continued to be played and printed; he continued to write it with no alteration of style; and he went on receiving a salary from the Composers' Union. He lived in Moscow, as before, got married, went on working. He was poor and unhappy, drank heavily, we are told by people who visited him; but he was not destitute. He also wrote during this time two symphonies, both of which were rehearsed and performed privately, the last of them only, however, his Fifth, being accepted for public audition. That he had lost no popularity in the meantime was proved by the enormous lines that for three weeks before it was given stood to get seats for the new symphony.

In the case of the literary purge that has been going on since 1936, the majority of those being disciplined have lived in about the same circumstances as Shostakovich had done ten years earlier. Graver cases, however, especially those involving political disaffection or extreme and recalcitrant individualism, have received graver sanctions. Zoschenko, Pasternak, and Akhmatova, for example, were expelled from the Writers' Union. This meant a cutting off of their income and the loss of priority on a Moscow apartment. Until ration cards were abolished it meant also the loss of access to a reasonably nourishing diet. I have not heard of a verified case of a mere writer being sent recently to the Siberian salt mines, as was done with political offenders in the mid-1930s. Expulsion from the Writers' Union (or the Composers' Union) remains, however, a grave form of excommunication, not only for its moral stigma and for the virtual exile from intellectual company but also for the great physical dangers entailed. It has not yet been employed against any of the composers recently denounced.

Whether Shostakovich and Shebalin, professors at the Moscow Conservatory, will be temporarily retired from their posts I cannot say, though it is rumored that they have already left. Certainly Kharapchenko, the director, has lately been discharged. And it seems likely that Khachaturian, president of the Composers' Union, may find it difficult to remain at that post while under a disciplinary cloud.

What have they done, these composers, to provoke denunciation and

disciplinary action? And what moral right has the Central Committee to order their even temporary disgrace? Well, what they have done is to fail, in the judgment of the Party leaders, to conform to the esthetic of Soviet music in its relation to the whole public, as this was laid down by the musicians themselves back in 1929. That conception is, in our terms, certainly a false one; but it is already an old one, and it is certainly nothing imposed from above. The Russian Association of Proletarian Musicians worked on it for five years before they got it stated the way they wanted it. And though the Association itself was dissolved in 1932, the declaration of 1929 remains to this day the basic esthetic of Soviet music, of the proper relation of any Soviet composer to decadent "bourgeois" Western culture and to the rising masses of Russia.

In this conception, a composer is a writer of editorials. He is supposed to elevate, edify, explain, and instruct. He is to speak a language both comprehensible to all and worthy by its dignity of a nationwide public. He is to avoid in technique the overcontrapuntal and the overharmonic, in expression the abstract, the tricky, the mystical, the mechanical, the erotic. He is to turn his back on the West and make Russian music for Russia, for all of Russia, and for nothing beyond. His consecration to this aim is to be aided and reinforced by public criticism, as well as by the private counsels of his colleagues. Judgment as to the accomplishment of the aim is not, however, his privilege nor that of his critics. That belongs to the Communist Party, which has the responsibility for leadership and guidance in artistic as in all other matters. The composers, in other words, have determined their own ideal and accepted, along with the ideals and forms of the society in which they live and work and which they have helped toward the achievement of its present internal solidity, the principle that the professional body alone, and still less the listening public, is not the final judge of music's right to survive.

This idea is not in accord with our Western concept of the integrity of the professions. Nevertheless, it is that of the Soviet government and of all, so far as we know, Soviet musicians. The hasty *mea culpa* of the Soviet artist in trouble with the Central Committee shocks the Western mind, but I see no reason to doubt its sincerity. Seven of the boys are in a jam right now, and I suspect most of them will get out of it. I sincerely hope they will, because they are good composers and because I like to see good composers writing and getting played and published. Myself I have never taken much stock in Soviet music. I am too individualistic to like the idea of an artist's being always a servant of the same setup, even of so grand a one as a great people organized into a monolithic state. I don't like monolithic states anyway; they remind me of the great slave-owning empires of antiquity.

But my tastes are not involved in the matter. Soviet music is the kind of music that it is because the Soviet composers have formally and long

ago decided to write it that way, because the Communist Party accepts it that way, and because the people apparently take it. When the Party clamps down on it for "deviation," who am I to complain if the composers of it themselves don't? Whether they could do so with any hope of success, of course, is doubtful. All we know from previous occasions is that he who confesses and reforms quickest gets off the lightest. I do not find, given the whole of Russian political and esthetic theory, that the procedure is undignified; and apparently the composers do not find it so, however much they may regret having to submit to the sanctions. It seems likely that they would feel far worse, even if they could survive, excommunicated from the intellectual life and deprived of their forum.

Russians mostly, I imagine, believe in their government and country. Certainly these great, official public figures do. They could not, in a period so severely censored, have become national composers by mere chicanery. That is not what bothers me about them. Nor that they are always getting into trouble from excess of musical fancy. What worries me, and has for twenty years, is that, for all their devotion, noble precepts, faith in their fatherland, and extraordinary privileges, their music, judged by any standard, is no better than it is. I only hope, against all reason and probability, that a similar preoccupation on the part of the Central Committee is at least a little bit responsible for the present disciplinary action. Russian music may or may not need ideological "purification." But it certainly needs improvement.

FEBRUARY 22, 1948

Claude Debussy

✍ THIRTY YEARS AGO last Friday, on March 26, 1918, Claude Debussy died in his fifty-sixth year. Though his three decades of artistic productivity lie on both sides of the century mark, just as Beethoven's did a hundred years earlier, musically he is as clearly a founding father of the twentieth century as Beethoven was of the nineteenth. The history of music in our time, like any other history, is fully to be reviewed only in the light of all its origins and all its roots. Nevertheless, modern music, the full flower of it, the achievement rather than the hope, stems from Debussy. Everybody who wrote before him is just an ancestor and belongs to another time. Debussy belongs to ours.

It is doubtful, indeed, whether Western music has made any notable progress at all since his death. Neoclassicism, the evoking of ancient styles in general and of the early eighteenth-century styles in particular, he invented. Polytonal writing existed before him. Even atonality, if we define this as the consistent employment of contradictory chromatics, is present in his later works, notably in the ballet *Jeux*. No succeeding com-

poser has augmented his dissonant intensity, though some have made a louder noise. Stravinsky's early picturesque works and his later formalistic ones are no more radical in either sound or structure than Debussy's landscape pieces and his sonatas. Schönberg's twelve-tone row, though Debussy never knew about it, is merely a rule of thumb to make atonal writing easy. Expressively it has added nothing to any composer's gamut of sensibility. If, as Busoni believed, one could reconstruct the whole German Classic and Romantic repertory out of Sebastian Bach alone, certainly modern music, all of it, could be rebuilt from the works of Debussy.

What music has lost since Debussy's death is sensitivity of expression and expressivity of instrumentation. Our feelings are more brutal and our statements about them less precise. Similarly, our language of chord dispositions and musical sounds is less competent, less richly evocative than his. We have all gone in for broader, cruder effects. We have had to, because his way of writing was at the end of his life almost unbearably delicate. Refinement could be pushed no further, though Anton Webern tried and succeeded at least in not falling far short of Debussy's mark. But the others could not face going on in that way. Sensibly they turned to easier paths. The fact remains, nevertheless, that Debussy's work is more radical than theirs and, in the ways both of expression and of the use of musical materials to this end, more powerful.

Curiously enough, Debussy's employment of orchestral sound, though commonly described as "colorful," was not so envisaged by him. Variety of coloration is certainly present, and knowingly, in his piano writing. Like that of Schumann and that of Mozart, it is full of the imitation of both orchestral and naturalistic sounds. But he avowed the aim of *Fêtes*, for instance, to be monochromatic, "a musical equivalent of the *grisaille*," which is a watercolor or ink-brush drawing done entirely in grays. The secret here is that Debussy did not, in this piece or in any other, ever, save for the purpose of avoiding them, seriously respect the gamut of orchestral weights. He used the orchestral palette as the impressionist painters used theirs, not for the accenting of particular passages but for the creation of a general luminosity. And the surface tension of his scores in performance is no less equalized than that of a Renoir, a Pissarro, a Monet canvas. Something like this must have been what he meant by comparing them to a *grisaille*.

Debussy's instrumentation, though it is an advance over Berlioz, is derived from the latter's practice, from the use of sound as a purely acoustical phenomenon. He depersonalizes all instruments. His piano writing too, though an advance over Chopin's, is derived from that of the Great One. It is not designed, like that of Liszt, for ease of execution but all for delighting the ear and for making music mean things. His

melody is Massenet purified, plainsong, and memories of popular song. His counterpoint, though rarefied almost to the point of nonexistence, is straight out of Mozart by way of the Paris Conservatoire. Every line communicates. Even his harmony, for all its imaginative quality and its freedom, is made up out of Satie plus a taste for the archaic. Maybe there is just a touch of Moussorgsky, too. But his profound originality lies in his concept of formal structure. Where he got it I do not know. It may have come out of Impressionist painting or Symbolist poetry. Certainly there is small precedent for it in music. It remains, nevertheless, his most radical gift to the art.

This formal pattern is a mosaic texture made up of tiny bits and pieces all fitted in together so tightly that they create a continuity. The structural lines of the composition are not harmonic, not in the bass, but rhythmic and melodic. Debussy freed harmony from its rhetorical function, released it wholly to expression. He gave everything to expression, even structure. He did not sculpt in music or build architectural monuments. He only painted. And no two of his canvases are alike. They are all different and all intensely communicative. The range of their effective expression is the largest our century has known, the largest that music has known since Mozart. Piano music, the song, the violin sonata, the cello, chamber music, the opera, the oratorio, the orchestral concert piece all receive from his hand a new liberty, say things and mean things they had never said or tried to mean before. His power over all the musical usages and occasions comes from his complete disrespect for the musical forms and from his ability to replace these by a genuinely satisfactory free continuity.

That France, classically the land of freedom, should have produced a model of musical freedom is only natural. All the same, Debussy, even for France, is something of a miracle. No composer ever wrote with such absence of cliché, detailed or formal. And few have achieved such precision, such intensity, such a wide range of expression. His music is not only an ultimate, for our century, of sheer beauty. It is a lesson to us all in how to make use of our liberty.

Isidore Philipp, the great piano pedagogue, now in his middle eighties, tells of a visit received in Paris from Béla Bartók, then a young man. He offered to introduce the young Hungarian composer to Camille Saint-Saëns, at that time a terrific celebrity. Bartók declined. Philipp then offered him Charles-Marie Widor. Bartók again declined: "Well, if you won't meet Saint-Saëns and Widor, who is there that you would like to know?" "Debussy," said Bartók. "But he is a horrid man," said Philipp. "He hates everybody and will certainly be rude to you. Do you want to be insulted by Debussy?" "Yes," said Bartók.

MARCH 28, 1948

In Waltz Time

∾ ARNOLD SCHÖNBERG's Five Orchestral Pieces, which Dimitri Mitropoulos conducted at last night's concert of the Philharmonic in Carnegie Hall, were written in 1909, nearly forty years ago. Previously they have been played in New York, I believe, one and three-fifths times. They are among the more celebrated works of our century, and yet few musicians or music lovers have heard them. The present writer, though the owner of a printed orchestral score for twenty-five years, listened to them last night with a virgin ear. Having followed the performance with score in hand, he is able to certify that Mr. Mitropoulos and the Philharmonic boys read them to perfection and faithfully. His opinion of the work is that it deserves every bit of its worldwide prestige and none of its worldwide neglect.

The orchestral sound of the work is derived from French impressionism in general and from the music of Debussy in particular. The orchestra is delicate, coloristic, and clean, at no point emphatic or demagogic. There is not in it one doubling of a note for purposes of weight. Harmonically the work is dissonant and atonal, though there is no twelvetone row in it. Contrapuntally and rhythmically its texture resembles that of the Brahms intermezzi, though it offers a more advanced state of the technique.

That technique tends toward fragmentation of the musical material through rhythmic and contrapuntal device. Schönberg here carries it close to the state of ultimate pulverization that his pupil Anton Webern achieved fifteen years later. Rhythmic contradictions, the gasping, almost fainting utterance of intense emotion in short phrases conventional of curve, the chromatic character of these phrases — all this is out of Brahms, though the harmony is far harsher and the sound of it all, orchestrally, is French.

The expressive character of the Five Pieces is deeply sentimental, in spite of a touch (and more) of irony. Four of the five are in triple time. Composed, as they are, almost wholly of phrases consecrated by Vienna to waltz usage, your reviewer is inclined to consider them a sort of apotheosis of the waltz. He realizes that their waltz structure is no obvious or perhaps even consciously intended communication. All the same, except for the one called "The Changing Chord" (in reality an unchanging one), which is an essay in pure orchestration, he finds them evocative of waltz moods and waltz textures, an etherealization of a theme that is at bottom just good old Vienna. He also suspects that in another decade they may be understood by all as something like that.

The rest of the program was carefully executed, a little dry, perhaps,

but very neat, very pretty as workmanship, and only occasionally a bit loud.

OCTOBER 22, 1948

Contemporary French Music

∾ ERIK SATIE's *Cinéma: Entr'acte,* which opened last night's program at the Juilliard School (the second in a series devoted to contemporary French music), is, in the judgment of this reviewer, the finest film score ever composed. The film itself, made by René Clair after a scenario of Francis Picabia, is a brilliant piece of work but completely, if also delightfully, a period piece. Produced in 1924 as a divertissement joining two scenes of a ballet, *Relâche* (composed by Satie and decorated by Picabia), it takes us back to the still innocent last days of Dada, before surrealism had turned our fantasies sour, sexy, and mean. It is not about anything at all but being young and in Paris and loving to laugh, especially at funerals. In those days there was still comic cinema too.

The excellence of the musical score composed to accompany with real orchestral sounds this otherwise silent film (these were played last night by two pianists) is due to Satie's having understood correctly the limitations and possibilities of a photographic narrative as subject matter for music. Also to the durable nature of his musical invention. The whole is made out of short musical bits like building blocks. These are neutral enough in character to accompany appropriately many different scenes and images, but also interesting enough as music to bear a great deal of repetition without fatiguing the listener. These minute musical blocks are organized into a sort of rondo form, as squarely terraced as a New York skyscraper and every bit as functional.

Satie's music for *Entr'acte,* consequently, is not only beautiful in itself. It is also efficient; it is appropriate to the film. It avoids banality of sentiment not by avoiding sentiment but by keeping its expressivity objective, by never becoming subjective, never identifying itself with any person on the screen. By remaining ever as cool and clear as René Clair's photography itself, it remains also as clear in meaning and as satisfying intrinsically. I do not know another film score so durable, so distinguished, so complete.

Francis Poulenc's secular cantata *Le Bal Masqué,* on poems of the late Max Jacob, a piece in six sections for baritone and chamber orchestra, shows us a master of musical exuberance at the climax of his youthful period. It was composed in 1932, about the last year anybody in Europe was really carefree, and it is musical high jinks from beginning to end. Its pasticcio of urban banalities, melodic and rhythmic, is rendered interesting by the extreme elegance of the vocal lines and of the instrumental textures. Thin, clean, brilliant, frank, and delicate, its charm, its good

humor, its wit and poetry, like those of Satie himself (though the invention is less jewel-like than Satie's), is as fresh as the day the piece was written.

DECEMBER 2, 1948

1949

Prince of Impressionism

℘ CRIES OF "Bravo!" sounded in Carnegie Hall last night as Ernest Ansermet, conducting the Philadelphia Orchestra, brought to a close the final dazzling pages of Debussy's *La Mer*. The whole concert had been dazzling, indeed, and not through any playing of tricks on audience psychology or any of the grosser forms of tonal appeal. The great Swiss conductor had held us all enthralled, as he had the orchestra itself, by sheer musicianship, by knowledge, by understanding, by a care for aural beauty and for exactitude.

In appearance a simple professor, touched up perhaps toward both Agamemnon and the King of Clubs, he is at once a sage, a captain, and a prince. With wisdom, firmness, and grace he rules his domain; and that domain is the music of impressionism. For other leaders the center of the world may be Beethoven or Brahms or Wagner. For him it is the music of Debussy and all that borders thereon. No one living, not even Monteux, can command him in that repertory. Smooth as a seashell, iridescent as fine rain, bright as the taste of a peach are the blends and balances of orchestral sound with which he renders, remembering, the lines, the backgrounds, and the tonal images of the great tonal painters who worked in France round the turn of our century.

Mozart he plays with love and with light too; and he began last night with the "Prague" Symphony, just to show us how a classical rendering can be clean and thoroughly musical without being dry or overcrisp. The Philadelphia players found his company on that ground a privilege and gave of their best, which is the world's best. But it was only royalty on a visit. With Stravinsky, Fauré, and Debussy the king was back in his land, in his own house reigning, informed, understanding, understood, obeyed from a glance.

Stravinsky's *Song of the Nightingale*, arranged from an earlier opera score and reorchestrated into a symphonic poem in 1919, may well represent this composer at his highest mastery of instrumental evocation. Musically, nevertheless, the work is weak from lack of thematic integration and harmonic structure. It gives pleasure as sound, page by page, palls as musical continuity in the concert room. It needs to be played from time

to time because it is a work of the most striking fancy, but heaven preserve us from it as a repertory piece.

Fauré's *Pelléas et Mélisande* suite, on the other hand, is a work of deep loveliness that could stand more usage in repertory than it gets these days. When played with such sweet harmoniousness and such grace of line as it was last night, one wonders why one had forgotten how touching it can be.

Debussy's *La Mer* brought the wonders of the evening to a radiant close. It is a piece this reviewer has always found a shade disappointing; but it is a popular repertory work; and if one has to hear it, Ansermet's reading of it is more welcome than most. Actually, while listening to it, this unfriendly witness forgot all about his prejudices and enjoyed himself thoroughly, almost as thoroughly as during the Mozart and the Fauré.

JANUARY 19, 1949

Specialty of the House

 RICHARD WAGNER's *Twilight of the Gods*, as performed on Wednesday night at the Metropolitan Opera House, lasted from half-past-seven till five minutes of twelve (a saving of five minutes on the normal run); and there was not, for this listener, a dull moment in the second half. The first act and a half were talky, save for two fine orchestral interludes. Dramatically and musically the script just will not move along. But beginning about the middle of the second act, with the entrance of the male chorus, the stage takes on animation, ensemble singing adds brilliance to the musical effect, and the whole work grows in grandeur until the final curtain falls. A wealth of musical thought and an opulent elaboration of musical textures pile up for two hours, till it is impossible, given a reasonably good musical rendering, to leave the theater without some feeling of fullness, of fulfillment.

Wednesday's rendering was, moreover, far better than reasonably good. It was first-class clean through, thoroughly grand and wonderful. The orchestral direction of Fritz Stiedry, the singing of Helen Traubel, Set Svanholm, and Dezso Ernster, were what anybody could know for memorable. Refinement, power, and beauty marked the reading in all its leading roles; dignity and musicianship in the secondary ones gave shape to the whole. Even the stage movement, deliberately static and statuesque, was executed with decorum. And the scenery, new last year, is still, along with the costumes that go with it, an integrated design and reasonably clean.

It becomes increasingly evident to this observer that Wagner's works are the branch of repertory to which the Met, in the present decade, is best adapted. The German-language singers available there are far supe-

rior to those whose preparation has destined them chiefly for Italian-, French-, or English-language work. So are the present staff conductors. And eminently suitable is the size of the house and stage. Wagner fills the place with resonance and visibility. Big sounds, big scenic effects, fires, mountains, vast sunsets, demolitions, and characters whose emotions and conflicts are as huge and as impersonal as those of any leviathan — all are at home in that house and becoming to it.

Set Svanholm's slender figure is of no help to Wagner, though his handsome singing is. Wagner's music dramas are conceived for a theater of whales. These move slowly, relentlessly, on an epic scale, require space, offer sounds of infinite power and complexity to fill up that space. At the Met, they and the house are of a proportion. Italian opera has never since Caruso's death been loud enough for it, and French opera never has been loud like that at any time.

The management and executants, moreover, seem to take Wagner for music's central figure. They work more carefully for him, more confidently, and with more dignity, project a sense of having studied everything more thoroughly than is apparent in the rest of the repertory. Occasionally another composer gets a fair deal; but Wagner always gets the best of everything — the best playing, the best singing, the best scenery, the best direction and lighting, the most impressive effects of every kind. It is as if only he were worthy the deployment of so vast a machine. The contrast between these works and the rest of opera, as given year after year in that house, is striking and revelatory. Not of Wagner's musical primacy, however. Mozart remains a greater composer and Verdi just possibly an equal. But it does show us what the Met, its whole setup and management, are good for. Good *for* because good *at*.

JANUARY 21, 1949

Russians Recover

❦ DMITRI SHOSTAKOVICH, the most popular of living Russian composers, inside the Soviet Union or out, has apparently been reinstated in the favor of the Politburo. A year ago he had been removed from that favor, along with five other well-known composers — Prokofiev, Khachaturian, Miaskovsky, Shebalin, and Popov. He had also been removed, along with some of these others, from public office. Shostakovich and Miaskovsky ceased to teach composition at the Moscow Conservatory. Shebalin was replaced as head of that institution by A. Sveshnikov, a choral conductor. Khachaturian lost to Tikhon Khrennikov the position of secretary general of the Union of Soviet Composers. He also ceased to be head of its Orgkomitet, or organizing committee. This group, working in close collaboration with the Committee on Arts of the Ministry of

Education, has huge power, since it decides what works will be printed and recommends works for performance to opera houses, symphony orchestras, and touring virtuosos.

Prokofiev, who did not teach or hold any official post, was ostracized by the simple means of removing nearly all his works from the opera and concert repertories. The same measure was applied, of course, to the other purged composers, but less drastically. Shostakovich's First and Fifth symphonies, Miaskovsky's Symphony on White-Russian Themes, Khachaturian's Cello Concerto, and divers other pieces by the denounced "formalists" have gone right on being played, at least occasionally, since the purge.

Last year's offense, let us recall, was not the first for Shostakovich. Back in 1936 he had been subjected to disciplinary measures of a similar nature lasting a year and a half. His chief offense had been the opera *Lady Macbeth of Mzensk* and his work of restitution the Fifth Symphony. This time the troublesome piece was his Ninth Symphony; and his comeback has been accomplished through two film scores, *The Young Guard* and *Michurin*. The first of these is a heroic and optimistic melodrama about the exploits of the Komsomol during the defense of the Don Basin. The other is a biography (in color) of a Soviet hero, I. V. Michurin, founder of Soviet anti-Mendelian biology. Though neither film has yet reached the Stanky Theater, they have passed the musical judges; and two musical excerpts from *The Young Guard* have been printed in *Sovietskaya Muzyka* of October 1948.

The cases of Khachaturian and Shostakovich are simpler than that of Prokofiev. The former's "illness," as the Russians like to refer to any artistic deviation, is only recently contracted and is fifty percent non-musical, anyway. This half is a result of his political position. As a Party member, president of the Orgkomitet, and secretary general of the Composers' Union, he was naturally held responsible for whatever protection the "formalists" had enjoyed prior to their denunciation. A first offender, a man of charming personality, and a convinced Bolshevik from the periphery of the Union (Armenia), he represents to the Politburo the achievements of a national-culture policy dear to its initiator Stalin. Of all the purged six, he has been the most played since his purge. As a Party member, he has continued, moreover, to serve on Union subcommittees. Professor T. Livanova (sole woman member of the Presidium of the Composers' Union) dealt with him indulgently in the July 1948 number of *Sovietskaya Muzyka*. His successor as secretary general of the Composers' Union, T. Khrennikov, also patted him on the back (for effort) in his "state of the Union" message of January 1, 1949.

If Khachaturian appears now as on his way out of trouble, Prokofiev seems to be in no such position. Not a product of Soviet culture but of the prerevolutionary czarist regime, a traveled man long resident in such

centers of "bourgeois corruption" as Paris and the U.S.A., an associate of the Russian émigré enterprise, Serge de Diaghilev's Ballets Russes, and a resident of the Soviet Union only since 1933, this composer is being referred to more and more in the Soviet press as an incorrigible case. The recently deceased Boris Asafiev, acting president of the Composers' Union (Stalin being honorary president), also Khrennikov and Marion Koval, editor of *Sovietskaya Muzyka* and a party-line whip, have all denounced him. Consistently and, one surmises, deliberately nowadays, his name is linked with such "servile and corrupt musical businessmen" as Stravinsky, such "degenerate, blackguard, anti-Russian lackeys of the Western bourgeoisie" as Diaghilev. His latest opera, moreover, composed under the purge, has been found unacceptable.

The latter, based on a story by Boris Polyevoi and entitled *The Life of a Real Person* (libretto by the composer's companion, Mira Mendelssohn), deals with a Soviet flier and hero who lost both legs in the war. In December of last year the conductor Khaikin, who seems to admire Prokofiev deeply, organized in Leningrad a public reading of the opera. He apparently overstepped his prerogatives in this case, for the Leningrad papers scolded him severely; and Khrennikov called the incident "a fatal one for Prokofiev." Khrennikov specified further that "this opera shows that the traditions of Western modernism have captivated his consciousness." Moreover, "to him an acute dramatic situation is an end in itself; and the overplay of naturalistic details seems more important than the creation of musically truthful and convincing images of a Soviet hero with his life-asserting, ebullient will and his bold outlook into the future." Khrennikov also regrets that Prokofiev did not submit the work to his comrade-composers for criticism before its unfortunate concert hearing. The critic of *Izvestya*, Mr. Kukharski, dismisses the piece as "impractical, ivory-tower workmanship" and the composer as "an artist who has severed all connections with real Soviet life." *Pravda* thinks it "doubtful" whether one "can expect anything to satisfy the needs of the great Soviet people" from a "composer whose work is penetrated to the core" by "Western formalist decay."

In contrast to the apparently incurable maladjustments of Prokofiev (who is physically ill, as well, for he seems to have had last spring another stroke like the one he suffered in 1946), Shostakovich is clearly on the road to recovery. Not only is he being sent to us on a mission; he has also been praised by the head of his union for his "successful" film music. His position last year was grave. As a second offender he might easily have lost his apartment. Koval actually suggested at a Composers' Union meeting as late as last October that those afflicted with "decadent, bourgeois tendencies . . . could very profitably move out of Moscow to the periphery of the vast Soviet land and get their inspiration from a close contact with the life of the people in the provinces, in collective farms

and factories." Happily, however, Mr. Shostakovich encountered nothing so drastic as forced residence on the "periphery" of the Soviet Union.* His case was argued in the magazines; his confession was accepted at face value; his penitential work has been judged good. And so (the United States willing) he is going to be sent to visit us.

Koval has analyzed his chronic "illness" as follows. Shostakovich's great natural gift has been perverted by:

1. Discordant German counterpoint (presumably the Hindemith style).
2. Introducing into the "sacred soil of the pure classic Russian tradition jazz neurosis and Stravinskyan rhythmical paroxysms."
3. Inability to write "singable" melodic lines.
4. Naturalistic approach to subject matter. (The love scene in *Lady Macbeth* had shocked some here too.)
5. "Limitless adulation of a chorus of sycophants" (in other words, popularity).

He can, however, be cured by the following regimen:

1. Avoiding "dissonance."
2. Avoiding any harmonic syntax more advanced than that of the late Sergei Rachmaninoff.
3. Learning to write "easy" tunes.
4. Avoiding dependence on "abstract" instrumental and symphonic forms.
5. Writing more songs.
6. Strictly abstaining from jazz rhythms, paroxystic syncopation, "fake" (meaning dissonant) polyphony, and atonality.
7. Writing operas about Soviet life.
8. Turning his attention in general to the songs of the great Soviet people and forgetting about the West.

Whether sending him to visit the West is the best way to make him forget about it is not for a mere Westerner to judge. Certainly his Western admirers will give him an unforgettable welcome. But before we submit him to the temptations of a bourgeois publicity apotheosis, let us remember him as last described from home sources, piously glorifying Soviet science. In *Pravda*'s art magazine of January 1, 1949, he is mentioned as having written successful music for a charming episode in the film *Michurin*. The biologist is therein described as "standing high above a blooming apple tree and in total self-oblivion conducting a rapturous, wordless chorus of the Voices of Nature." "These Voices," it is added, "have been clearly heard and well expressed by the composer."

* By " 'periphery' of the Soviet Union" Russians usually understand Siberia.

Hollywood itself could not, I am sure, provide a musician with a more glorious opportunity than the scene here described; nor could any composer wish for a more auspicious way to salute the U.S., hereditary home of "formalistic decadence," than by indulgence in such unashamed hamming.

The above, or, rather, the information contained in it, is derived from a report of some length on the Russian musical press, furnished me, with translations, by the composer Nicolas Nabokov. I regret that space restrictions forbid more extensive quotations from this entertaining material.

FEBRUARY 27, 1949

Béla Bartók

ༀ BÉLA BARTÓK's music, always respected by musicians, seems now, some three years after his death, to be coming into its reward of love. Not only is the number of musicians who are attached to it increasing; laymen are beginning to bear it affection. Every orchestra plays a Bartók piece now once a year, and his string quartets appear regularly on the chamber music programs. The Juilliard String Quartet played three of these last month and will complete the cycle of six at Times Hall on Monday evening, the twenty-eighth of this month.

This examiner has never been deeply impressed with the technical originality of Bartók. His major virtues, in my view, lie in the expressive domain. He was a master, of course. He had a good ear and abundant fancy. He knew the technical innovations of our century, used most of them, invented innumerable small adaptations or variants of them. But there is very little of textural ingenuity in his music that could not have been derived by any active musical mind from the works of Debussy and Stravinsky. Exactly such a mind, that of Manuel de Falla, did derive a comparable rhetoric from those sources, employing Spanish local color as Bartók did Hungarian and achieving a musical result not essentially different, a nationalistically oriented impressionism admirably suited to evoking the dance.

Bartók, however, though he began as a picturesque composer, had another string to his harp. He wrote chamber music of a reflective character. Impressionism was paralleled in his practice not by neoclassic constructions, as was the practice of Western composers (even de Falla, in his harpsichord concerto, essayed the formal), but by expressionism, by an outpouring of private feelings that is related as an esthetic method both to the loose formal observances of nineteenth-century central European chamber music and to that extreme subjectivity of expression that is characteristic of Arnold Schönberg's early works.

The formal preoccupations of Western neoclassicism do not lend them-

selves easily to emotional effusion, and neither do the techniques of picturesque sound. Emotional outpourings work best with loose structures and a gray palette. So Bartók kept his continuity loose, abbreviating it more and more into a semblance of tight form, and neutralized his color. At heart, however, he loved bright colors; and in his concertos he continued to employ them. In his later quartets he replaced surface color with emotional vividness. And if this last is less lurid and private than it is in Schönberg's chamber works, it is no less tonic.

Hans Heinsheimer, visiting in Boston the premiere performance of Bartók's Concerto for Orchestra, has recounted how at the end of the piece a neighbor turned to her husband and said, "Conditions must be terrible in Europe." She was right, of course. They were, especially in central Europe, where Bartók had lived. And she was right in sensing their relation to the expressive content of Bartók's music. It is here, I think, that his nobility of soul is most impressive. The despair in his quartets is no personal maladjustment. It is a realistic facing of the human condition, the state of man as a moral animal, as this was perceptible to a musician of high moral sensibilities just come out of Hungary.

No other musician of our century has faced its horrors quite so frankly. The quartets of Bartók have a sincerity, indeed, and a natural elevation that are well-nigh unique in the history of music. I think it is this lofty quality, their intense purity of feeling, that gives them warmth and that makes their often rude and certainly deliberate discordance of sound acceptable to so many music lovers of otherwise conservative tastes. Nobody, as we know, ever minds expressive discord. The "modern music" war was a contest over the right to enjoy discord for its own sake, for its spicy tang and for the joy it used to give by upsetting apple carts. Bartók himself, as a young man, was a spice lover but not at all an upsetter. He was a consolidator of advance rather than a pioneer. As a mature composer he came to lose his taste for paprika but not for humanity. His music approached more and more a state of systematic discord, rendered more and more truly and convincingly the state of European men in his time. His six string quartets are the cream of Bartók's repertory, the essence of his deepest thought and feeling, his most powerful and humane communication. They are also, in a century that has produced richly in that medium, a handful of chamber music nuggets that are pure gold by any standards.

MARCH 20, 1949

Hollywood's Best

∾ AARON COPLAND's musical accompaniments to a film called *The Red Pony* (by Milestone, out of Steinbeck) are the most elegant, in my

opinion, yet composed and executed under "industry conditions," as Hollywood nowadays calls itself. Mr. Copland himself has not in his earlier films — *Of Mice and Men*, *The North Star*, and *Our Town* — produced for cinematic drama a musical background so neatly cut and fitted.

It is the excellence of the musical tailoring in this picture that has made clear to me in a way I had not understood before just where the artistic error lies in the industry's whole manner of treating musical backgrounds. Honegger, Auric, Milhaud, and Sauguet in France, William Walton in England, Kurt Weill in Germany, Prokofiev and Shostakovich in Soviet Russia have all made film music that was more than a worthy contribution to film drama. Here privately produced or government-produced documentaries have occasionally made film and music history, but our industry-produced fiction films have not included in their whole lifetime five musico-dramatic productions worthy to rank beside the fifty or more European films that as musico-dramatic compositions merit the name "work of art."

It is not talent or skill that is lacking here. It is not intelligence either, or general enlightenment on the part of directors and producers. The trouble goes deep and has, I think, to do with our distribution rather than with our production system. But first let me talk a bit about *The Red Pony*.

The film itself, as a visual narrative, is diffuse; it tries to tell more stories than it can bring to a conclusion. Also, it has too many stars in it. It is about a boy and a pony, both admirably played. What the child star and the animal need is acting support. What they get, however, is not acting support at all but the glamour competition of Robert Mitchum and Myrna Loy. As a result, the composer has been obliged to hold the show together with music. There are some sixty minutes of this; and Mr. Copland has made it all interesting, varied, expressive. If he has not made it all equally pointed, that is not his fault. He has met beautifully and effectively all the possible kinds of musical demand but one. That one is the weak spot in all American fiction films. It is a result of our particular treatment of the female star.

Wherever Copland has provided landscape music, action music, or a general atmosphere of drama he has worked impeccably. Wherever he has essayed to interpret the personal and private feelings of Miss Loy, he has obscured the décor, stopped the action, killed the story, exactly as Miss Loy herself has done at those moments. His music at such times goes static and introspective, becomes, for dramatic purposes, futile. In a landscape picture, which this is, interpreting emotion directly in the music destroys the pastoral tone. Miss Loy's sadness about her marital maladjustment might have been touching against a kind of music that suggested the soil, the land, the farm, the country life — all those attach-

ments which, not shared by her husband, are the causes of her sadness. But the sadness itself, when blown up to concert size and deprived of specific musical allusion, loses point.

American films have occasionally omitted all such fake *Tristan und Isolde* music, using simply dialogue or sound effects to support the stars' close-ups. It is much easier, moreover, to handle musically a male star in emotional crisis than a female one, since our mythology allows character and even picturesqueness to the hero. Our heroines, on the other hand, are supposed to be nymphs — all grooming, all loveliness, all abstract desirability, though capable of an intense despair when crossed in love. It is not easy to make a successful picture about one of these goddesses unless the contributing elements — music, costumes, furniture, housing, male adoration, effects of weather, and triumphs of technology — are made to contribute to the myth. Our industry, our whole design, manufacture, and distribution of fiction films, is the commerce of this goddess's image. She is what Hollywood makes and sells. It is easy for a classically trained composer, one for whom art means reality, to enhance the reality of scenic backgrounds, to animate passages of action, to emphasize dramatic values, to give shape and pacing to any narrative's progress. But it is quite impossible for him to be a salesman of soul states in which he does not believe.

No composer working in Hollywood, not even Copland, has ever made me believe that he believed in the reality of our female stars' emotions. That is the spot where American films go phony, where they fail of truth to life. Insofar as this spot is a box-office necessity (and with million-dollar budgets it may well be a necessity), it is impossible for the film industry to make a musico-dramatic work of art. The film, as Europe has proved, is an art form capable of using to advantage the best composers. The film as produced by the American industry has never been able to show any composer at his best. *The Red Pony*, in spite of its mediocrity as a film drama, comes nearer to doing this than other American fiction films I have seen. It is the nearness of its miss, indeed, that has made me realize where the fault in our Hollywood musical credo lies. It lies in the simple truth that it is not possible to write real music about an unreal emotion. An actress can communicate an unreal emotion, because tears, any tears, are contagious. But no composer can transform a feeling into beauty unless he knows in his heart that that feeling is the inevitable response of a sane human being to unalterable events.

APRIL 10, 1949

Beecham at 70

ॐ ON THE 29th of April Sir Thomas Beecham was seventy years old. The British Broadcasting Corporation, in honor of the event, put on a

week of concerts, opera, and divers other events dedicated to the great man. Naturally he took part in most of them, for the doughty knight (and baronet) is no passive recipient. If this writer knows that joyful energy, he was all over the place, conducting everything, making speeches, cracking jokes, delighting everybody, terrifying everybody, horrifying the thin-skinned, and solemnly alerting his country to the dangers of musical negligence and irresponsibility.

A glorious festival it has been, I am sure, and one impossible to imagine taking place here. Toscanini's eightieth birthday, the seventieths of Koussevitzky, Walter, and Monteux, all were passed off with a few editorials in the press and a sanctimonious mention on the radio. Even Koussevitzky's retirement from the Boston Symphony Orchestra after twenty-five years netted him in New York one public dinner and one platinum watch. The truth is, of course, that no musician means to America what Beecham means to Britain. The music life of America has come to maturity through the efforts of many. Today's vigorous music life in England is traceable in virtually every branch to Sir Thomas.

His taste and his talents, aided in the beginning by his father's benefactions, made Covent Garden for thirty years a synonym for quality in operatic production. His insistence on playing the works of his countrymen brought British composers, from Delius to Vaughan Williams, a world public. His loving attention to Handel, Haydn, and Mozart revolutionized the contemporary attitude toward these composers and changed them, as Albert Schweitzer did with Bach, from formal classics into a living force. He was at the heart of the movement, too, that revivified the Elizabethan and pre-Elizabethan music of England, restored England's glorious musical past to her living tradition.

Wherever a musical job needed doing, there was Sir Thomas, sleeves rolled up, doing it. Folklore studies, the Renaissance revival, the masters of the Classical period, neglected Romantics like Berlioz, moderns from Strauss to Stravinsky, the discovery of Sibelius, importation of French masters and of the Russian ballet, the encouragement of British composition, British soloists, British ballet, opera in English, modern music concerts, touring opera companies, everything sound in music from the most scholarly research to the most radical experimentation has benefited from his enlightened assiduity.

To build a musical new Jerusalem in England's green and pleasant land has from youth been his aim; or, failing this, to make of that country, which has for a century and more borne music an unrequited love, a fit place for musicians. And if England is not today quite yet a musical Garden of Eden, the erosion of her once-rich musical resources has been arrested. From now on she can take a place among the world's music-producing countries comparable to that she has long occupied among the consumers. I am not saying that the whole British revival is Sir Thomas's work, for

some of it began before he was grown. I merely wish to point out that he has been the greatest single animator, living or dead, in that whole astonishing movement. It is no wonder that his country owes him honor, pays him thanks.

In the course of giving to England all the music there is in all the kinds, this man of taste, talent, and energy became not only an impresario but also a great conductor. As the former (and also as a philanthropist), he provided survival for Britain's four chief orchestras during World War I. As the latter, he has toured the world ever since, offering to the astonished continents the spectacle of a British musical artist comparable in every way to the best from any land and superior to most. Germany found his Mozart a revelation. France has considered his renderings of French opera, from Berlioz to Debussy, as exemplifying perfection and authority. Russians have taken his Moussorgsky and his Rimsky-Korsakov, Italians his Verdi and his Rossini right into the body of their tradition. The present writer is witness too that when he plays American music he gets it right.

Beecham's interpretative and technical skills are available at their highest in that most modern branch of the executant's art, gramophone recording. Sir Thomas is not always at his best in the concert hall. When he is in form, there is nobody so live, so loving, so gracious. But sometimes he gets excited and falls short of his own standards. Not so in the recording studio. There he works in calm, rehearsing, playing back, retaking each record side over and over till every sound in it is a musical sound and contributes to the whole piece's meaningful design. The result is a body of recorded music unequaled by that of any other conductor.

Considering his excellent health and undiminished vigor we may hope for a great many more fine concerts and recordings from Sir Thomas, as his enemies may also look for lots more trouble from him, and for a long time. His quarrels, his lawsuits, his indiscreet public addresses are signs of that vigor, its overflow. But the vigor itself is in the music he makes, in the humane culture of his mind, in the warmth of his sentiments, in the liveliness of his wit and spirits, in the huge and undaunted devotion of a great man and a grand seigneur to all that music means, ever did, ever will, or ever could mean in the life of a great people.

MAY 8, 1949

Piano Playing as Music

✿ MIECZYSLAW HORSZOWSKI played the piano last night in Town Hall, and that is news. This extraordinarily sensitive and powerful musician, though he lives no farther away than Philadelphia (where he teaches at the Curtis Institute), seldom crosses the Delaware for our benefit.

When he does, it is a good day for us, for few pianists play with such beauty, such distinction, such unfailing seriousness of thought.

The first quality one notices in his work is the beauty of the sound that it makes, the genuinely musical character of all that strikes the ear. The second is grace, the airy way he treats a melody and its ornaments, throwing up the latter like spray round the coastal contours of the former, using two kinds of tone, one resonant and weighty, the other light as bubbles, the presence of both making depth, perspective, roundness.

Then little by little one grows aware of the man's strength — physical, emotional, intellectual. He does not let the composer down. He goes straight to the meaning of a piece and gives it to you. His ways are subtle but never devious, his readings at once elaborate and straightforward. For all his preoccupation with detail, which is great, he indulges no personal or outlandish fancy. The whole complex variation of tonal color, accent, and phraseology that goes to make up great piano playing is dominated by a grand line that sweeps through a piece, holds it firm and clear, makes it meaningful, keeps it a composition.

Two works were particularly happy under this breadth of conception last night; Beethoven's Sonata in B flat major, opus 106, a far from easy piece to keep in motion, and the Chopin B-flat minor Scherzo, which regularly falls apart in lesser hands. Everything played had shape, as well as beauty of sound, depth, and clarity of communication.

Least communicative — and that through no fault of Horszowski — was Villa-Lobos's *Homage to Chopin*, a seasonal offering that seems little likely to survive the frost. Surprisingly full of drama was Haydn's hackneyed Andante (with variations) in F minor. Utterly welcome at this time, when everybody rattles off Chopin in his own version of the standard international touring style, was a certain Polishness in the pianist's understanding of that composer. National origins here, instead of presenting a difficulty to surmount, offered occasion for added picturesqueness of style, especially in the mazurkas, without intruding on their period elegance.

OCTOBER 20, 1949

Religious Corn

᭜ OLIVIER MESSIAEN's *Three Short Liturgies of the Divine Presence*, which received their first American hearing last night under the direction of Leopold Stokowski, have been known to musicians here and in Europe for some five years as their composer's most generally successful work in large form. By successful I mean both typical of his procedures and having a direct audience appeal.

Somehow a good deal of that appeal got lost last night in the broad

spaces of Carnegie Hall. Though small of instrumentation, the piece needs to sound loud and full and penetrating. Heard that way, its rhythmic and instrumental variety holds immediate attention. Heard at a distance, its trite melodic content and static structure dominate. There is no question that this work is the product of a delicate ear and an ingenious mind. Its esthetic value has not seemed entirely convincing to the purely musical world, though laymen have usually cast their vote in its favor. My own opinion is that its author is a case not unlike that of Scriabine. That is to say that he is a skilled harmonist and orchestrator, full of theories and animated by no small afflatus, but that there is a sugar in his product which keeps it from congealing.

The two composers have an identical preoccupation with ecstasy and an identical inability to keep a piece moving along. Their religious inspiration has no energizing force; it is drug-like, pretty-pretty, hypnotic. In Messiaen's case all the paraphernalia of commercial glamour are mobilized to depict the soul in communion with God — a ladies' chorus, divided strings, piano, harp, celesta, vibraphone, Chinese cymbal, tam-tam, and of course an electronic instrument playing vibrato (in this case the ondes Martenot). The sounds of such an ensemble, however intelligently composed, cannot transport this listener much farther than the Hollywood cornfields. Placing them at the service of religion does not ennoble them; it merely reduces a pietistic conception of some grandeur to the level of the late Aimee Semple McPherson.

NOVEMBER 19, 1949

Gloomy Masterpiece

∾ THE STAR of last night's Philharmonic program was the late Alban Berg, author of the violin concerto played by Josef Szigeti. Mr. Szigeti himself, who also played a Bach concerto (the G-minor), and the other composers represented all fitted modestly into a background for this striking work. Only Dimitri Mitropoulos, who conducted, stuck out a bit. Apparently in one of his febrile moods, he kept getting between each work and its rendering, standing out against it, till closing the eyes, with all the risks of somnolence entailed, became the only escape. Even then one could not avoid an awareness that everything was being overplayed, overpushed, overdramatized, overexpressed. Everything, at least, but the Berg concerto, itself so powerful, so lucid an introspection that even a tortured and twisting conductor could not overshadow its gloom.

German expressionism at its most intense and visceral is the work's esthetic. The twelve-tone-row technique is the method beneath its coherence. Pure genius is the source of its strength. Somber of coloration, its sound is dominated ever by the soloist, the string section, and the horns. Based on a row that outlines a circle of fifths, the constant recur-

rence of this easily noticed progression brings some monotony to the texture. Expressive chiefly of basic pleasure-pain and tension-relief patterns (the reason for my calling its expression visceral), its few cerebral references (to a Viennese waltz in the first movement and to a harmonized Bach chorale in the last) stand out like broken memories in a delirium.

The piece is too continuous, of course, too consistent to represent mind-wandering. It is a work of art, not a madman's dream, though its gloom is almost too consistent to be real. Nevertheless, it would not be fair to suspect a piece clearly so inspired in musical detail of essential second-rateness. One must, I think, take it or leave it as a whole. Your reviewer has long been willing to take it, to enjoy its musical fancy, and to admire its coloristic intensities, without, however, at any time finding his emotions transported. Such an experience often accompanies the hearing of works removed from one's personal sensibilities by space and time. It does not prove a thing against a masterpiece.

Alban Berg is dead; he has joined the classic masters. One does not have to vote about his work, to love it or to hate it. It exists in perfection, for whatever use we may care to make of it. I suspect that the world will be making more and more use of this particular piece.

DECEMBER 16, 1949

1950

The First Fifty Years

 THE FIRST decade and a half of this century were a glorious time for music. Creative originality has rarely run so high. In the flowering of modernism that took place during that time, the prize blooms were from three gardens. France gave us Debussy and Ravel, the impressionist technique of detailed musical description. Austria produced Schönberg and his school, the expressionist esthetic, the use of atonal harmony as a psychological microscope. Russia's cultural ambitions also received international blessing through the ballet successes of Serge de Diaghilev, whose original offering was the nationalistic primitivism of Igor Stravinsky. When the first World War interrupted for four years artistic expansions in all forms, the garden of musical modernism was already laid out.

During the two decades that followed, the structure rose. The modern techniques got disseminated rapidly, in part through the aid of mechanical media such as the gramophone and the radio. They were popularized, vulgarized, generalized, taught in the schools. Neoclassicism was the official esthetic everywhere. Originally a Romantic invention and tainted for the modernists by its associations with Mendelssohn and Brahms,

this had been rediscovered by Debussy and the Impressionists, who used it not for faking the past, as the Romantics had done, but for evoking it, for making hand-colored picture books out of it.

The atonal school during this time was not very successful. Its practitioners did not get the good teaching jobs, and their works rarely made the big concerts. The first upturn of their fortunes would seem to date from the late 1920s, when Alban Berg's opera *Wozzeck* began making the big opera houses, at least in central Europe. The racial and political persecutions that began in Germany shortly after this retarded, I think, the rising movement, though they hastened its dissemination throughout the Western world. The Schönberg school at this time became a sort of musical underground. When the smoke of World War II blew away in 1945, that underground turned out to have been an aid in what we may call, to carry out a metaphor, the musical liberation of France.

Today atonalism is on the rise again, and the neoclassic school wanes. In the final edifice of our century's music, it seems probable now that atonal harmony, completed by new researches in asymmetrical rhythm, will have a place in the upper structure comparable to that already assigned to it in the ground plan. Impressionism and expressionism, in other words, are approaching integration. It is not yet predictable whether that integration will be a European achievement, like their invention, because both movements have today a worldwide practice. The French, the Italians, the Americans, and the Argentines are equally adept at their handling.

The most remarkable changes in the musical scene that have become visible since World War II are the removal of the world center of music's distribution from Europe to America and the emergence of an American school of composition. In 1900 everything good in music came out of Europe — works, even of popular music, executants, styles, ideas, teachers, publications. Today we own the world market in light music and export as much of the rest as anybody. New York has not yet monopolized contemporary "serious" publication, but it determines the world price of executants and pedagogues. It has become the musical stock exchange, the center of stabilization for musical opinion. It establishes reputations and fees, crowns careers with the ultimate honor just as Paris did in 1900, as Vienna did in 1800, and as Venice had done a century before that.

The 1950 picture, by nations, reads something like this. Three countries produce new music abundantly in good quality — France, Russia, and the United States. The Russian production, on account of political interference, is lacking in scope just now, in elbow room both technical and expressive. The other two countries produce in all the kinds and keep up experimental effort. They lead the world, in fact, for "advance" in all directions. Italy, Argentina, and Chile are also among the advanced; but

none of these countries is doing much in the vein of public-pleasing serious music. That is Russia's specialty and a little bit England's, with Benjamin Britten a local Shostakovich. Neither country, however, produces this kind of work at as high a level of sincerity and refinement as France's Poulenc and Messiaen (the latter also an innovator).

Germany, Austria, Central Europe in general form a small part of 1950's musical scene. Greece, Spain, and Mexico have the beginnings of a musical movement and an avid public; but their social institutions are unfavorable. Brazil and Canada are good publics. The former has excellent composers but no school, no style, no source save indigenous folklore. The republic of Israel is music-mad from top to bottom. It offers, however, chiefly executants and a warm audience. Its composing time is far from ripe.

I do not think musical execution has improved in fifty years, but the number of skilled executants available today is much larger than it was. The number of symphony orchestras is also larger, hugely. The number of opera houses is smaller. Neither do I believe that musical pedagogy has improved at the top, though there is far more good instruction available in provincial centers than there used to be. Opera — its singing, its production, its composition — has declined spectacularly. So has ballet since Diaghilev's first five years in France, 1909–14. The films, which scarcely existed in 1900, have, on account of their higher cost and the consequent necessity of appealing to a very large public, made a virtually negligible contribution to the history of music.

Radio's services and those of the gramophone have been rather to distribute than to create. They have helped the spread of knowledge, hastened the using up of works, activated composition very little. In Europe, however, the state radio, aware of its cultural privileges, has by-passed the small audiences of metropolitan elites that used to serve as opinion formers for advanced movements. Broadcasters now speak straight to the nation. In America radio plays no such cultural role, being wholly in the hands of salesmen.

In conclusion, one may say that nothing has improved since 1900 save the size of the musical machine. The world situation of music has altered in every detail, and in most cases there has been a loss of distinction. Even the audience, though much larger and, in the provinces, better informed than it was, is less subtle, less intelligent, less sure of itself. As for Sunday articles, they are written nowadays by people like me. In the early years of this century the critical fraternity contained Ernest Newman, a better historian, and Claude Debussy, a better composer.

JANUARY 8, 1950

Dramatizing the Structure

CLIFFORD CURZON, who played yesterday afternoon in the Town Hall, is far and away the most satisfactory interpreter I know of the piano's Romantic repertory. Horowitz may play Liszt with a more diabolic incandescence, and anybody can fancy himself a specialist of Chopin. But Schubert and Schumann are composers whom almost nobody plays convincingly anymore. Certainly no one brings them to life with quite the delicacy and the grandeur of Mr. Curzon.

He prefaced them yesterday afternoon with a Mozart sonata, as if to show us how his special treatment of the Romantics had been arrived at. If I understand correctly, he has approached them not so much with a romantic feeling about them as with a taste for classic rhythmic and dynamic layouts. His Mozart sonata (the G-minor, K. 457) was treated as a symphony. Huge varieties of shortness in the articulation of notes, of color in the sound, of loudness levels sharply differentiated gave it the variety and the proportions of an orchestral score. Metrical steadiness without the imposition of any regular downbeat gave freedom to the Mozart stresses (as written), gave rhythmic perspective and objectivity to the musical shape. He exposed the work as a wide and solid building, made no effort to use it for personal meditation.

The Schubert Sonata in D, opus 53, a far wider and more personally conceived structure, he walked around in. He did not get lost in it or allow us to forget its plan, but he did take us with him to the windows and show us all its sweet and dreaming views of the Austrian countryside, some of them filled with dancing folk. The terraced dynamics and the abstention from downbeat pulsations, just as in the Mozart piece, kept the rendering impersonal at no loss to expressivity. On the contrary, indeed, the dramatization of it as a form, the scaling of its musical elements gave it evocative power as well as grandeur of proportion. And its enormous variety in the kinds of sound employed, its solid basses, and a dry clarity in the materials of its structural filling prevented monotony from becoming a concomitant of its vastness.

With the Schumann Fantasy in C, a work of intense personal lyricism and very little shape at all, Mr. Curzon's objective, orchestral approach turned out, surprisingly, to be just what was needed. It interfered at no point with eloquence or poetry. It merely held the piece together, gave it a color gamut, provided a solid setting and a rich frame for the passionate feelings that are its subject. Again the impersonal, the dramatic approach gave power to the work and breadth to its communication. By sacrificing all improvisatory, all minor-poetry attitudes, he gave us the piece as a large composition and as great poetry.

JANUARY 8, 1950

The Intellectual Audience

✑ ANYONE WHO attends musical and other artistic events eclectically must notice that certain of these bring out an audience thickly sprinkled with what are called "intellectuals" and the others do not. It is managements and box offices that call these people intellectuals; persons belonging to that group rarely use the term. They are a numerous body in New York, however, and can be counted on to patronize certain entertainments. Their word-of-mouth communication has an influence, moreover, on public opinion. Their favor does not necessarily provoke mass patronage, but it does bring to the box office a considerable number of their own kind, and it does give to any show or artist receiving it some free advertising. The intellectual audience in any large city is fairly numerous, well organized, and vocal.

This group, that grants or withholds its favor without respect to paid advertising and that launches its ukases with no apparent motivation, consists of people from many social conditions. Its binding force is the book. It is a reading audience. Its members may have a musical ear or an eye for visual art, and they may have neither. What they all have is some acquaintance with ideas. The intellectual world does not judge a work of art from the talent and skill embodied in it; only professionals judge that way. It seeks in art a clear connection with contemporary esthetic and philosophic trends, as these are known through books and magazines. The intellectual audience is not a professional body; it is not a professors' club either, nor a publishers' conspiracy. Neither is it quite a readers' anarchy. Though it has no visible organization, it forms its own opinions and awards its own prizes in the form of free publicity. It is a very difficult group to maneuver or to push around.

In New York it is a white-collar audience containing stenographers, saleswomen, union employees of all kinds, many persons from the comfortable city middle-aged middle class, and others from the suburban young parents. There are snappy dressers too, men and women of thirty who follow the mode, and artists' wives from downtown who wear peasant blouses and do their own hair. Some are lawyers, doctors, novelists, painters, musicians, professors. Even the carriage trade is represented, and all the age levels above twenty-five. A great variety of costume is always present, of faces and figures with character in them. Many persons of known professional distinction give it seasoning and tone.

The presence of such an audience at a musical event is no result of paid advertising or of standard publicity. Its representation is small at the Metropolitan Opera, the Philharmonic, and the concerts of the NBC Symphony Orchestra, though it will go to all these places for special works. Dimitri Mitropoulos, for example, drew a brilliant audience for

his recent performance at the Philharmonic of Strauss's *Elektra*. The smaller symphonic ensembles, the City Center opera, the New Friends of Music, and the League of Composers bring out lots of intellectuals. So do certain ballet performances and the spectacles of Martha Graham, though not, on the whole, for musical reasons. The International Society for Contemporary Music, the Composers' Forum, concerts and opera productions at the Juilliard School and at Columbia University, and certain recitalists are definitely favored. Wanda Landowska, harpsichord players in general, Jennie Tourel, Maggie Teyte, Martial Singher, Gold and Fizdale, sometimes Josef Szigeti are all notable for the interest they offer to persons of high mental attainments.

The conductors chiefly favored by this group are Reiner, Monteux, and Ansermet. The intellectuals often come in a body to hear them. They come individually from time to time to hear Toscanini, Koussevitzky, Bernstein. They have shown no consistent interest in Rodzinski, Mitropoulos, Munch, Ormandy, or in recent years Stokowski. Beecham's audience appeal, for all his high cultural equipment, remains strictly musical, though his recordings are collected by many persons from other professions.

Flagstad too is a purely musical phenomenon; and so is Horowitz. The latter, indeed, no longer pleases wholly even the musical world, if I read his public right. One sees fewer and fewer known musicians at his recitals, more and more a public clearly not familiar with standard piano repertory. The music world attends en masse Landowska, Schnabel, and Curzon. The last two, however, have never made full contact with the world called intellectual, the world of verbalized ideas and general esthetic awareness.

Management's aim is to mobilize the ticket buying and propaganda power of this world without alienating the mass public. The latter is respectful of intellectual opinion, which it learns about through the magazines of women's wear, but resistant to the physical presence of the intellectual audience. The varieties of fancy dress and interesting faces, the pride of opinion in overheard conversations, the clannish behavior of these strange and often monstrous personalities are profoundly shocking to simpler people. Their behavior expresses both a freedom of thought and a degree of ostentation that are not available to the standardized consumer. Much as he would like to enjoy everything that is of good report, he is really most comfortable among his own kind listening to Marian Anderson. This is why the Philharmonic and the Metropolitan managements make little or no play for the intellectual trade and discourage efforts in that direction from the musical wing. They have a mass public of sorts already, do not need intellectual promotion. They seem to fear, moreover, that the intellectual influence, bearing always toward the

left in program-making, may keep away more paying customers than it brings in.

Beneath all of management's dealings with the intellectual group lie two assumptions. One is that intellectuals like novelty and modernity. The other is that the mass public dislikes both. I think the first is true. I doubt the second. I am more inclined to believe, from long acquaintance with all sorts of musical publics, that it is management which dislikes novelty and everything else that interferes with standardization. I suspect that management's design is toward conditioning the mass public to believe that it dislikes novelty. Some success has already been achieved in this direction. If intellectual opinion has any carrying power beyond the centers of its origins, there is a job to be done, a war to be fought across the nation. The intellectuals' own survival, even, may depend on winning it. For unless these bright ones carry some weight in the forming of everybody's opinions and tastes, they are a useless body and can be by-passed by any power group that wants to use art for its own ends.

JANUARY 15, 1950

Star Dust and Spun Steel

↬ ANTON WEBERN's Symphony for Chamber Orchestra, the novelty of last night's Philharmonic concert in Carnegie Hall, was "advanced" music when first played here twenty years ago; and it still is. For all the worldwide spread of twelve-tone technique that has taken place since then, it would be hard to find today five living adepts of it whose writing is so firm and so sophisticated as Webern's was. The audience effect of this work attested also to its vitality. Not only were repeated bows taken by Dimitri Mitropoulos, there was actually booing in the hall, a phenomenon almost unknown at the Philharmonic.

The piece itself offends, as it delights, by its delicacy, transparency, and concentration. The first movement, for all its canonic rigor, is something of an ultimate in pulverization — star dust at the service of sentiment. Each instrument plays just one note, at most two; then another carries on the theme. The theme itself is a row of tones isolated from one another by wide skips. The texture is thin too. One note at a time, just occasionally two or three, is the rule of its instrumental utterance. And yet the piece has a melodic and an expressive consistency. It is clearly about something and under no temptation to fidget. Its form, I may add, is roughly that of a binary, or Scarlatti-type sonata; and its rhythmic pulse, save for a few retards in the second movement, is steady.

This movement (there are only two) is a set of variations on the work's whole twelve-tone row, first stated completely at this point. Rhythm is broken up into asymmetrical fragments. The melodic pulverization is less

fine, however, than that of the first movement. Occasionally an instrument will articulate as many as eight or ten notes at a stretch. Some of these are even repeated notes. Metrical fragmention has taken the place of melodic. The sonorous texture becomes even thinner at the end than anything one has heard previously. A tiny sprinkle of sounds, two widely spaced ones on the harp, and vaporization is complete.

There is every reason to believe the Philharmonic's reading of this tiny but ever-so-tough work to have been correct. Musicians following the score could question only the size, here and there, of some minute crescendo. The rendering was clear, clean, tonally agreeable, and expressive. Expressive of exactly what would be difficult to say, as it is of any work. Nevertheless, consistency and self-containment, ever the signs of expressive concentration, were present to the ear, just as they are to the eye reading the score. Once again there was cause to be grateful to Mr. Mitropoulos for his assiduity toward neglected distinction and for his enormous loyalty to the text of a work rare, complex, and in every way difficult.

The rest of the program, standard stuff, sounded gross beside Webern's spun steel. Robert Casadesus played a Beethoven concerto in businesslike fashion, with dispatch and efficiency. A Rachmaninoff piece gave the conductor the conventional odds. Only the Cherubini overture *Anacreon*, long absent from programs, reminded us that ancient springs can still run fresh when overuse ceases to pollute them. It also reminded us that Rossini's lively spirits were not so much a personal gift as a heritage from fellow countrymen, from this one in particular. A jolly piece and a shapely one.

JANUARY 27, 1950

Atonality Today

∾ EVERY musical epoch, as Lou Harrison once pointed out, has its chromatic and its diatonic style. Atonality is our chromatic style. Indeed, now that we have it in so highly evolved a form as twelve-tone composition, it seems to be the ultimate condition toward which chromatic harmony has always aspired. That condition is one of extreme fluidity, and its attraction for the pioneer-minded is that of the open sea. Classical scales and harmonic relations, in this conception, constitute reefs and treacherous currents and are hence to be avoided. Arnold Schönberg's twelve-tone-row syntax is a device for avoiding them. It is not the only modern one, but it is the easiest to handle. Its simplicity and general practicability have caused its adoption by such a large majority among atonal writers that it may now be considered, I think, as the official, the orthodox method of composing in tones without composing in tonalities.

Other methods, however excellent or even superior, constitute deviations from standard practice.

That practice is common to most of the mature music of atonality's Big Three — Schönberg, Berg, and Webern. Now two of these three are dead, and the other is seventy-five years old. Their favorite syntactical device, moreover, now available to all, is widely employed. Hence there is every reason to consider the epoch of advance that they represent to be a closed one. Certainly those of their musical progeny who work by identical or nearly identical methods bear the mark of the epigonous. Others, however, who accept the twelve-tone row and its canonic application as their basic method are not satisfied with this as a complete method. For them it is satisfactory only as a way of arranging tones with regard to their pitch. They wish a method equally convenient for ordering their length. Present-day efforts by twelve-tone composers to build a rhythmic technique comparable to their tonal system have initiated a second period in atonal research and composition.

If the first problem in atonality is to avoid familiar tonal relations, its second is surely to avoid familiar metrical ones. Complete renewal of the musical language and not a mere abandonment of its decayed portions, still less a spicing up of spoiled material, let us remember, is the aim of the atonal group. Also we must not forget that the Big Three, with slight exceptions in the work of Webern, made virtually no effort at originality in the rhythmic direction. Here they remained conservative, though less by principle, I should think, than from the fact that all advance needs to proceed in an orderly fashion, one thing at a time. The rhythmic achievements that now form the backlog of the second-period atonalists, the knowledge they start from, came almost wholly from outside the atonal tradition.

These achievements are many. The exactly written-out rubato of Mahler, the fragmented developments of Debussy, studies of Chinese, Javanese, East Indian, and other exotic musical systems, acquaintance with American ragtime and jazz, the epoch-marking Danse Sacrale from Stravinsky's *Rite of Spring* with its long, rhythmic phrases developed from tiny cells or rhythmic motifs, the experiments of Varèse and others in pure percussion, the introduction into Western music by Messiaen of a Hindu device for varying a meter's minimum note length — all have prepared the way for the new atonalists. Since the new rhythmic efforts have not yet brought about any standardization of rhythmic procedures, the field of rhythm is still full of sectarian dispute. Anybody with a new trick can imagine himself as in possession of the golden key. So far, however, there is no golden key. The period is a lively one, and all doors are still open, even to tonal writers.

The ideal of nonmetrical rhythm, like that of atonality, is asymmetry.

Pierre Boulez states it as *d'éviter la carrure*, that is to say, the avoidance of everything square. This means that metrical repeating patterns are out and that even the rhythmic canon by inversion, the hardest to hear of all rhythmic imitations, requires violation of its exactitude by means of the Hindu added dot. There are problems of rhythmic construction too that require solution, though conservative twelve-tone composers like René Leibowitz consider them subsidiary to tonal relations and not soluble independently. John Cage employs a numerical ratio in any piece between the phrase, the period, and the whole, the phrase occupying a time measure which is the square root of the whole time and the periods occupying times proportional to those of the different rhythmic motifs within the phrase. This procedure, though it allows for asymmetry within the phrase and period, produces a tight symmetry in the whole composition and is not therefore quite the rendering of spontaneous emotion that the European atonalists hope to achieve.

The expressive aim of the atonalists has always been a romantic one, the depiction and provocation of intense, introverted feelings. Berg's music, in this respect, is closely related to that of Hugo Wolf and Mahler. Schönberg oscillates in his feeling allegiance between Wagner and Brahms. Webern is more personal, more fastidious in his expression, as he is more original, more reflective in his applications of the twelve-tone technique. In both respects, and also through his pulverization of sound into a kind of luminous dust, he is an Austrian cousin of Debussy. He it is, in fact, and not Schönberg or Berg, whom the French atonalists tend most to revere and to stem from. He it is too who will probably remain most loved among the founding fathers when the atonal world shall have got round to doing over the art of instrumentation. But that will not be for another decade, at least. Just now a new rule of rhythm is the instrument lacking for traveling the trackless ocean of atonality, where the brave adventurer has, by the very nature of his renunciation, no harmony to guide him. The twelve-tone-row technique is a radar for avoiding shoreline hazards, but it has not yet taken any composer beyond the sight of Europe's historic monuments. For that a motor source will have to be found.

FEBRUARY 5, 1950

Unique and Unforgettable

∾ Arturo Toscanini directed in concert performance last Saturday afternoon the first half of Verdi's *Falstaff*. Next Saturday at the same hour — 6:30 E.S.T. — the other half will be given. This reporter would like to add to the above bare announcement his feeling that those who miss hearing these performances (or their broadcast) will have passed up a unique and probably irreplaceable musical experience.

It is not that this opera does not here and there get given. It is simply that Verdi's great farce, for divers and complex reasons, almost never comes off in the theater. As instrumental music, as vocal music, and as pantomime, it is powerful like a bulldozer, elaborate like an electronic calculator, and yet simple and broad in its humor like a comic strip. It is the busiest opera in the world and the most exigent as to timing. It asks the singers to behave like clowns while singing with animation and precision. What they sing, moreover, is vocally difficult without being, in terms of audience effect, grateful. It is a conductor's opera, a virtuoso piece for the musical director. One might almost imagine it as having been especially designed for Mr. Toscanini.

The NBC opera broadcasts in general are conceived as starring machines for this conductor. Timing, the trajectory of an overall musical line comes first, orchestral refinement second, vocal charm last in his hierarchy of values. As correctives to a music world that more commonly cherishes these values in reverse order the NBC operas have been tonic. They have also given us an opportunity to hear the most admired opera conductor of our century in the repertory that first brought him fame. Save for these broadcasts, Toscanini has not directed opera here in many years and seems determined not ever again to work in the American theater.

Falstaff, moreover, among all the works of standard repertory, is the one that profits most by the Toscanini treatment. No other conductor, in my experience, has ever made it sound so light and fast, filed its delicacies and its accents to so sharp an edge. He gives us too, along with the music of it, an evocation of the stage, an essence of the theater, a concentration of comedy speeds and farce timings, a zest, an outline incomparable. His reading is a lesson to all who think that the theatrical circumstance profits by coarseness of texture or appeal. Its steely elegance, like that of the score itself, is a far more powerful mover of audiences than any concession to easygoing vulgarity could possibly be.

The vocal execution on Saturday, though less brilliant, on the whole, than the orchestral, was clean and generally agreeable. This observation, I hasten to add, applies strictly to the center balcony seats of Studio 8-H. What the singers sounded like elsewhere in that tricky hall, or when heard through engineering adjustments, I cannot report. Listeners to these broadcasts have given highly divergent testimonies about vocal effectiveness.

APRIL 3, 1950

Glorious Loudness

〰 GUSTAV MAHLER'S Eighth Symphony, as directed last night by Leopold Stokowski, was a glorious experience to one who had not heard

it before. Its sculpture of vast tonal masses at the end of each of the two movements was handled by the conductor in so noble a manner that the sound achieved monumentality while remaining musical. The effect was unquestionably grand.

The whole work, indeed, has both grandeur and humility. In its eighty minutes of execution time no touch of the meretricious mars its devotional concentration on the meaning of its texts. These are two, the Latin hymn *Veni Creator Spiritus* and the last scene (in German) from Goethe's *Faust*. The symphony holds together as a musical piece and expresses its author's religious impulses, as well as his cultural convictions. A master workman, he gave to this work his utmost of seriousness. It is a statue to his memory, if not his finest music.

Both as music and as a monument it is weakened by its melodic material, which is banal. Also by its harmony, which, though structurally adequate, is timid, unoriginal, unexpressive. The orchestral writing is ingenious, as always, though lacking somewhat in color for so long a piece; and the handling of the huge choral masses is both firm and delicate. The solo parts are lovely, too, as vocal writing. What the work lacks is melodic point, sharpness of outline. Weak thematic material, developed beyond its natural strength, becomes repetitive, loses communicative power. The last five minutes contain a real tune. The rest, for all the thought and skill involved in its composition, is pretty amorphous.

Some of this amorphousness comes from the composer's basic esthetic assumption. This assumption, derived from the finale of Beethoven's Ninth Symphony, seems to be that it is possible to make an artistically perfect work of music that will combine in equal proportions the symphony and the oratorio (or cantata). No such work has yet been produced. Even the Beethoven movement has never been universally voted by musicians to be successful. I do not think Mahler's Eighth is successful either. It is not, in my estimate of it, a pure crystal. It is ambitious and sincere, and it has character. But its grandeur lies in certain skillful handlings and in the conception. It does not permeate the piece, which is soft inside.

One is grateful to Mr. Stokowski and to his assembled forces for letting us hear it. Also for giving it to us with such great care for musical decorum. Such handsome loudnesses as took place in both perorations one does not encounter often.

APRIL 7, 1950

Kurt Weill

❧ KURT WEILL, who died last Monday at the age of fifty, was a composer who will be missed. Nothing he touched came out banal. Everything he wrote became in one way or another historic. He was probably

the most original single workman in the whole musical theater, internationally considered, during the last quarter century.

His originality lay in his ability to handle all the forms of the musical theater with freedom, to make them expressive, to build structures with them that serve a story and sustain a play. He was not a natural melodist like Richard Rodgers or George Gershwin, though he turned out some memorable tunes. Nor was he a master of thematic development, though he could hold a long scene together. He was an architect, a master of musico-dramatic design, whose structures, built for function and solidity, constitute a repertory of models that have not only served well their original purpose but also had wide influence as examples of procedure.

Weill came to the light musical theater, for which most of his American works were conceived, from a classical training (he was the pupil of Humperdinck and of Busoni) and long experience of the artistic, the experimental theater. His literary collaborators were consistently writers of distinction. Georg Kaiser, Ivan Goll, Bertolt Brecht, Arnold Sundgaard, and Maxwell Anderson were among them. Brecht was the librettist of the epoch-marking works of his German period — *Der Jasager, Der Dreigroschenoper* and *Aufstieg und Fall der Stadt Mahagonny*. Also of a ballet with words, composed in Paris, *Les Sept Péchés Capitaux*, played in England as *Anna-Anna*.

These works have transformed the German opera. Their simplicity of style and flexibility of form have given, indeed, to present-day Germany its only progressive movement in music. Without them the work of Boris Blacher and Carl Orff would be inconceivable. Without their example also we would not have had in America Marc Blitzstein's *The Cradle Will Rock* and *No for an Answer*. Whether Weill's American works will carry as far as his German ones I cannot say. They lack the mordant humanity of Brecht's poetry. They also lack a certain acidity in the musical characterization that gave cutting edge to Weill's musical style when he worked in the German language.

Nevertheless, they are important to history. His last musical play, *Lost in the Stars*, for all that it lacks the melodic appeal of *Mahagonny* and even of *Lady in the Dark*, is a masterpiece of musical application to dramatic narrative; and its score, composed for twelve players, is Weill's finest work of orchestral craft. His so-called folk-opera, *Down in the Valley*, is not without strength either. Easy to perform and dramatically perfect, it speaks an American musical dialect that Americans can accept. Its artfulness is so concealed that the whole comes off as naturally as a song by Stephen Foster, though it lasts a good half hour.

Weill was the last of our local light theater musicians to orchestrate his own scores and the last to have full mastery of composition. He could make music move in and out of a play with no effect of shock. He could write a ballet, a song, a complex finale with equal ease. (A successful

Broadway composer once asked me, "What is a finale?") These skills may turn up again in our light theater, but for the present they are gone. Or they may be replaced by the ability of Menotti, Blitzstein, and other classically trained composers to hold public attention through constructed tragic music dramas. Just at present the American musical theater is rising in power. But its lighter wing has lost in Kurt Weill a workman who might have bridged for us the gap, as he did in Germany, between grand opera and the *singspiel*. The loss to music and to the theater is real. Both will go on, and so will Weill's influence. But his output of new models — and every new work was a new model, a new shape, a new solution of dramatic problems — will not continue. Music has lost a creative mind and a master's hand.

APRIL 9, 1950

Taste Survey

✧ THE Indianapolis Symphony Orchestra has recently tabulated the results of a musical preference poll carried out last spring among season-ticket holders. The survey was conducted by Dr. Dennison Nash of Washington University, St. Louis, Missouri, and seems to have observed all the devices of fairness required by the statistical profession. Answers were sought to the following questions:

1. What types of music does the Indianapolis audience prefer?
2. What specific composers?
3. Does the symphony audience approve of Dr. Sevitzky's [the conductor's] policy of fostering American music?
4. What is its attitude toward "modern" music?
5. Do men and women differ in their music tastes?
6. What types of music are preferred by listeners of different ages?

The answers to questions 1 and 2 will astonish no one. By dividing the symphonic repertory into five style periods — classic (meaning before Beethoven), classic-romantic (meaning Beethoven), romantic (centering around Brahms and Tchaikovsky), modern (including Debussy, Sibelius, and Gershwin), and extreme modern — the result obtained was that symphony subscribers prefer the romantic style. This taste, however, tends to diminish in those over forty in favor of the classic-romantic style, which is that of Beethoven. Music written before Beethoven has its highest preference among the very young and the very old. Those in middle life care least for it. Ten composers are preferred by the whole audience in the following order — Beethoven, Tchaikovsky, Brahms, Bach, Mozart, Wagner, Debussy, Chopin, Sibelius, and Haydn. American music and its performance are resoundingly encouraged by

the poll. One-fourth of the audience would accept as much as half the playing time from this category. Another fourth would limit American works to five percent of the repertory. Forty-five percent of the listeners would settle for a ten percent Americanism in the programs, which has long been the proportion observed in Indianapolis. No particular American composer seems to be favored. It is American work in general that the audience enjoys, very much as Italian and French and Russian audiences have long been known to respond favorably to a musical diet rich in home-grown products.

This preference contradicts the conviction of many orchestral managements that American music is not popular. The truth is probably that it is not comparable with name soloists for attracting to the box office single-concert ticket purchasers, but that it is highly approved by season subscribers. Boston's experience corroborates this judgment. Its sold-out subscription houses have never raised any serious complaints against American music. Indeed, these have ever taken pride in the interest and toleration they have been able to show toward the large amounts of American music long characteristic of Boston programs.

Modernism also comes in for an accolade. The Indianapolis audience (and this surprises even me) expresses a willingness to hear as much "extreme modern" music as it does of Beethoven, its favorite composer. Beethoven's present percentage of the playing time is probably around twelve. Thirty-one percent of the subscribers would even accept as much as half the programs devoted to modern music.

Sex, you may be pleased to learn, plays no role in musical taste. Men and women at all ages, according to Dr. Nash's survey, appear to like exactly the same works, authors, and styles.

Age, on the other hand, is a huge determinant. Those really receptive to modernism are almost all under forty and mostly under thirty. These ages want lots of modern music, including all the "extreme," or "dissonant" types; and they constitute an audience for this by no means negligible in numbers. Our orchestras should ideally, in order to serve the whole public, play two series of programs, one for the elderly and another for those under forty. Their present efforts to please everybody at once derive from a paucity of rehearsal time, no doubt; but I am sure that somewhere behind them is an assumption that mature taste is the best taste and that it should dominate. The present survey has surely rendered culture a service in calling attention to the fact that those under forty have tastes of their own, that these are not the same as those of their elders and that there will be a long period after forty when they will be older persons themselves and can listen to all the Beethoven there is.

Another service of this survey (although a shocking one) is contained in a study of the influence of regular symphony-concert attendance on

anybody's taste. For the first year romantic preferences run high, and so do those for modern composers. After one year of attendance, however, there is a sharp drop in both kinds of taste and a strong move toward the classic-romantic, or Beethoven-dominated repertory. After that there is little change save for a slowly increasing interest in the classic, or pre-Beethoven masters and a decreasing toleration of the contemporary. This evolution runs parallel, of course, to the changes in taste that accompany maturity. The striking data for education are those that show the active influence of regular orchestra-concert attendance on any subscriber's taste to be limited to the first year. That is the time when the whole educational benefit is operated. Afterward very little of it takes place. Dr. Nash concludes his report with the statement that "an increasing length of concert attendance is associated with a narrower and narrower preference range, i.e., a greater preference for fewer [and fewer] composers."

SEPTEMBER 17, 1950

Golden Throat

VICTORIA DE LOS ANGELES, singing last night in Carnegie Hall, won the votes of a large audience with her very first piece. By the last one, these had turned into a general acclaim. Success was hers and by no narrow margin. Speaking purely as a musician, your reviewer finds himself wholly in accord with that success. The voice is one of rare natural beauty, the schooling impeccable, the artistry first class. Miss de los Angeles is a real singer. Make no mistake about it.

She is also a young singer. Her interpretations of German lieder are still a little mannered. And she withholds her high notes. She takes them commandingly but she usually diminishes before they have given their full delight. Only a few times during the evening did she omit to tease the searcher after effects of obvious vocalism. Indeed, so careful was she not to insist on bravura utterance that it is a little hard to know just how high and how loud she can sing. A perfect vowel projection, whether in pianissimo or in forte singing, filled the hall at all times with vibrancy, beauty, warmth of tone. Nothing was ever forced and nothing failed to carry. She is a true lyric soprano and does not need to falcon.

Her most striking gifts are a natural cantilena, or sense of melody, and a complete ease in florid passages. She tossed these in the Handel aria as lightly and as accurately as a pianist might play them in a piece by Mozart or Chopin. Indeed, an unhesitating precision about pitches marked all her work. She sang not only beautifully but true. Her kind of ear and training are rare these days, and one could not be more grateful to be reminded that they have not been lost to music. To find them guiding a voice that is sweet, young, and fresh is more than surprising. Here is vocal delight unique in our time. I must say that this delight, being

attained wholly through vowel vocalism, was not accompanied by much clarity of enunciation. At least not in the Italian and German works, plus one English piece, that made up more than half her program. In Spanish she really pronounced. Consonants clicked like castanets, and the bright Spanish vowels glowed like copper and brass. Perhaps she does not have the gift of tongues. But she does relish her own. And whatever the tongue, she has a golden throat.

OCTOBER 25, 1950

1951

Reactionary Critic

∾ EDUARD HANSLICK, a Bohemian born in 1825 in Prague, came to Vienna in 1846 as a law student. He had already received a musical education, had met Schumann and Wagner, corresponded with Berlioz, and written music criticism. While preparing his doctorate in law, which he took in 1849, he continued to write music criticism, for most of which he was not paid. His first Viennese contribution was an analysis of Wagner's *Tannhäuser*, published by the *Wiener Musikzeitung* in eleven installments. Hanslick was at this time a deep admirer of Wagner's genius and music. Till his death he continued to admire the genius; but from *Lohengrin* on, which he reviewed in 1858 from the Vienna production, he did not approve the music.

Meanwhile, by easy stages, he had given up law (or rather the civil service career for which it had prepared him) and become a salaried reviewer of music in the daily press. From 1855 to 1864 he wrote for *Die Presse* and from 1864 to his retirement in 1895 for *Die Neue Freie Presse*. From 1861 he was Extraordinary Professor of the History and Esthetics of Music at the University of Vienna. In the middle 1850s he had written a book on *Beauty in Music*. Thereafter, at the university and in print, he posed as world expert and final authority on the subject. A classical education and a facile pen enabled him to defend his assumed position with ingenuity and wit. His determination to uphold the cause of classicism in music involved him in systematic denial of the artistic validity of Liszt, Berlioz, Wagner, Bruckner, Hugo Wolf, Verdi, and Richard Strauss. He barely tolerated Tchaikovsky and Dvořák, ignored wholly the rising movement in Russia and France. Henselt, Lachner, and Johann Strauss he always mentioned benevolently. The dead — Schumann, Schubert, Mendelssohn, Weber, Beethoven, Mozart, Handel, Bach — he treated with respect. The only living composer of class that he deigned to defend was Brahms. His banner Hanslick carried aloft as the banner of counterrevolution till his own death in 1904.

Except for his early brochure on *Beauty in Music* Hanslick's work has not till now been available in English. Henry Pleasants III, formerly music critic of the *Philadelphia Evening Bulletin*, has recently edited and translated admirably a selection of Hanslick's reviews, complete with notes and biographical preface, under the title *Vienna's Golden Years of Music: 1850–1900* (Simon and Schuster, New York, 1950, 31 illustrations, 341 pp.). One is grateful for even this brief acquaintance with the man Wagner pilloried as Beckmesser in *Die Meistersinger*. One is pleased to learn that he was not, as Wagner gave him to us, a bad composer, a lecher, and a boor, but a skilled belles-lettrist and a master reporter. One is charmed too by his literary culture, his musical penetration and easy man-of-the-world ways. Reading him lightly, one might almost take him for the perfect music critic, if perfection is conceivable in so invidious a genre.

But no, three times no! Once because there was no real warmth in the man. Twice because the truth was not in him. And thrice because he never stuck his neck out.

To those who may think a twenty-five-year war with Richard Wagner enough bravery to ask of any man, I recall that Wagner did not live in Vienna and that Hanslick's readers, who did, were middle-aged, well-to-do, bourgeois. He wrote for a conservative paper. His readers asked no better than to see a man of novel genius reduced to the level of an incompetent entertainer. Critics writing all over Europe on conservative papers — Chorley in London, Fétis in Paris, not to speak of the German reviewers — had given Wagner the same treatment; and in 1856 *The New York Times* had denied to *Lohengrin* "a dozen bars that could be called real melody." Anybody knows it is easier to defend the public against novelty in art than it is to defend an original artist against the public's comfortable conservatism.

Actually there is not a point in Hanslick's attacks on Wagner that had not been made before. Berlioz, Meyerbeer, Rossini, and the young Bizet had long since put their finger on the inequalities in his talent. These were common knowledge in music circles. Time has not altered, moreover, their reality. Wagner's contemporaries, including Hanslick, denied him no excellence for which he is still cherished. Nor were even his closest friends, save a few, unaware of his imperfections. Even Hanslick's main theme about how for all its beauties this music is not "the music of the future," not a beginning but a glorious and dangerous dead end, was a familiar idea. That is what the famous Wagner "case" has always been about, and Hanslick did not invent it. As a matter of fact, his reviews spent far more space unmasking Wagner's literary weaknesses, which he was capable of doing quite well, than analyzing musical structures which he could not always follow, even with a score. He knew that Wagner could orchestrate, paint tremendous musical landscapes, and prosodize

in German; but he had not the musical technique to understand Wagner's complex chromatic harmony and asymmetrical rhythm. So he complained about the "lack of melody," made fun of the librettos, and refuted the advertising. Compared with Nietzsche on Wagner, he was thoroughly superficial.

To protect himself against the possible charge of not patronizing home industry, Hanslick had sagaciously picked on Brahms as his "side" in the Brahms-Wagner war. He was sold this position by a surgeon named Billroth, who was a close friend of Brahms and who, according to Dr. Max Graf, Hanslick's successor on the *Neue Freie Presse*, furnished the critic with analyses of Brahms's works. Hanslick cared little for Brahms; what he really liked was waltzes, light airs, and Offenbach. But Brahms was useful to him, and he to Brahms. The pair of them, if stories of the time and Bruckner's letters are to be believed, carried on a relentless intrigue, aided by two other critics who were also friends of Brahms, to prevent Bruckner's rise in popularity from endangering the carefully constructed celebrity of the older man. Brahms's ironic gesture of gratitude was the dedication to Hanslick of his *Love Waltzes*. To Billroth, who understood depth and complexity, he dedicated two of his grander quartets.

Hanslick could describe a performer to perfection — Liszt, von Bülow, Clara Schumann, Lilli Lehmann, Adelina Patti. He tells you what they looked like, the kind of sounds they made, the nature of their technique, and the character of their temperaments. His musical analysis of any composition was elementary and timid, reads like a quoted program note. Also he was a dirty fighter. He was a dirty fighter because his extraordinary intellectual and literary powers were used solely to convince people that he alone was right and all the living composers, except for a few minor melodists and for Brahms, were wrong. A mere reviewer, a belles-lettrist, a reporter, and a professor of Music Appreciation (the first, I believe), he pitted himself in his own column against the creative forces of the age. Anywhere but in his own column, or surrounded by its glamour in a Viennese salon, he was just another irate customer complaining about modern music. In his column, and in private intrigues, he was formidable.

Having gone through my two provable indictments in reverse order, I am now back to the first, which is a matter of feeling. For me there is no warmth in the man, no juice, no passion for music. Sensuality, grace, some sparkle, a gift for ridicule, and a colossal vanity shine through his selected reviews. So does the insincerity of his pretended love for Brahms's music. He states it over and over, but he cannot make it glow. What comes through everything is an ever-so-careful conformism to the bourgeois tastes of his time, which, I am very sorry to say, are still the tastes of bourgeois Vienna at home and abroad. But he did not invent even these. He invented nothing but the style and attitude of the modern

newspaper review. That, with all its false profundity and absurd pretensions to "sound" judgment, he will probably have to defend at everybody's Last Judgment. He was second-rate clean through, and he had no heart. Max Graf thinks highly of Hanslick's literary gift. "His essays and articles," says Dr. Graf in his excellent book *Critic and Composer*, "have been published in twelve volumes, in which his intelligence, charm, clarity, and wit are preserved, like drugs and poisons in cut-glass vessels on the shelves of a pharmacy." "Venom from contented rattlesnakes" was the late Percy Hammond's term for similar critical contributions.

FEBRUARY 4, 1951

Pretentious and Unclear

∾ BUSONI's *Arlecchino* (*The Harlequin*) was the novelty of last night's Philharmonic program. Though the Busoni comic opera is subtitled a "theatrical capriccio," your informant has long found himself resistant to the idea that there is either fun or funniness in this work. At this point his objections end. It is skillfully composed, intellectually and musically sophisticated to the last degree, a major effort of a major musician. Also, its execution, though a bit loud throughout, was a triumph of loving care on the part of Dimitri Mitropoulos, who conducted.

Reviewing this opera from a Berlin performance in 1946, your correspondent found that its music contained everything but "plain feeling." Having recently read it in score and last night heard it again, he remains of that opinion. It represents a hopeless effort to combine Italian animation with the heaviest sort of German satire and an equally impossible desire to eliminate schmaltz from the German operatic style without renovating the late Romantic and early Modernist harmonic vocabulary of Germany, in which that schmaltz is firmly embedded. The composer had, besides, no talent at all for writing tunes. The result is a mess all the more pitiful from its author's accomplished musicianship, high motivation, and, let's say it, overweening ambition.

OCTOBER 12, 1951

Spokesman for the Met

∾ DURING an intermission of the Metropolitan Opera broadcast of December 15 the general manager of that esteemed institution said, "Now you might say that only by trying out these new operas, even if they are not too exciting, can an opera house hope to find the great work that no doubt one day will appear. This frankly is a moot question."

Will you say that again, please, Mr. Bing? What is it you consider a moot question? If I read you right (and I have before me a copy of the manuscript you spoke from), you consider that there are other methods

of adding great works to the opera repertory than by putting new operas into production. I have never heard of any such method. Reading scores will, of course, enable your musical directors to eliminate many works. But it cannot pick out the "great" ones of any decade or epoch. That is done by the public. And if there is any way the public can be led to consecrate with its favor the greatness of a *Carmen* or *Lohengrin* or *Aïda* or *Figaro* without some opera house having actually produced that work first, then I am sure we should all like to know what it is.

Perhaps Mr. Bing means that the Metropolitan does not need to give world premieres, that it can let the subsidized European houses do our tryouts for us. By skimming thus the cream off the world's production we might indeed procure a quite good contemporary repertory at small risk. But such a policy does not seem to be this manager's idea. In referring to Alban Berg's *Wozzeck*, a famous opera now thirty years old and consecrated by some quite impressive box offices, he admits it to be an "extremely important opera" that "has been played in many European opera houses." But he also remarks that it has become part of the standard repertory in very few theaters.

Just a minute, Mr. Bing. You know perfectly well that it was removed from the German and Austrian theaters in the 1930s both for its political content and for its composer's religion. You also know that both its political content and its musical style place it out of bounds today everywhere behind the Iron Curtain. Also, that last summer's production in Salzburg, which you mention as selling less well than Verdi's *Otello* (hardly surprising) had to run against the opposition of the powerful Austrian clergy, determined to remove it from the repertory on theological grounds. You know too that Switzerland and Italy have seen the work revived since the war and that Paris will see the Vienna Opera Company's production next spring. Nobody ever suggested to you that *Wozzeck* would be a draw at the Metropolitan like *Cav* and *Pag*, though it would probably do as well in any season as *Parsifal*. It has merely been pointed out that if the Met is looking for twentieth-century works of unquestioned musical "importance" and tested appeal, *Wozzeck* is up near the top of the list. And if the Met is afraid of attempts at political or religious censorship, then I am ashamed of it.

Mr. Bing later in his speech denied acquaintance with any recommendable modern works and suggested "that anybody should send [him] a list of those new works performed in recent years that live to see a second season." I should not care to offer such a list myself lest it be thought I were proposing that the Met mount all the operas on it. But just for fun I might mention Prokofiev's *The Love of Three Oranges* from the City Center, Poulenc's *Les Mamelles de Tirésias* from the Paris Opéra-Comique, Milhaud's *Bolivar* from the Paris Opéra, Britten's *Peter Grimes*, not so long ago of the Met itself. All these have seen second seasons in

one house, two of them even more. As for modern operas that have survived in the repertory of many houses and even in some cases enjoyed runs in the commercial theater, there are Hindemith's *Mathis der Maler* and the late operas by Richard Strauss, all of them current in Germany and Switzerland these days, Menotti's *The Medium* and *The Consul*, worldwide successes both, and Gershwin's beloved *Porgy and Bess.*

Opera writing is, by actual count, not at all a dead art. And neither, by actual count, is opera production. It may be at the Met but not in the world picture. And when Mr. Bing states it as "a highly regrettable fact that so few new operas of real musical consequence are being offered" one wonders what he means by "real musical consequence." But one does not wonder long. He means and I think I read his thoughts correctly, pure box office. He "regrets" that Beethoven "receives greater support" than Schönberg from symphony audiences, though why he should regret it I do not know. He ought to be happy that our symphony audiences have access to Schönberg as well as to Beethoven. We opera audiences get no such heady diet.

But the slip about Beethoven is minor. Here is the evidence on which I accuse him of a box-office view of music. He says: "No one in the world of the theater puts on any show unless he is convinced that it will either be a 'hit success' or at least attract sufficient public acclaim to justify the effort. I cannot see why this sound principle, which is commonly accepted in the theater, should become a criminal offense when applied to opera."

Some member of the Metropolitan board should explain to the general manager that the Metropolitan Opera Association is not engaged in show business, that it is a nonprofit society vowed to the advancement of musical art and of public taste, that this purpose has been recognized by the state of New York as justifying an exemption from real estate taxation and recently by the federal government as justifying exemption from the amusements tax. Gifts to the Metropolitan, moreover, can be deducted from anybody's taxable income up to fifteen percent. Such privileges are not granted to the amusement trades.

It is not a "criminal offense" to play so conservative a repertory as Mr. Bing has laid out for this season, and nobody ever said it was. It is merely a neglect of duty. I have long found his program regrettable; and I found his radio speech of two weeks back acceptable only for the frankness of his admissions, shocking as they were. He admitted his lack of faith both in the music of his own time and in the public's aspirations regarding this. He does not believe, apparently, that good operas are being written now or are likely to be written in the near future; and he considers that it would be a waste of the Met's money to produce the contemporary stuff that *is* written. He does not think the Met audience wants to hear new things anyway and says he did not get one letter all last year asking for them.

All the same, he plans to take a flyer next season with the new Stravinsky opera. "We shall then see what the public reaction will be," he added. Does this mean that he is giving contemporary music just one chance to compete with *Carmen*? Really, one has heard double-talk before from Metropolitan spokesmen but nothing quite so cynical as this.

DECEMBER 30, 1951

1952

A Great Temperament

❧ GUIDO CANTELLI, conducting the Philharmonic last night in Carnegie Hall, risked everything, program-wise, and lost nothing. Indeed, if applause is the measure, his winnings were large. Even Monteverdi, a far from sure thing, paid off. On Beethoven, at the end of the concert, he really cashed in.

A young man making his first bow before a great orchestra risks a great deal by filling half his program with arrangements of music by seventeenth-century organists. He risks even more — all, in fact — by essaying Beethoven's Fifth Symphony, the hardest piece in the repertory with which to show originality or to compete with the interpretations of older men. Mr. Cantelli held his audience firmly, triumphantly in both halves. Here is obviously a great music-making temperament.

The four organ pieces by Frescobaldi, in Ghedini's instrumentation, were noble and rigid, evocative of a primitive instrument and of pre-Bach church services. The Monteverdi *Magnificat*, also orchestrated by Ghedini, seemed even more archaic in its contrapuntal textures, though its lengthy pedal points (or long held notes against which other voices move) were really a modernism in 1610. They gave architecture to a piece, and poignant expressivity could take place against them. Equally a modernism then (and still surprising) is the intense emotional expression which this composer achieved. The emotional resources of the time both for composing and for receiving music must have been vast. Certainly Monteverdi's music, like that of Schütz in Germany, is vibrant with feelings more powerful than anything that preceded or followed it by nearly a century. And its rendering of verbal texts is heartbreakingly meaningful.

Mr. Cantelli, though a protégé of Toscanini, gave us no streamlined Beethoven. He gave us a young man's Beethoven, all passion and lyricism. His reading was not at all times orchestrally elegant. Once or twice roughnesses were heard that were certainly not his intention. But they mattered little beside the grace of his line, the warmth of his assertions. We are used to a colder violence in this piece and a more calculated showmanship. Mr. Cantelli was not occupied with either. He made it sing; he

made it dance; he even made it rejoice. Let us be thankful for the presence among us of so pure a spirit.

JANUARY 4, 1952

Recital Songs

 SINGERS' recital programs come up for attack about once a year from this reviewer. In past times he has complained vigorously against the multilingual convention which leads vocal debutants to expose their ignorances of German, French, and Italian all in one evening, along with, more often than not, their lack of a cultivated English diction. He has also lamented the musical poverty of the English-language song repertory.

Not much can be done to change the multilingual convention so long as our music schools enforce it for degrees and credits. Young artists have to sing what they have studied. And what they have studied is the standard scholastic requirement of selections from German lieder, French art songs, Italian airs and arias, and English verse settings. Fine programs can be assembled from these sources. And if few singers are prepared to shine in so grand a galaxy, they can usually do pretty well in one of the groups. Also, their program's musical offering is far richer in such a layout than would be possible in a program devoted to English vocal literature alone. The only way out of the difficult situation is to specialize, to really sing well German lieder or French songs and to stick fairly close to that specialty.

For these two repertories are the great vocal repertories. Neither the English nor the Italian communicates so urgently. You have only to hear a whole evening of music from England's or from Italy's finest vocal period, which in both cases is the seventeenth century, to realize that for all that music's noble proportion and infinite grace of line, it does not work in depth like those fusions of music and poetry that are the particular glory of Germany's nineteenth century and of France's early twentieth.

Not Dowland, not Purcell, not Handel nor Blow, not Cesti, Carissimi, nor even Monteverdi has the psychological power in short songs of Schubert, Schumann, Brahms, Wolf, Mahler, Fauré, Ravel, and Debussy. Neither were they able to extend their inspirations into long vocal forms without some cost to their expressive intensity. The Romantics and the moderns in Germany, Austria, and France have worked far closer to poetry's meaning than did their predecessors; and they have worked with poetry of greater complexity. The classical and preclassical masters, though they often set the best poets of their time, never faced — such things were not there to be faced — the emotional elaboration and verbal subtleties of Goethe, Heine, Baudelaire, Verlaine, Mallarmé, Apollinaire, and Max Jacob.

The modern Italian and modern English vocal repertories do not come

up to the French and German either. The poetic texts used are less substantial, the musical settings less detailed. The Italians have written in the last century and a half lots of fine arias for the theater. In English we have Sir Arthur Sullivan, also of the theater, and Stephen Foster, strictly for the home. The Russians have a handful of wonderful songs by Moussorgsky that are appropriate for recital use and some by Rachmaninoff that are far from negligible. Grieg wrote some in Norwegian, and Sibelius has composed well in both Finnish and Swedish. De Falla, in Spanish, and Villa-Lobos, in Portuguese, have written charmingly for the solo voice; but their work is closer to folklore evocation than to those psychologically powerful fusions of music and poetry that stem from Schubert. It is all a little objective, impersonal, does best in any program's final group.

German and French songs of the last century and a half are to the song recital what Haydn, Mozart, Beethoven, Brahms, and Debussy are to the orchestral concert. They are the center of the repertory, its real weight and grandeur. All the rest is contributory. And only in France, in the work of Francis Poulenc and Henri Sauguet, is that great tradition being carried on today. The English, the American composer has not seized, not understood the fusing of music and poetry into an alloy stronger than either alone. He has realized, I think, the nature of lyric poetry. But he has underestimated the need, in this kind of expression, for a personal intensity, the kind that can come only from sincerity, emotional concentration, and self-containment.

The great composers of art songs have all identified themselves with the poet's feeling or with some aspect of it. They have got inside the poetry. The rewards of doing this are Franz Schubert's great and original contribution to music, and his six hundred songs are a corpus of achievement now basic to the art. The composers who have not built on this foundation have built weakly. Their songs do not stand up under usage. It is a matter of regret to us all that the English-speaking composer has not achieved that inward-turned concentration that is the sine qua non of great song writing since Schubert.

Consequently our recital singers are obliged, like those of many another country, to work mostly in foreign languages. I have heard rumors ever since I was a child that a few English and American composers were about to change all that. Certainly most of our composers have tried their hand at the recital song, many of them assiduously. But if the usable American repertory is any larger or more distinguished today than it was in the time of Edward MacDowell and George B. Nevin, I am unaware of the fact. Neither is Benjamin Britten, in England, one whit more significant as a song writer, for my money, than the late (and thoroughly charming) Liza Lehman.

It is pathetic to hear our artists, especially the younger ones, mouthing

French and German that they scarcely understand. But it is even more painful to see them struggle with poorly conceived and amateurishly written English songs. There is nothing to be done about the matter. Only a great repertory of English songs can change it. And for that we must wait till our composers acquire the knack of working closer to poetry than they are accustomed to do just now. A good melody is not just a poem's new suit. It must be a new skin, inseparable.

APRIL 27, 1952

1953

Musically Enchanting

∾ *The Rake's Progress* brought yesterday afternoon to the Metropolitan Opera House the brilliance of a great premiere. The cast, headed by Hilde Gueden, Eugene Conley, and Mack Harrell, sang impeccably. The orchestral accompaniments, after forty hours of rehearsal under Fritz Reiner, were perfect. The scenery of Horace Armistead was adequate, the stage direction of George Balanchine brilliantly unobtrusive. As for the opera itself, it has a fine libretto by W. H. Auden and Chester Kallman; and its music by Igor Stravinsky is enchanting.

The subject is a young man's downfall through money, drink, gambling, sex, and speculation. He ends up in bedlam, imagining himself Adonis in the arms of Venus, but really being rocked to sleep by his hometown sweetheart. He is abetted in self-destruction, I may add, by a Mephistophelian servant named Nick Shadow. The story is thus a morality play touched up with Goethe's *Faust*. Setting it in eighteenth-century England has allowed the authors to lean on the prestige of Hogarth's engravings of the same title and also to stylize their poetic language. Very pretty is that language too. Few composers in our time have been served by an English libretto so high-class throughout.

Dealing with a poem made up so largely of references to a period of literature, it was appropriate (indeed inevitable) that the composer should derive his inspiration from the same period in music. Mr. Stravinsky has clearly used as his model the operas of Mozart and Pergolesi, adding touches of thematic material and devices of musical syntax from classical composers as closely related to the Mozart tradition as Bach, Gluck, and Donizetti. There is even, here and there, a memory of Beethoven's *Fidelio*. But *The Rake's Progress* is no eclectic score. Its style is powerfully Stravinskian. I should say that it sounds throughout more like Stravinsky than any other single piece we have heard from this master in twenty or more years, since *Oedipus Rex* and the *Symphony of Psalms*, to be exact.

Its difference from those earlier vocal works lies in the greater freedom, variety, and expressive power of the vocal line. The opera is full of fine airs, set pieces, and recitatives, all handsomely designed to show off both the human voice and the English text. Its similarities lie in the harmonic texture, a dissonant diatonic idiom of almost arbitrary simplicity, and in the complexity of the musical metrics. Stravinsky's inspiration, let us remember, has always been rhythm, dancing, gesture. Song is secondary with him. And although the present work is chock-full of good tunes, many of them more or less familiar, it is the rhythmic structure of the instrumental accompaniments — elaborate, subtle, and tense — that gives to the whole work its electric potential. This tension, characteristic of all Stravinsky's music, is in his stronger works the most powerful musical individuality of our time. Its permeating pressure in *The Rake's Progress* is grounds for suspicion that this work is probably among his finest.

If so, it will stay in the repertory. If not, it will still have delighted us all with its musical fancy. Certainly there is no weakness in the poem or in the possibilities of its dramatic mounting that would tend to make the work, like *Les Noces* and *The Rite of Spring*, fall out of the theater into the concert hall. If there were any such weakness, it would lie, I think, in the passages having to do with the Bearded Lady, a character drawn from female impersonation and not easy to make convincing. All the rest works perfectly, in my opinion, and should continue to do so for quite a time. In the Metropolitan's admirable production, the artists will probably (unless the cast begins to shift) little by little add characterization to a spectacle that so far has been drilled primarily for musical excellence. *The Rake* is a fine opera in an extraordinarily perfect musical production. It is no tear-jerker nor much of a melodrama. It is simply a quite good poem on a moralistic theme, and the music is enchanting.

FEBRUARY 15, 1953

Germany's Funeral Song

↭ BRUNO WALTER, conducting the Philharmonic last night, gave a burningly clear and moving performance of Gustav Mahler's *Das Lied von der Erde*. The excellent soloists were Elena Nikolaidi and Set Svanholm.

This *Song of the Earth* is really six songs, plus a short orchestral interlude, set alternately for tenor and alto voice to German translations of Chinese poems. The sadness of wine, of the seasons, and of growing older is their theme. And if a certain self-pity is not absent from the composer's treatment, neither is the enjoyment of nature. The breadth of the work's expressive content comes, indeed, from the placement of personal sadness in a landscape that sets it off by every device of contrast.

This sumptuous orchestral landscape is no attempt to reconstruct an authentic China. It is rather a wish, a yearning toward a China picturesque and exotic in detail but filled to the brim with Germanic pathos. The permanence of the East is there only as décor for the decline of the West. And make no mistake about it, Mahler's sadness at the approach of his fiftieth year was no private vanity. He thought of himself as the end of German music, just as Brahms had done. Brahms in spite of Wagner, Mahler in spite of Strauss, and later, Alban Berg in spite of Schönberg and Webern, all considered their music to be the closing off of a great epoch.

All were right in the sense that German music was experiencing in their time a sumptuous and deliquescent decay. It had lost all sense of form, all reserve, all ethical distinctions among the sources of emotion; and the aging giant had no strength to revive him. He could only die in grandeur. And each of these introspectives, bound to pessimism by clarity of mind as well as by temperament, wished that the whole great fireworks could expire with him in one final bursting.

It did not happen that way. German music still goes on, running weaker and thinner, but alive. It is all a very sad story; and Mahler was right to be sad. But he did leave, in *The Song of the Earth*, at least one lovely burst, an opulent and ornate poetic address to the musical decline of the great tradition of which he was so proud to be a part. All this somehow came through last night in the reading of it, tender, eloquent, and grand, by Bruno Walter and the two soloists.

FEBRUARY 20, 1953

Loud and Grand

❧ BEETHOVEN'S Missa Solemnis is a work which this reviewer has long preferred reading or thinking about to actually hearing. The grandeur of its conception cannot be questioned, but much of its detail is weak and does not carry. Nor does a great deal of the choral writing really "sound"; it is too loud and too high too much of the time. Orchestrally the work has little to offer of charm or variety. The scoring lacks color, as does the harmony, which is limited almost entirely to its architectural function. The work is of an extraordinary plainness, in spite of its length and seeming complexity. Its glory lies in its straightforwardness, its insistence, its triumphal assertion, as if the whole Mass were one dauntless, relentless Hallelujah.

Naturally the execution by mere musicians of so grand a concept is limited by human possibilities. And Mr. Toscanini resolved none of the work's well-known practical difficulties save only that of giving us whole and straight its noble simplicity of mood. The NBC Orchestra did not play throughout with an agreeable sound, nor did the Robert Shaw

Chorale so sing. The soloists were lovely, especially the soprano Lois Marshall; but the conductor left them little leeway for singing other than at the top of their power all the time.

The whole reading seemed to me weighted on the loud side, and there derived from this loudness a certain monotony. Excitement there was, yes, a tension of rhythmic insistence and a tension of strain. Also that fullness of affirmation that is the glory of Beethoven. A not dissimilar affirmation on the interpreter's level, of course, is the glory of Toscanini, just turned eighty-six. For these gifts let us be thankful. All the same, I do repeat, every time I hear the Missa Solemnis, that there seems to be no satisfactory way of making this work sound less like a tempest over the Atlantic and more like a piece of music comparable in intrinsic interest to any of the same composer's symphonies.

MARCH 30, 1953

Singing English

∾ THE INCREASING use of English on our operatic stages has begun to make evident the inefficiences of many an opera singer's diction in that language. Also the fine verbal projection of certain others, of Mack Harrell's, for instance. Several times lately, in reviewing such occasions, this reporter has mentioned the tendency, encouraged by many vocal studios, to mute, to neutralize all unstressed English vowels into a sound such as might be represented in spelling by the letters *uh*. This sound exists in many modern languages; and it has a sign in the international phonetic alphabet, which is a lowercase *e* printed upside down. It is also recognized by all students of pronunciation that English vowels, unless they bear the stress accent of a word or word group, tend toward neutral sound. The first and last syllables of *potato* and *tomato* are partially neutralized vowels; but they remain *o*'s nevertheless, especially in speech destined for large-hall projection. The last syllable of *sofa*, on the other hand, is completely worn down to the neutral state of *uh*; and no speaker can say it otherwise without seeming affected.

Several letters from phonetic students have seemed to invite discussion of these matters, and almost all of them have assumed as axiomatic that musical declamation should imitate as closely as possible the customs of spoken language. I find the assumption hasty, if only in view of the fact that conversational speech and shouted speech do not observe the same vowel qualities. Nowadays that public speaking is done more and more through electrical amplification; it tends more and more also toward the conversational tone. But the great orators and the great actors, when working without a microphone, still project their phrases through vowel observances that at a lower level of loudness would be considered frank distortion.

Singing requires even greater distortion of speech customs, since tonal resonance must be preserved at all times. It is most curious, once you think about it, that while no one would ever mistake a British actor's speech for that of an American, and vice versa, there is practically no difference at all in the way that British and American artists articulate their common language in song. This means that some dominant consideration wipes out in their singing all localisms of speech. What is that consideration? It is the essential difference between speech and song, the simple fact that singing permits an extension of the vowel sounds that is outside the conventions of speech.

It is unfortunate that most of the phonetic studies available in print deal only with speech. They are all right so far as they go; but they do not, as a rule, deal at all with the tonal problem that is cardinal to musical declamation. They are like qualitative analysis in chemistry. The next step will have to be a quantitative analysis of English vowels and diphthongs. Because our vowels are not equally extensible. Those of *pit, pat, pet,* and *put* allow of hardly any holding time at all. Whereas the *o* of *home* can be sustained to the farthest limit of breath, though the identical *o* in *pope* resists extension.

All these matters need study. And for singers a great refinement in vowel intonations is needed if the unaccented ones are not to be hastened pellmell into that limbo of similarity where popular radio and movie artists tend to throw them. Singing is by its nature conservative in this regard, because neutralized vowels are neither beautiful nor sonorous. And composers can be ever so cruel in asking for extension of these weak sounds. The word *garden* is correctly spoken as *gahdn,* but it cannot be sung that way if the second syllable has a long note. A vowel must be invented for it by each singer, a sound at once becoming to his voice and not too absurdly inappropriate to the speech sound of the word. *Jerusalem* is another tricky word, at least the first syllable of it. *Jee* and *Jay* are clearly absurd, though I've heard both in New York City. On the whole, American artists prefer *Jeh,* though the British have long maintained that only *Juh* is correct.

Gradations of vowel color are necessary even for long accented syllables, because vocal beauty demands some darkening of the bright *ay*'s and *ee*'s, some brightening of the dark *oh* and *ou,* especially if the notes involved are high or loud. Further gradations are needed for the vocalization of unaccented vowels. The *er* of *river* in *Swanee River* comes out best, for instance, if sung as something very like the French sound *eu.* The *y* in *melody,* though it may seem to ask for an *ee* sound, admits tempering in some cases. The word *little* is a headache all round, and so is *bottle.* The last syllable of *Saviour* is clearly neither *yrrr* nor *yaw;* as in *river,* something approaching the French *eu* is probably the best solution.

A cultivated singing speech does not fear to exaggerate, to color, to alter English vowel sounds (as these are used in speech) for clarity, for resonance, for carrying power. What it must avoid like sin, for it is one linguistically, is the undue neutralization of vowels, which can endanger clarity, resonance, and carrying power. Studios teach the correct declamation of Italian, German, and French. Some teach good singing English too. Many do not. And many English-speaking singers sing a corrupt and vulgar English. This fault should be corrected in the studios. Indeed, it *must* be corrected if English-langauge opera is to be successful. The music public will accept an occasional folksy touch, but by and large it wants a classical style in its musical executions. Declamation and diction are a part of musical execution. They are in need, right here and now, of serious attention.

<div align="right">A PRIL 12, 1953</div>

A Powerful Work

✵ ELLIOTT CARTER'S String Quartet, played last night at the Y.M.H.A., is a sumptuous and elaborate structure that lasted forty-five minutes without losing at any point its hold on this listener's attention. The piece is complex of texture, delicious in sound, richly expressive, and in every way grand. Its specific charm is the way in which it sounds less like a classical string quartet than like four intricately integrated solos all going on at the same time. Each instrument plays music which is at any given moment melodically and rhythmically complete. It could be played alone. But it also serves as contrasted thematic matter against which three other seemingly independent parts all stand out as if in relief. As in fugal writing, the tunes, rhythms, figurations, and placements as regard pitch are mutually contrasted and mutually contributory. Their relation to one another lies in their studied differences.

They are all in the same key; but often, by the use of double-stops, each instrument makes its own harmony. They also swap their tunes and counter-tunes about, too, as in the fugal style. Only toward the very end do they actually cooperate in the production of a communal, a blended harmony. And this passage seemed less interesting than the rest of the piece, simply because the rhythmic contrasts of the work's contrapuntal texture were no longer present to animate its flow — again a phenomenon not uncommon in fugal writing.

The work is not a fugue; it is a free composition deriving equally from the improvisational toccata style and the constructed sonata. It is a summation of many composing methods, though its source lies in neoclassicism. Richness and variety are its glory, freedom and mastery its most impressive message on first hearing. It is difficult to play; it was beauti-

fully played by the Walden String Quartet of the University of Illinois. It is an original and powerful piece, and the audience loved it.

MAY 5, 1953

Henri Sauguet

∾ THE MUSIC of Henri Sauguet, as presented in the Museum of Modern Art under the auspices of the International Society for Contemporary Music and of the Juilliard School, came to many as a surprise as well as a delight. The warmth and the spontaneity with which New York responded both to the music and to the person of the composer was a match, indeed, for the same warmth and the spontaneity that are his music's most powerful qualities. And the rarity of these qualities in contemporary music makes them all the more welcome in a time when music lovers have grown used to hearing from composers every imaginable idiom save the language of the heart.

Sauguet has been speaking his heart in music for nigh on to thirty years, and he has long been loved in Europe for doing so. But America has had little chance to love his work. His operas, of which there are four, have not been produced here, presumably because our troupes are not staffed for producing French opera. And his ballets, of which there are upwards of twenty, have mostly been composed for organizations that do not visit our shores. Even his chamber music and his songs, which constitute a large repertory, have scarcely been touched; and when isolated works of any kind have been given, they have usually passed almost unperceived. It took a whole concert of Sauguet's work to make clear that it is the expression of a remarkable personality, one of the strongest musical personalities, in fact, now alive and working.

Perhaps the time has not been ripe till now for America to love and understand a music at once so elegant and so humane, so void of insistence and so deeply felt. We have had to work our way through all the fashionable forms of stridency to arrive at the point of being able to hear again that which is not strident and to exhaust our delight in violence, frigidity, and the obsessions of abnormal psychology before we could notice again the dignity of the more nourishing sentiments, the ones we live on. Perhaps also a few vested interests have discouraged up to now any venturings of the contemporary music societies into paths not clearly marked as leading to the further success of already successful movements.

The quickest musicians to take up Sauguet may well be the recital vocalists. His production of songs has been large and ever distinctive. Admirably composed for singing and perfectly prosodized, these comprise settings of some of the finest French lyric poetry by Paul Eluard, by George Hugnet, by Max Jacob, by Mallarmé, Laforgue, and Baudelaire, as well as French translations of Rilke and of Schiller. These are French

songs in the tradition of Poulenc and Fauré, the lyrical tradition, rather than the more declamatory vein of Debussy and Berlioz. They have not Poulenc's bounce nor Ravel's irony; they simply have a lovely tenderness and a tragedy all their own. Like all fine songs, they are a distilled poetic essence, different each from each yet all full of the composer's own flavor.

It is surprising that a composer so gifted for the theater and so versed in the dramatic forms should indulge so little in rhythmic surprise or weighty emphasis. It is Sauguet's sharp sense of character differences and of distinctions among the sentiments that make violence no temptation to him. Everything in his music is made up out of contrasts and oppositions; but these elements are composed into a harmony, not set at war. The result is a vibrant equilibrium rather than a tension. Sauguet does not purge the emotions; he makes them flower, give off perfume. The drama in his stage works is as intimate as in his chamber music, just as his chamber music is capable of evoking vast scenes and lofty laments worthy of the opera.

This primacy of expression makes him a Romantic; and the consistent shapeliness of his work unmasks him as a neo-Romantic. He is, indeed, one of the founding fathers of the musical movement so denominated, as he was the close friend and frequent theatrical collaborator of Christian Bérard, its leader in painting. Whether this movement has run its course or scarcely begun, I shall not argue here, though my faith is in the latter outcome. But whatever the future may decide, Henri Sauguet has already brought us a sweetness, a beauty, a sincerity, and a savor that contemporary music has long lacked and that are dew and strawberries to us just now.

MAY 9, 1953

Scientists Get Curious

❧ THE SCIENTIFIC schools, long a fortress of reasoning and practicality, have lately been encouraging in their students a curiosity about the arts. The Massachusetts Institute of Technology and other technical training centers have introduced music to the elective parts of their curricula with notable success. Even on the philosophic plane the scientific world, classically disciplined to a positivistic attitude, has begun to wonder if perhaps there is not something to be learned from the more spontaneous working methods of the musician, the painter, the poet.

Last week at a convention held in this city the Engineering College Research Council of the American Society for Engineering Education devoted a whole morning to "creativeness." The painter John Ferren, the novelist Ralph Bates, and the present writer, as composer, were asked to explain "creativeness" and answer questions about it. The assignment

was a tough one, partly because artists and scientists do not use the same vocabulary, and also because the very word *creativeness* assumes a good deal.

For scientists it seems to imply that something has been invented out of nothing, or at least that some object or principle has been arrived at without its discoverer having followed the deductive procedures. For artists it implies nothing at all about method; it means originality rather, the bringing into existence of something different from everything else. This difference may be vast or very small, but it must be there. If it is, something has been created. If not, we have merely a copy.

Copies are legitimate, of course. The world lives on them. Their production and distribution are a province of engineering, as witness the printing press and the gramophone. But music recognizes two kinds of copies, the multiple and the unique. Multiple copies, all pretty much alike, are an industrial product. Single copies made by hand are an art product. A painter's copy of another painter's picture has a personal expression in spite of all attempts to keep it out. And an executant musician's rendering of a composition is as individual an achievement as what a builder erects from an architect's design. This duet of design and execution, thoroughly familiar to engineers, is characteristic of music. Painting is a one-man job and does not, in its high-art aspects, envisage reproduction. Poetry is a one-man job which envisages (or hopes for) multiple reproduction by print. Music, like architecture, envisages from the beginning collaboration. It is a design for execution.

Now considering the design as "creative" and its execution merely as "interpretation" is customary among musicians. But it applies better to the execution of scores from the past than to contemporary music. Co-operation between the living composer and his executants is an essential part of musical creation, of bringing a work into real existence. Because music's real existence is auditory; it is sound, not notes on a page. Actually, music and architecture, music and engineering, are similar in their dependence on execution. Who am I to say that the executant's contribution to my work is not a "creative" act? It is certainly part of one.

What scientists want to know, of course, is how a composer arrives at his design. Well, sometimes an expressive, a communicable idea is arrived at by reasoning. Sometimes it bursts up from the unconscious. And its organization into a piece of music comes in the same two ways. Often a practical workman will write it all down quite rapidly, as if he were taking dictation. At other times it comes more slowly. And if he hits a snag he has to reason his way around it. The simplest parallel I know for what a composer does is what anybody does when he writes a letter. He wants or needs to make a communication. He thinks about it a little. He writes it. Then he reads it back to find out whether he has said what he

meant to say and, most important of all, whether he is willing to mean what he has actually said.

Music, all art for that matter, depends on meaning. The prestige of non-Euclidean geometry has all through this century caused artists to insist that their work at its best and most "advanced" is theoretical, an abstraction comparable to the higher equations. At the same time they have hoped that within twenty years its acceptance as communication would make them loved and famous. Actually music does not work like that. The most novel modern music has always had a public that understood and accepted it. The battle has been one of obtaining access for it to the existing mechanisms of distribution. All music is about something, just as all music that can stand up under concert usage has a sound technical structure. There is no abstract music. There is only expressive music. This expression may depict an inner or an outer reality. But it always depicts something. And unless both the reality depicted and its manner of depiction have an essential uniqueness, a personality strongly different from that of all other existing artifacts, there is no work of art; "creation" has not taken place.

Science deals with a unified universe governed by laws universally applicable. Art deals with a multiple universe in which no two apples or carburetors or love affairs are alike. Revealing the common properties of apples and carburetors and love affairs is the business of science. To individualize them is the province of art. As to what is "creative" and what not, I suppose that the defining of all that is the critic's job. But critics can be terribly presumptuous. Who is to say that Stravinsky is more creative than Einstein? As Gertrude Stein used to say, there is the "human mind" and there is "human nature." There is also the visible or knowable universe. The human mind, like the rest of the knowable universe, follows patterns. That is its strength. Human nature, which is essentially unknowable, is at its most interesting when least predictable. And art, poetry, music are similarly most powerful when from work to work, school to school, age to age, and decade to decade they show the widest imaginable diversity from their own standard patterns of style, of subject matter, of communicative effect.

OCTOBER 18, 1953

Kapell

⚬ THE PIANIST William Kapell, who died in an airplane accident near San Francisco on October 29, was a fine artist. So were Grace Moore, soprano, Ginette Neveu and Jacques Thibaud, violinists, who have died in similar fashion in recent years. Every time an airplane falls persons distinguished in professional, political, business, or military life are among

the dead. Because it is exactly such persons to whom the speed of air travel offers an irresistible convenience. A musician who moves about the globe in this way can play twice to three times as many engagements a season as the one who is earthbound. Also it is known that aviation fatalities per passenger-mile traveled are far fewer than those due to the deadly automobile. Still, the number of famous names that appear in the aviation accident lists is impressive. And still the advantages, economic and artistic, that come from being able to move quickly from one date to another will keep a large number of our most valued musicians among the inveterate air travelers.

Among musicians of his generation William Kapell, just thirty-one on September 20, was one of the great ones. His career, like that of Ginette Neveu, was at the point where he was no longer considered just a young genius but was recognized by his colleagues as a mature artist. At nineteen he was winning big prizes. At twenty he began his career as a touring recitalist and a much-in-demand orchestral soloist. But for a decade his repertory had remained heavily weighted with the easy-to-put-over works of Rachmaninoff, Tchaikovsky, and Khachaturian. It was only in the last two years that he had gained real access to the grand repertory of the piano, to the concertos of Mozart and Beethoven and Brahms and Chopin and to the suites of Bach and Debussy, and that he had been genuinely successful with that repertory.

Kapell had fought hard for this access and for this success. He had fought with his management and with the press. And he had wrestled with the repertory itself, not only alone but also with the counsel and the detailed cooperation of musicians who knew that repertory. He had studied, labored, consulted, digested, ripened. Kapell had become a grown man and a mature artist, a master. He could play great music with authority; his readings of it were at once sound and individual. He had a piano technique of the first class, a powerful mind, a consecration and a working ability such as are granted to few, and the highest aspirations toward artistic achievement.

Kapell was conquering the world. In one decade he had won a worldwide audience. At the beginning of a second he was recognized as a master to be taken seriously in the great repertory. He was already laying plans (and operating too) toward the renewal of this repertory through the application of his great technical and interpretative powers to contemporary piano music and through devoted cooperation with contemporary composers. And his conquests were not easy. Few artists have ever battled so manfully with management or so unhesitatingly sassed the press. He was afraid of nobody, because his heart was pure.

It is not germane that as a man he was a good son and brother, a good husband and father, and a loyal friend, though he was all these. What is important to music is that he was a musician and a fighter. He did not

fight for himself or for just any music. He fought to play well and to play the best music. Also to take part in the creative life of his time. And he was winning, would have gone on winning, for he had a star.

He had also an unlucky star, else he would not have been taken from us. And our loss, music's loss, is irreparable. Other men of comparable genius and sincerity may arise; but none will ever take his place, because that place was unique. Kapell had built it to fit his own great talents. And built it so that his talents could serve the whole world of music in their own particular and powerful way. Past services will remain and be of use to others. But Kapell himself, that huge life force, is dead; and his continuing musical presence will not be with us anymore. Since he was buried last Monday it has been a week of mourning for musicians.

NOVEMBER 8, 1953

Rich Resources

✑ THE Philharmonic Chamber Ensemble, which opened its third annual series of concerts on Saturday night at the Y.M.H.A., is the richest among all our chamber music groups in instrumental resources. Drawing its players from the whole Philharmonic-Symphony Orchestra, and organized as a cooperative society, this group offers regularly in its programs works for a great variety of instrumental combinations; and the great expertness of the players permits them also to offer works of unusual stylistic and technical difficulty.

The star number of last Saturday's program was Arnold Schönberg's early *Kammersymphonie*, opus 9, for fifteen solo instruments, conducted by Dimitri Mitropoulos. Rarely performed at all, on account of its great technical difficulty, this deeply passionate and eloquent piece is at once a monument of late Romanticism and a picture window turned toward twentieth-century chromatic experiment. It is a powerful work that seems to invite (like its predecessor *Verklärte Nacht*) choreography by Antony Tudor.

No less expert and stylish (in the best sense) was the performance of Beethoven's Quintet for Woodwinds and Piano, with Aba Bogin at the keyboard. Mozart's Duo for Violin and Viola (No. 2, in B-flat major) came off less well. The string players of the Philharmonic, many of them at least, seem less accustomed to the refinements of chamber music execution than the wind players are, used, these latter, to the constant playing of solo passages. Nevertheless Leon Temerson and Bernard Andreasson, accompanied by Mr. Bogin, gave a delicious and even brilliant performance of Manuel Rosenthal's *Sonatine* for Two Violins and Piano. This lively work, composed in 1923 when Rosenthal was nineteen, is musically inspired by Milhaud and Poulenc, rather than by Ravel, who was Rosenthal's teacher. It is an outgoing work, frank, vigorous, and

entertaining. Thirty years later, one can still find it valid. It is not only skillful but, for all its youthful enthusiasms, strongly personal.

Milton Babbitt's Woodwind Quartet, an Alma Morgenthau–Locust Valley Festival commission which received its first performance on this occasion, is also a strongly personal work. Music composed in the twelve-tone-row syntax has long tended in its finer examples toward a supercharged emotional expression and in its more commonplace ones toward a sterile academicism. It is Mr. Babbitt's distinction to have produced in a twelve-tone technique derived, like that of the contemporary Parisian school, from Webern rather than from Schönberg or Berg, music of an airy elegance wholly his own. It is not crabbed like the French stuff, nor does it seek pathos at any point. It is lacy, good humored, disinvolved, water clear. At its least concentrated it goes a bit abstract. At its most intense it has a studied relaxation that is very American, very Princetonian, and utterly distinguished.

NOVEMBER 23, 1953

Irresistible

 THE PROGRAM that Nathan Milstein played last night in Carnegie Hall, accompanied at the piano by the impeccable Artur Balsam, was a serious one. Three great chunks of uncompromising music for the violin made up its first three quarters — a Vitali chaconne, a Bach unaccompanied suite, and the Beethoven "Kreutzer Sonata." Even the final plate of tidbits offered pieces by Schumann and Brahms. And nothing is more serious than Paganini, especially when it is a set of variations of the utmost difficulty composed by Mr. Milstein himself on a theme from one of the Caprices and executed with the utmost brilliance.

Everything seemed, indeed, to be executed with brilliance, even the severest of the classical selections. For it is the gift of this artist to make music shine. His tone is bright, his rhythm is alive and compelling. His music-making glows not with a surface luster but with an inner light and a warmth all its own, an animal warmth. Soul is not his specialty; nor are tears. For emotional satisfaction he gives us a clean reading of the text and a boyish humility before the great masters. He gives us too a boyish delight in fine technical workmanship, in controlled muscular activity exercised to his powers' limit.

And that limit is a far one, for nobody plays the violin more expertly. But along with the expertness there is a love of the violin and of playing it well that is irresistible. Mr. Milstein is no great or original interpreter. Nor is he any authoritative spokesman for the masters of musical thought. There is no vulgarity in him, but neither is there any deep penetration or especial sensitivity. There is simply a personal vibrancy that makes his work at all times completely alive.

In the "Kreutzer" of Beethoven the dramatized emphases and strong accents were almost overlive, but they were not rough or ugly. They were simply an interpretation and a legitimate one. And they were matched by fine delicacies and many a full-singing line. Fullness of sound at all the levels of softness and loudness is one of this artist's grander gifts. It gives his playing an equalized surface tension, a power of complete projection, that holds the attention in a way that the work of few artists is capable of doing. And so his exact interpretative conception of a piece is never a very important matter.

It is by sheer efficiency and charm, by modesty, enthusiasm, and an utter loyalty to what he is doing that Milstein makes his mark. After twenty and more years on the concert stage he is still the perfect pupil, reasonable, master of his trade, devoted to the sound of his instrument, and not afraid of it. Neither is he afraid of the great classics nor of approaching them with passion and with common sense. The latter quality, of course, is as rare among musicians of any age as is technical mastery. The combination is irresistible.

DECEMBER 15, 1953

1954

Remembering Mahler

ᴖ YESTERDAY AFTERNOON's Philharmonic concert, with Bruno Walter conducting, was a very great pleasure. The program was two symphonies, a Haydn and a Mahler, both evidently beloved of the conductor. And the orchestra played perfectly, sweetly, beautifully. One didn't have to worry about what one thought of the symphonies as musical scripts. It was enough that they were being played, understood, rendered into loveliness.

Mr. Walter's reading of the Haydn G-major, commonly known as Number 88, was robust, straightforward, an ultimate in rightness and ease. The kind of sophistication that avoids superrefinement is the ultimate sophistication in the reading of this work. And this kind of sophistication is Walter's gift with the German classics. He can make them seem as natural as breathing. And he can make the Philharmonic, which can do everything, sound as if playing a classical symphony were the most natural thing in the world. All the care for beauty and exactitude that goes into such a reading is great workmanship, of course, on his part and on that of the orchestral players. But the result is not any awareness of workmanship at all, it merely brings a piece to life, makes it real. At least that was your reviewer's experience yesterday.

The experience was no less intense in Mahler's First Symphony than

in the Haydn. The Mahler is a young man's work, written at thirty, ambitious as to length, abundant in musical ideas. Most of these ideas are orchestral, the ingenuities of a conductor. Expressively the symphony is a patchwork of contrasts. It begins as a pastoral scene with bird calls and hunting horns but turns military by the end of the first movement. The second is a waltz, something between a real country waltz and the urban kind. One might call it suburban if the term were not derogatory. In any case, it bounces along with good spirits and turns military at the end.

The third movement, the most original of the four, is a joke about a funeral march, beginning with a solo passage for one bass viol and going on to a ravishing orchestral imitation of Hungarian nightclub style before returning to the funeral, at which point it adds a French children's ditty, *Frère Jacques,* to its comical allusions. The last movement starts apocalyptically, imitates a Viennese sentimental song, adds trumpets, and ends with a brassy coda. Everywhere the tunes are good and the orchestral treatments picturesque. There is a young man's fascination with rhetorical structure elements — with introductions, transitions, and perorations. It is charmingly immodest and delightful for the outrageousness of its satire. I think it is the loving hand beneath it all that gives the work its reality. Mahler loved writing music and loved dramatizing the relation between the composer and his material. This drama, I think, is his music's most intense expression and its most original.

The vigor with which this drama came forth yesterday was Mr. Walter's contribution. Among all living conductors he has the freshest remembrance, I suspect, of exactly how Mahler's music felt in Mahler's time. Certainly it all felt fresh at that time, and certainly the First Symphony felt like a striking and somewhat scandalous piece by a young conductor of genius. Walter did not underline the scandalousness; he leaned rather on its sweetness. And by doing so he made it seem youthful and aspiring, which it also is. He could have given it the portentous treatment. Some do. Instead, he read it as if remembering his own youth, which was not far, after all, from Mahler's — only a decade and a half.

JANUARY 25, 1954

Composer and Critic

♒ MUSIC IN the twentieth century is the subject of a congress to be held in Rome this spring from April 4 through 15. Composers, critics, and interpreters from everywhere will be present as the guests of the inviting organizations, which are the European Culture Center (Geneva, Switzerland), the Congress for Cultural Freedom (Paris and New York), and the Italian State Radio. Twelve composers, including the Americans Ben Weber and Lou Harrison, have been commissioned to write works which will compete for three large cash prizes (plus other benefits). There will

be lots of twentieth-century music performed by the visiting soloists and conductors. And there will be forum discussions of subjects especially interesting to composers, critics, and interpreters.

This writer has been asked to lead a discussion entitled *The Composer and the Critic*. The choice was an obvious one, I suppose, since he has long been active in both roles. But that very fact may have led him to lack consistency. When another composer's music is unfavorably reviewed, for example, he knows that, just or unjust, the reviewer has done his best. But when his own or that of one of his close colleagues receives such a review he tries to convince himself, just as any other artist does in that circumstance, that the reviewer is ignorant, stupid, and very probably in the pay of some enemy.

The truth is, at least in America, that music critics do not take graft. They are not even offered it on any scale that might be tempting. Neither do they fight very vigorously against the survival of new techniques, new talents, new esthetic positions. They inform the public as well as they can about these; that is what they are hired for. They cover the musical front, report on it as knowingly and as sympathetically as they are individually capable of doing.

Actually critics, composers, and performing artists have at least one motivation in common, namely, the advancement of music, which is the art they live by. They are also busy advancing their own careers. Now any workman in the arts is entitled to consider his own career important. Every career is, as a matter of fact. The music of this our time, indeed, is simply the music composed by the present writer and his colleagues, nothing else. And this goes for music criticism in our time too. All living musicians — and no critic is respected by his readers unless he has some skill in the technique of music and some responsibility to it as an art — all living musicians, I say, are part of one great band (or conspiracy, if you will) vowed to the defense of the musical faith and to its propagation.

Their methods of going about this differ widely, and they are always treading on one another's toes. Treading on the toes of composers and performers is, indeed, considered by many as the main business of critics. This is not so. Their main business, really their only business, is explaining the creative or executant artist to the public. Explaining the public to the artist is management's business and that of older artists. Defending the public against the artist is nobody's business, not the impresario's nor the politician's, nor the clergy's, still less that of the critic, whose living depends on the survival of the art he speaks for. Civic and religious leaders are permitted in free countries to alert the public to the danger of circulating seditious or immoral ideas; but their power to stop such circulation is based in really free countries wholly on an agreement among the adult population about what actions are to be considered seditious or immoral. Critics have a different role; they are commentators,

not censors. And artists are producers, not traitors or charlatans. Neither is the public a fool.

A newspaperman once advised me, "Never underestimate the public's intelligence; never overestimate its information." The moral of this for the critic is that he does his duty best by his readers when he describes and explains to the public what the artist is doing. If he adds a paragraph of personal opinion, that is his privilege as a musician. It is also his duty as a reporter, since the confessing of his personal prejudices and predilections helps the reader to discount them. But the description of music is his business, as the performance of music is the performer's business and the designing of it for possible execution the composer's. Consuming it is the public's business and, to this end, judging it. We all judge it. That is a human right granted even to the reviewer. But if the reviewer is not to be mistaken by artists and managements for just a cog in their publicity machine, neither should he set himself up as a Bureau of Standards. We still live in a Republic of Art, thank God. And I, as a member of that republic, as a plain consumer, want access to all the music there is. I also want all the description and information about it I can get, as a consumer's guide. I even enjoy knowing, as a consumer's guide, who likes it and who doesn't. But as an artist, I do not enjoy being disapproved or misinterpreted.

A climate of receptivity is what the artist most desires. It is also a thing that even the most experienced reviewer cannot always offer. Individuality and originality are the bedrock of musical achievement, not ease of learning or technique, which anybody can have. And individuality, originality are no end shocking. The reviewer sometimes takes the shock of them harder than the public. At other times he acts as a buffer, transmits the shock gently to his public. At still other times he serves for nothing at all.

Haydn, Mozart, and Beethoven came to maturity as artists without benefit of the press and without any hindrance from it either. The artist can perfectly well do without criticism — prefers to, in fact. But he loves praise, flourishes on it. And his publisher, his manager help him to live by publicizing the praise that he receives. So any artist tends to consider that praising him is the critic's business, or at the very least giving him lots of space. The critic, on the other hand, is an essayist who knows that he can write a more interesting article about something he knows than he can do about a work or personality that he has only recently encountered. There is the further fact too that a vigorous attack is more entertaining than any defense. (As William Blake said, "Damn braces; bless relaxes.") And so any critic, faced with the even faintly unfamiliar, will tend, like any knight-errant, to attack it, or at the very least to dismiss it with a snort.

To the critic every producing composer is a challenge. To the com-

poser every critic is a danger. All this makes tonic the musical air. But there are fools in both camps. The composing fool thinks the press is out to get him, does not realize that he is merely grist for its mill and that as long as he gives it grist the mill will grind for him. The reviewing fool thinks he can make his fame by praising successful performers and dead composers, not knowing at all that critical championships have always been won and are only won still in bouts with a living composer.

The audience for all this is one audience, for the same people read about music that listen to it. Toscanini's public, Stravinsky's public, and Olin Downes's public are drawn from the same pool of music consumers. And all three men are workers before that public and are not, except as individual consumers, members of it. What they have in common is membership in the professional world of music. Their quarrels about music are family quarrels. A critic is therefore a musician who offers to the public as his contribution to the art an inside view of loves and hatreds and mechanisms and methodological warfares that were never intended to be exposed, but of which the public exposure is considered to be good for business. Your critic, as we know, seldom kisses, but he always tells.

FEBRUARY 14, 1954

Critic and Performer

✺ REVIEWING performances of familiar music takes up the largest part of a critic's week. It is also the easiest part. Reviewing new pieces is the hardest and the most important, for that is where criticism touches history. The history of music, we know, is the history of its composition, not of its performance. But musical performance, by mere abundance, occupies the foreground of the contemporary scene. Consequently the reviewer is largely occupied with reporting it.

He is usually, moreover, fairly well prepared to report on it, because his musical education has surely given him some experience of a musical instrument. Rare is the reviewer who is not able to identify himself with a man at a piano. Others play a stringed instrument. Many have a vocal history. And if they know before they start reviewing music something of performing techniques, they also, through going to concerts, soon become familiar with the repertory and with current standards of interpretation. It is not hard to spot an ugly tone, an off-pitch phrase, a messy jumble of notes, a lovely sound, a transparent texture, an authoritative personality. One critic can make a mistake, hear wrong; but the ensemble of the press in any musical center rarely misjudges gravely a performing artist.

Misjudgments in this field occur most frequently with regard to advanced styles of interpretation. Reviewers tend to accept the customary approach to any piece as an inherent characteristic of that piece. A radi-

cal change based on the most advanced musicological research they not infrequently mistake for clumsiness. They imagine a norm of interpretation to exist for any work or school of works and consider the artist to have failed who deviates from that norm. The opposite is true, however. No such norm exists; there are merely habits imitated from successful artists. The true version of a work is not to be found in the most admired contemporary interpretation but rather in its printed notes and in such historical information as is available about what these notes meant to the composer and to other musicians of his time. Styles of interpretation change about every quarter of a century, and the great interpreters are the ones who change them, not those who copy yesterday's changes.

It is this constant restudy of the classics that gives life to our musical tradition. Attempts to discourage such restudy whenever it does not originate in Vienna, which it seldom does, are characteristic of that large segment of our music world that stems from Vienna. Berlin was never so reactionary and Paris never so powerful. Our musical press in America owes some of its finest qualities (its consecration, for instance) to the influence of Vienna, but also its tendency to reject without examination any restudy of the great classical and Romantic repertories.

But if our musical press lacks (and sometimes willfully) an intellectual background for the judging of new interpretations, interpreters themselves have for the most part no clear conception at all of the reviewer's assignment. They think every review is written to them, is a personal communication. It is no such thing, of course. It is not a free lesson offered the artist; it is a description *for the public* of how the artist works. And if it involves, as it must, some analysis of technical faults and virtues, that analysis has as its only purpose answering the question, "How did he get that way?"

I admit a tendency among reviewers to give vocal lessons in public, and I deplore it. No critic ever complains that a pianist used too little arm weight or that a violinist's bow lacked control from the forefinger. They do not correct the soloist's fingering of octaves or the conductor's beat. But they do say that Miss So-and-So failed to "support her tones." This phrase does not describe an auditory effect but a state of muscular control. Bad pitch, gasping breath, false notes, wavering tone can be heard; and it is legitimate to mention them. It is not legitimate to tell an artist in public how to correct them. Our business is to describe the symptom, not to diagnose its cause or prescribe a cure.

Another common fault of the reviewer, and one which causes the greatest bitterness among artists, is carelessness of statement. The reviewer all too frequently fails to meet the performer on the performer's own level of workmanship. When an artist has devoted large sums of money and years of his life to acquiring a skill, however imperfect the result may be, the reviewer owes him the courtesy, the proof of integrity,

of exercising a comparable care in his report to the public about the artist's work. He does not have to be right; nobody does. But if he wishes the public to believe him and musicians to respect him, he must arrive at his opinion by fair methods; and he must state it in clear language.

The reviewer gets tired toward the season's end of hearing music, all too often the same music, and of sitting through third-class performances. The music world is incredibly full of third-class artists, many of them in first-class posts. It takes some self-control to keep one's patience with them. But they are doing their best; and they have a great deal to lose, even the famous ones, from a review which lowers their dignity. And the kind that lowers their dignity most is the kind that is badly written.

An artist's privilege is to make music as beautifully as he can, and a critic's privilege is to write about the artists as truly as he can. This involves some thought and some care. Also some humility. The artist works best when his ego is big, when he feels confident. The reviewer works best when his ego is small, when he feels respect for the artist's integrity, however minor may be his interest in the artist's work. The poorest performance does not justify a poorly written review or any assumption of the right to grant or withhold degrees. Writing a review is not giving an examination; it is taking one. The subject is whatever musical occasion one has attended. One has, as in any examination, a limited time in which to produce an essay on some theme suggested by the occasion, preferably one which permits the reviewer to include in his essay a clear report and a fair estimate. It has been my experience that the public is invariably grateful for an informative and well-written review and that the artist rarely resents it. It is my conviction that he has every reason, however, to resent from the reviewer inaccurate reporting and slovenly writing.

FEBRUARY 21, 1954

Casals and the Matterhorn

∾ SWITZERLAND contains forty-three big climbs, thirty-nine of which start from Zermatt. The most celebrated of these are the Monte Rossa and the Matterhorn. To this diamond necklace of summits surrounding the village, itself as charmingly intimate, and about as inaccessible, as Aspen, Colorado, has lately been added that gem and pinnacle of music-making in our time, Pablo Casals. For three weeks, from August 18 to September 8, the great cellist presided over a summer academy, small but ever so distinguished, and gave for the first time in many years public master classes in the interpretation of cello literature. He says that he cannot remember exactly when he gave his last course of the kind at the Ecole Normale de Musique in Paris but that surely it was not later than the 1920s. I remember his course on the Bach suites, given there in 1922; but I do not know whether it was the last.

In any case he has been giving such classes again; and this season their subject was the cello works of Beethoven. The Zermatt Summer Academy of Music, let me add, bears little resemblance to its famous elder brother, the Prades Festival. The latter is a recording deal, and its concerts are largely concerned with showing the master cellist in musical association with some of our younger pianists, violinists, and conductors. It does not cater to cellists or attract them much, save for a few former Casals pupils who turn up now and then for a private lesson.

Zermatt, on the other hand, is chiefly for cellists. A string quartet in residence (the Vegh) illustrated this year a course in quartet playing. A trio (Arpad Gerecz, Madeline Foley, and Carl Engel) did the same for a course in the Beethoven trios given by Paul Grümmer, who also gave, under Casals, a cello class. Sandor Vegh (of the quartet) handled the Beethoven violin sonatas and played them with Engel. Vocal coaching, not limited to the works of Beethoven, was offered by Hans Willi Häuslein. Mieczyslaw Horszowski played a recital of Beethoven piano sonatas but did not teach. He also played (but perfectly) with Casals in two private concerts, limited to the students of the Academy and a few invited guests, all five of the Beethoven sonatas for cello and piano, plus the horn sonata, opus 17, which for over a century has been played as a cello piece and which was probably familiar to Beethoven in this form. Casals's own class included sixteen cellists, four pianists who came as members of cello-and-piano teams, two pianists who came independently to study the Beethoven cello-and-piano works (twenty-two working students in all), and nine auditors.

This listener climbed the steep mountain valley (by car and electric train) to hear the master play with Horszowski Beethoven's chief cello works. (The three sets of variations were omitted.) And the experience was both memorable and revelatory. He discovered for himself that Casals is not only a fine musician, which everybody knows, but also a great technician of the cello still, a fact which has been little played up in the Prades publicity and a fact of cardinal importance to music today. Because, though there are fifty, at least, living musicians of the cello literature who are comparably enlightened about it, there is none other, to my knowledge, who knows so well the limitations and possibilities of the cello as an instrument of music and who can demonstrate them so convincingly in their application to the cello's classical repertory. If this is true, as I believe it to be, then the cellists of the world should remain in contact, for as long as Casals himself remains in the world, with their instrument's chief present source of artistry and excellence.

There is no doubt that the cello's present period of technical expansion derives from the playing of Pablo Casals. Anybody in the cello world will tell you that. And, though many of the devices involving the so-called thumb positions (for playing high passages, for instance) were in-

vented by the nineteenth-century Belgian virtuoso Franz Popper, their application to music-making in a first-class musical way was made by Pablo Casals alone more than forty years ago. His technique has always excited musicians profoundly because of his musical penetration. And his musicianship has always stirred them because of his technical superiority. He has viewed music through the technician's lens and studied technical problems through the microscope of musical analysis. As a result he makes Beethoven sound better than it ever did before, and he makes the cello sound better too. He has done this for many years; he still does it. And if other cellists are doing it more and more of late, that is because he is the father of them all.

His technical mastery (and musical too, for with him they cannot be separated; in that way his mind is as Spanish as a bullfighter's) — his mastery in general, let us say, has always been remarkable for three qualities. These are, still are, his ability to play on pitch, his ability to move his left hand up and down the fingerboard without sliding, and the studied character of his vibrato. The first two are technical skills; the other is a matter of musical analysis. All apply to the left hand. It was easily observable the other day in Zermatt that for simple harmony notes that were not part of the thematic discourse he used no vibrato at all. But as soon as melody spoke vibrato began. If a melody note diminished in volume, his vibrato diminished in speed and width, coming completely to rest just before the end of the note. For a crescendo on the bass strings he used a very wide vibrato, produced by means of it a tone of great power. At other times, especially playing without vibrato, his tone was so soft that only its penetrating and stringy character seemed to give it any presence at all.

Great presence it had, nevertheless; and this presence all came from the right arm, from the bow. The evenness of his bow from heel to tip, moving very slowly and playing ever so softly, betrayed a muscular control that few cellists of any age have at their command. In fact, the bow was so wholly under his command, at all times in optimum contact with the strings and moving at exactly the necessary speed, that not once in either of the sessions did the cello's tone whistle, grunt, growl, or scratch. Neither did it weep, I may add, though tears on the cello are a matter of deliberate musical taste rather than of technical abandon. If Casals does not indulge in them, that is because his expression has ever been impersonal, objective, a little distant. His Catalan reserve has no place for self-pity, for what the Spaniards call *patetismo*.

His personal expressivity nowadays is toward a straightforward vigor in vigorous passages, a healthy muscular vigor quite void of emotional urgency, toward a meditative quality in all those *misterioso* passages that were so dear to Beethoven, and in the songful ones toward an intense sweetness that is less an outpouring than it is an evocation of the mem-

ory of song. At the peak of his senescent years, for he is only seventy-two, it was with Beethoven's last cello sonata that the Casals qualities of sensitivity, of sadness, and of resignation seemed most perfectly paired. One understood, both in the work and in its performance, the meaning of the poet's phrase "all passion spent." And the whole presence of both was the more vibrant since every other vigor had remained intact.

Vibrancy in resignation is what makes of Casals today a sort of musical saint. But the miracle that he performs, and a true saint must do miracles, is to make familiar music flower and a familiar instrument sing. For doing this he has, like any saint, both inspiration and method. And if the result seems at times almost supernatural, that effect comes from an interpenetration of ends and means so complete that we wonder however it could have been achieved. One can name the elements of it, but not explain their fusion.

Cellists have a great deal to gain from studying that result and consulting the author of it. As does any other musician too. But let no one ever forget that when Casals plays the classical masters he is also playing the cello, an older and possibly more miraculous creation than any piece ever written for it. I suspect, indeed, that the instrument itself, even more than Bach or Beethoven, is his true love. There is something almost marital about Casals's matter-of-fact command, as if the way he plays the cello were the true way finally found, the way it always should have been played, the way it finally now can be played, and surely the way it will henceforth always demand to be made to sound.

SEPTEMBER 14, 1954

❧ PART 6

Later Articles

ᴗ Music for "Much Ado"

*A*DDING MUSIC to Shakespeare's plays is for the composer a disci-
pline of modesty. Some music is invariably required; but this has
been so carefully limited by the poet, boxed in to the play's bare needs,
that one comes out of the experience convinced that the Bard was wary
of all music's disruptive dangers and ever so careful lest musicians, a
powerful and privileged group in Shakespeare's England, steal the show
from poetry.

The tragedies sometimes ask for just one song, rarely more. Occasion-
ally it is possible to add at the end, as in *Hamlet*, a funeral march. The
rest of the music can be done with trumpets and drummers, two of each.
They announce royal exits and entrances, indicate from off stage the ad-
vance and retreat of soldiers, even evoke (by an antiphony of pitches
and motifs) armies in combat, triumphs, and defeats. The drummers can
also, on cymbal, bass drum, thunder drum, tam-tam, bells of all sizes,
wind machines, and other sound effects, produce the storms, fogs, and
other species of foul weather that play so important a part in the tragedies.

It is usually better to produce these effects through musicians rather
than through stagehands, to score them and conduct them, to control
them in timing and volume through a series of electric light cues coming
directly from the stage manager. (No one can hear word cues while play-
ing percussion.) Only in this way, and after much rehearsal, can they be
used to build an actor's vocal resonance acoustically, like a good musi-
cal accompaniment, rather than compete with it, fight against him, de-
stroy his finest flights.

The comedies require few battles and no bad weather, allow for a bit
more music. There may be an extra song, sometimes a moment of danc-
ing, the evocation of a balmy night, a brief wedding, and, instead of the
funeral march, with luck a gracious musical ending not unlike our mod-

ern waltz finales. In general, however, the music cues are brief and, as in the tragedies, limited to the minimum needed for defining an atmosphere. Nowhere in Shakespeare, save in *Henry VIII*, which is not wholly from his hand, will the composer be allowed to create the massive ecclesiastical ceremonies, grand marches, ballets, balls, and dream sequences that abound in Marlowe and Webster. Everywhere the music must be straightforward, speak quickly, take no time at all out of the play's dramatic pacing.

Under modern union rules and heavy costs, the musicians may be as low as four in number. The choice of instrumentalists for meeting the play's musical requirements with a minimum of monotony is a matter for much care. Gone are the days when Mendelssohn could use a full orchestra for *A Midsummer Night's Dream*, filling the theater with symphonic sound and holding up the play for the musical working out of themes, the injection of intermezzos and of expansive "numbers." Today's stage music must offer economy in every domain.

Stylistically, music for a spoken play must always be subservient to the visual element and to the verbal as well. A production, first conceived by the director, must be sketched for the sets and costumes before the composer of incidental music can effectively plan his contribution. A sumptuous visual style needs richness in the auditory too, and a meager, or bare-stage, production invites music of minimal luxuriance. In every case, music is an extension of the decorative scheme.

There is also the matter of time and place. Many a director and his stage designer find it helpful to take a script out of its period. Sometimes the script itself gives such a choice. *Hamlet*, for instance, can with equal ease be put into a medieval Denmark, into a Renaissance Denmark (contemporary with Shakespeare), or into modern dress. Music should accentuate, underline the chosen background. Consequently it should not, for the best result, be even thought about by the composer before the period references of the production have been determined. Suggesting through the musical style of Richard Wagner or of Tchaikovsky the plush comforts of Queen Victoria's time (which was theirs), or using neat Mozartean turns and balances, however appropriate these might be in a setting of eighteenth-century court life, is not likely to be of much help in *King John* or in *The Merchant of Venice*. Stage music need not be historically authentic, but it should help to evoke, like the settings and the costumes, whatever time and place the director has chosen to evoke in his production.

The performances of *Much Ado About Nothing* that were first produced at the American Shakespeare Festival Theatre in Stratford, Connecticut, during the summer of 1957 represented in their visual and musical design exactly the sort of director's choice that I am describing. That choice has seemed arbitrary to many. Taken originally by the co-directors, John Houseman and Jack Landau, accepted with delight by

Katharine Hepburn and Alfred Drake, the Beatrice and Benedick, as well as by Rouben Ter-Arutunian, who designed the sets and clothes, and by the present writer, who wrote music for the production, it seemed to us all, and still does, I think, imaginative and wise, a contribution even, to the play and to its comprehensibility in our time.

The decision, a radical one, was to set the play somewhere in northern Mexico, in what is now Texas or southern California, in the middle of the nineteenth century. Shakespeare had put it in a Sicily of his own time, or a little earlier, under the Spanish occupation. Now, this locale is not a vague one like "the seacoast of Bohemia" in *The Winter's Tale* or the Illyria of *Twelfth Night* or the even vaguer Vienna of *Measure for Measure*, slight masks, all of them, for English country life, or for London. The people in *Much Ado* are as characteristically Spanish as those in *Othello* and *The Merchant* are Venetian. They are proud, simple, sincere, energetic, and deeply sentimental. Even the villain is proud of his villainy and quite frank about it. None of them has the malice or the snobbery or the vainglory or the need of being two-faced about things, the divided mind or the indirection that abound in Shakespeare's other plays. Everybody is childlike, surely Catholic, and deeply, tenderly, permanently oriented toward affection. Also there is no war between the generations.

Since Shakespeare says these people are Spanish colonials, and since their characteristics are in fact recognizable today as those of Spanish colonials, changing their nationality would be a mistake. Surely the young Claudio who, believing he has caused the death of his beloved by doubting her virtue, accepts as a penance for his sin to marry sight unseen a cousin (nonexistent) invented by his fiancée's father is none of Shakespeare's English young men. Only as a Spaniard, believing in sin and its consequences, fatalistic, loyal to the results of his own actions, can he be believed and sympathized with. No matter how the setting of it may be altered, the play must remain a picture of life among well-to-do Spanish landed gentry.

The Sicilian background is less demanding — not demanding at all, in fact. The monuments of that isle, its history, and its geography, save for some casual mention of Messina, play no part. Using Sicilian landscape or architecture, Hispano-Sicilian clothes, especially from three or more centuries back, would tend to confuse rather than to clarify the play's understanding today. And transporting it to Shakespeare's England, always a possible choice, would not be a happy one, so thoroughly un-English is the love story.

And so, as a result of meditations and of searches after other alternatives, the idea was conceived that a rich ranch house in Spanish North America would be just the place for Hero and her father, for Claudio and his young friends just back from brilliant conduct in some military

action. Beatrice and Benedick, of course, fit into any time or place that offers a background of mating and matchmaking. The whole play, it was agreed, could be brought to life in such a setting with a maximum of recognition on the part of twentieth-century Americans and a minimum of violation to the poet's meaning.

Now, the music cues in such a setting are no different in placement or in length from what they would have been had the play been left in Sicily. But their character, their whole style and texture, were of necessity determined by the adopted time and place. Like the scenery and the costumes, the easy movements and the formal dances, they had to evoke nineteenth-century Spanish America.

With that in mind I went to the New York Public Library and examined all the collections of folklore and old popular tunes from northern Mexico and the American Southwest. I copied out everything that I thought might possibly be useful. Then I consulted with my directors to determine the spots where music might be needed, desired, possible to introduce, and about the number of musicians the production budget would allow.

As it turned out, I got nine instrumentalists; and I chose a flute (doubling on piccolo), a clarinet, one percussion player (who could also play bells, or glockenspiel), two trumpeters, one viola, one cello, and a man who could play both guitar and double bass. In addition, the management provided, just for singing the songs, the famous countertenor Russell Oberlin (dressed as a peon of the ranch). There was also a conductor, not really necessary; but since he was attached to the theater that season, and could also play the piano, he was a useful luxury. I arranged placement for my musicians in a covered pit where they could be heard but not seen; and the electrician placed microphones and loud-speakers so as to amplify my string section without that amplification being detectable.

I shall not give here the list of music cues, because we did not follow exactly the script of the play. Nowadays virtually any director does make cuts for brevity and for modern pacing. He transposes the order of scenes. He allows only one or two intermissions. He may add moments of pantomime and dancing, if the story invites them. He may even interpolate an extra song from some other Shakespeare play, if he has a charming singer, or omit those already there, if he does not. In short, he cuts and reshapes the play to a modern audience's taste for a clean trajectory. He does not, of course, rewrite the prose or poetry. What he does is comparable to the cuttings, transpositions, instrumental substitutions, and adjustments of orchestral balance that any conductor makes for the performance today of an oratorio by Bach or Handel. Such changes are every bit as legitimate as using women instead of the boys that Shakespeare's time required in the female roles. But they do make

every director's production a "version," and they do determine for that version the placement of the music cues.

In the Houseman-Landau version of *Much Ado* the soldiers returned from war by marching down a main aisle, led by a fife and drum playing quickstep. For this I used the most commonplace tune possible, the familiar Jarobe Tapatio, generally known as *Mexican Scarf Dance*, and speeded it up for excitement. I later used *La Golondrina* too, this timed as a habanera. These tunes, plus another almost equally familiar, reappeared in different instrumentations, as if they were familiar banalities of the time and place (which, indeed, they were). They helped to establish a folksy and easygoing Spanish-American ambiance. They also served to set off by contrast the more refined musical background of the ball.

For these latter I found authentic bits from the old Southwest, took two dance tunes from Spain, and composed a waltz. I needed a waltz for romantic feeling. But our Spanish Americans had no waltzes of their own. They used (bought copies of it by the thousands) a German waltz called *Over the Waves* (to them, *Sobre las Olas*). This did not seem right to me to use; it is too familiar to be effective save in ironic or caricatured version. And I needed a waltz with some lift in it. So I wrote one that might have come from anywhere, that evoked the romantic feeling that upper-class people everywhere in the nineteenth century associated with three-four time.

The famous song beginning "Sigh no more, Ladies" I composed in two versions and used in two places. One version was in espagnoloid Scottish style, with syncopations derived naturally from the word accents, and a vocal flourish at the end. The other was a fandango in which the words clicked like castanets. This latter so deeply offended the taste of my singer, an expert in Elizabethan songs and madrigals, that eventually it was removed from the production, just to please him.

It so happened in this production that almost every cue was "source" music, a situation ever to be wished. "Source" music means, in show business, music that can be supposed to come from some source, on or off stage, that is part of the play. It includes the trumpets that announce a king, the drums of the military, anybody singing a song, music that might be part of a household, such as dance music, dinner music, anything present or overheard that offers a realistic excuse for being present or overheard. This kind of music is truly "incidental," though it may be as necessary as any property sword or goblet. And it is the most expressive of all play music, because, its presence being dramatically explained, it can underline moments of tenderness, produce suspense, emphasize climaxes, aid the play through music's great power of producing emotion, without the audience experiencing the shock that comes from a breaking of the dramatic illusion.

More dangerous, but sometimes indispensable for creating a mood, is music that is purely atmospheric, an auditory addition to the scenery. Forests, moonlit gardens, shooting stars (I once produced this last effect through one chord on a celesta), all those states of nature that need to be felt as palpable but that cannot be rendered delicately enough by scenic or lighting effects — these can be, must be, essayed through music. Here the music has a poetic, not a realistic source. It is the voice of Nature.

Music can also speak with the voice of Memory. Soliloquies, confessions of yearning, recalls of innocence and childhood can without embarrassment to the listener be accompanied by soft music of specifically evocative character. Shakespeare, we are told, used for this purpose recorders, a species of flute. Intermezzos and introductions, when not truly "source" music, can also recall, announce, or anticipate without stepping out of the play. Overtures, of course, can only announce, and consequently are best when justifiable as "source" music. Anything else becomes the voice of the manager, the barker at a side show, and is ill suited to the poetic theater. An overture that is like a preview of the scenery can be very effective, however.

Beyond those conventions I know no musical usages that are appropriate to the poetic stage. "Source" music is always the best, but the voices of Nature and Memory need not be excluded. They must only be handled with tact. Occasionally a brief sound effect can be good too, if introduced and ended before the audience has time to realize its instrumental source. This is like physical pain made audible. A tam-tam roll *ppp poco crescendo* as Othello's epilepsy comes on him, a disembodied electronic whine as Banquo's ghost appears to Macbeth, such effects are in the best Elizabethan tradition. If they come off, they are very powerful. But if anyone in the audience laughs, they must be abandoned.

Among the voices I do not consider it proper to represent through stage music are those of the author, who has chosen language as his idiom and should not step out of that convention; the voice of the producer, who is no part of the play; and those of the director, designer, costumer, and composer. These collaborators are speaking, we may presume, for the author by helping the play to speak for him. Their self-exploitation is as offensive as that of an actor who insists on playing some publicized or imaginary image of himself instead of the role we have come to see him do. Stage music, to serve well in performance, must be objective, modest, and as loyal a collaborator of the director's and the designer's plan as of the author's play. That way lie all the possibilities of boldness and of daring. And that way too, so far as Shakespeare's plays allow music at all, lies the only possibility there is for a composer to serve, as a worker, the great Shakespearean texts.

In our Spanish-American *Much Ado*, there was a short overture, a

habanera, to set the locale. Its "source" in the play's reality might be considered to be a café or dance hall outside the gates of the ranch, where our first scene was placed. There was reception music, Hispanic, for the opening of our second scene. From time to time a sentimental Spanish melody, one of those heard elsewhere in the play as café or dance music, was overheard on a guitar beneath some love scene or soliloquy. And there was formal dancing to music during the masquerade. Also, waltz music for the grand march out to supper. Balthasar sang his song to guitar accompaniment. And we ended our Act I on Beatrice's soliloquy with waltz music under it, like a memory, crescendo.

Act II began with café music, and the Dogberry scenes of municipal justice were framed in similar material. Dressing the bride was preceded and in part accompanied by an *alborada,* a salute to the marriage morn. Later there were wedding bells and wedding music. Then more café music, dance tunes on a tinny piano, to mark the police action as taking place among persons of banal taste, whose lives were drenched (literally) in hand-played bar ballads, as ours are in mechanized musical banalities.

Exactly such a tune opened our Act III, and comic drums accompanied a change of guard at the police station. Benedick's song, brief, amateur-ish, and absurd, was not accompanied. Then came funeral music for the tomb scene and for the song *Pardon, Goddess of the Night,* followed by wedding music again, by dance music, and at the end by a fanfare and general waltzing.

Transitions from one scene to another were usually covered by music, either in continuation of the preceding mood or in anticipation of what was to follow. We put as much music into the play as we could, en-deavoring thus to keep the comic and the sentimental tones constantly present and warm. We hoped also that the abundant presence of music on two levels of taste — the vulgar and the genteel — would help us to underline the basic premise of the production, which was that the story takes place on a vast estate with many sorts of people around and many kinds of life going on. It is all a shade provincial; but there are great hospitality, many arrivals and departures, injustice administered casu-ally, military forays, cooks, chambermaids, peons, and musicians con-stantly available for producing a ball, a wedding, a funeral, anything needed in the life of this rich, easygoing, isolated Spanish family.

My music cues would not be applicable stylistically to a production differently conceived. I have described them here for what they were, an auditory extension of the scenery and costumes. These latter illustrated visually the directors' conception of the play. That conception was based on what the directors and their collaborating artists considered to be the nature of the play's people and message. Theirs is not the only legitimate view of these. But once decided on and accepted as a basis for produc-tion, it determined the character of the scenery and of the music. As for

the amounts of music used and its exact placement, we were obliged, in spite of all our efforts toward abundance, to limit our largesse. The controls that Shakespeare once and for all built into this script, as he did into every other, cannot be broken through without doing violence to the script. To make an opera (or even an operetta) out of a Shakespeare play requires abandoning most of the Shakespeare in it.

From *Theatre Arts*, June 1959.

❧ Nadia Boulanger at 75

Nadia Boulanger, who will conduct the New York Philharmonic in four concerts beginning February 15, and who will later this year celebrate her seventy-fifth birthday, has for more than forty years been, for musical Americans, a one-woman graduate school so powerful and so permeating that legend credits every U.S. town with two things — a five-and-dime and a Boulanger pupil.

Her discovery by America occurred back in 1921 when three American students, all new to Paris, came upon her independently. The first of these, Melville Smith, is now director of the Longy School of Music in Cambridge, Massachusetts. The others were Aaron Copland and this writer. All three found her so perfect a purveyor to their musical needs that they quickly spread the news of her throughout America.

She was thirty-four years old at that time and a stately brunette. She held professorships at the French National Conservatoire, at the Ecole Normale de Musique, and at the newly founded American Conservatory in Fontainebleau. She was also second organist at the church of the Madeleine and a member of score-reading committees for the Concerts Colonne (second oldest orchestra in Paris) and the Société Musicale Indépendante (the most advanced of the modern-music groups).

She had already suffered bereavement, including that of her sister Lili, a composer of unquestioned gifts for whom she still wears mourning. Already too, she had renounced all worldly desire for personal fulfillment as a woman or as a composer, devoting herself solely to her remaining parent and to nurturing the musical young. And she was already enmeshed in that schedule of seeming overwork that she has maintained without fatigue to this day, quite commonly receiving students as early as seven in the morning and as late as midnight.

In her fourth-floor apartment at 36, rue Ballu she gave, still gives,

private lessons in all the chief musical branches — piano-playing, sight-reading, harmony, counterpoint, fugue, orchestration, analysis, and composition. There too, among the 1900 furniture and the mortuary mementos of her father, who had also been a professor at the Conservatoire, and of her beloved sister, first woman ever to win the *Prix de Rome*, she held her organ classes at a built-into-the-parlor instrument of two manuals and full pedal keyboard.

And there, of a Wednesday afternoon, took place weekly gatherings of pupils (strictly by invitation) at which the most modern scores of the time (by Stravinsky and Schönberg and Mahler) were analyzed and played on the piano, and the rarest madrigals of the Renaissance (by Monteverdi, Luca Marenzio, and Gesualdo di Venosa) were sung in class. At the end of each session copious cakes were served and tea poured with frightening accuracy by the trembling hand of Mademoiselle Boulanger's aged, roly-poly, and jolly Russian mother, the Princess Mychetsky.

Within the first decade of Boulanger's discovery by America, there came as students to this consecrated circle of pedagogy and high musical thought Walter Piston, Herbert Elwell, Roy Harris, Roger Sessions, Douglas Moore, Theodore Chanler, and Elliott Carter. There also passed through her masterful teacher's hands during the 1920s and '30s Robert Russell Bennett, Arthur Berger, Marc Blitzstein, Paul Bowles, Israel Citkowitz, David Diamond, Irving Fine, Ross Lee Finney, Peggy Glanville-Hicks, Alexei Haieff, John Lessard, Harold Shapero, Elie Siegmeister, Howard Swanson, Louise Talma, and John Vincent. George Gershwin she refused to teach lest rigorous musicianship, acquired at thirty, might impede his natural flow of melody.

For she could not conceive, still does not admit, that musical training without rigor can be of value. Herself a product, on the French side, of musician-ancestors of the highest professional standing who go back into the eighteenth century, she favors a no-nonsense approach to the musical skills and a no-fooling-around treatment of anyone's talent or vocation. As a Russian woman, on her mother's side, she is furiously loyal to her students, deeply affectionate, and relentlessly maternal. By both national standards she insists that every composer must be a musician and every musician, at least by training, a composer.

For all her authority and high recognition in the French musical establishment, her greatest influence has been on foreigners. Jean Françaix is almost her only French composer-pupil of international standing. The other French composers of our century have been taught by Fauré, by André Gédalge, by Charles Koechlin, and, during the last two decades, prodigiously by Olivier Messiaen. But it was Boulanger who formed, in addition to literally hundreds of Americans, the Russian Igor Markevich, the English Stanley Bate and Lennox Berkeley. And she powerfully

influenced by her teaching the great Rumanian pianists Dinu Lipatti and Clara Haskil.

If today there are fewer Americans than formerly in her immediate entourage, they have been replaced by fantastically gifted Turks, Iranians, Lebanese, Indians, and Egyptians. Being midwife to developing musical nations would seem to be her basic role.

She told the first Americans who came to her that they would find no model in Western Europe for their growing pains, and very little sympathy. On the other hand, she maintained, America in the 1920s was very much like Russia in the 1840s, bursting with inspiration but poorly trained. Strict training and real musicianship needed to be inculcated without injury to the music-writing urgencies. These it was important to establish early in daily habit, like the bodily functions, so that difficulties of unaccustomed musical exercise would not be uselessly added to the labor of creation.

Her teaching of the musical techniques is therefore full of rigor, while her toleration of expressive and stylistic variety in composition is virtually infinite. She does not, however, encourage her students in twelve-tone-row composition, which she considers to be a form of musical "speculation," in the philosophical sense of the word, rather than a road to expression. She has found that Stravinsky, whose "genius" has already protected him through many another perilous adventure, experimenting with it in his seventies is not reproachable. Nor can she find it in her heart to blame the young Pierre Boulez for far-outness, considering the phenomenal brilliancy of his mind and the impeccable nature of his musical ear. She does believe, however, that serial dodecaphony is in general a musical heresy and that its influence risks creating as permanent a division among musicians in the West as the Protestant Reformation did among Christians.

All this, the musical Left might easily answer, is also "speculation." And if the young need lessons in traditional music-making, as Boulez himself admits, then these can be accepted from any competent musician, even from Nadia Boulanger. But competence at teaching the musical disciplines and a conservative-to-tolerant attitude toward students' compositions do not fully explain the vast musical influence she has exercised over the last forty years.

The real utility of this remarkable woman would seem to be not in her mastery of musicianship or in her devotion to high standards, virtues that are not hers alone. What she does possess to a degree rarely matched is critical acumen. She can understand at sight almost any piece of music, its meaning, its nature, its motivation, its unique existence; and she can reflect this back to the student like a mirror.

Suddenly he sees that which has caused him pain, struggle, and much uncertainty unveiled before him, without malice or invidious compari-

sons, as a being to which he has given birth. Naturally he is grateful. His work has been taken seriously, has received the supreme compliment of having its existence admitted.

Viewed in this warmly objective way, his piece may seem to him worth correcting, or it may not. If its faults appear to be minor, eliminating them can be a joy. If his child seems born to be permanently a cripple, he may cherish it but not let it out into the world. Or he may let it die in a drawer and try to avoid the next time whatever has caused the hopeless deformity. All such decisions are up to him.

The lessons take place with the teacher at the piano, the student in a chair at her right. She reads the score before her silently at first, then little by little begins to comment, spontaneously admiring here and there a detail of musical syntax or sound, expressing temporary reservations about another. Suddenly she will start playing (and perfectly, for she is a fabulous sight-reader) some passage that she needs to hear out loud or that she wishes the student to hear as illustration to her remarks.

She may eventually ask if the author does not perhaps find the whole work underdeveloped or overextended. She may point out the stylistic sources of its material and how these have been not at all considered, may even have been gravely contradicted, by their harmonic treatment.

Throughout the session she will have perceived music avidly and with pleasure, described it quickly, diagnosed its needs with humility.

About these needs the student can always argue, either right then with her or later with himself. Anyone who allows her in any piece to tell him what to do next will see that piece ruined before his eyes by the application of routine recipes and of bromides from standard repertory. The student who seeks his remedies at home, alone, will grow in stature. And she will wrestle with him in talk week after week, building up his strength for him as he himself wrestles his musical ideas into clarity and coherence.

Writing music, as Boulanger understands it, is exactly like writing a letter. It can come painfully or with ease; but it must come from the heart, and it must communicate. Speaking "from the heart," let us add, means speaking only for oneself. Nobody can write your music for you.

In the long run, learning to write music under Boulanger's care is a matter of training the hand and ear, and of establishing the custom, the habit, of giving birth to musical works. It is as simple as that and as utterly valuable, particularly so in countries where giving birth to musical works has become intensely urgent but is not yet a schooled procedure.

Preconceiving the kind of works her pupils are to write was never the Boulanger method. Nor does she encourage it in her students either. Strictness and premeditation, in her book, are only for training circumstances, like a dancer's exercises at the bar. The creative act should be free,

a gratuitous communication or, as Tristan Tzara put it once, "a private bell for inexplicable needs."

That way, she believes, lie all the possibilities there are of originality, of individuation, of truth, and of humane expressivity. Any other approach to the creative act in music, according to Nadia Boulanger, is timid, conformist, and artistically dishonorable.

Certainly the intensity of her belief and the speed of her musical understanding have filled the non-French world with musicians grateful to France on account of her. The honors being offered her here are not her first. She has led the Philharmonic before; and she has conducted too the Boston Symphony, the Philadelphia Orchestra, the Royal Philharmonic of London, the best Parisian orchestras, and many others. She has taught at Harvard, at Santa Barbara, and in Baltimore.

Nowadays she travels constantly, especially behind the Iron Curtain to Poland, Rumania, and Hungary, though she is by no means a Communist, being by conviction both Catholic and Royalist. What she likes to observe there is the way music survives under political change.

Countries large and small, new and old, are grateful to her, though perhaps the newer countries use her powers best. And America, it would seem, must be considered musically a new country. At least it is not a long-ago-matured one like France or Germany, Italy or England, though it ripened musically before any other country in this hemisphere except Brazil.

All this is part of the Boulanger world-picture. She is a one-woman Musical UN, encouraging growth and obliterating ignorance. She does not fear the largest, like America, nor neglect the smallest, like Monaco, where she bears the title of Maître de Chapelle to His Highness the Prince. At the drop of a hat she would probably move in on Russia. She speaks the language, knows the problems, could certainly give advice on how to exploit more fully than is being done the talent resources there and the possibilities of creating on a vast scale music of beauty and distinction.

America does not greatly need her now, though she remains our alma mater. Her pupils are teaching in our every conservatory and college, carrying on her traditions of high skill, expressive freedom, and no nonsense. She loves us for old times' sake, as we love her: and she adores revisiting us. But her real work today is with students from the just-now-developing musical regions. That way lies her ability to go on being the greatest music teacher in the world so long as her physical powers shall remain. As of now, they seem to be limitless.

❧ Wanda Landowska

Landowska on Music
Collected, edited, and translated by Denise Restout, assisted by
Robert Hawkins. Stein and Day, 434 pp.

BORN IN 1879 in Poland, Wanda Landowska was characteristically a
product both of the nineteenth century and of Eastern Europe. In War-
saw she studied piano with teachers who specialized in Chopin. At sixteen
she went to Berlin to learn to compose; and it was there that she formed
the musical attachment that was to guide her life, an unquenchable pas-
sion for the works of J. S. Bach.

At twenty-one she "eloped" to Paris with a compatriot, Henry Lew,
who, though he had adventured in journalism and in acting, was pri-
marily an ethnologist. It was largely under his guidance, in fact, and
certainly with his help, that she shortly began the historical studies that
led her to publish in 1909 a pioneering book about the harpsichord and
its repertory, *Musique Ancienne*, titled in its American edition of 1924
Music of the Past. She had formed friendships almost instantly, more-
over, with the French performing musicologists of the Renaissance,
Charles Bordes and Henri Expert, with the medievalist Maurice Em-
manuel, and with the Bach scholars André Pirro and Albert Schweitzer.

Presented to Paris in 1901 as a rising composer and as a piano virtuoso
of some renown, by 1903 she was beginning to play Bach on the harpsi-
chord — to the vigorous disapproval of Charles Bordes, though not of
Schweitzer. In the latter's famous *Jean Sebastien Bach, le Musicien-Poète*,
of 1905, he praised her performance of the *Italian Concerto* on a Pleyel
harpsichord, though this instrument has usually been thought of as hav-
ing come into existence later, since the public debut of the large Pleyel
with octave bass did not occur until 1912.

In the meantime, however, Landowska toured Europe unceasingly from
Russia to Portugal, always with some sort of harpsichord, at first playing
on it only one piece per concert, so disturbing was its sound in Bach to

piano-conditioned ears; and everywhere by mouth and by print she preached its virtues. Everywhere too Henry Lew was her personal representative and impresario. Indeed, she became so used to his care that she took it for nonexistent and refused to believe, touring America alone in 1923 with four very large Pleyels, that she needed either a concert manager or anyone in charge of logistics.

During her touring years she amassed a notable collection of keyboard instruments, old and new, acquired valuable books and manuscripts, bought eventually at Saint-Leu-la-Forêt, just north of Paris, a comfortable house to lodge them all, adding to its garden a hall for playing concerts of a Sunday to paying pilgrims and establishing there her *Ecole de Musique Ancienne.*

Save for one unhappy essay at teaching in Berlin, where she moved with Lew in 1913 and where, being caught by the 1914 War, they were prisoners on parole until its end, France was her home from 1900 till the end of 1941. When on Pearl Harbor day she arrived in America as a Jewish refugee, she was interned at Ellis Island because the name on her passport was Lew and not Landowska, as on the ship's list. Letters from known musicians, however, procured by the singer Doda Conrad, got her released overnight, along with her cased-in-lead harpsichord. This going-away gift from a Swiss pupil she had awaited some eighteen months in Marseilles, her own instruments and library having all been left behind in her hasty departure from Saint-Leu of June 1940. Henceforth she lived only in New York and in Lakeville, Connecticut, where till near her death at eighty, in 1959, she continued to play, teach, and record her repertory.

Denise Restout, her pupil, musical assistant, and constant companion for twenty-six years, has preserved the notes, diaries, and manuscripts that were not lost in the systematic sacking of her house in France; and a selection of these, translated, forms the main part of the present book.

These vary in seriousness from the highly documented emendation of a Bach fugue — subject to the casual remark that this same fugue (the first of the forty-eight) always makes her "think involuntarily of the overture to *Die Meistersinger.*" They are in fact a monologue at once learned and lively, penetrating, and to any musician communicative, yet as often as not improvisatory, dithyrambic, and embarrassing.

The book's beginning part is a condensed version of *Musique Ancienne* incorporating six earlier articles and one later one. The second section, mostly new, details the observations of a knowledgeable and passionate interpreter about the keyboard works of J. S. Bach, W. F. Bach, C. P. E. Bach, of Handel, of all three Couperins, of Rameau, Chambonnières, Scarlatti, Purcell, and the Elizabethans — in other words the harpsichord repertory as established by Landowska. Also, on the Haydn Concerto, which she brought to light, and on certain piano concertos and sonatas by Mozart. Biographical items are being kept back for another volume

and those considered overtechnical for mere reading reserved for direct pedagogy. A third part, which might well have been entitled *Rhapsodic Remarks*, is salted up here and there by a neat malice toward contemporary composition. For of recent times she really liked only Gershwin and jazz.

Wanda Landowska was an interpreter of high temperament, a technician of phenomenal finger discipline (one wholly invented by her for the harpsichord), and a scholar whose learning was used only to facilitate familiarity with times past and identifications with composers long dead. Her origins as an East European still remembering Romanticism, her subsequent submission in France to the disciplines of musicology, and her constant covering of the entire continent on scholarly errands and concert tours all made of her an exemplary European and an embodiment of what used to be called "*la grande sensibilité européene.*" Her view of Europe as a diversified breeding ground of individuals rather than as a stud farm for producing characteristically French or German genius types, enabled her to see differences and similarities in European history with a fresh eye. And her special position in the great musical centers as both a foreigner and a woman made it urgent to permit herself no weaknesses regarding mastery.

A certain Easternizing of the West (in Vienna absorbed by "pop" music, in France this went straight to the top) was clear in the 1830s with Liszt and Chopin being adopted by Paris. Later the Russian virtuosos also came to stay, and in our time the whole entourage of Diaghilev, including Stravinsky. Only eight years younger than Landowska, the half-Russian Nadia Boulanger gave also to the teaching of music in France a dimension just newly available. And this novel dimension, the same indeed as Landowska's — for in its origins it was both an outsider's view and a woman's — was an ability to recognize in any music its uniqueness and particularity, in other words, to spot by instinct what makes one piece of it different from another, surprising resemblances, of course, helping out this identification.

Wilhelm Friedman Bach, for example, "makes [Landowska] think of Brahms, while Karl Phillip Emanuel strongly evokes Schumann. His [C.P.E.'s] excessively sorrowful and morbid character indicates degeneracy . . . Whereas Johann Sebastian's music, carved out of granite, powerful and inexorable, is sensuousness itself, that of . . . Karl Phillip Emanuel, the king of the gallant style, is emotive, but devoid of sensuousness."

And as one argument for the influence on Chopin of Chambonnières, Couperin, and Rameau (indirect, for Chopin surely did not know their music) she remarks that "the fundamental trait of the harmony in Couperin as well as in Chopin is the consubstantiality of this harmony with the melody . . . This is why it is impossible to suppress the slightest

retard and to change the placement of an imperceptible passing note without altering the logic of the harmony or the expressive truth of the phrase."

"Rameau's Sarabande in A-major, [though] only twenty-eight bars long, . . . is the queen among [his] works for the harpsichord. Its unrestrained surrender, its ardor, the rustling of its immense arpeggios, the irresistible sweetness of its melody, and its regal deportment give a most shattering denial to those who see Rameau only as a calculator and maker of treatises."

"Scarlatti," on the other hand," depicts neither the sumptuousness of palaces nor the ostentatious magnificence of princes. It is the people whom he loves . . . the motley and swarming crowd."

And in her description of individual pieces by Bach, Handel, Purcell, and the rest she is always alert to identify a dance rhythm. None so quick as she, indeed, to unmask an allemande, or to observe (though not in the present book) that a certain middle movement in Mozart is a love scene between two persons who are at the same time dancing a minuet.

This kind of detective work is always intuitive and as often as not unconvincing. A dance meter once revealed remains revealed, but a feeling identified bears little evidence. In fact, another speed than the accustomed one can radically change any assumption about a passage's meaning. But that is of no matter. Because for choosing a speed, every performer is obliged to assume a meaning. And this meaning must take into account not only the author's notation but all that can be learned from interior and exterior evidence about what the piece might originally have been intended to mean. For all music has meanings, often multiple meanings. And the music of a past time cannot be restored as communication without a great deal of study, a great deal of worrying about it, and a great deal of trying it on for fit with respect to known models. It is not that in the long run any one solution is the right one; it is rather that many solutions are demonstrably wrong. And certainly Landowska in her playing and in her recording came far more often than not to articulate a piece in a way that all musicians, both the knowing and the merely instinctive, could be happy about. This was her gift, an early facility for rightness perfected through study.

An awareness of the dance was always present in her playing wherever the music gave excuse for that, along with a certain relentlessness in the rhythm that was neighbor and kin to that of Boulanger — a feminine, all too feminine relentlessness, but nonetheless commanding. And though her way with an expressive line could lean toward a Chopin-playing manner of the 1890s, of personal display there was never any trace; she worked wholly within the framework of the music, clarifying it with knowledge, warming it with all her resources of training and temperament. Consistently hot in the blood but cool of head, she was as incom-

parable a pedagogue, moreover, as she was a performer. She could animate any student to his potential. Indeed, there are in all today's welter of harpsichordists virtually none who are not her pupils or the pupils of her pupils.

Yet not one plays with her especial grandeur. Some have her share of learning, a few of them more than that. But there is something a bit parochial about them all. For no one is nourished today by the whole of Europe. Its partition has made that impossible, its partition plus sterilization in the virile parts, all of which lie in the East. "*La grande sensibilité européene,*" which came out of the East, will not exist again in our century. Nor will anyone collect out of the present book pearls comparable to those that are everywhere in Landowska's recordings. Students may get a hint or two helpful toward the rendering of Landowska's repertory. But her rhapsodic style may well put other readers off. ("Oh, the burning delights, the mortal anguish I experience in playing!") For indeed she was a gusher, in every use of the term.

The truth is that performing artists rarely write well about music. Though they may communicate wisdom, they tend rather to overstate everything, simply because language for them refuses to sing. To verbalize the emotional content of music is impossible anyway. Nevertheless, it has to be tried. Because the history and analysis of a work without reference to its content are futile, and musicology's only proper end is musical performance. The rest is fringe benefits. Nor is there value in any scholastic hope of "merely playing the notes." Notation is too vague for that; its translation into sound depends on too many unwritten conventions, most of them lost. Where these cannot be retrieved they must be imagined. Not to have the courage for this is to bury a resurrected past all over again.

The aging Wanda knew how personal were many of her readings, and she confesses it. At the same time she claims her right, on grounds of experience, much learning, and an impeccable sincerity, to restore to our hearing as best she can the sound and sense of Bach. That is where the young Wanda had started out; she wanted to see him truly. At the end she was far from sure about the objective truth of what she saw; but she knew she had seen many, many wonders and that she had put some on view. And if she was not exactly modest, never that, humble she remained before music's miracles.

But not before big modern reputations. Of Tchaikovsky she wrote, "He cries louder than any suffering could justify." She found Prokofiev's *Suggestions Diaboliques* "ridiculously silly." "The sumptuousness of Stravinsky dazzles me," she writes, "but rarely gives me happiness." "An air-conditioned room," she finds him, "compared to the normal temperature of the street." She speaks with consideration of Poulenc and of de Falla, both of whom wrote harpsichord concertos for her; but her disap-

pointment with the de Falla work, often expressed privately, does not appear in this volume. Actually she played it seldom, considering the composer to have made errors of balance that should have been corrected when she pointed them out. She even warned one pupil that "it injures the hands." Toward the end of the book she begins to wonder "what modern music can bring me." She had never doubted the music of earlier centuries.

Though this book gives us close-up views of the long-since-ended harpsichord war and of its winning general, it is finally tedious because we know beforehand how that war came out. Landowska's sketchy notes, moreover, though sharply penetrating about composers and their pieces, are too deeply overlaid with self-advertisement to constitute a worthy or becoming self-portrait. There is charm, however, in the persistent gallicisms of their translation — *genial*, for instance, where informed by genius is meant; *wonderment* for, I presume, *émerveillement*; *appeasement* for the calming of a fever; the use as English words of *chatoyant* and *melisms*, not to mention the innocent confusions that result from calling Chopin "the Cantor of Poland" and from constantly referring to music of the seventeenth and eighteenth centuries as "ancient."

A life-and-times objectively reconstructed could have had major interest. A fingered and phrased edition of the Landowska repertory would certainly have value for professionals. The present grab bag of casual observations and incomplete analyses, for all its air of being the harpsichord's inside story, is woefully short of hard-core material. Though the volume is handsomely designed and has glowing photographs, as a ten-dollar book it is strictly for the fans.

From *The New York Review of Books,* January 28, 1965.

~ How Dead Is
Arnold Schönberg?

Arnold Schoenberg Letters
Selected and edited by Erwin Stein. St. Martin's, 309 pp.

In 1910 Arnold Schönberg, then thirty-five, began to keep copies of all the letters he wrote. Many of these were about business — teaching jobs, the publication of his works, specifications for performance. He would seem around that time to have arrived at a decision to organize his career on a long-line view involving the dual prospect of his continuing evolution as a composer — for he was clearly not one to have shot his bolt by thirty — and of his counting on pedagogy, for which he had a true vocation, as his chief support.

His plan was to become a private teacher (*privatdozent*) at the Academy of Music and Fine Arts in Vienna, avoiding by the modesty of such a post both the anti-Semitic attacks and the anti-modernist attacks that he felt would make it impossible for him to be offered a staff appointment. Actually he was offered a staff appointment two years later; but by that time he had got what he could out of Vienna and removed to the more lively center that was Berlin.

The plan of 1910 had been calculated to play down his own music and call attention to his qualities as a teacher by bringing to the notice of the academic authorities the work of two pupils, Alban Berg and Erwin Stein.

> Perhaps after all the two men in whose hands the Conserva-toire's destiny lies, can be brought to realize who I am, what a teacher the Conservatoire would deprive itself of, and how un-gifted it would be to take on someone else when I am to be had for the asking. And alas I am to be had!!!

But no sooner was he had than he found a way, always his preoccupa-tion, of leaving Vienna. For though he loved his native city, he suffered

from its perfidy toward music. And indeed Vienna is a bitch. Her treatment of Mozart and Schubert proved that. And even those who led her on a leash — Beethoven, say, and Brahms — got little profit out of their dominance, save in Brahms's case a certain satisfaction from administering through a henchman on the press local defeats to Wagner and to Bruckner.

Schönberg at twenty-six, in 1901, had moved to Berlin, but two years later he was back home. The 1910 displacement lasted five years, till 1915, when he was obliged to return for mobilization. He was then forty. At fifty he left Vienna again, this time for good, to accept a teaching post in Berlin at the Prussian Academy of Arts. By then he was world famous, but he was still poor. And he had come to insist in the hearing of all not only on his skill as a teacher but on his absolute authenticity as a composer. He left no slighting remark of foe or friend unprotested.

"I am much too important," he wrote in 1923 to Paul Stefan, "for others to need to compare themselves to me." Further, "I thoroughly detest criticism and have only contempt for anyone who finds the slightest fault with anything I publish." These are the words of one who has long since lost youth's bravado, who has been critically flayed and left with no skin at all to cover his nerve ends.

Except for his usual reaction to critical attacks, mostly foreign by this time, the years from 1926 to '33 seem to have been his least painful. He was an honored artist well paid; and he worked for only six months a year, these of his choosing. This freedom allowed him to spend winters south, eventually in Catalonia, where he found relief from a growing respiratory weakness.

The letters from this time are those of almost any successful musician. To conductors and impresarios he itemizes everything, exactly how his works are to be played and exactly what circumstances he will not tolerate. To enemies and to friends he draws an indictment for every rumored slight, then offers full forgiveness if they will admit him right. In fact, he is right; he has had to be. After all the persecutions and misunderstandings he has suffered, he cannot bother to blame himself for anything. He protests, though, against all who refuse him understanding and honor and against all anti-Semitism, especially the anti-Semitism of Jews who descend to that level by refusing his music. For in success he still must fight; fighting has become a conditioned reflex. And he cannot quite relax enough, even with time and money, for going on with the two great opera-oratorios, *Moses and Aaron* and *Jacob's Ladder*. Indeed, he did not ever finish them. For he was tired; his health was undermined; and soon he was to be a refugee.

From the summer of 1933, when he left Germany for good, till his death in 1951, he wrote a great deal of music and did untold amounts of teaching in the Los Angeles region, where he had gone for his health in

the fall of '34 and where UCLA picked him up cheap at sixty, then at
seventy threw him on the scrap heap with a pension of thirty-eight
dollars a month for feeding a family of five. America, no less than Aus-
tria, be it said, behaved like a bitch. And though he found here through
Germanic connections publishers for his work, money dispensers such
as the Guggenheim Foundation could not see their way to helping him.

The sweetness and the bitterness of Schönberg's American letters are
ever so touching. The European correspondence rings like a knell, for he
never ceases to sing out that save for himself and his pupils music is dead.
In America he fancies for a moment that his teaching can bring it to life.
Then come the disillusionments, first that the basic teaching is too poor
for him to build on (he can thus teach only the simplest elements) and
second that American music has detached itself from the Germanic stem.
He despises equally the reactionary concert programs of Toscanini and
the heretical modernisms of Koussevitsky, neither of whom plays his
works. And in his mouth the word *Russian* has become an injury.

He writes in 1949 to his brother-in-law Rudolf Kolisch:

> Fundamentally, I agree with your analysis of musical life here.
> It really is a fact that the public lets its leaders drive it unre-
> sistingly into their commercial racket and doesn't do a thing to
> take the leadership out of their hands and force them to do
> their job on other principles. But over against this apathy there
> is a great activity on the part of American composers, la Bou-
> langer's pupils, the imitators of Stravinsky, Hindemith, and
> now Bartók as well. These people regard musical life as a
> market they mean to conquer [in contrast to his own Germanic
> view of it as a religion] and they are all sure they will do it
> with ease in the colony that Europe amounts to for them. They
> have taken over American life lock, stock and barrel, at least in
> the schools of music. The only person who can get an appoint-
> ment in a university music department is one who has taken
> his degree at one of them, and even the pupils are recruited
> and scholarships awarded to them in order to have the next
> generation in the bag. The tendency is to suppress European
> influences and encourage nationalistic methods of composition
> constructed on the pattern adopted in Russia and other such
> places.

He is quite right, of course; and the shoe pinches. The only advantage
he can see is that

> the public is at the moment more inclined to accept my music,
> and actually I did foresee that these people, so chaotically writ-
> ing dissonances and that rough, illiterate stuff of theirs, would
> actually open the public's eyes, or rather ears, to the fact that
> there happen to be more organized ways of writing a piece,

and that the public would come to feel that what is in my music is after all a different sort of thing.

The basis of Schönberg's claim had not before been that he was doing "a different sort of thing," but rather that he was doing the same thing Bach and Brahms had done, and even Mozart, and that any novelty involved was merely a technical device for continuing classical music-writing into modern times. He did not consider himself different from the earlier German masters (for him the only ones one need take seriously) or from living ones either, but merely, as regards the latter, a better workman. But in America's wider musical horizon, which included (along with Germany) France, Italy, Russia, and the Orient, he felt obliged to assert his distinction as a difference in kind. His neighbor in Hollywood, Igor Stravinsky, was doing in fact just that, had been doing so ever since he had observed it being done in Paris by Pablo Picasso. In Picasso's assumption geniuses were a species, with only a few available, and with consequently the right to a very high price. Poor Schönberg, who for all his artist's pride was humble before talent, even student talent, may not have been considered eligible for the big money simply because he naively believed that professional skill and an artist's integrity were enough. In any case, never in his published letters or other writing did he lay claim to special inspiration, to divine guidance, to a genius's birthright, or to any form of charismatic leadership.

But in America he felt impotent and outraged that music should be taking off without his consent, that pregnancy should not await the doctor. Indeed he tended to consider all such independences as irresponsible and as probably a plot against his music. Another plot, indeed, where there already had been so many! And so he came to view our movement as the work of men differing from him not only in degree but also in kind. And the integrity represented by himself and his pupils he ended by denying to almost everybody else.

Yet he remained a fine companion; there was no deception in him. And he went on writing letters to everyone in praise of the artists he had loved — in painting Wassily Kandinsky and Oskar Kokoschka, in architecture Adolf Loos, in music Gustav Mahler, Anton Webern, and Alban Berg. For himself he demanded honor and begged money. He despised the State of Israel for trying to create a music "that disavows my achievements"; then later he aspired to citizenship and offered to revise the whole of music education there.

The self-portrait that is distilled from these letters is that of a consecrated artist, cunning, companionable, loyal, indefatigable, generous, persistent, affectionate, comical, easily wounded, and demanding, but not the least bit greedy. That artist we know from his music to have been a Romantic one; but he was not romantic about himself; he was too saga-

cious for that, too realistic. And he was too preoccupied with the straight-forward in life ever to have become aware, even, of the great dream-doctor Sigmund Freud, though they were contemporaneous in Vienna, with neither of them exactly ignorant about contemporary thought.

We know him for a Germanic artist too, for whom every major deci-sion was a square antithesis, an either-or, for whom a certain degree of introversion was esteemed man's highest expressive state (*inwardness* is the translation word for what must have been *Innigkeit*), and for whom our century's outbreak of musical energies represented only a series of colonial revolutions to be suppressed, floods to be dammed, drained off, and channelized, naturally by himself acting alone. The dream is unbe-lievable, but in today's world not far from having come true, like Dr. Freud's sexual revolution.

Schönberg's music and teaching are at present a world influence of incomparable magnitude. Nor have the vigor and charm of his personality ever been in doubt. Nevertheless his work is still not popular. Like the music of Bruckner and of Mahler and, until in recent decades only, that of Brahms, it has the savor rather of a cause than of plain nourishment. Mozart, Beethoven, and Schubert in the past, Debussy and Stravinsky in our time, have been as clear to us as Santa Claus. Not so Arnold Schön-berg, at least not yet. But the man has long been precious to those who knew him; and now the letters, with their punctilious indignation and casual buffoonery, their passionate friendships and irascible complaints, their detailed accountings and their Olympian self-regard, their undying optimism under the most humiliating poverty and disregard, have given us a man that many will come to love and laugh at and get angry at and cherish, just as if he were still with us.

And perhaps he is. In Vienna, certainly, Mozart still walks beside one, Beethoven is at his window, and Schubert is drinking and writing songs in any tavern. The whole career of Arnold Schönberg resists historical pinning down. Not in the Vienna of 1874, where he was born, nor in that of 1900, where he was virtually unnoticed, nor in Berlin of the early teens and late twenties, where he was a power, nor in the Hollywood of '34 to '51, where he was merely beloved, in none of these places did he sum up a time. He slipped into and out of them all, just being Arnold Schönberg, and everywhere except in Berlin being roundly persecuted for that. Even today I would not be too sure he is not writing music over many a student's shoulder and putting in many a violation of his own famous method just to plague its more pompous practitioners.

Certainly he is being a plague to Igor Stravinsky, whose adoption of that method after the master's death has left him in a situation almost as skinless as that of Schönberg in life. Certain known attacks on Stravin-sky's music, therefore, some of them published here, have obliged him, as a confessed Schönbergian, to take cognizance of these with what grace

he can muster, which is considerable. Reviewing the *Letters* last October in the London *Observer*, he accepted their strictures with a gallant mea culpa and paid higher praise to their author than he has ever paid, I think, to any other musician.

"The lenses of Schönberg's conscience," he said, "were the most powerful of the musicians of the era, and not only in music." Also, "the *Letters* are an autobiography . . . the most consistently honest in existence by a great composer." Actually Stravinsky's exit from a seeming impasse has been ever so skillful and handsome. And its warmth of phrase is such as to make one forget almost that the gesture was imposed. Imposed by what? Simply by the fact that a great and living master had been resoundingly slapped by a dead one.

As for how dead Arnold Schönberg really is, let us not hazard a guess. The Viennese composers have never rested easy.

From *The New York Review of Books*, April 22, 1965.

∿ On Being Discovered

Music in a New Found Land: Themes and Developments in the
History of American Music
by Wilfrid Mellers. Knopf, 543 pp.

AMERICA'S art music has not heretofore aroused much enthusiasm
among Europeans. Our ragtime was parodied lovingly, if not enviously,
by Debussy, Satie, and Stravinsky. And jazz, though harder to make
grow, did flower in the fugal finale of Milhaud's La Création du Monde
of 1924. It also stimulated, beginning in the 1920s, serious historical
studies by Robert Goffin and Hugues Panassié, more recently by André
Hodeir. The examination of our Appalachian folklore had been started
around 1915 by Cecil Sharp, an Englishman. And our commercial popu-
lar music had already, after World War I, replaced the Viennese for
worldwide export. George Gershwin had even been successful in both
kinds of production, since his Rhapsody in Blue for piano and orchestra
and his opera Porgy and Bess had become, by the mid-1950s, as familiar
to everybody everywhere as his songs.

But the Gershwin experience remains unique and not clearly a witness
for America's art-music tradition. Everywhere our jazz and pop are re-
spected, but not so our symphonic and opera creations, our chamber music
and our lieder. How comes it, then, that a European musicologist devotes
a whole book to them? The answer is simple; he has fallen in love with
us. Not with all of America, perhaps, but certainly, as is clear on every
page, with our music. He has felt the energy and the violence behind it
and come to penetrate its surfaces, whether these be rough or glassy, ar-
riving through a composer's understanding — for Wilfrid Mellers is also
a creative artist — at acceptance (and with joy) of the fact that American
music is at its best when least entangled with Europe.

Though his title, Music in a New Found Land, suggests that Professor

Mellers (now of York University) has only recently discovered us (per-
haps through his two years' tenure as Mellon Professor at the University
of Pittsburgh), this is not exactly the case. As early as 1950, in his book
Music and Society, he was treating the transatlantic theme as *American
Music and an Industrial Community.* This essay seems to be the fruit of
his wartime friendship in England with the late Marc Blitzstein, through
whom he had got to know not only the latter's social-consciousness
operas but also the music of Aaron Copland and Charles Ives. In fact, it
is almost exclusively out of these three composers that a viewpoint, or
aussicht, was erected, somewhat after the Marxian plan, for interpreting
the "good" strain in American music as ethical, objective, didactic, and
mainly of the theater.

The present book, dedicated to Aaron Copland and to the memory of
Marc Blitzstein, enlarges that view to include almost everybody, naturally
reducing somewhat the salience of these two, but not removing from the
central position Charles Ives, whom he considers "the first authentic
American composer and . . . still the closest America has come to a great
composer, parallel to her nineteenth-century literary giants." Blitzstein
has even been demoted from this high intellectual company to a place in
"sincere" show business, somewhere between Gershwin and Leonard
Bernstein. And Copland has been flanked, in Edgard Varèse, Elliott Car-
ter, and John Cage, with figures seemingly of his size, and hieratically
extended, through Roy Harris, Roger Sessions, Samuel Barber, and my-
self, by secondary figures occupying, at least in this book, comparable
space.

All such rearrangements of official history are easy for a foreigner to
do. And Mellers has long been adept, as in *François Couperin and the
French Classical Tradition* and in his earlier studies of Erik Satie, at see-
ing around corners. For his mind is fast and sure-footed like a squirrel,
storing up nuts for a long feast in the hollow of any tree. But the tree has
to be there.

His tree, though another might have done as well, is a set of ideas
about American literary history that have been standing available for
some years now, ideas about the influence on American art of the Puritan
Tradition and of the Genteel Tradition, about how Americans are domi-
nated by dreams of purity (hence of childhood) and a yearning for the
absolute (hence utter tranquillity, outer space, or death), and about how
every artist is at heart either a country boy or a city boy. All these ideas,
once serviceable, are a little tired by now, better for hanging out journalis-
tic light wash than for housing nourishment. Which is not to call them
wholly valueless, though through overuse they have indeed lost mean-
ing. And none of them is specific to America, anyway. The Puritan Tradi-
tion is stronger in Spain, the Genteel more terrifying in Soviet Russia, the
preoccupation with death more prevalent in Germany; and as for iden-

tification with childhood, it is a solid literary tradition in both England and France.

It would be a pleasure to credit the patent excellence of Mellers's judgments to some intellectual method better suited to either deriving them or defending them, but I can find no such reasoning. I see rather an intuitive recognition of quality, good guesses, and a brilliantly improvisatory literary style. In whatever he says Mellers tends to carry you with him. And the amazing rightness of his estimates, which may well remain for a decade or two ninety percent definitive, are all the more impressive from the fact that they are not very different from the estimates confidentially circulated now among the members of music's in-group. Their surprisingness comes partly from their being so suddenly gathered together in one package, and partly from the blinding brightness of their expression. Mellers, as a scholar, could easily be convicted on points, for his book contains many errors and omissions. But no writer on the subject has before described our music so faithfully or handled it with so much love.

Ives's integrity, we read, "is synonymous with his experimental audacity"; and this in turn springs from, first, "the pioneer's courage: his desire to hack a way through the forest since he has, indeed, no alternative," and second, "the radical innocence of spirit without which — as we have seen in the literary figures — the pioneer could hardly embark on so perilous an adventure." The core of Ives's work is "acceptance of life-as-it-is in all its apparent chaos and contradiction," every kind of musical material and technique being usable "as experience dictates, and often simultaneously, since all experience is related and indivisible." The search for unity within such a chaos is, moreover, "a transcendental act" and his view of the sonata "an attempt to impose the unity of the Will on the chaos of experience," as he believed Beethoven to have done. But having behind him only "the American wilderness, not Viennese civilization and a long musical history," he cannot travel so far and consequently merely "glimpses, but does not enter, his paradise."

In Carl Ruggles's music "the surging spring of the lines, the persistent tension of the dissonance, is like the pain of birth; nothing is preordained, all is a growing." And comparing him to Arnold Schönberg, he says:

> both were amateur painters who, in their visual work, sought the expressionistic moment of vision. Both . . . found that the disintegrated fragments of the psyche could be reintegrated only by a mystical act. Schoenberg, as a Viennese Jew, had an ancient religion and the spirit of Beethoven to help him; Ruggles had only the American wilderness and the austerities of Puritan New England. For this reason he sought freedom — from tonal bondage, from the harmonic straight-jacket, from

conventionalized repetitions, from anything that sullied the immediacy and purity of experience — even more remorselessly than Schoenberg.

But "his dedication to the sublime also means that he has to be inspired to carry it off." Hence the very small production.

Roy Harris is for Mellers a "primitive" and his music "fundamentally a religious affirmation," where often, toward the end of any work, "the religious lyricism has been metamorphosed into the American violence."

In Aaron Copland's case, complete artistic realization has been achieved, but only by a "severe limitation of [expressive] range," for the "quintessential Copland" is "a wistful urban loneliness." The Piano Variations of 1930, his "first masterpiece," is "bare and hard," "almost skeletal," differing from European music and from most of that by Ives, Ruggles, or Harris in its "lack of lyrical growth." As a construction it is "steely and monumental, yet at the same time a profoundly human expression of courage." The Piano Fantasy of twenty-five years later — "the third of Copland's major piano works — is also the greatest: for it fuses the stark energy of the Variations with the still serenity of the Sonata's last movement." He considers Copland "not a 'great' composer" but "a very important composer in twentieth-century history, for he is the first artist to define precisely, in sound, an aspect of our urban experience."

In Elliott Carter, "the values represented by Ives and Copland come to terms," which is to say that the polymorphous spontaneity of Ives has been transformed through Copland's constructivist influence, into controlled composition, with no loss to expressivity. Ives's realistic depiction, however (of country fairs and such), has been abandoned by Carter, as in Beethoven's last quartets, for transcendental unity-in-multiplicity and for seeking at the end a breakthrough into the beatific.

A similar dream of salvation through the procedures of monumentality Mr. Mellers posits as the drama of Roger Sessions. In fact, it seems to him the essential drama of all the New England composers. And he identifies it with the soul struggle of Beethoven, in one chapter praising such an aspiration to power and integrity, in another finding it profitless to seek repetition of Beethoven's experience.

Certainly the more novel and "progressive" of our composers — from Griffes and Varèse to Harry Partch and John Cage — have "taken off" not from Beethoven's achievement but from Debussy's, from his isolation of individual sounds as sensuous experience and the recomposing of these into contiguities of continuous delight with no care for either monumentality or personal salvation. Cage himself has indeed, rather more effectively, I suspect, than today's painters and poets, carried the post-Impressionist, post-cubist Dada tradition into our time and become,

through a willed Will-lessness that prays to, and moves toward, silence, "a beatnik saint whose disciples proliferate."

Whether Samuel Barber's music is mainly an evocation of adolescence, like Tchaikovsky's and Rachmaninoff's, anyone can argue. Certainly, for all its sweetness and fine workmanship, it is no part just now of our intellectual life. And I should be the last to know whether there is justice in the oft-drawn parallel between Satie and myself. Mellers says that "both the technical methods and the cultivated naivety are the same." But when he essays to identify the disciplines of spontaneity as "inconsequential" and "childish" regressions (in both my case and Gertrude Stein's) he misses the fact that simplifications, abstractions, radical compactions, and restored-to-beauty commonplaces, no less than Debussy's and Cage's "liberation of the individual sound," are inherent to all our century's radical art, and especially to that Paris-centered modernism which from Picasso in painting to Robbe-Grillet in writing has served as norm and mainstream for artists working west of the Rhine. Even music's Vienna School, though it tampered little with Romanticism's meaning-clichés, early strove to neutralize and to pulverize music's materials.

With Copland, the author's city-dweller premise still allows Mellers to admire the landscape music, provided it is from a lonesome landscape. With Carter, his determination to find everywhere a search for transcendental experience leads him to suspect in the Double Concerto, where he finds no lyric line, a denial of "man's humanity," which is "his first offering to God." And with me he has a hard time making his "adult child" hypothesis fit the *Mass for the Dead*, while before *A Solemn Music* he simply gives up and admits "unexpected emotional depth." The Violin Sonata and the string quartets he wisely avoids to review.

One of the great joys of Mellers as a musical analyst is the ease with which he throws away his instruments of meaning-detection for an instantaneous, instinctive, on-the-spot, straight-to-the-heart-of-the-matter interpretation of anything and everything. And if this practical spontaneity leads him to understand, through his composer's empathy, virtually everything but schooled spontaneity, it gives his musical heart permission to love whatever sounds in a fresh way, or speaks from another heart. So that one scarcely feels a need to argue with him. It may be just as well, all the same, to remark that an increasing number of persons are writing about twentieth-century modernism who were never connected with it. Also that England, even more than America, occupies in that movement a provincial situation. So that when an English musical mind (one, moreover, quite free of ties to the British Establishment and also one remarkably informed regarding France) turns its illuminating scrutiny on to the American musical mind, there is the possibility, as happened when Ernest Newman discovered Sibelius in Finland, of undue

gratitude being shown for survivals from the gamut of feeling of another century.

But since Mellers is the only European so far to look us over with any completeness, and since his view, however hasty, is wildly favorable, it is perhaps ungracious to cavil. Just the same, for all its pellucid penetration and warmth of love, his examination of American art music does seem a bit casual, when compared to the best European studies of jazz.

His treatment of popular music in the book's second half, though many of its descriptions of disc performances may be as spontaneous in thought as in phrase, profits from the existence of a dozen other histories. Its justification is that pop and jazz are needed to make a whole picture of America. For jazz is the most astounding spontaneous musical event to take place anywhere since the Reformation. And pop music here has come so near giving birth to top music — in Gershwin, Blitzstein, and, just maybe, Bernstein — that a Marxian philosopher could not resist opening the question of its relation to musical authenticity.

The three cases are not identical, obviously. Gershwin came from Tin Pan Alley, by way of the Lisztian rhapsody, to giving a Broadway play operatic status. And although the theme of that is a white man's view of Negro life (hence phony throughout), its translation into melody is a lovely one because Gershwin was a pure heart.

Blitzstein was an intellectual musician, a pupil of Schönberg and Boulanger, also a Marxist, who found in the operas of Kurt Weill out of Brecht a populist formula capable of being used for passionate propaganda. In so using it, he revealed himself as a natural theater composer and a master of characterization through the parody of musical styles. Copland, in films or ballet, never went so far.

Leonard Bernstein is an even more elaborately trained classical musician — by Harvard, the Curtis Institute, Fritz Reiner, and Koussevitzky. But he also spent certain youthful years in Tin Pan Alley working for Warner Brothers. His symphonic works are coated with Broadway, and his Broadway shows are braided throughout with Tanglewood. Successfully to court a mass audience in the language of Stravinsky and Milhaud proves the musical sophistication of that audience to be far greater than that of any mass audience in Europe. But it does not make Bernstein an operetta composer like his earlier French counterpart, André Messager, who was a no-less-fine classical conductor.

"Blitzstein, in 'purifying the dialect of the tribe,' " to quote again, "creates works which are related to musical comedy but could not be mistaken for it; Bernstein, in writing a musical comedy, cannot entirely avoid capitulation to commercial values." In other words, Gershwin and Blitzstein have in different ways fulfilled their talents. Bernstein, perhaps because of their stultifying abundance, has not yet fulfilled his.

Here endeth the second lesson from Wilfrid Mellers, the first having been a 1950 sketch for this, now extended and improved. Further extension and improvement may come or not; but American music will be better off for what he has told us already about ourselves. Professor Mellers has other preoccupations too, notably, I believe, a history of English words-and-music from medieval times. Everything he writes is full of enlightenment; I should not care to limit him, or to miss one essay. But seeing ourselves as others see us is as good as having your fortune told. And Mellers has given us not only the joy of being looked at, but the satisfaction of being voted for as well.

From *The New York Review of Books,* June 3, 1965.

✌ The Tradition of Sensibility

Debussy: His Life and Mind (Volume II)
by Edward Lockspeiser. Macmillan, 337 pp.

CLAUDE DEBUSSY, our century's most original composer, was ill born, ill bred, and virtually uneducated save in music. In that he had the best (Paris Conservatoire) and earned his *Prix de Rome.* Though an autodidact in the non-musical branches, he was alive to painting and to poetry, including the most advanced. Already in youth he had made friends with the difficult and demanding Stéphane Mallarmé; and he himself had literary gifts. He wrote about music as *Monsieur Croche, antidilettante* (a personage fabricated after the Monsieur Teste of his friend Paul Valéry); he indited *proses lyriques* and set them; and he carried on with all those close to him a correspondence phrased in racy language. Those close to him included the poet Pierre Louÿs, the romancers Marcel Proust and André Gide, the composers Ernest Chausson and Erik Satie, later Maurice Ravel, Igor Stravinsky, and Edgard Varèse. And if eventually he broke with virtually all of these but Satie, or they with him, Debussy was for all his bearishness, bad temper, and constant money dramas, a delicious friend and tender companion, even to his wives and mistresses, two of whom tried suicide when he moved out.

Abstention from personal discipline, organization, and plan was part of his working method, for sensibility cannot be maintained by rule. It needs to be coddled, teased, caressed, enraged. The eye that can see through fog, the ear that can penetrate a din, the instinct for pain that can lead one to touch his own nerve knots — these faculties were sought out in Debussy's time. One need only remember Whistler's London landscapes, the *Elektra* of von Hofmannsthal and Richard Strauss, the *Salomé* of Oscar Wilde, to realize that on a still grander level Proust, Monet, and Dr. Sigmund Freud were also dealing with the dark and the foggy, but using far more sensitive antennae.

The disciplines of sensitivity are in every way exasperating. And the highly sensitized Debussy was not an easy one to bear with, for he lived at both the geographical center and the time center of a movement in all the arts that required the artist to vibrate constantly. The epoch was for dredging the unconscious, for catching a moment of truth on the wing through awareness of some fleeting impression, through keeping one's senses sharp and clear, one's emotions undefined. To live by intuition and to create through a sensuality intensely imagined is not easy for youth, still overpowered by childhood's traumas and by bourgeois prestige. And after thirty-five, vibrancy cannot always be depended on; it may need the help of drugs or drink, or of elaborately varied sexual fun and games.

From Baudelaire through Rimbaud, the best poets have not in general made good husbands. Not in France. Nor yet the composers there — Fauré, Chabrier, Debussy, Satie, Ravel. And painters everywhere are the very prototypes of bohemia. But simple roistering is not enough. I am talking of an art seemingly fluid and unseizable but which yet remains in memory because it comes out of unnamed feelings intensely experienced. And this was the art that centered in France between roughly 1850 and World War I. This was the art, moreover, that in all its forms — impressionism and the *fauve* in painting, diabolism and psychological acuities in literature, helped out by the philosophico-sensual music-dramas of Richard Wagner — shaped the life and mind of Claude Debussy, the time's only musical mentality capable of carrying on the Wagnerian ecstasy.

"His life and mind" is the subtitle of Edward Lockspeiser's two-volume account, the second volume's debut being today's occasion. Lockspeiser has been about his Debussy research for more years than I could certify. His *Debussy* in the Master Musicians series bears a preface date of 1936; and since that time he has issued amplified editions and other books, Volume I of the present study having come out in 1962.

The work completes, corrects, and binds into a bouquet all previous studies of this composer, of which there are many in French and English, also a few in German. It is entertainingly footnoted, copiously illustrated, and elaborately appendixed. Among the rare materials included are (in French) Mallarmé's article on Maeterlinck's play *Pelléas et Mélisande*, a stenographically reported conversation about German music between Debussy and his former teacher, the composer Ernest Guiraud, a ten-page account of Debussy's project for making something operatic out of Shakespeare's *As You Like It* (a plan that occupied him from early youth till death without any of the music ever getting written), and an article by Manuel de Falla on Debussy's uncanny ability to evoke Spain. The only error I noted anywhere is the statement that André Caplet was, from 1910 to 1915, musical director of the Boston Symphony Orchestra instead of the Boston Opera Company.

It is not my desire to reduce Lockspeiser's rich volumes to a digest. But mention may be made of his perspicacious treatment of the painting influences on Debussy, since a parallel between his music and impressionism has long been current. Nor is this wholly without meaning, especially when applied to the piano music. Lockspeiser, however, assures us that Debussy's attitude toward painting as a style source was no mere fixation on the impressionists, but rather an awareness that evolved with modern art itself. Throughout his youth, for instance, he was attached to the composition style of Hokusai and to the Japan-inspired layouts of Degas, both of which got into his songs and piano pieces. Of the three great triptychs for orchestra — *Nocturnes, La Mer,* and *Images* — the first, composed in the early and late '90s, bears surely an imprint of the painter Monet; while the second, though through its fragmented continuity still (1905) an impressionist work, is suffused by luminosities out of Turner. *Images,* from 1911 — consisting of *Ibéria, Rondes de Printemps,* and *Gigues* — reflects the sharper colorings of *fauve* painting, though in all three of its sections literary origins dominate, especially in the tragic *Gigues,* probably inspired by a poem of Verlaine.

Though Debussy himself was reticent about parallels to his work, he actually said, or wrote, as I remember, regarding the early *Nocturnes,* which have always seemed to us so "coloristic," that his intention had been to create with orchestral timbres the equivalent in music of an all-gray painting method known as *grisaille.* This surprising remark can only mean that he was using timbre contrasts as the impressionists used colors, for their ability, by seeming to come forward or to retreat, to give an illusion of foregrounds and distances. In this sense the work is only incidentally coloristic, like Monet's early landscapes of the Normandy coast, brightness being merely a by-product of color's functional use for creating luminosity and perspective.

The opera *Pelléas et Mélisande* breathes quite another air. The Merovingian family of Maeterlinck's play can be imagined as seated somewhere north of Rouen, perhaps in the sunny and fertile country around the Abbey of Jumièges, which is after all not far from Saint-Wandrille, where Maeterlinck himself had an establishment. Debussy's characters and score, on the other hand, are hardly romanesque at all, but rather out of *art nouveau.* This form of decoration (known in French as *le modern-style*), coming from the pre-Raphaelites by way of Barcelona and Holland, had found in France its ultimate sinuosity of line, its coloristic pallor, its devitalized females and giant floral forms.

And the people of Debussy's opera, just like those in 1900-manner art, are ineluctably enmeshed and intertwined with their décor. Not with outdoor scenes of sheep and meadows, as in the play, but with wells and parapets and slippery stone stairs and tidal caves and tower bedrooms from which long blond hair let down till it enwraps Pelléas brings on the

only climax in the score. This opera is not landscape music but passion music about people who feel intensely all the time. And their watery medieval residence is neither Metrostyle nor romanesque nor gothic. It is actually, it would appear, Poe's *House of Usher*, a theme the composer had cherished from his youth.

One should not go too far with the visual-arts approach to Debussy's music. It is useful as a stylistic reference, but his main source was literature. Even when inspired by sea views, landscapes, weather, perfumes, architecture, night, or fireworks, his music is no direct transcript of experience. It is more likely to be an auditory evocation of a verbal evocation of some sensuous delight, and that delight itself a dream of art. Debussy's evocations, whether visual or not, are immobile, the emotion that holds them in suspense being a response to style itself, *une émotion d'art*. And his most vibrant pages are those in which a literary transcript of some visual or other sensuous experience has released in him a need to inundate the whole with music. This music, though wrought from a vast vocabulary of existing idiom, is profoundly independent and original. This is as true of the piano music as of the orchestral pictures. None of it really sounds like anything else. It had its musical origins, of course; but it never stuck with them; it took off.

The most remarkable of these flights is that of the opera *Pelléas et Mélisande*, in which for the first time in over a century (or maybe ever) a composer gave full rights to subtleties below the surface of a play, not merely to action and to verbal discourse. The result is a union of music and poetry inspired in general by Wagner's ideal (itself straight out of Schubert) and specifically by the sound of the orchestra in *Parsifal*, of which Debussy declared that it glowed "as if lighted from behind." And the sensitivity with which the whole is knit, also an ideal that dominated European art for upwards of a century, never again produced so fine a fabric.

Richard Strauss, taken to *Pelléas* by Romain Rolland, remarked that if he had been setting that play he would have used a different kind of music. I'm sure he would have, and no doubt much louder. But *Pelléas* is part of music's high canon in a way no Strauss opera is. And if opera today is to be saved from itself (and Strauss) — for its present enslavements to "theatrical" values and mere plot are suicidal — there is no other model so propitious as this work, which is at the same time, and intensely, both poetry and music.

The last time it was in repertory at the Metropolitan, quite several years ago, a well-meaning person is said to have asked the conductor Pierre Monteux, "Do you suppose *Pelléas* will ever be really a success?" He answered, "It was never intended to be."

From *The New York Review of Books*, December 9, 1965.

❧ "Craft-Igor" and the Whole Stravinsky

Stravinsky: The Composer and His Works
by Eric Walter White. University of California, 608 pp.

Themes and Episodes
by Igor Stravinsky and Robert Craft. Knopf, 352 pp.

REVIEWING Igor Stravinsky's life, works, career, polemical statements, or any books regarding these, one can stipulate that he has been since 1910 a major modern force, that he is now the most admired living composer, and that in the present decade he has revealed himself as a remarkably sharp musical observer. The latter personality let us call Craft-Igor, since it is a double one, in which the voice is the voice of Robert Craft, but the head is of Igor Fyodorovitch.

In *Themes and Episodes*, fifth volume of this perfect impersonation, though the voice takes formal leave of personal diary-keeping, surely Craft has not for the last time served as chief of English language protocol for the master's many verbalizing needs. Also, the composer's wife, Vera de Bosset, becomes a speaking member of the trinity. And most welcome she is, since with her painter's prodigious visual memory she gives us Stravinsky in domestic close-up while watching over him as one might a patient or a child, and writes about his life, his house, his habits with unfailing warmth, good humor, and good sense. This in two long letters written to a cousin in Russia and translated anonymously with infinite grace. One does hope that in future chats she will be present, if only to give us the logistics of a life so far flung geographically and at the same time so tightly tied into a three-person package by the great man's urgencies regarding daily work, liquor, bodily symptoms, and the highest fees.

Craft has served Stravinsky during fifteen years as assistant conductor and during ten as interviewer for eliciting from him printable statements

of musical opinion. Also, as traveling companion and cultural guide the young-man-who-reads-many-books has been a door opener. It was not till Craft became a close associate that Stravinsky showed any notable interest in either Arnold Schönberg or in twelve-tone serial music, both of which he now follows piously, at least within the limits of his eighty-five-year-old's power of self-transformation, which is considerable. And in the domain of Renaissance vocal music, which he has taken in late years almost for his own discovery, he must have been guided toward many an odd practitioner — Heinrich Isaac, for instance, or Gesualdo di Venosa — by the reading of the younger musician. If not to these, then at least to the minor Elizabethan poets and to Dylan Thomas; for Craft, right along with his alertness to music, is a *fin lettré* aware of trends in literary prestige.

As a writer he is less straightforward than either of the Stravinskys. Vera, in this regard, is the perfect one. Igor, as a Russian experienced in at least four other languages, is fascinated by words of Latin origin. And as an artist, moreover, he is prone to lay out any contemporary composer or rival performer who displeases him, which most of them do, as well as to rewrite the history of music for his own benefit, as every other composer throughout music's history has done who has written at all.

Is it Stravinsky's love of verbal legerdemain that has led Craft on, or his own propensity for giggles that makes him so fond of "hard" words? In his latest travel diary one comes upon: nictitating, clerihew, mystagogical, anastomosis, antitragus, geminate (a noun), pendunculates, pargeting, testudinarious, stercoral, scorbiculated, examinate, strigil, castrametation, cyclothymic, paranomasia, enchaféd, eldritch (adjective), coffle, and deturpation, as well as "the marvering and crizzling of the parison, which is glass in its bubble-gum state."

In turning Stravinsky's own pages, do not miss the interview on Anton Webern and the present state of "Anton-olatry" (p. 115 *et seq.* of *Themes and Episodes*). Here are a major musician's work described, current trends observed, esthetics compared, an estimate proposed, and the interviewer gently teased — all with a knifelike critical penetration, a compacted irony, and a wealth of sideswipes, even at himself, that are a lesson in how to deflate a cult without injury to the revered composer inside.

And for plain answers to far from simple questions, let me paraphrase a reporter's interview that does not appear in these books, published in 1957 by *Buenos Aires Musical*.

 Q. Is musical form "mathematical"?
 A. It is neither exactly arithmetical nor an affair of equations; but it is related to a mathematical way of thinking.
 Q. What of electronic music?

A. I find its sounds boring. What interests me is the nota-
tion.

Q. What does sincerity mean to you?

A. It is a *sine qua non*, but guarantees nothing.

Q. Is your duration-universe the same as formerly?

A. No. Nowadays my music is more compact. Certain parts
of *Agon*, for instance, contain three times as much music, by
the clock, as many of my earlier works.

Q. Isn't there something oriental about the duration-uni-
verse of serial music?

A. Not specifically. Moreover, I have no contact with the
orient nor any understanding of it.

Q. Are there any new developments today in rhythm?

A. In *Le Marteau Sans Maître* by Pierre Boulez and in
Zeitmasse by Karlheinz Stockhausen *accelerando* and *ritar-
dando* are regulated from point to point by metronomic indi-
cations. Thus speed control eliminates fixed *tempo* and gives
to music a wholly new agility. Beyond this interesting device,
there has been nothing new in rhythm for fifty years, not since
my own *The Rite of Spring*.

Q. Is there any danger in today's search for mere novelty?

A. No. But it does make life hard for critics, especially in
Germany, where they are supposed to act as a brake on im-
petuosity.

One could cite, I am sure, the whole of Stravinsky's contribution to
the Craft-Igor books without noting one deviation from clarity, though
of malice (as against a fellow-Russian composer, Vladimir Dukelsky,
whom he addresses as V. D.), venom (attacking with vitriol a puny re-
viewer who had not admired his work), and self-praise (the constant in-
sistence on his own importance to the history of music) there are aplenty.

Musicians, we know, tend toward extreme irritability; and exaspera-
tion, of course, is the right of any artist. We like it when a life-giving
spillover breaks through the proprieties. But when a great man takes to
quibbling about the obvious, one could wish he would pick on someone
near his size. And that he would remember too the importance of the
place, as great as can ever be estimated with certainty during an artist's
life, that has long been stipulated in this one's favor.

However, though a sizable niche is certain, the placement of it is far
from settled. The present study of his life and works by Eric Walter
White, which aims to clarify the matter, is a compendium of virtually all
that is known about both the man and his music. It is one of those ter-
minal biographies, like Lockspeiser's of Debussy or Ernest Newman's of
Richard Wagner, that are the glory of England's music-and-letters tradi-
tion. After publishing a book called *Stravinsky's Sacrifice to Apollo* at

the exact point, 1930, where Paul Collaer's illuminating *Stravinsky* left off, White has gone forward with a will to make his study complete, and backward with a determination to get everything right, attesting on every page his devotion to both truth and music.

Collaer's book, long out of print in French and never, I think, available in English, contains a more lively analysis of the early works, white-lighted as it is by a near-contemporary's understanding. The Swiss conductor Ernest Ansermet, writing of the same early works in various volumes, has a comparable way of carrying us back to a time when the Russianness of all musical Russians, with their so-fresh tunes and so-fresh harmonies, was heady nourishment, and when the shocking, immense presence of Stravinsky's music, from *The Firebird* and *Petrushka* through *The Rite of Spring*, was making clear that the century was on.

Stravinsky's work has received the homage of analysis and explication in book form by composers as impressive as Alfredo Casella, Gian Francesco Malipiero, Nicolas Nabokov, Alexandre Tansman, and Roman Vlad, not to mention critical examinations by the hundreds, among which those of Boris de Schloezer and of the conductor Robert Siohan are in my judgment the most meaty. Heretofore, Italians and the France-centered have done best by him. The Germans, though voluminous, have not been notable; nor have the Americans nor previously the English, save for White's earlier (1948) *Stravinsky: A Critical Survey*, itself to come out in German two years later.

From now on, any serious study of the composer must begin with White's *Stravinsky: The Composer and His Works* if only because of its completeness — completeness of biographical matter, of documentary aids, of contemporary opinion quoted, of works described and musical examples analyzed. Besides all this there are reprints, in their original French or English, of divers articles and lectures by Stravinsky and a selection of letters to Stravinsky from Debussy, Delius, Ravel, and the novelist Jules Romains. The analyses and their musical quotations, especially if one fills them out from Collaer's book, are prodigiously abundant and revealing. Nothing is lacking but the Craft-Igor conversations.

It is doubtful whether any composer, saving only Richard Wagner, has ever been so expansive in print. Nor were any, save Wagner, Rossini, and possibly Satie, one half so entertaining personally. And among all those whom we know from their writings, only Wagner and Stravinsky seem to have felt the need for reasserting constantly their demand for a particular place in history.

One regrets this insistence, while realizing its probable source. Both composers, of course, through coming late to music, retained the insecurity of the autodidact. Both achieved success early through a remarkable gift for orchestration and through the soundness of their instinct for the

stage. Both, moreover, lavished on their stage works the richest symphonic textures. Wagner, however, as a German, had to explain away not writing symphonies. He knew that theater music alone, no matter what its excellence, would not admit him to Valhalla. And so, all perfectly true and tiresome and repetitive, he explained over and over what he had done, and gave it a new name, *Musikdrama.*

Stravinsky, being Russian, had no qualms about writing for the stage; but as a Russian with affinities toward the West, he knew he must become a Western master. He could not be a primitive like Moussorgsky, since no one can be a stay-at-home and a traveler. In his three most famous ballets, all composed before he was thirty, he had so firmly proved himself a master of impressionism that he scared the daylights out of Claude Debussy. That French road he never explored extensively again. For the rest of his life he yearned toward Italy, through the *opera,* both *seria* and *buffa,* and toward Germany, through oratorio and the symphony.

Opera he never quite mastered, terrified lest the human voice escape his strict control. But he did, in *Oedipus Rex,* produce an oratorio about a Greek tragedy that is closer to the original aims of opera than anything else written in the whole time of opera. Craft considers it Stravinsky's masterpiece, though others choose *Petrushka,* and there are supporters for *The Rite,* even for *Les Noces* and *L'Histoire d'un Soldat.* In any case, *Oedipus* is a mighty work composed at forty-five by the century's "most lucid creative genius," to quote Henri Sauguet. What it lacks of directness, as in *Petrushka,* it replaces with irony and with a stiff-necked, almost doctrinaire, absorption in the history of music. I doubt that its formal perfections completely save it. Anyway, *Petrushka* is no less perfect; and its form is less self-conscious, more organic.

Organic form is an invention of the German classic masters. Possibly derived as a concept from the German literary sentence, of which the outcome remains in suspense till the very end, when verbs appear, it was developed for fugal writing by Bach and Handel. In Haydn, Mozart, Beethoven, and Schubert it became sonata form, though not one of these knew the term. For them it grew like people or like trees, no two alike but all with a morphological identity.

On Schubert's death, through Brahms and Bruckner and Mahler, it ran to giganticism and finally fell apart. French efforts by César Franck and his pupils to reconstitute scholastically the species brought no life infusion. Vienna wisely neglected these and relaxed in happy decay, later to tie itself in tight chromatic knots.

The only composer after Schubert to achieve lifelike organic forms, self-sustained and self-contained, of which the inner complexities, as in Mozart, reflect no outward strain, was Debussy. In this sense, *La Mer* is

a true and proper symphony, held together not by passion or by pathos or by storytelling, but simply by its own well-functioning muscular and nervous systems.

Organic form is the ideal Stravinsky has struggled toward in all three of his mature symphonies, including the choral one, and beginning even earlier, is my guess, in the Symphonies for Wind Instruments in Memory of Claude Debussy. The Symphony of Psalms is a lovely oratorio with a theme-song ending. The Symphony in Three Movements is a touching selection, or olio, of remembered patriotic and Russian feelings. Edward T. Cone's analysis of the Symphony in C, first published five years ago in *The Musical Quarterly*, reveals this extraordinarily interesting work (a "masterpiece," in Mr. Cone's opinion) to be a wrestling match with the ghost of Josef Haydn in which Stravinsky changes all the rules.

Formerly, one might have taken Stravinsky's past-oriented sonatas, concertos, duos, and the like for witty evocations of some epoch or personality, a cubistico-impressionist reassembling of characteristic detail with everything delightfully in the wrong place. Both Collaer and Ansermet knew, all the same, that below the fashionably equalized surface tensions were diversified interval tensions and harmonic distortions, and rhythmic controls too, of the highest musical interest. In the Symphony in C, as in the Symphonies for Wind Instruments, these almost produce life. That they do not quite, perhaps, succeed in doing so is due in large part, I am sure, to the composer's unwillingness to sacrifice one jot or tittle of his modernity, of his unbreakable surface tensions and high-viscosity dissonance content. The rest of the failure (still relative, for it was a more-than-noble effort) is probably due to the fact that all other attempts to revive organic form, excepting only that of Debussy, have run afoul of the modernist esthetic. How Debussy succeeded no one knows; but I am sure that he did succeed and that Stravinsky has continued to try. Also that in the short works of his old age he seems to be maybe approaching success. That he has not quite produced the miracle is proved, I think, by the fact that believing him to have done so remains a sectarian view. Had he succeeded, the works in question would have become popular without delay, as his early impressionist ballets did.

He failed to master the opera, *if* he did, for a comparable reason. He could not let go of his dissonance controls and his rhythmic corsetings. Gravest of all, he tried to incorporate ballet stylizations. When he finally abandoned these, and also his high-dissonance saturation (though he kept the rhythmic corset), he produced *The Rake's Progress*, a popular piece that travels. It is not a success, however, in any meaning of the term that musical consensus would sustain. The poetry of W. H. Auden, though pretty, is too eighteenth-century–mannered for strong impact. The musical setting of this, for all its fragmentation into static syllables

— a way with Stravinsky ever since his earliest Russian-language works — is surprisingly comprehensible verbally and melodically diverting. Even within its metrical straightjacket, put there to prevent interpretational freedom, it could still communicate the story, were not that story — an incredible mélange of *Little Red Riding Hood, Dr. Faustus,* and an inversion of *Oedipus Rex* in which the hero murders not his father but the woman in his motherly sweetheart and marries, in the form of a bearded lady, his father-image — were not all this, I fear, so utterly silly as to preclude any emotional involvement that the music might provoke.

Stravinsky has known these problems and faced them manfully. He has, in fact, talked and written about little else in the last forty years. They are the fulfillment theme of his dearest aspiration and the burden of his critical denouncements. He may win through yet on the symphonic level. Meanwhile, thanks to his insistent self-exposure in the matter — as well as of all his daily pains and vigorous quarrels, his joyous hospitality, and his happy home — his friends and readers would pardon an occasional failure. His glory as the last master of impressionism, could he be satisfied with that, would do ever so nicely for posterity. Moreover, no one is a universal genius. Neither Bach nor Beethoven, for example, was at home in opera; and Mozart, in either choral works or lieder, was nowhere so tightly packed with meanings as in his chamber works, his symphonies, his still unmatched, incomparable operas.

Could it be that the masters of modernism, in aiming to make everything as different as possible from what came before and at the same time aspiring to resemble preceding masters both in freedom of composition and in the organizing of that freedom into a humane discourse universally meaningful, have all stubbed their toe on the same rock? In other words, can a modernist become a classic? The answer is certainly yes. Because Debussy did it. And so did Stravinsky, barely thirty. After that? Well, he has worked and traveled and talked and traveled and worked. He has worked well and talked well and, as one says of wine, traveled well. He has perhaps not yet solved all of music's problems, but he has through his brilliantly arbitrary and essentially happy music and through his lively talk become an indispensable part of our lives.

What is it Macaulay said of Samuel Johnson? That "our intimate acquaintance with what he would himself have called the anfractuosities of his intellect and of his temper serves only to strengthen our conviction that he was both a great and a good man."

From *The New York Review of Books,* December 15, 1966.

✌ The Genius Type

Notes of an Apprenticeship
by Pierre Boulez, translated by Herbert Weinstock. Knopf, 398 pp.

Penser la Musique Aujourd'hui
by Pierre Boulez. Editions Gonthier (Mainz), 170 pp.

Sémantique Musicale
by Alain Daniélou. Hermann (Paris), 118 pp.

THAT THE concept represented in popular esthetics by avant-garde is applicable to music today, or in our century for that matter, would be hard to demonstrate. The idea that art has a continuous history which moves forward in both time and exploration is no less a trouble for dealing with the real artifacts, though a bit of it is required for explaining short-term developments like the classical symphony — Haydn through Schubert is only fifty years — or the growth of non-tonal music from its germinal state of 1899 in Arnold Schönberg's *Verklärte Nacht* to the completed formulation of the twelve-tone method around 1923.

The trouble with *avant-garde*, originally a term in military tactics, is that it assumes the adventures of individual and small-group experimenters to be justifiable only as they may open up a terrain through which some larger army will then be able to pass. But it fails to explain who constitutes this army and what is its objective, since a military advance, however massive, is not a migration. It cannot be the world public of concert subscribers and record buyers, since many important achievements, both unique and influential, arrive at such distribution far too meagerly and too late to serve culture consumption efficiently. The music of Erik Satie and of Schönberg's group are cases in point. It is all published now and largely recorded but still not much played; the armies of musical exploitation, industrial and academic, have not carried it along with them in their world conquest.

The idea that original work of this quality nourishes the younger composer is no less hard to justify. It becomes a part of his education, naturally; but his uses of it are inevitably dilutions, since innovations in art are generally brought to full term by their inventors (and a few close comrades) long before distribution gets hold of them. Actually, distributors tend to adopt only that which seems complete, presenting it as a novelty, which it may be for them, or as "experimental," which by this time it is not, save as a sales line. Short-term developments certainly represent a true evolution. But incorporating them through the professional conservatories into the living tradition of music is a hit-or-miss affair, any occupation rights in these centers of power being reserved for successful modernists, themselves mostly diluters of their sources. American universities have a way of taking up the more successful moderns, subjecting them to institutionally certified examination, and then sinking their remains in a mud puddle ironically called "mainstream."

Europeans tend to think of history less as a river and more as a library or museum, where any citizen can seek to be culturally entertained, informed, or inspired by high example. (The designers of women's fashions are forever adapting to their use models from the libraries of historic costume; working as fast as they do, they are less bound than prouder artists to the fads of merely yesterday.) Western Europe, in fact, tends to view itself altogether as a museum and the creators of its major artifacts as a special type of workman, the "genius." This kind of artist cannot be imagined without the background of a long cultural history and a pedagogical tradition based on the achievements of that history. The German composer, the French painter, the English poet — Beethoven, Schubert, Cézanne, Degas, Shakespeare, Keats — can often create remarkably with only minimal preparation, since the tradition of sound workmanship and a full history of it have been as close to his childhood as sports and cars and soda fountains to ours. In the American language genius merely means a high I.Q.; in Europe it means that you can speak for your time in language of precision and freedom.

Now the very idea that artists of genius have existed and still appear and that their works are entitled to preservation tends to destroy confidence in progress and also in history as a stream. Nevertheless, it is not possible today for the artist in any metropolitan center to conceive his talents as functioning otherwise than in some kind of continuous career. And it is equally impossible for him to carry on such a career without a belief in some version of his art's recent history. It may even become necessary for him to retell polemically that history, in order that it may appear to others a preparation for him. The European composer's view of himself as not only an heir of music's past — a member of the family — but also an end-of-the-line genius terminating an important short-term development has turned him into an inveterate explainer of music.

No major composer of our century, I think, possibly excepting Ravel, has failed to write at least one book. The painters have written too, and brilliantly; but criticism, scholarship, and the price conspiracy have all denied them authority. The writings of Schönberg, Webern, Berg, Debussy, Satie, Stravinsky, Bartók, Milhaud, Messiaen, and Pierre Boulez are living witnesses to musical thought in our time; and they constitute, right along with historical studies, a valid part of music's verbal script.

Boulez, now forty-three, is unquestionably a genius figure and typically a French one, though the Germans captured him some fifteen years ago through a publication contract (with Universal of Vienna), later taking physical possession through a well-paid composer-in-residence post in Baden-Baden at the Southwest Radio. Meanwhile he had toured the world constantly as music director for the theatrical troupe of Madeleine Renaud and Jean-Louis Barrault. From 1954 they offered hospitality in the Théâtre Marigny, later in the Odéon-Théâtre de France, for his Concerts du Domaine Musical, the only musical series in the world, to my knowledge, which attracts a broad intellectual public of not only musicians but also painters, poets, scholars, and others professionally distinguished. Along with Boulez's own works these programs contain whatever is most far-out in Germany, France, Italy, and Belgium, and quite regularly homage-performances of works by the founding fathers of dodecaphony and occasionally of Bartók, Varèse, Stravinsky, Elliott Carter, Earle Brown, Iannis Xenakis.

Boulez himself is responsible for rehearsing these concerts and for most of the conducting. Passionate, painstaking, and aurally exact, as well as long used to exercising musical responsibility, Boulez is today a conductor of such remarkable powers that although he still works chiefly in the modern repertory, he has been led (or captured) to undertake lengthy tours in Germany, England, and the United States, as well as gramophone recordings, that have in the last decade placed him among the world's most-in-demand directors and at the same time diminished radically his output as a composer.

That output, before 1960, was in spite of its textural complexity both large and, in the view of all who follow post–World War II music, of the very first importance. Actually today's modern movement, though it contains at least a dozen composers of high quality, is dominated by the three over-forty masters who genuinely excite the young — Pierre Boulez, Karlheinz Stockhausen, and John Cage. All three, moreover, have proved effective teachers of their own composing methods. And two of them, the Frenchman and the American, have long been engaged in criticism and musical polemics. As to whether the former's conducting career will remove him from critical writing, as it seems already to have done from composing, my guess is that it will, though the Boulez tongue, sharp and fearless, will not easily be kept quiet.

More than a decade back, Boulez's writing of music already showed a tendency to taper off, though without any remarked lowering of quality. On the contrary, his last contribution, of 1960, to a long-labored work in progress for divers instrumental and vocal combinations, entitled *Pli selon pli* (a "portrait of Mallarmé" in nine movements of which the last, "Tombeau," impressed me deeply) was notable for its technical maturity, sonorous vibrancy, and full freedom of expression. Should his composition cease altogether, nobody would be more regretful than I, because I like this music, find it full of energy, fine thought, and beauty to the ear. For anybody's orchestral conducting, on the other hand, I lack the ultimate in admiration. There has been so much of it around, all absolutely first class; our century has been rich that way, richer than in first-class composition. I would trade in a Toscanini any time for a Debussy.

Is Boulez another Debussy? He seems to have all the qualities. Excepting the one that only shows up in retrospect, the power of growth. Without that, or lacking confidence in that, he may be, as I have written elsewhere, another Marcel Duchamp. This case is rare, but not unknown in France. (Rimbaud is another.) The strategy is to create before thirty through talent, brains, determination, and hard labor a handful of unforgettable works, then to retire into private or public life and wait for an immortality which, when all can see production is complete, arrives on schedule. What does not arrive is technical freedom and the expressive maturing that enables a genius type to speak at forty still boldly but now with ease, with freedom, and with whatever of sheer humane grandeur may be in him.

The heartless mature artist does of course exist, even in the upper levels. Richard Wagner, though financially a crook and sentimentally a cheat, was not one. Just possibly Mallarmé was. Max Jacob said of him, "a great poet, were he not obscure and stilted" (*guindé* was the word). And Boulez, who loves the deeply calculated, expressed in a very early essay (from *Polyphonie*, 1948) his private hope for a music that would be "collective hysteria and spells, violently of the present time"; and he admits to "following the lead of Antonin Artaud" in this regard. At twenty-three (he was born in 1925) some can produce hysterical effects at will. But for professional use, dependably, a method is needed; and the methodical stimulation of collective hysterias (in class warfare, in politics, in religion) has been plenty frequent in our time. I doubt that Boulez today aspires in music just to be a Beatle. Actually Boulez today is as impressive in his musico-intellectual celebrity as the Beatles are in their more modest operation. How he got that way will no doubt be told us, in some version, by recorded music's press agents. What they will not tell us is what he thought about on the way up. And that is exactly the subject of his book from 1966 called *Relevés d'Apprenti*, translated as *Notes of an Apprenticeship*.

This is an anthology of reflections on music published between 1948 and 1962, written, as he speaks, with brio and with a vast repertory of allusions. In French it is not easy to make out, because the vocabulary is overreplete with technical terms from mathematics (which Boulez seems fairly familiar with), from philosophy (less confidently used), from musical analysis (where he is both precise and inventive), and from the slang of intellectual Paris (also the source of his syntax when in polemical vein). The translation, though obviously made with care, is in the long run no less labored than the composer's own prose and often just as hard to follow.

The pieces of high technical interest are among the earliest, from the years of his twenties, when he was building a method and formulating principles. Here we find electronic music and its possibilities (which he does not overestimate) studied from experience and thoughtfully, its Paris Establishment radically debunked. We also find dodecaphonic theory taken apart by an expert. He recognizes that there is nothing about the tempered scale of twelve equal semitones (a tuning adopted by J. S. Bach to facilitate modulation) that renders it indispensable to modern music. True intervals, of which there are at least fifty-two, could as well be employed. Audible octave-spacings are limited to seven. Loudness-levels, though theoretically infinite in number, are surely not practical to distinguish by ear beyond five or six. The shapes of a tone's duration — wedge, pear, teardrop, and their mirror images, including the double wedge — are not many more. And the extent of durations — the raw material of rhythm — is not governed, save for ease of performance, by any numerical necessity at all, though lengths of time, unlike music's other variables, are measurable, hence describable, by numbers. Timbres also are practically infinite; and though they are possible to serialize, few composers have bothered to try.

With all this variability inherent in music's materials, and the number twelve not essential to any of them, it is not surprising that Boulez considers the twelve-tone music of Schönberg to be "a failure," though the idea of serialism itself a boon to music. His admiration for Anton Webern's music, however, is not diminished by the dodecaphonic nonsense; rather he considers it saved by the tension of its intervalic layout and by its creation of forms out of musical materials rather than out of pathos from Old Vienna, which Berg and Schönberg were likely to use. Boulez, like Cage, for all his disillusioned view of dodecaphony, remains convinced that in serialization of some kind lies music's only hope. I must say that virtually all the composers who deny a hierarchy among intervals come sooner or later to substitute for this hierarchy an order of tones arbitrarily chosen for each work and called a row, or series.

At one time or another everything that regards today's music is discussed, always with a furious intensity and generally with penetration.

For hazard and its planned use he has only disdain, unless it comes about that his own cerebration (should we read the unconscious?) leads a writer toward unexpected revelation, toward organic form, or toward some vastly valid experiment. In favor of all these he quotes from Mallarmé, "Every thought occasions a cast of the dice."

How to choose a row that will lend itself to development, expression, and intrinsic musical interest is treated in another book by Boulez, published in Germany, 1963, and entitled *Penser la Musique Aujourd'hui*. Here his love of Webern and his own penchant for arithmetic lead him into much eloquence about the hidden symmetries available through subdivisions of the number twelve. Also into a lumpiness of style ever so hard to keep the mind on.

From recent years there are in the present book ten articles written for the *Encyclopédie Fasquelle*. Here the tone is not polemical at all but informative, and the judgments are fair and generally warm, though without conventional compliments. They are entitled "Chord," "Chromaticism," "Concrete (Music)," "Counterpoint, Series," "Béla Bartók," "Alban Berg," "Claude Debussy," "Arnold Schoenberg," and "Anton Webern," with an extra one on Schönberg's piano works, written for the jacket of a complete recording of these by Paul Jacobs. The article on Debussy is considered by Jean Roy in *Musique Française* (of the *Présences Contemporaines* series), Debresse, 1962, to be "the most penetrating and complete study [of this composer] ever published." In passing, I should like also to recommend from the same brilliant but erratic musical encyclopedia the understanding article on Richard Wagner by a Boulez pupil, Gilbert Amy.

Here, and indeed throughout the book, the Boulez skill in musical analysis and his preoccupation with rhythmic discovery dominate the investigations. He cannot forgive Schönberg and his group for their rhythmic conventionality, as he cannot forgive Stravinsky, who was rhythmically radical, for not really knowing how to write music. He recognizes that a certain impotence in that regard led toward rhythmic construction of the most original kind. All the same, Stravinsky's lack of aptitude for writing in the Western conventional way, with Conservatory solutions always at hand to use or to avoid, he finds deplorable and probably responsible for the neoclassic "decline" into which Stravinsky fell after World War I, when he could not carry forward his rhythmic researches because of poor "writing." By "writing" (*écriture*) Boulez means harmony and counterpoint and the procedures of development (not orchestration, of course, at which Stravinsky was a master).

Beyond the intercourse with a major musical mind which this book offers as a delight throughout, for all the linguistic jambs, its major contribution to musical understanding is a long and detailed examination of Stravinsky's *Rite of Spring*. Every piece of this is given some attention

and the two most original ones (hence most resistant to analysis), the Prelude and the Sacrificial Dance, receive depth study such as is rare today and has been since Donald Tovey's now fifty-year-old writings on Beethoven. The fact is mentioned that much of this material, especially the rhythmic analysis of the Sacrificial Dance, is the work of Olivier Messiaen. So be it. The full treatment is there, replete with musical quotations; and its availability now in English makes it an item for every college and music library to own.

The Sacrificial Dance, as examined in 1951, turns out to be exactly the sort of calculation toward collective hysteria that Boulez had declared his faith in three years earlier. The piece represents, as we know, a dancing to death by exhaustion on the part of a young girl chosen for sacrifice. And the collective hysteria that sustains her in the ordeal is not at all a product of rhythmic monotony, so commonly the provoker of group excitement. The rhythms that accompany this event are designed rather to stimulate hysteria in the theater, in the hope that this may induce an illusion of meaning shared, of presence at an ancient savage rite. These rhythms induce hysteria, if they do, by simulating it. The simulation consists of insistence on asymmetrical thumps, tonally and percussively huge. Their hugeness is standard orchestration. Their asymmetry, though novel, is also achieved by method, by a rhythmic calculation seemingly so secret that no amount of rehearsing will reveal to the merely spontaneous ear an identifiable pulse. (Robert Craft, who has heard and conducted the work possibly too often, now finds that "in the last section of the Sacrificial Dance, . . . where the basic meter is three and twos are the exceptions, the effect can sound precariously like a waltz with jumped record grooves.")

What is revealed by Messiaen and Boulez, as rhythmic analysts, is the fact that the continuity is constructed out of small rhythmic cells arranged with a certain symmetry, as structures always are, but with non-symmetrical interruptions by other cells. All are composed of twos and threes, naturally, since the mind breaks down all number groupings into these (plus fast fives, just occasionally possible to hear as units). The whole is a hidden pattern not altogether different from those found in folklore by linguistic students and anthropologists. Not that the Dance was composed by instinct only, though Stravinsky never confessed that it was not; but its asymmetry is so strongly organized that the exposure of a plan behind it is almost as exciting a discovery as that of the symmetries governing marriage customs among Australian aborigines.

Boulez indeed reminds one of the French anthropologist Claude Lévi-Strauss. His language is confusing, but his mind is not confused; it is merely active. Active and very powerful. So powerful that no music resists for long its ability to dismantle a whole engine and put it together again. It is moreover a loyal mind that puts things back right. Darius

Milhaud said of him, "He despises my music, but conducts it better than anyone." As an analyst, a critic, and an organizer of musical thought I do not know his equal. As a composer I know none other half so interesting. The personality — in the best French way both tough and tender — has been proved in every musical circumstance and every careerlike stance irresistible. Its toughness is half the charm, its tenderness the source of critical acumen and, in his music, an emotional dynamo wired for power transmission and shielded by mental rigor.

That a European genius type of such clear-to-all authority should give up creative work is unbelievable. That he should be tempted by the Klingsor gardens of orchestral celebrity is not strange at all; but if his heart is pure, as it heretofore has seemed to be, he will possibly make his way through to the Grail. That would mean complete artistic fulfillment — which can only be what he aims toward, and what we hope for. There is precedent for a major artist's resting in his forties. Richard Wagner, Arnold Schönberg, and William Blake are noted examples, seven years the usual period for lying fallow. But Boulez has already been silent, as composer and as critic, for most of eight years; and his orchestral adventure is still on an up-curve. No signs of let-up there. On the contrary, I note a temptation even more dangerous than mere conducting. So far, Boulez has made his career almost entirely out of modern music, a phenomenon not witnessed in big-time since Mary Garden. And that way, for a conductor, lies missionary madness.

So I am worried. Strauss, Mahler, and Leonard Bernstein are another case. They had always conducted; they needed money; and they wrote music like windmills, at the turn of a leaf. Wagner and Schönberg are better parallels. And they finally came through; that's the best I can say.

Meanwhile, another pungent book has come from France, this one directly — *Sémantique Musicale* by Alain Daniélou (Paris, Hermann, 1967). Subtitled *Essai de Psychophysiologie Auditive*, it examines the musical experience through communications theory, the physical structure of the ear, and the known, or supposed, facts about auditory memory. In 118 pages, including diagrams, it opens a major matter and offers believable information about it.

Ernest Ansermet's *Les Fondements de la Musique dans la Conscience Humaine* (Neuchâtel, Editions de la Baconnière, 1961) purports to do the same (without information theory but with lots of mathematics and phenomenology) in two large volumes. I shall not discuss the latter work since brevity would be unfair. I merely mention it as another example of Europe's interest in certain musical facts-of-life which before long we shall all be turning our minds to. Musicology is all right, when useful. Analysis and professional judgments are cardinal to the act. But polemical esthetics, commonly referred to as "criticism," are for any purpose but salesmanship, so far as I am concerned, pure lotus-eating. As prac-

ticed by Boulez in his twenties, however, they seem a mere incrustation to analysis and judgment and, before the authority with which he already exercised those prerogatives, appear not deeply ingrained, but more like colored lichens on a rock.

P.S. Regarding the difficulties of translation presented by the Boulez supercolloquial style, let me cite a passage from the chapter "Alea," first published in 1957 in the *Nouvelle Revue Française*. Comparing a facile use of chance (the "aleatory") in music-making to the "never very miraculous" dreams described by hashish fanciers, the French text reads: *"Paix à l'âme de ces angéliques! on est assuré qu'ils n'iront point dérober quelque fulguration, puisqu'ils n'en ont que faire."*

Herbert Weinstock renders this: "Peace to the souls of these angelic beings! One is sure they will never steal any lightning, that not being what they are up to."

In *Perspectives of New Music*, fall-winter 1964, this same passage translated by David Noakes and Paul Jacobs reads: "Peace to these angelic creatures; we can be sure they run absolutely no risk of stealing any thunder, since they wouldn't know what to do with it."

Now using *thunder* instead of *lightning* for *fulguration* is not important. Less exact literally, it is perhaps more apt as image. What arrests me about the sentence is its ending. And here I find the Noakes and Jacobs rendering superior.

I have not counted up or noted down all the suspect items, but here are just a few examples of how tricky this kind of French can be.

[*Debussy*] *est un fameux, un excellent ancêtre.* Now the basic meaning here of *fameux* must be *whopping,* or something like that, for that is the common slangy use of it and far more emphatic in this connection than the literal, the one-dimensional *famous,* used on page 34.

The American localism *tacky* is used on page 331 for *pâteuse* to characterize the parody music in Berg's *Lulu*. *Thick* or *muddy* would have been closer to the French and more descriptive.

Again of Berg, his propensity for allusions to other music is several times referred to as *citation,* though this word in French means less often that than simply *quotation.*

The year of the *Wozzeck* première is given on page 315 as 1923 (impossible since it was the result of fragments having been heard by Erich Kleiber at a concert conducted by Hermann Scherchen in 1924). The French text gives 1925, which is correct.

For using the word *conduct* to signify the medieval form *conductus* I find among my household dictionaries no precedent. The French word is *conduit,* a past participle like the Latin word, which is standard usage among English-language musicologists. If *conduct* had not been paired

on page 294 with *motet*, and both words italicized, I doubt if I should have been able to identify it.

Of Schönberg, *"la suite de ses créations qui commence avec la Sérénade,"* would have been perfectly clear as "the works that followed the Serenade," or better, "the series of works that began with the Serenade." Its rendering on page 271 as "the sequences of Schoenberg's creations that began with the Serenade" is confusing, since sequences, in the plural, are a compositional device and one practically never employed by Schönberg.

Just flyspecks, one may say, on a fine book; and I agree. But there are far too many for easy reading. Time after time one is obliged to consult the original, and that is not easy to read either. But it means what the author wishes it to mean; and with such tightly reasoned trains of thought, his language could not have been simplified much farther. Again a reminder of Lévi-Strauss and of all that exuberant intellection spouting nowadays in France like springs and geysers.

From *The New York Review of Books*, September 26, 1968.

⁓ Berlioz, Boulez, and Piaf

The Memoirs of Hector Berlioz
translated by David Cairns. Knopf, 636 pp.

Baudelaire-Berlioz
Adam International Review. University of Rochester, N.Y. Nos.
331–333, 124 pp.

Berlioz and the Romantic Century
by Jacques Barzun. Columbia, 2 vols., 573 and 515 pp., 3rd edition.

Berlioz and the Romantic Imagination
Catalogue of an exhibition organized by the Arts Council and the
Victoria and Albert Museum on behalf of the Berlioz Centenary
Committee in cooperation with the French Government. The Arts
Council, 146 pp.

Pelléas et Mélisande
*Drame lyrique en 5 actes de Maurice Maeterlinck et Claude
Debussy, partition d'orchestre.* Durand (Paris, 1904). First perform-
ance by the Royal Opera House, Covent Garden, December 1, 1969,
Pierre Boulez, conductor

Piaf
by Simone Berteaut. Robert Laffont (Paris), 459 pp.

The Memoirs of Hector Berlioz, in a new translation by David Cairns,
I had got involved with as a book for possible review. Good reading
it was too, all about music in Romantic times, written by a man who
could really write and who was also a real composer. Nothing phony
there, no self-deception, no bluffing, no self-pity, just the tale of a French
musician who was successful in England, Austria, Hungary, Germany,
Russia — everywhere but in France. Invited everywhere to remain, also to
visit the United States for a very large fee, he could not keep away from

Paris long, where the cabals, intrigues, and dirty deals (in all of which he knew exactly who his enemy was and why and usually said so) gave to his career the aspect of an intermittent volcano as dangerous to the establishment as only a clear mind with a sharp tongue can be.

Nevertheless, in spite of all the hindrances, his career grew, his works got written, performed (most of them), and even published, he became a member of the Institute, he received important commissions. It may have been the sparks and rosy glow sent up by his local explosions which brought invitations from afar. But all the same, honors received, return visits ever more profitable, were not merely the benefits of celebrity. There were solid musical satisfactions too, due to the superior musical facilities available in Germany, in Austria, in England, and even in Russia — the competent players, the good halls, the musically educated listeners, the warmth and generosity of foreign colleagues. And all these availabilities seem to have been the direct result (or so Berlioz believed) of, in England, managerial monopoly, elsewhere of absolute monarchy, as a circumstance favorable to art.

His inability to speak well or to write a letter in any language other than his own may also have been a help on tour since nowhere could he provoke the quarrels, take the liberties, indulge the ironies that his fatal facility with French and his experience as a journalist rendered so tempting to him on home ground.

The picture of Paris between 1821, when young Hector (from near Grenoble) arrived at eighteen to study medicine, and 1869, when he died there, is highly detailed in Jacques Barzun's two-volume biography *Berlioz and the Romantic Century*, originally published in 1950, now out in a new edition. And a quarterly "international review" called *Adam* (anagram for Arts, Drama, Architecture, Music) published simultaneously in London and at the University of Rochester, New York, devotes a sizable issue (Nos. 331–333) to making a duet out of Berlioz and Baudelaire, stormy petrels both.

Particularly charming among the publications celebrating the centenary of Berlioz's death is the catalogue of a show entitled *Berlioz and the Romantic Imagination*, which took place from October 17 to December 14 in London at the Victoria and Albert Museum. Here some 419 items are listed, almost a third of them reproduced — letters, documents, musical manuscripts, photographs, drawings, engravings, and paintings of all sizes from the miniature up to very large ones by Delacroix, Ingres, Turner, and many more. There was music by Berlioz discreetly audible in the rooms, and a miniature theater where one could gaze down as from a dark top gallery to a lighted stage whereon a tiny photograph of Harriet Smithson (whom Berlioz both loved and unsuccessfully married) seemed to be heard reading the lines of Ophelia.

The Paris Opéra, we read, has revived (to generally unfavorable opin-

ion) Berlioz's five-hour opera *The Trojans* (on his own poem, after Virgil); but Covent Garden had got ahead of Paris by giving this work (complete for the first time ever) in 1967. The English press has been dithyrambic in the matter, though whether because of the work itself, which is not only long but theatrically static, or because of Colin Davis (England's newest good conductor, heard last session at the Metropolitan in Berg's *Wozzeck* and Britten's *Peter Grimes*) I cannot testify.

I have heard cut versions of *The Trojans* several times, first in Paris, 1921, most recently in Los Angeles last year. It has always struck me as being full of remarkable music, almost none of which I recognize. There must be a great deal of variety in the degree to which different conductors infuse it with animation. For animation, save in certain spots like the Storm and Royal Hunt, and the military march to which Dido mounts her funeral pyre, is not built into the work, though the music is often busy.

That busy-ness is special to Berlioz. In Mozart, Weber, Rossini, Verdi, the florid writers in general, when the vocal parts are active the accompaniment is not. In Wagner the orchestra tends generally to be very active indeed against a vocal line moving only by long notes, a most effective contrast. In *The Trojans* vocal and orchestral activity seem to run parallel, producing no contrast at all, whether there are lots of notes on stage and in the pit or whether the animation drops out of both, leaving us with a slow solo and a virtually motionless accompaniment.

An alternation of static pictures and oratoriolike choruses with numbers that run like a house afire is characteristic of Berlioz. The ball scene and the "Queen Mab" scherzo from *Romeo and Juliet*, the Rakoczy March and "Song of the Flea" from *The Damnation of Faust* are famous examples of the latter. The static first three movements of the *Symphonie Fantastique*, followed by the fiery last two, exemplify the jerky pacing that permeates this composer's work. The result is, for all his music's high originality and much grandeur in the literary content, a certain embarrassment whenever the stage is evoked. I have not heard the operas *Benvenuto Cellini* or *Beatrice and Benedict*, but I tend to view *The Trojans* as less an opera than an oratorio *about* an opera.

Certainly this composer's dramatic works have over a century and more rebuffed the best intentions of producers and conductors, whereas his concert music and certain excerpts from his stage works, if presented in concert form, have long proved rewarding to both performers and public. The truth is, I think, that while the Berlioz music, like Beethoven's, is full of an abstract "drama," as his life and emotions seem also constantly "theatrical," he did not really possess, any more than Beethoven did, the stage sense. Only in the concert forms, the closed ones, did his highest powers come to life.

Accounts of Berlioz can be a delight, even though a good part of that pleasure comes from the picture of Romantic times that goes along with the account. He himself, though artists' portraits and eyewitness stories are numerous, his life and career documented almost to a fault, remains largely unknowable beneath all the detail. He tells you about his music, his family affections, his passions, his finances; but the why of them all is slippery. And the same is true of his esthetics and his professional attitudes. Nothing leads to anything else; the violent intentions are never carried out; the passions are never assuaged; the lonesomeness is never relieved. His life and art do not lead parallel courses; how could they, being each so jumpy? For a man of his brains, breeding, gifts, and positive genius to have failed so signally at projecting a clear image of himself, either as a private man or as a public figure, has left posterity with plenty of anecdotes and lots of quite wonderful music, but little human reality to remember, as with Beethoven or with Wagner, or as with Mozart and Schubert, to love.

His statue, meditating, is in the small Paris square named Vintimille, near which he lived. Max Jacob used to tell a story that illustrates his way of appearing to be always present and yet not quite. It seems that in his later years he used to come there after lunch and meditate. And two music students would come there too, to watch the great man meditate. Then on the day when they had read in the paper of his death, they said, "Let's go just the same and pay our respects." So they did. And the man they had watched so lovingly for so long was seated there, meditating, just as before.

⮞ ⮞ ⮞

After all the exasperations and delights of dealing with Berlioz, it was a pleasure to move from the V. and A. over to Covent Garden, where Pierre Boulez was conducting Debussy's *Pelléas et Mélisande*. Here is a work all vaporous, if you like, but nowhere presenting the esthetic obscurities of Berlioz and at no point refusing itself the stage.

For the record, let us set down that the orchestral reading was of a perfection previously not encountered by this reporter, who has heard virtually all of them, including that of André Messager, its first conductor. The textures were everywhere transparent but never misty, the emotions frank, warm, and never dissociated from the stage. It is the special quality of this work that though the orchestra comments constantly, and even individual instruments comment on the progress of the play, the pit never becomes a Greek chorus speaking for the author; it remains an extension of the stage. And in scenes of conflict it speaks for the stronger character, for him who dominates. Even the interludes, added originally to fill up time during changes of set but preserved nowadays for their intrinsic

beauty, are extensions of the drama. They are not scenery, not warning of events to come, but quite simply the way some character, the one we are following at that instant, feels.

The composer has in fact so completely identified himself from moment to moment with his characters' sensibilities that he has largely omitted, save possibly in the death scene, any structuring of the music that might support the dramatic structure. Heard in concert the work has continuity but little shape; and even its continuity is constantly broken into by stage emotions so intense that the singers are likely to be left suddenly all alone with the words, unaccompanied. They are alone with the play too, for at all those moments when the orchestra seems to hesitate, the dramatic line, the impetus, is largely a responsibility of the stage.

It is this particular relation between stage and pit that makes *Pelléas* unique. Every other opera in the world, even those with spoken dialogue, is carried forward by musical forms. In classical opera these forms are arranged, in spite of their individual ABA and similar layouts, to move forward as expression, like a cycle of songs. Since Wagner, each act or scene has tended to be an open-ended musical form thematically inspired by the dramatic action but controlled by musico-emotional timings. Even the series of concert forms — sonata, variation, and the like — that underpins Berg's *Wozzeck*, in the end adds up to an open form governed by the needs of expression; and for a certainty that expression is paced at a musical rate of audience absorption rather than at a verbal one, as in a play, or at a visual one, as in a film.

Now *Pelléas* is really an opera, or *drame lyrique*, as Debussy called it. It is a play recounted through music, not a language-play with incidental music. And the timing of that music is under the control of one musician, the conductor. Nevertheless, the music's expressivity does move back and forth from the pit to the stage. And every time the orchestra, by pausing, hands this expressivity to the stage, it becomes necessary that the singers sing their words so urgently and move in a pantomime so convincing that the lack of an instrumental continuity is never felt.

That is why the work requires in its major role not just any singer, but a singing actress. And this leader of the team, whose presence must be felt always, even when she is absent, needs to be surrounded, as in chamber music, by cooperative soloists. The stage director, moreover, should guide them all toward creating a pantomime as tense as the musical score that describes it. Debussy himself, in a 1908 testimonial to the services rendered by Mary Garden in the 1902 premiere, remarked that the role of Mélisande had from the beginning seemed to him virtually impossible to project ("*difficilement réalizable*") on account of all those "long silences that one false move can render meaningless."

Mélisande, so eager to be loved but so skittish about being touched, is rarely shown in the opera as in contact with even her husband. When

he is ill she gives him her hand for a moment, only to have him discover she has lost her wedding ring. Later he takes hold of her twice, once by the hair in a jealous fury, again to plead on her deathbed for some fact that might justify his jealousy. Only with Pelléas is she not averse to the laying on of hands; and when standing just below the tower window he winds her hair about him in orgasmic ecstasy, she is probably, though no party to it, aware of what has happened. In any case, from that time on, a magnetic field of force moves them closer and closer till love is declared and the harsh castle gates, by locking them out, precipitate embrace.

The tension of animal magnetism is the basic drama of this opera, its tragedy, and in the long run its theme. For Mélisande, beneath her reticence, is a flame that consumes. That is why she is a star in the play and must be played by a star. The others resist destruction; she resists nothing but physical contact, a resistance that makes it in each case inevitable. And in the emergency that she has brought about, in every emergency indeed, even dying, she lies. She wants to be loved. She will do anything to be loved. Except tell the truth. Or show gratitude. Utterly self-centered and reckless, she wreaks havoc without thinking or recognizing. And the play of her unbridled libido against the fixities of a well-bred French family (Merovingian minor royalty) reveals character in each instance. It turns Golaud, her husband, repeatedly to violence. It lights the fires of passion in his half-brother Pelléas, a young man easily enough inflamed. It brings forward the essential indifference and all the sententiousness of Arkel, their grandfather (according to Pierre Boulez, "Pelléas grown old"). The other two, Geneviève their mother and Golaud's young son Yniold, horrified by all the violence unleashed, can only view any of it as disaster.

There is somewhere a theory that Mélisande is really Bluebeard's eighth wife. This might explain her having brought along in her flight the golden crown which she has just dropped into a forest pool when Golaud discovers her, "C'est la couronne qu'il m'a donnée," she explains. She has clearly been through a traumatic experience which has left her terrified of bodily contact. Whether it is the experience that has turned her psychopathic or whether she just grew up that way we shall never know. But dangerous she is for sure, behind that sweet façade; and never are we to divine what she thinks about. All we shall know are her refusals and her compulsions.

And never does Debussy's orchestra give us her feelings. Her leitmotif is a shifty one, harmonically and rhythmically undecided. The others are all straightforward; and through them the play of passions, fears, joys, and resignations can be expressed. Though her physical presence is a powerful one, we are never allowed to view the story from her point of feeling; she seems to have none. She is the source of everyone else's feelings and consequently of their actions. But she herself sits at the dead

center of a storm; everything takes place around her, nothing inside her. Nothing, at least, that we can see or hear.

Now the Covent Garden production, for all its orchestral warmth and musical perfection, gave us little of the Maeterlinck play as I have described it and as Debussy set it into music. It is not that the singers did not work well; they did everything the conductor had asked of them in the coaching rehearsals. They even sang a highly reputable French, though for not one of them was the language native. It was rather that the stage director, Vaclav Kaslik, did not seem to feel the same tensions in the play that Debussy did. His characters moved around the stage like items out of a libretto, who did not need to worry because the music would take care of everything. The fact remains, however, that it does not. There are spots in that opera, many of them, where the poetry is so heightened by a vocal line half sung, half spoken but yet on pitch, and the accompaniment so thinly washed in, or so absent, that only an acting line intensely controlled by a choreographic line naturalistically conceived (and concealed, as was the custom of its time) can sustain the spectacle at the level of its orchestral presence.

These excellent singers will no doubt be able in the recording just now completed to give more character and more conviction by "acting with the voice," as they had done occasionally in the seated piano rehearsals. But publicly both stage and staging seem to have got in their way, and certainly some bulky costumes did. The set, a unit structure with changing backdrops and forestage elements added, was the work of Josef Svoboda, the costumes by the third member of a team from Czechoslovakia, Jan Skalicky. Among all these elements I found only the scenery helpful, and that I fancy Debussy might have approved, for its use in outdoor scenes of hanging gauze strips to produce different kinds of hazy weather and different times of day. Quite effectively and often charmingly did these strips, aided by shifting lights and heights and by the imaginative backdrops, produce the dank tarn, house of Usher atmosphere that we know to have been desired by both Maeterlinck and Debussy. The only scenery that squarely failed was that of the final bedchamber, which resists an open stage, since the high small window and shaft of sunlight required by the text, not to speak of Mélisande's hushed fading away and tranquil death, virtually demand enclosure.

Unit sets, whether firmly constructed or assembled out of modules that get regrouped, are ever a disappointment for portraying the difference between indoors and outdoors. And there is nearly always one scene at least in which they fail entirely. The elements that are constantly being reassembled, moreover, are rarely of sufficient intrinsic beauty to permit being looked at for a whole evening. Their lack of visual novelty, by halfway through the show, becomes oppressive. The story advances and the music moves forward, while the scenery just plays a game. I sometimes

think the unchanging set, whether built for the purpose or independently monumental like the steps of a library, injures a dramatic spectacle less than the most ingenious selection of movable elements. These can save time at scene changes, though there are other ways of doing that; but nothing can make them suit all parts of a play equally, and nothing can relieve their aggravating monotony.

The conductor, who had hoped for Wieland Wagner to direct the stage, eventually chose the Czech team, though there is little precedent for a well-organized and well-organizing Eastern European mind effectively coming to grips with this seemingly unorganized and ever-so-French triumph of sensibility *over* organization. For *Pelléas* is not only unique as an opera (recitative throughout and a highly emotional, willfully formless accompaniment); it is also an anti-opera. It avoids all the devices that make Verdi and Wagner, Mozart and Monteverdi easy to listen to — sustained song, rhythmic patterns, structural harmony, orchestral emphases, solos, ensemble pieces, built-in climaxes.

Even its naturalistic vocal line is not always so natural regarding the words as one might think. Much of it is closer to psalmody than to speech. Then at times it actually does imitate speech, using small intervals only, as Jean-Jacques Rousseau had recommended for French recitative. At others it employs, as Paul Landormy describes, an evocation of language such as we hear it silently inside ourselves — "a manner of speech quite strange," he says, "but striking, and very hard for singers to achieve, tending as they do to stiffen the vocal line through an overstrict observance of note-values, instead of making it supple, as they should."

I am afraid the Covent Garden cast, also chosen by Boulez and carefully prepared, sinned in exactly this respect. Being foreigners to French and with little residence in France to loosen their tongues, they gave us the written notes as exactly as any English horn or flute player in the orchestra. They performed indeed as if they were a part of the orchestra rather than as real persons who might be the subjects of the orchestra's comment. Except for the small boy singing Yniold, who really got into his role — the French of it, the music of it, the impersonation of fear — the stage artists in large part simply stood or moved without much meaning, while following in excellent voice the conductor's beat.

I am also afraid that Pierre Boulez, like Toscanini before him, does not really enjoy accompanying star performers. He has chosen before — in the Paris *Wozzeck* of several years back — a cast of just-under-first-class singing actors, exactly as Toscanini was wont to do for his NBC broadcasts. And they have seemed in both cases a bit awed by the honor. Also thoroughly preoccupied with making no mistakes. His casting of the singing voice has long seemed to me less a loving one than that of an executive seeking a sensible secretary. He can love words, I know, es-

pecially those of Mallarmé, which have inspired him, and of René Char, whom he has so often set. But the sound of the singing voice, the personality of a singer acting out his role, seem rather to bring out the carefulness in him than to invite the incandescence of joint effort. This he achieves with the orchestra, and it could not be more ravishing to hear. But I do miss, as I so often did with Toscanini, a catering to the stage, a feeling that singing and the acting out of a role could be allowed to give us pleasure without our being held to a one hundred percent concentration on him and his sacred instrumental score.

After all, singers are not oboes or horns. They are voices with personalities, and the opera is a musical exercise that cannot long exist without exploiting voices and personalities. *Pelléas et Mélisande*, in particular, is an opera, or *drame lyrique*, that depends far more than many another on an equality between pit and stage. An intimacy of musical with dramatic communication is its essence, its need, its sine qua non. It is the hardest opera in the world to perform satisfactorily, because it is the model, the dream that all French opera since Gluck has sought to realize, an exact balance of music with dramatic poetry. And wherever this opera has approached equilibration, its needle of balance has become so quivery that many like Toscanini, like Boulez, have seemed to hope that a wholly disciplined rendering would dissolve that nervousness. Which it does, of course, but at the cost of radically unbalancing the spectacle and forcing it to depend not on the vibrancy and miracle of a poetry-and-music duet, as in the best lieder, but on a musical run-through controlled by one man.

And so in Boulez's *Pelléas* we have no opera at all but rather the rehearsal of one, a concert in costume destined to end up as a recording. I will spare its excellent singers publication of their names in this connection. On discs they will surely make a better effect. There a complete subjection to the musical score may seem more suitable than in an opera house. I am sorry about the Covent Garden production, musically so sumptuous, orchestrally so stunningly alive, stage-wise so casual in spite of pretty sets. Musical accuracy is of course always welcome, and far from universal. But for the rest of opera, I have never been convinced that Boulez had much liking for fine voices or for striking personalities. And as for visual investitures, very few musicians have taste in that domain.

❧ ❧ ❧

From Berlioz, with his perpetual frustrations, amorous and professional, by way of Mélisande, so timid and so destructive, to the life of Edith Piaf may seem a far jump. And yet in London I made it. Somehow, just that far enough from France but not too far, these three sad stories became suddenly for me illustrative of the French tragic sense of life,

with all the rigidity, the sweetness, and the violence that things French can have. For those who knew her living, the memories of her joviality and her wild intransigence have scarcely at all begun to fade; and for those who knew her only through her art the discs are there preserving that enormous voice and all that vast authority of singing style.

And now there is a book called *Piaf*, by her half-sister Simone Berteaut, long-time confidante and beloved chum. This runs in large octavo to 459 pages of French. The French of a child who grew up without schooling, French of the streets, of the *parigots*, of Ménilmontant the toughest neighborhood, the most picturesque language in the world. If only for its imaginative vocabulary the book is a gem. (By comparison Raymond Queneau's *Zazie dans le Métro* reads like the scherzo of a professional grammarian, which it is.) And the life of "La Môme Piaf" therein told with such impeccable compassion and high spirits is so grand, so moving, and so tragic that one is inclined to salute the volume as a great book. Certainly, for anyone who can mobilize an understanding of its dialect, it is great reading.

Born of a mediocre pop-style singer and a street acrobat, Edith Gassion was passing the hat for papa at six and singing alone for pennies by nine. Meantime, during papa's military service, she had been brought up quite nicely in a whorehouse, and by an operation cured of blindness. The name Edith had been given her at birth in 1915 because of the heroic English spy Edith Cavell, whom the Germans had just shot in Belgium. "Piaf," which means sparrow, came with her first indoor singing engagement, along with its preface La Môme, or Babychild, since she was right off the streets and so tiny. After the murder of her boss had closed the nightclub, "La Môme Piaf" was abandoned for "Edith" as she fought her way back to jobs and to public favor. The recounting of all this and of her eventual worldwide fame, her primacy indeed, in that most demanding of musical genres, the French *chanson*, is the framework of the narrative, studded too with the listing of her chief lovers, who included the heavyweight champion Marcel Cerdan, of her chief pupils (Yves Montand and Charles Aznavour among many), and of her faithful friends (especially Marlene Dietrich and Jean Cocteau).

As a star she bought fur coats, dresses, and jewelry, lived in a fine house, gave costly presents. And yet she remained a slave to the slum ways of her childhood. She believed bathing dangerous to the health, drinking-water to be full of microbes, and alcohol (along with wine, of course) beneficial for preventing "worms." During the later years of her life she became addicted to morphine. And she was constantly being broken up in car crashes. With all these disasters knocking her out, she constantly sang in public, constantly took on new lovers. She even married one of them, a Greek hairdresser, leaving him at her death 45 million francs of debt ($90,000), which he paid off. To a doctor who warned her

late in 1960 not to fulfill an engagement at the Olympia with, "Madame, to go out on a stage now would be suicide," she answered, "I like that suicide. It's my kind."

And she did appear, stumbling, weaving about, screaming her songs, including a brand-new one, *Les Blouses Blanches*, about madness, at the end of which she cried out triumphantly to her almost-not-breathing public, "I am not mad." And after singing every night for something like fifteen weeks, she went on tour for six, finishing up in a hospital, as she so often did toward the end.

Between 1951 and 1963 her sister lists:

> 4 motor accidents
> 1 attempt to kill herself
> 4 morphine cures
> 1 drug-induced sleeping cure
> 3 comas from liver disease
> 1 attack of raving madness
> 2 of delirium tremens
> 7 operations
> 2 bronchial pneumonias
> and a pulmonary oedema.

In addition she had an inoperable cancer.

When she died in early October of 1963, on the same day as her good friend Jean Cocteau, who died preparing a broadcast in her praise, an ambulance brought her secretly from the South, where she had been resting, to her apartment in the boulevard Lannes. It seemed more suitable that she should be thought to have died in Paris, that she lie there in *chapelle ardente* for her friends, and that there be a proper Paris funeral. Actually no Mass was sung, the archbishopric having forbidden any service for one who had "lived publicly in a state of sin." Some forty thousand fans, however, broke through the barriers at Père-Lachaise; and there was a detachment from the Foreign Legion in full uniform, with regimental flag unfurled, standing at attention for the prayers.

Like Mélisande, she had been ever destructive to herself and to others. One of her lovers died in an air crash hurrying to meet her on demand. Another crashed too, but not by fault of hers. The car crashes seem mostly to have been drenched in alcohol, as was her life in fact. Marcel Cerdan's defeat in New York as world's champion boxer was clearly a result of her insistence that he go places with her, stay up nights with her, and break training. She lived for love and art, consuming her lovers and creating artists — song-poets and composers as well as singers. She was relentless, ruthless, inexhaustible, courageous, and self-indulgent to the ultimate degree, without self-pity. If my pairing her with Hector Berlioz and with Debussy's heroine may seem due to a merely fortuitous encounter of them in a foreign land, let us remember that Piaf's art, that

of the French *chanson*, is the one that most nearly parallels the higher musical endeavors, not only in style, power, and guts but also in the dedication of its masters.

In this respect Edith Piaf was no Mélisande at all, nor yet a creator like Berlioz or Debussy. But she was, in the discipline of her preparations and performances, a not unworthy colleague of Pierre Boulez. This discipline she could inculcate too in forming other artists; it was that logical and her mind was that clear, her musical ear, her sense of the stage, equally faultless. It is even possible that had she put her mind to it (and for twenty-five years she did read books, knew poetry) she might have arrived at a woman's comprehension (though the role itself was surely not for her) of Mélisande. It takes a special kind of ruthlessness, like Piaf's or Mary Garden's, to see through another ruthless one, to respect her for not whimpering, and to avoid in consequence betraying her to men.

From *The New York Review of Books*, January 29, 1970.

✌ William Flanagan

WILLIAM FLANAGAN's sudden death last summer has left us our memories of him, of course, and his music. Both are precious. But it does seem a shame to have lost him so early (he was only forty-three) and so tragically (since he was in full evolution as an artist, not gravely threatened by poverty, and in the midst of composing a work that he set store by).

Rereading his music recently and re-hearing the recordings, it occurred to me that in Flanagan we have a striking parallel to the poet Hart Crane, who died at thirty-three, leaving behind him a small production but a major one.

Personally they were not too different either. Both physically strong, self-destructive, given to wrestling with angels as well as with the demon rum, they were pursued by violence only in the flesh. It seemed to leave their art alone, which remained serene, ecstatic, richly textured, standing outside of time.

Also like Crane, Flanagan was largely self-taught. Aaron Copland showed faith in him and David Diamond gave advice about form, but mostly Flanagan ripened as an artist by choosing his influences. He knew what he could grow on, and he grew rapidly.

His first major choice for the nourishment of his vocal works was Copland's songs to poems of Emily Dickinson. These inspired him early, and their examples of the disjunct vocal line and of concentration on the emotional content of poetry rather than on the verbal recitation of it not only marked the early Herman Melville songs but actually developed into a method that in his late works was deliberately anti-prosodic.

He would choose poems of quality and then seemingly throw them away by setting them to a vocal line which by its indifference to the meaningful syllables and by its love for extreme vocal ranges made clear

enunciation of the text virtually impossible. This willful distortion of the prosodic values gave him at the end a certain connection with far-out Europeans like Berio, Boulez, Bussotti, and even more extreme vocal manipulators. Flanagan did not despise verbal clarity in music, but he grew more and more impatient with it. After all, we can read the poetry, and in many cases we know it already.

His A. E. Housman songs do get into a lilt whenever the verses do, which is quite often. And Flanagan's writing for male singers is a model of prosodic propriety. But in his very best work, such as *Another August*, he threw overboard the whole consideration of correct declamation, at least where it interfered with flexibility and with the musical exploitation of those very high soprano ranges for which he had a great love.

Another August, like all of Flanagan's music, is notable for the extreme beauty of its musical materials. Also for its imaginative and constant transformation. The sound of it, vocally and instrumentally, is to me an utter delight, as the richness of its musical thought and statement are beyond compare.

If the parallel between Flanagan and Hart Crane holds at all, this work will be in Flanagan's production what *The Bridge* was in Crane's.

For the beauty of its materials, its distinguished harmony, its far-darting melodic line, the freedom and grandeur of its structure, the vastness of the concept and simplicity of the proportions produce in this work a wholeness at once voluptuous and pure. We shall not soon hear its like, I think. For there is nothing like it. It is a monument which, though it has traceable origins, stands alone, as all great music does, giving off its own secret, powerful essence to performers and to listeners alike.

I knew it was fine and told him so. But I regret that I did not tell him oftener. And besides, though it was beautiful to start with, it has become, I think, even more so since his death, as is the way with all things genuinely original.

Tribute read by Virgil Thomson at the Flanagan Memorial Concert, Whitney Museum, New York, April 14, 1970.

℘ *Opera Librettos*

The Tenth Muse: A Historical Study of the Opera Libretto
by Patrick J. Smith. Knopf, 1970, 417 pp.

HISTORICALLY opera is a branch of the poetic theater. That is what
it started out to be, and that is still its most permanent identity. Indeed,
the constant correction of its besetting faults, such as commercialism of
management, artistic irresponsibility of singers, and the perpetual weak-
ness of its public, of any public, for mechanized scenery, has been aimed
less toward eliminating humanity's low motives than at restoring to
favor its highest ones. So that all those famous operatic "reforms," which
since the seventeenth century have taken place about every fifty years,
have used as their source of energy a faith in worthy (or "noble") themes,
in dramatic integrity, and in poetic diction.

In other words, opera's dramatic and verbal basis has over and over
again gone back to school, regularly sent there by powerful musicians
like Gluck and Wagner, occasionally by professional poet-or-playwright
librettists like Metastasio in the seventeenth century, Calzabigi and da
Ponte in the eighteenth, Eugène Scribe and Arrigo Boito in the nine-
teenth, Hugo von Hofmannsthal and Bertolt Brecht in the twentieth. As a
matter of fact many of these historic returns, as well as certain works
of individual perfection, like Mozart's *Le Nozze di Figaro* and Bizet's
Carmen, have owed their successful outcome to teamwork between a
composer and a librettist.

This was not the case with Metastasio, who was more influential than
any composer of his time, and whose librettos were actually published
and read, though the music to his operas was not. Metastasio, out of
sheer artistic need, produced the first Italian Reform by daring to elimi-
nate sentimental subplots and distracting scenic displays and by taking
the trouble to couch his dramatic actions in clear mellifluous verse, thus
circumventing with *opera seria* vulgar show biz and establishing it for

the next century and a half as a noble form. Actually he created *opera seria* by firmly imposing on a loose Italian practice the formalities of the French classical theater.

Eugène Scribe too, though less careful in his verse, accustomed the composers of French *grand opéra* — Meyerbeer, Auber, and Halévy — to the structural advantages of a well-made play, a tradition that has survived in opera through Bizet, Puccini, and Richard Strauss, exactly as it was developed on the spoken stage through Sardou, Dumas *fils*, Ibsen, and Shaw.

Gian Francesco Busenello had worked closely enough with Monteverdi to produce in *L'Incoronazione di Poppea* both a perfect play and a perfect libretto. Lully had established in France serious opera, or *tragédie lyrique*, by working through his librettist Philippe Quinault. And Raniero da Calzabigi had operated the second Italian Reform largely working for Gluck.

Berlioz and Wagner wrote their own librettos. And if the former's *Les Troyens* is a bit loosely organized, covering as it does most of Virgil's *Aeneid*, it also contains, according to Patrick J. Smith, "some of the most beautiful stage poetry in the language" — strong words about a dramatic literature that includes Corneille, Racine, and Molière.

Calling Richard Wagner "a librettist who also wrote music" may similarly shock some. It is probably intended to. But it is not intended to diminish his musical credits, merely to emphasize his extreme expertness as a dramatic author. And if Mr. Smith considers Metastasio's "astonishing achievement" as "the zenith of librettistic art," he states also, early in the book, that "not until Richard Wagner would there be a librettist who could handle complexity with such assurance and dexterity."

Smith's own amazing achievement is to have produced a word's-eye view of the musical stage covering nigh on to four centuries. And if he considers the actual verse of librettos (or the prose in which they sometimes now appear) as not needing to be quite first class, and complexities of characterization as also a luxury, he is firm in his history-based conviction that a libretto's strength is its dramatic organization.

For that there is no substitute, not even good music. And if the nineteenth-century Italian melodrama, as exemplified in Verdi, leans less on the well-made play than on excitement produced by a series of highly emotional moments, that too can serve for structure if the excitement is kept up, even though certain plots from Spanish sources, such as *Il Trovatore* and *La Forza del Destino*, may seem loose-hung without their musical showpieces and their tense timing trajectory.

In discussing these matters from full historic reading and with copious quotations from Italian, French, and German librettos, all elegantly here translated, Mr. Smith has given us a work not only of unusual learning but also of many distinguished judgments and surprising insights.

Classical-tragedy opera and mythology opera, which filled the houses for more than two centuries and which came to an end with Richard Wagner and his running mates of the French *grand opéra* and with Verdian melodrama, contain an astonishing number of happy endings. The *lieto fine* was in fact their norm. Modern operas that end with some personal disaster unmitigated by any theory of dramatic justice, but exemplifying rather the fatalistic view that nobody can win, not even the bad guys — this kind of opera, from *Carmen, Cav,* and *Pag,* all the Puccini works, *Salomé, Pelléas,* and *Wozzeck* to Menotti's *The Consul,* the operas of Benjamin Britten and Carlisle Floyd and Alberto Ginastera — all are *opéras-comiques* in their descent from the amorous pastoral, the comic skit, the cruel joke. Also in their occasional use of the spoken word for cutting through music to reveal some raw reality.

But from the beginning, opera's best authors, either librettists themselves or musicians working through librettists and stage designers (a department ever important in French theater), have aimed for, and occasionally achieved, total organization and (for performance) total control. Lully got it; so did Gluck, Wagner, the masters of French *grand opéra,* Boito (though he was unable to "bring off," or even to complete, his ambitious *Nerone*), Richard Strauss, and, in one opera each, Claude Debussy and Alban Berg. And every time it has occurred there has been a vast reverberation down the corridors of history.

Whether it is soon to reoccur Mr. Smith does not opine. Certainly no signs of it are visible here, in Europe, or in Europe's Eastern marches. But any writer of music or of poetry itching to flex his muscles in a stage work could not do better than to begin his exercises with *The Tenth Muse* as sparring partner. By taking libretto writing for a serious art it restores one's faith in opera, which for all its past and present ailments is approaching a four-hundredth birthday.

It will go on too, for sure. Because any composer with stage sense can write an opera. Indeed they mostly do, and often quite pretty ones. But for libretto writing there ought to be a textbook. Just possibly this is it.

Tidbits:

> It cannot be emphasized too often that any considerations of the libretto which ignore its dramaturgic elements ignore the life-pulse of the work. Music can develop and strengthen that pulse, and in some cases even supply it when it is missing in the libretto, but the basic drive must be found in the libretto.

> Wagner's stage grasp of the proscenium esthetic is as comprehensive as Shakespeare's of the Globe Theater thrust stage with balconies.

> [Wagner's *Ring* cycle offers] a macrocosmic overview of the cosmos of which *Das Rheingold* is a microcosm — the whole

standing as a staggering tour de force, by far the greatest structural achievement ever carried to fruition by a librettist.

[Emile Zola, who wrote six librettos for Alfred Bruneau,] is the most underrated of the French libretto writers. [If] his librettos are a classic example of the libretto overshadowing the music — another example are the operas of Ferruccio Busoni.

[Boito's life was haunted by] the duality of the creative vs. the critical and adaptive mind. Because opera is a combination of libretto and music, and because the question of creativity is secondary to the value of the whole, Boito will live for his Verdi adaptations [of plays by other men].

The W. H. Auden–Chester Kallman librettos achieve less than their intentions, partly because their verse is inferior to Auden's other poetry but largely because they show too clearly their philosophical and structural seams. [They are] patchworks of half-assimilated ideas.

The librettos to the operas of Benjamin Britten and Gian-Carlo Menotti can be instanced as demonstrating the continuing power of nineteenth-century ideas on the shaping and content of the libretto.

Gertrude Stein must be considered as the librettist who created a positive approach to a redefining of language and [of] play structure ... In this sense she stands in relation to Erik Satie in music.

❧ Aaron Copland

JULIA SMITH'S book on Aaron Copland refers to him on its first page as "this simple and great man in our midst." And indeed from his youth Copland has so appeared. Having known him as friend and colleague for nigh on to fifty years, I too can attest that his demeanor is sober, cheerful, considerate, his approach direct and at the same time tactful. I have never seen him explode or lose his temper. His physical appearance has not radically changed since 1921; nor have the loose-hung suits and unpressed neckties, the abstemious habits and seemly ways which by their very simplicity add up to a princely grace.

Considering the irritability of most musicians, Copland's diplomat façade might well be thought to conceal a host of plots and poutings, were it not so obviously his nature to be good-humored and an ancient principle with him not to quarrel. When he came home from Paris at twenty-four, his study time with Nadia Boulanger completed, and began to be a successful young composer, it is said that he determined then to make no unnecessary enemies. It is as if he could see already coming into existence an organized body of modernistic American composers with himself at the head of it, taking over the art and leading it by easy stages to higher ground, with himself still at the head of it, long its unquestioned leader, later its president emeritus.

This consecrated professionalism was Copland's first gift to American music; it had not been there before. Varèse and Ruggles, though consecrated artists, showed only a selective solidarity with their colleagues. Ives had been a dropout from professionalism altogether. And earlier professionals, the lot of them, had all been individual operators. Copland was the very first, I think, to view his contemporaries as a sort of Peace Corps whose assignment in history was to pacify the warring tribes and to create in this still primitive wilderness an up-to-date American music.

His first move in that direction in 1924 was to take over de facto the direction of the League of Composers. This gave him a New York power enclave; and his classes at the New School for Social Research, held from 1927 to 1937, were soon to give him a forum. He also wrote in magazines, listing about every three years the available modernistic young and offering them his blessing. Also from the beginning, he had established a Boston beachhead, where the new conductor Serge Koussevitzky, taking over from Walter Damrosch Copland's Symphony for Organ and Orchestra, 1925, thereafter performed a new work by him every year till well into the 1930s.

Copland had in New York from 1928 to 1931, in addition to his access to the League of Composers, his own contemporary series, shared with Roger Sessions and called the Copland-Sessions Concerts. At these he played both American and European new works, attracted attention, distributed patronage, informed the public. His collaboration with Sessions, the first in a series of similar teamings-up, marks a second stage of his organizational work. Having by that time solidified his own position, he could enlarge his American music project by calling on, one after another, personalities comparable to his own for weight and influence.

After the Sessions concerts ended in 1931, Copland shared briefly with Roy Harris, just returned then from his studies with Boulanger, an influence centered chiefly in Boston, where Koussevitzky was launching Harris with the same steadfast persistence he had used for Copland. A close association with Walter Piston began in 1935, when Copland took over for a year the latter's composition class at Harvard. In 1937 with Marc Blitzstein, Lehman Engel, and myself, the four of us founded the Arrow Music Press, a cooperative publishing facility, and with several dozen others the American Composers' Alliance, a society for licensing the performance of "serious" music, a need at that time not being met by existing societies.

During the mid-1930s there were five composers — Copland, Sessions, Harris, Piston, and myself — whom Copland viewed as the strongest of his generation both as creators and as allies for combat. And all were to serve under his leadership as a sort of commando unit for penetrating one after another the reactionary strongholds. Their public acknowledgment as co-leaders of American music took place in 1935 at the New School through five concerts, one devoted to each composer's work, all presented as Copland's choice for contemporary excellence in America.

Two foreign composers — Carlos Chávez, during the 1930s conductor of the Orquesta Sinfónica de México and an official of the Fine Arts Ministry, and Benjamin Britten, England's most accomplished composer since Elgar — were to benefit from Copland's friendship, as he did from theirs. But his American general staff did not participate in these alliances. Nor have they shared in Copland's influence over our two remarkable com-

poser-conductors Leonard Bernstein and Lukas Foss, though as recognized composers they have all been played by these leaders. In general Copland's foreign affairs and postwar domestic alliances, as well as his worldwide conducting tours in the 1960s, seem more specifically aimed at broadening the distribution of his own music than at sharing the wealth. And this no doubt because his commando comrades had all become successful independently, while the postwar young (Elliott Carter, Boulez, Cage), having placed their hopes in a newer kind of music, the complexity gambit and the serial-to-noise-to-electronics gambit, have not been able to muster up the personal loyalties needed for calling on his organizational experience.

I have dwelt on Copland as a colleague, a career man, and a mobilizer, because I consider his contribution in those domains to be no less remarkable than that of his music. This music has been analyzed in books by Julia Smith and by Arthur Berger. All its major items are in print and most are recorded. It comprises piano music, chamber works, orchestral works, and ballets, all of high personal flavor and expert workmanship. Less striking, I think, are the vocal works — consisting of two operas, several sets of songs, an oratorio, and a handful of short choral pieces. Among these the choral works are possibly the happiest, because of their animated rhythmic vein. And five Hollywood films made under first-class directors (three, I think, were by Lewis Milestone) on first-class themes (two from John Steinbeck, one from Thornton Wilder, one from Lillian Hellman, one from Henry James) are imaginative and distinguished in their use of music.

Julia Smith has discerned three stylistic periods in Copland's work. His first period, from age twenty-four (in 1924) to age twenty-nine, includes but one non-programmatic, non-local-color work, the Symphony for Organ and Orchestra, composed for Nadia Boulanger to play in America. I found this work at that time deeply moving, even to tears, for its way of saying things profoundly of our generation. The rest of that production time — *Music for the Theatre*, the Concerto for Piano and Orchestra, the necrophiliac ballet *Grogh*, the *Symphonic Ode*, the trio *Vitebsk* (study on a Jewish theme), and divers smaller pieces — is largely preoccupied with evocation, as in *Grogh* and *Vitebsk*, or with superficial Americana, characterized by the rhythmic displacements that many in those days took for "jazz" but that were actually, as in George Gershwin's vastly successful *Rhapsody in Blue*, less a derivate from communal improvising, which real jazz is, than from commercial popular music. No wonder the effort to compose concert jazz came to be abandoned, by Copland and by others.

Its last appearance in Copland's work is in the otherwise nobly rhetorical *Symphonic Ode* of 1929, which led directly into the Piano Variations, high point of his second period, which in turn initiated a series of

non-programmatic works that was to continue for the rest of his pro-
ductive life. The *Vitebsk* trio, in spite of its allusions to Jewish cantila-
tion, can on account of its tight musical structure be listed, I think, among
Copland's abstract works. And so can the orchestral *Statements* of 1933–
34, so firmly structured are these mood pictures. Of more strictly musical
stock are the Short Symphony of 1932–33, later transcribed as a Sextet
for Piano, Clarinet, and Strings, the Piano Sonata (1941), the Sonata for
Violin and Piano (1943), the Piano Quartet (1950), the Piano Fantasy,
and the Nonet for Strings (these last from the 1960s). One could include
perhaps the Third Symphony (1946) on grounds of solid form, but I tend
to consider it, on account of its incorporation of a resplendent *Fanfare
for the Common Man* (from 1942), one of Copland's patriotic works,
along with *A Canticle of Freedom* and the popular *A Lincoln Portrait*.

The initiation of a third period, or kind of writing, followed that of the
second by less than five years; and it too has continued throughout his
life. This embodied his wish to enjoy large audiences not specifically mu-
sical, and for that purpose it was necessary to speak simply. Its major
triumphs are three ballets — *Billy the Kid* (1938), *Rodeo* (1942), and
Appalachian Spring (1944) — all of them solid repertory pieces impec-
cable in their uses of Americana and vigorous for dancing.

Actually the dance has always been for Copland a major inspiration,
largely as an excitement of conflicting rhythms, contrasted with slow in-
cantations virtually motionless. As early as 1925 the unproduced ballet
Grogh had been transformed into the prize-winning *Dance Symphony*.
And his jazz experiments of the later 1920s were closer to dancing than
to blues. In 1934 he composed for Ruth Page and the Chicago Grand
Opera Company a ballet, or dance drama, entitled *Hear Ye! Hear Ye!*,
satirizing a murder trial and based largely on nightclub music styles. It
was not a success, and with it Copland said good-by to corrupt musical
sources, as well as to all attempts at being funny.

Actually his return to ballet and his entry into other forms of show
business had been somewhat prepared that same year by the production
on Broadway of my opera *Four Saints in Three Acts*. Its willful harmonic
simplicities and elaborately-fitted-to-the-text vocal line had excited him;
and he had exclaimed then, "I didn't know one could write an opera."
He was to write one himself with Edwin Denby three years later, *The
Second Hurricane*, designed for high-school use. But my opera had set
off trains of powder in both our lives. In 1936 it led me into composing
a symphonic background for *The Plough That Broke the Plains*, a docu-
mentary film by Pare Lorentz, in which I employed cowboy songs, war
ditties, and other folk-style tunes. Again the effect on Copland was elec-
tric; as a self-conscious modernist, he had not thought that one could do
that either. Shortly after this, Lincoln Kirstein proposed to commission
from Copland a work for his Ballet Caravan (the parent troupe of today's

New York City Ballet), an offer which Copland declined, no doubt still unsure of himself after the failure of *Hear Ye! Hear Ye!* I, on the other hand, with a brasher bravery, did accept such a commission and produced in 1937 *Filling Station,* another work based on Americana.

At this point Copland reversed his renunciation and returned to his earliest love, the dance, this time by my way of cowboy songs, producing in 1938 for Ballet Caravan *Billy the Kid,* a masterpiece of a dance score and a masterpiece of novel choreographic genre, the ballet "Western." Copland's *Rodeo,* of 1942, made for Agnes de Mille and the Ballet Russe de Monte Carlo, is another "Western." And *Appalachian Spring* (for Martha Graham, 1944) is a pastoral about nineteenth-century Shakers. All make much of Americana, the hymn lore of the latter piece having as its direct source my uses of old Southern material of that same kind in *The River,* of 1937, another documentary film by Pare Lorentz.

If I seem to make needless point of my influence on Copland, it is less from vanity than for explaining his spectacular invasion, at thirty-eight, of ballet and films, and less successfully of the opera. His love for the dance was no doubt inborn, and an acquaintance with the theater had been developed through long friendship with the stage director Harold Clurman. But his previous ballet experiments had come to naught, and his essays in writing incidental music for plays had not led him toward many discoveries. He yearned, however, for a large public, the social-service ideals of the 1930s and the musical successes of Dmitri Shostakovich having created in him a strong desire to break away from the overintellectualized and constricting modernism of his Paris training. To do this without loss of intellectual status was of course the problem. Stravinsky's neoclassical turn toward conservatism, initiated in 1918, had offered guidance to the postwar School of Paris and to all those still-young Americans, by the 1930s quite numerous and influential, who through Nadia Boulanger had come under its power.

But they had all preserved a correct façade of dissonance; and this surfacing, applied to every species of contemporary music, was making for monotony and for inflexibility in theater situations. The time was over when composers — Debussy, for instance, Alban Berg, Richard Strauss — could comb literature for themes suited to their particular powers. On the contrary, themes appropriate to a time of social protest and of trade-union triumphs seemed just then far more urgent, especially to Copland, surrounded as he was by left-wing enthusiasts. He wanted populist themes and populist materials and a music style capable of stating these vividly. My music offered one approach to simplification; and my employment of folk-style tunes was, as Copland was to write me later about *The River,* "a lesson in how to treat Americana."

A simplified harmonic palette was being experimented with everywhere, of course; and a music "of the people," clearly an ideal of the

time, was one that seemed far nobler then than the country-club-oriented so-called jazz that many had dallied with in the 1920s. And thus it happened that my vocabulary was, in the main, the language Copland adopted and refined for his ballet *Billy the Kid* and for his first film, *Of Mice and Men*. The German operas of Kurt Weill, which were known to him, performed no such service, though they were all-important to Marc Blitzstein, whose *The Cradle Will Rock* was produced in 1937. Shostakovich's rising career and some Russian film music may have also been in Copland's mind. But his breakthrough into successful ballet composition, into expressive film-scoring, and into, for both, the most distinguished populist music style yet created in America did follow in every case very shortly after my efforts in those directions. We were closely associated at the time and discussed these matters at length.

Copland's high-school opera *The Second Hurricane* (to a text by Edwin Denby), produced in 1937, followed Blitzstein's lead into a city-style harmonic simplicity, rather than to my country-style one. It contains delicious verse and a dozen lovely tunes, but it has never traveled far. Nearly twenty years later he wrote another opera, *The Tender Land*, again a pastoral involving Americana-style songs and dances; but that also failed in spite of resonant choruses and vigorous dance passages. When he moved from ballet to films (*Of Mice and Men*, 1939; *Our Town*, 1940) he carried with him no such baggage of vocal ineptitude; nor was he obliged to use the dance for animation. His powers of landscape evocation in pastoral vein and his slow, static, nearly motionless suspense-like moods were useful for psychological spell-casting; and a struggle-type counterpoint, suggestive of medieval organum with rhythmic displacements — taken over from his non-programmatic works — gives dramatic intensity, as in the boy-fights-eagle passage toward the end of *The Red Pony*. For a man so theater-conscious and so gifted both for lyrical expansion and for objective depiction to be so clearly out of his water on the lyric stage is surprising. The choral passages in his operas are the happiest, for in these he can mobilize four parts or more to produce the same polyrhythmic excitements that are the essence of his dance works, as indeed they often are of his abstract, or "absolute," music. But for vocal solos and recitatives none of that is appropriate; and his dramatic movement tends in consequence to lose impetus, to stop in its tracks. There is no grave fault in his prosodic declamation, which is on the whole clear, though here and there, as in the Emily Dickinson songs, the solo line may be a little jumpy and the vocal ranges strained. His melody in general, however, his harmony, and his musical form are those of a master. What is wrong? My answer is that just as with Stravinsky, also by nature a dance man muscle-oriented, and even with Beethoven, whose work is so powerfully rhythmicized, the vocal writing, however interesting intrinsically, neglects to support the play's dramatic line.

A strange and urgent matter is this line. And its pacing in spoken plays is not identical with the pacing required for a musical version of the same play. Mozart with his inborn sense of the theater is virtually infallible on a stage; and so is Wagner, even when in *Das Rheingold* and in *Parsifal* the dramatico-musical thread may unwind so slowly that it seems almost about to break. But it never does break, and as a result each act or separate scene develops as one continuous open-ended form. Composers whose music requires rhythmic exactitudes work better with the dance or in the closed concert forms. Composers conditioned to producing mood units also tend to be ill at ease about dramatic progress and to treat the story as a series of moments for static contemplation, like Stations of the Cross. On the other hand, operas constructed as a sequence of "numbers" (Mozart to Gershwin) do not of necessity lack dramatic animation. Even the musical dramas of Monteverdi, the *opere serie* of Handel and Rameau and Gluck, can move forward as drama through their closed-form *arie da capo* and their oratorio-style choruses. I suspect it is their naturalistic recitatives that carry them from set piece to set piece toward a finale where a priest in full robes or some deus ex machina, in any case a bass voice singing *not* in *da capo* form, releases the dénouement.

The basic need of any ballet or film score is an appropriate accompaniment for the dance narrative, for the photographed landscape, or for the mimed action. Opera demands of music a more controlling rein, for its function there is not to accompany a dramatic action but to *animate* it — to pace it, drive it, wrestle with it, and in the end to dominate. For that Copland lacks the continuing dynamism. His schooling in the concert forms (in the sonata with Rubin Goldmark, in the variation with Boulanger), the rhythmic and percussive nature of his musical thought, its instrumental predominance, the viscosity of his intervalic textures — all of motionless fourths and seconds, as in medieval organum, plus tenths, so beautiful when finally heard but so slow to register — have created a musical vocabulary strong, shining, and unquestionably of our century.

My favorite among the concert works, the most highly personal, the most condensed, and the most clearly indispensable to music, it seems to me, is the Piano Variations of 1930. The Short Symphony in its sextet form and the Nonet also remain handsome under usage. The Piano Quartet, though structurally imaginative, suffers from a tone-row in which two whole-tone scales just barely skirt monotony. The Piano Sonata, the Violin Sonata, and the Piano Fantasy have failed on every hearing to hold my mind. And the charming Concerto for Clarinet (1948) with strings, harp, and piano is essentially "light" music long ago retired to the status of an admirable ballet by Jerome Robbins, *The Pied Piper*.

Suites from the three great repertory ballets, nuggets from films and operas, one overture, divers mood-bits and occasional pieces, and the

rollicking *El Salón México* constitute a high-level contribution to light music that may well be, along with Copland's standardization of the American professional composer, also at high level, his most valued legacy. Certainly these works are among America's most beloved. Nevertheless, the non-programmatic works, though not rivals to twentieth-century European masterworks, have long served American composers as models of procedure and as storehouses of precious device, all of it ready to be picked right off the shelf.

"It's the best we've got, you know," said Leonard Bernstein. And surely this is true of Copland's music as a whole. Ruggles's is more carefully made, but there is not enough of it. Ives's, of which there is probably far too much for quality, has, along with its slapdash euphoria, a grander gusto. Varèse, an intellectually sophisticated European, achieved within a limited production the highest originality flights of any. Among Copland's own contemporaries few can approach him for both volume and diversity. Roy Harris has five early chamber works and one memorable symphony, his Third, but he has written little of equal value since 1940. Piston is the author of neoclassical symphonies and chamber pieces that by their fine workmanship may well arrive at repertory status when revived in a later period; for now, they seem a shade scholastic. Sessions, I should say, has for all his impressive complexity and high seriousness not one work that is convincing throughout. And I shall probably be remembered, if at all, for my operas.

But the Copland catalogue has good stuff under every heading, including that of opera. He has never turned out bad work, nor worked without an inspiration. His stance is that not only of a professional but also of an artist — responsible, prepared, giving of his best. And if that best is also the best we have, there is every reason to be thankful for its straightforward employment of high gifts. Also, of course, for what is the result of exactly that, "this simple and great man in our midst."

From *American Music Since 1910* by Virgil Thomson. New York: Holt, Rinehart and Winston, 1971, pp. 49–58.

ꙮ The Ives Case

Aᴍᴇʀɪᴄᴀ'ꜱ most remarkable native contributors to our century's music, Charles Ives and Carl Ruggles, were born in New England and grew up there. Their remarkableness comes not only from strong personalities but also from the fact that almost alone among New England composers (Henry Gilbert, 1868–1928, was another exception) they never got seriously involved with teaching. Ruggles will be our subject later; for now, let us examine his more popular contemporary.

Charles Ives started life in 1874 at Danbury, Connecticut, an upland rural county seat manufacturing felt hats. He had for father a bandmaster, a Civil War veteran who trained his son's ear and hand and who exposed him at the same time to all the musical pop art of his day — dance tunes, sentimental songs, darnfool ditties, revival hymns, and patriotic marches. Undergraduate years at Yale, with the expert instruction of Horatio Parker, turned him into a church organist and a well-based general musician. Throughout this time his student works and other youthful pieces passed for wild, and no doubt would today (*vide* the horseplay of his Variations on "America" for organ, composed at eighteen).

Ives's music life quite early went underground, for fighting public sentiment was never his pattern. As a high-school boy he had captained the baseball team; at Yale he played varsity football and was elected to a senior society. He was completely successful at being a conventionally successful American boy. He did everything right, made good marks in school and college, offended no one, though being a musician was certainly no help to his acceptance. Wishing no part of a martyr's life, he worked in a New York insurance firm, later formed his own with a partner named Myrick, married his roommate's sister, wrote a textbook for insurance salesmen, made money, retired (effectively) at fifty-three. For a few years he had played church organs, held in fact an excellent post

at New York's Central Presbyterian. But he seems to have learned quite early that reputable musicians in general viewed his compositions with such disapproval that fighting for position would have merely wasted his time. So he renounced all visible connection with music and kept his work a secret occupation known only to his wife and to a few close friends. His open life was that of a businessman, conventional, respected, impregnable to scrutiny. His secret life was that of a romantic artist — wildly experimental, ambitious, unchanneled, undisciplined, and unafraid.

His years of most abundant outpouring were those from thirty to forty, roughly 1905 to 1915, though the full mature production covers five earlier years and three later, effectively ending at forty-four, when his health broke. After 1924, when he was fifty, he wrote one song (1925) and two accompaniments (1929) to melodies by his daughter; from 1927 he went rarely to his office, and in 1930 he retired completely from business. His medical diagnosis has not been published; the weakened heart and incipient diabetes sometimes referred to seem insufficient to explain a life change so radical and one which was maintained, with progressive deterioration of the nervous system, till the age of eighty. But the fact is clear that his mighty energies and towering determination were gone before his life as a grown man was one third over. After that he reviewed, when able, the editing of his works, subsidized their publication, blessed younger composers with bits of money, and also helped his contemporary Ruggles, whose work he admired.

Ives never actually heard during his composing years any of his major orchestral works or choral projects. The piano sonatas, violin sonatas, works of chamber music, and songs — all of which he could no doubt hum or strum — may be accepted as more or less finished. I say more or less because quite often there are aleatory passages. But the larger orchestral and choral works — the Fourth Symphony, for example, requiring three instrumental bodies and three conductors — remained at his retirement merely plans. And if they all "come off" today more than handsomely, that is due to the loving editorial hands of Lou Harrison and Henry Cowell, among others, and to the no less loving conductor's hands of Lou Harrison, of Leonard Bernstein, and of Leopold Stokowski.

For Ives's music has attracted the admiration of discerning observers — of Mahler and Webern, of Stravinsky and Schönberg, of Aaron Copland, John Cage, Elliott Carter, and lately of the English composer-historian Wilfrid Mellers, as well as the devotion of his pianist-editor John Kirkpatrick, who has not only performed and recorded the major piano works, including the massive "Concord" Sonata, but actually catalogued every scrap of the seemingly inexhaustible Ives manuscripts. The publication of this sonata in 1919, followed in 1924 by 114 Songs (both at the author's expense) marked Ives's official emergence from clandestinity and his retirement from composition. His music writing had never, of course,

been entirely secret. He had occasionally shown something to a European virtuoso of the piano or violin, who would declare it hopeless; and in 1910 Gustav Mahler, then conductor of the New York Philharmonic, had proposed to play his First Symphony in Germany, a promise cancelled in 1911 by Mahler's death. But for the most part his partisans were to declare their faith far later, since access to his works and a favorable climate for admiring them were not available till after World War I.

Ives has frequently been cited by analysts for his early (so early indeed that in many cases it would seem the very first) consistent use of free dissonant counterpoint, of multiple metrics, of polychordal and polytonal harmonic textures, of percussively conceived tone-clusters and chord-clusters, and of stereophonic orchestral effects requiring several conductors. Practically all these devices, as he employed them, are describable as free, since whatever formal patterning is involved (and very often there is none) has been chosen for each occasion. Ives never explored harmonic, tonal, or rhythmic simultaneities for their intrinsic complexity, as the European composers did who were to follow his example so closely in time (all unaware of him). His temporal precedence has remained therefore a historical curiosity without relation to such systematic investigations of polyharmony, polytonality, and polyrhythm as occurred in the work of Richard Strauss and Debussy, subsequently in that of Igor Stravinsky and Darius Milhaud, of Arnold Schönberg's pupils, and of Edgard Varèse.

The popularity of Ives's music and its present wide distribution by performance and recording in America, even somewhat in Europe, are actually a response to the direct expressivity of certain works. *The Housatonic at Stockbridge*, for instance, is an impressionistic evocation, an orchestral landscape piece about a river, that even Europeans can enjoy. Longer works such as the Second (or "Concord") Piano Sonata and the Fourth Symphony, though actually structured for holding attention, are seemingly improvisational (even aleatoric) in a way that today's youth finds irresistible for effects of grandeur and chaos. And the jamborees of patriotic marches and evangelical hymns that climax *Putnam's Camp*, the Second Symphony, and many another calling forth of early memories are so deeply nostalgic for Americans that the California critic Peter Yates could sum them up as the only American music that made him cry.

The present writer too has wept at these. He is less impressed, however, by the "Concord" Sonata, with its constant piling of Pelion on Ossa. It has been his experience that Ives's work in general, though thoroughly interesting to inspect, frequently comes out in sound less well than it looks on the page. Some of this disappointment comes from musical materials which, although intrinsically interesting for appearing to be both highly spontaneous and highly complex, seem to be only casually felt.

Their extensive repetition in sequences and other structural layouts would tend to reinforce this suspicion, since real spontaneity does not repeat itself. The opening of the "Concord" Sonata is a case in point. Here is improvisational and, though busy enough, quite easygoing material that simply will not develop; it only riffs, makes sequences. And if it gets transformed as it goes along, its successive states are as casually conceived as the first; none sticks in memory.

Another sort of material, Ives's simplest, can be found in some of the songs. These seem so aptly related to the words both by sentiment and by a naturalistic declamation (for which he had a gift) that one expects almost any of them, embellished as they so often are by inventive accompaniments, to be a jewel. And yet they do not, will not, as we say, come off. Again there has been dilution, a casual filling-in of measures that would have needed for full intensity an unrelenting tinycraft, thought through and hand-made, such as one finds in Schubert, who was surely his model for song-writing just as Beethoven admittedly was for the larger instrumental statements. Ives's weakness is seldom in the vocal line, which is musically sensitive even when the poetry is poor, but quite regularly in the piano part, which fails to interweave, harmonically or rhythmically, with the voice. As a result it seems to be following the melody rather than generating it or providing a structure for it.

Among the rewarding songs is *Two Little Flowers*, composed in 1921 to a poem by his wife, a simple piece in the lieder style of Brahms, say, or Robert Franz. But even here the harmony can seem casual unless carried forward in performance by a rhythmic thrust.

Paracelsus, also for voice and piano, composed in 1921 to excerpts from Browning, begins with an instrumental page of the highest rhythmic and tonal complexity (actually a quotation from Ives's "Browning" Overture). According to the analysis of this work in *Charles Ives and His Music* by Henry and Sidney Cowell, it is thematically and motivically integrated to ideas expressed in the poem. Nevertheless, the music loses impetus when the poetry begins. Though the voice declaims eloquently, the piano seems to wait for it. The free rhythms in both parts support no clear trajectory, but leave to the singer all responsibility for carrying the music forward.

This unequal and ultimately ineffectual division of labor shows up most clearly in two songs of folkloric appeal — *Charlie Rutledge* of 1914–15 (on a cowboy ballad) and *General William Booth Enters Heaven* of 1914 (out of Vachel Lindsay). The words in both have a tendency to announce the music's illustrative effects rather than to comment on them, a vaudeville routine ill suited to serious music. To invent examples: "I hear a bird," followed by a piano trill, or "His big bass drum" (boom boom) are comic effects. Only the reverse procedure can properly evoke. *Charlie Rutledge*, moreover, is overdramatized in the voice. A deadpan

cowboy lilt against a dramatic piano part might have turned the trick.
Also, Vachel Lindsay's not entirely ingenuous apotheosis of a Salvation
Army leader would surely have benefited by a bit of musical irony. With
the bass-drum-like boom-booms and the triumphal hymn so frankly
overt, the piece can become an embarrassing game of let's-play-revival-
meeting.

Ives in his writings about music made a point of preferring "sub-
stance" to "manner." And indeed throughout his work, in spite of refer-
ences to gospel hymns and village bands, of massive tone-clusters and
rhythmic asymmetries, there is virtually no method of writing consis-
tently enough employed to justify a charge of "mannerism." He moves
from method to method eclectically, as great composers have always
done, to bring out meaning; and his imitations of choiring voices and
bands and bugle calls are as literal as he can make them. His ingenuities
toward exemplifying ethical principles and transcendental concepts
through thematic invention I find less rewarding from the simple fact
that they seem self-conscious, lacking in spontaneity. Moreover, they
are sometimes not quite first class; the effect desired is easier to recall
than the music itself.

In this sense, though there is no doctrinaire Romanticism of "form de-
termined by content," neither is there any arriving at emotional or other
fulfillment through strictly musical means, as in the classical *and* Ro-
mantic masters. By "substance" Ives means, I think, sincerity in the con-
ception of musical pictures or ideas. He cannot mean the identity of a
musical theme with what he hopes to express by means of it, for if he
did the music would be stronger knit around these ideas, whereas ac-
tually it tends to exist beside them like a gloss or commentary. When
time shall have dissolved away his nostalgias and ethical aspirations, as
they have largely done for Beethoven and for Bach and even for the de-
scriptive leitmotifs of Wagner, what sheer musical reality will remain in
Ives's larger works? Where will be the "substance" he wrote so elo-
quently about and desired so urgently? For all their breadth of concept
and their gusto, I have no faith in them. Intentions are no guarantee of
quality.

In remaining somewhat unimpressed by the Ives output in general —
though there are certainly delicious moments and even perfect whole
pieces, usually small, like the orchestral *Housatonic at Stockbridge* and
The Unanswered Question, possibly also the third of the "Harvest
Home" chorales — the present writer has no wish to underesteem the
aspiration, the constancy, and the sacrifice that Ives's musical life bears
witness to. Nor to undervalue a creative achievement that posterity may
prize. Actually, the man presents in music, as he did in life, two faces;
on one side a man of noble thoughts, a brave and original genius, on the
other a homespun Yankee tinkerer. For both are there; of that one can

be sure. How they got to be there need not worry us, for every artist begins in a dichotomy. But how this could remain unresolved to the very end of his creative life might be of interest to speculate about.

Every artist's work life has its strategy; without that there is no career. And we know from his own words that Ives, in renouncing music as a chief breadwinner, did not walk out on music. When he shortly came to renounce it as even a contributory source (through church jobs) he made that renouncement in order to save his leisure. We also know that busy as he was in business hours, and soundly successful, he still produced between the ages of twenty-four and forty-four a repertory of works larger by catalogue than that of most masters. Sometimes these were corrected carefully; sometimes he threw scarcely decipherable pages over his shoulder and never looked into the piles of them. It is certain that parts of works are lost, probable that whole ones also are, and possible that others may have been destroyed by intent.

But for all his haste, he was not really careless. He labored with a fury unrelenting; he also held strongly by certain of his works and cherished prejudices violently sectarian about many other composers past and present, which he stated with wit and profanity. He valued his "Concord" Sonata so highly that after it was finished he wrote a book about it. This book, called *Essays Before a Sonata,* though it was actually written after, is less an explanation of the music than a hymn of praise to the characters who were the inspiration of its four movements — Emerson, Hawthorne, Thoreau, and for comic relief the Alcotts. The greatest of these, for him, was Emerson; and there his confidence was so unquestioning that clearly for Ives the Unitarian preacher-essayist had replaced revealed religion. Would that we all could thus say, "I believe!" But the fact that Ives did have this source of faith — along with insurance, of which he also wrote a book in praise — helps us to picture the years of his complete devotion to music and to business, a devotion shared only with the domestic affections — with a wife named Harmony and an adopted daughter, neither of whom caused him any trouble or took much time.

His aspiration to be a great composer would be clear from the *Essays* if it were not equally revealed on every page of his music. And a need for working abundantly to accomplish this is proved by both the voluminousness of his production and the state of his manuscripts. This need must also have led him to a plan. For a man of his ability and known powers of organization to go all self-indulgent and careless during his twenty best years, and regarding music, which was very nearly his whole private life, is not believable. It must be that he simply decided to pour forth his inspiration at all times, finishing off in clean score only such works as demanded that and leaving the rest to be copied out in his retirement years.

Retirement from composition came earlier than he had expected, and the First World War would seem to have hastened his breakdown. His Emersonian confidence in democracy through the "over-soul," and his business-based optimism derived from an idealistic view of insurance, were shaken by Europe's suddenly revealed corruption and her suicidal holocaust, which America had joined. So that when his bodily strength, after years of overstrain, collapsed in 1918, something also happened to the brain. He may have seemed to be just physically ill, but his creative life was arrested.

It is possible to imagine this arrest as an acceptable, though unplanned, consequence of the total strategy. For Ives began immediately to behave with regard to his works as if his retirement from music had been foreseen. He initiated their publication, subsidized their performance, aided young men whose devotion to them and pity for him caused them to spend untold hours on their cataloguing, editing, and promotion. Since it was clear to all, including himself, that he would not write again, his *oeuvre* came to be treated like those of the immortal dead. So confidently, in fact, that by the time of his actual death in 1954 the congress of devoted younger men which was to take care of itemization, description, biography, analysis, and praise had so far done its work that the subject of this might well have been satisfied to wind up his campaign. He had composed voluminously and without fear; later he had witnessed the well-timed issuance of his works, their performance, publication, and recording. Not the present high state of their fame, of course, but enough to show that an apotheosis had begun.

There is no reproach to such a strategy, nor much probability that the sequence of events was accidental. An artist's life is never accidental, least of all its tragic aspects. And the tragic aspect of Ives is neither his long and happy domestic existence nor his short, abundant, and successful-within-his-own-time creative life. It is the fatal scars left on virtually all his music by a divided allegiance. Business may be a less exacting mistress than the Muse, what with staffs and partners to correct your haste. But Ives's music does show the marks of haste, and also of limited reflection. Dividing himself as he did, he had to run that risk. I doubt that he knew, either young or later, how great a risk it was. For if he had, would he have dared to make the ploy for both God *and* Mammon?

I prefer to think he did not, that the transcendental optimist and all-American success boy was simply trying to have everything, and at no cost save the strenuous life. Then the darker aspects of the world, which he had avoided ever and of which his music, all health and exuberance, shows no trace, surfaced with the First World War; and they put the fear of God into him. He stopped composing, became an invalid, retired from business, and abandoned all his earnings beyond what seemed to him a competence. One view of the bottomless pit, plus a decent income re-

tained for his family, plus care taken for his music's survival, all add up to a New England story complete with personal devil, an angry God, and a maimed production. Less maimed perhaps than that of his pedagogical contemporaries (though among those MacDowell may well survive him), but maimed nevertheless. For it is not teaching that cripples; no master has ever feared that. It is gentility, the divided mind, not giving one's all to art.

From *American Music Since 1910* by Virgil Thomson. New York: Holt, Rinehart and Winston, 1971, pp. 22–30. Originally published in *The New York Review of Books,* May 21, 1970.

❧ *Ruggles*

T HERE IS nothing notably genteel about Carl Ruggles. He is a bo-
hemian rather, who up to the age of forty earned a living out of
music, then found a patron on whose kindness he has lived for over fifty
years, supporting also till her death a wife passionately loved and bring-
ing up one son. He has also been for many years a landscape painter.
Music he has followed from his youth without qualms about failure, pov-
erty, disapproval, or what-will-people-say. Wiry, salty, disrespectful, and
splendidly profane, he recalls the old hero of comic strips Popeye the
Sailor, never doubtful of his relation to sea or soil.

A revealing story about him is the familiar one told by Henry Cowell
twenty years ago. Having gone to see him in Vermont, Cowell arrived
at the former schoolhouse that was Ruggles's studio and found him at
the piano, playing the same chordal agglomerate over and over, as if to
pound the very life out of it. After a time Cowell shouted, "What on
earth are you doing to that chord? You've been playing it for at least an
hour." Ruggles shouted back, "I'm giving it the test of time."

As of today, all of Ruggles's music has withstood that test, as has the
man. His oldest surviving piece — a song to piano accompaniment com-
posed in 1919 — is more than fifty years old; his latest, from 1945, is
twenty-five; and he himself, as I write, is ninety-four. His works have
traveled in America and in Europe; and though they have not experi-
enced the abrasions of popularity, they have been tested microscopically
by the toughest analysts without any examiner finding anywhere a flaw.
Excepting perhaps himself, since he has rescored some works several
times before settling on their final sound and shape.

Born in 1876 of whaling folk on Cape Cod, he learned to play the
violin in Boston and had lessons in the composer's craft at Harvard. Then
he got experience of the orchestra in the good way, by conducting one for

eleven years. That was in Minnesota. During all this learning time he wrote no music that he cared later to preserve.

There was some work done on an opera, its subject Gerhard Haupt-mann's play *The Sunken Bell;* but this was never finished, Ruggles hav-ing gained through the effort a conviction that he had no talent for the stage. His earliest work that he has allowed to survive is the song called *Toys,* composed in 1919 when he was forty-three. Over the next twenty years he produced virtually all his surviving repertory, each piece in-tensely compact, impeccably inspired, exactly perfect, and exactly like all the others in its method of workmanship.

This method, of which the closest model is the music that Arnold Schönberg composed before World War I, can be classified among musi-cal textures as non-differentiated secundal counterpoint. By non-differen-tiated I mean that the voices making up this counterpoint all resemble one another in both character and general shape; they are all saying the same thing and saying it in much the same way. This manner of writing music, whether practiced by Bach or by Palestrina or by Anton Webern, for all of whom it was their usual method, produces a homogeneity highly self-contained, and more picturesque than dramatic.

By secundal counterpoint I mean that the intervals present at the nodal points of the music (say roughly at the downbeats) are predomi-nantly seconds and sevenths. This interval content distinguishes it from the music dominated by fourths and fifths (composed chiefly between the years 1200 and 1500; we call this music quintal) and from the music colored by thirds and sixths (the tertial) that followed the quintal for four centuries. Secundal writing, compared with quintal, which is rock-like, and with tertial, which is bland, produces through continuous dis-sonance a grainy texture that in most of Ruggles's music is homogenized, or made to blend, by the use of closely similar timbres, such as an all-string or all-brass instrumentation. And as happens in most of Bach, the music comes out polyphonic as to line but homophonic as to sound.

In spite, however, of all its homogeneity (exterior mark of its intro-spective nature) music like this is never quite without objective depiction. For observing this in Ruggles, the early song *Toys* is most revealing. The words, written by Ruggles himself, are:

> *Come here, little son, and I will play with you.*
> *See, I have brought you lovely toys.*
> *Painted ships,*
> *And trains of choo-choo cars, and a wondrous balloon,*
> * that floats, and floats, and floats, way up to the stars.*

Let us omit reference, save in passing, to the fact that the father seems to have let go of the balloon before his son could lay hands on it. Also, since stars are mentioned, that the play hour seems to be taking place

out of doors on a moonless night, a most unlikely circumstance. But these are literary quibbles.

Musically the piece, for all its steadily dissonant sound-texture, is illustrative throughout.

It begins with a gesture-like call in the piano accompaniment, stated both before and after the summons, "Come here, little son, and I will play with you."

The phrase "painted ships" is accompanied by a rocking motion that leads to a splash.

The "choo-choo" mention is followed by rhythmic sounds, low in the register and accelerating, that clearly picture a steam-driven locomotive.

And the "balloon that floats" not only does so in the piano part, which arpeggiates upward, but also in the vocal line, which leaps and leaps till on the word "stars" it reaches high B-natural and stays there.

Similarly, the piece for strings called *Lilacs*, though I doubt whether any description quite so specific is intended, is all of short rounded lines at the top and of long gangling tentacular rootlike curves in the bass.

And *Portals*, another string piece, has high-jutting points to it that might be either Gothic arches or simply man's aspiration. The quiet moment at the end of an otherwise energetic work could represent man's humility on entering the high portals; but if the earlier part is not the noble gates themselves but merely the soul of man climbing toward them, then the ending must represent him arrived and sitting down to rest. The motto on the score tells us nothing so specific; it merely asks, "What are those of the known but to ascend and enter the unknown?"

Angels, for seven muted trumpets and trombones, is quietly ecstatic from beginning to end, and the angels are not individualized. They are clearly a group, a choir perhaps. I do not even know whether they are singing; they may be merely standing close together and giving off light, as in the engravings of William Blake. Whatever is happening, they are doing it or being it together, for the instruments all pause together, breathe together, start up again together, as in a hymn. Whether this close order depicts a harmony of angels or merely one man singing about them in seven real parts is not important; it could be both. But in any case, the music's sentence structure, always clear in Ruggles, is nowhere more marked than in his work, where ecstasy is communicated through a series of statements about it, each with a beginning, a middle, and a tapered ending, and all separated from one another like formal periods.

The Sun Treader and *Organum*, both scored for large orchestra rather than for a blended small ensemble, achieve homogenization of sound through the constant doubling of strings by wind instruments. And this device, so dangerous in general to the achievement of variety, is here not

monotonous, but eloquent rather, as if one speaker were carrying us along on winged oratory. The Ruggles counterpoint is there too, constantly chromatic, flowing, airily spaced but also compact and dissonant, and speaking, for all its rhythmic diversity, as with a single voice. This may be the voice of the sun treader, or it may be a picture of his actions; it matters little. What matters is that the piece goes on. It lasts eighteen minutes (long for Ruggles) without any let-up of intensity. *Organum* is longish too, but less choreographic, more songful. Both are full of their message, which is apocalyptic, and yet systematically, intensely self-contained.

The way that Ruggles has of making his music always come out in nonsymmetrical prose sentences — a planed spontaneity, one might call it — is not really in opposition to his preoccupation with ecstasy. For that ecstasy in the expression, that unrelenting luminosity of interval and sound, is needful for producing the quality that was his overall intent and which he calls "the sublime." Now what does he mean, what does anybody mean, by "the sublime"? I should say that this word, when applied to a work of art, can only mean that the work expresses and hence tends to provoke a state of ecstasy so free from both skin sensuality and cerebral excitement, also so uniformly sustained, that the ecstasy can be thought of as sublimated into the kind of experience known as "mystical." Ruggles, in fact, once said as much, that "in all works there should be the quality we call mysticism. All the great composers have it."

The titles of his works and their explanatory mottos mostly tend to evoke, if not a mystical experience, at least the familiar cast and décor of religious visions — *Men and Mountains, Men and Angels, The Sun Treader, Vox Clamans in Deserto, Organum,* or, quite vaguely for once, just *Evocations.* These subjects, save for the presence of angels and for a voice from the wilderness, are not nearly so close to Christian mysticism as they are to pantheism, to a spiritual identification with nature such as can be called forth in almost any New Englander by the presence of lilacs, or of mountains measurable by the size of man.

But it is not the subjects of his ecstasy that create sublimity. Many a witness has gone dizzy looking at beauty. With Ruggles it is with the need for sublimity that dizziness ends and hard work begins. For there is no sublimity without perfection; and for Ruggles there is no perfection until every singing, soaring line, every subtle rhythm and prose period, every interval and every chord has received from his own laborious hands the test of time. There must be no gigantic proportions, no ornamental figurations, no garrulous runnings-on, no dramatization, no jokes, no undue sweetness, no invoking of music's history, no folksy charm, no edifying sentiments, no erotic frictions, no cerebral cadenzas, no brilliance, no show-off, and no modesty. There is nothing in his music but

flexible melodies all perfectly placed so as to sound harmonious together, and along with these a consistently dissonant interval-texture, and a subtly irregular rhythm that avoids lilt.

The auditory beauty of Ruggles's music is unique. It actually sounds better than the early Schönberg pieces, *Verklärte Nacht* and *Erwartung*, that are perhaps its model, almost I should say its only model. It sounds better because it is more carefully made. Its layout is more airy; no pitch gets in any other's way; the rhythm is more alive; it never treads water, only sun. It is by very hard work and all alone that this perfection has been attained. And it is through perfection, moreover, the intensely functioning refinement of every musical grain and chunk, every element of shape and planning, that a high energy potential has been both produced and held in check, like a dynamo with its complex insulation. And it is this powerful energy, straining to leap a blue-white arc toward any listener, that constitutes, I think, what Ruggles means by sublimity. It is no wonder that out of a ninety-year lifetime there remain fewer than a dozen pieces. Intensities like that cannot be improvised.

Wilfrid Mellers, comparing Ruggles to Arnold Schönberg, has written in his book of praise to America, *Music in a New Found Land,* that "both were amateur painters who, in their visual work, sought the expressionistic moment of vision. Both, in their music still more than in their painting, found that the disintegrated fragments of the psyche could be reintegrated only by a mystical act. Schoenberg, as a Viennese Jew, had an ancient religion and the spirit of Beethoven to help him; Ruggles had only the American wilderness and the austerities of Puritan New England. For this reason he sought freedom — from tonal bondage, from the harmonic straightjacket, from conventionalized repetitions, from anything that sullied the immediacy and purity of existence — even more remorselessly than Schoenberg."

Ruggles's dilemma, of course, has been the perpetual dilemma of American composers. On one side lie genius and inspiration, on the other an almost complete lack of usable history. We have access to the European masters, to Bach and Mozart and Beethoven and Debussy, but only through their music; we cannot remember them nor reconstruct what they were thinking about; and what we *can* remember, through our documents and our forebears, is so different from anything Europe knows or ever knew that both to the European listener and to the American, naif or learned, every inspiration is a scandal. A Frenchman or an Austrian of gifts can be fitted early into his country's immortality machine — nurtured, warmed for ripening, brought to market. An American of talent is from the beginning discouraged (or overencouraged), bullied by family life and by schoolteachers, overworked, undertrained, sterilized by isolation or, worse, taken over by publicity, by the celebrity machine.

American composers have tried several solutions. One has been to

fake a history; that is to say, to adopt some accepted European method of working and to hide behind it so effectively that the ignorant are impressed and the intellectuals immobilized. Horatio Parker, Edward Mac-Dowell, and Walter Piston did this. And their inspiration, discolored by its own shield, lost personality and some of its meaning; but these men did write music of distinction that has not died.

Another way of facing the awful truth is to face it squarely — to discard the concept of distinction, to use any and all materials that come to hand and to use them in any context whatsoever. Walt Whitman did this in poetry, Charles Ives in music, also Henry Cowell in his early years. And though they mostly could not make their art support them, they produced in quantity and their inspirations were not deformed. By sacrificing the ideals of perfection and distinction, as well as all hope of professional encouragement — Ives actually for twenty years hiding away (and wisely, I think) from the danger of professional persecution — they achieved in their work an enormous authenticity.

Ruggles faced the dilemma in still another way, which was to slowly construct for himself a method for testing the strengths of musical materials and a system of building with them so complex, so at every point aware of tensile strengths and weaknesses, that by this seemingly neutral application of psychological and acoustic laws, works were constructed that are not only highly personal in content but that seem capable of resisting wear and time. Poe is a somewhat parallel case in letters. In music Elliott Carter is surely one. And in all three cases — Ruggles, Carter, and Poe — not only has authentic inspiration survived, but beauty and distinction have not been sacrificed. Such artists may wear their integrity like a chip on the shoulder, but it is real. Ambition, "that last infirmity," though it may torment their sleep, has been kept from their work. With Ruggles and Carter the output has been small; but no compromise has taken place, nor has any hindrance occurred to the artist's full ripening.

Good music, reputable and palatable, has been composed in all three of the circumstances I describe — by copying Europe, by working without rule, or by constructing a method — and I fancy that all three ways for getting around the American dilemma will continue to be used. For there is still no "spirit of Beethoven" here, either walking beside you down the street as he does in Vienna, or buried nearby in any of our graveyards. It will be some time before one of our young musicians, feeling the call to speak to man of God, to God of man, or of man to men, will find his feelings channeled by understanding or his consecration accepted. Everything is set here to educate him, to brainwash him, and to reward him with success; nothing is prepared to help him become a great man, to carry out his inspiration, or to fulfill his blessedness.

For inspiration, as we can learn from all great work, comes only out

of self-containment. And style, that touchstone of authenticity, comes only from authentic inspiration. What is style? Carrying power, I say; nothing more. At least, carrying power is style's direct result. From carrying power come distinction and fame, recognition while one is still alive. And from them all — from inspiration, style, and distinction, provided the inspiration be authentic, the carrying power through style very strong, and the distinction of personality visible to all — from all these comes immortality.

Now both Ives and Ruggles have through their music achieved a modicum of that. To Ives has come also, of late, popularity. The music of Ruggles, far more recondite, is also more intensely conceived and more splendidly perfected. Ives belongs (though he is grander, of course) with the homely tinkerers like the eighteenth-century tanner William Billings, and also with the roughneck poets of his own time Carl Sandburg and Vachel Lindsay. But for all of Ives's rude monumentality and his fine careless raptures — welcome indeed in a country vowed to a freedom that its artists have rarely practiced — he falls short, I think, of Whitman's total commitment, as he does also of Emerson's high ethical integrity. Ruggles, judged by any of these criteria, comes out first class. Europe, where he has been played more than here, has never caviled at such an estimate; nor has his music, under use or after analysis, revealed any major flaw. Standing up as it does to contemporary tests, including public indifference, how can one doubt that it will also stand the test of time?

From *American Music Since 1910* by Virgil Thomson. New York: Holt, Rinehart and Winston, 1971, pp. 31–39.

℘ Cage and the Collage of Noises

I N 1967 John Cage, working at the University of Illinois in Urbana with the engineer-composer Lejaren Hiller, began to plan, design, and move toward the final realization in sound (with visual admixtures) of a work lasting four and a half hours and involving a very large number of mechanical devices controlled by engineers, along with seven harpsichords played by hand. Nearly two years later this work, entitled *HPSCHD* (a six-letter version, suited to computer programming, of the word *harpsichord*) was produced on May 16, 1969, in the university's Assembly Hall, seating eighteen thousand people.

By this time the work had come to include as sources of sound not only the keyboard instruments of its title (which Cage pronounces *harpsichord*) but also fifty-two tape machines, fifty-nine power amplifiers, fifty-nine loud-speakers, and two hundred eight computer-generated tapes. The visual contributions to this performance employed sixty-four slide-projectors showing sixty-four hundred slides and eight moving-picture projectors using forty cinematographic films, probably silent in view of the general auditory complexities just mentioned.

Richard Kostelanetz, reviewing the event for *The New York Times*, reported further that "flashing on the outside under-walls of the huge double-saucer Assembly Hall . . . were an endless number of slides from 52 projectors" (a part of the sixty-four?). Inside "in the middle of the circular sports arena were suspended several parallel sheets of semi-transparent material, each 100 by 400 feet; and from both sides were projected numerous films and slides whose collaged imagery passed through several sheets. Running around a circular ceiling was a continuous 340-foot screen, and from a hidden point inside were projected slides with imagery as various as outer-space scenes, pages of Mozart's music, com-

puter instructions, and nonrepresentational blotches. Beams of light were aimed across the undulated interior roof. In several upper locations mirrored balls were spinning, reflecting dots of light in all directions ... The audience," he adds, "milled about the floor while hundreds took seats in the bleachers."

The auditory continuity he describes as "an atonal and structural chaos ... continually in flux." However, "fading in and out through the mix were snatches of harpsichord music that sounded ... like Mozart; ... these came from the seven instrumentalists visible on platforms in the center of the Assembly Hall." The sound appealed to him as in general "rather mellow, except for occasional blasts of ear-piercing feed-back that became more frequent toward the end."

Mr. Kostelanetz identifies the esthetic species to which this work belongs as "that peculiarly contemporary art, the kinetic environment, or an artistically activated enclosed space." Actually this "artistically activated" space is not very different from the Wagnerian *gesamtkunstwerk*, or music drama (also a mixed-media affair), except for its very modern emphasis on the mechanics of show business. Wagner took these for granted, preferring to use them less as glamour items than for underlining myths and morals. In both cases, I think, the production of ecstasy was the aim; and in both cases surely music (or sound, in any case) was the main merchandise. For Wagner's music is clearly what has survived best out of his whole splendid effort to create a new kind of tragedy. And as for the Cage-Hiller *HPSCHD*, it was already on sale as a musical recording, completely shorn of its visual incidents and compacted down to twenty-one minutes of playing time, when the great mixed show of it all was put on in Urbana.

In 1937, thirty years before this work was started, Cage had proclaimed his credo regarding the future of music: "I believe that the use of noise to make music will continue and increase until we reach a music produced through the aid of electrical instruments which will make available for musical purposes any and all sounds that can be heard." The composer, in these prophesied times, will not limit himself to instruments or concepts based on the overtone series but "will be faced with the entire field of sound." And new methods for composing with this vast vocabulary, he also stated, were already beginning to be developed, methods which were free and forever to remain free (I quote) "from the concept of a fundamental tone."

The idea of making compositions out of noise, that is to say of sounds not responsible to a common fundamental, had been in the air ever since the Futurist painter Luigi Russolo in 1913 praised as sources for an "art of noises" "booms, thunderclaps, explosions, clashes, splashes, and roars." Busoni too saw music as moving toward the machine. And Varèse was dreaming of electrical help by 1920 certainly. Also George Antheil,

Leo Ornstein, and Darius Milhaud had very early composed passages for non-tonal percussion. Cage, however, when he began to compose in 1933, was virtually alone in following out the Futurist noise principle as a career. Others had worked occasionally in that vein, but none other seemed really to believe in it as a destiny or to be able to perfect for its mastery devices for giving it style, structure, and variety. Cage's own music over the last thirty years, though not entirely free of interrelated pitches, has nevertheless followed a straighter line in its evolution toward an art of collage based on non-musical sounds than that of any other artist of his time. He seems to have known by instinct everything to avoid that might turn him aside from his goal and everything that could be of use toward achieving it. Precious little service, naturally, was to be expected out of music's classical models.

The ultimate aim was to produce a homogenized chaos that would carry no program, no plot, no reminders of the history of beauty, and no personal statement. Nowadays, of course, we can recognize in such an ideal the whole effort of pop art. But I do not think that pop art's obvious jokes and facile sentiments were a major motive. I think Cage wanted, had always wanted, to save music from itself by removing its narcotic qualities and its personalized pretentiousness, as well as all identifiable structure and rhetoric. In this regard his aim has been close to that of Erik Satie, whose music he adores. But its consistent pursuit presents a story so utterly American, even West Coast American, that the Frenchman from Normandy with a Scottish mother, though he might well have delighted in Cage's salt-sprayed humor, would have lacked sympathy, I suspect, for his doctrinaire determination.

John Cage is a Californian born in Los Angeles in 1912, whose father had come there from Tennessee. A lanky redhead with white skin that freckles, a constant walker, a woodsman, and a tinkerer, he has all the tough qualities of the traditional mountaineer submissive to no authorities academic or federal. He had good lessons in piano-playing and in composition, the latter from Arnold Schönberg among others. Teaching during the late 1930s at the Cornish School in Seattle, he made friendships in the Northwest that stimulated his takeoff as a composer toward East Asian art principles. The painter Morris Graves, the composer Lou Harrison, and the dancer Merce Cunningham all came into his life at this time; and so did the young Russian woman from Alaska whom he married.

He also conducted percussion concerts and composed percussion works. His *Construction in Metal*, of 1939, for bells, thunder-sheets, gongs, anvils, automobile brake drums, and other metallic objects, is organized rhythmically after the Indian *tala*, in which the whole has as many parts as each section has small parts; and in Cage these parts, large and small, are related to each other in lengths of time as square and square root. In

1938 he also began to "prepare" pianos by inserting coins, bits of rubber or wood, bolts, and other small objects between the strings at nodal points, producing a gamut of delicate twangs, pings, and thuds that constitutes for each piece its vocabulary.

At this time, and for the next decade, Cage's music continued to be organized for phraseology and length after the square-and-square-root principle. Its melodic structure, if one may use this term for music so far removed from modes and scales, is expressive, in the Indian manner, of "permanent" emotions (heroic, erotic, and so forth) though in some cases he does not hesitate, as in *Amores* (1943), to describe things personally experienced, in this case a lovers' triangle. But his melody remains aware of Schönberg's teaching about tetrachordal structure, and it also observes a serial integrity. Since music without a thoroughbass can seek no structure from harmony, and since Cage's orientalizing proclivities inclined his expression toward "permanent" emotions, as opposed to those which by their progress and change might suggest a beginning, a middle, and an ending, he had available to him no structural method save what he could invent through rhythm.

Now rhythm, being the free, the spontaneous, the uncontrolled element in Schönberg's music and in that of his Viennese companion-pupils Berg and Webern, appealed strongly to Cage's inventive mind as a domain offering possibly a chance for innovation. The Schönberg school had made few serious attempts to solve problems of structure; they had remained hung up, as we say, on their twelve-tone row, which by abolishing the consonance-dissonance antithesis had relieved them of an age-old problem in harmony. The fact that in doing so it had also abolished the scalar hierarchies, previously the source of all harmony-based form, led them to substitute for harmonic structure an interior cohesion achieved through canonic applications of a twelve-tone row, but not to any original efforts at all regarding organic form. Rhythm they never considered for this role, since rhythm, in the European tradition, had long before been judged a contributory element, not a basic one like melody or harmony. And besides, the Germanic practice, in which they had all grown up, had lost its rhythmic vitality after Beethoven's death, and no longer distinguished with any rigor between rhythms of length and rhythms of stress, as Beethoven and his predecessors had done to so remarkable a result.

What the Schönberg school actually used as a substitute for structure was the evocation of certain kinds of emotional drama familiar to them from the Romantic masters. This is why their music, though radical in its interval relations, is on the inside just good old Vienna. Even Italians like Luigi Dallapiccola and Frenchmen like Pierre Boulez, who took up the twelve-tone method after World War II, being not attached atavistically to Vienna, could not hold their works together without a libretto.

Their best ones are operas, oratorios, cantatas. And their only substitute for organic structure was the *sérialisme intégral* actually achieved by Boulez in a few works, a complete organization into rows of all the variables — of tones, lengths, heights, timbres, loudness, and methods of instrumental attack. The result was so complex to compose, to play, and above all to follow that little effort was made to continue the practice.

The experiment had its effect on Cage, all the same, almost the only direct musical influence one can find since his early lessons with Cowell and Schönberg and his percussion-orchestra experiments with Lou Harrison. For Cage, like everybody else, was deeply impressed by Pierre Boulez, both the music and the mentality of the man. Knowing well that twelve-tone music lacked both rhythm and structure, Cage had early aspired in his works for percussion groups and for prepared piano to supply both. Whether he had ever thought to serialize the rhythmic element I do not know; he may have considered his *tala* structure more effective. But he was impressed by the Boulez achievement in total control, and Boulez in return was not without respect for Cage's forcefulness.

At this point — we are now in the late 1940s — Cage sailed off toward the conquest of Europe. But Europe by this time was in the hands of its own youth-centered power group. Boulez in France, Karlheinz Stockhausen in Germany, a henchman or so in Belgium and Italy were beginning to be a tight little club. They ran a modernist festival at Donaueschingen and a concert series in Paris, dispensed patronage and commissions through the German radio, and influenced publishers. Cage, always pushing, assumed his right to parity in the European councils. He can be overbearing, I know, and maybe was. I do not know what confrontations occurred; but he came back chastened, retired to his backwoods modern cabin up-country from Nyack, became a searcher after mushrooms, found solace in Zen Buddhism.

By 1951 he had come up with another novelty, one that was to sweep through Europe, the Americas, and Japan without bringing him any personal credit. I refer to the aleatory method of composition, in which the variables so strictly controlled by Boulez through serial procedures were subjected, all of them, to games of chance. We may suppose, I think, that between a numerically integrated work of sound and one showing arrangements and orders that reflect only hazard, there is not of necessity much recognizable difference. A similar degree of complexity is bound to be present, provided the variable elements are sufficiently numerous and the game of chance used to control them sufficiently complex to avoid the monotony of a "run." If John Cage was not the first aleatory composer, he may still have been the first to hit upon the aleatory idea. It fits with his modest but perfectly real mathematical understanding, with his addiction to things oriental (in this case to the Chinese *I Ching, Book of Changes*, where he found the dice game he still uses), with the Zen

Buddhist principle that nothing really has to make sense (since opposites can be viewed as identical), and above all with his need at that particular time for a novelty.

According to Gilbert Chase in *America's Music*, Cage first started using chance in connection with thematic invention for getting from one note to the next. Then at each small structural division chance was also used to determine whether the tempo should be changed. This was in a work for prepared piano called *Music of Changes*. But inevitably, with chance involved in the tempo changes, hence in the overall timings, "it was not possible," says Cage, "to know the total time-length until the final chance operation, the last toss of coins affecting the rate of tempo, had been made." And since the work's length could not be decided in advance, the square-and-square-root structural proportions could not be used. Therefore structure, for the first time in Cage's experience of it, became as indeterminate an element in composition as texture, both shape and meaning disappeared, and composition became in Cage's words "an activity characterized by process and essentially purposeless." He has not yet fully explained, however, just how in choosing by chance his musical materials he arrives at the ones to be processed through the dice game, though there is no question of his "inventing" these materials. He does not; he "finds" them through objective, impersonal procedures.

And so it came about that after Schönberg had dissolved all harmonic tensions by assuming dissonance and consonance to be the same, and Boulez had through his *sérialisme intégral* removed seemingly all freedom, all elements of choice from composition beyond the original selection of materials themselves and their initial order of appearance, Cage had now made music completely free, or "indeterminate," an achievement he was especially pleased with because it eliminated from any piece both the history of music and the personality of the composer. And such personal elements as were in danger of governing the choice of materials he has endeavored to obviate by treating imperfections in the paper and similar accidents as real notes. His subsequent elaborations of indeterminacy for working with electronic tape, though ingenious, are merely developments of the aleatory or impersonal principle. And thus we arrive with *HPSCHD*, the harpsichord piece of 1969, at an effect of total chaos, completely homogenized save for occasional shrieks of feedback.

Let me trace again the surprisingly straight line of Cage's growth in artistry. His father, for whom he had deep respect, was an inventor; not a rich one, for he lacked business sense, but a fecund one. And his inventor's view of novelty as all-important has been John's view of music ever since I first knew him at thirty, in 1943. He prizes innovation above all other qualities — a weighting of the values which gives to all of his judgments an authoritarian, almost a commercial aspect, as of a one-way tunnel leading only to the gadget fair.

He has, I know, felt warmly toward certain works and composers, especially toward Satie; but he has never really accepted for his own all of music, as the greater masters living and dead have done. Stravinsky's distrust of Wagner, almost anybody's suspicion of Brahms, or Schönberg's utter impatience about Kurt Weill — aside from such minor irritations, generally composers have considered the history of music as leading up to them. But Cage has no such view. He thinks of himself, on the contrary, as music's corrective, as a prophet denouncing the whole of Renaissance and post-Renaissance Europe, with its incorrigible respect for beauty and distinction, and dissolving all that in an ocean of electronic availabilities. Electronic because those are what is around these days. He knows the sound of any loud-speaker, through which all this must come, to be essentially ugly (he has said so), and he probably knows that the presence of Mozart in *HPSCHD* gives to that work a neoclassical aspect definitely embarrassing. But the enormity of his transgression in both cases humanizes after all the overweening ambition. It is not the first time that an artist has fancied himself as destroying the past, and then found himself using it.

Actually Cage is less a destroyer than a typical California creator. Like many another West Coast artist — Gertrude Stein, for example — he selects his materials casually and then with great care arranges them into patterns of hidden symmetry. The difference between such artists and their European counterparts lies not in occult balances, which have been standard in Europe ever since Japan was revealed to them in the 1850s, but in the casual choice of materials. That Europe will have none of. From Bach and Mozart through Debussy and Stravinsky to Boulez and Berio and Xenakis, just as from Chaucer through Byron to Proust and Joyce, or from Giotto through Picasso, forms themselves, the words, the colors, the sounds, the scales, the melodies are ever precious, the psychic themes adventurous and terrible. Their treatment may be comical or tragic, sometimes both; but the matter must be noble no matter how ingenious the design.

Cage would say of all that, "just more post-Renaissance imitation of nature." He believes, or pretends to believe, that the artist, instead of copying nature's forms, should follow her ways of behavior. As to what these ways are, unless he believes them to be really without pattern, I cannot imagine. A man as well read as he must know that neither biological forms nor crystal shapes are matters of chance, also that animals and plants are as ruthless about seizing food and holding a place in the sun as any European artist ever was.

The truth is that Cage's mind is narrow. Were it broader his remarks might carry less weight. And his music might not exist at all. For with him the original gift, the musical ear, is not a remarkable one. Neither did he ever quite master the classical elements, harmony and counterpoint

— a failure that has led him at times into faulty harmonic analysis. His skill at rhythmic analysis and rhythmic construction is very great, one of the finest I have known. And his literary facility is considerable. One book, called *Silence*, contains most of the best among his writings on musical esthetics. *A Week from Monday* is a joke book, the clownings of a professional celebrity who has admired Gertrude Stein and played chess with Marcel Duchamp. *Notations* is a collection of reproduced musical manuscripts from 261 composers, some laid out in staves and measures, many in the mechanical-drawing style or the multitudinous chicken tracks that are the individual shorthands, no two alike, of today's musical inventors. The aim of this vastly revealing book, with its gamut of personalities and handwritings, was to raise money through the publication and eventual direct sale of these gift manuscripts for the benefit of a foundation through which Cage aids musicians, dancers, and other artists congenial to his tastes. In *Virgil Thomson: His Life and Music* (the biographical part is by Kathleen O'Donnell Hoover) my works, every scrap of them up to 1959, have all been analyzed with care and described, as often as not, with love. There is some frankly expressed petulance too, and a sincere regret that my career has not followed an undeviating modernism. The catalogue of my music — complete, detailed, and accurate — is a bibliographic triumph. For Cage is at all times a precision worker.

He is also a major musical force and a leader among us. This leadership is not merely a matter of position and of precept; it is also kept up by mammoth shows like *HPSCHD* and the one produced in 1966 at New York's 69th Regiment Armory and entitled modestly Variation VII. Nobody else among the far-outs can lay hands on so much expense money or has the persistence to carry through such detailed projects in score-planning and in electronic manipulation. Nobody, perhaps, except Iannis Xenakis, who works by a mathematics of probabilities. All this assiduity at the service of music's physical aggrandizement I find more admirable for pains taken than for its ability to hold my attention. Lasting for twenty-one minutes or four and more hours, the Cage works have some intrinsic interest and much charm, but after a few minutes very little urgency. They do not seem to have been designed for holding attention, and generally speaking they do not hold it. Constructed not for having a beginning, a middle, and an ending but for being all middle, all ambiance, all media massage, they turn out easy to taste and quick to satisfy.

A lack of urgency has been characteristic of Cage's music from the beginning. The instrumental sounds, whether altered or normal, are charming at the outset and agreeably varied from one piece to another, even in such delicate gradings of variety as from one piano preparation to another. But whenever I have played his recorded works for students I have found that no matter what their length they exhaust themselves in about two minutes, say four at most. By that time we have all got the

sound of it and made some guess at the "permanent" emotion expressed. And there is no need for going on with it, since we know that it will not be going any deeper into an emotion already depicted as static. Nor will it be following nature's way by developing an organic structure. For if the mind that created it, though powerful and sometimes original, is nevertheless a narrow one, the music itself, for all its jollity, liveliness, and good humor, is emotionally shallow.

It is at its best, I think, when accompanying Merce Cunningham's dance spectacles. These could as well, I fancy, do without music at all, so delicious are they to watch. And Cage's music for them is never an intrusion, but just right — cheerful, thin, up-to-the-minute in style. The last of his big machines I have listened to (I avoid those that employ amplification) is the Concert for Piano and Orchestra of 1958. This, heard live, is all of precious materials, since its sounds come from classical instruments, themselves the product of evolution and of careful manufacture. And though the composer has tried hard to remove their dignity — playing trombones without their bells, putting one tuba's bell inside another's, sawing away at a viola placed across the knees for greater purchase — the fact remains that even treated rudely these instruments give a more elegant sound than electric buzzers and automobile brake-bands, or even than tom-toms and temple blocks. As for the spectacle of David Tudor crawling around among the pedals of a piano in order to knock on the sounding board from below, that too was diverting to watch, though the knocking was not loud enough to be funny. All in all the visual show added so much to the whole that when, again for students, I played the recording of this piece (made in the hall itself at Cage's twenty-fifth-anniversary concert), we were all disappointed, I think, at its inconsequential sound.

In the long run non-classical sound sources, especially the synthetic ones, are as great a hazard to music as industrially processed foods can be to gastronomy (not to speak of nutrition). And Cage's compositions, in the days when he used to play or conduct them *live*, were far more agreeable to the ear than the electronically generated ones which dominate his later production. Even those earlier ones conceived for direct audition are less likely nowadays to turn up in the concert hall than they are in the form of recordings. So that the whole of his repertory (saving the famous *4'33"* of silence) tends to be sicklied over with the monochrome of transmitted sound. And this is a misfortune for us all, since much of his work is inspired by the joy of cooking up a piece out of fresh sounds.

The trouble with loud-speakers is as follows. Their transmission of familiar music performed on familiar instruments can be highly resembling, even deceptively so, provided the acoustical size of the original combo is appropriate to that of the room in which it is being heard. This

lifelikeness diminishes with large reduction or amplification, as with an opera or symphony cut down to bedroom size or a harpsichord solo piped into a theater. Now any resemblances to an original, as with photography, for example, depend for their vivacity on the receptor's acquaintance with the original or with its kind. Faults of transmission can therefore be forgiven in return for the delights of recognition. But when the source is unfamiliar no comparison is at hand. How can we know what a sound electronically designed would resemble if we heard it pure? We cannot, of course, since it does not exist until transmitted. A flavor of the canned is inevitable to it.

And what is this canned taste? In music it is a diminution of the parasitic noises that condition every instrument's timbre, the scratching of resin on a fiddle string, the thump of a piano key hitting bottom, the clatter of a flute's finger mechanism, a slight excess of breath intake, the buzzing of a reed. I know that these things get picked up too, often in exaggerated form, so exaggerated in fact that they are on the whole better kept out of a recording. But the effort to do this does neutralize a bit the timbre of any instrument or voice. Just as oil painting done by artificial light tends to lose frankness of color and to wear a slight veil, so does any musical sound transmitted by loud-speaker lose some of its delight for the ear. And when that sound is one for which no compensatory acquaintance exists with any original, a whole range of musical creation (that of today's far-outs, for instance) gets drowned in a sea of similarity.

Many of America's far-outs (old masters Foss, Babbitt, and Luening among them) have endeavored to liven up the deadness of speaker transmission by combining tape music with that of a live orchestra. Even Varèse, in *Déserts*, tried it once. John Cage, so far, has seemingly abstained from this apologetic stance. For even in *HPSCHD*, with all that went on together in that monster auditorium, I judge there is little likelihood of the seven harpsichords' not having also undergone amplification.

The gramophone, as a preserver of standard music, pop or classical, has ever been an instrument of culture, because the record collectors complete their listening experiences through attendance at musical occasions. This was demonstrated in the early 1940s at Columbia University's Institute of Social Research. Radio, it was also determined there, led culturally nowhere, since persons whose musical experience began with that medium rarely proceeded to make acquaintance with the real thing. Considering today's immersion of everybody everywhere in transmitted sound, and especially of the young in high amplification, there seems little chance that any music not transmitted and amplified will long survive outside its present classical habitats — which is to say, opera houses, concert halls, conservatories, studios, and certain low dives where jazz is played, maybe too in mountaineer heights far from Nashville, and a few

churches. Unless, of course, the young, today so hooked on amplification, should suddenly say to rock itself, "Good-by."

But for now the troubled waves are like a sea; and whether the youths and maidens gather three hundred thousand strong in fields near Woodstock, New York, just to be together while rock artists, even amplified, cannot combat the distances; or whether they mill around inside an auditorium built for a mere eighteen thousand souls while a thoroughly prepared electronic happening (accompanied by visuals and swirling lights) is served up, along with allusions to Mozart, under the highest academic auspices and the authorship of two famous masters, is all the same, so far as I can see, though Woodstock, by report, was much more fun.

Both, however, are thoroughly contemporary in feeling. And either or both may mean, like any children's crusade, that we have come to the end of that line. Also that the Vietnam War, by ending, might change all sorts of things. Could it send John Cage back to making music, turn him aside from the messianic hope of giving birth to a new age? Destroying the past is a losing game; the past cannot be destroyed; it merely wears out. And moving into a higher age by playing with mechanical toys is a child's game. New ages in art come slowly, silently, unsuspected. And publicity can bring only death to a real messiah. My instinct is to believe that whatever may be valid for the future of music as an art (and *as* an art is the only way I can conceive it) must be taking place underground. Today's prophetic ones, I truly believe, either lie hidden, or else stand around so innocently that none can see them. Otherwise someone would for certain betray them, and the price-controlling powers would shoot them down. I cannot see today's mass-conscious celebrities as anything but a danger to art, whatever in their youthful years they may have left behind for us that is authentic and fine.

Music has its fashion industry and its novelty trade. And John Cage, as a composer, seems today's leader in novelty fashions, at least for America. From modest musical beginnings, through ambition, perseverance, and brains, he has built up a mastery over modern materials, their choice, their cutting and piecing, their sewing into garments of any length and for many occasions. And he has exploited that mastery, at first as a one-man shop, later as an enterprise employing many helpers, always as a business internationally reputable, and essentially a novelty business. None other on that level, or in America, is so sound. Rivalries, if any, will come from Europe, from that same post-Renaissance Europe he has so long despised and feared. Boulez, for the moment, is not a danger, being chiefly occupied with conducting. But Stockhausen has novelty ideas. And Xenakis, with a higher mathematical training (for that is a requisite now in musical engineering), might well be about to take over the intellectual leadership.

European far-outs are a team and a cartel, as Cage learned more than

twenty years ago. No American composer knows any such solidarity. The best substitutes we can mobilize are foundation support, ever capricious; a university position, where everybody is underpaid, ververbalized, and paralyzed by fear of the students; or a celebrity situation, in which one can have anything, but only so long as the distribution industry permits and the press finds one diverting. In the contrary eventuality artistic death, with burial in an unmarked grave, comes quickly, for unlike Europe, we have no immortality machine.

Perhaps John Cage, with his inventor's ingenuity, should try building us one. And I don't mean the kind that destroys itself, such as the artist Jean Tinguely used to construct. Nor yet the kind that Cage has so often assembled of late years, designed to destroy, with luck, the history of music. I mean something that might relieve today's composers from the awful chore of following "nature's ways" and give them building blocks again for constructing musical houses that might, by standing up alone, tempt us to walk in and out of them.

But Cage's aim with music, like Samson's in the pagan temple, has long been clearly destructive. Can he really pull the whole thing down around him? You never know. He might just! And in that way himself reach immortality. But his would be no standard immortality of structured works and humane thoughts. It would be more like a current event, "Sorcerer's apprentice sets of H-bomb in Lincoln Center."

It could happen, though. For Cage, like Samson, is a strong one; and he has helpers. They admire what he does and, what is far more dangerous, believe what he says. The young, moreover, seem to be yearning nowadays after a messiah. And a musical one might be the likeliest for them to follow. Indeed, Cage's rigid schedule of beliefs and prophecies, his monorail mind and his turbine-engined, irreversible locomotive of a career all make it easy for the young to view him as a motorized and amplified pied piper calling out, "Get on board-a little children; there's room for a million more."

From *American Music Since 1910* by Virgil Thomson. New York: Holt, Rinehart and Winston, 1971, pp. 67–81. Originally published in *The New York Review of Books*, April 23, 1970.

✎ Varèse, Xenakis, Carter

Edgard Varèse
by Fernand Ouellette, translated by Derek Coltman. Grossman, 270 pp.

Varèse: A Looking-Glass Diary, Volume I: 1883–1928
by Louise Varèse. Norton, 290 pp.

Formalized Music: Thought and Mathematics in Composition
by Iannis Xenakis. Indiana, 269 pp.

Flawed Words and Stubborn Sounds: A Conversation with Elliott Carter
by Allen Edwards. Norton, 128 pp.

Varèse

✎ EDGARD VARÈSE, born 1883, was on his Burgundian side, the mother's, robust in fellowship and deeply loyal toward any object, place, person, or experience that had once touched him. Thus his grandfather Cortot, with whom he spent his first ten years in a village near Mâcon, remained throughout his life a memory idolized. But Varèse could also move with violence. And he could be ever so demanding, early in life for serious musical instruction, later for recognition of his music by all those whom it might concern.

From his half-Italian father, a prosperous engineer whom at ten he went to live with in Turin and whom he came to hate, he probably learned those wild and sudden angers that all his life he never could control. His mother had warned him at fourteen on her deathbed that his father was "an assassin." At sixteen he ran away, to be brought back by the director of the Turin Conservatoire, who thereupon with the help of the local bishop negotiated a treaty whereby the boy was to drop out of technical high school, be given remunerative office work, and allowed music lessons. At twenty, on seeing his father raise a hand to his step-

mother, he gave "the bastard" a thrashing and left home again, this time for Paris, and for good.

There for five years he led the poverty life, taking music training (the best) at the Conservatoire and the Schola Cantorum, knowing everybody far-out from young Picasso to Lenin, and acquiring the valued friendship of Debussy. The latter's influence was definitive, for it was from him, at twenty-five, that Varèse took over and kept for life the view that harmony is a free element, as free as orchestration and rhythm. Imaginative advance in all three of these domains had been for a century, and indeed still is, the hallmark of Romanticism in music.

In 1908 he went to Berlin and stayed seven years. There again he knew everybody. He also conducted choirs and orchestras, collaborated on theatrical productions with Max Reinhardt, had an orchestral work (called *Bourgogne*) played by a major orchestra, became famous as a musical enfant terrible, started an opera on a classical subject (*Oedipus and the Sphinx*), and for six years was close to Ferruccio Busoni, his second major influence.

The services of this friendship, which included introductions to all the leading professionals, were as much literary and philosophical as directly musical. For Busoni was full of speculations about acoustics, about tunings and pitch relations, and most important of all, about mobilizing the scientists for discovering new sources of sound that might be used in composition, especially for producing (possibly by electricity) micro-intervals more precise than anything tuned by hand.

No such instruments were available then, though Busoni was pleading with the manufacturers to make him a pianoforte for playing sixths of tones. But these speculations did reawaken in Varèse his early taste for engineering-oriented thoughts, long rejected as recalling the hated father but now acceptable for their possible tie-up with music. And here we go still deeper into Romanticism, into science as a dream — a science-fiction dream, in fact, since none of the devices really existed (or existed *yet*, a dreamer would have said).

In any case, by World War I Edgard Varèse was in possession of what he needed to become the kind of composer he was forever afterward to be, a technically original, an advanced (or advancing) composer whom nothing could stop, not even a worldwide war with its unavoidable restrictions. He was married too, had a child, and was subject to mobilization by the French army. Nevertheless he managed to burn his bridges (along with most of his musical production, caught in a Berlin fire). By the end of 1915 he had been freed from his military servitudes (through illness), had left the wife and child with her relatives, and arrived (the third and last of his major displacements) in New York. He had ninety dollars and he knew Karl Muck, still conductor of the Boston Symphony Orchestra, later to be interned as a German spy.

For Varèse America was not a musical influence; it was merely the place where his musical maturity occurred. Revved up by Debussy and Busoni (after a sound conservatoire training and a richly international background), at thirty-three he was ready to take off. Another year of war-bound Europe and he might have gone down — died of consumption or despair, got killed. From another place than New York he could never have taken off; there was no other field for so large a craft — not in Mexico surely, nor in Spain, nor South America. But from here take off he did, first as a conductor (for America just the right beginning), then as an organizer of far-out concerts (all modernism was considered to be far-out), finally three years later as a composer (with a vast orchestral tribute to his new country entitled, in the plural to symbolize all discovery, *Amériques*).

His earlier music had borne contemplative or literary titles — *Rhapsodie Romane, Gargantua, Le Prélude à la Fin d'un Jour.* From here on they leaned toward hope, toward science and mathematics, only occasionally toward dreams of adventure or imaginary travel. His second American work, *Offrandes,* though dedicated to his American wife Louise Norton and to his French partner of the International Composers' Guild, Carlos Salzedo, bears for its two parts the titles *Chanson de Là-Haut* and *La Croix du Sud.* For the future there were to be *Hyperprism, Octandre, Intégrales, Arcana, Ionisation, Ecuatorial, Espace, Density 21.5, Déserts,* and *Le Poème Electronique.* The only throwbacks toward literature are *La Procession de Vergès* (from a film about Joan Miró), *Nocturnal,* and *Night* (the latter two being settings of psychological horror texts out of Anaïs Nin).

Varèse's music, constructed out of sound blocks not unlike crystals in their vast and precise variety, in their constant overlappings are suggestive of the intersecting polyhedrons that are so commonly the forms of modern architecture. His bibliography, though rich in reviews, articles, and chapters, contains, I believe, only two full books. There are a life and works by Fernand Ouellette (published in both French and English) and the recent *Varèse: A Looking-Glass Diary* by his widow. Neither is a critical study; I doubt whether at this time an examination in depth of Varèse's work is possible. Its resistance to analysis has over a fifty-year period been so stubborn that that fact alone leads one to suspect in the music a comparable power of resisting erosion. Indeed, after Debussy, Varèse may well be the century's other great voice. We can recognize in Stravinsky and in the Schönberg trinity (which includes Webern and Berg) a well-deserved popularity and undoubted pedagogical interest. But there is very little mystery left in any of them, or characteristics still needing to be explained, though there does remain of course much juice to be squeezed out for the market.

Ouellette's book is a valued biography, regarding the works fully

descriptive, and completed by all the lists and calendars one needs for reference. The other, its no less valuable twin, tells the same stories (as well as many more) from a wife's-eye view. One needs both for looking up almost anything about Varèse. The latter, based on diaries covering a half century of life together and brought into vigor through a poet's power to relive the past, is a delight where the earlier book is mainly informative. Ouellette gives relatively deadpan accounts of the five-year Paris stay between 1928 and 1933 and of the cold shoulder there received from Cocteau, Milhaud, Auric, Honegger, Poulenc, and the salons (not to mention their kingpin Stravinsky), in spite of high praise from the best French critics. One might have enjoyed a bit more malice, but malice is not his tone; and Mrs. Varèse's volume, announced as one of two, stops short of the 1928 return to Paris and the composer's firm rebuff there by the musical power set.

Both being involved with the earlier years, we come off better regarding the five-year war between Varèse's concert society in New York, the International Composers' Guild, and the League of Composers. The latter group offered in 1922 energies and organizational help that were most welcome. By fall, when Varèse returned from a summer trip, he found that his valued Guild had been completely taken over — programs, direction, everything. Only a lawyer's intervention got the invaders out. After that the two societies were enemies. The Guild survived till 1927, the League effectively till 1947, and though in principle friendly toward all contemporary music, without ever playing anything by Varèse.

These once bitter animosities have been covert gossip in New York for years, but somehow the League has largely avoided their exposure. Now that Mrs. Varèse has let the lid off there may be "talk," though so far I have heard none. Surviving League members are still silent. And fifty years later it is mostly the historians who care. All the same, without a full story of the League's quarter-century power play it will not be easy to reshuffle the reputations made and unmade during the 1920s and '30s into an order that today's young are likely to accept.

Xenakis

❦ IANNIS XENAKIS, French composer of Greek forebears, was in his early years a product of the engineering schools. He also became an architect and was during that master's last years assistant to the Swiss Edouard Jeanneret Gris, known as Le Corbusier. In music he was the pupil of Olivier Messiaen and the conductor Hermann Scherchen, in mathematics of a Professor G. Th. (so abbreviated in the text) Guilbaud. He is at present a professor of music at Indiana University, where he directs for three separate months each year a Center for Mathematical

and Automated Music. His preoccupation with engineering music re-lates him to Varèse, though he was never a pupil. Actually he was at one point a patron of Varèse, whose work he admires, Xenakis having been responsible for the commissioning of Varèse to create an electronic com-position to be played in the pavilion erected at the Brussels Fair in 1957 by the Philips Electrical Company.

Le Poème Electronique would seem to have appeared to Le Corbusier in a dream, along with the idea of putting his pavilion on show twice an hour with a montage of cinema shots on the ceiling accompanied by original electronic music. And just as he had farmed out the building's design to Xenakis, the latter appointed Varèse, with Le Corbusier's con-sent, to create the music. Le Corbusier seems to have taken some part in the choice of film shots. Otherwise he was mostly absent, though he did do battle with the Philips Company over the hiring of Varèse and over his right to keep him hired when the whole plan, building and music, turned out to be more modernistic than the company esteemed advan-tageous.

It seems also that Le Corbusier had hoped for a closer relation between cinema and music than he ever got. For Varèse would have none of merely accompanying a surrealistic montage of newsreels. So that in the end there was no connection between the visual and the auditory ele-ments beyond the fact that, as exhibited, they began and ended together. When the Fair itself ended, Philips caused the building to be destroyed, the musical wiring layout with it. If the film was preserved, as I hope, its place of deposit is unknown to me. Varèse, however, kept the title of *Le Poème Electronique*, and his music for this, without its ceiling travel through 240 tiny speakers, has been recorded as a composition "for elec-tronic tape." A beauty it is too, in ever-so-delicate chamber-music mood.

The design of the Philips building, though credited to Le Corbusier, was created (at the master's request) by Xenakis, who also supervised its construction. And according to Xenakis's book *Formalized Music*, its shape, illustrated there by graphs, photographs, equations, and geometric projections, represents a solid, or three-dimensional form, generated by rotating three straight lines conoidally around their end points. The result is the equivalent in space of a musical composition by its author entitled *Metastasis*, for which the calculations are also given and the musical score in part reproduced.

The calculations, if I understand aright, have to do with a situation of indeterminacy governed, as all such situations are (short of an unob-tainable *absolute* in chance), by the calculus of probabilities. And here the composer has adopted the adjective *stochastic* to describe his results and to cover everything that could be included under the ideas of proba-bility, chance, the aleatory. The word *stochastic*, first used in 1713 by

the mathematician Jacques Bernouilli in his *Ars Conjectandi*, is a pretty one and quite Greek enough for science; but somehow it has not caught on for music. So that twenty years later, or thereabout, Xenakis remains stuck with it, though still using it proudly for justifying his own method of composition.

The equations invoked to elucidate stochastic theory are all, so an investigator assures me, correctly applied. The metaphysical chapters, backed up though they are by much praise of logic and by quotations from the Greek philosophers, are to me not invariably convincing. But these are not needed for creating graphically, by means of a computer, the "clouds" of seemingly random dots that are said to be the origin of the music.

These random dots may be considered to represent almost anything — clouds, crowds, protozoa, or the molecules of gas in a chamber. Musically they are expressible by points of dry sound, such as string pizzicatti or percussive taps, and their variations of pattern and density are infinite, like those of gases under volume change. Subjected, however, to heat changes at the same volume, gas molecules, like any crowd stirred up, will start rubbing against one another and bumping around till their casual contacts take on, at least from a distance, the aspect of an unbroken contiguity. And this effect Xenakis renders by multiple string glissandi.

He further finds that by drawing the moving dots on graph paper as short straight lines, these tiny dashes will often assemble as tangents defining a curve. And so we arrive at something not unlike tunes, crescendos, rhythmic patterns, and even larger musical shapes, within a continuum all the more delightful to swim around in when constituted of classic musical sounds rather than of their electronic substitutes. Also, as an architect, Xenakis, in the Montreal and Osaka Expos, has been known to create for his interiors special room shapes which place his hearers and performers in patterns of proximity far different fom those now standard.

All this would be just games and happenings were not the auditory results so "musical," so genuinely imaginative, so clearly the work of a high temperament. It is not important to me that Xenakis uses recondite procedures toward so pleasurable an end, though by now it is clear that today's complex musical textures, if they are to avoid a personalized expressivity and to achieve effects related more to space rockets than to heartbeats — for such indeed is the modern dream — will have to be achieved through following the higher equations, no matter how much handwork may also be involved. For surely the well-prepared engineer (prepared in music I mean, and esthetically sophisticated as well as mathematically) is likely to carry further the science-in-music ideal than the

electronic improvisers or the merely classically educated. For an interesting complexity cannot be faked.

That the complexity of Xenakis's music is real I cannot doubt. It would not sound so handsome otherwise, or stand up as it does under usage. That his great showpiece of a scientifico-philosophical volume is all of it for real I do doubt. Not that I suspect a put-on, not at all. But its straight passages, its nontechnical sermons are a bit dithyrambic as argument. For that matter, so were the architectural propaganda books of his teacher Le Corbusier. So let us not be difficult with a multilingual musician not really the master, perhaps, of any idiom. And let us take the Greek-letter equations on faith till we can have them tested. A man whose music is so strong cannot in writing about it have turned overnight into a weakling.

The word *overnight* is not applicable anyway, since the bulk of *Formalized Music* was published in French in 1963 as *Musiques Formelles* and large chunks of that as early as 1955 and 1956 (along with a German version, I presume) in *Gravesaner Blätter*. The present edition contains new thoughts and much graphic material. To a mere musician its mathematical presentation is forbidding, its full understanding out of the question.

But its faith in music's imminent transformation is a romantic view long familiar, just as the application of scientific method toward this end is recognizable as a contemporary dream. The author's belief in the authenticity of his own work is admirable. His explanations of how it got that way are no more to be believed, I suspect, than those of any other creator. And his yearning toward a future for the musical art largely disengaged from its humanistic past is a puritan ideal all too reminiscent of antiseptics and sterile gauze.

For the birth, presumably under laboratory conditions, of what Xenakis calls "a metamusic," let us turn to his own prophetic statement.

> It cannot be said that the informationists or the cyberneticians — much less the intuitionists — have posed the question of an ideological purge of the dross accumulated over the centuries as well as by present-day developments. In general they all remain ignorant of the substratum on which they found this theory or that action. Yet this substratum exists, and it will allow us to establish for the first time an axiomatic system, and to bring forth a formalization which will unify the ancient past, the present, and the future; moreover it will do so on a planetary scale, comprising the still separate universes of sound in Asia, Africa, etc.
>
> In 1954 I denounced *linear thought* (polyphony), and demonstrated the contradictions of serial music. In its place I pro-

posed a world of sound-masses, vast groups of sound-events, clouds, and galaxies governed by new characteristics such as density, degree of order, and rate of change, which required definitions and realizations using probability theory. Thus stochastic music was born. In fact this new, mass-conception with large numbers was more general than linear polyphony, for it could embrace it as a particular instance (by reducing the density of the clouds). General harmony? No, not yet.

Today these ideas and the realizations which accompany them have been around the world, and the exploration seems to be closed for all intents and purposes. However the tempered diatonic system — our musical terra firma on which all our music is founded — seems not to have been breached either by reflection or by music itself. This is where the next stage will come. The exploration and transformations of this system will herald a new and immensely promising era.

Carter

✧ SINCE World War II Elliott Carter has been our most admired composer of learned music and the one most solidly esteemed internationally. His chamber music in particular (which includes the Double Concerto for Piano and Harpsichord, each accompanied by a separate instrumental group) is respected by composers and viewed by instrumentalists as a challenge to their virtuosity. Extremely well written for exhibiting virtuosity, Carter's music is always hard to play, but seldom hard to listen to; though complex for eye and hand, it ever delights the ear. In this sense, though in no other, Carter is a parallel to Franz Liszt. For high seriousness and monumental form, however, his aspiration, like that of so many other Americans — Ives, Harris, and Sessions, for example — emulates Beethoven. (This is not a European habit; the monumentally inclined over there seem content with Tchaikovsky and Mahler.)

Elliott Carter, moreover, is a man of culture. He knows languages, reads Greek, has traveled. His musical history includes not only the Harvard and Nadia Boulanger orbit, long standard for American composers, but also a close friendship with Charles Ives. He learned the choral routines under Archibald T. ("Doc") Davison, show biz under Lincoln Kirstein and George Balanchine, for whose early dance companies he served as musical adviser and composed two ballets. For a short time too he taught at St. John's College in Annapolis, which is probably where a good deal of his classical reading took place, such as Plato and Lucretius. For some years I have noticed that the Great Books method of instruction, however quickly it may run off of the undergraduates, will occasionally go deeper with the young instructors, especially those for whom it is a second plunge.

In any case Elliott Carter has read everything and been everywhere, and he has reflected about music as well as written it. He has also written *about* it under that impeccable trainer Minna Lederman, editor of the regretted quarterly *Modern Music*. So that whatever he has to say about music is not only penetrating as thought but gracefully expressed. And if a certain pessimism permeates his view of whatever or whomever has not contributed to the blazing of his own fine complex trail, he is courteous for the most part toward those who have.

It is surprising that at sixty-three, with so solid a career laid out and so splendid a repertory to exploit, Carter has not been the subject of a biographical brochure, nor has there yet appeared regarding his work any sustained attempt at analysis. The recently issued *Flawed Words and Stubborn Sounds: A Conversation with Elliott Carter*, by Allen Edwards, aspires to give us the composer along with his views on music. But the questioner is so full of his own views that the composer has to spend time blowing away fog which might have been employed to greater advantage in direct observation. All the same, a great deal of Carter's remarkable intelligence and good sense does come through. And if these offer less enlightenment regarding his own work than about the musical situation in general, that is only natural, to his credit even, since no artist, especially a successful one, is ever much good at explaining himself.

His account of his youth and educational background, however, is very good indeed, involving as it does practically everybody, practically everybody's music, and the adventures of a very bright young man in sizing them all up and picking out everything that he might eventually, in his full maturity, be using. The thoroughness of his investigations and the decisiveness of his rejections, especially his acquisitiveness in stockpiling musical, literary, all sorts of humane and other cultural experiences, is virtually without parallel among American musicians, though his predecessors in this essay, Varèse and Xenakis, being Europeans, were as young men no less avid and no less determined in finding their way about among the treasures.

Actually Carter, in spite of economic and cultural advantages, was slow to ripen. The process was long and painful, also complicated (perhaps cushioned) by psychosomatic maladies. He was thirty-seven when his first breakthrough occurred, his first work wholly free and original, the Piano Sonata of 1945. Since then his production has been steady, its quality stable, its individuality unquestioned. His excellence in general renders academic much of the technical talk in the latter half of the present book. When he mentions, for instance, music's having moved into a "post-tonal" epoch, the word has little meaning. So has the assumption that music has "moved," has in fact ever "moved," though it changes constantly, if not in syntax, surely in meaning.

Carter also refers to his use in certain later "works" of four-note chords containing all the intervals. One such would be C-C♯-E-F♯. Whether this is in any acoustical sense a chord, rather than merely an agglomerate, I question. It is certainly a combination of intervals numerically arrived at, hence easy to manipulate in today's vernacular. It is also bound irretrievably to the conventions of tempered tuning, so tightly bound indeed as to render it acoustically void of identity in any music that might aspire to be considered "post-tonal."

But Carter is not far-out in either theory or practice. His music's textural basis is the invertible counterpoint characteristic of fugue. His game is instrumental virtuosity, and it is in this field that his most ingenious discoveries have been made. His expressive sources are likely to be literary though not narrative (philosophical meditations on infinity, rather) and its forms asymmetrical. It is therefore both Romantic (by inspiration) and neo-Romantic (through its dependence on planned spontaneity). His neoclassical allegiance to invertible counterpoint is also a Romantic element tending toward sequence structure, though its preoccupation with virtuosity is hard-edged baroque. All in all, it is a past-oriented music, not one that dreams of transforming the art, and Carter is a conservative composer, in the sense that his aim is to say modern things to the classically educated.

His youthful taste for quality and flair for finding it, along with his nowadays wisdom in defining it, are all a part of the man and of his music. And the spectacle of him, as Carter's unusual mind and forthright tongue bring out, is that of an artist very little fooled by anyone, or self-deceived. As a man of culture and skills he believes in an elite. As a man of means he disdains to make the adjustments that would be required for seeking popularity. He writes therefore as an elite composer for an elite public, for consumers with education, some leisure, and a consecration to cultural experience.

As we know, who can remember when plays, ballets, concerts, and museum shows were frequently aimed at such a public, its being educated and well-to-do was never enough. The only consumer we respect today is one whose life is consecrated to a skill, in other words a professional. Beyond these lie the limbo of nonresponsibility, of mass publics addicted to mere consumption.

The view is not a popular one. And Elliott Carter is not a popular composer, not in any sense now possible to conceive. But he is an interesting man and his music is interesting. Interesting intrinsically, I mean, not just fun and games or a jolly noise, but appealing to the mind and to the heart as well as to the musical ear. A great deal of the man is in this book, not any of the music; but the man is seen wrestling, if not quite with music, with the formulation of ideas provoked by the wrestlings that unques-

tionably went on during the gestation of his music. That is certainly the meaning of its title, which is a quotation from the poet Wallace Stevens. And if maybe some of this is shadow play (inevitably), some of it is also real (it has to be). That too is interesting. Intrinsically.

From *The New York Review of Books,* August 31, 1972.

❧ Making Black Music

Bird Lives!
The High Life and Hard Times of Charlie (Yardbird) Parker
by Ross Russell. Charterhouse, 404 pp.

Black Music: Four Lives
by A. B. Spellman. Schocken, 241 pp. (originally, *Four Lives in the Bebop Business*, Pantheon, 1966).

Black Music
by LeRoi Jones. Morrow, 221 pp.

Black Nationalism and the Revolution in Music
by Frank Kofsky. Pathfinder, 280 pp.

Reflections on Afro-American Music
by Dominique-René de Lerma. Kent State University Press, 271 pp.

Black Talk
by Ben Sidran. Holt, Rinehart and Winston, 201 pp.

URBAN black music (more often called "jazz") was formerly written about, say back in the 1930s, as if it were an objectively describable modern phenomenon like French impressionism, with a clear history of derivations, influences, and individual achievements.

Any armful of such studies would have to include, among the very best, those in French by Hugues Panassié, Robert Goffin, and André Hodeir, in American by Winthrop Sargeant, Wilder Hobson, Rudi Blesh, Gunther Schuller. And there are more, excellent compendia, fully respectful of the miraculous. For jazz and blues were recognized early, especially by Europeans, as a domain of musical creation quite different from any "classical" or "light" music then existing. And the practice of communal improvisation, the essential jazz miracle, was indeed the most

remarkable explosion of musical energies since Lutheran times, when whole populations took to the road in song.

Jazz music had been quite skillfully imitated in the early 1920s by a white group called Dixieland. To describe it and to catalogue it was a further step toward encompassing it. Another had been the incorporation of certain rhythmic, melodic, and verbal devices into the reigning "light" style of show songs and social dance, a surface transformation that gave to America — in the work of Jerome Kern, George Gershwin, and their colleagues — a commercial product that rivaled for worldwide favor the Viennese. This music too was sometimes called jazz, at least by whites; and its distribution involved the better nightclubs, the recording industry, show business, radio, and after 1929 musical films.

Black urban music, the real thing, led a separate existence, continuing to evolve, for the most part, in the gangster-controlled slums of Chicago and Kansas City, where its lovers kept one another in touch and recordings got put out on modest labels. It never got into the movies or noticeably on chain radio. Its complete intolerance of anything not itself, its innate strength for rejecting impurities, made it virtually useless to big commerce. The rapidity of its evolution, moreover, especially after 1940, and the internal dissensions among blacks themselves regarding this have kept everyone busy. There has been no time of late for neat packaging or for massive distribution, even were such deemed desirable. And anyway, ever since the middle 1950s rock-for-ages-nine-to-fourteen has so thoroughly occupied the seekers after mindlessness that radical changes in both the style and the expressive content of jazz have taken place with very little interference from outside.

The essentially black content of real jazz was signaled as early as 1948 in *Jazz: A People's Music* by Sidney Finkelstein (Citadel Press). Fifteen years later, 1963, LeRoi Jones, in *Blues People: Negro Music in White America* (William Morrow), essayed a sociological view of the art, replacing the earlier musicological approach with one based on direct knowledge of black life. This kind of study, a parallel to the discovery of black English, has revealed black life as a subculture strongly concentrated on music. Religion, ethics, sexual mores, and family life are also highly developed there, and characteristic. There is a gift for cooking too, though as yet no cuisine. The visual arts are hardly visible at all; but literature, I fancy, may be approaching a takeoff through the stage, where the eloquent, poetic, and vividly ironic black language might one day come to make white diction sound as vapid as most white music.

Certainly music is for now the chief Negro art, and black life is sewn through with it. At every instant it is the understood reference, the universal binder. European classical composition, Anglo-Saxon folklore, Hispanic dance meters, hymns, jungle drums, the German lied, ragtime, Italian opera, all are foods for the insatiable black hunger and grist to its

grind. As if inside all U.S. blacks there were, and just maybe there really is, some ancient and African enzyme, voracious for digesting whatever it encounters in the way of sound.

The technical and stylistic developments in black urban music that have taken place since the late 1930s are recounted in a whole shelf of books; but even when musicology still comes to the fore in these, sociological and political backgrounds tend nowadays to dominate the picture. Charlie Parker, according to his biographer Ross Russell, was "the first of the angry black men." Born in Kansas City, Kansas, 1920, brought up musically in a Missouri-side ghetto, dying world famous at thirty-five in, of all places, the Stanhope Hotel on upper Fifth Avenue, he was, again to quote, "the last of a breed of jazzmen apprenticed at an early age, styled in emulation of great master players, tempered in the rough-and-tumble school of the jam session, a master of his craft by the end of his teens, disciplined to the exacting requirements of the big swing bands, and, eventually, the maverick who turned his back on the big bands to create, almost singlehandedly, the musical revolution of the Forties." This sentence tells mostly all, except that the tenor sax was his instrument, and that before his early death in 1955 he had planned to study formal composition with Stefan Wolpe and Edgard Varèse.

～ ～ ～

Black Music: Four Lives, by A. B. Spellman, examines the achievements and hard times of pianist Cecil Taylor (classically educated in music), saxophonist (chiefly on soprano) Ornette Coleman, pianist Herbie Nichols, and Jackie McLean (alto sax player and college dropout). This generation, still under fifty, frequently well educated, and in private life approaching the bourgeois, believes in jazz as the important serious music of our time. And if most of their professional dates, or "gigs," still take place in white-owned, exploitative, small nightclubs (dismal dumps backstage every one of them and grim saloons out front), this still unbroken bondage is the economic straightjacket of all jazz musicians' lives and a constant burden of their complaints.

Education has developed their artistic thought, however, or at least their verbalizations of it. A great deal of discussion seems to go on among them now about inside matters like "form" and "meaning." And if the form employed for improvising is still that of variations on a chosen melody, the bass beat under these has become so free and the harmony surrounding them so far-out (read non-tonal) that the melodic transformations they undergo on trumpet and sax are rarely recognizable anymore as related to the original theme.

Nevertheless, these far-out jazzmen work closer than most of our far-out intellectual composers do to classical principles of rhythm and harmony. They do not throw traditions overboard; they reinterpret them,

aiming rather toward creating a music based decreasingly on the monotonies of dance accompaniment and more on the songfulness of blues, the common-ground nobility of gospel hymns. There is even a tendency, derived probably from the example of Ornette Coleman, to do without piano, guitar, or whatever else might enforce tempered tunings, and to work both in and around true intervals and their expressive variants. But improvisation is still insisted on as a musical method (no arrangements, no big bands). And a special attitude toward knowledge and culture is recommended, namely, "learn everything but keep it in the subconscious." While at work never analyze, merely improvise — that, after all, is the true discipline of spontaneity.

༄ ༄ ༄

Black Music, LeRoi Jones's second book on the subject, is sociology, criticism, a preachment, and just possibly literature, so clearly is it thought, so straightforwardly expressed. It treats all the main artists in New Jazz, explains their work musically, the expression in it humanely in terms of black life. And since black life takes to religious experience as naturally as to music, the sermonizing comes through quite void of self-consciousness.

His thesis is summed up in a quotation from tenor sax player Archie Shepp: "The Negro musician is a reflection of the Negro people as a social and cultural phenomenon. His purpose ought to be to liberate America aesthetically and socially from its inhumanity. The inhumanity of the white American to the black American as well as the inhumanity of the white American to the white American is not basic to America and can be exorcised, gotten out. I think the Negro people through the force of their struggles are the only hope of saving . . . the political or the cultural America."

Fine by me; let them save us if they can. And their best chance is through music. Besides, should God himself turn out to be a Negro mammy ("She's black," they do say) nobody would feel more secure than this unreconstructed Confederate. But the trouble is that in spite of TV and radio, possibly because of them, many whites hate music; too few have any ear for it at all.

༄ ༄ ༄

Black Nationalism and the Revolution in Music, by Frank Kofsky, takes off from an assumption that "hard bop reflected and gave musical expression to . . . the first stirrings of the contemporary black liberation movement." Further parallels between music and life are noted in the ways the more advanced players strive to simulate the sounds of human speech, and not just speech in general but "the voice of the urban Negro ghetto, . . . to distill for your ears the quintessence of Negro vocal pat-

terns [e.g., Archie Shepp's "growly, raspy tenor saxophone locutions"] as they can be heard in the streets of Chicago, Detroit, Philadelphia, Harlem." Also in the persisting practice of group improvisation, which symbolizes a "recognition among musicians that their art is not an affair of individual 'geniuses,' but the musical expression of an entire people, . . . the subordination of the individual to the group."

Bebop is here defined as "harmonic improvisation[,] with the metrical unit an eighth-note [replacing] melodic improvisation with the metrical unit a quarter-note." The latter was characteristic of pre-1940s jazz. In my judgment, adoption of the eighth-note unit, long prevalent in Caribbean dance music, was the radical change that set off all the others. By eliminating a thumped-out quarter-note bass, it invited metrical complexities in all the parts, including bass and drums. And this new freedom virtually imposed harmonic elaboration, which in turn weakened the tyranny of the tune and led, at least with Ornette Coleman, to a fantastic development of the florid bel canto style. All three of these developments seem, both in Coleman and in John Coltrane, to have caused their abandoning the customary piano, thus dispensing with "the framework of tempered pitch."

The marketing of so sophisticated an art in "dingy rooms before half-drunk audiences" is the burden of a litany that appears and reappears in all these books.

The summing up of previous examinations plus testimony from virtually all hands comes in a remarkably readable book edited, prefaced, and concluded by Dominique-René de Lerma. This covers in essay form and in dialogues black music in college and in pre-college curricula, soul music, gospel music, field work in Africa, the black composer himself in relation to dance, journalism, white history, white society, Negro society, information sources, and every known kind of establishment. How to teach black kids classical music without turning them off, how to cure academic prejudice against playing by ear, against the fact that blues are "about sex," against teaching anything at all not chronologically, against admitting black music to the history books, against an ingrown pedagogy that assumes "white is right." All these things and more are in this richly charged volume. And black control of Black Studies is declared a sine qua non.

℘ ℘ ℘

But the main text of my sermon today is *Black Talk*, by Ben Sidran, white American jazz performer with a Ph.D. in American Studies from the University of Sussex in England. Its basic assumption is "that black music is not only conspicuous within, but *crucial to*, black culture." This culture is, moreover, an *oral culture* and thus radically opposed to our *literate culture*, which was once an oral tradition, of course, but which is

now congealed by its literacy into verbal, hence largely visual, methods of transmission. Orality, therefore, though "a common denominator for all cultures, is, after extended generations, the basis for an alternative breed of culture." And the relation of black music to other oral traditions of Afro-American life is still a question which has been far more ignored than explored.

Now the literate world, dependent on print plus pictures, is a visual world, existing only in space, which is essentially static. Whereas the things that we hear exist in time, which runs on; they relate to an oral continuum. There has come about, it would seem, from these radically different ways of receiving communication an "utter misunderstanding" of each other by blacks and whites which, through the consequent rejection of oral-mindedness by the essentially literate, has by reaction "contributed to the cohesiveness and coherence of the black culture." Moreover, since the orals are more given to moving around than to sitting still (reading), they tend to be restless. And here rises a "unique problem of leadership within the oral community, how to impose leadership, in the Western sense," on a group that values nothing so much as spontaneous improvisation. Therefore, since music, which, "in terms of social sanctions, is one of the more legitimate outlets for black actionality — indeed, during various periods of black history, it has been the only outlet — it follows that black musicians have traditionally been in 'the vanguard group' of black culture."

Now "orality" leads not only to music but to many other forms of group action, and all groups easily adopt rhythmic communication. Also, "tension released through rhythm is strongly associated with the sexual act." And since in sexual as well as other rhythmic acts, time (measured clock-time) tends to get lost, "rhythm can be used to manipulate the greater environment, inasmuch as alterations in time concept can affect the general 'structure of feeling.'" As for losing one's sense of time, anybody knows that with our black friends punctuality is not to be counted on. What one may not have noticed, certainly not much read about, is that "the development of rhythmic freedom has generally preceded social freedom for black Americans." Interesting if true; at any rate, cases are cited.

Now we all know educated and uneducated blacks — professionals, people of business, performing artists, even hired help — who *work* by the clock, though they may not *live* by it. They *read* too, are scholars, handle money, write books. Probably their great psychic skill is moving in and out of orality, to drop at will one way of living and take up another. The Japanese have this faculty, especially those who work in Western clothes, then at six go home to put on kimonos and toe-socks, sit on the floor, and feel normal. We understand an actor moving in and out of a role. Why not anyone out of a verbal situation into music?

How long can black oral culture survive in our verbal civilization? As long, I suppose, as there is black music. The National Advisory Commission on Civil Disorders (the "riot commission" appointed by Lyndon Johnson in 1967) reported, to the president's extreme embarrassment: "Our nation is moving toward two societies, one white, one black — separate and unequal." Just why they are so separate and so unequal is the question raised in *Black Talk*. It seems certain that there is a fundamental opposition of oral vs. literate, auditory vs. visual between the two societies and that this has so far resisted all efforts — cultural, sexual, legal, criminal, and humane — to bridge the chasm.

To live within a nonverbal, if somewhat dizzy, continuum has certainly been the aim of many rock addicts. But the politically radical movements of the 1960s among white college students were not nourished on rock but on the very best black avant-garde jazz. Ben Sidran has information about that. And the black underground itself has been joined aplenty by whites without losing any of its blackness.

Whether there is to be a black political revolution remains doubtful indeed, though if such a thing were to come about, black music and black musicians would likely control its "structure of feeling." As to black music redeeming us all, including the tone deaf, Ben Sidran surely knows better than that, though he does believe music (any music?) to be "a great force for unity and peace today." I find him most convincing when in a final paragraph he esteems it "not altogether irrelevant to suggest that a subculture emotionally and culturally entrenched is not one that can be coerced by violence — or even blatant injustice — nor one that is willing to retreat very far."

Musically there has been no retreat. Since jazz, its best music, and perhaps eventually ours, does seem to be going onward and upward.

From *The New York Review of Books*, October 17, 1974.

❧ Stravinsky's Operas

STRAVINSKY'S first opera, *Le Rossignol (The Nightingale)*, conceived in 1909 and partly composed that year (he was twenty-six), is an Impressionist work, highly colored orchestrally, and fragmented as to musical structure. Its locale, the timeless China of legend and scroll, invites ornamental costuming and stylized movement. An ideal presentation would be as near to ballet as can be achieved without the use of dancers in major roles. It is an opera, however, because its actors sing. In this opera the language they sing in is Russian.

For four years *The Nightingale* remained incomplete, during which time Stravinsky wrote three ballets — *The Firebird, Petrushka,* and *The Rite of Spring.* At thirty-one, after this rapid ripening of his musical powers, Stravinsky returned to *The Nightingale,* completing it very much as he had conceived it. In 1914 it was produced in Paris. But *The Nightingale* did not remain for long merely an opera. Before the First World War was over, it had got itself another version, entitled *Le Chant du Rossignol (The Song of the Nightingale),* this time purely orchestral and suitable either for ballet performance or for concert. Both versions have remained available. The opera version is almost a ballet. And the ballet is almost an opera, though in the ballet both the real nightingale, originally a soprano, and the toy nightingale are evoked by orchestral means. The ballet version, nevertheless, still yearns to sing, just as the opera version strained toward the dance.

Stravinsky had never needed to reflect much about ballet. He had understood this medium from his beginnings, understood it so well, indeed, that he had been able in three powerful works to do for it what Richard Wagner had done for the opera — to underpin it with symphonic structure. But the opera itself, having experienced symphonic apotheosis already, through Gluck and Meyerbeer and Wagner, was no longer

capable of being carried forward in that direction. What it needed, indeed all it could offer to a young composer of genius in 1914, was the possible restoration of its earlier powers of vocal expression, as in Mozart, with just possibly the additive of twentieth-century dance. But for a young man already world famous for his ballets to take up the lyric stage, following two centuries of accepted masters, a circumspect approach was essential.

Stravinsky's next operatic essay, two years after *The Nightingale*, was a modest one called *Renard (The Fox)*. For this theme out of Russian folklore (a fable about barnyard animals) he proposed separation of song and dance, four male vocalists to sing the dialogue while four acrobats mime the animals. Again the text is in Russian, but this time the orchestra is small and the piece quite short.

The strain on credulity is considerable when double impersonation (by dancers and by singers) is added to the normal unconvincingness of animal mimings. The piece almost does not work as a spectacle. But the high power of its music does offer a major experience and one which, in fact, has so long proved its amplitude in concert that the work has tended chiefly to survive in that forum. I mention *Renard* here not because it is an opera, which it is not, but because it is a song-and-dance work that follows *The Nightingale* in Stravinsky's slow progress toward mastery of the singing stage. This progress was slow because he had not yet renounced the dance as an essential element.

Five years later, in 1921, he again approached the lyric theater, this time with a one-act opera buffa called *Mavra,* a story out of Pushkin about a cavalryman in boots impersonating a female. This time there is no dancing, no acrobatic miming; the singers do everything. Whether they are supposed to be acting out a lumbering Russian farce or an Italian clownery about a lumbering Russian farce I have never been sure. But the music, both vocal and instrumental, is of the utmost animation. It is also vivacious intellectually, since virtually every page contains irony. There are jokes about Italian opera, jokes about Russian opera, jokes about Russians singing in the Italian manner, jokes about everything that the work touches, including the class structure of pre-Soviet Russian society. This score, though interesting as music, has not yet detached itself from stage presentation. Nor has it ever firmly attached to itself any particular scheme of staging. The work is not given very often, probably because a satisfactory acting manner has yet to be found for it.

Before *Mavra*, Stravinsky had composed three highly successful works employing both song and dance, but none of them were, in any sense, operas — *L'Histoire d'un Soldat, Les Noces,* and *Pulcinella*. The first of these, *The Story of a Soldier,* from 1918, is a shortish piece for speaking voice and seven instruments which can be performed either with or with-

out pantomime. It represents Stravinsky's first major engagement with a language other than Russian (its text is in French), and it is the only stage work of his entire career that deals with contemporary life. (It concerns a displaced conscript, his violin, and his conversation with the Devil.) It is rarely effective as a show, but it is always grand as music. Indeed, it is a musical masterpiece so strong that it tends to slough off both the pantomime and the spoken text and to become an instrumental suite.

The ballet *Les Noces (The Wedding)*, 1917–23, fully choral and in Russian, is a masterwork certainly, and like *The Rite of Spring* so strong as music that even its powerful first choreography by Bronislava Nijinska has not invariably accompanied it. Nor, indeed, has any other. It does not choreograph easily. Its transfer to the concert stage, I suspect, has been influenced further by the fact that an orchestral management can more easily mobilize a chorus than can a touring ballet troupe. In any case, this work designed for dancing approaches the oratorio, not the opera. The oratorio and the cantata, in fact, were to be the region of Stravinsky's major achievements for the next fifty years.

Pulcinella, of 1920, is a ballet employing singers (three soloists) incidentally. Its subject, like that of *Petrushka*, is clowns (this time Italian clowns, *pagliacci*), perennial pretext for making fun or pathos out of the stage artist's private life. Its music employs themes from Pergolesi; and by stating these in discordant reminders of eighteenth-century harmony, we have one of the earliest Stravinsky works to be composed in the manner now called "neo-Classical."

Let us remember that Stravinsky, only twenty years younger than Debussy and eight years younger than Ravel, had formed himself, after their model, as a pictorial composer. The Impressionist approach to music had served him well for representing fireworks and for illustrating fairy tales, both Chinese and Russian. Expanded toward realism, it had given him in *Petrushka* a traveling fair complete with folk dancing and marionettes. Enlarged further in *The Rite of Spring* to include double harmonies, quintuple counterpoint, and a highly original employment of nonsymmetrical rhythms arithmetically developed out of the simplest rhythmic cells, this extension of Impressionist techniques had so powerfully evoked human sacrifice in pagan Russia that audiences were deeply shaken, and at its 1913 premiere rioted.

Les Noces and *Mavra*, though deeply Russian, are in no way picturesque. In these works the paraphernalia of tone-painting, with its inevitable dependence on orchestral device, had been abandoned for another form of evocation, one intrinsic to the musical syntax. And so began, even in *Les Noces*, which marked Stravinsky's farewell to Russian subjects, a depicting of faraway times and places through the fragmentation of their characteristic musical idioms, a procedure that served him for

the rest of his life. I think, though I cannot be sure, that it served him even in his use of the serial technique from Vienna, which became available to him only after the accumulated deaths of its inventors — Berg, Webern, and Schönberg. I say "became available" because one can evoke only that which is not present. The present can be parodied, imitated, or taken for normal; but it cannot be summoned or glamorized. In view of this simple fact, and also in view of Stravinsky's whole career as a composer of evocations, I cannot believe that the twelve-tone works of his Third Period represent either direct expressivity or homage to a living style. I think they are pictures from music's history, just as his neo-Classical works are, the subject this time being Schönberg's Vienna.

It has been necessary to identify the composing method called neoclassical with the evocation techniques of Stravinsky's youthful period in order to make clear what happened to his operatic aspirations when he was about forty-five. Till just past thirty he had been inspired chiefly by visual memories and by kinetic, or muscular, experiences. Then, little by little, he began to use his auditory memories, as Mozart too had done, and to give us back in this way the whole of Western music as a history of styles. These evocations were not emulations of the past, like the neoclassicism of Brahms, but pictures of it — cubistical pictures, if you wish — all excitingly fragmented and distorted. But they were not pictures for the eye; they were memories of music's past for the ear to recognize and to delight in.

In his Octet, the subject had probably been J. S. Bach. In the Piano Sonata, C. P. E. Bach. In the Serenade in A for piano, surely something of Brahms. In the much later Symphony in C, Haydn perhaps. In the Concerto for Two Solo Pianos, my guess is late Beethoven. In the Sonata for Two Pianos one can hear, just maybe, and ever so faintly, the very special sound-spacing of Bach's "Goldberg" Variations for harpsichord.

When Stravinsky used master models for making new ballets — as, for instance, he used quotations from Tchaikovsky in Le Baiser de la Fée (The Fairy's Kiss) — he sometimes admitted the fact. Regarding other themes from the past he mostly kept silent. Unmasking them is a game for musical analysts. It is not my hope to offer definitive solutions now. I merely feel that some identification is necessary of Stravinsky's evoking-the-musical-past technique before speaking about the masterpiece of opera (and of oratorio too) that he composed in 1926 under the title of Oedipus Rex.

Since 1909, or earlier, the elements that made this work possible had slowly, very slowly, been assembled. In some cases the sacrifice of a cherished element had also helped. Let us review at this point both Stravinsky's musical history and his theater history.

First, the young master of visual suggestion in music had broken through the limits of that, had worn them out really, substituting for

them direct musical quotations and the delight of muscular jerks, then wore out too the excitement of these. He had not worn out their interest for his public, only for himself; he simply could not develop them any further. After the ballet successes of his youth, he had aspirations certainly toward the lyric stage; but his progress toward mastery of that had been slow. He tried mixing song with dance or with pantomime, and found no operatic breakthrough there. He also tried the speaking voice as an adjunct to music. That too wore out quickly. Blending chorus with ballet, as in *Les Noces,* and reducing the instrumental factor to a steel-girder support of pianos and percussion had done wonders toward throwing words into relief. Here was an absolutely novel discovery: the fact that one need not use high instrumental colorations when working in the vocal forms. (I have long felt, for instance, that Rimsky-Korsakov's bright textures are more effective in concert than in the opera pit.)

His next discovery was that he could conceive a long vocal work which would at no point be dependent on dancing. It is not certain that his intention in *Oedipus Rex* had been quite so radical as to present for Diaghilev in 1927 at the Théâtre Sarah Bernhardt a work for music lovers only, a simple cantata, and in Latin at that. One had known the work was coming up, and it did seem to us all, from the musical grapevine, that its presentation in the oratorio manner was a last-minute decision rather than any long-laid plan.

The idea of translating the Sophocles *Oidipous Tyrranos* from Jean Cocteau's cutting (in French) into an easy and straightforward Latin had been a stroke of genius during the work's planning. It rid the composer of Cocteau's literary personality, it helped him to avoid exposure to possible faults in the setting of French, and it gave him words with sonorous vowels and lots of *K* sounds, which he could set almost as if they were Russian. He could distort their stresses at will too, for by sheer verbal repetition the sense could be got across, exactly as in any old-style opera.

Handel's operas (his oratorios too, for their styles are identical) appear to be the historic musical evocation in this work, though a certain stiffness in the bravura solo writing recalls Bach. All the same, the musical themes and their harmonic treatment, as well as a minimal presence of polyphony, follow closely the Handelian model. And the orchestral accompaniments, animated but plain, are closer to what we know of Handel's scoring for vocal accompaniment than they are to Bach's not-at-all-theatrically-conceived complexities. The effect of the whole is electrifying. The trajectory of the tale is unhindered by musical scene-painting, by sentimental graces, by appeals for emotional identification with the characters, by any shade of self-pity on their part, by tenderness, timidity, sex appeal, sweetness, or compassion. The language of the Latin text is lapidary; it hits like stone. The vocal line is florid, baroque, always loud, constantly varied, in every way urgent. The choral parts

are plain, massive, cleanly articulated as to interval and chord. The orchestra, as cheerful and bright as a circus band, offers support, animation, clarity above all.

Clarity to what? Chiefly to the vocal line, but also to the play. And what is this play? A dramatic action involving parricide, incest, suicide, and a self-inflicted blindness. It all took place in Thebes more than twenty-five hundred years ago among people who behave not at all like us, since avoiding parricide and incest are not our preoccupations. All the same, its musical grandeurs make the tragedy moving. It shakes us, indeed, more terribly than the amorous insanity and peaceful death of Tom in *The Rake's Progress.*

At this point a further musical identification seems desirable. From the very beginning, Stravinsky's music has been corseted by a peculiar rhythmic tension. A small metrical unit (an eighth or sixteenth note) is almost constantly present, expressed by short pings, taps, or plunks, all equally accented. And these are organized into phrases by rests, which interrupt them, or by strong accents, which divide them into asymmetrical patterns. This rhythmic continuity supports the tonal structure far more than it depends upon it. It makes, in fact, a rhythmic discourse involving through its asymmetry constant surprise, a thing which holds anyone's interest. And its perfectly real integration as a structure more often than not sustains the whole continuity, freeing the intervalic and chord content of the work for pungent emphases and ironic comments.

Now the unaltered small metric unit (that almost constant presence of staccato eighth notes which the Mexican composer Silvestre Revueltas used to call in his own music *el stile russo*) serves in any piece or section of a piece as a foil for expressivity. And such a foil is all the more needed when a musical idiom of non-Russian character is being employed. For all such idioms, especially the ways of the Germanic and Italian masters, are sown throughout with booby traps, with notes that any singer would like to hold and with smoothly harmonized melodies that invite to schmaltz. Indeed, our century's attack on Romanticism's musical legacy to us has been necessitated by the fact that in their deliquescence and decline, our standard melodic style and thoroughbass harmony have had so much fat rubbed into them that it is being seriously proposed today that the only way to save our musical language is to destroy its grammar altogether.

Igor Stravinsky, who has never shown fear of the destructive element, has long been president of the Anti-Schmaltz League. And he was still well under thirty when he discovered that certain rhythmic ways that he had come by merely from being Russian were of inestimable value in tidying up Western materials. In this respect he was more advanced than Tchaikovsky, who kept his Russian rhythms for Russian themes.

If any other composer were to apply a rigid rhythm to Germanic or to Italianate melodies he would be guilty of either plain ignorance or willful mannerism. When Stravinsky does it, which is virtually always, he is doing a valid thing, which is to hold musical license in check. He is also doing a valid theatrical thing, which is to produce excitement. He has composed in *Oedipus Rex,* and later in *The Rake's Progress,* vocal solos of the most extreme floridity that never get out of the conductor's control. Their freedom of expression is real because it is planned and written in, not subject to the singer's fancy. And the discipline behind that freedom is written into the accompaniment. No permissive conductor can loosen very much the rigidity of Stravinsky's rhythmic figurations. He has made tension in the musical pacing of his operas unavoidable, not just a luxury that turns up with expensive conductors. For *Oedipus* is an opera, even when given in the oratorio circumstance. It is an opera because it presents a dramatic action through impersonation by singers. The personages are characterized, moreover, by the music that they actually sing, the instrumental accompaniments and interludes being pretty well limited to pacing the dramatic action. The whole does exactly what the inventors of opera in Florence (around the year 1600) had hoped opera would do. It revives a Greek tragedy convincingly. It also simplifies, and quite radically, the whole problem of opera in our century just as Alban Berg's *Wozzeck,* completed only a year or so earlier, does the exact opposite by offering us intrinsically beautiful (all too beautiful) complexities.

I have tarried with *Oedipus* because I esteem it a wonder-work. Stravinsky must have known too that his efforts of more than fifteen years toward writing a true opera had come to fruition, for he did not ever again experiment with the medium, not even in *The Rake's Progress.* His last effort to blend the speaking voice into a musical work had been made in 1932 with *Perséphone,* which involves choral singing, solo singing, reading, and dancing. After that, straight ballet and straight concert music occupied him till 1948. Among the concert works are two fine choral pieces, both of them in Latin — the *Symphony of Psalms* and the Mass. Indeed, except for *Perséphone,* the speaking and singing ballet of 1932, which is in French, Latin has remained Stravinsky's chief language for song, with English (the libretto is by W. H. Auden and Chester Kallman) raising its head for the first time in *The Rake.*

It raises, I may say also, quite a pretty head both as poetry and as music. For the work is full of jolly verses and a vast variety of musical occasions are all imaginatively exploited. Since its first presentation in Venice, 1951, it has been played and sung round the world. It may well be becoming a standard repertory piece. I hope so, because it is musically good fun, and because it is after all by Stravinsky, a purveyor of

sound musical nourishment, like Mozart, not just of habit-forming musical hangovers, like Strauss and Puccini. Whether it carries either opera or Stravinsky any further than *Oedipus* I am not sure.

The direct descendants of *Oedipus* all speak liturgical Latin. These are the *Symphony of Psalms*, the Mass, the *Canticum Sacrum* (or Canticle of St. Mark), and *Threni* (out of Jeremiah). *The Rake*, for the first time in Stravinsky's music, speaks English. Its story suggests the earlier *Soldier's Story* about a displaced person and his personal devil. It recalls a little bit too Mozart's *Don Giovanni*. Not very much, I admit, because poor Tom, as his own devil admits, is just a fool, not da Ponte's compulsive raper. The musical model is *Così Fan Tutte* with bits of Bellini added. Its play evokes the English eighteenth century, but its music, save for a couple of folkish songs and some children's games played in a bawdy house, bears allegiance to Austria. And strangely enough, though composed more than twenty years after *Oedipus* and fathered by different librettists, *The Rake* turns out in many ways to be an inversion of *Oedipus*. It follows the Oedipus story of a young man who sets out to make his fortune. In *Oedipus* the oracle pursues him; in *The Rake* a personal devil accompanies. But whereas Oedipus actually, as the oracle prophesied, marries his own mother, Tom the rake, after having been taken off to bed just once (and drunk at that) by a madam named Mother Goose, really marries not his mother, nor any mother image, but in the form of a bearded Turkish lady, a father image. Also, where Oedipus with Greek literalness actually kills his father, Tom, by modern tortures, kills off all womanly hope in his ever-so-motherly sweetheart, sterilizes her, and turns her into an old maid.

The Rake has a Germanic Faust element too, in that hell is foiled by a woman's intervention. Only, in this case, the pure maiden does not take him to heaven; instead she simulates (to please his folly) Venus's arms, then leaves him to die in pagan bliss while she goes home with her father.

Let us not examine too far the strange pastiche that is the story of *The Rake*. Stravinsky accepted it, after all; and it inspired him to the composition of much lovely music. Some of the loveliest indeed comes at the end of the story, where Tom, here in parallel with Oedipus, dies witless in Bedlam, as eventually Oedipus was expected to die blind in the wilderness, while Ann, like Jocasta, goes home to hang herself, only in a more modern manner, to wit, round her father's neck. Observers in both cases sing their pity.

The musical effectiveness of nearly all the ensemble scenes and most of the arias is unquestioned; indeed we expect no less from Stravinsky. The arias are florid too, as in *Oedipus,* while the orchestral accompaniments fulfill at once their dramatic function, as in *Oedipus,* and very often make musical illustration, as in the hurdy-gurdy music that goes with the children's game in the bawdy house, or the several places where

guitarlike accompaniments underlie songs of roistering. There are musical ironies also, as when the composer pokes fun at Baba's anger by underpinning it with the scale thrusts of Don Giovanni's sword combat. All these picturesque elements are both familiar and welcome.

Where novelty appears in this opera is in the setting of English, hitherto not attempted by Stravinsky and hitherto rarely carried out by anyone on so accomplished a scale. When read on the musical page, with bar lines jumping to the eye, much of this musical declamation seems mannered, even clumsy, full of false accents, arbitrary as to word groupings, and often, as to vowel placements, vocally inept. Heard in the theater, it falls into place. The accents, which almost never hit bar lines, are right enough for clarity; and the vowel extensions are amazingly subtle as expressions of passion or of tenderness.

This way of not allowing a square measure-beat to determine, or even to influence in any way, a declamation line that has no squareness in it seems to come out of Erik Satie's treatment of French in *Socrate*. I have not, previous to *The Rake*, heard employed in any language such a high degree of verbal freedom against so rigidly measured an accompaniment. The result is that the words come through with a clarity all unusual to the serious musical stage, and with a minimum of interference from both the orchestra and the throat strains of power vocalism. Stravinsky does write, on the whole, for voices of robust timbre and wide register. It is surprising, under such a setup, with constant loudness and floridity required, and with the orchestra not timidly scored — it is astonishing, really, that the words come through at all. That they do come through is owing to Stravinsky's delicacy and boldness in handling English. Let it be an example to us all. Not an example to follow in detail, any more than any composer's musical methods are, for these are always highly personal; but of the value of a rational method sensitively applied to the troubling problem that is English declamation today.

Actually, for all that the successive musical movements of *The Rake* are constantly entertaining, even touching, the major drama of the work lies in a certain conflict between the composer and his singers, a conflict that has not yet been resolved. All our symphony orchestras, after fifty years, can now play *The Rite of Spring;* and its opening bassoon solo is so well taught in the schools that it hardly sounds tense at all. When singers of this opera shall have learned to utter their parts without apparent strain, they will have settled the same conflict, and the composer will have been rewarded for his patience. For at that point, *The Rake* will have become securely a repertory opera like *Pelléas et Mélisande* or *Carmen,* and perhaps even a vehicle for vocalism like *Tristan und Isolde.* In any case, its major cultural values will surely lie, as with Verdi's *Il Trovatore* and Bellini's *Norma,* in its music. That element of the work is vastly rewarding.

Even the ballet music of Stravinsky has often, after a few seasons, dissociated itself from the stage and moved into the concert hall. His early operatic efforts, *The Nightingale* and *Mavra*, have so far failed in both places. *Oedipus Rex*, though it makes a grand effect when performed with masques and costumes, is just as comfortable in the oratorio circumstance. Of all his operatic works *The Rake's Progress* seems to grow in public favor without losing character as a stage piece. This fact is owing, I think, not so much to the effectiveness of its rather silly story as to the fact that it permits a naturalistic staging. All the others require dancing or miming or stylized movement, procedures that repertory troupes find it virtually impossible to achieve. Stravinsky's love of the hieratic has made him world famous as a ballet composer and as a writer of oratorios. *The Rake*, on account of its naturalistic setting of English, invites naturalistic stage deportment. Hence its present currency in repertory houses. *Oedipus Rex*, however, I find the grander experience — the top one, indeed, among Stravinsky's many trials at climbing the Alps of opera.

This climb was weighted down at the beginning by an orchestral palette more complex than opera needs. Its second hindrance was Stravinsky's formation as a dance composer. A third trouble lay in his whole concept of composition — his rhythmic rigidities and his addiction to historical references.

The overcomplex palette he threw away after *The Rite of Spring*. It took him still more than thirty years to conceive a stage work without regulated movement. Even the farcical *Mavra* seems to imply a *commedia dell'arte* treatment. His musical methods, stiff, and intractable like those of J. S. Bach, proved wondrously effective, however, in oratorios and cantatas. One of these, *Oedipus Rex*, actually makes an opera. And with no picturesque orchestral passages competing for attention, it invites stylized movement.

This work comes nearer to the Stravinsky ideal of opera than any other work of his, save perhaps the youthful *Nightingale*. In his one non-dancing opera, *The Rake's Progress*, he abandoned the ideal of a controlled stage. As a result, the work, for all its musical charms, is a little silly to watch. The music itself, moreover, is too stiff for the acting style of present-day singers. It needs real miming and constantly guided movements, not the relaxed floundering that goes on with it everywhere.

The ballets of Stravinsky's early years, the oratorios and cantatas of his later ones, define him as a musical master. But not all masters have had the opera gift. Handel and Mozart did certainly. Bach and Brahms did not. And Beethoven, like Stravinsky, wrote more effectively for chorus than for solo singers. He lacked, too, the instinct for stage timings and stage pacings. I am inclined to think that Beethoven's *Fidelio* and Stravinsky's *Rake* share this ineptitude, and that even *Oedipus Rex*,

though a perfect cantata, makes a satisfactory stage spectacle only because it is based on a perfect play. But it is less a real opera than it is an oratorio about an opera.

Reviewing the whole history of Stravinsky's experiments with opera, I do not think that he can be considered a master of the medium. Certainly he has not worked in it with freedom, as he has in ballet, nor handled it with anything like the boldness he has shown toward the concert forms. Neither do I find that his operas embody any original solutions, save two. These are the voluntary abstention from coloristic orchestration and the expressive use of prosodic distortion in setting English poetry.

Perhaps these are enough.

From *Musical Newsletter,* Fall 1974.

❧ The State of Music Criticism

TODAY'S OUTPOURING of classical music through professional con-
certs, not to speak of college and community orchestras, as well as
by records and radio, plus 124 subsidized opera houses in the two Ger-
manies alone, is a phenomenon strictly of our time. The Appreciation
industry in America and *Les Jeunesses Musicales*, spreading out from
Europe, have also worked to increase distribution, by offering, along with
the music itself, technical explanations designed for laymen. In no ear-
lier epoch ever has the ear been so helpfully drenched. And yet the criti-
cism of it all, the reporting of music events by knowing and skeptical
minds, has not, as an art itself, grown by what it feeds on.

Actually, reviewing music in the daily press of Europe and South
America or across the United States has altered very little during our
century. Altered in kind, I mean. The attitudes adopted for reacting to
music or used in observing it, the styles considered acceptable for writ-
ing about it, even the types of reviewer appointed to major papers —
none of these has gone through notable change.

It is merely that the amount of everything is smaller. In no American
city is there the number of papers there were in, say, 1910 or 1920. And
among those still surviving, none can offer its former spaces or the late
deadlines appropriate for filling them. Musical coverage is further obliged
to brevity by a reader interest in the dance, of late become sizable and
demanding.

Time was when the dailies of New York, Chicago, Boston glowed with
happy hatreds and partisan preachments. Today there are too few in any
city to sustain a controversy or to reflect a consensus. Consequently, the
tone just now is blander and less urgent. Occasionally one finds a Sun-
day article animated by perspicacity, a columnful of red-hot controversy

among correspondents, or a brilliant review of some novel item, though rarely, it must be admitted, very rarely in the daily papers.

The musicological quarterlies still take on old music, though seldom its performance. Depth analysis of written notes is their method, and one which keeps them inevitably a bit late about picking up the contemporary.

The monthly magazines fail with live music for other reasons. Their delay in production, sixty to ninety days, tends to produce in both reader and writer an inattentive attitude toward events so long gone by. They cover recorded music admirably, but for anything else the retard is killing. Actually it limits them mainly to discussing trends and careers.

It is the weekly magazines that still produce, as they have always done, our most readable reports on music, whether as studies of composers' works and temperaments or as straight concert coverage. B. H. Haggin (formerly) in *The New Republic*, Leighton Kerner in *The Village Voice*, Herbert Kupferman in *The National Observer*, Robert Craft in *The New York Review of Books* (a fortnightly), Irving Kolodin (however brief) in *The Saturday Review*, and *New York* magazine's Alan Rich (now and then outrageous for inaccuracies but the only muckraker we have), these are the writers that I tend to keep up with, if only in the hardcover reprints that keep so many of their best reviews an actuality.

Andrew Porter, formerly of *The Financial Times* (London), is, after a year's absence as a Fellow of All Souls (Oxford) now working again at *The New Yorker*. His previous year's articles written here have already been republished and reviewed. *A Musical Season* is their title (Viking, 1974). Opera is their chief subject. Opera is also Porter's liveliest activity — as translator, editor, historian. Like many another English reviewer, he writes in sentences; his thought seems to come out that way. I don't mean oratorical or poetical sentences, just plain declarative ones, straightforward and grammatical. Their lack of splash does not mean they don't dive deep.

As for operatic knowledge, just now that field is pretty vacant. Nobody reviewing in America has anything like Porter's command of it. Nor has *The New Yorker* ever before had access through music to so distinguished a mind. And if Porter seems once in a while to be plugging his English friends, I am sure that if I were working on a London paper (the Anglo-American musical blockage being what it is) I should look for occasions to mention American composers.

Not that Porter is immune to faults of judgment, or even of style. He can get so tied up in detail that decision fails him. Explaining the past has small value unless it leads to conclusions and to fair statements of them. Similarly for his reviewing style, the itemized report card can be a let ball; it has no bounce. Reviewing, unless it is an interplay between facts correctly stated and ideas about them fairly arrived at, makes no

point. And Porter, I must say, whether writing of old music or of new, on most days keeps within the rules. So comfortingly, indeed, that when I do not see his magazine, I miss him. It is not his well-informed stance that especially holds me, or his "inside opera" serve. What I find absorbing is the spectacle of a good mind playing with good equipment on a good court.

Robert Craft, once his master's voice for Igor Stravinsky, has become since the latter's death the no less official biographer, with access to books and documents concerning the composer's early life, all translated, presumably, with help from the widow. Publication of these proceeds irregularly in *The New York Review of Books*, by Craft impeccably edited and by him quite frankly thrown into question when suspect of inaccuracy.

Other Craft reviews from that paper and elsewhere have been gathered along with these into a volume called *Prejudices in Disguise* (Knopf, 1974) notable for its musical penetration and journalistic punch. Craft takes a joy in polishing his sword that reminds one of his mentor's deadly way. The Leonard Bernstein *Mass*, for instance, is given a sustained high kidding, along with bits of sharpshooting at Harold Schonberg. And the philosopher Theodor Adorno's politicized twelve-tone commitment seems almost to be riding toward an equal pratfall. What saves it here is Craft's own no less shocking commitment to the Stravinsky interests. In a text of 200 pages, less than half of which is about Stravinsky, that master's name appears 360 times.

But Craft is fun to read, hilarious, explosive, wild with puns and pornographies. He is also, as a conductor, thoroughly knowledgeable about scores and precise in citing passages from them by their measure numbers. And if he is a shade overzealous as salesman for one composer, he is no less active regarding another. Indeed, I have suspected that for all his twenty-five-year service to Stravinsky's person, career, and family life and his obviously real attachment to these, his musical preferences actually lean toward the works of Arnold Schönberg, Alban Berg, and Anton Webern. Certainly such an allegiance preceded his joining Stravinsky; and it seems to have influenced, after Schönberg's death, Stravinsky's own turn toward twelve-tone composition.

Ned Rorem's reprint of formal pieces from *The New Republic,* along with bits of more improvisatory material, is frankly titled *Pure Contraption* (Holt, Rinehart and Winston, 1974). The essays themselves, less penetrating musically than Craft's and less learned than Porter's, are nonetheless better made for easy reading. They are more gracefully written, for one thing; their English is meaningful, picturesque, idiomatic, in every way alive. And their malice is far less seriously intended. He pays off a few scores — against Copland and myself, for example — without bothering to make any musical point at all. And he pokes equally

harmless fun at Elliott Carter's tendency toward "the big statement," a sort of music-writing that we used to mock in French as *"le style chef-d'oeuvre."*

Actually Rorem is not a dependable critic, in spite of a good mind and a pretty good ear; his egocentricity gets in the way. It prevents his seriously liking or hating anything. He is scarcely involved anymore even with his private life, which for some years furnished him literary materials as well as a devoted public. In a recent interview published jointly in San Francisco by *Fag Rag* and *Gay Sunshine*, his burden is how little he cares about his prose and how devotedly he indites his music. Actually it is his lack of literary ambition, I think, that gives to his writing so much charm, along with the eight years' residence in France that firmed up his mind and his manners. His music has no such ease. But the writing reads, as our black friends say, right on.

Henry Pleasants has been publishing polemical criticism for many years, much of which may have come out first in periodicals. I know that before the last war he worked on a Philadelphia paper and that he now reviews music from London for the *New York Herald Tribune*, Paris edition. Some years ago he defended in a book the theory that serious American music is inferior to pop and jazz. Marc Blitzstein remarked of it, "That's sixty percent true, but we're not taking it from him."

His apparent eagerness to get on some winning side showed up in a book of panegyrics, *The Great American Popular Singers* (Simon and Schuster, 1974). Mixing up blues, gospel, and straight commercial is not uncommon in discussions of the singer's art, though it is not an ideal approach. Confusing the term *bel canto* with the florid, or coloratura, style is even farther from sound practice. Treating only highly paid artists, as he does here, tends to remove any book from serious consideration, notwithstanding that Pleasants himself is an informative journalist and a straightforward writer.

Rolling Stone, a thick weekly tabloid devoted to pop and rock, is charmingly written for the most part and sometimes distinguished. I recommend it. It does not read like paid advertising; it reads like criticism, though I am no judge of the materials it purports to cover. Nor do I know what interests own it. I merely enjoy its vigor.

If the reviewing of pop music and rock is largely blurb, the reviewing of jazz, both performance and recordings, tends toward wild statement, intolerable eloquence, billingsgate, denunciation, and patriarchal poetry. Since much of this is written both about and by blacks, it is full of protest too, about white monopoly of management and of the recording industry, about hopes for liberation and its possible achievement through a black revolution. Not since the 1920s Marxist dithyrambs from Russia have I read such passionate statements of hope-in-spite-of-a-sewed-up-situation. Hope defines our blacks' attitude toward society. Toward mu-

sic they show pure faith, complete confidence, and pride in a communion. Naturally any expression of this reads a bit like the psalms of David.

Some remarkable reviews of jazz recordings of rock groups from Ann Arbor and Detroit, originally published in the magazine *Jazz and Pop*, are reprinted as *Music and Politics* (World Publishing, 1971). These are by John Sinclair and Robert Levin, white men both, though you might not suspect this from the writing, only from their high tolerance of rock music, a syndrome rare among blacks. Sinclair, the more ecstatic, was actually chairman, when he wrote, of the White Panther Party; and he composed these essays in Marquette Prison while serving a nine-and-a-half-to-ten-year sentence, presumably for his political views, though his indictment had been for "possession of two marijuana cigarettes."

In any case, he was allowed a record player, received discs, wrote about them, and sent the reviews out. The longest and finest of these, entitled "Self-Determination Music" contrasts the freedom expressed in good pop music, as by the Rolling Stones, for instance, or by an impecunious Detroit group, with the enslavement of the musicians themselves, whether to publicitary lives and conspicuous consumption or to economic repression and virtually no consumption. In either case his faith lies with the music and his hope is in its power, if not to redeem the social economy, at least to transcend its horrors.

Robert Levin's lead article is a story told him by the black drummer Sunny Murray of how repeated efforts were made both in New York and in Europe to assassinate him because of his addiction to the New Jazz and to playing it with Cecil Taylor. His tale is a gaudy one and quite impressive. Ornette Coleman, when told of an attempt made right on Seventh Avenue to run down Murray with a Thunderbird, is said to have answered, "Listen, those people paid me *not to play* for a whole year." The story goes through poison efforts in Denmark, drugged drinks, and eventually a ship bound for America being evacuated by helicopters because of a provoked epidemic aimed at killing off Murray. All this was part of a war among blacks over (believe it or not) a way of playing jazz, a "new system" he calls it (actually polymetric and nontonal) for improvising. Then one day the attacks on him "suddenly, strangely, just stopped . . . Since around that time," adds Murray, "I've been cool."

Cuba has a musical magazine called *Musica*, which treats generally of Latin folk styles and reports programs from that country's major cities. Havana maintains a symphony orchestra, a classical ballet troupe, and some chamber music. Since the revolution, except for lots of Czech guest conductors, Cuba has lost outside contacts so radically that even Afro-Cuban popular styles, including the famous steel bands, have been very little exported. As a result, Havana's position as the leading Tin Pan Alley for Hispanic pop tunes has been taken over by Rio and Mexico

City. Since Hispanic constitutes roughly fifty percent of the world's pop consumption (the rest is made in the U.S.A.) Cuba's losses in both money and prestige have been considerable.

Musica now proposes that Cuba lead all of Latin America toward a prestige apotheosis in which modernistic far-out techniques will be put to ideological uses, thus relieving a popular music stalemate that is not merely Latin but worldwide. My dear children, ideologies, Marxist or other, have never done much for music. Nor is anybody in Latin America, I think, disposed right now to let Cubans, exiled or native, run anything. Moreover, I for one believe strongly that today's far-out music techniques, however novel they may seem when dimly heard about behind a blockade, are in general tired, run down, and overadvertised.

Which brings me back to the state of music criticism. Essentially, this practice seems not to have evolved or declined within my lifetime, although music itself, the material of reviewing, has experienced during that time an enormous rise and fall.

I mean music as composition, of course. Performance may or may not have improved since 1900; that is disputable. There is more of it, in any case. But composition, contemporary composition, is where reviewing comes to life. Complaining about interpreters or rooting for them, however legitimate, is just fidgeting. Criticism joins the history of its art only when it joins battle with the music of its time. But music right now, after more than a century of a modernism grand and powerful, has taken to playing with mechanical toys and to improvisational tinycraft or, at best perhaps, gone underground.

It may be that hiding from the distribution mafias is music's last hope for sweetness and freedom, not to mention for protecting what remains of any composer's musical ear. But such an event would even further constrict the press by leaving it very little new to write about.

Two Conversations

❧ John Rockwell: A Conversation with Virgil Thomson

THE FOLLOWING interview with Virgil Thomson, conducted by John Rockwell of *The New York Times*, took place in Thomson's apartment at the Chelsea Hotel on April 6, 1977, in the mid-late afternoon. It has been condensed, edited, and, in two spots, slightly rearranged, but is otherwise presented verbatim.

JOHN ROCKWELL: I don't really know what Herbert Leibowitz had in mind for this.

VIRGIL THOMSON: He doesn't have anything in mind. He's getting up a sort of birthday garland, which is not necessarily intended to be a batch of favorable speeches or of obits, but perfectly serious views of me from various angles.

JR: I know he's asked Don Henahan to do a piece. As I understand it, mine is meant pretty strictly as a straightforward interview. In other words, I'm not going to be writing a critical essay around it.

VT: Maurice Grosser wrote him a piece about my life among the painters and Lou Harrison wrote a piece about our musical acquaintances. I don't know who all else . . . except Donald Sutherland, with whom I did some musical translations. He's a poet, translator, philosopher, actually a classical scholar, the author of some vastly entertaining books. One called *On, Romanticism,* which proposes a classification of art a little different from the conventional ones of classic versus romantic. Sydney Finkelstein said things were either romantic or neoclassic. Classic isn't a domain, simply a state things get into after use. Donald makes a triple division — classical, romantic, and baroque . . . he finds baroque writing clear back to Aeschylus.

JR: In your autobiography you called your own music in the late

twenties a kind of New Romanticism, then implied that it got swept aside by events in the early thirties. Do you still feel that that's a good definition of your own style, at least in that time?

VT: Names are never very good definitions for things like that. Names become attached. After all, cubism is not a system of painting in cubes — somebody *called* it cubism.

JR: But in this particular instance, *you* called it New Romanticism.

VT: No, I didn't invent that. That was a term invented by an art critic named Waldemar George to describe the painting of Tchelitcheff, Bérard, Eugene Berman, and his brother Léonid. He called this Neo-Romantic painting and the term stuck with regard to painting. It was applied around Paris before the war to various composers — Henri Sauguet and me, Nicolas Nabokov, Henri Cliquet-Pleyel. And we were all close friends of the painting people, and frequently in ballets and things like that these painters and composers would work together. But the name has stuck better to painting than it has to music. I wouldn't hold by anything like that. Romanticism is far too vague a term for me to stick to. Anyway, I am very little a romantic character by nature. Neo-Romantic might work. But Neo-Romantic would have to be a branch of the Neo-Classical.

JR: Or a reaction from it.

VT: No. It's more likely that the neoclassical would include the neo-medieval, the neo-baroque, neo-Romantic — and the neo-modern, which was what Stravinsky was up to when he wrote in the twelve-tone system. He was not writing *in* the spirit of Vienna, he was writing *about* it. You evoke the past . . . that's the neo thing.

JR: Do you think he thought he was doing that?

VT: Doesn't make any difference whether he thought he was or thought he wasn't. (Laughs.)

JR: Obviously, a principal form of serious art music in the twentieth century — or at least the type that's gotten the most attention — has been an extension of expressionism, very cerebral, very complex, and so forth . . .

VT: Now wait a minute. I'm not so certain that I would accept that premise. I have another layout of the twentieth century, which is that the main group of composers functioning in the first two decades were "picture composers," that is to say, they were impressionists in France or expressionists in Germany. And they are the same people who invented and wrote in the neoclassical style. You see, Stravinsky is an impressionist who in the middle of his life, instead of evoking landscapes, started evoking the history of music. Richard Strauss did the same in *Le Bourgeois Gentilhomme*. And Debussy did it in his late sonatas, you see — Hindemith, anybody that you want to include as a neoclassical writer, has also written picture music, and the neoclassicism of those picture

composers is an evocation of past times and styles rather than an emulation of them, as was true of Brahms.

JR: But certainly in America the sort of epigones after Hindemith or Schönberg or Stravinsky have pushed a lot of academic American music into a very cerebrally complex direction.

VT: European too, of course. They've gone very cerebral. Can't be more cerebral than Pierre Boulez.

JR: Your music, whatever the degree of complexity underneath the surface, is in some rather wonderful way, I think, simple. It uses diatonic idioms, it uses short phrases, it is clear, one can hear the language in your vocal works, you pay attention to declamation. Do you think that your music's reputation in the last ten, twenty, or thirty years has suffered from a prejudice built up by the more cerebral kinds of composers?

VT: Of course it has. It's suffered that from the time I started writing simply. Being born in 1896, I grew up as an impressionist and a neoclassical writer and in an ambiance of maximum dissonance, which was the pre–World War I setup of Schönberg, Stravinsky, Debussy, and so forth. One hundred percent dissonance saturation, we all learned to do it. It was about 1926, when I was thirty years old, that I had a kind of enlightenment, a moment of truth if you wish, in which I said to myself, "This is old-fashioned and there is very little profit to be derived from trying to continue it beyond its recent masters. What I had better do is to write as things come into my head rather than with any preoccupation of making it stylish and up to date, and it was the discipline of spontaneity, which I had come in contact with through reading Gertrude Stein, that made my music simple. It became quite radically something or other — it's not for me to describe — that's for other people. I was accused, oh very early, as were indeed my colleagues in France, of being arbitrarily *simpliste*. Henri Prunières, who published and edited a rather important magazine called *La Revue Musicale,* said of Sauguet's first ballet of 1927, "We have spent twenty years learning to enjoy large quantities of dissonance. Now must we start all over again learning to appreciate *do-mi-sol?* That is too much." He was a learned man, a musicologist.

JR: One can certainly see kinships to that kind of French music from Satie on. Do you feel a kinship with other deliberately simple or even minimalist (to use the current term) composers outside of the French tradition? I mean people like Orff or any of the American composers who are working in a simple way.

VT: I didn't meet Orff or know his music until 1946, at which time I was fifty years old. I feel no especial consanguinity there. Ever since I simplified my machinery, I've kept a list of people who I think should've simplified theirs. That doesn't mean that when I simplified my machinery, I didn't later go back and write extremely complex pieces. But the basic

simplicity applies even to the complex setups. I've always thought that Bartók would've been better off if he'd done something like that.

JR: He was heading toward that in the end, wasn't he?

VT: The last three quartets are very directly emotional, rather than occupied with composing tricks, as so much of his earlier music is. By tricks I mean devices — nothing wrong with them.

JR: Who else?

VT: You can't put all these uncomplicated people in the same baskets. Benjy Britten is a fairly simple composer and so is Shostakovich, but they're simple in a different way from me. My simplicity was arrived at through an elaborate education. Now that doesn't mean it's superior for that, but it came about that way, so that it's a simplification of all the methods there are. I'm not a naive composer, you see, and neither was Satie. A fellow in England did an enormous Ph.D. thesis at Cambridge about ten years ago on Satie's early works. He found in the Bibliothèque Nationale exercises in various forms of music writing, novel chord sequences, and a great many other devices which later showed up in Satie's music. This gives a great clarification of his musical attitude. He was not either *simpliste* or *simpliciste*. He was a man looking for clarity rather than for resemblances to other people. Now, he was a great friend of Debussy, and he knew all about what Debussy was up to. They had lunch together every week, all Debussy's life, and they talked about those things and warned each other of dangers. Satie warned Debussy against going all Wagnerian. He said, "Look out for this business of developing leitmotifs. Music should stay where it is, not follow the play. It should be like a décor. A property tree doesn't go into convulsion because an actor crosses the stage." (Laughs.) Well, that's the kind of thing they talked about constantly, to mutual benefit. Debussy had a good ear, he was a good pianist, and he was well trained. Satie wrote more slowly and in a way more intellectually. He was not a mood writer.

JR: When you came back to America for good in 1940 and when you were on the *Herald Tribune*, both in your music and in your writing, you represented a Francophile position, battling against German influence.

VT: You always have to fight against the Germans. Everybody has to fight the Germans.

JR: Do you feel that the battle has been won or lost?

VT: Oh, no, the battle goes *right on.* The French have the advantage of a broader gamut. They have composers of all ages and styles. The Germans, having lost their classical wing when Hitler beheaded it, have today an enormous business machine of publication which is the most powerful in the world. They publish French composers and American composers — they publish everything — but it's always understood that German music is the model that should be followed. When you own Bach and Mozart and Haydn and Beethoven and Schubert, you're not going to

think that anybody else has had your advantages. The Germans just don't know that they went stale around 1890.

JR: Or worse yet maybe they secretly do know it and are desperately trying to compensate.

VT: You see the Germans had set up by that time a powerful publication machine and a factory of pedagogues. They exported music teachers all over the world. They were all teaching the great German classics, but when you suggest that they are not really reproducing them anymore, then they get worried, and begin to exercise power. There's another thing about the Germans that I find extremely interesting, which is their situation since the last war, with the partition of Germany. No German-language poet, musician, or painter can really aspire to speak for a divided Germany. Consequently they speak for the new Europe. In the case of Henze and Stockhausen they've got a pair, a conservative European and a radical one. Their Germanness is only in the psychological inheritance that any German would have. They're not writing German music consciously. On the contrary, they're writing European music.

JR: Surely that's part of a more general internationalism of style. Do the French write French music? Is Boulez's music French?

VT: Boulez is a German agent. The Germans taking up the international style *late* have found in it their only hope for grandeur. Through their radio chains and their publication cartels, they can dominate the new Europe. I want to give them a little more credit for sincerity in the matter when I say that since they can't aspire to speak for Germany, they can with some dignity aspire to speak for all of Europe. So that their music and the music that they publish and plug — because a lot of it would die if it weren't for the big publishers and the big radio chains in Germany — is as neutral as the steel and coal reports from Luxembourg. That's what's on their minds: being neutral. The Germans have to write in that way because they haven't any tradition left. The Russians don't dare take on modernism because it's libertarian, hence politically dangerous. The English never took it on seriously because England views everything as a possibility for business monopoly.

JR: How about the Poles in the 1960s?

VT: The Poles are the freest of all those peoples and they're coming out with some pretty flashy methods.

JR: Well, the Italians have done something, Nono and others.

VT: They're practically dead right now. Nono still exists and Berio still exists. They're branches of the international setup. But they don't represent Italy any more than Boulez represents France.

JR: Do you think there's any place left for a composer who does represent national traditions?

VT: Well, that's exactly what Messiaen does, in France. And of course it's what Benjamin Britten did.

JR: It's what you do. Much of your music, especially the operas, makes use of very American materials. You go straight back to nineteenth-century hymn books.

VT: It isn't just the musical idiom. It also has to do with the fact that I can make the words-and-music thing function probably better than anybody else. Then you make your music to fit the subject. Now *Four Saints* is about sixteenth-century Spain and it's all full of medieval chants and little bits of Spanish — plus total recall of my Southern Baptist upbringing in Missouri.

JR: It *is* about sixteenth-century Spain, but it's about as American as an American portrait can be.

VT: The Southern Baptists in Missouri are not that far from sixteenth-century Spain. You don't do these things consciously but they come out a certain way. *Lord Byron* is graceful nineteenth century; it's not a primitive nineteenth century like *The Mother of Us All. Lord Byron* is all about upper-class people, frightfully posh. No folklore around there.

JR: There is something in your music very rooted to this country. It's the exact opposite of bland international cartelism.

VT: That is what one, as a young person, hopes to accomplish. Aaron Copland and I were young together and we both knew that. And so he took Jewish chant in Brooklyn, which was his background, and I took mine, which is Southern Baptist Missouri. Don't forget, I'm not so Goddamned American, if you want to compare me with those overeducated New Englanders or with the California boys, all full of China. I come from Missouri, which is the home of Mark Twain and Harry Truman, the stubborn boys.

JR: So how does that work out in music?

VT: Well, I'm stubborn — I just don't do it a particular way because they tell me to. I learn how to do it and then I decide my own way. You don't have to belong to a story to tell it, though. When you reach down in your subconscious, you get certain things. When Aaron reaches down, he doesn't get cowboy tunes, he gets Jewish chants. When I reach down, I get Southern hymns and all those darn-fool ditties we used to sing — "Grasshopper sitting on a railway track . . ."

JR: There has been a huge rise in the past twenty years in the seriousness with which popular music is taken. People now are soberly considering the blues and Bob Dylan with the same seriousness that was reserved thirty years ago for "serious" composers. What do you think of that kind of interest?

VT: America has a priceless repertory of folklore which has been collected, and we have another priceless repertory of it in its, what you might call, black transmutation. Then there's the thing which is above all that in sophistication, the jazz business. Jazz is an American inven-

tion; it's gone all over the world and it still exists in a pure state. Jazz resists impurities, and the commercial world can't handle it. Any attempt to advertise rock music as the equivalent of jazz, of course, is tommyrot. Jazz is sophisticated and rock is actually a retrogression to childish rhythms and loudness levels.

JR: Childish or childlike.

VT: An old friend of mine, Jerry Leiber, who won forty-eight hit-parade diplomas in the business, told me ten years ago, "Rock is designed for people aged nine to fourteen." Now later you still remember what you liked at age nine to fourteen. And it's still designed for very simple minds. The sophistication of the Rolling Stones or the Beatles — the Beatles are old English melody style; it's not tonal, it's modal — is very slight compared to what Ornette Coleman does, which is multi-rhythmic, polytonal, in an elaboration of musical device that the classical world can hardly match. Alain Daniélou thinks that the wildness with which the adolescent world takes on the pop stuff — has for the last ten or more years — is simply a reinstatement of the old Greek corybantic troupes.

JR: I think he's right.

VT: Not that they know that, but life repeats itself. Certainly Woodstock could have come right out of *Orpheus*.

JR: I'm interested in pop music sociologically but I'm also interested in it musically, and because of the cross-fertilization now between it and "serious" music. Jerry Leiber may have said that rock-and-roll is primarily for the nine- to fourteen-year-old market. The kind of stuff he and Mike Stoller wrote for the Coasters twenty years ago was wonderful music of its kind but it was a teen music. All of popular music is not necessarily that, especially now.

VT: It spreads farther down in the social strata than the pseudo-jazz of Gershwin, Kern, and all ever did. The flaws are (a) it makes too much money. Good music should be persecuted, and nobody's persecuting it — they only buy it. The other flaw is that there seems to be a fairly solid wall between it and the blacks. Every now and then a black takes it up to make some money.

JR: I agree with you, but there are some exceptions to that, Stevie Wonder being one.

VT: There's an enormous spread, and Americans can do what they like. If you feel a need for a European blessing, well then you can play games like Roger Sessions or Elliott Carter. But you would have a hard time putting your finger on anything very Americanski in Elliott or Roger. I think Elliott's the far more interesting composer. I think he's more gifted. But they're both aiming to wow the European intellectuals.

JR: Or the European-oriented American intellectuals.

VT: Well, same thing — that's the group.

JR: What did you think of the recording of *The Mother of Us All* that came out of Sante Fe?

VT: The musical framework is extremely good. I think an error was made in putting a mezzo in the dramatic soprano part — they didn't ask *me* about that.

JR: It's a great pity in a way — she's not a bad singer.

VT: She's a very good singer, but it's out of her range.

JR: Has anybody made noises about recording *Four Saints in Three Acts* complete?

VT: I haven't heard any noises. That will take place at the proper time.

JR: The proper time would be now.

VT: What I'm looking around for is a first-class production of *Lord Byron*.

JR: As someone who admires your music, I've been fascinated by what seems to be the relative infrequency of major performances, at least of the operas. Do you think that has anything to do with the backlash from your days as a critic?

VT: No, I don't think so. I think the big-time opera houses are very hard to break into. I've had access over the last forty or more years to first-class soloists, string quartets, orchestras, choruses, all of that. I've never yet been offered a first-class opera house.

JR: Do you think that *Four Saints* or *The Mother of Us All* would work as well in a house the size of the Met as it would in a smaller house?

VT: *The Mother of Us All* could work as a spectacle, as it did out yonder in Sante Fe; and *Four Saints* could work because of the massive choral layouts; also it needs space for choreography. Actually the orchestra in both cases is smallish, but it's no smaller than in some of the things they do.

JR: I was a little disappointed with the production out in Santa Fe because, although the setting and whole conception of it was spectacular, it sort of blitzed it. All those fireworks and brass bands at the beginning seemed to be taking a subtle and beautiful chamber work and shaking it by the hair . . .

VT: People do that when they don't trust the work. Why they shouldn't have trusted it I don't know. It's never flopped. It's a foolproof opera.

JR: You mentioned the "California boys" and their fascination with China. More and more American composers seem to be absorbed in oriental music of one kind or another, to the point of immersing themselves in it. Do you think that represents an interesting avenue for Western composers? Or do you think it's a trap?

VT: No. It's an effort that we make and that the Japanese make to-

ward producing a fusion. No fusion has yet taken place. The nearest has been some French evocations of Javanese style, or occasional usage of India's methods without sounding Indian. Then there's a fellow here named Chou Wen-Chung, whom you know, who has made beautiful impressionist landscapes, evoking the Chinese style.

JR: Morton Feldman evokes them a little bit, too . . .

VT: Does he know any Chinese?

JR: I don't know, but the feeling is certainly there.

VT: It isn't that easy when you start cross-breeding animals. Sometimes it doesn't take.

JR: Certainly there are more and more people who are trying.

VT: Well, it's been tried for a long time. Jacob Avshalomov's father (Aaron) was a Russian musician living in China. He wrote Chinese music with Western instruments and made it sound almost Chinese. And there was a fellow long before him — who used to be played by the Boston Symphony (Harry Eicheim) — who did the same thing. And that of course is exactly what Colin McPhee was up to with the Balinese. He made it sound pretty convincing.

JR: So does Lou Harrison's *Pacifika Rondo,* for instance.

VT: Oh well, Lou Harrison writes in all the styles. He makes good music, but his Javanese pieces are *not* Java. A fusion between real Africa, real Asia, and real Europe (of which America is a part) has not taken place. Everybody tries it but it doesn't take place yet. Maybe it will, maybe it won't. And if it does, it'll be in some unexpected manner.

JR: And perhaps not deliberately sought after when it does. As I recall from your *American Music Since 1910,* you were pretty suspicious of electronic music, synthesizers, and computers.

VT: Well, let's say I'm disappointed. 'Cause it's been going on now for thirty years and it has failed to develop a striking repertory.

JR: What do you think that would be?

VT: I think it has to do with the lack of limitations. Because you can play a complete glissando, made-up scales, even true intervals. You can do anything. What it lends itself to best is whish and whee. It's like trying to make sculpture out of putty: it's too soft. Besides which, it's tied to the loud-speaker and you get that 60-cycle hum, for one thing, and you get, in almost any circumstance, that taste of canned music. That's why I think for the last twenty years the better twelve-tone composers both in Europe and here have pretty consistently added live instruments to it so as to take away the canned taste.

JR: Yes, except they point it up though, because if they're juxtaposing both live and canned . . .

VT: Well, that can be kind of exciting — oh, chic in a way. I knew a French lady who made the most beautiful bouquets you ever saw, with real and artificial flowers mixed. And stylish decorators like mixing real

marble with painted marble, which is more expensive. (Laughs.) All those are elegances, you see.

JR: As someone who grew up with electronic sounds in the air, the fact that a sound is canned doesn't bother me in itself. That just represents a difference rather than any kind of qualitative judgment.

VT: The entire population of the world, I think — certainly nine-tenths of the population — considers live music to be a rehearsal for a recording and a hand-painted picture to be a sketch for a reproduction. Oh, yes, that's firmly believed. It's taken for natural. These things like music and painting, handmade, are really upper-class luxuries.

JR: When consumed and propagated they are. They also can be made in the home on any social level.

VT: What homes do *you* find them making music in? You don't know anybody who has string quartets in the home — except a few rich.

JR: Or a few musicians.

VT: People don't stand around the piano and sing part songs anymore. Occasionally there'll be a moment of recorder experiment . . .

JR: Or guitar.

VT: Well, that's something else again. You don't hear much good guitar playing around the home. What you hear are the mating ceremonies where girls in ponytails and boys in tight pants sit down very, very softly and look at one another and nestle.

JR: Do you think that the fears expressed fifty years ago that the record player would destroy natural musicality . . .

VT: It's been wonderful! All those methods have helped business. The invention of photography created an enormous boom in oil painting.

JR: But you just said that nobody sits around and sings part songs anymore and nobody plays string quartets. Is that a decline?

VT: Well, I never thought that domestic string quartets were very good anyway. I'm a professional; I like professional playing. And if you can afford good playing in the home, well, that's just fine. The mechanical piano, gramophone, possibly the radio (there's a question there about the radio) have been contemporaneous with the most enormous expansion of live concerts and opera. Same way as photography and oil painting. One helps out the other. People today get their cultivation in the classical repertory in high school and college in the appreciation courses. And those have been so effective that the American population is far more sophisticated musically at any level than the Europeans.

JR: As someone who has written so damningly of the "Music Appreciation Racket . . ."

VT: I have! I invented the term. But music instruction for laymen is a perfectly serious affair, and we've got the bugs out of it now. For a long time it was in the hands of people selling records. Now it's in the hands of the college people. Music appreciation is taught technically, not emo-

tionally. When I wrote about the music appreciation racket in 1939, already serious musicians were taking it in hand. And it was perfectly well handled way back in my college days at Harvard, also at Columbia, but practically nowhere else. Later, Walter Damrosch did radio talks about music very successfully. Deems Taylor was on the radio — very popular, very successful. They weren't talking foolishness any more than when Lenny Bernstein talked for children at the Saturday Philharmonic concerts. Absolutely sound musically. There's never been any better explanation of Beethoven's Fifth Symphony than he offered right there.

JR: Have you had any changes of feeling about who in American music is likely to last and who is likely to be regarded as a fad? I remember you had some rather damning things to say about Cage in your book.

VT: Well, Cage — he may be a nine days' wonder. I don't know what is in his repertory that would be likely to survive. Actually, Cage's performances are most salable with him.

JR: Maybe some of the prepared piano music might last.

VT: Well, they are recorded and they are pretty . . . I don't consider them of enormously high musical or imaginative content. He doesn't think that kind of thing is necessary. He thinks that glory and permanent fame come only from innovation. It remains to be seen whether there's more innovation in his music or in mine. Now, Cage and I are very old friends and we've quarreled; that's okay. I still like his music and he likes mine. And I enjoy watching his career. But I don't see too much that you could use as a basis for instruction in schools.

JR: Whatever the value of his music may ultimately be, he certainly had an impact in providing an alternative way of living one's life and looking at art. He certainly had a large influence on a whole variety of younger composers who live in lower Manhattan right now.

VT: I'm not sure that that's true.

JR: Oh, I think it is. They certainly think kindly of him, that's for sure. He's also had influence on dancers.

VT: Now, look, I can tell you the composers that have been directly his pupils and who have been good — Morty Feldman, Christian Wolff . . .

JR: Earle Brown, I suppose.

VT: Earle Brown is on the seesaw.

JR: But once removed from that: there are a lot of younger people for whom the contact may only have been by reading *Silence* or having seen him do one of his lectures.

VT: Well, *Silence* is a mind liberator; it's not a musical work at all.

JR: That's what I'm talking about. In other words, the influence may be profound whatever the ultimate reputation of the music.

VT: That's true.

JR: The influence may be in terms of attitudes.

VT: Oh, I think the Cage books will remain readable, very definitely.

JR: Are there any of the younger composers that you are interested in or find particularly suggestive? People under forty?

VT: Well, I don't know them terribly well, because I don't go to musical things a great deal. Especially since I don't hear right anymore. It's hardly worth the trouble. There's a very pleasant, I think solid fellow — Jacob Druckman. There's something probably to be said for David Del Tredici. I'm not sure just what. I have a Chinese friend on the faculty at Harvard. He's the youngest son of Sascha Tcherepnin — Ivan. I think he's bright, gifted, and I can listen to the music. A lot of it is electronic. There are people about — I just don't know them all. I haven't encountered anything awfully striking on the West Coast. Oh yes, there's the thing that was such a big success about ten years ago. You know . . . you play the C-major chord over for half an hour in different forms.

JR: Terry Riley.

VT: Yes. And there's a fellow named Steve Reich — he's a little bit like that. Those are what you might call experimental. And perfectly valid. But how could anybody bet on the future? If you're a publisher, you have to. The American publishers think they don't have to, because they're all run by large consortiums. The German publishers will publish anything because they have lots of money. You see, Germany doesn't keep a big army so they don't tax very high.

JR: They managed to put out a lot of published music when they were keeping a rather big army too.

VT: They didn't publish so much foreign music as they do now. Their present slogan is "The fortunes of tomorrow are in the copyrights of today."

JR: Do you think that New York's centricity has changed any in terms of its place in musical life?

VT: It became central in 1940, with the European war, and has pretty well remained so. Before, it was the center of America but it wasn't a world center. America became an important world center of book publication after World War I, and it became an important world center in painting during and after World War II. I don't think we're quite as authoritative in music as in those two other branches. There are still very powerful publishers in Europe and radio stations that play everything.

JR: You mentioned painting. It's of interest that so many composers of this century have been so closely associated on a social level with the art world; sometimes even more than with the musical world. What do you think the connection is between twentieth-century new music and art?

VT: Real estate.

JR: How so?

VT: It's when you're young and have no money that you all live in the

same neighborhoods. When musicians have enough money to live on, they live among themselves, like college students. In my Harvard days musicians paid no attention at all to the boys from the Fogg Museum. On the other hand you go to Greenwich Village or Montmartre or Montparnasse or wherever the real estate is cheap, and the musicians, the poets, and the painters live there, and you're surrounded by painters, that's all. And you learn to like 'em, because they're awfully companionable.

JR: Do you think that the explanation of the preeminence of painting in our century is primarily based on economics?

VT: No. Because things take a spurt when there is an inside reason for the spurt to be possible. Painting directly on the landscape became possible in the 1840s with the invention of the tin tube. Simple as that. Before that they had to make notes and then take them back to the studio. It was all kind of dead. And the impressionist business came up with the stimulus of photography. The nineteenth century was cleaning up in music with harmonic and orchestral advances, and once these were over, then you had the little stuff. And that's what's going on now — hardly anything at all. Just tiny little stuff. No major novelty. It was thought that just possibly electronics might provide that, but it hasn't done so. The best part of electronics is reproduction, and that's excellent.

JR: If painting has seized the imagination in this century, do you think that will keep up, or will music reestablish its claim?

VT: Well, painting is already on the down. Oh, boy, if you own any Picassos, sell 'em. They'll never be hotter than now.

JR: Well, what do you think is going to be the next focus?

VT: How do I know? I don't think the world is about art today. I think the world is about international organization — in business, in government, and in the arts of war. The artistic achievements of the entire twentieth century are now available to all and taught in the schools. Nothing's happening but consolidation of achievement. They have courses in Gertrude Stein and James Joyce — everything. And the French classes explain Mallarmé.

JR: Let's talk for a minute about criticism. People get together occasionally and wonder how the quality of the daily press could in some way be improved. The Music Critics Association likes to think it's doing that. I was talking with Conrad Osborne (an opera critic) the other day. He's not involved with the music critics' organization, and I asked him that question and he said, "How can you have an organization designed to solve the problems of American music criticism when the members are the problem?" Is there any way they could upgrade the quality of music criticism in this country?

VT: You'd have to decide what spots you want to work on. Now, what would you work on?

JR: I don't frankly know, because I have a kind of heretical view of what makes good criticism. That is, I don't have any view at all. It seems to me that there have been good music critics who have come from almost every different conceivable background, and that all backgrounds bring obvious advantages and disadvantages. Clearly the more you know about music the better.

VT: Whenever I've given courses in writing music criticism, I've always treated them as courses in English composition. Get your grammar right, make your words mean what they say, and if you can end by being willing to mean what you *have* said you're lucky. Naturally you have to have musical knowledge. And you have to belong to the musical profession, with some kind of loyalty to music itself. But it's a writing job.

JR: Do you think too many critics dwell in the past?

VT: It's so much easier to stick with your college education than to keep up.

JR: But it seems if you don't keep up, you miss the whole point.

VT: Well, that's what happens.

JR: When you look back at your own life, how important a place does your critical writing hold? Do you regard yourself as a composer who, in one brief moment, happened to be a critic, or do you think of yourself as a composer *and* a critic?

VT: I have to admit, when I look at my life, that I have written music all of it and performed music all of it; and that I have written about music practically ever since I was, say, twenty-five. I started writing musical articles for Henry Mencken (*American Mercury*) and for Frank Crowninshield (*Vanity Fair*), and then I went back to live in Paris and I didn't want to do that, so I spent several years not doing that. Then pretty soon I was persuaded to write a piece for *Modern Music*, and I started again doing that. It was through all that early practice that I kind of polished up the technique for doing it. I've written about music all my life. So did Berlioz. It's not unknown.

JR: Schumann, Wagner, lots of people did.

VT: Well, Wagner wrote forever. A number of them did it for a short time, like Debussy or Liszt.

JR: Have you ever thought of the two actions as in any way antithetical? Writing *about* music and writing it?

VT: No, I think they're mutually contributory — up to the point when you get stale at one or the other. It's the same thing as giving lessons. It's good for a pianist or a violinist to give lessons, because it forces him to organize his knowledge. And composers practically all give lessons at one time or another. But when teaching overpowers you, then you should stop it.

JR: Is that why you stopped in 1954 as a critic?

VT: Oh, no. I thought you better stop while *you* were still enjoying it and *they* were still enjoying it. I knew I was going to stop one day. It wasn't overpowering me at all — it was too easy. I could see boredom way off on the horizon and I said, "Uhm — time I left." You see, I have a long history of giving up things as soon as I discover I can do them. I was a perfectly successful instructor at Harvard, and I said, "Okay, I don't have to do that." I was a perfectly successful organist and choir director. "Fine, I don't have to do that." And the same way with criticism. The only thing I've stuck to really is composition. You never know when you're successful in it. It isn't a thing you *do,* like teaching or playing the organ or reviewing. It's a thing you *have* to do.

JR: When we talked last fall, you were working on a choral piece. How's that coming?

VT: Not coming at all! Oh, I'm having a terrible time. I just let it alone, which is my technique for hoping that things will revive, and it hasn't *peeped.* (Laughs.) So we'll see. Either I write it off or I start over again. I think I better get at something else. What actually I've been doing in the last couple of weeks is getting a book together.

JR: Your writings from *The New York Review of Books?*

VT: Well, there are all sorts of things. You see, the middle chunk is taken care of by the *Herald Tribune.* But before that, there's a series of rather brilliant pieces in *Modern Music* and some early curious items. I wrote the first serious attempt at a musical analysis of jazz that anybody ever did. It was published in 1924 by Mencken in his *American Mercury.* There are some early pieces like that — pieces about swing that have never been replaced or acknowledged. And then there're things in *The New York Review* and some other places. There's a piece about Stravinsky's operas from the *Musical Newsletter.* Anyway, I've still got a pile like that which is unused. These I got at and looked at and found that I could make, I think, quite a good book out of them. I have a publisher who wants one and so he's looking at it now. We'll see what happens.

JR: How else do you fill your days?

VT: I have a secretary who comes at nine A.M., and I read the mail and answer it . . . What do I do? I do whatever is to be done next. I write if I have anything to write. I've written less music in the last year. I don't think people ought to talk about their health, but I had an operation a year ago, which was extremely successful. All the same, a major operation, particularly for a person my age, is not like getting over a cold. Although it left no visible traces or symptoms, my *energy* has been slowed. I think that's over now. I'm feeling peppy, and if that God-damned Plutarch piece doesn't work, I'll write something else.

JR: Do you still socialize a lot in the evenings?

VT: I have half a dozen friends. I see them and we eat meals together.

I rarely go to parties. You see, the deafness has made changes in my life, because if there are more than ten people around, I don't hear. Traffic noise kills it. Oh, you can manage by talking close to people, to get through an occasion. But I find it fruitless so I don't go to such things, unless it's to do a favor to some friend who's having a party or being given a party. Same with concerts. I still go occasionally, but I don't do anything more than make an act of presence, because I hear it wrong.

JR: I can understand how one hears less, but how does one hear intervals wrong?

VT: Well, you see, there's a good deal more than mere volume in the deafness affair. I have a diminution of volume; practically anybody does at an advanced age. But what they call nerve deafness, which is due to the deterioration of the auditory nerve itself, has different effects. Sometimes people find the upper partials all jangled and painful. My upper range is perfect. It's with violin G and below that everything's at least a half tone flat. Well, that falsifies all the chords, of course.

JR: So if an orchestra plays a perfectly in-tune, widely dispersed triadic chord, you hear it as a dissonance?

VT: I can't ever be sure what the strings are doing because they are such a complex of overtones. Now pure sounds like the brasses, they make harmony that I can deal with. And even with the tuba and trombones being off pitch, I can still compensate or reconstruct them from the upper partials. Woodwinds don't bother me because they're all up within a range I can hear, except the bassoon, which does me no good. And the percussion I always hear. The strings simply do *not* make chords.

JR: From my perspective, you've had a pretty good life.

VT: It's been all right.

JR: I can think of many, many considerably worse lives than yours. You have wonderful friends and you've had accomplishment and happiness and success. You could do worse. When you look back, do you have any obvious regrets?

VT: You can't afford 'em. What good do regrets do you?

JR: Some people live lives based on guilt, on regrets.

VT: I have never been psychoanalyzed, so I have no guilt. I'm a reasonably cheerful character anyway, and absurdly self-confident. Always have been. As a child I was. I'm not afraid of anything. I walk around anywhere at night alone. I don't *remember* to be afraid. And if I see a funny character, then I look straight ahead. I don't invite notice. So far nothing unpleasant has happened to me. But you can never tell if you'll be the next to be mugged. I think I've been extremely fortunate to have a quite good brain, and a quite good ear, extremely good health, and a fair disposition. Actually, the composers of my age and group, at least those who have survived, have all had perfectly nice lives — like Roger

and Aaron and Piston and Roy Harris. And the next group along: Dello Joio and Sam Barber and Gian-Carlo. They have perfectly good lives. But the way to look like a success in the modern world of course is to complain about everything and make yourself a martyr. Nobody wants *too* many successful characters around.

From *Parnassus: Poetry in Review,* Spring/Summer 1977.

✌ Diana Trilling: An Interview with Virgil Thomson

DIANA TRILLING: I am doing an oral history of the advanced literary-intellectual culture of New York City between 1925 and 1975,* and what I want to talk about with you, Virgil, is the relation of music to that world. I define advanced literary-intellectual in a rather arbitrary way. I have in mind a small group of periodicals that were, it seems to me, definitive of the way that advanced intellectual opinion was created and disseminated in the period I'm dealing with: *Partisan Review, Commentary, The New Republic, The Nation, The New Masses* in the late twenties and thirties, *The New Leader, The Reporter* while it was in existence. Then later there is *The New York Review of Books,* of course. That's where we'll perhaps find that the musical aspect of New York artistic life was most recognized by literary people. Do you think of other magazines I've left out?

VIRGIL THOMSON: Well, I lived in Europe for a great many of those years, and one read *Horizon* in the days when it was subsidized by Peter Watson and edited by Cyril Connolly, which was a quite bright literary and even political magazine.

DT: How much American stuff did it have?

VT: I don't think it had much. But literary and political advanced movements weren't limited to America. Eliot had his own paper called the *Criterion,* and there were half a dozen or more very good French magazines at that time. Living in France, I read them.

* The series, when completed, will be on deposit in the Oral History Department of the Columbia University libraries.

DT: Did you know that *Partisan Review* published some of Eliot's *Four Quartets*? He sent at least one of the *Four Quartets* to *Partisan Review* but that may have been after the *Criterion* stopped publishing in 1939. "The Dry Salvages" was 1941 and "Little Gidding" was 1942.

VT: *The Dial* had published *The Waste Land* back about 1922. They gave it a prize, I believe, or some sort of award.

DT: When you think of the advanced intellectual life of America between 1925 and 1975 who first comes to your mind, Virgil? Among Americans, that is.

VT: Resident in America?

DT: No, native to America even if they were resident abroad.

VT: Well, my closest association during those years was with Gertrude Stein. I knew Ezra Pound and I read early Eliot — I never went too far with him. I'd like to point out, though, as we go into the intellectual life, particularly the poets of high repute, that whereas the magazines you mentioned tended to be liberal in politics — that is to say, modified socialist — the most celebrated and probably the most advanced poets of the time — Eliot, Stein, Pound, Yeats — were all conservative to reactionary in their politics. And the same holds for the French. Claudel, who was a Catholic convert, and Cocteau, whose family was well-to-do, were politically to the right. The surrealists were Marxists without being members of any party. They were put on the spot in 1928 by the Communist Party: either join up or stop talking Marxism, and they refused both. I think two of them left the surrealists at that time and did join the Party, Tristan Tzara and Louis Aragon. And there were two real Trotskyites, Benjamin Péret and René Char. The rest were more or less like our American liberals, only a little more extreme because they were trying to blend Marx with Freud and at the same time to take a classical French proto-revolutionary position, that of insulting everybody and everything. Subversiveness was their ideal and their program. There was nothing like that going on here except in the Communist Party itself.

DT: It was politically programmatic in this country but artistically programmatic in France, is that it? But tell me, you name these names and we're immediately very remote from the names which come to people's minds in writing about the thirties. They talk of Pound, Eliot, Joyce, Lawrence as the influential bridge generation between the nineteenth century and the twentieth century, but their twentieth century doesn't begin with the people you've mentioned. Particularly a person like Gertrude Stein is seldom spoken of.

VT: You see, Eliot was considerably younger than Stein, and Pound was a little bit younger. Gertrude was born in 1874. That puts her back with the musical masters like Ives and Schönberg, in that part of the nineteenth century when people really were radical.

DT: What about Stravinsky? You'd certainly think of him as having

been powerfully influential in the music world, but it wasn't until suddenly when Auden started to write libretti for him and when *The New York Review of Books* got Craft to write for him and about him —

VT: I preceded him in *The New York Review*.

DT: — that Stravinsky was all at once voted into our literary-intellectual culture. Do you recognize what I'm saying when I say that?

VT: Yes, but he'd had similar relations with the French literary world.

DT: Who were the people in the literary world of France that he associated with?

VT: He had collaborated on several musico-dramatic works with Jean Cocteau, for instance; and with André Gide, when he started writing to French texts. He had composed in Russian almost exclusively, I would say, up to about 1925–6–7. Then he tried French, and then French translated into Latin. The latter was successful in *Oedipus Rex. Perséphone*, in French, was less so. He was afraid of French, afraid of making errors of prosody in a language which is so rigidly governed by its living grammarians and writers. He spoke German perfectly well but he never composed in it, and German was unfavorably viewed in those days anyway, on account of World War I. And he put a few phrases of Hebrew into a Latin cantata after the next war. He came to setting English late in life. Stravinsky's high point as a member of the intellectual community took place, I presume, with his giving the Charles Eliot Norton lectures at Harvard, which he read in French. They were actually composed by a musician, Roland-Manuel, and a good deal of the philosophic thought in them about esthetics was the result, if I am not mistaken, of Stravinsky's conversations with a Swiss philosopher named Ramuz; but the actual writing, I believe, was done by Roland-Manuel. He was a good writer and a good friend of Stravinsky's and he could see that it came out in proper French, which the old man could pronounce quite well.

DT: He was already an old man when he gave the Norton lectures?

VT: I'm just referring to him affectionately as the old man. In the music world one used to refer to Toscanini also as "the old man."

DT: When were Stravinsky's Norton lectures?

VT: In 1942, and he was born in 1882.

DT: So he was a young man in his sixties.

VT: He was under sixty when he wrote them.

DT: Were Stravinsky and Gertrude Stein close?

VT: I don't think they knew each other. They may have met casually, but Gertrude didn't frequent music circles.

DT: Weren't you a bridge?

VT: Well, Stravinsky had certain literary friends, but if he went out of music circles or Russian circles — which were his background — he went into the elegant world, introduced by Jean Cocteau and Cocteau's friends, and by Diaghilev. Diaghilev frequented the elegant world to get

money for his ballet seasons and the elegant world — some of it — gave him money for the ballet seasons in return for access to the dancers. They could have the dancers at their parties and sometimes in their beds. Before World War I the elegant world described by Proust didn't receive artists, and after World War II the elegant world in France no longer received artists. But between the wars it did. Now it's gone back to money and yachts. And nobody of course now has to have dancers in order to get sexual exercise.

DT: When did you first meet Gertrude Stein?

VT: It was, I think, in January of 1926. I had been reading Gertrude Stein since my college days, since 1919, shall we say. I discovered *Tender Buttons* in the Harvard library, and a few years later there came out a volume published in Boston at her expense — something I never knew at the time — called *Geography and Plays*, a much larger selection of work, although not as intensely concentrated as *Tender Buttons*.

DT: What about *Melanctha*?

VT: That was a much earlier piece, and I never saw it until later. It wasn't easy to lay your hands on. It had been published in England and languished there until Gertrude began to be a little more famous in Paris, through the publications of Robert McAlmon and with Hemingway's help. At that point I think *Three Lives*, which contained *Melanctha*, came out in an American edition.

DT: I think it was about 1929 or 1930 when I first came across it. It may have been published well before that. Virgil, you speak of Hemingway's having promoted Gertrude Stein's work. But for my literary generation in New York Gertrude Stein existed chiefly as the person who told Hemingway that his was a lost generation. Or maybe as the person who had collected and first appreciated Picasso.

VT: That places you as being a little younger than I, then.

DT: A little younger.

VT: In Paris in the middle twenties it was felt that Hemingway's success was largely due to Gertrude's help because she read his manuscripts and encouraged him. In return he proofread the whole of her *The Making of Americans* as it went through the press. They did each other professional favors and were very close.

DT: When you and Gertrude Stein met in 1926 did you feel that you were meeting each other as fellow Americans, as fellow expatriates?

VT: Americans living in Paris never thought of themselves as expatriates. *Expatriate* was a dirty word used by the home folks who couldn't live abroad. If they were too rich to live abroad, or too middle class through having to earn money for wife and children by teaching in a college or something, they called us expatriates. We thought we were just Americans living in another country, in the same way that people lived in Italy or China or Turkey or India without being called expatri-

ates. Expatriate was only applied to the Paris group. And, by the way, the term "the lost generation" is a mistranslation into English. It was *une génération perdue*. A man who manufactured things down in the country where Gertrude lived in the summer said to her after the war that the French boys who had spent four years in the army came out a little too old to be apprenticed to a trade, a *métier*, and so, he said, they were a lost generation — "ils sont tous une génération perdue"; that is to say, *perdue* for the trade or profession. Now if he had meant that they were in any way spiritually or psychologically lost, the French would have been "une génération *de* perdus," in the plural. But these were simply a generation lost to shoemaking or whatever. They had skipped four years. When Gertrude Stein said to Hemingway and some young people one evening, quoting her friend down in the country, "Oh, you are all a lost generation," she knew perfectly well what lost generation meant in French, but she was also perfectly capable of stimulating them by the possible double meaning in English. Yet at the bottom of her mind she considered them a lost generation in the French sense, that they had fought a war and then had come to live abroad so that really about all they could do was journalism. They were lost to scholarship or research or really advanced literary work.

DT: I've never heard that explained. It's terribly interesting. But to go back: When you and Gertrude Stein first got to be friends, you didn't think of yourselves as expatriates but as Americans living in France.

VT: As I remarked in a book of memoirs I wrote later, I went to Gertrude Stein's one evening with George Antheil, being invited by George. Actually he was afraid to go alone. She didn't care for George very much, but she had been curious about him because he was a protectorate of Joyce. And I remarked in my account that Gertrude and I got on like Harvard men. We loved the whole Harvard affair, and we had both loved World War I. We talked about it constantly.

DT: Many writers I have known refer to the people who stand in back of their typewriters when they write a piece. They mean the audience to which they direct themselves. When you and Gertrude Stein worked together, or even when you worked separately, were you writing for Americans and Europeans, or were you writing primarily for Americans?

VT: Well, you don't write music for one country.

DT: A writer is likely to have a particular audience in mind, maybe a group of friends — five, eight people — and he thinks that if those people like what he's done, then he'll have done what he set out to do.

VT: Stein once said, "I write for myself and strangers," and I think Joyce did exactly that too. Eliot I wouldn't be sure about because, again to quote myself, "Between the idea and its realization comes always the shadow of his education." With Eliot, somewhere in the back of his

mind, he had to please Irving Babbitt or some such professor of Comp. Lit.

DT: Well, there's also something else. When you say that, I think not of his pleasing Irving Babbitt or whoever it was at Harvard, but of the fact that he had in back of him Mark Twain and the Mississippi River; he had an idiom available to him of this magnificent concreteness. Wherever he carried this intellectually, it had been given him by Mark Twain, an American, and you don't find it in any of the English writers. But Eliot has it straight from his American background, and it would be my guess that Gertrude Stein had it in just that sense too. She had that wonderful commonplace idiom.

VT: And she had read all of Mark Twain. Mark Twain and Henry James were her forebears.

DT: Now this is what I'm trying to get at. She was an American writer and stood in a tradition. She had a very clear awareness of her American literary heritage. Did anybody coming after her in the New York literary world that I am dealing with have a sense of her place in that heritage?

VT: I don't know whether they ever sensed her place in it, but believe me, the most successful and widely admired American poets of, say, around thirty-five to forty-five today — John Ashbery or Frank O'Hara, Kenneth Koch, that particular trio and even the San Francisco group, although there were other influences out there — all reflected Stein's literary methods. With Ashbery I am particularly aware of what you might call the late manner of Gertrude; it appears in a long poem of hers called *Stanzas in Meditation*, which again — the sound of them, the feel of them — are modeled on Shakespeare's sonnets. But you can't put your finger on the meaning very easily, and I find John Ashbery very closely resembles Gertrude in his manner.

DT: Do you think he would acknowledge that?

VT: He knows it, I think, but I wouldn't ask him to admit it.

DT: If I think back to roughly her age group among influential American poets, of course the first name that comes to my mind is William Carlos Williams. The next generation all said they got their American speech from him. They don't mention Stein.

VT: They got from him the courage to use the kind of speech they knew. He didn't give them a vocabulary.

DT: They got their vocabulary out of something way in back of him in the American past.

VT: Well, the courage to use your own grass roots is the big American acquisition, if you can make it.

DT: One of the things that really interests me is that here in Stein we have a key figure in the American tradition who's never been given her

due in the advanced literary world. To my knowledge there has never been a serious essay about Gertrude Stein in any of the literary journals. Am I mistaken about that?

VT: There are a couple of quite serious books. There's one by Donald Sutherland, from Princeton and Colorado, and one by a man named Richard Bridgman, from California.

DT: Oh, of course scholars have worked on her, and I'm sure her papers are very valuable to scholars, but that's not what I'm talking about.

VT: But you see, Gertrude is much harder to explicate than her rival Mr. Joyce. Picasso said of Joyce, "He's an obscure writer that everybody will end by understanding." Well, as he said that, a man named Sherman or something was writing a whole concordance of *Ulysses*, so *Ulysses* was explained, and *Finnegans Wake* was about to come out and it too is reasonably clear, if you do your homework, whereas there are many passages in Gertrude Stein that resist explication. And don't forget that the ideal of the obscure artists — Picasso himself — was to conceal the message. The same with Mallarmé in French poetry. The ideal of obscurity is to produce something that will forever remain obscure. That's very hard to achieve, something you won't understand even thirty years later.

DT: With many obscure works you not only learn to understand them but pretty soon they become part of your received ideas, of your received culture. Did Gertrude Stein formulate a theory of the obscure? Consciously, I mean? Or did she just work that way?

VT: No, no, she had theories. Don't forget that she was very elaborately educated in psychology and medicine, and when she had really mastered the obscure thing with *Tender Buttons*, she described it by saying, "This is an effort to describe something without naming it," which is what the cubist painters were doing with still life.

DT: But it's also what musicians are always doing.

VT: Well, I got myself into a lovely little — shall we say controversy — with André Breton, by pointing out that the discipline of spontaneity, which he was asking his surrealist neophytes to adopt, was new for language but something that composers had been practicing for centuries.

DT: Of course you must always have been aware of this. But now let's get back to New York.

VT: Well, I had been back and forth a little bit in the thirties and in the twenties, but I came back to work here in the fall of 1940, some time after the fall of France. I had spent the first year of the war in France, and then the next year I found that I couldn't be of any use to my French friends and I couldn't make any money, so I came back to New York on borrowed money, and fell into writing as chief music critic of the *Herald Tribune*. I had previously written a number of articles for magazines, particularly a quarterly called *Modern Music*, and I had published a

book in 1939 called *The State of Music*. It was on that evidence that I could write that I was offered the job, because of course reviewing music or reviewing anything is a writing job. It's nice if you are experienced in the field you are writing about, but writing is what you are doing.

DT: Well, as a composer you had been close to certain very distinguished writers when you were living in Paris. Now that you were back in America, writing for a living, did you feel connected either as a composer or as a writer with the literary community of New York? So to speak, the cream of the New York literary community?

VT: What you're assuming to be the cream of the literary community in New York — and you may very well be right — was largely a Jewish cream, and the Jewish cream wasn't too favorable to me as a *goy*. And at the age of forty-five I didn't very much like elbowing my way into the literary world other than by my writing. I had many friends there. Individually, I could be chummy and happy with them. But of course in literature as in music there was a kind of Jewish Mafia that passed the jobs around among themselves.

DT: I'd like you to talk about this very specifically, if you wouldn't mind.

VT: I had previously seen in New York during the early twenties and before — and this continued — that there was a German Mafia. The German musical community, which was the governing body in American music before and during World War I, was not too happy about the rise to favor of French music and, even more dangerous to them, the adoption at Columbia and Harvard of a French pedagogy. The music world in New York was still governed by German and German-educated musicians. I won't say they were not in many cases Jewish, like the Damrosch family, but it was their Germanness which was the source of their solidarity. They didn't like the idea of the Boston Symphony Orchestra having a French conductor, Pierre Monteux, and they managed, by dirty cracks and underground dealings, to see that he didn't sell out in New York when the Boston Symphony came here. It sold out in Boston and everywhere else on tour, but not in New York. Consequently, at the end of five years Monteux was let out, and Serge Koussevitzky was employed. Serge Koussevitzky was not German, but he was Jewish and that helped, and as we were getting on into the twenties, Jewishness was approaching the sacred status that it acquired in the 1930s with persecution and martyrdom.

DT: You say that Monteux could not sell out his New York concerts but —

VT: In spite of the fact that he was Jewish. You see, his Jewishness didn't count. It was the fact that he was French and not German that mattered in the early 1920s.

DT: Were there namable individuals who subverted that enterprise? Agencies?

VT: Oh, no, no, no.

DT: Critics? Who was doing it?

VT: The important establishments, which were the Institute of Musical Art here on Claremont Avenue, which was established by Walter Damrosch's brother Frank, and whose chief pedagogue in musical theory and composition was Percy Goetschius, a very learned German-American. The German pedagogy of composition had lost its footing during World War I. The teachers at Harvard and at Columbia who were already using French methods were there before World War I, like Archibald T. Davison and Edward Burlingame Hill and Daniel Gregory Mason at Columbia, but they would not necessarily have been able to implant a new pedagogical method, except that the whole power basis of German groups came from their Germanness. Once we got into a war against Germany, Germanness became something they couldn't really talk about or organize too much. Before World War I, people went to Munich to study painting just as often as to Paris, you know. Of course, after World War I not only had Germany lost credit with the intellectual world, but Germany was impoverished, and continued to be so for a number of years, so that Germany could not receive students. After World War II Germany had been impoverished intellectually because Hitler had destroyed the musical movement and much of the other intellectual movements by his anti-Jewish policies, and anti–Social Democratic policies, although the victims of this last were less numerous, certainly less well known to us all, than the Jewish victims. So the preparation between the two wars — of the twenties, shall we say, and early thirties — for a new and stronger American literary and artistic development was further enriched by the German immigration of the thirties. By the time World War II was over, we had a new German establishment. But this is a German-Jewish establishment, conscious of being Jewish, not so conscious of being German — it takes German for granted — but very anti-French.

DT: Virgil, you came back to America and New York at a moment when the influence of the radicalization of the thirties was still very strong despite the considerable ground that had been lost by the Communist Party in the Nazi-Soviet Pact.

VT: Yes, but our joining the war . . .

DT: Yes, of course, we were an ally, and that made it all right again. How did this manifest itself in your personal experience in the musical world?

VT: Well, I was much closer to the warfare that took place in and around the Communist Party in the middle thirties than I was later. I was in the Federal Theater. I was in America, you see, from 1934 through 1935 and 1936. And the Communists were a legal party; they ran a can-

didate for president in 1936. Every union had Communist cells, and if I complain about the Jews squeezing me out, believe me the Communists would squeeze you out much worse.

DT: This is very hard for people to believe today. They think of Communists as a handful of innocent liberals who existed only to be persecuted by McCarthy in the fifties. They can't believe they were the cultural power they actually were.

VT: New York was Stalinist. The Trotskyite center was Boston and, for union matters, Minneapolis.

DT: Yes, the Trotskyites had the transport workers in Minneapolis; that was their one strong union, the only one they really controlled. But they had great power in New York in the intellectual world. They formulated the dissident theory.

VT: Trotsky was a far more intelligent intellectual than Stalin, and probably even than Lenin. He was very verbal.

DT: How were you able to work as comfortably as you did, when you weren't a Stalinist, with all these Stalinists who were around you? What was your method?

VT: The same way I worked with Jesuits. I get on beautifully with Jesuits. I don't get along with Dominicans very well; I find them tricky . . .

DT: Now I want to go to the forties for a minute. When you were writing for the *Herald Tribune,* earning your living as a writer, did you feel that you were part of the New York intellectual community and that you had a natural place in it?

VT: My fan mail told me that I did. I didn't seek to join the intellectual gatherings. Heaven knows I had enough to do to carry on my own musical life and my journalistic work.

DT: You didn't have a sense that the intellectual life was a coterie life?

VT: Oh, I did indeed.

DT: But you said, "I'm going to fight that." Is that the idea?

VT: I wasn't fighting it; I was just by-passing it.

DT: Did you know that at some time — I believe it was in the fifties — Robert Lowell and William Meredith were given fellowships or grants or something to go to the opera all the time in the hope that they might write libretti for operas?

VT: These were the Metropolitan's ideas, yes.

DT: This came in response to a sense that there was a great rift between poets and composers.

VT: There was a rift between poets and the opera, not between poets and composers. Poets' poetry is the best evidence. It's been set to music frequently by very good composers. But poets lost touch with the opera in English back in the seventeenth century. The poets that you and I have

known, and even their predecessors for fifty or one hundred years, were
so completely egocentric, so interested in their own position in the ideal
world, that they couldn't write a dramatic thing, because they couldn't
keep themselves out of the play. That was the trouble with Auden's
early work. Of course Auden had no real sense of the theater anyway,
but he did a few pieces with Isherwood, who had a tiny sense of the
theater. Auden never could do much with those early works; he would
never have gotten into the translation and libretto business — and he
wrote several librettos, as a matter of fact, for very good composers —
if it hadn't been for Chester Kallman. Vulgar as Kallman's mentality
was, he knew what a stage was.

DT: Could we talk for a moment about Marc Blitzstein's work? When
he became a Stalinist, did you feel that he was using musical composi-
tion effectively for social purposes?

VT: His most effective work was his big Commie opera, or *Singspiel*,
The Cradle Will Rock. Oh, yes. And that he did within a very few
months after his wife Eva's death, as a kind of homage to her and her
teaching, and to Kurt Weill, because the Kurt Weill German operas,
which had been made with Brecht, were Communist morality plays.

DT: Did you have a sense that the Brecht-Weill team was doing very
much in terms of influencing people? Were they influential when their
work was first done here?

VT: I was present at all that, and I knew Weill from Europe. He post-
poned his influence deliberately, because he no sooner arrived than the
whole world of music, including Broadway, wanted to use him. He had
a little operation to do, which was to sever all his Communist connec-
tions, so he cut off the Brecht friendship, he cut off the collaborations,
he wouldn't let his wife appear in any major role on the stage. He just
sat this out; he prevented me from producing *Mahagonny* at Hartford.
When we first spoke about it, he kept saying, "Yes, yes," but then he
arranged so we couldn't do it.

DT: *Mahagonny* didn't begin to have any effect upon people in this
country, to my knowledge, until the mid-fifties.

VT: No. Weill became a model of show writing to show writers very
early. In the early forties Dick Rodgers said to me that obviously Kurt
Weill was a remarkable composer of great charm and great ability. "And
don't you admire him?" says he. I said, "Indeed I do. As a matter of
fact, he's the only writer on Broadway who knows how to write a finale."
And Dick Rodgers said, "What's a finale?" You see, Victor Herbert knew
what a finale was. But there were no finales in Rodgers's time.

DT: Did your world of musical composition and idea have a natural
connection with the world of Rodgers and Hammerstein, people like
that?

VT: Our connection was as colleagues, and they were nice fellows. As

a matter of fact, for thirty to thirty-five years I've been sitting on boards and committees with those popular writers in ASCAP and having a wonderful time, because they are loyal colleagues and intelligent people, and we are all in show business. They respect me, I respect them.

DT: In other words, you never had to make the kind of conscious effort that has had to be made among writers to bring into some kind of coherent association the ideas of high and popular art?

VT: I don't know. The writers were very early to like Ring Lardner. And before World War I, George Ade. *Fables in Slang* had a high repute as literature.

DT: Well, Mark Twain wrote in the tradition of the folk humorists, and of course Constance Rourke was very powerful in establishing the concept of American folk humor. But I think there's a slight condescension involved in this. I don't think there was an easy acceptance even of Ring Lardner among intellectuals.

VT: The idea of a group of intellectuals who are liberal in politics and presumably tolerant in art has an integral and important connection with art and music as well as with literature. It has a connection with literature because they are all writers, it's all words. But the magazines that you mentioned have never had very much space for music or a very professional approach to it.

DT: What I am trying to say is that, from where I'm sitting, music was peripheral, it wasn't a concern of the intellectual community in the way that literature was. Neither was painting, though painting was more connected.

VT: Not necessarily. Both eye people and ear people were separate.

DT: Many writers whom I've known in this community which I've lived in most of my life have been so ignorant about music that it's absolutely appalling. They're often more intelligent about painting, but about music they're ignoramuses. They'd be ashamed to be that ignorant about anything else.

VT: Joyce considered himself a musician and he could sing. He used to come to my concerts. Gertrude would come to my concerts simply because they were mine. Gertrude didn't enjoy music or have any particular sense of it. Brought up in a well-to-do Jewish family, she had gone to symphony concerts and the opera as a girl, but it didn't take. And afterward she always said music is for adolescents. Alice Toklas was a musician. She had a real education, and she played a piano concerto once with an orchestra. She could read a score and all that, but Gertrude just liked being put to music. I don't think there's any music in Eliot. There was a bit in Pound; he actually wrote an opera on a text of Villon in old French, which he knew quite well.

DT: And who did the music?

VT: Pound.

DT: He knew music enough to write an opera?

VT: He could prosodize the vocal line and write it down, then he would add a little bit of counterpoint or a bass note here and there to make it a little fuller. He was not really trained in harmony, but he knew how to write down a prosodized vocal line. That he would do himself. So he took the text — with some cutting — of the *Testament* and made an opera out of it. I heard it. He had very good singers. It's not a musician's music, but it may very well be the best poet's music since Campion.

DT: In the days when there was so much Communist domination of the musical and intellectual community, was there actually a great deal of stress upon music as an instrument of propaganda, just as there had to be socialist realism in painting? You know Prokofiev's *War and Peace*, and the way it gets progressively worse as the opera goes on, and becomes more and more propagandistic.

VT: Well, he may have been getting ill too, because his illness was a progressive one; it was not an instantaneous stroke. I don't know whether you saw a book that was written by John Houseman, who produced plays for the Federal Theater and later the Mercury Theater, all during the thirties. He was very active. He mentions there what I knew perfectly well at the time, that you really couldn't do anything in the theater in New York without asking a certain commissar in charge of intellectual matters. His name was Jerome, and Houseman will tell you all about him. He was a sort of *éminence grise* who could stop things. He could pull the union workers off the show if he didn't find it acceptable ideologically.

DT: Did you yourself have much to do with the Mercury Theater?

VT: Nothing at all. I left the association before they formed that. I was with John Houseman and Orson Welles when we started the first of all the Federal theaters, which was the Negro one in Harlem, the Lafayette.

DT: This is probably *lèse majesté*, but I've always thought that *Citizen Kane* was one of the most overestimated things that was ever done.

VT: I've never seen it. But my view is that Welles couldn't touch the theater without magic taking place. The same is true of Jean Cocteau. He often had silly ideas, but the theater came to life the minute he was there. So from the point of view of the gift, the talent, the operation, it was wonderful. And Orson could do it. He was still in his teens when he started, you know. He was done before he was twenty-five. And he could do it on radio, and he could do it with actors; he could do it with movies. He knew how to handle a camera; he knew about angles; he knew how to tell a story; he knew good from corny dialogue. Orson was an all-purpose theatrical genius with the most beautiful bass speaking voice that ever has been heard. He lived his life in his career. And that lasted from nineteen to twenty-five.

DT: Would you say something about the role of the newspaper critics and the magazine critics of music in the last ten years: Has it changed?

VT: No.

DT: Just the same as it always was?

VT: Hasn't changed in fifty years.

DT: You don't feel that there has been a deterioration of standards?

VT: I think *The Times* has a better staff than it's had in a very long time.

DT: Are you kidding?

VT: And if you read *The New York Times* music reviews back in the 1900s — they were very spotty. Carl Van Vechten worked there for a few years, but mostly they were stuffed shirts. My colleagues on *The Times* were Olin Downes and Noel Strauss, both of whom were musicians and could write perfectly well. Beyond these two they were not musicians for the most part. Today I think they are all musicians.

From *Partisan Review*, no. 4, 1980.

❧ Bibliography of Published Writings by Virgil Thomson

Books

1939 *The State of Music*. New York: William Morrow, 1939 (reprint: Westport, Conn.: Greenwood Press, 1974); 2d ed., rev. with new preface and postlude, New York: Random House, 1962.

1945 *The Musical Scene*. New York: Alfred A. Knopf, 1945 (reprint: Westport, Conn.: Greenwood Press, 1968). Selected writings from the *New York Herald Tribune*, 1940–1944.

1948 *The Art of Judging Music*. New York: Alfred A. Knopf, 1948 (reprint: Westport, Conn.: Greenwood Press, 1969). Selected writings from the *New York Herald Tribune*, 1944–1947.

1951 *Music Right and Left*. New York: Henry Holt, 1951 (reprint: Westport, Conn.: Greenwood Press, 1969). Selected writings from the *New York Herald Tribune*, 1947–1950.

1966 *Virgil Thomson*. New York: Alfred A. Knopf, 1966; London: Weidenfeld and Nicolson, 1967 (paperback reprint: New York: Da Capo Press, 1977).

1967 *Music Reviewed, 1940–1954*. New York: Random House, 1967. Selected writings from the *New York Herald Tribune*, 1940–1954.

1971 *American Music Since 1910*. New York: Holt, Rinehart and Winston; London: Weidenfeld and Nicolson, 1971. Paperback: New York: Holt, Rinehart and Winston, 1972.

Selected Articles, Reviews, Essays, Interviews, Addresses

(not including articles and reviews from the *New York Herald Tribune*, 1940–1954)

1924– "Jazz," *The American Mercury*, August 1924.

1929 "Admit," a poem, in *The Gad-Fly* (publication of the Student Liberal Club of Harvard University), April 1925.

"How Modern Music Gets That Way," *Vanity Fair*, April 1925.

"The Satirical Tendency in Modern Music," *Vanity Fair*, May 1925.

"The Cult of Jazz," *Vanity Fair*, June 1925.

"The Profession of Orchestra Conducting," *Vanity Fair*, August 1925.

"The Future of American Music," *Vanity Fair*, September 1925.

"On Wooing the Muses," *Vogue*, September 15, 1925.
"The New Musical Mountebankery," *New Republic*, October 21, 1925.
"Enter: American-made Music," *Vanity Fair*, October 1925.
"Music and Economics," *Vanity Fair*, December 1925.

1930– "Aaron Copland (American Composers — VII)," *Modern Music*, Jan-
1939 uary 1932.
"Igor Markevitch, Little Rollo in Big Time," *Modern Music*, November 1932.
"Home Thoughts," *Modern Music*, January 1933.
"Now in Paris," *Modern Music*, March 1933.
"A Little About Movie Music," *Modern Music*, May 1933.
"Most Melodious Tears," *Modern Music*, November 1933.
"Paris News," *Modern Music*, November 1933.
"Composition and Review," *New York Times*, March 11, 1934.
"Socialism at the Metropolitan," *Modern Music*, March 1935.
"George Gershwin," *Modern Music*, November 1935.
"Swing-music," *Modern Music*, May 1936.
"The Official Stravinsky," *Modern Music*, May 1936.
"In the Theatre," *Modern Music*, January 1937; March 1937; May 1937; January 1938; March 1938.
"Films Seen in New York," *Modern Music*, May 1937.
"Swing Again," *Modern Music*, March 1938.
"French Landscape with Figures," *Modern Music*, November 1938.
"More from Paris," *Modern Music*, January 1939.
"More and More from Paris," *Modern Music*, May 1939.

1940– "Paris, April 1940," *Modern Music*, May 1940.
1944 "Chaplin Scores," *Modern Music*, November-December 1940.
"Music in Films, A Composer's Symposium," *Film, A Quarterly of Discussion and Analysis*, Winter 1940.
"Composing for the Movies," *National Board of Review of Motion Pictures Magazine*, January 1941.
"The Criticism of Music," *Musical America*, February 10, 1941.
"Music," *Mademoiselle*, January 1943.
"The Music Flows with the Stream," *Saturday Review*, January 30, 1943.
"I Say It's Music . . . Hot," *Vogue*, February 15, 1943.
"America's Musical Autonomy," *Vanderbilt Alumnus*, March 1944.
"Equilibrium of the Musical Elements," *New Friends of Music Program Book* (1944–45).
"Music," *Mademoiselle*, May 1944.

1945– "About Taste in Music There Should Be Dispute," *Town and Coun-
1949 try*, February 1945.
"Being a Musician," *The Peabody Notes*, Spring 1945.
"Looking Forward," *Musical Quarterly*, April 1945.
"Music, Music Everywhere," *Cosmopolitan*, May 1945.
Review of Samuel Barber's Second Essay for Orchestra (published ed.), *Music Library Association Notes*, June 1945.
"A Guide to Contemporary Music," *Vogue*, July 1945.
"Processed Music," *Music Publishers Journal*, September-October 1945.
"Books and Plays Prosper in Paris," *International Herald Tribune* (Paris), October 1945.

"La Nouvelle Musique en France, aux Etats-Unis et en Russie," *Ving-tième Siècle*, October 18, 1945.

"Paris," *Town and Country*, February 1946.

"Singing To-day," *The Musical Digest*, August 1947.

"Putting 'Space' into Opera Recordings," *Saturday Review*, August 30, 1947.

"Is Reviewing Fun?" *Harper's*, November 1947.

"The Art of Judging Music," *Atlantic Monthly*, December 1947.

"Answers by Virgil Thomson," *Possibilities*, Winter 1947/48.

"Ist Musikkritik ein Amusanter Beruf?" *Neue Auslese*, February 1948.

"The Last Time I Saw Kansas City," *Junior Bazaar*, March 1948.

"High Costs," *Music Journal*, November-December 1948.

"Gertrude Stein Portrayed by an Old Friend," review of W. G. Rogers, *When This You See Remember Me* (New York: Rinehart, 1948), *New York Herald Tribune Weekly Book Review*, July 11, 1948.

"Ideas to Watch in Music," *Vogue*, January 1949.

"A Critique of Criticism," *Vogue*, March 1, 1949.

"Amerikanisches Divertimento," *Der Monat*, March 1949.

1950–
1952
"Foreword," in E. Robert Schmitz, *The Piano Works of Claude Debussy*. New York: Duell, Sloan, Pearce, 1950.

"Foreword," in Victor I. Seroff, *Rachmaninoff*. New York: Simon and Schuster, 1950.

"Current Chronicle, San Francisco," *Musical Quarterly*, January 1950.

"Three Essays," *The Score*, January 1950.

"Three More Essays," *The Score*, January 1951.

"Why Bach Festivals?" 13th Annual Herald Tribune Fresh Air Fund football program, September 20, 1951.

"How Modern Can You Be?" Program Book of the Boston Symphony Orchestra, 72nd Season, 1952–53.

"Notes sur les Perspectives du Ballet et de l'Opéra en Amérique," *La Revue Musicale Numéro Spécial: L'Oeuvre du XXᵉ Siècle*, April 1952.

"El Compositor como Crítico," *Buenos Aires Musical*, December 15, 1952.

1953–
1959
"Preface" and notes, in Gertrude Stein, *Bee-Time Vine and Other Pieces [1913–27]*. New Haven: Yale University Press, 1953.

"The Critic and His Assignment," *Toronto Royal Conservatory Monthly Bulletin*, January 1953.

Review of Erik Satie's *Socrate* (recording), *Musical Quarterly*, January 1953.

Extracts from "The Critic and His Assignment," *Magazine of Arts* (Pittsburgh), May 1953.

"The Music Reviewer and His Assignment," *Proceedings of the American Academy of Arts and Letters and the National Institute of Arts and Letters*, 1954.

"Komponist und Kritiker," *Melos*, September 1954.

"The Music of Scandinavia, 1954," *American Scandinavian Review*, Winter 1954.

"Introduction," in Robert Erickson, *The Structure of Music: A Listener's Guide*. New York: Noonday Press, 1955.

"Etats-Unis," *Inter-Auteurs*, 1955.

"La Crítica Musical," *Informaciones*, August 1955.

"Interview with Virgil Thomson," *Ritmo* (Buenos Aires), November–December 1956.

"Presentation to Aaron Copland of the Gold Medal for Music," *Proceedings of the American Academy of Arts and Letters and the National Institute of Arts and Letters*, 1957.

"An Inquiry into Cultural Trends," a published report, with direct quotes by VT, of a panel discussion held by The American Round Table at the Yale Club (New York City), May 22, 1957.

"A. Everett Austin, Jr.: A Director's Taste and Achievement," in A. Everett Austin, Jr., *The Friends and Enemies of Modern Music*. Hartford, Conn.: Wadsworth Atheneum, 1958.

"Virgil Thomson on the House of Ricordi," *Music Journal*, March 1958.

"Music — Ending the Great Tradition," *Encounter*, January 1959.

"Tradición e Innovaciones en la Música," *Cuadernos*, January-February 1959.

"Music's Tradition of Constant Change," *Atlantic Monthly*, February 1959.

"From 'Regina' to 'Juno,' " *Saturday Review*, May 16, 1959.

"Music for *Much Ado*," *Theatre Arts*, June 1959.

"La Tradición Musical del Cambio Constante," *Buenos Aires Musical*, December 1959.

1960 "Music for *Much Ado About Nothing*," in William Shakespeare, *Much Ado About Nothing*. New York: Dell, 1960 (The Laurel Shakespeare series).

"John Cage Late and Early," *Saturday Review*, January 30, 1960.

"Music in the 1950s," *Harper's*, November 1960.

"Looking Back on a Decade," *Encounter*, November 1960.

1961– "Music Now," Blashfield Address in *Proceedings of the American*
1964 *Academy of Arts and Letters and the National Institute of Arts and Letters*, 1961.

"Music's Tradition of Constant Change," *Ongakunotomo* (Japan), February 1960.

"Stravinsky — Gesualdo," *New York Times*, September 28, 1960.

"Conversation Piece: Virgil Thomson," *Bravo*, 1961.

"Musical Europe," *Musical America*, January 1961.

"Panorama de la Musica Europea (I and II)," *Correo de la Tarde*, March 7 and 8, 1961.

"Music Now," *Opera News*, March 11, 1961.

"Twain Meet," *New York Times*, April 24, 1961.

"Thomson Answers Helm," *Musical America*, June 1961.

"Toward Improving the Musical Race," *Musical America*, July 1961.

"America's Musical Maturity," *Yale Review*, Autumn 1961.

"Music: Vanishing Intellectual," *Show*, October 1961.

"Recording Some New Notes on the Scale," *New York Times*, December 10, 1961.

"Kansas City 40 Years Ago," *Kansas City Star*, December 18, 1961.

"The Philosophy of Style," *Showcase*, Winter 1961–62.

"The Gallic Approach," *Juilliard Review*, Winter 1961–62.

"Greatest Music Teacher — at 75," *Piano Quarterly*, Spring 1962.

"Opera: *The Crucible* and *The Dove*," *Show*, January 1962.

"The Rocky Road of American Opera," *HiFi/Stereo Review*, February 1962.

"Conversation Piece: Virgil Thomson (II)," *Bravo*, February 1962.

" 'Greatest Music Teacher' — at 75," *New York Times Magazine*, February 4, 1962.

"Music Now," *The London Magazine,* March 1962.

"Igor Stravinsky," *Show,* June 1962. Featured quote in article by Jay S. Harrison.

"*The Flood* — An Opera for TV," *Observer Weekend Review* (London), June 17, 1962.

"Opera: It Is Everywhere in America," *New York Times,* September 23, 1962.

"Sound Off at the Center," *Observer Weekend Review* (London), September 30, 1962.

"Is Kindness Killing the Arts?" *MacDowell Colony News,* December 1963.

"Preface," in Jacques Chailley, *40,000 Years of Music,* trans. Rollo Myers. New York: Farrar, Straus, Giroux, 1964.

"The Greeks Had No Word for It," introduction to David Posner's *Philoctetes* in *The Charioteer,* Spring 1964.

"Then and Now," published report of a symposium at The American Center for Students and Artists, Spring 1964.

"Two Festivals," *G. Schirmer Newsletter,* Winter 1964/65.

1965– "Wanda Landowska," *New York Review of Books,* January 28, 1965.
1969 "How Dead Is Arnold Schoenberg?" *New York Review of Books,* April 22, 1965.

"Neither a Mother nor a Goose," *HiFi/Stereo Review,* May 1965.

"On Being Discovered," *New York Review of Books,* June 3, 1965.

"The Tradition of Sensibility," *New York Review of Books,* December 9, 1965.

"Edgard Varèse, 1883–1965," *Proceedings of the American Academy of Arts and Letters and the National Institute of Arts and Letters,* 1966.

"Prefacio," trans. Julio Cortazár, in Jorge d'Urbano, *Musica en Buenos Aires.* Buenos Aires: Editorial Sudamericana, 1966.

Published letter in Leon Stein, ed., *Twentieth-Century Composers on Fugue.* Chicago: DePaul University School of Music, 1966.

"The Burning Question," *Opera News,* March 15, 1966.

"A Portrait of Gertrude Stein," *New York Review of Books,* July 7, 1966.

"A Distaste for Music," *Vogue,* September 1, 1966.

"The Paper: A Critic's Tale," *Hifi/Stereo Review,* November 1966.

"Comments on the Contemporary Art Scene," *The MacDowell Colony News,* December 1966.

" 'Craft-Igor' and the Whole Stravinsky," *New York Review of Books,* December 15, 1966.

"Strawinsky und 'Craft-Igor,' " *Der Monat,* April 1967.

"Acceptance by Mr. Thomson [of the Gold Medal for Music]," *Proceedings of the American Academy of Arts and Letters and the National Institute of Arts and Letters,* 1967.

"Is Opera Dead? One Man Says No . . . ," *New York Times,* June 16, 1968.

"The Interaction of Vernacular and Formal Music," published transcript of a panel discussion. *Proceedings of the International Music Congress,* 1966.

"The Genius Type," *New York Review of Books,* September 26, 1968.

"Music," in Louis Kronenberger, ed., *Quality: Its Image in the Arts.* New York: Atheneum, 1969.

"What Is Quality in Music?" *New York Review of Books*, June 19, 1969.

"Frederick Kiesler's Opera Sets," *Zodiac: A Review of Contemporary Architecture*, July 1969.

"Virgil Thomson Replies," *New York Review of Books*, September 11, 1969.

"Authenticity," *American Musical Digest*, October 1969.

1970 "Preface," in Herbert Haufrecht, comp., *Folk Songs in Settings by Master Composers*. New York: Funk & Wagnalls, 1970 (reprint: New York, Da Capo Press, 1977).

"Douglas Moore, 1893–1969," *Proceedings of the American Academy of Arts and Letters and the National Institute of Arts and Letters*, 1970.

"Berlioz, Boulez, and Piaf," *New York Review of Books*, January 29, 1970.

"Cage and the Collage of Noises," *New York Review of Books*, April 23, 1970.

"The Ives Case," *New York Review of Books*, May 21, 1970.

"Virgil Thomson Replies," *New York Review of Books*, September 3, 1970.

"The Tenth Muse," *New York Times Book Review*, October 4, 1970.

1971– "Presentation to Martha Graham of the Award for Distinguished Ser-
1977 vice to the Arts," *Proceedings of the American Academy of Arts and Letters and the National Institute of Arts and Letters*, 1971.

"A Very Difficult Author," *New York Review of Books*, April 8, 1971.

"Virgil Thomson Replies," *New York Review of Books*, June 3, 1971, July 1, 1971, October 7, 1971.

"Instruments of Criticism," *Prose*, Spring 1972.

"Scenes from Show Biz," *New York Review of Books*, May 4, 1972.

"Untold Tales," *New York Review of Books*, May 18, 1972.

"Varèse, Xenakis, Carter," *New York Review of Books*, August 31, 1972.

"Where Is Music Going?" *Vogue*, October 1, 1972.

"Eugene Berman, 1899–1972," *Proceedings of the American Academy of Arts and Letters and the National Institute of Arts and Letters*, 1974.

"Schoenberg's Music," *Contact*, Autumn 1974.

"Wickedly Wonderful Widow," *New York Review of Books*, March 7, 1974.

"Making Black Music," *New York Review of Books*, October 17, 1974.

"A Drenching of Music, but a Drought of Critics," *New York Times*, October 27, 1974.

"Stravinsky's Operas," *Musical Newsletter*, Fall 1974.

"Virgil Thomson Replies," *New York Review of Books*, January 23, 1975, May 1, 1975.

Interview by George Wickes, in "A Natalie Barney Garland," *Paris Review*, Spring 1975.

"Looking for the Lost Generation," *New York Review of Books*, February 19, 1976.

"Virgil Thomson Replies," *New York Review of Books*, April 29, 1976.

"Of Portraits and Operas," *Antaeus*, Spring/Summer 1976.

"American Music and Music Criticism," *Otterbein Miscellany*, December 1976.

"Leonid Berman, 1896–1976," *Proceedings of the American Academy and Institute of Arts and Letters*, 1977.

"Virgil Thomson as Virgil Thomson," in *A Salute to Virgil Thomson*, Symposium of the Society for Arts, Religion, and Contemporary Culture, *ARC Papers*, May 7, 1977.

"Introduction to *La Seine*," "A Conversation with Virgil Thomson (interviewed by John Rockwell, music critic of *The New York Times*)," and "Introduction to Jazz and Swing Pieces," *Parnassus: Poetry in Review*, Spring/Summer 1977.

1978–
1979
"Preface," in Leonid Berman, *The Three Worlds of Leonid*. New York: Basic Books, 1978.

"On, Donald Sutherland," *Denver Quarterly*, Fall 1978.

"Entretien avec Virgil Thomson," *Canal*, December 1978.

"Foreword," in Daniel Kingman, *American Music: A Panorama*. New York: Schirmer Books, 1979.

"Letter to the Editor," *Helicon Nine: A Journal of Women's Arts & Letters* (Kansas City, Mo.), Fall 1979.

1980
"A Good Writer," *New York Review of Books*, January 24, 1980.

"It Was Like That," preface to George Wickes, *Americans in Paris*. New York: Da Capo Press, 1980 (paperback edition).

1981
"The New *Grove*," *Notes: The Quarterly Journal of the Music Librarians' Association*, September 1981.

Reviews from the *"New York Herald Tribune"* after 1954

"Olin Downes," Book Review section, January 27, 1957.

"Arturo Toscanini's 'Rightness' vs. That of Bernard Haggin," Book Review section, April 12, 1959.

"Leonard Bernstein Conducts a Stimulating Medley of Essays in Music," Book Review section, November 29, 1959.

"On Good Terms with All Muses," Book Review section, September 8, 1963.

"When the 'Cradle' Was Young," April 19, 1964.

Translations

"The Feast of Love," from the Latin *Pervigilium Veneris*, in *Art and Literature: An International Review*, Summer 1964; also in Virgil Thomson, *The Feast of Love*, for baritone and small orchestra, 1964. New York: G. Schirmer, 1977.

Mass for Two-Part Chorus and Percussion, by Virgil Thomson (1934), trans. from Greek and Latin. New York: MCA Music, 1972.

"Sports and Diversions," trans. from the French of Erik Satie's *Sports et Divertissements* (1914). Paris/New York: Editions Salabert, 1975.

"The Seine," trans. from the French of the Duchess of Rohan's *La Seine*, in *Parnassus: Poetry in Review*, Spring/Summer 1977. Music for voice and piano by Virgil Thomson, 1928.

Dix Portraits, with original English text by Gertrude Stein (*Ten Portraits*) and trans. into French by Virgil Thomson and Georges Hugnet. Paris: Editions de la Montagne, 1930.

❧ Index